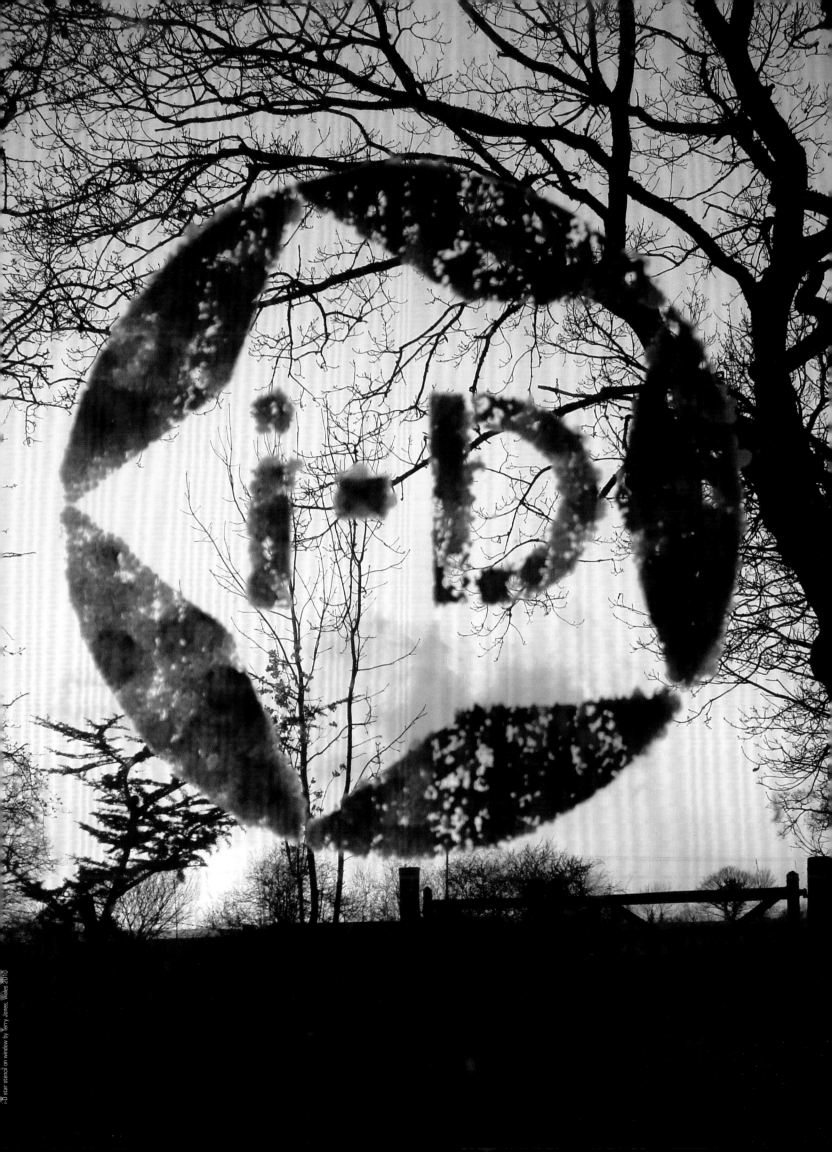

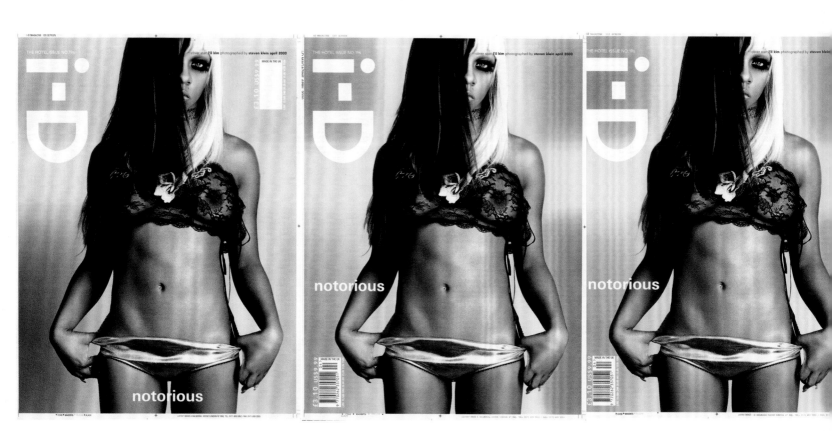

The Hotel Issue, No. 196, April 2000?
I only had half an hour to shoot L'il Kim because even though
she arrived in the morning, she had to have her footbath and
toe manicure, so she took almost fifteen hours to get ready for
the camera and then I shot her for maybe twenty minutes.
Steven Klein, Photographer

TASCHEN

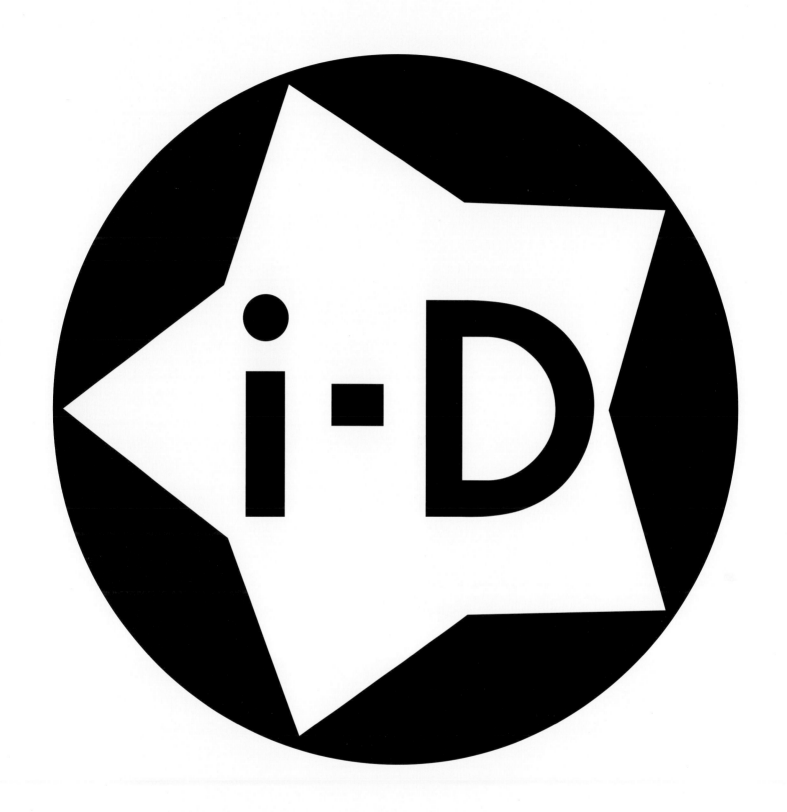

i-D COVERS 1980 – 2010

EDITED BY TERRY JONES & EDWARD ENNINFUL GUEST EDITOR RICHARD BUCKLEY

As with all collaborative journeys, the biggest thank you's go to the contributors; photographers, cover stars, stylists, make up artists and hairdressers who have, over the years, given so much time and passion to making the covers that you'll find within this book. If with the limited time available, we have been unable to track you down, please accept our apologies and let us know where you are and what you're doing now.
We'd love to hear from you.

With a very special thanks to all the sponsors without who's support, this project wouldn't have been possible.

Diesel
Gucci
Italo for Calvin Klein
Margaret Howell
Nike
Paul Smith
Pringle
Raf Simons
Stone Island
Y-3

Imprint
To stay informed about upcoming TASCHEN titles, please request our magazine at www.taschen.com/magazine or write to TASCHEN, Hohenzollernring 53, D-50672 Cologne, Germany; contact@taschen.com; Fax: +49-221-254919. We will be happy to send you a free copy of our magazine, which is filled with information about all of our books.

© 2010 TASCHEN GmbH
Hohenzollernring 53, D-50672 Köln, Germany
www.taschen.com

Editorial coordination: Simone Philippi
Production coordination: Ute Wachendorf
German translation: Clara Drechsler
French translation: Claire Le Breton

Printed in China
ISBN 978-3-8365-2157-4

Contact sheet for The Holiday Issue, No.50, August 1987, Cover Star Sarah Stockbridge, photography Nick Knight.

Roll M

by and available from Better Badges,286 Portobello R'd,

I.D. Is a Fashion/Style Magazine.Style isn't what but how you wear clothes. Fashion is the way you walk,talk,dance and prance.Through I.D. ideas travel fast and free of the mainstream - so join us on the run!

I.D.
Fash
fast and free of the mainstream

BACK COVER

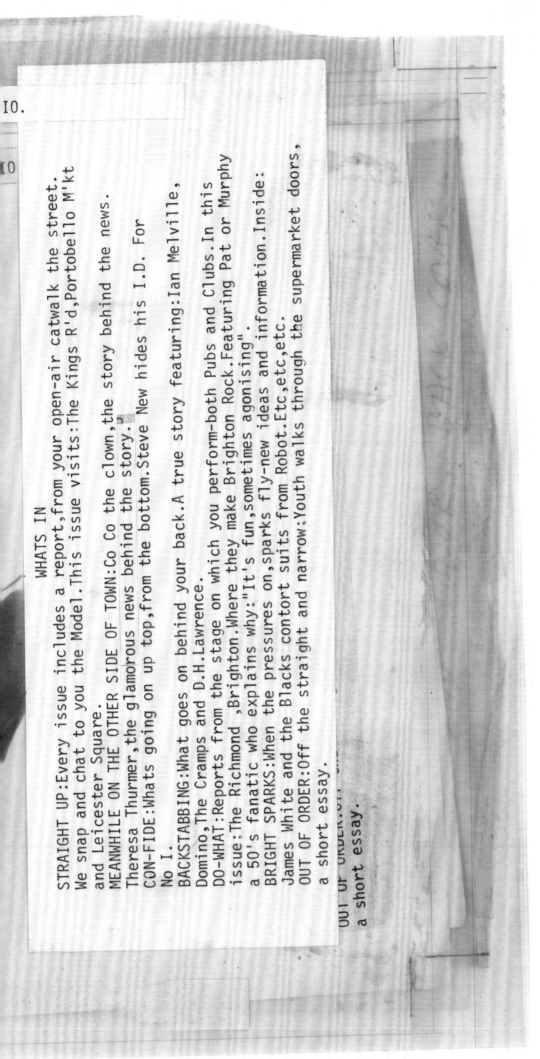

WHATS IN

STRAIGHT UP:Every issue includes a report,from your open-air catwalk the street.
We snap and chat to you the Model.This issue visits:The Kings R'd,Portobello M'kt
and Leicester Square.
MEANWHILE ON THE OTHER SIDE OF TOWN:Co Co the clown,the story behind the news.
Theresa Thurmer,the glamorous news behind the story.
CON-FIDE:Whats going on up top,from the bottom.Steve New hides his I.D. For
No I.
BACKSTABBING:What goes on behind your back.A true story featuring:Ian Melville,
Domino,The Cramps and D.H.Lawrence.
DO-WHAT:Reports from the stage on which you perform-both Pubs and Clubs.In this
issue:The Richmond ,Brighton ,Brighton.Where they make Brighton Rock.Featuring Pat or Murphy
a 50's fanatic who explains why:"It's fun,sometimes agonising".
BRIGHT SPARKS:When the pressures on,sparks fly-new ideas and information.Inside:
James White and the Blacks contort suits from Robot.Etc,etc,etc.
OUT OF ORDER:Off the straight and narrow;Youth walks through the supermarket doors,
a short essay.

OUT OF ORDER:
a short essay.

CONTENTS
Foreword by Richard Buckley **10**
Introduction by Terry Jones **16**
2010 – 2000 **46**
1999 – 1990 **148**
1989 – 1980 **230**
Biographies **308**
Index **314**
Acknowledgements **318**

"I was spotted on a train by Simon Foxton, who said I should be a model. Within the first week he introduced me to Nick Knight, who took a lot of pictures of me when I was younger. When I turned 17 Nick introduced me to Terry and Tricia at i-D because I wanted to work for magazines. I was made Fashion Editor at 18. From early on in my career all these people were very paramount."
Edward Enninful, i-D Fashion Director

Me posing with Dianne Brill, New York, 1982 or 1983 · Photo by Martin H. Schreiber

Finding a copy of i-D in its early years was not an easy task. You had to really search it out. I am not sure where I bought my first copy, but I do know it was the second issue.
I distinctly remember that graphic cover with the i-D logo inside a five-pointed star inside a circle. Since then, I have made it a point to buy every new issue. Writing the foreword to this book, it was interesting to discover just how much i-D has informed contemporary culture over the last three decades. Reviewing 30 years of i-D covers not only allowed me to relive my past, but to literally visualise how dramatically people, fashion, technology and pop culture have changed since that first issue was published in August 1980.

It is rare in life that things just happen by chance; more often than not, events are a reaction to an action. Cause/effect. The eighties New Romantics movement, for example, was a reaction to seventies punk, which was a reaction to early seventies glitter rock, and so on. While people today have little use for history, i-D's back-story is fascinating in how it contextualises the way in which the magazine continues to move forward. While i-D celebrates the beginning of its fourth decade this year, my own knowledge of Terry Jones, i-D's Founder, Art Director and Editor-in-Chief, goes back almost 40 years to the summer of 1973, when I bought my first copy of British 'Vogue'. By the end of the seventies, Terry was already a legend in the world of visual arts, magazines and fashion, known for his work as British 'Vogue's Art Director from 1972 until 1978.
I spent the summer of 1973 in London: David Bowie and Bianca Jagger were fashion's muses; disco music was the new sound; Tim Curry was onstage at the Royal Court's Theatre Upstairs performing 'The Rocky Horror Picture Show'; and everyone was waiting for the opening of Biba, Barbara Hulaniki's megastore in the former Derry and Toms department store, an Art Deco palace on Kensington High Street. A true visionary, Hulanicki's Biba would be

In den Anfangsjahren war es gar nicht so einfach, eine Nummer von i-D aufzutreiben. Es erforderte richtigen Spürsinn. Ich bin nicht sicher, wo ich mir mein erstes Exemplar kaufte, aber ich weiß noch, dass es die zweite Ausgabe war. Ich erinnere mich noch genau an den grafischen Titel, mit dem i-D-Logo in der Mitte eines fünf-zackigen Sterns in einem Kreis. Seit damals habe ich es nie versäumt, jede neue Ausgabe zu kaufen. Beim Schreiben dieses Vorworts war es interessant zu sehen, wie sehr i-D in den letzten drei Jahrzehnten die Gegenwarts-kultur durchdrungen hat. Mir i-D-Titelbilder aus 30 Jahren wieder anzusehen, ließ nicht nur meine Vergangenheit wieder aufleben, son-dern führte mir vor Augen, wie dramatisch sich Menschen, Mode, Technologie und Popkultur verän-dert haben, seit im August 1980 die erste Ausgabe erschien.

Aux tout débuts d'i-D, trouver un exemplaire du magazine n'était pas chose aisée. Il fallait vraiment le vouloir. Je ne me souviens plus de l'endroit où j'ai acheté mon premier i-D, mais je sais que c'était le deuxième numéro. Je me rappelle distinctement le graphisme de la couverture, avec son logo i-D à l'intérieur d'une étoile à cinq branches elle-même entourée d'un cercle. Depuis, je me suis fait un devoir d'acheter chaque nouveau numéro. En écrivant la préface de ce livre, j'ai découvert avec intérêt à quel point i-D a documenté la culture contemporaine de ces trois dernières décennies. Ce retour sur 30 ans de couvertures d'i-D m'a non seulement permis de revivre les années passées, mais aussi de visualiser littéralement les changements spectaculaires qui se sont opérés chez les gens, dans la mode, la technologie et la culture pop depuis la publication du premier numéro en août 1980.

the first total lifestyle emporium, seven floors stocked with Biba clothes, shoes, furniture, paint, cosmetics, toys and even baked beans. The Rainbow Restaurant and adjoining garden with live flamingos were on the roof. At the end of the summer, I returned to graduate school in Washington D.C. with the idea that I would return to London to dance in the New Year at the Rainbow Restaurant. I never made it, but letters from London arrived later recounting every fabulous detail of that party. I was left to console myself with the January 1974 issue of British 'Vogue' with Manolo Blahnik posing with Anjelica Huston on the cover. The two of them, champagne in hand, photographed by David Bailey, captured everything elegant and glamorous that London represented to me, despite the fact they were shot on a tropical beach rather than in Mr. Chow or The Rainbow Restaurant. To this day, I cannot think of another magazine cover that has been more evocative of a time and place as that one was. From then on I haunted the news stands waiting for the next issue of British 'Vogue'. I was never disappointed as Bianca Jagger's glossy, lipsticked mouth and veiled face shot by Eric Bowman graced the March cover. And Norman Parkinson's photo of Jerry Hall with a blue bathing cap and powder blue telephone receiver was, to use the parlance of the day, 'to die for'. All those iconic covers — tapping into the zeitgeist of the decade — were art directed by Terry Jones. From the crude look of i-D's landscape-formatted pages, which were stapled, not bound, its lo-tech production values and its focus on street fashion, I was convinced club kids put the magazine together somewhere in a dimly lit basement. One look at the graphic covers of i-D's early issues, with provocative headlines like 'Health, Hygiene, Herpes, Heroin', and you knew this was something new and radically different. There was, therefore, an immediate disconnect between my first impressions of i-D and coming face to face with Terry Jones, whose work at 'Vogue' had left such an indelible mark on my own aspirations and visual culture. I came to interview Terry in 1981 or 1982 — neither of us can remember for sure — about his new magazine and we sat down at the table in his brightly lit kitchen where he cobbled together each new issue. Terry's own reaction to the glossy magazines and staid fashion system from which he came provided the action and motivation to launch i-D. The magazine's creation also happened to coincide with the time London was experiencing a burst of creative energy, the likes of which had not been seen since the sixties. By 1980, the rough, raw and testosterone-fuelled elements of punk had evolved into the extravagance, face paint and androgyny of the New Romantics, a group of young people who used their imagination and fashion to flaunt conventions and establish their own identity in a way

Es passiert nicht oft im Leben, dass sich Dinge einfach aus glücklichen Zufällen ergeben; die meisten Ereignisse sind eine Reaktion auf eine Aktion. Ursache/Wirkung. Die New Romantics der Achtziger zum Beispiel waren eine Reaktion auf den Punk der Spätsiebziger, der wiederum eine Reaktion auf den Glitterrock der Frühsiebziger war, und so weiter. Heute interessiert sich zwar kaum jemand für Geschichte, aber es ist doch im Kontext der zurückliegenden Ausgaben umso faszinierender, zu sehen, wie i-D sich immer weiter entwickelt. Während i-D dieses Jahr in seine vierte Dekade geht, reicht meine Bekanntschaft mit Terry Jones, dem Gründer von i-D, fast 40 Jahre zurück, bis zum Sommer 1973, in dem ich meine erste Ausgabe der britischen Vogue kaufte. Ende der Siebziger war Terry schon eine Legende in der bildenden Kunst, der Mode und der Zeitschriftenlandschaft, bekannt durch seine Arbeit als Art-Director der britischen Vogue von 1972 bis 1978. Ich verbrachte den Sommer 1973 in London: David Bowie und Bianca Jagger inspirierten damals die Mode; Disco war der neue Sound; Tim Curry stand im Royal Court's Theatre in The Rocky Horror Picture Show auf der Bühne, und jeder wartete auf die Eröffnung von Big Biba, Barbara Hulanikis Megastore im ehemaligen Kaufhaus Derry and Toms, einem Art-Deco-Palast auf der Kensington High Street. Hulaniki war eine echte Visionärin, und Big Biba wurde der erste totale Lifestyle-Tempel, sieben Stockwerke bestückt mit Biba-Klamotten, -Schuhen, -Möbeln, -Farben, -Kosmetik, -Spielzeug, und sogar einer eigenen Baked-Beans-Marke. Auf dem Dach befand sich das Rainbow Restaurant mit angeschlossenem Garten und lebenden Flamingos. Als ich Ende des Sommers an meine Universität in Washington D.C. zurückkehrte, war es in der Vorstellung, ich würde wieder nach London kommen, um im Rainbow Restaurant ins neue Jahr zu tanzen. Daraus wurde zwar nichts, aber später erfuhr ich aus Briefen aus London jedes einzelne fabelhafte Detail von der Party. Ich musste mich mit der Vogue-Ausgabe vom Januar 1974 trösten, auf deren Titel Manolo Blahnik mit Anjelica Huston posierte. Die beiden, Champagnergläser in der Hand, fotografiert von David Bailey, verkörperten alles Elegante und Glamouröse, das London für mich repräsentierte, auch wenn die Fotos an einem tropischen Strand entstanden waren, nicht bei Mr. Chow oder im Rainbow Restaurant. Bis heute lässt kein anderes Titelbild für mich so sehr eine Zeit und einen Ort erstehen wie dieses. Von da an lauerte ich an den Zeitschriftenständen auf jede neue Ausgabe der britischen Vogue. Ich wurde nie enttäuscht, denn das März-Titelbild zierten Bianca Jaggers volle, lackglänzende Lippen und ihr halb verschleiertes Gesicht auf einem Foto von Eric Bowman. Und Norman Parkinsons Foto von Jerry Hall mit blauer Badekappe und einem babyblauen Telefonhörer war, um es im damaligen Sprachgebrauch zu sagen, einfach traumhaft. Alle diese Kulttitel, die den Zeitgeist des Jahrzehnts so perfekt wiedergaben, entstanden unter Terry Jones als Art Director. Bei dem primitiven, kunstlosen Look der querformatigen Seiten von i-D, nicht gebunden, sondern nur grob getackert, der Low-tech-Produktion und dem Schwerpunkt auf Street Fashion, ging ich davon aus, dass irgendwelche Clubkids das Ding in einem schlecht beleuchteten Keller zusammenschusterten. Ein Blick auf die grafischen Cover der frühen i-D-Ausgaben mit provokanten Headlines wie „Health, Hygiene,

Dans la vie, les choses arrivent rarement par hasard ; les événements résultent en général d'une réaction. Cause et effet. Par exemple, le mouvement des Nouveaux Romantiques dans l'Angleterre des années 80 est né en réaction au punk des seventies, lui-même engendré par le rock glitter du début de la décennie, etc. Bien que les gens d'aujourd'hui ne s'intéressent pas à l'histoire, les archives d'i-D sont fascinantes dans la mesure où elles replacent dans son contexte l'évolution constante du magazine. Alors qu'i-D entame cette année sa quatrième décennie d'existence, j'ai personnellement découvert Terry Jones – fondateur, directeur artistique et rédacteur en chef d'i-D – il y a près de 40 ans, lorsque j'ai acheté mon tout premier exemplaire du Vogue anglais à l'été 1973. A la fin des années 70, Terry était déjà une légende dans les domaines de l'art visuel, de la presse et de la mode. Il s'était notamment fait connaître grâce à son travail de directeur artistique pour l'édition britannique de Vogue entre 1972 et 1978. J'ai passé l'été 1973 à Londres. David Bowie et Bianca Jagger étaient alors les muses de la mode, on découvrait la musique disco, Tim Curry jouait dans The Rocky Horror Picture Show sur la scène du Royal Court's Theatre Upstairs et tout le monde attendait l'ouverture de Big Biba, le mégastore de Barbara Hulaniki installé dans l'ancien grand magasin Derry and Toms, un palais Art Déco sur Kensington High Street. Concept véritablement visionnaire, Big Biba s'apprêtait à devenir le premier emporium du lifestyle, avec sept étages remplis de vêtements, chaussures, meubles, tableaux, produits cosmétiques, jouets et même haricots blancs à la sauce tomate siglés Biba. Et sur le toit, le restaurant Rainbow côtoyait un jardin peuplé de vrais flamands roses. A la fin de l'été, j'ai repris mes études universitaires à Washington D.C. avec l'idée de revenir à Londres pour fêter le Nouvel An sur la piste de danse du Rainbow. Je n'ai finalement pas pu le faire, mais j'ai reçu des lettres de Londres me relatant les moindres détails de cette fabuleuse fête. Je me suis consolé avec le numéro du Vogue anglais de janvier 1974, où Manolo Blahnik posait en couverture avec Anjelica Huston. Coupe de champagne à la main et photographiés par David Bailey, ces deux-là incarnaient toute l'élégance et tout le glamour que Londres représentait à mes yeux, même s'ils étaient mis en scène sur une plage tropicale, et non pas au restaurant Mr. Chow ni au Rainbow Restaurant. Encore aujourd'hui, aucune autre couverture de magazine ne me semble mieux refléter un lieu et son époque. Dès lors, j'ai hanté les kiosques à journaux pour ne pas rater un seul numéro du Vogue anglais. Je n'ai certes pas été déçu par la couverture du mois de mars, pour laquelle Eric Bowman a immortalisé les lèvres rouges brillantes et le visage voilé de Bianca Jagger. Quant à la photo de Jerry Hall en bonnet de douche bleu et combiné téléphonique bleu pastel prise par Norman Parkinson, je l'ai trouvée « à tomber par terre », comme on disait à l'époque. Misant en plein dans le zeitgeist de la décennie, toutes ces couvertures étaient autant d'icônes nées de la direction artistique de Terry Jones. Face au look cru des pages d'i-D en format paysage, agrafées et non brochées, à ses valeurs de production low-tech et sa focalisation sur la mode de la rue, j'étais convaincu que ce magazine était assemblé par de jeunes clubbeurs dans une cave mal éclairée. Un seul regard sur les couvertures graphiques des premiers numéros d'i-D, avec leurs titres provocants

that wasn't too dissimilar to the eccentric behaviour of the Bright Young People of the twenties. While this earlier group was comprised of aristocrats and socialites, the New Romantics were mainly working class kids and students and yet another substrata in various anti-establishment youth subcultures had formed in Britain since WW II. Dick Hebdige's 'Subculture: The Meaning of Style', which I've read back to front at least twice, remains the seminal text differentiating all these non-conformist tribes. Hebdige's premise, in a sentence, a subculture's challenge to the status quo is expressed through style. By the early eighties each of these subcultures, which included hippies, mods, teddy boys, punks, rockabillies and New Romantics, not only had their own sartorial identity, but also their own music and clubs, such as the Beetroot, Dirtbox, Blitz or Taboo. A trip to London in the early eighties, no matter how frequent, was always a voyage of discovery, and, as a fashion journalist for 'Daily News Record', a menswear trade paper, I was always on the hunt for a new story, whether that meant searching Olympia's apparel show for John Galliano and finding him, with his first collection, 'Afghanistan Repudiates Western Ideas', in a fire exit, or climbing a rickety flight of stairs in a building that should have been condemned in Dickens' time to view the jewellery of Tom Binns. I went to see Sue Clowes, a printmaker who outfitted Boy George in the early days of Culture Club, in her Brick Lane studio, long before that area became a destination. The first stop in London was always Kensington Market, a souk of individual stalls selling apparel and accessories, including individual designs that had been stitched up, more often than not, by fashion students in their bedsit the night before. Kensington Market, which no longer exists, encapsulated London's ever-evolving avant-garde fashion scene. The speed at which things changed was famously noted by Chris Sullivan, host of the Wag Club who said, "One look lasts a day". There were the outrageous catwalk shows by Vivienne Westwood, Body Map and Katharine Hamnett, to name only a few, as well as the theatrics of designer-turned-performer Leigh Bowery, who once tried to kiss me while made up to look like he had pus-oozing sores all over his face. During the early eighties, it seemed like everyone in London was in a band, or dressing a band. These groups would have one hit in the UK charts, become an overnight sensation, and then just disappear. But as fleeting as their success might be, they always had a style that was instantly picked up as the next big thing. i-D captured all of the energy of that unique moment in time. There was nothing else like i-D if you wanted to know what was really new in London. On its covers and inside pages, i-D presented its own brand of art-directed subversion and social documentation,

Herpes, Heroin", und du wusstest, das hier war etwas Neues und radikal Anderes. Deshalb passte es für mich überhaupt nicht zu meinen ersten Eindrücken von i-D, als ich mich plötzlich Terry Jones gegenübersah, dessen Arbeit bei Vogue meine eigenen Ambitionen und meine Sehkultur so entscheidend geprägt hatte. Ich interviewte Terry 1981 oder 1982 – wann genau kann sich keiner von uns beiden erinnern – zu seinem neuen Magazin, und wir saßen gemeinsam an dem Tisch in seiner hell erleuchteten Küche, an dem er jede neue Ausgabe zusammenbastelte.
Terrys eigene Reaktion auf die Hochglanzmagazine und das Modeestablishment, aus dem er kam, lieferten die Action und Motivation, i-D auf den Weg zu bringen.
Die Gründung des Magazins fiel in eine Zeit, in der in London ohnehin die kreative Energie explodierte, wie man es seit den Sechzigern nicht erlebt hatte. 1980 hatten sich die harten, rauen, testosteronlastigen Elemente des Punk weiterentwickelt zur Extravaganz, den bemalten Gesichtern und der Androgynität der New Romantics, einer Gruppe junger Leute, die über Fantasie und Mode mit Konventionen spielten und sich eine eigene Identität schufen, nicht unähnlich dem exzentrischen Auftreten der Bright Young People der Zwanziger Jahre. Während die Bright Young Kids jedoch der Aristrokratie und Schickeria entstammten, waren die New Romantics in erster Linie Kids aus der Arbeiterklasse und Studenten, und schon wieder hatte sich im Nachkriegsengland ein neuer Nährboden verschiedenster Jugend-Subkulturen gebildet. Dick Hebdiges nonkonformistisches Buch Subculture: The Meaning of Style, das ich mindestens zweimal von vorne bis hinten gelesen habe, ist und bleibt der maßgebliche Text, der alle diese nonkonformistischen Kulturen einzeln erfasst. Hebdiges Prämisse lautet grob vereinfacht: Das Aufbegehren einer Subkultur gegen den Status Quo geschieht durch ihren Stil. Anfang der Achtziger hatte jede dieser Subkulturen – Hippies, Mods, Teddy Boys, Punks, Rockabillies und New Romantics – nicht nur ihre eigenen Kleidung, sondern auch eigene Bands und eigene Clubs wie Beetroot, Dirtbox, Blitz oder Taboo, um nur einige zu nennen. Selbst regelmäßige Besuche in London waren Anfang der Achtziger immer eine Entdeckungsreise, und als Modejournalist für Daily News Record, einem Branchenblatt der Herrenbekleidungsbranche, war ich immer auf der Jagd nach einer neuen Story. Das bedeutete, auf der Olympia-Modenschau nach John Galliano zu suchen und ihn mit seiner ersten Kollektion – Afghanistan Repudiates Western Ideas – auf einer Feuertreppe zu finden. Oder eine ausgetretene Stiege in einem Haus, das schon zu Dickens' Zeiten hätte abgerissen werden sollen, zu erklimmen, um mir die Schmuckkollektion von Tom Binns anzusehen. Ich besuchte Sue Clowes, eine Grafikerin, die in der Frühzeit von Culture Club Boy George ausstattete, in ihrem Studio in der Brick Lane, lange bevor die Gegend zu einem Muss beim Londonbesuch wurde. Meine erste Anlaufstation in London war immer der Kensington Market, ein Souk mit individuellen Ständen, in denen Kleidung und Accessoires verkauft wurden, einschließlich Einzelstücken, die erst in der Nacht zuvor von Modestudenten in ihren beengten Zimmerchen entworfen und genäht worden waren. Kensington Market, der heute nicht mehr existiert, war ein Mikrokosmos von Londons sich unaufhörlich erneuernder Avantgarde-Modeszene. Das Tempo, in dem sich die Dinge veränderten, zeigt sich im be-

comme « Health, Hygiene, Herpes, Heroin » (Santé, hygiène, herpès et héroïne), suffisait pour comprendre qu'on avait affaire à quelque chose de nouveau et de radicalement différent. Il n'y avait donc aucun rapport entre mes premières impressions d'i-D et ma découverte de Terry Jones, dont le travail chez Vogue avait laissé une marque absolument indélébile sur mes propres aspirations et ma culture visuelle. Je suis venu interviewer Terry à propos de son nouveau magazine en 1981 ou en 1982 – aucun de nous ne se souvient de la date exacte – et on s'est assis à la table de sa cuisine saturée de lumière où il concoctait chaque nouveau numéro.
Terry a eu envie de lancer i-D en réaction aux magazines sur papier glacé et au système de la mode traditionnel dont il était issu. Il se trouve que le magazine a été créé exactement au moment où Londres vivait une explosion de créativité telle qu'on n'en avait pas vue depuis les années 60. En 1980, les aspects bruts, crus et « testostéronés » du punk avaient cédé la place à l'extravagance, aux visages peints et à l'androgynie des Nouveaux Romantiques, un groupe de jeunes gens qui utilisaient la mode et leur imagination pour défier les conventions et affirmer leur propre identité, avec un comportement excentrique qui rappelait un peu celui des Bright Young People des années 20. Alors que ce groupe-là se composait d'aristocrates et de membres de la haute société, les Nouveaux Romantiques réunissaient principalement des jeunes de la classe ouvrière, des étudiants et encore d'autres strates sociales que les diverses subcultures de la jeunesse anti-establishment avaient engendrées en Grande-Bretagne depuis la Seconde Guerre mondiale. Le livre Subculture : The Meaning of Style de Dick Hebdige, que j'avais lu au moins deux fois de A à Z, reste le texte phare qui distingue chacune de ces tribus anticonformistes. Pour faire court, le principe d'Hebdige énonce que le défi lancé au statu quo par une sous-culture s'exprime à travers le style. Au début des années 80, chacune de ces subcultures, dont les hippies, les mods, les teddy boys, les punks, les rockabillies et les Nouveaux Romantiques, possédait non seulement ses propres codes vestimentaires, mais aussi sa propre musique et ses propres clubs, comme le Beetroot, le Dirtbox, le Blitz ou le Taboo.
Peu importe à quelle fréquence on s'y rendait, le Londres du début des années 80 représentait toujours une découverte en soi. En tant que rédacteur mode pour le Daily News Record, une revue professionnelle spécialisée en mode masculine, j'étais toujours en chasse de nouveaux sujets, qu'il s'agisse de mettre la main sur John Galliano dans une issue de secours d'un défilé Olympia pour parler de sa première collection, « Afghanistan Repudiates Western Ideas », ou de monter un escalier branlant dans un immeuble qui aurait déjà dû être condamné du temps de Dickens pour découvrir les bijoux de Tom Binns. J'ai rencontré Sue Clowes, une spécialiste de l'imprimé qui habillait Boy George aux débuts de Culture Club, dans son atelier de Brick Lane bien avant que ce quartier ne devienne branché. Dès que j'arrivais à Londres, je fonçais à Kensington Market, un souk de stands vendant des vêtements et des accessoires, dont des créations uniques souvent cousues à la hâte par des étudiants en mode dans leur petit meublé la nuit précédente. Kensington Market, qui n'existe plus aujourd'hui, reflétait la mode avant-gardiste et sans cesse changeante du Londres de l'époque. Chris Sullivan, directeur du Wag Club, a d'ailleurs

offering an insider's look at British pop culture that you would not see in print anywhere else. The fact that i-D was, in general, illegible made the magazine all the more mysterious, and what you saw on its pages were secret signs that only those 'in the know' would be able to decode.

Terry Jones has been the driving force behind i-D throughout these past 30 years. He never takes credit for i-D's success himself, but always emphasises that each copy of the magazine is the result of the collaborative efforts of a large creative team. That said, he has directly, or indirectly, launched the careers of dozens upon dozens of editors, art directors, photographers, writers and stylists, many of whom came to i-D because something they saw in the magazine resonated with who they wanted to become. These people shaped i-D and the magazine shaped them. Over the last three decades, i-D has been a launching pad for many photographers including Nick Knight, Juergen Teller, Craig McDean, Ellen von Unwerth and Wolfgang Tillmans. Madonna, Sade and Björk all had their first magazine covers on i-D, while model Kate Moss, who has appeared on the cover 11 times, has matured before our eyes over the last 16 years from a waif to a woman.

Looking through 30 years of the magazine, there have been many surprises to rediscover: Mario Testino's first magazine cover in December 1984; David Bailey's portrait of young architect Sophie Hicks with gaffer tape over one eye; and Naomi Campbell's debut on the August 1986 cover, shot by Robert Erdmann with a fashion story inside by Sam Brown. Because of i-D's strict budget constraints, Terry remembers that the film for Wolfgang Tillmans' fashion story in July 1992 was developed at a One Hour Lab. I saw large-scale prints from that shoot a year or two later in an exhibition of new photographers at New York's Museum of Modern Art. The deeper you dig into i-D's past, the bigger the treasures you'll find.

The distance technology has evolved over the past 30 years is staggering, and it is easy to see the progress from the handmade graphics of i-D's first cover to Nick Knight's recent work with 3-D scanning. In 1980 people didn't own computers. Many newspapers and magazines were still being typeset. The first issues of i-D were published by offset printing, a technique that would reproduce — with varying degrees of quality — original artwork onto A4 paper. Photocopy machines easily do the same thing now, but in 1980 those were few and far between, not to mention expensive, and it would have been next to impossible to find a colour copier then. The lo-fi techniques used to create the magazine's homemade look were, in fact, done by hand.

In the last decade we have seen the platform for listening to music change from compact discs to electronic files. i-D's third issue published in January 1981 included a flexi disc (a thin, bendable phonographic record, played on a turntable) of a song

rühmten Ausspruch von Chris Sullivan, dem Veranstalter des Wag Club: „Ein Look überlebt nur einen Tag."

Es gab die irrwitzigen Catwalk-Shows von Vivienne Westwood, Body Map und Katharine Hamnett, um nur einige zu nennen, oder die Eskapaden von Designer/Performer Leigh Bowery, der mal versuchte, mich zu küssen, während er so geschminkt war, dass es aussah, als hätte er das Gesicht voller eitriger Pickel. Während der frühen Achtziger konnte man den Eindruck haben, jeder in London sei in einer Band oder kleide eine Band ein. Diese Gruppen hatten meistens einen Hit in den britischen Charts, wurden über Nacht zur Sensation und verschwanden dann sang- und klanglos. Aber so kurzlebig ihr Erfolg auch war, sie brachten immer einen Stil mit, der sofort als das nächste neue Ding aufgegriffen wurde.

i-D fing die gesamte Energie dieser einmaligen Zeit ein. Wenn man wirklich wissen wollte, was es in London Neues gab, musste man i-D lesen. Auf den Seiten und Titeln präsentierte i-D seine persönliche Marke visuell umgesetzter Subversion und sozialer Dokumentation, einen Insiderblick auf die britische Popkultur, den man so nirgendwo sonst abgedruckt sah. Die Tatsache, dass i-D im Großen und Ganzen unleserlich war, machte die Zeitschrift umso geheimnisvoller, und das, was man auf den Seiten sah, waren geheime Zeichen, die nur Eingeweihte entschlüsseln konnten.

Terry Jones war während dieser 30 Jahre die treibende Kraft hinter i-D. Er beansprucht den Erfolg von i-D nie für sich, sondern betont immer, dass jede Nummer des Magazins die Gemeinschaftsarbeit eines großen Kreativteams ist. Abgesehen davon hat er direkt oder indirekt die Karrieren von Dutzenden von Redakteuren, Art Directors, Fotografen, Schreibern und Stylisten auf den Weg gebracht, von denen es viele zu i-D gezogen hatte, weil sie in dem Magazin irgendetwas sahen, das bereits dort war, wo sie hinwollten. Diese Leute prägten i-D, und i-D prägte sie. Während der letzten 30 Jahre war i-D das Sprungbrett für viele Fotografen, unter anderem Nick Knight, Juergen Teller, Craig McDean, Ellen von Unwerth und Wolfgang Tillmans. Madonna, Sade und Björk hatten alle bei i-D ihr erstes Titelbild, während Model Kate Moss, die insgesamt elf Mal auf dem Cover war, in den letzten 16 Jahren vor unseren Augen vom kleinen Strolch zur Frau herangewachsen ist.

Bei dem Durchsicht von 30 Jahrgängen des Magazins gab es viele Sensationen wiederzuentdecken: Mario Testinos erster Zeitschriftentitel im Dezember 1984, David Baileys Porträt der jungen Architektin mit Gafferband über einem Auge, und Naomi Campbells Debüt auf dem Cover vom August 1986, fotografiert von Robert Erdmann für eine Modestory von Sam Brown im Heft. Terry erinnert sich, dass er wegen des überaus knappen Budgets bei i-D den Film von Wolfgang Tillmans' erster Modestory im Juli 1992 in einem Schnelllabor entwickeln ließ. Ich habe davon ein oder zwei Jahre später großformatige Abzüge bei einer Gruppenausstellung junger Fotografen im Museum of Modern Art in New York gesehen. Je weiter man in die Vergangenheit von i-D zurückgeht, desto größere Schätze findet man.

Die technologische Entwicklung der letzten 30 Jahre ist atemberaubend, und hier kann man den Weg von der handgemachten Grafik des ersten i-D-Covers bis zu Nick Knights jüngsten Arbeiten mit 3-D-Scans nachvollziehen. 1980 besaß kein Mensch einen Computer. Viele Zeitungen und Zeitschriften wurden noch

décrit la vitesse vertigineuse de ces changements dans sa célèbre phrase : « Un look dure une journée. »

J'ai assisté aux défilés extravagants de Vivienne Westwood, Body Map et Katharine Hamnett, pour ne citer que quelques noms, et admiré la théâtralité du couturier devenu artiste de performance Leigh Bowery, qui a un jour essayé de m'embrasser alors que son visage maquillé donnait l'impression d'être recouvert de plaies suintantes de pus. Au début de la décennie, on aurait dit que chaque Londonien faisait partie d'un groupe de musique ou qu'il en habillait un. Ces groupes sortaient un tube classé dans les hit-parades anglais, devenaient célèbres du jour au lendemain puis disparaissaient de la circulation. En dépit de leur succès éphémère, le style qu'ils arboraient dictait toujours la nouvelle tendance.

i-D a saisi toute l'énergie de cette époque unique dans l'histoire. Rien n'arrivait à la cheville de ce magazine quand on voulait savoir ce qu'il y avait de vraiment nouveau à Londres. Sur ses couvertures et dans ses pages, i-D présentait sa propre interprétation de la subversion stylisée et du documentaire social, offrant un regard d'initié sur la culture pop britannique que l'on ne trouvait nulle part ailleurs dans la presse. La quasi-illisibilité d'i-D rendait le magazine d'autant plus mystérieux, ses pages recelant des codes secrets que seuls « ceux qui savent » étaient en mesure de déchiffrer.

Terry Jones est le moteur d'i-D depuis 30 ans. Loin de s'en attribuer le succès, il insiste systématiquement sur le fait que chaque numéro du magazine est le fruit des efforts collaboratifs d'une vaste équipe créative. Cela dit, il a directement ou indirectement lancé les carrières de dizaines et dizaines de journalistes, directeurs artistiques, photographes, écrivains et stylistes, dont la plupart sont venus travailler chez i-D parce qu'ils y trouvaient quelque chose qui résonnait avec la personne qu'ils espéraient devenir. Ces gens ont façonné i-D tout comme le magazine les a façonnés. Au cours des trois dernières décennies, i-D a fait office de tremplin pour de nombreux photographes tels que Nick Knight, Juergen Teller, Craig McDean, Ellen von Unwerth et Wolfgang Tillmans. Madonna, Sade et Björk ont toutes fait leurs premières couvertures de magazine avec i-D. Apparue 11 fois à la une au cours des 16 dernières années, la pré-pubère Kate Moss s'est transformée sous nos yeux en femme fatale.

J'ai eu bien des surprises en redécouvrant 30 ans de numéros d'i-D : la première couverture de magazine de Mario Testino en décembre 1984, le portrait signé David Bailey de la jeune architecte Sophie Hicks avec son œil recouvert de gaffeur, et les débuts de Naomi Campbell sur la couverture d'août 1986, photographiée par Robert Erdmann avec un dossier mode de Sam Brown. En raison des contraintes budgétaires d'i-D, Terry se rappelle que la pellicule du premier shooting mode de Wolfgang Tillmans en juillet 1992 a été développée en une heure dans une boutique One Hour Lab. Un ou deux ans plus tard, j'ai retrouvé des tirages grand format de ces photos au Museum of Modern Art à New York lors d'une exposition consacrée aux nouveaux photographes. Plus on plonge dans le passé d'i-D, plus beaux sont les trésors qu'on y déterre.

Depuis ces 30 dernières années, la technologie ne cesse d'évoluer à un rythme exponentiel. Entre le graphisme fait main de la première couverture d'i-D et le récent travail de Nick Knight avec les scans en 3D, les progrès réalisés sautent aux yeux. En 1980, les gens n'avaient

recorded by The Scars. That was a year before CDs were even commercially available.

Fashion has changed significantly over the last 30 years as well. In 1980 there were still 'sitting editors' at magazines, not stylists, and you would never find credits that read 'stylist's own' or 'customised by the stylist'. In fact, the fashion in the early issues of i-D that documented the street style of London's various tribes was often made from the imagination of their wearers, rather than something they bought in a store. In the eighties, individual style was celebrated over branding and marketing, and there were no smug 'fashionistas'. Street fashion today consists of celebrities, papped on the red carpet or shopping. Fashion is so co-opted now there are even ads that urge consumers to 'celebrate originality', which is another way of saying, 'buy me'. If everyone's hip, then what's cool?

Despite all these changes in people, fashion and culture, i-D has remained faithful to its initial purpose, which Terry Jones said was to give an "alternative voice to new ideas and people with innovative views". While I am definitely older since the magazine's launch 30 years ago, i-D only grows younger with each new issue. On the back cover of the first issue were the words, "Style isn't what but how you wear clothes. Fashion is the way you walk, talk, dance and prance. Through i-D ideas travel fast and free of the mainstream – so join us on the run". I am most grateful to i-D, its photographers, various editors and Terry Jones for allowing me to take part in the journey.

im Bleisatz erstellt. Die ersten Ausgaben von i-D wurden im Offsetverfahren gedruckt, eine Technik, mit der man – in unterschiedlichen Qualitäten – grafische Vorlagen auf A4-Papier übertrug. Fotokopierer erreichen heute mühelos dasselbe, aber die waren 1980 noch dünn gesät, und es war so gut wie unmöglich, an einen Farbkopierer zu kommen. Die Lo-fi-Techniken, mit deren Hilfe der hausgemachte Look erzielt wurde, waren tatsächlich von Hand gemacht.

Im letzten Jahrzehnt haben wir gesehen, wie die digitale Übertragung die CD als Plattform des Musikhörens ablöste. Der dritten Nummer von i-D im Januar 1981 lag eine Flexi-Disc (eine dünne, biegsame phonographische Platte) mit einem Song der Scars bei. Das war ein Jahr bevor die ersten CDs überhaupt auf den Markt kamen.

Auch die Modewelt hat sich in 30 Jahren deutlich gewandelt. In den Achtzigern gab es bei Magazinen noch den „Verantwortlichen im Sinne des Presserechts", keine Stylisten, und man las nirgendwo Credits wie „Stylist's own" oder „customized by the stylist". Nein, die Mode in den frühen i-D-Ausgaben, die den Street Style von Londons unterschiedlichen Gruppen dokumentierten, entsprang oft dem Ideenreichtum der Träger selbst und war nicht im Laden gekauft. In den Achtzigern feierte man den individuellen Stil, nicht Branding und Marketing, und es gab keine blasierten „Fashionistas". Street Fashion ist heute, wenn Prominente auf dem roten Teppich oder beim Shoppen von Paparrazi abgelichtet werden. Mode ist mittlerweile derart vereinnahmt, dass der Konsument sogar in Anzeigen gedrängt wird, „die Originalität zu feiern" – auch nur ein anderer Ausdruck für „kauf mich!". Wenn jeder hip ist, was ist dann noch cool?

Trotz all dieser Veränderungen bei Menschen, Mode und Kultur ist i-D seinem ursprünglichen Konzept treu geblieben, nämlich, wie es Terry Jones sagt, „neuen Ideen und Leuten mit innovativen Sichtweisen eine Stimme zu geben". Während ich in 30 Jahren seit der Gründung des Magazins unübersehbar gealtert bin, wird i-D mit jeder Nummer jünger. Auf der Rückseite der ersten Ausgabe stand: „Stil ist nicht, was du trägst, sondern wie du es trägst. Mode ist, wie du gehst und stehst, redest und tanzt. Durch i-D reisen Ideen schnell und am Mainstream vorbei – kommt mit, wenn ihr schnell genug seid." Ich bin i-D, seinen Fotografen, seinen zahlreichen Redakteuren und Terry Jones mehr als dankbar, dass sie mich mitreisen ließen.

pas d'ordinateurs. La plupart des journaux et des magazines étaient encore composés en imprimerie. Les premiers numéros d'i-D étaient imprimés en offset, une technique qui reproduisait – avec différents niveaux de qualité – les illustrations originales sur feuille A4. Aujourd'hui, les photocopieurs font la même chose sans problème, mais en 1980, ils étaient très rares et onéreux. D'ailleurs, il aurait été presque impossible de trouver une photocopieuse couleur. En fait, les techniques « low-fi » qui ont servi à créer le look fait maison du magazine relevaient purement de l'artisanat.

Dans les années 2000, nous avons vu le support musical évoluer du disque compact au fichier téléchargé sur Internet. Le troisième numéro d'i-D publié en janvier 1981, incluait le « flexi disc » (un vinyle fin et pliable à écouter sur une platine disque) d'un morceau enregistré par The Scars, un an avant l'apparition des premiers CD dans le commerce.

De même, la mode a considérablement évolué au cours des trois dernières décennies. En 1980, on trouvait encore des « sitting editors » dans les magazines, et non pas des stylistes. Les légendes photo n'indiquaient jamais « propriété du styliste » ou « personnalisé par le styliste ». En fait, la mode des premiers numéros d'i-D qui documentaient le style des diverses tribus des rues londoniennes était souvent née de l'imagination de ceux qui la portaient, et non pas achetée en boutique. Dans les années 80, le style personnel était encensé aux dépens des marques et du marketing, et la fashionista n'avait pas encore fait son apparition. Aujourd'hui, la mode de la rue se résume à ce que portent les célébrités qui paradent sur les tapis rouges ou sont surprises en plein shopping. La mode est désormais une telle affaire de cooptation qu'on voit même des publicités incitant les consommateurs à « célébrer l'originalité », ce qui revient à dire «Achetez-moi ! ». Mais si tout le monde devient branché, comment savoir ce qui est cool ?

Malgré tous ces changements au sein de la société, de la mode et de la culture, i-D est resté fidèle à son objectif de départ qui, selon Terry Jones, consiste à donner « une visibilité alternative aux idées inédites et à ceux qui innovent. » Si je suis nettement plus vieux que lors du lancement du magazine 30 ans plus tôt, i-D ne fait que rajeunir à chaque parution. Sur la quatrième de couverture du premier numéro, on pouvait lire : « Le style n'a rien à voir avec les vêtements que vous portez, mais avec votre façon de les porter. La mode, c'est votre manière de marcher, de parler, de danser et de vous pavaner. A travers i-D, les idées voyagent vite, insensibles au courant dominant : fuyez avec nous. » Je suis très reconnaissant envers i-D, ses photographes, ses rédacteurs et Terry Jones de m'avoir embarqué dans leur voyage.

One eye open. One eye hidden. Wink! The blink of a shutter. The right eye is the right eye. Catch the moment in an instant. Knowledge transmitted by secret insiders. i-D is more than a magazine, and i-D covers have caught and continue to catch the moment when the imaginative power of a collection of people comes together. The best covers register and are recognised, as a marker of the month, year and place. Hidden is the energy that has accumulated over 30 years, and there are now more than 320 covers — plus the ones that never got printed — each with a personal story.

i-D covers do not follow any strict commercial rules. I take chances with covers, but with chance there is always an element of risk. Covers can often cause unexpected controversy as I learnt from my previous days as Art Director at 'Vanity Fair', where Frank Horvat's photograph of Susan Moncler looking down at a dark triangle in her crotch had me answering to the publisher. Equally, at British 'Vogue' a number of the covers that I worked on broke 'the rules', most notoriously the famous green jelly cover that Grace Coddington and I pushed to run on 'Vogue's February 1977 edition, somehow with Editor-in-Chief Beatrix Miller's support. Not all risky covers, however, were as commercially successful as that one. During my tenure as a consultant with German 'Vogue', the only cover shot I tampered with was the January 1980 issue, where I cropped the full-face shot of a model to reveal only her blue eyes. Co-Art Director Helmut Schmidt came up with the single cover line 'Jawohl' ('Yes Sir!'). The publisher kept the layout, but changed the cover lines.

Before developing i-D, I had thought of creating a newspaper that I was going to call 'Picture Paper'. The idea would be to publish random images I would often see in photographers' portfolios that were funny but were never going to be seen in a glossy magazine. A brilliant photo called 'Cigarette Crammer', where someone had taken 20 cigarettes and stuffed them into their mouth, was the kind of photo that I imagined would be the basis of 'Picture Paper'.

I was 27 when I became Art Director of British 'Vogue'. Four years later the punk movement was going strong in London. It was during this time that I first became aware of the work of a young photographic student from Carlisle, Steve Johnson, and said to him: "Go down to the Kings Road, find a white wall and document the punks head-to-toe." I didn't know I was going to do a book at the time, but after Steve left I thought about what it would have been like if someone his age had recorded what was going on in London during the sixties. The result would have been an incredible document of what was happening on the streets at that time. Steve disappeared for three months. When he came back he brought a collection of amazing street portraits with him. He'd also physically transformed into a punk himself! I intended to use Steve's photos in 'Picture Paper', but when 'Picture Paper' didn't happen, Steve's street portraits became the basis of a new book. I left 'Vogue' in 1977, and a year later Aurum Press published 'Not Another Punk Book'.
I was still working for Aurum in 1980,

Ein Auge auf. Ein Auge verdeckt. Zwinkern. Blende auf, Auslöser. Das rechte Auge ist das richtige Auge. Der Moment ist festgehalten. Geheimes Insiderwissen weitergegeben. i-D ist mehr als ein Magazin, und die i-D-Titel halten Momente fest, in denen die kollektive Vorstellungskraft unterschiedlichster Menschen zusammenkommt. Die besten Cover sind unverkennbare Marker für Monat, Jahr und Ort. Was man nicht sieht, ist die akkumulierte Energie von über 30 Jahren, und dass jeder der bisher 320 Cover (die unpublizierten nicht eingerechnet) eine ganz persönliche Geschichte hat. i-D-Cover halten sich nicht sklavisch an kommerzielle Regeln. Ich scheue bei Titeln keine Experimente, was auch schon mal schiefgehen

Un œil ouvert, un œil caché. Clin d'œil ! Le clignotement de l'obturateur. L'œil ouvert est le bon. Capturer l'instant à la seconde près. La connaissance transmise par de mystérieux initiés. i-D n'est pas qu'un magazine, et ses couvertures ont toujours saisi l'instant où plusieurs personnes mettent en commun leur pouvoir d'imagination. On mémorise et on reconnaît les meilleures couvertures comme les repères d'un mois, d'une année et d'un lieu. Cette énergie accumulée en 30 ans reste latente. i-D revendique aujourd'hui plus de 320 couvertures, sans mentionner celles qui n'ont jamais paru. Et chacune possède sa propre histoire.
Les unes d'i-D ne suivent aucune règle commerciale établie. Pour les couvertures, je laisse jouer le hasard, mais cela implique toujours des risques.

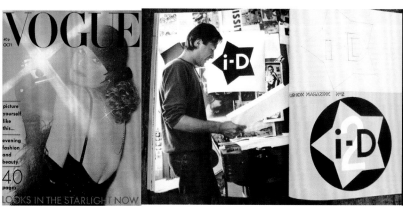

but the money was in Italy, France and Germany. 'Donna' magazine and Fiorucci, the clothing company, were my main Italian clients. I first pitched i-D to Flavio Lucchini, the Editorial Director of 'Donna', with the idea that he would publish it, but he never believed there would be any money in street-style. After waiting for six months, and being fired from 'Donna' because advertisers thought the graphics were too strong, I decided to go it alone.
My studio was called Informat Design, and when we were tossing names around for the new magazine one morning, my wife, Tricia, said i-D was definitely the best. Commercial artists trained in the sixties would doodle idents and logos in their sleep. i-D was a 'doddle' that was not only a reference to my punk book cover, which had been silk-screened fluorescent pink with black type, but also to the 1976 'Vogue' Diamond Jubilee cover that I had resigned over. The stencil type 'Fashion Magazine' was the only indication as to i-D's contents. Steve Johnson's portraits of people on the streets, shot for the punk book, became the foundation of i-D's fashion

kann. Titel können unerwartete Kontroversen auslösen, das habe ich während meiner wechselnden Jobs als Art Director gelernt.

Zuerst bei Vanity Fair, wo ich mich wegen Frank Horvats Foto von Susan Moncler, die auf das dunkle Dreieck ihrer Scham runterschaute, vor dem Verleger rechtfertigen musste, und ebenso bei der britischen Vogue mit einigen Covern, die gegen „die Regeln" verstießen, zum Beispiel das berühmte Grüne-Götterspeise-Cover der Ausgabe von Februar 1977, zu dem Grace Coddington und ich Chefredakteurin Beatrix Miller überreden konnten. Allerdings waren nicht alle riskanten Cover kommerziell so erfolgreich wie dieser. In meiner Zeit als Berater bei der deutschen Vogue dokterte ich nur an einem einzigen Titelfoto herum, dem für Januar 1980, für das ich von der Porträtaufnahme des Models alles bis auf ihre blauen Augen wegschnippelte. Helmut Schmidt, der andere Art Director, wollte nur eine einzige Zeile auf den Titel schreiben: „Jawohl!" Der Verleger übernahm das Layout, entschied sich aber für andere Titelzeilen. Ehe ich i-D entwickelte, schwebte mir eine Art Zeitung vor, die ich Picture Paper nennen

Les couvertures peuvent souvent provoquer une controverse inattendue, comme je l'ai appris lorsque j'étais directeur artistique chez Vanity Fair, où la photo de Susan Moncler – baissant les yeux vers un triangle sombre sur son entrejambe – prise par Frank Horvat m'a valu quelques problèmes avec l'éditeur. De même, plusieurs couvertures sur lesquelles j'ai travaillé pour le Vogue anglais brisaient aussi « les règles », en particulier la fameuse photo avec la gelée verte que Grace Coddington et moi voulions à tout prix pour le numéro de février 1977, avec l'improbable soutien de la rédactrice en chef Beatrix Miller. Cependant, toutes les couvertures risquées n'ont pas remporté le même succès commercial que celle-ci. Quand je travaillais comme consultant pour le Vogue allemand, la seule photo de couverture que je me suis permis de modifier sans permission est celle du numéro de janvier 1980, où j'ai découpé le gros plan du visage du mannequin pour ne garder que ses yeux bleus. Le co-directeur artistique Helmut Schmidt a imaginé un seul et unique titre : « Jawohl » (Oui chef !). L'éditeur a conservé la mise en page, mais modifié les gros titres.
Avant de développer i-D, j'avais envisagé de créer un journal que je comptais intituler Picture Paper. L'idée consistait à publier des images insolites et amusantes parmi celles que je voyais

identity. We called them 'Straight-ups', a West Country expression for telling it 'how it is'. Partially inspired by the honesty of August Sander's social documentary portraits, 'People of the Twentieth Century' and Irving Penn's 'Small Trades' series, as well as stories I'd already done at 'Vogue' with Oliviero Toscani that demonstrated a similar direct style of head-to-toe shooting. I liked that reportage kind of energy. These straight-ups, structured with vox pop mini-questionnaires as text, became the world's first fashion fanzine.

The back cover of the first issue featured a headshot by Steve and ran the i-D manifesto: "Style isn't what but how you wear clothes. Fashion is the way you walk, talk, dance and prance. Through i-D ideas travel fast and free of the mainstream — so join us on the run."

Joly MacFie, the master of fanzines and hippie of the universe, owned Better Badges, a company that manufactured pin badges to promote rock bands. Joly agreed, upon seeing my proposal, to offset-print 2000 A4 copies of the magazine with thicker paper covers

wollte. Die Idee war, Fotos abzudrucken, wie ich sie oft in den Mappen von Fotografen sah, Fotos, die einfach witzig waren, aber niemals in der Fotostrecke eines Hochglanzmagazins erscheinen würden. Ein grandioses Foto mit dem Titel „Cigarette Crammer", auf dem jemand 20 Zigaretten in den Mund gestopft hatte, war ein Beispiel für die Art von Fotos, die ich mir für Picture Paper vorstellte.

Mit 27 Jahren wurde ich Art Director bei der britischen Vogue. Vier Jahre später hatte die Punkbewegung London erobert. Genau in dieser Zeit wurde ich auf die Arbeiten eines jungen Fotostudenten aus Carlisle aufmerksam, Steve Johnson, und sagte zu ihm: „Stell dich auf die Kings Road, such dir eine weiße Hauswand, und dokumentier mir diese ganzen Punks in Ganzkörperansicht." Ich wusste damals noch nicht, dass ich ein Buch machen würde, aber nachdem ich Steve losgeschickt hatte, stellte ich mir vor, wie es gewesen wäre, wenn jemand in seinem Alter die Szenen in London während der Sixties fotografiert hätte: Was für ein fantastisches Dokument des damaligen Straßenlebens wäre das geworden. Steve verschwand für drei Monate, und als er wieder auftauchte, brachte er diese sensationellen Street Portraits mit. Außerdem hatte er sich selbst in einen Punk verwandelt! Ich wollte Steves Fotos ursprünglich für Picture Paper verwenden, aber als aus

souvent dans les portfolios des photographes et qui ne seraient jamais publiées dans un magazine de papier glacé. Une photo très réussie appelée « Cigarette Crammer », où l'on voyait quelqu'un se fourrer 20 cigarettes dans la bouche, était le genre d'images dont Picture Paper aurait fait sa spécialité.

J'avais 27 ans quand je suis devenu directeur artistique du Vogue anglais. Quatre ans plus tard, le mouvement punk battait déjà son plein à Londres. C'est à cette époque que j'ai découvert le travail de Steve Johnston, un jeune étudiant en photo de Carlisle. Je lui ai dit : « Va à Kings Road, trouve un mur blanc et prends les punks en photo devant. » A l'époque, je ne savais pas encore que j'allais en faire un livre, mais après le départ de Steve, je me suis demandé ce que ça aurait donné si une personne de son âge avait photographié ce qui se passait à Londres dans les années 60 : sans doute un incroyable document sur la vie de la ville. Steve a disparu pendant trois mois. Il est revenu avec d'incroyables portraits en pied. Et il était lui-même devenu punk ! J'avais l'intention de publier le travail de Steve dans Picture Paper, mais comme ce projet n'a jamais vu le jour, ces photos m'ont donné envie de faire un nouveau livre. J'ai quitté Vogue en 1977, et un an plus tard, Aurum Press publiait Not Another Punk Book.

 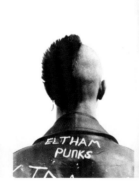

front and back that would be hand-stapled on the narrow edge. The first issue of this totally unique landscape-format fanzine, produced in the autumn of 1980, was printed at Better Badges on Portobello Road. We sold out. Three months later we printed Issue 2, The Star Issue. I was still on my fluorescent kick and wanted to stick to graphics and avoid personalities on the cover. So I made a design using a star with the i-D centre. The dot, as I explained to a fan of Masonic conspiracy theories, can be divided through the middle of the letter 'i' with a diagonal drawn between two points of the star. We also printed this logo on badges, with the words 'As seen in i-D', which contributing photographers Steve Johnson, Thomas Degen and James Palmer would give out to people on the street, in bars and clubs when they were photographed for the magazine.

Our first full-colour back cover star, Scrubber, was a young punk who worked at Better Badges. Scrubber, alongside a teenage Neneh Cherry, collated and hand-stapled the issue together. Latent Image, the repro house that I had used

Picture Paper nichts wurde, machte ich seine Straßenporträts zur Ausgangsbasis für ein neues Buch. Ich verließ die Vogue 1977, und ein Jahr später erschien bei Aurum Press Not Another Punk Book. 1980 arbeitete ich immer noch für Aurum, aber das Geld war in Italien, Frankreich und Deutschland zu machen. Donna und das Modelabel Fiorucci waren meine Hauptkunden in Italien. Der Erste, dem ich meine Idee für i-D vorstellte, war Flavio Lucchini, der Chefredakteur von Donna. Ich hoffte, dass er das Magazin verlegen würde, aber er konnte sich nicht vorstellen, dass mit Street Style Geld zu machen war. Nachdem ich sechs Monate abgewartet hatte und bei Donna gefeuert worden war, weil den Anzeigenkunden die Grafik zu krass war, entschied ich mich, es im Alleingang zu machen.

Mein Studio hieß Informat Design, und als wir eines Morgens mit Namen für das neue Magazin um uns warfen, meinte Tricia, i-D sei ganz klar der beste. In den Sechzigern ausgebildete Werbegrafiker konnten noch im Schlaf Idents und Logos kritzeln. i-D war eine Kritzelei, die nicht nur das Cover meines Punk-Buchs zitierte – Siebdruck mit schwarzer Type auf Neonpink –, sondern auch den Vogue-Titel zum 75-jährigen Bestehen 1976, der Schuld daran war, dass ich dort meinen Abschied nehmen musste. Das „Fashion Magazine" in schablonierten Buch-

En 1980, je travaillais encore pour Aurum, mais l'argent se trouvait en Italie, en France et en Allemagne. Le magazine Donna et la griffe de mode Fiorucci étaient mes principaux clients italiens. J'ai d'abord parlé d'i-D à Flavio Lucchini, directeur de la publication de Donna, en espérant qu'il en deviendrait l'éditeur, mais il pensait que la mode de la rue ne rapporterait jamais rien. Six mois ont passé et je me suis fait virer de chez Donna parce que les annonceurs trouvaient mon graphisme trop marqué. J'ai décidé de faire cavalier seul.

Mon studio s'appelait Informat Design, et un matin, alors que nous cherchions un nom pour le nouveau magazine, Tricia a déclaré qu'i-D était vraiment la meilleure idée. Pour des graphistes formés dans les années 60, concevoir des identités et des logos à partir de ce concept serait un jeu d'enfant. i-D, c'était « simple comme bonjour », une référence à la couverture de mon livre sur les punks, sérigraphiée en rose fluo avec une typographie noire, mais aussi à la couverture du 60e anniversaire de Vogue en 1976 qui avait abouti à ma démission. La mention « Fashion Magazine » (magazine de mode), réalisée au pochoir, était le seul indice révélant le contenu d'i-D.

Les portraits de rue réalisés par Steve Johnston pour mon livre sur les punks ont formé la base de l'identité mode d'i-D. On appelait ça des

for the 'Masters of Erotic Photography'
book I produced in 1977, made the scan
from Thomas Degen's 35mm slide. Joly's
badge printers enjoyed testing their A4
printing press to its limit. The print
run had doubled and was overstretching
their machinery.
The i-D eye is a graphic pun. Third
issue. Third eye. Perry Haines, who had
joined the magazine during the first
issue, became i-D's first Editor. Perry
was an ex-Blitz kid and a fashion
journalism student from Saint Martins,
responsible for coining the 'New
Romantic' title, which would define the
flamboyant style of Steve Strange, Boy
George and Blitz host Chris Sullivan,
as well as bands like Spandau Ballet
and Duran Duran. Perry was definitely
i-D's man about town. He ran the i-D
nights at Gossips in Soho. He also
became a stylist, dressing Duran Duran
in frilly shirts and the Stray Cats in
Robot's brothel creepers. Perry was the
wordsmith and master slogan maker for
i-D's early days, inventing 'i-D opens
idle eyes'.
Caroline Baker, an ex-'Nova' stylist who
was working with her friend Vivienne
Westwood developing ideas about fashion

staben war das Einzige, das erkennen ließ, was
einen im Heft erwartete.
Steve Johnsons Porträts von Leuten auf der
Straße wurden zur Grundlage der Fashion
Identity von i-D. Wir nannten sie „Straight-
Ups", ein typischer Ausdruck des englischen
Südwestens, der so viel bedeutet wie „ohne
Umschweife". Teils inspiriert durch die doku-
mentarische Wirklichkeitstreue von August
Sanders Porträts für Menschen des 20. Jahr-
hunderts und Irving Penns Small Trades-Serie,
teils von Stories, die ich noch bei Vogue mit
Oliviero Toscani gemacht hatte, bei denen
wir mit ähnlich direkten Ganzkörperfotos
arbeiteten. Ich mochte den Reportagestil,
das Lebendige daran. Aus diesen Straight-
Ups, aufgelockert mit je einem Minifragebogen
als Text, in dem die Leute selbst zu Wort
kamen, entstand das erste Mode-Fanzine
der Welt.
Auf dem Backcover der ersten Ausgabe, die
eins von Steves Porträtfotos zeigte, las man
das i-D-Manifest: „Stil ist nicht, was du
trägst, sondern wie du es trägst. Mode ist,
wie du gehst und stehst, redest und tanzt.
Durch i-D reisen Ideen schnell und am Main-
stream vorbei – kommt mit, wenn Ihr schnell
genug seid. "
Joly MacFie, der König der Fanzines und Hippie
des Universums, betrieb Better Badges, eine

« straight-ups », une expression de l'ouest de
l'Angleterre qui pourrait se traduire par
« portraits-vérité ». J'étais en partie inspiré
par l'honnêteté des portraits style documen-
taire social d'August Sander dans Hommes du
XXe siècle, la série Small Trades d'Irving Penn,
mais aussi par les photos d'Oliviero Toscani
à l'époque où je travaillais chez Vogue, dont le
style direct me rappelait les portraits de punks
en pied. J'aimais cette énergie proche du
reportage. Accompagnés d'un texte sous forme
de questionnaire minimaliste dans l'esprit
micro-trottoir, ces portraits-vérité ont ainsi
donné forme au tout premier fanzine de mode
de l'histoire.
La quatrième de couverture du premier numéro,
avec un très gros plan signé Steve, présentait le
manifeste d'i-D : « Le style n'a rien à voir avec
les vêtements que vous portez, mais avec votre
façon de les porter. La mode, c'est votre manière
de marcher, de parler, de danser et de vous
pavaner. A travers i-D, les idées voyagent vite,
insensibles au courant dominant : fuyez avec
nous. »
Joly MacFie, le maître des fanzines et plus grand
hippie de l'univers, possédait Better Badges,
une entreprise qui fabriquait des badges pour
promouvoir des groupes de rock. Joly a accepté
ma proposition : imprimer en offset 2 000 exem-
plaires du magazine au format A4, avec une

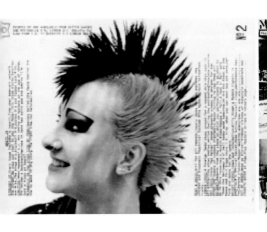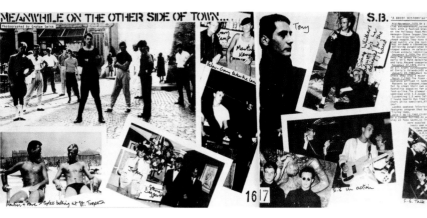

and bondage, was i-D's first fashion
editor. She styled the third issue's
back cover of a Westwood pirate girl,
while inside, Thomas Degen, another
regular member of the i-D posse at
Sherriff Road, photographed Vivienne and
her team at the World's End shop. The
insertion of a gold flexi disc of 'Your
Attention Please' by the Scars, one of
Alex McDowell's clients, was an added
perk to the 60 pence cover price.
Alex McDowell was a graphic
collaborator on i-D from the beginning,
and the early production of the
magazine was balanced between our house
on Sherriff Road and Rocking Russian
Design Studio in Berwick Street. I met
Al while he was a fine art student at
the Central School of Art. He was the
only punk artist I knew, and I had
included a graphic representation of
his work in the 'Punk' book (his
paintings had been destroyed by the
head of the college on the last day of
viewing). The moment he left, Al set up
Rocking Russian and began designing
cover sleeves for emerging music bands.
His first client was the band Rich Kids
with Glen Matlock (ex-Sex Pistols),
Midge Ure (future Ultravox), Rusty Egan

Firma, die Promo-Badges für Rockbands her-
stellte. Joly sah sich meinen Vorschlag an und
war einverstanden, 2000 A4-Exemplare eines
Hefts mit etwas dickeren Papierbögen vorne
und hinten als Cover, handgetackert an der
kurzen Seite, im Offsetverfahren zu drucken.
Die erste Ausgabe dieses durch sein Quer-
format einzigartigen Fanzines im Herbst 1980
wurde bei Better Badges in der Portobello
Road gedruckt. Wir verkauften die komplette
Auflage.
Drei Monate später druckten wir die zweite
Ausgabe, The Star Issue. Ich fuhr immer noch
auf Neonfarben ab, außerdem wollte ich bei
grafischer Gestaltung bleiben, anstatt Leute
auf den Titel zu nehmen. Darum entwarf ich
für das Cover einen fünfzackigen Stern, in
dem „i-D" stand. Der Punkt lässt sich vom
Rest des „i" abschneiden, indem man eine
Diagonale zwischen zwei Spitzen des Sterns
zieht, wie ich einem Freund mit einer Vor-
liebe für Verschwörungstheorien erklärte.
Dieses Logo druckten wir zusammen mit
dem Spruch „As seen in i-D" auf Badges, die
Steve Johnston, Thomas Degen und James
Palmer an die Leute auf der Straße, in Knei-
pen und in Clubs verteilten, wenn sie foto-
grafierten.
Scrubber, der Star unseres ersten farbigen
Backcovers, war ein junger Punk, der bei Better

couverture et une quatrième en papier plus
épais, le tout agrafé à la main le long d'une
tranche étroite. Produit à l'automne 1980, le
premier numéro de ce fanzine au format pay-
sage absolument unique a donc été imprimé
chez Better Badges dans Portobello Road. Nous
en avons écoulé le moindre exemplaire.
Trois mois plus tard, nous avons fait imprimer le
numéro 2, The Star Issue. J'étais encore dans ma
période fluo et voulais m'en tenir au graphisme,
en évitant les personnalités en couverture. J'ai
donc créé un logo avec une étoile et les lettres
« i-D » au milieu. Le point du « i », comme je l'ai
expliqué à un amateur de conspirations maçon-
niques, peut être divisé en son centre par la
diagonale tirée entre deux pointes de l'étoile.
Nous avons aussi fait imprimer ce logo sur des
badges, avec les mots « As seen in i-D » (vu
dans i-D), que Steve Johnston, Thomas Degen
et James Palmer offraient à ceux qu'ils
photographiaient dans les rues, les bars ou les
boîtes de nuit pour le magazine.
Scrubber, notre première star en couleur sur
une quatrième de couverture, était un jeune
punk qui travaillait chez Better Badges. Scrubber
et une Neneh Cherry alors adolescente ont
tous les deux assemblé et agrafé le numéro
à la main. Latent Image, l'entreprise de
reprographie avec laquelle j'avais travaillé pour
le livre Masters of Erotic Photography en 1977,

(future Visage) and Steve New, who were also all players in London's vibrant club scene.

At the beginning, i-D was only sold in select record stores, fashion boutiques and at the odd news kiosk. Even so, the number of copies kept doubling with each issue and a few newsagents started complaining about the staples piercing fingers and leaving bloody fingerprints on other magazines. So, saddle stitch was the only answer.

By issue 3, Better Badges had ceased trading and Joly had left the country. Our new printer on Tabernacle Street (strangely the same street the i-D office is located today) would not finish printing issue 4 until he was paid for issue 3. I had planned a gold cover for issue 4. The printer had put down the base, an okra yellow, but refused to do more without payment. I could only afford to pay half, so I collected and distributed half, and with those receipts, I went one month later to pick up the rest, which had been finished with the gold cover. The footprint in the sand for the gold-covered Dance + Stance Issue [No. 4, April 1981] was Perry Haines'

Badges arbeitete und zusammen mit Neneh Cherry (damals eine Teenagerin) die Auflage von Hand kollationierte und tackerte. Latent Image, die Reprofirma, mit der ich gearbeitet hatte, als ich 1977 den Fotoband Masters of Erotic Photography herausgab, machte den Scan von Thomas Degens 35-mm-Dia. Jolys Badge-drucker durften zeigen, was ihre A4-Druckmaschine hergab. Das Druckaufkommen hatte sich verdoppelt, ein echter Belastungstest für ihre Offsetmaschinen.

Das Auge mit dem i-D, i-Deye, ist ein grafisches Wortspiel. Dritte Ausgabe. Drittes Auge. Perry Haines, der zur Zeit der ersten Nummer zu i-D stieß, wurde der erste Redakteur des Magazins. Perry war ein Ex-Blitz-Kid, der Modejournalismus am Saint Martins studierte, und er war derjenige, der den Begriff „New Romantic" prägte, der den extravaganten Stil von Steve Strange, Boy George, Blitz-Veranstalter Chris Sullivan und Bands wie Spandau Ballet und Duran Duran definieren sollte. Perry war bei i-D definitiv der Mann, der alles und jeden kannte. Er veranstaltete die i-D-Nächte im Gossip in Soho und wurde nebenbei Stylist, steckte Duran Duran in Rüschenhemden und die Stray Cats in die Creepers von Robot. Perry war der Wortschöpfer und Sloganerfinder in den frühen Tagen von i-D, z. B. von „i-D opens idle eyes" („i-D öffnet faule Augen") .

a réalisé le scan à partir de la diapo 35 mm de Thomas Degen. Les imprimeurs de badges de Joly ont adoré tester les limites de leur presse A4. En fait, le tirage avait doublé et surpassait les capacités de leurs machines.

L'œil i-D est un jeu de mots graphique. Troisième numéro : troisième œil. Perry Haines, qui travaillait sur le magazine depuis le premier numéro, est devenu le premier rédacteur d'i-D. Ex-pilier du Blitz et étudiant en journalisme de mode à Saint Martins, on lui doit l'expression « Nouveaux Romantiques » qui devait définir le style flamboyant de Steve Strange, Boy George, du patron du Blitz Chris Sullivan et de groupes comme Spandau Ballet et Duran Duran. Perry était vraiment l'ambassadeur d'i-D en ville. Il a organisé les soirées i-D au Gossips dans Soho. Il est aussi devenu styliste, habillant les Duran Duran en chemises à volants et faisant porter des creepers Robot aux Stray Cats. Aux débuts d'i-D, Perry était le maître des mots et des slogans, l'inventeur du « i-D opens idle eyes » (i-D ouvre les yeux paresseux).

Caroline Baker, ex-styliste chez Nova qui collaborait avec son amie Vivienne Westwood au développement d'idées sur la mode et le bondage, a été la première rédactrice mode d'i-D. Elle a signé le stylisme de la quatrième de couverture du troisième numéro présentant une Westwood piratesse, tandis qu'à l'intérieur,

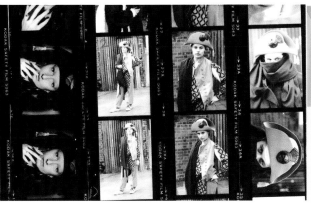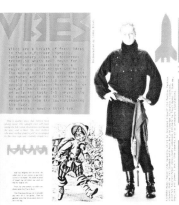

romantic idea. In the early days, Perry sold i-D from the boot of friend Malcolm Garrett's Cadillac. Malcolm was a busy graphic designer doing cover art for Duran Duran, Human League and ABC. His girlfriend, artist Linder Sterling, had created the iconic sleeve graphics for the 'Orgasm Addict' Buzzcocks album. (She later starred in and produced the collage for the Fall 2009 i-D cover.) Malcolm agreed to collaborate on Issue 5 [The Do It Yourself Issue, July 1981]. The cover was to be our first headshot, and as Prince Charles was just about to marry Lady Diana Spencer, we decided to make her the cover star. Coincidentally, Diana's elder sister, Sarah, had been my PA for six months when I worked for 'Vogue'. So I appropriated a wink from an advertisement and stuck it, identikit-style, onto a black-and-white press photograph of Lady Diana. Malcolm wanted the graphic repeat of i-D running front to back - i-Di-Di-Di-D. We came up with the compromise to print a fluorescent pink logo over a solid Royal blue background. That completed our first D.I.Y edition.

Caroline Baker, eine ehemalige Nova-Stylistin, die gemeinsam mit ihrer Freundin Vivienne Westwood mit Mode und Bondage experimentierte, war die erste Moderedakteurin von i-D. Sie stylte das Backcover der dritten i-D-Ausgabe, auf dem wir ein Westwood-Piratenmädchen hatten, und im Heft fotografierte Thomas Degen Vivienne und ihr Team in ihrem Laden, World's End. Die beigelegte Gold-Flexi-Disc mit „Your Attention Please" von den Scars war ein zusätzlicher Anreiz, die 60 Pence für das Heft zu bezahlen.

Alex McDowell war ein grafischer Mitstreiter der ersten Stunde, als i-D noch parallel in meinem Haus auf der Sheriff Road und im Designstudio Rocking Russian auf der Berwick Street produziert wurde. Ich lernte Alex kennen, als er noch an der Central School of Art Kunst studierte. Er war der einzige Punk-Künstler, den ich kannte, und ich hatte einige seiner Werke in mein Punk-Buch hereingenommen (seine Bilder waren am letzten Tag der Ausstellung vom Leiter des Colleges vernichtet worden). Als Al seinen Abschluss hatte, gründete er Rocking Russian und begann Cover für kommende Bands zu gestalten, das erste davon für die Band Rich Kids. Sie bestand aus Glen Matlock (Ex-Sex-Pistols), Midge Ure (später Ultravox), Rusty Egan (später Visage) und Steve New, allesamt wichtige Figuren der

Thomas Degen, autre pilier de la bande i-D de Sherriff Road, a réalisé les photos de Vivienne et de son équipe dans la boutique World's End. Pour le modique prix de 60 pence affiché en couverture, le lecteur s'est aussi vu offrir un 45 tours flexible doré de Your Attention Please, un titre des Scars, groupe comptant parmi les clients d'Alex McDowell.

Alex McDowell était l'un des tout premiers graphistes d'i-D, à l'époque où la production du magazine se partageait encore entre notre maison de Sherriff Road et le studio de création Rocking Russian de Berwick Street. J'ai rencontré Al quand il était étudiant en beaux-arts à la Central School of Art. C'était le seul artiste punk de ma connaissance, et j'avais inclus une présentation graphique de son travail dans mon livre sur les punks (ses tableaux avaient été détruits par le directeur de l'université le dernier jour de l'exposition). Dès la fin de ses études, Al avait créé Rocking Russian et commencé à réaliser des pochettes d'album pour des groupes émergents. Ses premiers clients étaient les Rich Kids, avec Glen Matlock (ex-Sex Pistols), Midge Ure (futur membre d'Ultravox), Rusty Egan (futur membre de Visage) et Steve New, autant de musiciens qui contribuaient à l'effervescence de la scène club de Londres.

Au départ, i-D n'était vendu que dans certaines boutiques de disques, de vêtements et plus

By Issue 6 [The Sweat is Best Issue, August 1981] we had attracted international attention. Suddenly we had strangers coming to our house and buying bundles of i-D to ship back to Tokyo, Paris and Sydney. The cover of Issue 6, a photograph of an oriental face by Thomas Degen, was graphiced over. This was the second issue published by a new printer based in Peckham. All the pages were hand-artworked to size. To keep costs down, I prepared artwork to view on boards. For the cover I convinced the printer that my hand-making separations for each of the four colours would work and that mis-registration was intended. The yellow face was not a mistake and the mash of Letraset headlines was a design decision. Six was our first tongue-in-cheek 'sex' issue.

Hand separations continued as each page was treated as a piece of art. For Issue 8 [The Head to Toe Issue, October 1982], I gave James Palmer's photo of a young model a fluorescent pink face and scribbled yellow hair. By its third year, i-D's artwork became even more elaborate. I wanted to get back to the physical side of design where it was

pulsierenden Londoner Clubszene.
Anfangs wurde i-D nur in ausgesuchten Plattenläden, Modeläden und dem ein oder anderen Zeitschriftenkiosk verkauft. Trotzdem verdoppelte sich die Auflage mit jeder neuen Ausgabe, und einige Zeitschriftenhändler beschwerten sich, dass sie sich an den Heftklammern in die Finger stachen und darum blutige Fingerabdrücke auf anderen Zeitschriften hinterließen. Die einzige Lösung war eine Rückendrahtheftung.

Zeitgleich mit Ausgabe 3 war Better Badges pleite. Joly hatte das Land verlassen, und unser neuer Drucker auf der Tabernacle Street (dieselbe Straße, auf der wir heute unsere Räume haben) war nicht bereit, Ausgabe 4 zu drucken, ehe Ausgabe 3 bezahlt war. Ich hatte für Ausgabe 4 ein goldenes Cover geplant. Der Drucker hatte die Grundfarbe gedruckt, ein Ockergelb, weigerte sich aber, mehr zu machen, solange er nicht bezahlt wurde. Ich konnte nur die Hälfte der Summe zahlen, also nahm ich die Hälfte der Hefte und gab sie in den Vertrieb, und mit den Einnahmen dafür holte ich mir einen Monat später den Rest mit dem fertigen Gold-Cover ab.

Der Fußabdruck im Sand für die goldene Dance + Stance -Ausgabe war Perry Haines' romantische Idee. In den frühen Tagen verkaufte Perry i-D aus dem Kofferraum eines Cadillacs,

rarement dans les kiosques à journaux. Malgré un réseau de distribution aussi modeste, le tirage doublait à chaque parution. Quelques marchands de journaux ont commencé à se plaindre des agrafes qui leur blessaient les doigts : ça laissait des empreintes de sang sur les autres magazines. Le moment était venu de passer au format broché.

Lors du numéro 3, Better Badges avait fermé boutique et Joly quitté le pays. Notre nouvel imprimeur dans Tabernacle Street (où, curieusement, se trouvent les actuels bureaux d'i-D) refusait de finir l'impression du numéro 4 tant qu'il n'avait pas été payé pour le numéro 3. J'avais prévu une couverture dorée pour le numéro 4. L'imprimeur avait déjà réalisé la base dans un jaune ocre, mais refusait d'en faire plus sans être payé. Comme je ne pouvais pas lui régler plus de la moitié du tirage, j'ai pris et distribué les magazines, puis suis revenu un mois plus tard avec les recettes pour récupérer les exemplaires restants, désormais parés de leur couverture dorée.

L'idée romantique de l'empreinte de pas dans le sable pour The Dance + Stance Issue tout d'or vêtu [n° 4, avril 1981] était celle de Perry Haines. Aux débuts du magazine, Perry vendait i-D depuis le coffre de la Cadillac de son ami Malcolm Garrett, un graphiste très sollicité qui faisait des couvertures d'album pour Duran

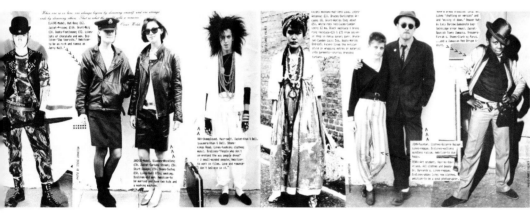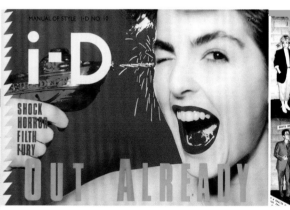

made with a sense of urgency, and the idea that it was made just before you picked it up and read it. Conceptually I wanted i-D to reflect that moment in time. By using hand skills, we could do that. Instant Design's philosophy is free from conventions, leaving room for accidents. We used old typewriters for text, handwriting, photocopies, stencils, potato prints, rubber stamps and Dymo strips, as well as tear, cut and paste montage to create our pages. In the early days of i-D we went through the stage of functional illegibility, until we perfected the art of illegibility, when even the headlines needed subtitles! These graphic layers added the illusion of speed, but at the same time slowed the reader down. i-D's raw, immediate look was pure controlled chaos.

The switch from landscape to portrait format, to appeal to distributor W.H. Smiths, happened with Issue 14, The All Star Issue, in April 1983. Nick Knight photographed Sade for the issue's cover, a year before she signed a recording contract. The following May, The SeXsense Issue, [No. 15], featured a very young Madonna shot by Mark Lebon

der seinem Freund Malcolm Garrett gehörte. Malcolm war ein sehr gefragter Grafiker, der Plattencover für Duran Duran, Human League und ABC gestaltete. Seine Freundin, die Künstlerin Linder Sterling, hatte das legendäre Cover für „Orgasm Addict" von den Buzzcocks entworfen. (Sie war später auf dem i-D-Titel im Herbst 2009 zu sehen, in einer von ihr selbst gestalteten Collage.)

Malcolm war bereit, an Ausgabe 5 [The Do It Yourself Issue, Juli 1981] mitzuarbeiten. Wir wollten zum ersten Mal eine Porträtaufnahme auf den Titel nehmen, und da Prince Charles' Heirat mit Lady Diana Spencer bevorstand, beschlossen wir, sie zum Titelstar zu machen. Übrigens war Dianas ältere Schwester Sarah in den sechs Monaten, die ich bei Vogue arbeitete, meine persönliche Assistentin. Ich klaute also ein Zwinkern aus irgendeiner Anzeige und klebte es über ein schwarz-weißes Zeitungsfoto von Lady Diana; es sah aus wie ein Identikit-Phantombild. Malcolm wollte eine rein grafische Lösung, eine Endloskette von i-Ds auf Titel und Rückseite: i-Di-Di-Di-D. Wir einigten uns auf einen Kompromiss, ein neonrosa Logo auf königsblauem Grund. Damit stand unsere erste Do-it-yourself-Ausgabe.

Mit Ausgabe 6 [The Sweat Is Best Issue, August 1981] hatten wir auch international

Duran, Human League et ABC. Sa petite amie, l'artiste Linder Sterling, avait signé la pochette désormais culte du disque Orgasm Addict des Buzzcocks (plus tard, elle a posé pour le collage de la couverture du numéro Automne 2009 d'i-D, dont elle est aussi l'auteur).

Malcolm a accepté de collaborer sur le numéro 5 [The Do It Yourself Issue, juillet 1981], dont la couverture devait pour la première fois présenter un portrait. Comme le Prince Charles s'apprêtait à épouser Lady Diana Spencer, nous avons décidé d'en faire notre star à la une. Il se trouve que la sœur aînée de Diana, Sarah, avait été mon assistante pendant six mois quand je travaillais chez Vogue. J'ai choisi un clin d'œil dans un visuel publicitaire et l'ai collé, façon portrait robot, sur une photo de presse en noir et blanc de Lady Di. Malcolm voulait répéter le logo en chaîne sur la couverture et la quatrième : i-Di-Di-Di-D. Nous avons trouvé un compromis consistant à imprimer le logo en rose fluo sur un fond uni couleur bleu roi. C'était notre premier numéro D.i.Y.

Au moment du numéro 6 [The Sweat is Best Issue, août 1981], nous avions déjà attiré l'attention du monde entier. Soudain, des étrangers débarquaient dans notre maison de Sherriff Road pour acheter des paquets entiers de magazines qu'ils envoyaient à Tokyo, Paris ou Sydney. La couverture du numéro 5, une photo

a month before her debut album, 'Madonna', was released in the USA. As she was still unknown in the UK, most Londoners mistook Madonna for Boy George's sidekick Marilyn, who had his hair styled at the Antenna hair salon on Kensington Church Street, where Michael Forbes made dreadlock hair extensions the style of the moment. Madonna's famous first cover was also our first issue distributed by W.H. Smiths. We received a letter from them almost immediately after it was published informing us that we had used the word 'sex' too many times, and never to do it again, also that the fluorescent pink background clashed with their new décor!

i-D covers started out as a pure graphic, with the i-D logo an iconic pictogram of a winking eye and smiling face. From Issue 5 [The Do It Yourself Issue, July 1981], I produced the first winking cover with Princess Diana and since then every person who has appeared on the cover of i-D has had to duplicate what has become the magazine's trademark 'wink and smile'. The wink was intended to prompt an interaction and collaboration between

Interesse geweckt. Plötzlich kamen wildfremde Menschen ins Haus und kauften ganze Stapel, um sie nach Tokio, Paris oder Sydney mitzunehmen. Das Cover dieser Ausgabe war ein orientalisches Gesicht, fotografiert von Thomas Degen und grafisch überarbeitet. Es war die zweite Nummer, die wir bei einem neuen Drucker in Peckham produzieren ließen. Das Layout für sämtliche Seiten war passgenau handgemacht. Um Geld zu sparen, bereitete ich die Layouts zum Ansehen auf Kartons vor. Für den Titel überzeugte ich den Drucker, dass meine handgemachten Vierfarbauszüge funktionieren würden und Passer-Ungenauigkeiten beabsichtigt seien: Das gelbe Gesicht sei kein Fehldruck und das Gewirr von Headlines in Letraset-Buchstaben eine Designentscheidung. Ausgabe Nummer 6 war unsere erste ironisierende „Sex"-Ausgabe.

Wir blieben bei den selbst erstellten Vierfarbauszügen, jede Seite wurde behandelt wie ein Kunstwerk für sich. Für Ausgabe 8 [The Head To Toe Issue, Oktober 1982] versah ich James Palmers Foto eines jungen Models mit einem neonpinken Gesicht und gekritzeltem gelbem Haar. Im dritten Jahr wurde das i-D-Artwork noch aufwendiger. Ich wollte zurück zu einem greifbaren Design mit einer Spur von Dringlichkeit, das den Eindruck erweckte, das Heft sei gerade erst zusammengeschustert worden,

de visage asiatique signée Thomas Degen, a été retravaillée dans un esprit graphique. C'était le deuxième numéro réalisé par un nouvel imprimeur basé à Peckham. Toutes les pages étaient dimensionnées à la main. Pour réduire les coûts, j'avais préparé la maquette en la collant sur du carton. Quant à la couverture, j'ai convaincu l'imprimeur que mes séparations manuelles pour chacune des quatre couleurs allaient fonctionner et que les erreurs de mise en page étaient intentionnelles. Le visage jaune n'était pas un accident et les titres qui bavaient en police Letraset relevaient d'une décision créative. Le chiffre six est venu s'insérer à la place du « e » de « sex » pour notre premier numéro ironique et décalé sur le sujet.

Nous avons continué à effectuer les séparations de couleur à la main car chaque page était traitée comme une œuvre d'art. Pour le numéro 8 [The Head to Toe Issue, octobre 1982], j'ai gribouillé des cheveux jaunes sur la photo d'un jeune mannequin prise par James Palmer et colorié le visage en rose fluo. A sa troisième année, la maquette d'i-D était devenue encore plus complexe. Je voulais revenir à l'aspect physique de la création, celle qu'on réalise dans une certaine urgence, comme si tout était fait à la dernière minute juste avant que le magazine ne se retrouve entre les mains du lecteur. Conceptuellement, je voulais que le

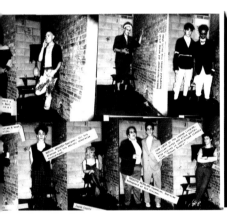 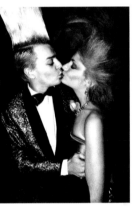 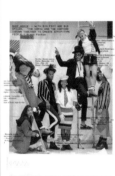 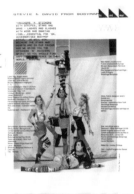 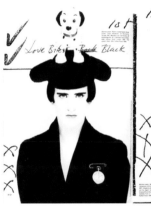 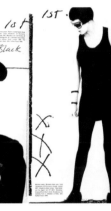

the photographer and the cover star. Each cover is a challenge that has to be solved in its own unique way. This has been proven over the past three decades by the broad variety of i-D covers. Brief sponsorship by Fiorucci for some of the early issues led to a partnership in 1985 with Tony Elliott and his management team at 'Time Out' magazine, and with their help i-D shifted out of our house to a space they provided in Covent Garden. From the very beginning creative people had always found their way to us, including Caryn Franklin, a graphics student at Saint Martins, who arrived one day in the eighties looking for a job. I have a habit of saying: "Here's a pencil, let's see what you can do." At the time I had this project to design 200 stickers for Fiorucci, so I enlisted her help and she started that afternoon. She brought in Stephen Male to lend a hand as well, and when I needed someone who could work our Apple IIE computer (which at the time was something entirely new as a design tool) Caryn recruited Robin Derrick, both of whom were fellow students from Central Saint Martins. Robin is now

kurz bevor man es kaufte und las. Konzeptuell wollte ich damit genau diesen speziellen Moment festhalten. Indem wir alles mit der Hand machten, konnten wir das erreichen. Die „Instant Design"-Philosophie ist frei von Konventionen, lässt Raum für Unfälle. Wir tippten die Texte auf uralten Schreibmaschinen, benutzten Handgeschriebenes, Fotokopien, Schablonenschrift, Kartoffeldruck, Gummistempel, Dymo-Prägebänder, außerdem Montagen und Collagen bei der Gestaltung unserer Seiten. In den frühen Tagen von i-D gingen wir durch eine Phase funktionaler Unleserlichkeit, bis wir die „Kunst" der Unleserlichkeit so weit perfektionierten, dass selbst die Schlagzeilen nicht ohne Untertitel auskamen. Diese grafische Vielschichtigkeit unterstützte den Eindruck von Schnelligkeit, während sie zugleich den Leser entschleunigte. Der halbfertige, unmittelbare Look von i-D war kontrolliertes Chaos pur.

Der Wechsel vom Querformat zum Hochformat, eine Konzession an W.H. Smith, damit sie uns in den Vertrieb nahmen, kam mit Ausgabe 14 [The All Star Issue] im April 1983. Nick Knight fotografierte Sade für den Titel – ein Jahr bevor sie ihren ersten Plattenvertrag unterzeichnete. In der Mai-Nummer desselben Jahres [The SeXsense Issue, Nr. 15] hatten wir eine sehr junge Madonna, fotografiert von Mark Lebon – einen

numéro reflète ce moment précis dans le temps. En travaillant de façon artisanale, on pouvait y arriver. La philosophie d'Instant Design est affranchie des conventions, ce qui laisse de la place aux accidents. Pour le texte, nous avons utilisé de vieilles machines à écrire, de l'écriture manuscrite, des photocopies, des pochoirs, des tampons en pomme de terre, des tampons en caoutchouc et des titreuses Dymo, ainsi que des montages déchirés, copiés et collés pour créer nos pages. Aux débuts d'i-D, nous avons traversé une phase d'illisibilité fonctionnelle jusqu'à ce que nous perfectionnions l'art de l'illisibilité, quand même les titres avaient besoin de sous-titres ! Ces couches graphiques ajoutaient une illusion de vitesse tout en ralentissant la lecture. Le look brut et immédiat d'I-D relevait purement du chaos contrôlé. Lors du numéro 14, The All Star Issue en avril 1983, le magazine a effectué sa transition du format paysage au format portrait pour séduire le distributeur W.H. Smith. Pour la couverture, Nick Knight a photographié Sade un an avant qu'elle ne signe son premier contrat d'enregistrement. Le numéro 15 publié en mai, The SeXsense Issue, présentait une très jeune Madonna photographiée par Mark Lebon un mois avant la sortie américaine de son premier album éponyme. La plupart des Londoniens ont confondu Madonna, encore inconnue en

Creative Director of British 'Vogue'. Moira Bogue was another student who had seen i-D and wanted to do her thesis on the magazine. She turned up to research the genesis of i-D and stayed for eight years. She even ended up as the cover star of Issue 10 [The Out Already Issue, December 1982]. By the end of the eighties, Moira was teaching graphics at the Royal College, and one of her students, Neil 'Easy' Edwards was at the i-D studio assisting Stephen. Another of Moira's students, Mathias Augustyniak, formed M/M, a successful art and design business in Paris with Michael Amzulag in 1992, one year after graduation. As the eighties ended, we marked its passing with a pocket-sized paperback, 'A Decade of i-Deas', published by Penguin Books. We moved office again in November of 1989 to 134 Curtain Road in Shoreditch, where we were on our own and finally had a sense of independence. Shoreditch was not very trendy in those days, and there was nowhere to find lunch apart from the Bricklayer's Arms.
There was an evolution of people who had worked their way up from interns to deputy editors and then left as

Monat bevor ihr erstes Album, Madonna, in den USA erschien. Sie war noch so unbekannt, dass die meisten Londoner sie mit Boy Georges ständigem Begleiter Marilyn verwechselten, der seine Haare beim Antenna Hair Salon stylen ließ, wo Michael Forbes Dreadlock-Extensions gerade zum neuen Trend machte.
Madonnas legendäres erstes Titelbild gehörte zur ersten Ausgabe, die über W.H. Smith vertrieben wurde. Wir bekamen beinahe postwendend einen Brief von ihnen, der uns informierte, dass wir das Wort „Sex" zu oft benutzt hätten und die grellrosa Grundfarbe sich nicht mit ihrer neuen Ladengestaltung vertrug!
i-D-Cover waren anfangs reine Grafiken, das i-D-Logo ein einprägsames Piktogramm: ein zwinkerndes Auge in einem lachenden Gesicht. Seit der Nummer 5 (Do It Yourself Issue, Juli 1981) mit der zwinkernden Prinzessin Diana war es für jeden, der auf dem Titel erschien, Pflicht, unser typisches „Zwinkern und Lächeln" zu reproduzieren. Durch das Zwinkern sollte sich ein Dialog, eine Zusammenarbeit von Fotograf und Coverstar ergeben. Jeder Titel ist eine Herausforderung, die immer wieder völlig neu und überraschend gelöst sein will. Das haben drei Jahrzehnte unterschiedlichster i-D-Cover belegt.
Dass Fiorucci einige der frühen Ausgaben gesponsert hatte, führte 1985 zu einer Partner-

Angleterre, avec Marilyn, le chéri de Boy George qui se faisait coiffer chez Antenna sur Kensington Church Street, salon où Michael Forbes a lancé la grande mode des extensions de dreadlocks.
La célèbre et première couverture de Madonna était aussi notre premier numéro distribué par W.H. Smith, qui nous a envoyé une lettre presque immédiatement après sa diffusion pour dire que nous avions utilisé le mot « sexe » à de trop nombreuses reprises et nous demander de ne plus jamais refaire ça. Le distributeur s'est même plaint que le fond rose fluo jurait dans ses nouveaux locaux !
Les premières couvertures d'i-D relevaient du graphisme pur, le logo i-D évoquant un clin d'œil et un visage souriant sous forme de pictogramme emblématique. Depuis le numéro 5 [The Do It Yourself Issue, juillet 1981], première couverture avec un clin d'œil de la Princesse Diana, toute personne apparaissant à la une d'i-D doit reproduire « le clin d'œil et le sourire » devenus la signature du magazine. Ce clin d'œil avait pour objectif de susciter l'interaction et la collaboration entre le photographe et la star en couverture. Toute couverture est un défi qui doit être relevé de façon unique à chaque fois, comme le prouve la grande variété des unes d'i-D depuis ces trente dernières années.

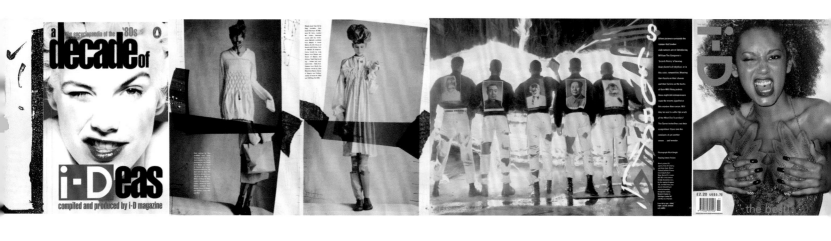

editors, such as Dylan Jones, Editor from 1988, who moved to 'The Face' and has now been the Editor of British 'GQ' for eleven years as well as being a highly respected broadcaster and author. Caroline Baker's job as i-D's first Fashion Editor, was taken over by Caryn Franklin in 1982. Caryn stayed at i-D for six years, with two as joint Editor from 1986 to 1988. She then went on to host 'The Clothes Show' for the BBC which, in its time, provided inspiration for so many of the current wave of UK designers. Caryn continues to be a prolific broadcaster, presenter and campaigner for many special projects. Alix Sharkey joined i-D in 1981, became co-Editor with Caryn and left in 1989 to follow his freelance journalistic career. Simon Foxton, i-D's Menswear Editor discovered Edward Enninful on the tube and used him as a model for a fashion shoot. Edward started hanging out at i-D and became a Junior Fashion Editor, assisting Beth Summers, who had in turn been Caryn's assistant. Beth, who tried to resign two or three times while we were producing 'A Decade of i-Deas', also managed to encourage several maverick

schaft mit Tony Elliott und seinem Management-Team bei Time Out, mit deren Hilfe i-D aus unserem Haus in neue Räume in Covent Garden umzog, die sie uns zur Verfügung stellten. Kreative Menschen hatten von Anfang an irgendwie ihren Weg zu uns gefunden, so auch Caryn Franklin, eine Grafikstudentin vom Saint Martins, die eines Tages in den Achtzigern aufkreuzte und einen Job suchte. Meine Einstellungsgespräche beginnen meistens mit den Worten: „Hier ist ein Bleistift, zeigen Sie mal, was Sie können." Ich hatte damals 200 Sticker für Fiorucci zu entwerfen, darum verpflichtete ich sie sofort zum Dienst, und sie fing noch am selben Nachmittag an. Sie schleppte Stephen Male an, damit er ebenfalls einsprang, und als ich dann jemanden brauchte, der mit unserem Apple IIE-Computer arbeiten konnte (damals ein völlig neues Designmedium), rekrutierte Caryn Robin Derrick; sie studierten beide mit ihr am Saint Martins. Robin ist heute Creative Director der britischen Vogue. Moira Bogue war eine weitere Studentin, die i-D gesehen hatte und ihre Magisterarbeit darüber schreiben wollte. Sie kam, um die Entstehungsgeschichte von i-D zu recherchieren, und blieb insgesamt acht Jahre. Sie landete sogar auf dem Cover von Ausgabe 10 [The Out Already Issue, Dezember 1982]. Ende der Achtziger lehrte Moira Grafikdesign am Royal College, und einer ihrer

Notre bref parrainage par Fiorucci pour certains des premiers numéros a abouti à un partenariat en 1985 avec Tony Elliott et l'équipe de direction du magazine Time Out. Avec leur aide, la rédaction d'i-D a quitté notre maison de Sheriff Road pour s'installer dans leurs locaux de Covent Garden. Dès les débuts du magazine, les gens sont toujours venus nous voir d'eux-mêmes, notamment Caryn Franklin, alors étudiante en graphisme à Saint Martins, qui a débarqué un jour dans les années 80 en quête d'un travail. J'ai l'habitude de dire : « Prends un crayon et montre-moi ce que tu sais faire. » Comme je travaillais à la conception de 200 autocollants pour Fiorucci, je l'ai embauchée et elle a commencé l'après-midi même. Elle a fait venir Stephen Male pour nous prêter main forte, puis quand j'ai eu besoin d'une personne capable d'utiliser notre ordinateur Apple IIE (à l'époque, rares étaient ceux qui savaient s'en servir comme d'un outil de création), Caryn a embauché Robin Derrick, qu'elle avait connu sur les bancs de Saint Martins. Robin est aujourd'hui directeur de la création du Vogue anglais. Moira Bogue est une autre étudiante qui connaissait i-D et désirait écrire sa thèse sur le magazine. Elle est venue pour étudier la genèse d'i-D et est restée avec nous pendant huit ans. Elle a même fait la couverture du numéro 10 [The Out Already Issue, décembre 1982]. A la fin des

photographers to join the i-D stable, including Norman 'Normski' Anderson, who arrived in our offices on his mountain bike, much to everyone's surprise, because the ride up to the first floor was via a metal staircase. Derrick Ridgers was another photographer who appealed to Beth's punk sensibility; he was working on an art project on the most dangerous women in the world at the time.

By the late eighties the magazine was going global with world tour exhibitions, collaborations and special i-D nights. In 1988, Moichi Kuwahara and Club King invited i-D to Tokyo to do a week at Spiral Hall. Steve Male developed the fluorescent pink, orange and green pop-op colour scheme and the surreal graphics based on the eye and mouth that would become the cover of The Graduation Issue [No. 60, July 1988]. The 'Pop Op Surreal' multi-media event we staged included images from the magazine projected onto a giant egg and afternoons where a DJ would play music while people watched the 1969 British comedy series 'On the Buses' and Mexican director Luis Buñuel's 'Un Chien Andalou' ('An Andalusian

Studenten, Neil „Easy" Edwards, arbeitete im i-D-Studio als Assistent von Stephen. Ein anderer von Moiras Studenten, Mathias Augustyniak, gründete 1992, ein Jahr nach seinem Abschluss, in Paris zusammen mit Michael Amzalag die erfolgreiche Kunst- und Design-Agentur M/M. Als die Achtziger zu Ende gingen, würdigten wir sie mit einem Taschenbuch, das bei Penguin Books erschien, A Decade of i-Deas.

Im November 1989 zogen wir erneut um, in die Curtain Road 134 in Shoreditch, wo wir ganz allein waren und endlich das Gefühl hatten, unabhängig zu sein. Shoreditch war damals nicht besonders trendig, und die einzige Adresse für die Lunchpause war das Bricklayer's Arms. Es gab einen stetigen Fluss von Leuten, die sich von Praktikanten zu Redaktionsassistenten hocharbeiteten und uns schließlich als Redakteure verließen. Dylan Jones war bei uns 1988 Redakteur, wechselte dann zu The Face und ist jetzt seit mittlerweile elf Jahren Chefredakteur der britischen GQ, daneben ein gefragter Autor und eine bekannte Fernsehpersönlichkeit. Caryn Franklin übernahm 1982 den Job von Caroline Baker, unserer ersten Moderedakteurin. Caryn blieb sechs Jahre bei i-D, zwei davon, von 1986 bis 1988, teilte sie sich das Amt als leitende Redakteurin. Sie wechselte von uns zur BBC, wo sie The Clothes Show

années 80, Moira enseignait le graphisme au Royal College, et l'un de ses étudiants, Neil « Easy » Edwards, travaillait comme assistant de Stephen dans l'atelier d'i-D. Un autre étudiant de Moira, Mathias Augustyniak, a fondé M/M, un studio d'art et de design à succès basé à Paris, avec Michael Amzalag en 1992, un an après l'obtention de son diplôme. A la fin des années 80, nous avons honoré le terme de la décennie en sortant A Decade of i-Deas, un livre de poche publié par Penguin Books. Nos bureaux ont à nouveau déménagé en novembre 1989 pour s'installer au 134 Curtain Road à Shoreditch, où nous étions enfin entre nous avec un vrai sentiment d'indépendance. Shoreditch n'était pas un quartier très branché à cette époque, et il n'y avait aucun endroit où déjeuner en dehors du Bricklayer's Arms. Certains collaborateurs, arrivés comme stagiaires, ont gravi les échelons pour devenir rédacteurs adjoints puis rédacteurs, à l'instar de Dylan Jones, rédacteur à partir de 1988, qui est ensuite parti chez The Face et occupe aujourd'hui le poste de rédacteur en chef du GQ anglais depuis onze ans tout en étant aussi un producteur et un auteur très respecté. Le poste de Caroline Baker, première rédactrice mode d'i-D, a été repris par Caryn Franklin en 1982. Caryn a passé six ans chez i-D, dont deux en tant que rédactrice adjointe de 1986 à 1988.

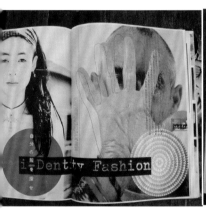
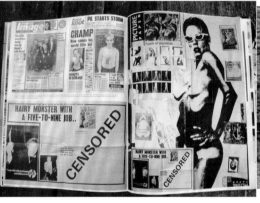
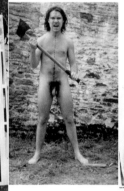

Dog'). No one will ever forget the performance by the band Choice, and lead singer Sarah Stockbridge's finale wearing nothing but a string of electric Christmas tree lights draped around her body.

London's meteoric rise as a hotbed of innovative talent in the early eighties had fizzled out just as quickly by the end of the decade. But during that short time, London's creative energy captured the attention of the international fashion and music industries.

What started out as one big fancy dress party, fuelled by the exuberant rebelliousness of college students and musicians, was turning into a morning after hangover. During the eighties designers and clothing manufacturers from all over the world were trawling London's streets, markets and vibrant club scene for inspiration, hiring design assistants fresh from Central Saint Martins or the Royal College of Art. These graduates went abroad to work, but were often sent back after a couple of seasons, or as soon as the ideas ran out, and a new bunch took their place. It was one thing to pull together looks for the street or

moderierte, die zu ihrer Zeit viele der neuen Welle britischer Designer inspirierte. Caryn ist heute erfolgreiche Fernsehproduzentin, Moderatorin und Ideengeberin für verschiedenste Projekte. Alix Sharkey kam 1981 zu i-D, war gemeinsam mit Caryn Redakteur und verließ uns 1989, um als freier Journalist zu arbeiten. Simon Foxton, der Männermoderedakteur, entdeckte Edward Enninful in der U-Bahn und engagierte ihn für ein Modeshooting. Edward trieb sich oft in den i-D-Büros herum und wurde schließlich Redaktionsassistent für Beth Summers, die wiederum Caryns Redaktionsassistentin gewesen war. Beth, die zwei oder drei Mal kündigen wollte, während wir an A Decade of i-Deas arbeiteten, gelang es auch, diverse nonkonformistische Fotografen an uns zu binden, unter anderen Norman „Normski" Anderson, der auf seinem Mountainbike in unserer Redaktion ankam – zur allgemeinen Überraschung, da man eine Metalltreppe hochfahren musste, um in den ersten Stock zu kommen. Derrick Ridgers war ein weiterer Fotograf, der Beths Punk-Instinkte ansprach, er arbeitete damals an einem Kunstprojekt über die gefährlichsten Frauen der Welt.

In den späten Achtzigern begann auch für i-D die Globalisierung mit weltweiten Wanderausstellungen, Kollaborationen und speziellen i-D-Nächten. 1988 luden Moichi Kuwahara und

Elle est ensuite devenue présentatrice de The Clothes Show sur la BBC, une émission qui, à l'époque, a inspiré une grande partie des créateurs de mode anglais actuels. Caryn est aujourd'hui une productrice, présentatrice et militante prolifique qui travaille sur de nombreux projets étonnants. Alix Sharkey a rejoint i-D en 1981, est devenu co-rédacteur avec Caryn, puis a quitté le magazine en 1989 pour poursuivre une carrière de journaliste free-lance. Simon Foxton, le rédacteur de la mode masculine chez i-D, a rencontré Edward Enninful dans le métro et l'a recruté comme mannequin pour une séance photo. Edward s'est mis à traîner dans les bureaux d'i-D avant de devenir rédacteur junior en mode pour assister Beth Summers, qui avait elle-même été l'assistante de Caryn. Alors qu'elle avait tenté de démissionner deux ou trois fois pendant la production du livre A Decade of i-Deas, Beth a également réussi à attirer plusieurs photographes dissidents dans l'écurie i-D, dont Norman « Normski » Anderson qui a débarqué dans nos bureaux sur son mountain bike, à la plus grande surprise de tous parce qu'on ne pouvait atteindre le premier étage que par un escalier en métal. Derrick Ridgers est un autre photographe qui a su titiller la fibre punk de Beth parce qu'il développait un projet artistique sur les femmes les plus dangereuses du monde.

clubbing, but quite another when financial backers started demanding: "Give me ten more ideas like that, but make them commercial."

For those who did manage to survive the intense hype and set themselves up in business, the outlook was often just as grim. Some young designers who had been showing in London, like Stephen Linard and Body Map, struggled financially and closed, while others, like John Galliano, packed up and moved to Paris. The fashion press and buyers were right behind them, as Paris was once again feeling energised by designers like Jean Paul Gaultier, Rei Kawakubo and Yohji Yamamoto, as well as an influx of edgy Belgians. Avant-garde fashion was no longer being shoved into a niche: it was becoming a business.

The nineties were also a period of change for i-D as we watched the homemade fanzine that began life on the kitchen table morphing into an international fashion magazine. When wordsmith Kate Flett left i-D to join Nick Logan at 'The Face' as Fashion Editor, Features Editor and six years later editor for 'Arena', John Godfrey was brought in by Dylan to assist. When

Club King i-D nach Tokio ein, um eine Woche im Kulturzentrum Spiral Hall zu gestalten. Steve Male entwickelte das neonrosa-orange-grüne Pop-Op-Farbschema und das surreale Grafik-design mit dem Auge und dem Mund, das wir auch auf den Titel unserer Graduation-Ausgabe nahmen [Nr. 60, Juli 1988]. Bei dem von uns ausgerichteten Multimediaevent „Pop Op Sur-real" sah man unter anderem Bilder aus dem Magazin auf ein riesiges Ei projiziert oder konnte Nachmittage erleben, an denen ein DJ auflegte, während die Leute sich die britische Comedy-serie On the Buses (1969) oder Ein andalusi-scher Hund von Luis Buñuel ansahen. Und der Auftritt der Band Choice wird wohl jedem un-vergesslich bleiben, besonders den der Sänge-rin Sarah Stockbridge, die zum Finale eine um ihren Körper drapierten Weihnachtslichterkette trug, sonst nichts.

Londons kometenhafter Aufstieg zum Nähr-boden innovativer Talente Anfang der Achtziger hatte sich zum Ende des Jahrzehnts ebenso schnell totgelaufen. Aber während dieser kur-zen Zeit war die internationale Mode- und Musikindustrie auf Londons kreative Energie aufmerksam geworden. Was als riesige, durch die übermütige Rebellion von Studenten und Musikern befügelte Kostümparty begonnen hatte, verwandelte sich in den Kater am nächsten Morgen. Im Laufe der Achtziger

Vers la fin des années 80, le magazine s'est internationalisé par le biais d'expositions itinérantes qui ont fait le tour du monde, ainsi que grâce à des collaborations et des soirées i-D spéciales. En 1988, Moichi Kuwahara et la société Club King ont invité i-D à Tokyo pour une semaine au Spiral Hall. Steve Male a conçu la palette « pop-op » de rose, d'orange et de vert fluo ainsi que le graphique surréaliste inspiré de l'œil et de la bouche qui ont fini en couverture de The Graduation Issue [n° 60, juillet 1988]. L'événement multimédia « Pop Op Surreal » que nous avons organisé incluait la projection d'images du magazine sur un œuf géant et des après-midi où un DJ passait de la musique pendant que les gens regardaient On the Buses, une sitcom anglaise de 1969, et Un Chien Andalou du réalisateur mexicain Luis Buñuel. Personne n'oubliera jamais la performance du groupe Choice, ni sa chanteuse Sarah Stockbridge qui a conclu le concert uniquement vêtue d'une guirlande de Noël électrique enroulée autour de son corps nu. L'ascension fulgurante de Londres au statut de pépinière de talent et d'innovation au début des années 80 s'est arrêtée net à la fin de la décennie, alors qu'au cours de cette brève période, la créativité de la ville avait pourtant captivé l'attention des industries internationales de la mode et de la musique. Après le grand

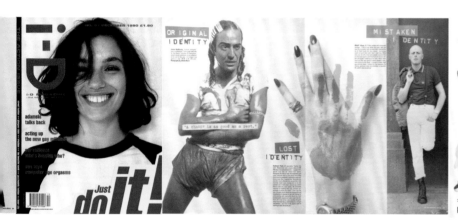
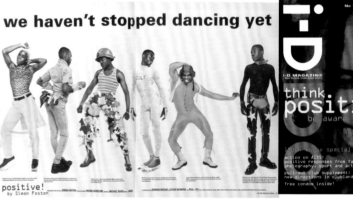

Dylan left to edit 'The Face' in 1988, John, as Editor, took the magazine into the nineties. We wanted to go beyond the facade and touch on social issues, the environment, food and pop culture. John went on to be an editor at 'Eurotrash' before moving to Australia. By that time, i-D had developed a reputation as a creative breeding ground, and the first wave of i-D talent from the eighties was passing the torch on to a new generation. Legendary contributing stylist Ray Petri, who often worked with Mark Lebon, was one of the high profile victims of Aids. For this reason we dedicated our 100th issue to the challenge of the epidemic, with Ray's friend and 'Buffalo girl' Neneh Cherry photographed by Jenny Howarth on the cover. In 1991 Erward Enninful, at age 18, was appointed i-D's Fashion Director. The process carried on, and the magazine expanded with each new team.

i-D had started life as my second job, but towards the end of the eighties and into the nineties I was juggling my job as European Art Director for Esprit, the San Francisco-based clothing

grasten Designer und Bekleidungsfirmen aus aller Welt die Straßen, Märkte und Clubs ab und engagierten Mode-und-Design-Assisten-ten direkt von Central Saint Martins oder dem Royal College of Art. Diese Absolventen gingen zum Arbeiten ins Ausland, wurden aber oft nach einigen Saisons wieder zurück-geschickt, wenn ihnen die Ideen ausgingen und der nächste Jahrgang an ihre Stelle trat. Ein paar Looks für Straße oder Clubbing zu-sammenzuwerfen, ist eine Sache, aber es ist etwas ganz anderes, wenn deine Finanz-investoren dir im Nacken sitzen: „Bring mir noch zehn Ideen wie die da, aber diesmal kommerziell."

Für die Überlebenden des mörderischen Hypes, die tatsächlich ins Geschäft kamen, waren die Aussichten oft ähnlich düster. Einige junge Designer, die Shows in London hatten, wie Stephen Linard und Body Map, kämpften mit finanziellen Schwierigkeiten und mussten aufgeben, während andere, wie John Galliano, ihre Sachen packten und nach Paris umsiedelten. Die Modepresse und die Ein-käufer gleich hinterher, weil Paris durch De-signer wie Jean Paul Gaultier, Rei Kawakubo, Yohji Yamamoto und trendige Belgier auf ein-mal eine Energiespritze bekam. Avantgarde-Mode war keine Nische mehr – sie war ein Ge-schäft.

bal costumé emmené par l'exubérante insub-ordination des étudiants et des musiciens, la capitale anglaise semblait avoir la gueule de bois. Pendant les années 80, stylistes et fabri-cants de vêtements du monde entier venaient traîner dans les rues, les marchés et les clubs effervescents de Londres en quête d'inspiration, recrutant des assistants à peine sortis de Central Saint Martins ou du Royal College of Art. Ces jeunes diplômés partaient travailler à l'étranger, mais on les renvoyait souvent chez eux au bout de deux ans ou dès qu'ils étaient à court d'idées pour les remplacer par du sang neuf. Ils n'avaient aucune difficulté à créer des looks pour la rue ou le clubbing, mais les choses se corsaient quand les financiers commençaient à exiger « encore dix idées comme ça, mais plus commerciales ».

Pour ceux qui ont survécu à cette intense hype et réussi à gagner leurs galons dans le métier, les perspectives étaient souvent tout aussi sinistres. Certains jeunes créateurs qui présen-taient leurs collections à Londres, comme Stephen Linard et Body Map, ne s'en sortaient pas financièrement et fermaient boutique, tandis que d'autres tels que John Galliano faisaient leur valise pour aller s'installer à Paris. Les magazines de mode et les acheteurs les suivaient, car Paris renaissait de ses cendres sous l'impulsion de couturiers comme Jean Paul

company, as well as running i-D. This double duty added a sense of urgency to every issue. With Tony Elliott's 'Time Out' team managing our finances, I would always be coming in to the i-D office just as we approached our deadlines. The editorial and art department would be ready with the content of the next issue laid out and spread on the floor. Then we would shift stuff around to get the final edit. Once I started travelling every week between London, San Francisco, Düsseldorf, Milan and Paris for Esprit, I asked Nick Knight to help me out as i-D's Picture Editor. The other editors were confident enough to carry on without me being there 100 percent of the time, and the magazine grew. With Stephen Male as Art Director, Nick Knight encouraged a new wave of photographic talent to be part of the i-D team including David Sims, Juergen Teller and Andrew MacPherson, as well as two of his own assistants, Sølve Sundsbø and Craig McDean. Craig's first cover, The Born Again Issue, No. 86, is one of my favourites and was shot whilst Craig was still working with Nick in November 1990. It all happened

Für i-D waren die Neunziger ebenfalls eine Zeit der Veränderung, und wir erlebten, wie das am Küchentisch entstandene Fanzine sich zum internationalen Modemagazin entwickelte. Als unsere Wortschöpferin Kate Flett i-D verließ, engagierte Dylan John Godfrey als Assistenten, und als Dylan ging, um Chefredakteur bei The Face zu werden, führte John als Redakteur die Zeitschrift in die Neunziger. Wir wollten weiterhin mehr als die Fassade zeigen und auch Themen wie soziale und Umweltfragen, Essen und Trinken, die Popkultur einbeziehen. John zog weiter in die Redaktion von Eurotrash, ehe er schließlich in Australien landete. Mittlerweile hatte i-D sich einen Ruf als Schmiede für Kreative geschaffen, und die erste i-D-Generation aus den Achtzigern gab die Fackel an ihre Nachfolger weiter. Unser legendärer freier Stylist Ray Petri, der viel mit Mark Lebon arbeitete, gehörte zu den prominenten AIDS-Toten. Aus diesem Grund stellten wir unsere Nummer 100 ganz ins Zeichen der Herausforderung durch die Seuche, mit Rays Freundin, dem „Buffalo Girl" Neneh Cherry, fotografiert von Jenny Howarth, auf dem Cover. 1991 wurde Edward Enninful mit 18 Jahren Fashion Director bei i-D. Der Prozess setzte sich fort, und die Zeitschrift expandierte mit jedem neuen Team. i-D hatte seine Existenz als mein Zweitjob begonnen, aber als die Achtziger zu Ende gin-

Gaultier, Rei Kawakubo et Yohji Yamamoto, sans oublier la vague de créateurs décalés venus de Belgique. La mode avant-gardiste ne se limitait plus à un marché de niche : elle était en train de devenir un vrai business.
Les années 90 ont également marqué une période de changement pour i-D, le fanzine fait maison sur une table de cuisine se métamorphosant en magazine de mode international. Quand la belle plume de Kate Flett a quitté la rédaction pour rejoindre Nick Logan chez The Face en tant que rédactrice mode, puis chef de rubrique avant de devenir rédactrice en chef d'Arena six ans plus tard, Dylan a recruté John Godfrey comme assistant. Ensuite, quand Dylan est devenu rédacteur en chef de The Face en 1988, John a repris son poste chez i-D et propulsé le magazine dans la nouvelle décennie. Nous voulions aller plus loin en abordant des sujets de société, par exemple l'environnement, l'alimentation et la culture pop. John est ensuite devenu rédacteur pour l'émission Eurotrash, puis il est parti vivre en Australie. A cette époque, i-D s'était déjà forgé une réputation de pépinière de créatifs, et la première vague de talents des années 80 passait le flambeau à une nouvelle génération. Le légendaire styliste Ray Petri, qui avait souvent travaillé avec Mark Lebon, figurait alors parmi les premières victimes célèbres du sida. C'est pour cette raison que nous avons

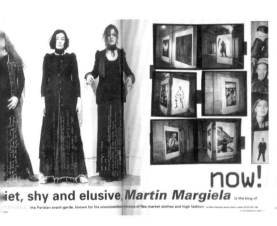

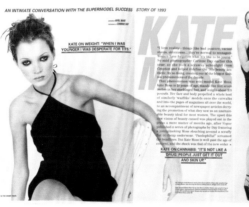

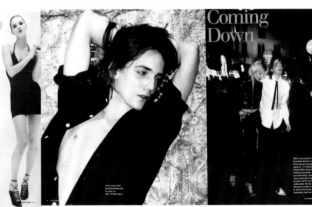

by chance as Craig had shot prep Polaroids of cover star, soul singer Mica Paris, and then Nick shot the film. Not happy with the film, Nick salvaged the ripped Polaroids out of the rubbish bin and collaged them together into a cover. Other photographers who made the transition from assistant to photographer were Eamonn McCabe, Steven Johnson's assistant, and David Sims, assistant to Robert Erdmann, who had done several covers in the eighties. David shot five covers in the nineties, including the first cover of a young catalogue model called Gisele Bündchen later in the decade. Mark Lebon had a lot of friends and assistants who worked with him at his photographic studio, Crunch, and who also went on to become successful photographers, including Glen Luchford. Ellen von Unwerth made a transition to pictures, doing her first shoot for i-D in 1986, just after she stopped modelling, while Jenny Howarth, who had been my children's, Matt and Kayt's babysitter, went on to become a famous model. [No 30, The Grown Up Issue, October 1985.] The nineties saw the rise of the

gen und die Neunziger begannen, wurde es schwerer, meine Jobs als europäischer Art Director für Esprit, die Modefirma aus San Francisco, und die Leitung von i-D unter einen Hut zu bringen. Diese Doppelfunktion brachte eine gewisse Atemlosigkeit in jede unserer Ausgaben. Da Tony Elliotts Team von Time Out unsere Finanzen abwickelte, kam ich immer kurz vor der Deadline ins i-D-Büro. Redaktion und Art Department waren fertig, und der Inhalt der neuen Ausgabe war auf dem Boden ausgelegt. Dann schoben wir Dinge hin und her für den endgültigen Seitenplan. Als ich anfing, für Esprit jede Woche zwischen London, San Francisco, Düsseldorf, Mailand und Paris hin und her zu reisen, bat ich Nick Knight, mich als Bildchef von i-D zu entlasten. Die anderen Redakteure hatten genug Selbstvertrauen, um weiterzumachen, ohne dass ich ständig präsent war, und das Magazin gedieh. Mit Stephen Male als Art Director kam eine neue Welle junger, vielversprechender Fotografen zum i-D-Team, unter anderem David Sims, Juergen Teller und Andrew MacPherson, außerdem zwei seiner eigenen Assistenten, Sølve Sundsbø und Craig McDean. Craigs erster Titel für uns (The Born Again Issue, Nr. 86 November 1990), gehört zu meinen liebsten. Er ist entstanden, als Craig noch für Nick arbeitete. Er kam ganz zufällig zustande, weil Craig vorbe-

consacré notre 100e numéro aux défis soulevés par cette épidémie ; pour la couverture, le compagnon de Ray et la « Buffalo Girl » Neneh Cherry ont posé devant l'objectif de Jenny Howarth. En 1991, Edward Enninful, 18 ans, a été nommé rédacteur des pages mode d'i-D. Le magazine a continué à se développer avec l'arrivée de chaque nouvelle équipe.
J'avais lancé i-D comme un emploi secondaire, mais vers la fin des années 80 et au début des années 90, je me suis retrouvé à jongler entre mon poste de directeur artistique européen pour Esprit, la marque de vêtements de San Francisco, et mes fonctions de directeur de la rédaction. Cette double casquette insufflait un sentiment d'urgence à chaque numéro. Comme l'équipe Time Out de Tony Elliott gérait nos finances, je débarquais toujours dans les bureaux d'i-D à l'approche des bouclages. Le département éditorial et artistique avait déjà préparé le contenu du prochain numéro. Les pages étaient étalées sur le sol et on les déplaçait pour obtenir la mise en page finale. Lorsque mon travail pour Esprit a commencé à me faire voyager chaque semaine entre Londres, San Francisco, Düsseldorf, Milan et Paris, j'ai sollicité l'aide de Nick Knight au poste de directeur photo d'i-D. Les autres rédacteurs étaient assez compétents pour se passer de ma présence à temps plein et le magazine avançait bien.

professional stylist, including early work for i-D by Jane How, Camilla Nickerson, Melanie Ward, Venetia Scott and Amanda [Grieve] Harlech. Since their first contributions to the magazine, these celebrated stylists have worked with Karl Lagerfeld for Chanel, Marc Jacobs, Helmut Lang and Stella McCartney amongst many others. Even though we had to keep one eye on commercial viability, graphic experimentation was still very much part of the i-D identity. Budgets have always been tight, however tight budgets often mean more creativity. We first met German-born artist Wolfgang Tillmans at an i-D world tour party in Amsterdam and then again at the i-D event in Copenhagen. "When you get to Hamburg," Wolfgang said, "let me take the pictures!" So we did, and this was, in 1989, Wolfgang's first shoot for us. The film for Wolfgang's controversial fashion feature, Like Brother like Sister, shot in 1992 (with mates Lutz and Alex hanging naked from a tree), was developed, because our budget was so small, at the One Hour Photo Lab near his home in Baker Street. It wasn't the first nor the last time a

reitende Polaroids von unserem Coverstar, der Soulsängerin Mica Paris, gemacht hatte, bevor Nick dann die eigentlichen Fotos schoss. Weil er mit dem Ergebnis der Fotosession unzufrieden war, rettete Nick die zerrissenen Polaroids aus dem Müll und verarbeitete sie zu einer Collage für den Titel.
Andere Fotografen, die als Assistenten bei uns anfingen, waren Eamonn McCabe, der Assistent von Steven Johnston, und David Sims, der Assistent von Robert Erdmann, der in den Achtzigern einige Cover für uns gemacht hatte. David schoss später in den Neunzigern fünf Cover, unter anderem mit einem jungen Katalogmodel namens Gisele Bündchen. Viele Freunde und Assistenten von Mark Lebon, die in seinem Fotostudio Crunch arbeiteten, wurden ebenfalls erfolgreiche Fotografen, zum Beispiel Glen Luchford. Ellen von Unwerth sattelte auf Fotografie um und machte ihren ersten Fotoshoot für i-D 1986, gleich nachdem sie mit Modeln aufgehört hatte, während Jenny Howarth, Matts und Kayts Babysitterin, später ein bekanntes Model wurde [The Grown Up Issue, Nr. 30, Oktober 1985].
Mit den Neunzigern kamen auch die Profi-Stylisten: Jane How, Camilla Nickerson, Melanie Ward, Venetia Scott und Amanda [Grieve] Harlech waren alle in ihren frühen Tagen für i-D tätig, ehe sie später mit Karl Lagerfeld für Chanel,

Avec Stephen Male à la direction artistique, Nick Knight a favorisé l'arrivée d'une nouvelle vague de photographes talentueux au sein de l'équipe i-D, notamment David Sims, Juergen Teller et Andrew MacPherson, ainsi que deux de ses propres assistants, Sølve Sundsbø et Craig McDean. La première couverture réalisée par Craig pour le numéro 86, The Born Again Issue, est l'une de mes préférées. Il l'a créée en novembre 1990 alors qu'il était encore l'assistant de Nick. Cette couverture est le pur fruit du hasard : pour préparer la séance, Craig avait pris quelques Polaroids de la star en couverture, la chanteuse soul Mica Paris, puis Nick s'était occupé des photos. Insatisfait du résultat, Nick a récupéré les Polaroids déchirés dans la poubelle et en a fait un collage pour la une du magazine.
Les autres photographes ayant débuté comme assistants sont Eamonn McCabe, assistant de Steven Johnston, et David Sims, assistant de Robert Erdmann qui avait réalisé plusieurs couvertures dans les années 80. Ensuite, David a photographié cinq couvertures dans les années 90, dont la première couverture d'une jeune mannequin de catalogue nommée Gisele Bündchen. Dans son studio photo Crunch, Mark Lebon travaillait avec beaucoup d'amis et d'assistants qui sont ensuite devenus des photographes à succès, notamment Glen

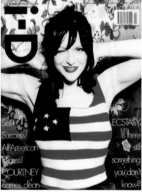

One Hour Photo Lab processed an i-D photoshoot.
One of our biggest live events at that time was in January 1992 at the Palazzo Corsini in Florence. Giannino Malossi, who organised projects for Pitti Imagine, invited me to curate an exhibition overlooking the River Arno. The Florence exhibition, i-D Now, was an ambitious project. I was not allowed to attach anything to the walls as the Palazzo's 16th century frescoes were extremely fragile and had already been damaged by floodwaters a few years before. My idea for the exhibition was to create life-size studio portraits during the opening party which we suspended from industrial scaffolding. Pitti and i-D had invited ten contemporary designers including Jean Colonna, Martin Margiela, Dirk Bikkembergs, Véronique Leroy, Joe Casely-Hayford and Bella Freud to bring their own four models to Florence. These models would be photographed by Mark Lebon and Takashi Homma in four looks chosen by each designer. My studio assistant, Corinna Farrow, helped organise one room to be a replica of my home studio space with a

Marc Jacobs, Helmut Lang und Stella McCartney arbeiteten, um nur einige zu nennen.
Obwohl wir immer ein Auge auf kommerzielle Tragfähigkeit haben mussten, gehörten grafische Experimente weiterhin untrennbar zur Identität von i-D. Die Budgets waren immer schmal, aber Minibudgets bedeuten auch oft ein Plus an Kreativität. Den Fotografen Wolfgang Tillmans trafen wir zum ersten Mal auf einer i-D-Party in Amsterdam, und dann wieder beim i-D-Event in Kopenhagen. „Wenn ihr nach Hamburg kommt", meinte Wolfgang, „dann lasst mich die Fotos machen!" Das machten wir, aber wegen unserer knappen Mittel wurde der Film für Wolfgangs kontroverse Modestrecke Like Brother Like Sister (mit seinen Freunden Lutz und Alex, die nackt von einem Baum hingen) in einem Schnelllabor nicht weit von den Redaktionsräumen von i-D entwickelt. Es war weder das erste noch das letzte Mal, dass wir ein i-D-Fotoshooting in einem Schnelllabor entwickeln ließen.
Eins unserer größten Live-Events veranstalteten wir im Januar 1992 im Palazzo Corsini in Florenz. Giannino Malossi, der Projekte für Pitti Imagine organisierte, lud mich ein, eine Ausstellung mit Ausblick auf den Arno zu kuratieren. Die Ausstellung in Florenz, i-D Now, war ein ambitioniertes Projekt. Ich durfte nichts an den Wänden anbringen, da die Fres-

Luchford. Ellen von Unwerth a débuté dans la photographie en réalisant son premier shooting pour i-D en 1986 juste après avoir mis un terme à sa carrière de mannequin, tandis que Jenny Howarth, la baby-sitter de mes enfants Matt et Kayt, est devenue une célèbre mannequin [The Grown Up Issue, n° 30, octobre 1985]. Les années 90 ont été témoins de l'ascension du styliste professionnel, notamment grâce aux premières missions de Jane How, Camilla Nickerson, Melanie Ward, Venetia Scott et Amanda [Grieve] Harlech pour i-D. Depuis leurs premières collaborations avec le magazine, ces célèbres stylistes ont travaillé avec Karl Lagerfeld pour Chanel, Marc Jacobs, Helmut Lang et Stella McCartney, pour ne citer que quelques noms dans une liste qui serait autrement interminable.
Même s'il fallait garder un œil sur notre viabilité commerciale, l'expérimentation graphique restait un pilier fondamental dans l'identité d'i-D. Les budgets ont toujours été serrés, mais de la contrainte naît la créativité. Nous avons fait la connaissance de l'artiste allemand Wolfgang Tillmans à Amsterdam lors d'une soirée i-D itinérante, puis l'avons revu à l'occasion de l'événement i-D organisé à Copenhague.
« Quand vous viendrez à Hamburg, laissez-moi faire les photos ! », a dit Wolfgang, qui a réalisé ses premières photos pour i-D en 1989. Par

large central worktable, and Metro Photographic's laser manager, Paul Nunneley, helped to produce the images. Portraits would be done on self-developing Polaroid film and then blown up to life-size prints on Canon laser copiers and Bubble Jet printers. The technology to capture and make i-D Now all came together with video cameras, photocopiers, printers and faxes. We felt that the whole collage thing would now be possible as long as we kept our heads clear.

As the evening started, the guests were a bit fazed as they arrived at an exhibition with blank 'walls'. Wolfgang Tillmans and our daughter Kayt with video editor Dominique documented the whole chaotic 24-hour event as people got into the party spirit. Although it felt quite nerve wracking at the time, this event ended up being one of the most exciting projects we had done to date. Takashi Homma got his first i-D cover [No. 102, The Technology Issue, March 1992] starring Lorella and Tatiana styled by Romeo Gigli. Takashi would be the first photographer I worked with on the early issues of i-D Japan.

ken aus dem 16. Jahrhundert im Palast extrem empfindlich waren und einige Jahre zuvor schon durch ein Hochwasser gelitten hatten. Meine Idee für die Ausstellung war, während der Eröffnungsparty lebensgroße Studioporträts anzufertigen. Pitti und i-D hatten zehn aktuelle Modemacher wie Jean Colonna, Martin Margiela, Dirk Bikkembergs, Véronique Leroy, Joe Casely-Hayford und Bella Freund aufgefordert, sich je vier Models auszusuchen und mit nach Florenz zu bringen. Die Models wurden dann von Mark Lebon und Takashi Homma in vier von den Designern ausgewählten Looks fotografiert. Meine Studioassistentin Corinna Farrow richtete einen Raum als genaue Kopie meines heimischen Studios her, mit einem großen, zentralen Arbeitstisch, und Paul Nunneley, der Laser-Manager von Metro Photographic, half mir, die Bilder zu erstellen. Die Porträts wurden mit selbstentwickelndem Polaroidfilm aufgenommen und dann auf Canon-Laserkopierern und Bubble-Jet-Druckern zu lebensgroßen Prints hochgezogen. Wir boten alles an Technologie auf, um i-D Now zu verwirklichen und festzuhalten, Videokameras, Fotokopierer, Drucker und Faxmaschinen. Wir waren sicher, dass dieses Collage-Experiment möglich war, solange wir einen klaren Kopf behielten.
Als es abends losging, waren die Besucher ein wenig ratlos, da sie eine Ausstellung mit lee-

manque d'argent, la pellicule de son shooting mode subversif, « Like Brother like Sister » (où ses amis Lutz et Alex sont pendus nus à un arbre), a été développée dans un One Hour Photo Lab près de chez lui dans Baker Street. Ce n'était pas la première fois, ni la dernière, que l'on confiait le développement des photos de mode d'i-D à ce genre de boutique « photo minute ».
Nous avons organisé l'un de nos plus grands événements en janvier 1992 au Palazzo Corsini de Florence. Giannino Malossi, qui avait géré divers projets pour Pitti Imagine, m'a demandé d'être le commissaire d'une exposition installée dans un lieu donnant sur l'Arno. Intitulé « i-D Now », ce projet florentin était ambitieux. Je n'avais pas le droit d'accrocher quoi que ce soit sur les murs car les fresques de ce palazzo du XVIe siècle étaient extrêmement fragiles et avaient déjà été endommagées par une inondation quelques années plus tôt. Mon idée consistait à réaliser des portraits grandeur nature pendant la soirée du vernissage. Pitti et i-D ont invité dix créateurs contemporains, dont Jean Colonna, Martin Margiela, Dirk Bikkembergs, Véronique Leroy, Joe Casely-Hayford et Bella Freud, à Florence avec quatre mannequins chacun. Ceux-ci devaient être photographiés par Mark Lebon et Takashi Homma dans quatre looks différents choisis par

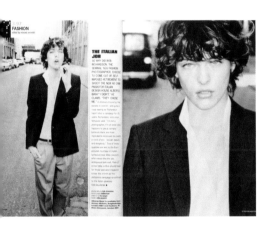 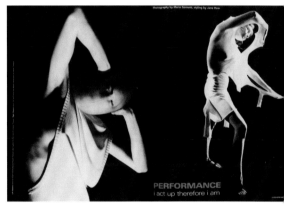

That year, out of the blue, Tokyo publishers, U.P.U. approached us insisting i-D was the best magazine for the Japanese youth market. They already published 'Esquire' and their research for a culture magazine was quite convincing, especially as on previous trips to Japan we had witnessed a strong street fashion scene. After many meetings and much negotiation, we concluded the deal. When I got the call — while in Los Angeles on a photo shoot with Peggy Sirota — my only condition had been that I wanted to set up my own design studio in Tokyo. That would have to wait six months as I was still under contract to Esprit, but it was just at that time that Doug Tompkins sold his stake in Esprit. I gave in my notice and began i-D Japan, an interesting project but one that sadly fell victim to Japan's economic crisis two years later.
Avril Mair, who was a strong presence at i-D in the nineties, began her career as a freelance music and clubs writer while still studying English Literature at Edinburgh University. She came down for work experience during

ren Wänden betraten. Wolfgang Tillmans und unsere Tochter Kayt dokumentierten mit dem Kameramann Dominique das ganze chaotische 24-Stunden-Event, als die Leute in Partystimmung kamen. Obwohl es damals nervenzerfetzend war, wurde das Event zu einem unserer aufregendsten Projekte bis heute. Takashi Homma bekam sein erstes i-D-Cover [The Technology Issue, Nr. 102, März 1992], auf dem Lorella und Tatiana gestylt von Romeo Gigli zu sehen waren. Takashi war dann auch der erste Fotograf, mit dem ich bei den frühen Ausgaben von i-D Japan arbeitete.
Im selben Jahr trat ganz überraschend der U.P.U.-Verlag aus Tokio an uns heran, fest überzeugt, dass i-D genau das Richtige für den japanischen Jugendmarkt sei. Sie verlegten bereits Esquire, und ihre Recherchearbeit für ein Kulturmagazin war recht überzeugend, besonders, da uns auf früheren Trips nach Japan eine lebhafte Street-Fashion-Szene aufgefallen war. Nach vielen Treffen und langen Verhandlungen machten wir den Deal. Als ich den Anruf bekam – ich war gerade in Los Angeles bei einem Fotoshooting mit Peggy Sirota –, war meine einzige Bedingung gewesen, dass ich mein eigenes Designstudio in Tokio einrichten könnte. Das musste sechs Monate warten, da ich noch vertraglich an Esprit gebunden war, aber es war gerade um die Zeit herum, als Doug Tompkins

chaque couturier. Mon assistante Corinna Farrow et moi avons transformé toute une pièce en réplique de mon studio photo, avec une grande table de travail au milieu, tandis que Paul Nunneley, responsable des impressions laser chez Metro Photographic, a participé à la production des images. Les portraits étaient photographiés au Polaroid, puis transformés en tirages grandeur nature sur des photocopieuses laser Canon et des imprimantes à jet d'encre. Toute la technologie nécessaire pour immortaliser « i-D Now » ne reposait donc que sur des caméras vidéo, des photocopieurs, des imprimantes et des télécopieurs. Nous avions l'impression que l'idée du collage allait fonctionner, du moins tant que nous gardions l'esprit clair.
Au début de la soirée, les invités ont été un peu déroutés en pénétrant dans cette exposition aux « murs » vierges. Wolfgang Tillmans, ma fille Kayt et le monteur vidéo Dominique ont documenté l'intégralité de cet événement de 24 heures au cours duquel les gens sont peu à peu entrés dans l'esprit de la fête. Même si la tension nerveuse nous a semblé insupportable à l'époque, ce projet s'est avéré l'un des plus excitants d'i-D à ce jour. Takashi Homma a photographié Lorella et Tatiana habillées en Romeo Gigli pour sa première couverture i-D [The Technology Issue, n° 102, mars 1992].

the summer. Avril had never been to London, didn't know a soul and ended up sleeping on then Editor Matthew Collin's floor. When she graduated in 1992, Avril was hired as an Editorial Assistant. She was quickly promoted to Assistant Editor and then took over from Matthew as i-D's Editor in September 1994.

Music still featured strongly on i-D's covers and editorial layouts, and Avril was quick to recognise the emerging Brit Pop movement, bringing Jarvis Cocker, Suede and Elastica into the magazine, as well as Courtney Love when grunge was happening. During the nineties, cover stars like Kylie Minogue, Sharleen Spiteri, Neneh Cherry, Brett Anderson, Goldie and PJ Harvey gave us their best winks. Björk's first cover [No. 116, The Europe Issue, May 1993] was also a first for photographer Matthew Lewis, who photographed the singer in his partner's garden in North London. Later that year Juergen Teller caught the energy and urgency of Justine Frischmann, the punky lead singer of Elastica, for the February 1994 cover [No. 125, The Talent Issue]. Four years earlier, we had published Juergen's first fashion story,

seinen Anteil an Esprit verkaufte. Ich kündigte und baute i-D Japan auf, ein interessantes Projekt, das jedoch nach zwei Jahren Opfer der Wirtschaftskrise in Japan wurde.

Avril Mair, während der Neunziger bei i-D nicht wegzudenken, begann ihre Karriere als freie Musik- und Szeneschreiberin, während sie noch in Edinburgh Englische Literatur studierte. Sie kam während des Sommers zu uns, um Arbeitserfahrung zu sammeln. Avril war noch nie in London gewesen und kannte keine Seele, aber dann pennte sie irgendwann bei unserem Redakteur Matthew Collin auf dem Fußboden. Als sie 1992 ihren Abschluss machte, kam Avril als Praktikantin zu uns. Sie wurde schnell zur Redaktionsassistentin befördert und übernahm dann ab September 1994 Matthews Stelle als Chefredakteurin von i-D.

Musik spielte immer noch eine wichtige Rolle auf den Titeln und im redaktionellen Teil von i-D, und Avril griff sofort die aufkommende Brit-Pop-Bewegung auf und brachte Jarvis Cocker, Suede und Elastica ins Heft, ebenso wie Courtney Love, als Grunge ein Thema wurde. Im Lauf der Neunziger gaben uns Coverstars wie Kylie Minogue, Sharleen Spiteri, Neneh Cherry, Brett Anderson, Goldie und PJ Harvey ihr bestes Zwinkern. Das erste Cover mit Björk [The European Issue, Nr. 116, Mai 1993] war auch das erste für Matthew Lewis, der

C'est aussi le premier photographe avec lequel j'ai collaboré pour le lancement d'i-D Japan. A notre plus grande surprise, l'éditeur tokyoïte U.P.U. nous a contacté cette année-là, répétant qu'i-D était le magazine idéal pour le marché des jeunes au Japon. U.P.U. avait déjà édité Esquire et leur motivation à publier un magazine culturel nous a convaincus, notamment parce que nous avions découvert une scène street et mode extrêmement riche lors de précédents voyages au Japon. Après de nombreuses réunions et de longues négociations, nous avons fini par conclure un accord. Quand j'ai reçu l'appel de confirmation – en pleine séance photo avec Peggy Sirota à Los Angeles – j'ai émis une seule condition : établir mon propre studio de création à Tokyo. Il fallait attendre six mois car j'étais encore sous contrat avec Esprit, mais il se trouve que Doug Tompkins a revendu ses parts dans la marque allemande exactement à ce moment-là. J'ai donné ma démission et lancé i-D Japan, un projet intéressant malheureusement victime de la crise économique nippone deux ans plus tard.

Avril Mair, collaboratrice incontournable chez i-D dans les années 90, a commencé sa carrière comme journaliste free-lance spécialisée dans la musique et le clubbing tout en étudiant la littérature anglaise à l'université d'Edinburgh. Elle s'est présentée un été en quête d'un stage.

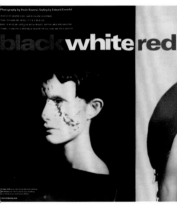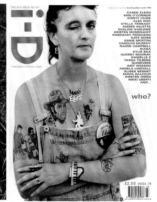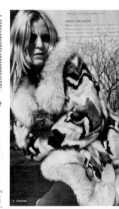

shot reportage-style in Romania and styled by Venetia Scott.

While the inhabitants of London's street, club and music worlds had fed the first ten years of i-D's covers and editorial content, the nineties marked the decade of the supermodel. Although money could often be made working on album covers, people in the music business, like make-up artist Pat McGrath, started making the cross over into the fashion industry. Nick Knight started photographing catalogues for Yohji Yamamoto in Paris. Photographers, stylists, hair and make-up artists were now hanging out and partying with professional catwalk models and other business-minded fashion colleagues. Suddenly there was a whole new dynamic going on. Quite literally the face of fashion was changing. i-D reflected that transformation as the faces of the world's top models dominated the magazine's covers throughout the nineties.

One of my favourite issues from the nineties is The Elevator Issue [No. 191, October 1999]. My idea was to photograph people on location in an

die Sängerin im Garten seines Partners im Norden von London fotografierte. Später im selben Jahr bannte Juergen Teller die Energie und den Biss von Justin Frischman, dem punkigen Sänger von Elastica, auf den Titel der Ausgabe vom Februar 1994 [The Talent Issue, Nr. 125]. Vier Jahre zuvor hatten wir Juergens erste Modestory gebracht, im Reportagestil in Rumänien geschossen und gestylt von Verena Scott.

Hatten die Einwohner der Londoner Straßen-, Club- und Musikszene i-D in den ersten zehn Jahren die Titel und redaktionellen Themen geliefert, markierten die Neunziger das Jahrzehnt der Supermodels. Obwohl sich auch mit der Gestaltung von Plattencovern Geld verdienen ließ, begannen Leute aus der Musikindustrie, so wie Visagist Pat McGrath, in die Modeindustrie zu wechseln. Nick Knight begann Kataloge für Yohji Yamamoto in Paris zu fotografieren. Fotografen, Stylisten, Visagisten, Haarstylisten mischten sich nun unter die professionellen Laufstegmodels und andere kommerziell orientierte Modekollegen. Plötzlich gewann das eine ganz neue Dynamik. Es veränderte buchstäblich das Gesicht der Mode. i-D spiegelte diese Transformation, da die Gesichter der Topmodels dieser Welt während der Neunziger die Titel des Magazins dominierten.

Avril n'était jamais venue à Londres, ne connaissait personne et s'est retrouvée à dormir par terre chez Matthew Collin, alors rédacteur. Une fois diplômée, Avril a été embauchée comme assistante de rédaction en 1992. Elle a vite été promue au poste de rédactrice adjointe, puis a repris le poste de Matthew en septembre 1994.

La musique occupait toujours une place importante sur les couvertures et dans les pages d'i-D. Avril a vite repéré l'émergence du mouvement Brit Pop et consacré des dossiers à Jarvis Cocker, Suede et Elastica, ainsi qu'à Courtney Love quand le grunge a décollé. Au cours des années 90, des stars comme Kylie Minogue, Sharleen Spiteri, Neneh Cherry, Brett Anderson, Goldie et PJ Harvey nous ont offert leurs plus beaux clins d'œil à la une du magazine. La première couverture de Bjork [The Europe Issue, n° 116, mai 1993] était aussi la première du photographe Matthew Lewis, qui a immortalisé la chanteuse dans le jardin de son petit ami dans le nord de Londres. Plus tard la même année, Juergen Teller a capturé l'énergie irrépressible de Justine Frischmann, la chanteuse punky d'Elastica, en couverture du numéro de février 1994 [The Talent Issue, n° 125]. Quatre ans plus tôt, nous avions publié les premières photos de mode de Juergen, dans le style reportage en Roumanie avec stylisme par Venetia Scott.

elevator anywhere in the world. The people featured included Alexander McQueen and Katy England making out in a goods lift, and on the opposite page jewellery designer Sarah Harmarnee riding a pony. Guinevere van Seenus, photographed by Craig McDean, wore a brilliant Louis Vuitton sowester on the cover. In a little bit of light-hearted rivalry, Terry Richardson photographed Guinevere holding a mock-up of her cover, which he had drawn over. (Some of his drawings had to be censored.)

By the mid-nineties Edward Enninful was working full force with all of his enthusiastic energy. His desk in the i-D office was party central, with assistants, hair stylists, models and friends dropping by. There was a point when Edward, Pat McGrath, Eugene Souleiman and Craig McDean were working and playing together so much they became affectionately know as 'The Four Musketeers'. But fashion, ever in transition, was changing once more as we edged towards the end of the millennium.

Insecurity is the best word to describe the mood that dominated the

Eine meiner Lieblingsausgaben aus den Neunzigern ist The Elevator Issue [Nr. 191, Oktober 1999]. Ich hatte die Idee, Leute on location in Aufzügen irgendwo auf der Welt zu fotografieren. Zu den Abgebildeten gehörten Alexander McQueen und Katy England knutschend in einem Lastenaufzug, und auf der gegenüberliegenden Seite Schmuckdesignerin Sarah Harmarnee auf einem Pony. Guinevere van Seenus, fotografiert von Craig McDean, trug auf dem Cover einen brillanten Südwester von Louis Vuitton. In einem Anflug freundschaftlicher Rivalität fotografierte Terry Richardson Guinevere mit einer Kopie dieses Titels, auf dem er herumgemalt hatte. (Einiges davon mussten wir zensieren.)

Mitte der Neunziger arbeitete Edward Enninful mit voller Kraft, Enthusiasmus und Energie. Sein Schreibtisch im i-D-Studio war die Partyzentrale für ständig hereinschneiende Assistenten, Haarstylisten, Models und Freunde. Es gab einen Punkt, an dem Edward, Pat McGrath, Eugene Souleiman und Craig McDean so oft zusammen arbeiteten und ausspannten, dass man sie liebevoll „Die vier Musketiere" nannte. Aber die Mode, immer in Bewegung, änderte sich erneut, als wir uns dem Ende des Jahrtausends näherten.

Verunsicherung ist die Vokabel, die die Stimmung zu Beginn des zweiten Jahrtausends am

Alors que la population des rues, des clubs et de la scène musicale de Londres avait alimenté les couvertures et les pages des dix premières années d'i-D, la décennie suivante a été celle du top-modèle. Même s'il y avait de l'argent à se faire en travaillant sur des pochettes d'album, les professionnels de l'industrie de la musique, comme la maquilleuse Pat McGrath, ont commencé à opérer la transition vers la mode. Nick Knight s'est mis à photographier des catalogues pour Yohji Yamamoto à Paris. Photographes, stylistes, coiffeurs et maquilleurs faisaient désormais la fête avec les mannequins des grands défilés et les financiers des marques de mode. Soudain, une toute nouvelle dynamique s'est mise en place. Le visage de la mode se transformait littéralement. Comme les plus grandes top-modèles du monde ont monopolisé les couvertures des magazines du début à la fin des années 90, i-D a reflété ce changement.

The Elevator Issue [n° 191, octobre 1999] est l'un de mes numéros préférés de cette période. Mon idée était de photographier des gens dans un ascenseur n'importe où dans le monde. Par exemple, Alexander McQueen et Katy England en train de s'embrasser goulûment dans un monte-charge, avec la créatrice de bijoux Sarah Harmarnee chevauchant un poney sur la page d'à côté. Sur une photo signée

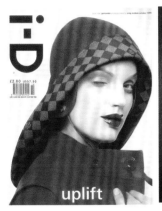

2000s. On New Year's Eve, before the decade even began, there was the fear, real or manufactured, that the rollover from one millennium to another would produce the Y2K bug which, we were told, could potentially wipe out all digital and computer data storage. It was a great relief, therefore, on January 1, 2000 to find that computers and other electronic devices still functioned. Despite this initial glitch, innovations in technology and communications not only shaped the noughties, but also permanently altered our lives. Ten years ago there were no iPods, no BlackBerrys, no YouTube, no iTunes. Neither were there social networking sites like Facebook, MySpace and Twitter. It was surprising how quickly all of these novelties, permanently and universally, insinuated themselves into our lives so that it is hard to recall a time when we didn't have them. This new immediacy of information also brought about the ascendancy of blogs. Progress can have its downside, however, as both photographers and magazines alike mourned the demise of Polaroid in

zutreffendsten beschreibt. An Silvester, noch bevor das Jahrzehnt überhaupt begonnen hatte, zitterte man vor der realen oder künstlich heraufbeschworenen Gefahr, dass mit dem Umspringen von einem Jahrtausend in andere ein Millenium-Bug über uns hereinbrechen würde, der, wie uns gesagt wurde, sämtliche digital und auf Computern gespeicherten Daten auslöschen könnte. Daher war es eine große Erleichterung, als am 1. Januar 2000 alle Computer und anderen elektronischen Geräte noch funktionierten. Trotz dieser Anlaufschwierigkeiten bestimmten technologische Neuerungen – besonders in der Kommunikationstechnologie – nicht nur das Jahrzehnt, sondern veränderten auch dauerhaft unser Leben. Vor zehn Jahren gab es keine iPods, keine BlackBerrys, kein YouTube, kein iTunes. Ebenso wenig gab es soziale Netzwerke wie Facebook, MySpace und Twitter. Es war überraschend, wie schnell sich all diese Neuerungen dauerhaft und flächendeckend in unseren Alltag eingedrängt haben, so dass man sich kaum noch ein Leben ohne sie vorstellen kann. Mit dieser neuen, schnelleren Verfügbarkeit von Informationen begann auch die Vorherrschaft der Blogs. Fortschritt kann allerdings auch seine unschönen Seiten haben, und sowohl Fotografen wie Zeitschriften betrauerten den Tod von Polaroid im Jahr 2008. Erfreulicherweise erleben wir jetzt, im Sommer 2010,

Craig McDean pour la couverture, Guinevere van Seenus portait un incroyable chapeau Louis Vuitton ; dans un esprit de légère rivalité, Terry Richardson a quant à lui photographié Guinevere en train de tenir une maquette de la couverture sur laquelle il avait fait des dessins (et dont une partie a dû être censurée).

Au milieu des années 90, Edward Enninful travaillait à plein régime, investissant tout son enthousiasme et toute son énergie dans le magazine. Son bureau chez i-D grouillait constamment d'assistants, de coiffeurs, de mannequins et d'amis. Au travail comme à la ville, Edward, Pat McGrath, Eugene Souleiman et Craig McDean ne se quittaient plus et faisaient la fête ensemble, à tel point qu'on a fini par les surnommer affectueusement « les quatre mousquetaires ». A l'approche du nouveau millénaire, la mode, toujours en transition, allait cependant encore changer. L'insécurité est le terme le mieux approprié pour décrire l'atmosphère qui a dominé les années 2000. Avant le passage au nouveau millénaire, tout le monde redoutait, que ce soit à juste titre ou le fruit du battage médiatique, que le supposé bug de l'an 2000 efface toutes les données stockées sur les supports numériques et informatiques. Quel soulagement, donc, quand on s'est rendu compte que les ordinateurs et autres systèmes électroniques

2008. Thankfully now, in the summer of 2010 we see a re-birth, and the one-off nature of the original may continue to be explored.

The 2000s were a roller coaster ride of a decade punctuated by September 11 2001 at the start, the Iraq War in the middle and the 2008 world financial crisis at the end. During the boom years between 9/11 and the crash, increasing consumerism made us feel as if the whole world was on a huge spending spree. Fashion seemed to have lost much spontaneity, as we could see the business of fashion going global and corporate. All these things contributed to uneasiness in magazine publishing, with advertising revenues becoming as manic and unpredictable as the times. By the end of the decade many magazines folded. i-D survived. Since 1980, when i-D started out as a fanzine, the stakes on the newsstands have changed beyond our imagination. Shelf space is now sold, with the best visibility going to those publishers with the biggest budgets. Although the experience of what geographically works in the international scrum at the kiosk has always been in my mind, we continue

eine Auferstehung, und dürfen vielleicht auch weiterhin mit dem Einmalcharakter des Originals experimentieren.

Die erste Dekade des neuen Jahrtausends war eine Achterbahnfahrt, am Anfang mit dem 11. September 2001, dem Irakkrieg in der Mitte und der globalen Finanzkrise 2008 am Ende. Während der Boom-Jahre zwischen 9/11 und dem Crash ließ die zunehmende Konsumkultur bei uns den Eindruck aufkommen, die ganze Welt sei im blinden Kaufrausch. Die Mode schien viel an Spontaneität verloren zu haben, während wir erlebten, wie das Modegeschäft global und industriell wurde. Alle diese Dinge trugen zur Verunsicherung der Zeitschriftenverlage bei, deren Einnahmen aus Anzeigen sich ebenso manisch und unvorhersehbar entwickelten wie die Zeiten. Bis Ende des Jahrzehnts hatten viele Magazine aufgegeben. i-D überlebte.

Seit 1980, als i-D als Fanzine begann, ist das Klima im Zeitschriftenhandel ungleich rauer geworden. Platz in den Regalen ist heutzutage eine Ware. Die Verlage mit den größten Budgets werden am besten und sichtbarsten platziert. Obwohl ich immer im Hinterkopf hatte, was meiner Erfahrung nach in dem internationalen Gerangel am Kiosk funktionieren könnte, haben künstlerische Entscheidungen bei uns auch weiterhin Vorrang vor Bilanzen.

fonctionnaient toujours le 1er janvier 2000. Malgré ce pépin technique, les innovations en matière de technologie et de communication ont non seulement façonné les années 00, mais aussi modifié nos vies pour toujours. Il y a dix ans, l'iPod, le BlackBerry, YouTube et iTunes n'existaient pas. Il n'y avait pas non plus de sites de réseaux sociaux comme Facebook, MySpace et Twitter. Il est surprenant de constater à quelle vitesse toutes ces nouveautés se sont insinuées dans nos vies de manière permanente et universelle, au point qu'on a aujourd'hui du mal à se souvenir de l'époque où l'on se passait d'elles. Cette nouvelle immédiateté de l'information a également provoqué la prolifération des blogs. Le progrès comporte toutefois ses mauvais côtés, les photographes et les magazines ayant dû faire le deuil du Polaroid instantané en 2008. Heureusement, nous vivons sa renaissance en cet été 2010 et la nature unique du support imprimé original peut continuer à être explorée.

Les années 2000 ont été une vraie virée en montagnes russes, du 11 septembre 2001 à la crise financière mondiale de 2008 en passant par la guerre en Irak. Pendant la période de prospérité qui s'est écoulée entre les attentats de 2001 et le krach boursier, le consumérisme croissant nous a donné l'impression que le

to take artistic decisions at the magazine over accountants' choices. My way to solve the increasing challenge from contributors of so many brilliant cover star options was to make multiple covers. We had first done a double when Björk and Goldie dated in the nineties [No. 154, The Love Life Issue, July 1996]. The idea was explored throughout the decade, from the 25th anniversary issue [No. 258, The Name Issue, September 2005] with our four cover stars — Kate Moss, Liya Kebede, Carolyn Murphy and Daria Werbowy — in their birthday suits, to the six covers of model Agyness Deyn in May 2008 [No. 287, The Agyness Deyn Issue], the first issue of i-D ever dedicated to a single person. i-D had previously given Agyness a new look by cutting and bleaching her hair for The Health Issue [No. 268, August 2006]. Our most ambitious print run was The Best of British Issue in March 2009, with a total of 12 different covers; the maximum I could put on the newsstand. For that issue, Sølve Sundsbø, who began his career as an assistant to Nick Knight, photographed four decades of British beauties from Twiggy to Daisy Lowe. Luigi Mureno

Meine Lösung für die Herausforderung, den zahlreichen hervorragenden Titelstar-Lösungen gerecht zu werden, die unsere freien Mitarbeiter lieferten, waren mehrere Cover für eine Nummer. Wir hatten zuerst eine mit Doppeltitel gemacht, als Björk und Goldie in den Neunzigern dateten [Nr. 154, The Love Life Issue, Juli 1996]. Auf die Idee kamen wir im Verlauf des Jahrzehnts immer wieder zurück, von der Ausgabe zu unserem 25. Geburtstag [Nr. 258, The Name Issue, September 2005] mit den Stars unserer vier Titel – Kate Moss, Liya Kebede, Carolyn Murphy und Daria Werbowy – so nackt, wie sie auf die Welt gekommen waren, bis zu den sechs Titeln mit Model Agyness Deyn im Mai 2008 [Nr. 287, The Agyness Deyn Issue], der ersten i-D-Nummer, die ganz einer Person gewidmet war. i-D hatte Agyness zuvor einen neuen Look verpasst, nämlich einen neuen Haarschnitt und neue Haarfarbe für The Health Issue [Nr. 268, August 2006]. Unsere ambitionierteste Ausgabe war The Best of British Issue im März 2009 mit insgesamt zwölf verschiedenen Titeln – das Maximum, das ich an einem Zeitschriftenstand unterbringen konnte. Für diese Ausgabe fotografierte Sølve Sundsbø, der als Assistent von Nick Knight angefangen hatte, britische Schönheiten aus vierzig Jahren, von Twiggy bis Daisy Lowe. Die Frisuren waren von Luigi Moreno, das Make-Up von

monde entier était atteint de fièvre acheteuse. La mode semblait avoir perdu une bonne partie de sa spontanéité, le marché s'orientant vers la mondialisation et les grands groupes de luxe. Tous ces facteurs ont généré un certain malaise dans l'univers de la presse, avec des revenus publicitaires aussi cyclothymiques et imprévisibles que l'époque en soi. A la fin de la décennie, de nombreux magazines avaient mis la clé sous la porte. i-D a survécu.

Depuis le lancement d'i-D au format fanzine en 1980, les enjeux auxquels nous faisons face dans les kiosques à journaux ont changé au-delà de notre imagination. Désormais, l'espace d'exposition est à vendre et les éditeurs dotés des plus gros budgets s'octroient la meilleure visibilité. Même si je sais comment se distinguer graphiquement de la mêlée internationale de la presse vendue en kiosque, les décisions artistiques du magazine comptent toujours plus que celles des comptables.

Pour résoudre le problème croissant qui consiste à faire un choix entre toutes les options géniales de célébrités en une du magazine, j'ai décidé de produire plusieurs couvertures. Nous avons fait notre première double couverture quand Björk est sortie avec Goldie dans les années 90 [The Love Life Issue, n° 154, juillet 1996]. Cette idée a été explorée tout au long de la décennie, comme dans le numéro du

styled the hair, Stéphane Marais and Peter Phillips were behind the make-up, and Edward Enninful styled every girl in the same Louis Vuitton tuxedo jacket for each cover.

We had published our first i-D book, 'Decade of i-Deas' with Penguin by 1988.

Delving into our history and ever-growing network of contributors, we continued with other books throughout the decades including 'Smile i-D', 'Fashion and Style', '20 Years of i-D Magazine', 'Fashion Now', 'Fashion Now 2' and '100 Contemporary Fashion Designers' all with TASCHEN. Alongside these books we also published four slim volumes 'Family Future Positive', 'Beyond Price', 'Learn and Pass it On' and 'Safe + Sound', which later became the compilation SOUL i-D, again published by TASCHEN in 2008.

Editor Avril Mair helped steer the magazine through the first four years of the noughties, which I like to think of as i-D's mature period, as the magazine's survival became more focused editorially on the fashion side of the business. Predicting the public's growing taste and obsession for cele-

Stéphane Marais und Peter Phillips, und Edward Enninful stylte jedes Mädchen für jedes Cover mit derselben Smokingjacke von Louis Vuitton. 1988 erschien bei Penguin unser erstes i-D-Buch, Decade of i-Deas. Unsere Heftgeschichte und das sich ständig ausweitende Netz von freien Mitarbeitern gaben mehr als genug her, um in den folgenden Jahrzehnten weitere Bücher herauszubringen – Smile i-D, Fashion and Style, 20 Years of i-D Magazine, Fashion Now, Fashion Now 2 und 100 Contemporary Fashion Designers, alle bei TASCHEN. Neben diesen Büchern veröffentlichten wir selbst außerdem die vier schmalen Bände Family Future Positive, Beyond Price, Learn and Pass It On und Safe + Sound, die 2008 gesammelt als Soul i-D erschienen, wiederum bei TASCHEN. Redakteurin Avril Mair half, das Magazin durch die ersten vier Nullerjahre zu steuern, die ich gerne als i-Ds erwachsene Phase ansehe, da sich das Magazin, um überlebensfähig zu bleiben, inhaltlich mehr zum Modeaspekt des Business hin orientierte. Avril Mair erkannte die Zeichen der wachsenden Neugier der Leser auf Celebrity Culture, verabschiedete sich radikal von der eher auf Street Credibility ausgerichteten Blattlinie unserer Anfänge und setzte auf Titel mit Victoria Beckham und Sienna Miller. Tatsächlich zeigte sich, je mehr das Jahrzehnt fortschritt, dass Supermodels auf den Titel-

25e anniversaire [The Name Issue, n° 258, septembre 2005] avec quatre stars en tenues d'Eve pour autant de couvertures – Kate Moss, Liya Kebede, Carolyn Murphy et Daria Werbowy – ou les six couvertures du mannequin Agness Deyn en mai 2008 [The Agness Deyn Issue, n° 287], premier numéro d'i-D jamais consacré à une seule et même personne. i-D avait précédemment relooké Agness en lui coupant et colorant les cheveux pour The Health Issue [n° 268, août 2006]. Notre tirage le plus ambitieux était celui du numéro The Best of British Issue en mars 2009, avec au total 12 couvertures différentes ; c'était le maximum que je pouvais caser dans les kiosques. Pour cette parution, Sølve Sundsbø, qui avait débuté sa carrière en tant qu'assistant de Nick Knight, a photographié quatre décennies de beautés britanniques, de Twiggy à Daisy Lowe. Luigi Mureno était en charge de la coiffure, Stéphane Marais et Peter Phillips du maquillage, tandis que le styliste Edward Enninful a habillé toutes les filles dans la même veste de smoking Louis Vuitton sur chaque couverture.

Nous avions publié le premier livre i-D, Decade of i-Deas, chez Penguin en 1988. En plongeant dans nos archives et notre réseau de collaborateurs en constante expansion, nous avons sorti d'autres livres au fil des

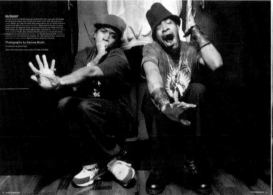

brity culture, Avril went against the grain of i-D's street cred beginnings and chose covers starring Victoria Beckham and Sienna Miller. As the decade progressed, supermodels would, in fact, be replaced on the covers of mainstream magazines in favour of actresses, B-list celebrities and reality TV stars. After a decade as Editor, Avril left the magazine at the end of 2004, with Assistant Editor Glenn Waldron taking over.

Throughout 2005 I wanted all ten issues of our Silver Jubilee year to be identified by a silver spine and different creative collaborations. Glenn shared creative duties that year with a series of guest contributors. Ashley Heath edited February's menswear special [No. 251, The Masculine Issue], while M/M (Mathias Augustyniak and Michael Amzalag) contributed to The Feminine Issue [No. 252] in March 2005. Kayt Jones photographed Ludivine Sagnier for the cover, an image that was later produced as a limited artwork by the designers.

That summer Alex McDowell juggled his time between working on a movie in London and taking on The Occupation

seiten des Zeitschriftenmainstreams von Schauspielerinnen, B-Prominenz und Reality-TV-Darstellern abgelöst wurden. Nach zehn Jahren als Redakteurin verließ Avril i-D Ende 2004, und Redaktionsassistent Glenn Waldron übernahm.

2005 wollte ich für alle zehn Ausgaben des Jahrgangs unseres silbernen Jubiläums wiedererkennbar einen silbernen Rücken und unterschiedliche kreative Gemeinschaftsarbeiten. Glenn teilte in diesem Jahr die kreativen Pflichten mit einer Reihe von Gast-Mitarbeitern. Ashley Heath war redaktionell verantwortlich für das Herrenmode-Special im Februar [Nr. 251, The Masculine Issue], während M/M (Mathias Augustyniak und Michael Amzalag) ihren Beitrag zu The Feminine Issue [Nr. 252] von März 2005 leisteten. Kayt Jones fotografierte Ludivine Sagnier für den Titel, und das Bild erschien später noch in limitierter Ausgabe als Originalartwork der Designer.

In diesem Sommer meisterte Alex McDowell den Spagat, bei Dreharbeiten für einen Film in London gleichzeitig die redaktionelle Verantwortung für The Occupation Issue [Nr. 256, Juli 2005] zu übernehmen. Alex, ein alter Freund und und einer der Gründungsredakteure von i-D, ist heute ein international gefragter Production Designer, der unter anderem für Kultfilme wie Fight Club, Charlie und die Schokoladenfabrik,

décennies, notamment Smile i-D: Fashion and Style: 20 Years of i-D Magazine, Fashion Now, Fashion Now 2 et 100 Contemporary Fashion Designers, tous avec TASCHEN. Outre ces ouvrages, nous avons aussi publié nous-mêmes quatre brochures – Family Future Positive, Beyond Price, Learn and Pass It On et Safe + Sound – qui ont formé plus tard le recueil SOUL i-D, édité une fois de plus par TASCHEN en 2008.

La rédactrice Avril Mair a contribué à maintenir le magazine à flot au cours des quatre premières années de la décennie, que j'aime considérer comme la période de maturité d'i-D, sa survie dépendant plus de la mode sur le plan rédactionnel. Anticipant le goût croissant et l'obsession du public pour la culture de la célébrité, Avril est allée à contre-courant des débuts « street cred » d'i-D en décidant de mettre en couverture Victoria Beckham et Sienna Miller. Au fil des années 2000, les actrices, les people et les stars de téléréalité ont pris la place des top-modèles à la une des grands magazines. Après dix ans passés à la tête de la rédaction, Avril a quitté le magazine fin 2004 et son poste a été repris par son rédacteur adjoint Glenn Waldron. Pendant toute l'année 2005, j'ai tenu à ce que les dix numéros de notre Jubilé d'Argent soient identifiés par une tranche argentée et différentes

Issue [No. 256, July 2005]. Alex, an old friend and one of the founding editors of i-D, is now an internationally renowned production designer with cult films such as 'Fight Club', 'Charlie and the Chocolate Factory', 'Minority Report' and 'Watchmen' on his CV.
Simon Foxton, our heroic and longstanding Menswear Editor, and Art Director Stephen Male, also members of the eighties i-D team collaborated on the August edition [No. 257, The Straight-up Issue, August 2005].
Dipping into i-D's original 'straight-up' concept of photographing real people in their own clothes, Simon and Stephen produced a front-to-back global street style report. Nick Knight guest edited The Nationality Issue [No. 259] in October 2005, digitally morphing model Gemma Ward's face with a 3-D scan on the cover.
Creative director David Lipman joint edited The Faith Issue [No. 260] in November with actress Naomi Watts on the cover photographed by her brother Ben. In the feature story inside, Naomi walked on the streets of New York with Ben's assistant dressed in an ape suit,

Minority Report und Watchmen verantwortlich zeichnet.
Simon Foxton, über lange Jahre unser heroischer Männermoderedakteur, und Art Director Stephen Male, die beide ebenfalls zum i-D-Team der Achtziger gehörten, taten sich für die August-Nummer zusammen [Nr. 257, The Straight-up Issue, August 2005]. Indem sie das ursprüngliche „Straight-ups"-Konzept von i-D reanimierten, nämlich Leute auf der Straße in ihrer eigenen Kleidung zu fotografieren, produzierten Simon und Stephen von der ersten bis zur letzten Seite einen globalen Street-Style-Report. Nick Knight übernahm die Redaktion für The Nationality Issue [Nr. 259] im Oktober 2005, für dessen Titel er Gemma Wards Gesicht digital mit einem 3-D-Scan morphte.
Creative Director David Lipman war Mitherausgeber der Faith Issue [Nr. 260]vom November 2005 mit Schauspielerin Naomi Watts, fotografiert von ihrem Bruder Ben, auf dem Cover. Für die große Story im Heft spazierte Naomi mit Bens Assistenten in einem Affenkostüm auf New Yorks Straßen herum, weil zeitgleich das Remake von King Kong anlief. Das Jahr endete mit The Home Issue [Nr. 261, Dezember 2005], bei dem der legendäre Grafiker Peter Saville mit Hand anlegte.
Anfang der Siebziger, während meines ersten Jobs als Art Director bei Vanity Fair, lernte ich

collaborations créatives. Glenn a donc partagé ses fonctions avec une série de rédacteurs invités. Ashley Heath a été rédacteur du numéro spécial hommes de février [The Masculine Issue, n° 251], tandis que Mathias Augustyniak et Michael Amzalag (fondateurs du studio de design M/M) ont participé à The Feminine Issue [n° 252] en mars 2005. Pour la couverture, Kayt Jones a photographié Ludivine Sagnier, une image ensuite produite en édition limitée par les designers.
Pendant l'été, Alex McDowell a jonglé entre la production d'un film à Londres et sa mission de rédac' chef pour The Occupation Issue [n° 256, juillet 2005]. Ami de longue date et membre fondateur d'i-D, Alex est aujourd'hui un chef décorateur mondialement réputé qui a signé les décors de films aussi culte que Fight Club, Charlie et la Chocolaterie ou Le Cobaye.
Simon Foxton, notre héroïque rédacteur mode masculine de longue date, et le directeur artistique Stephen Male, tous deux membres de l'équipe i-D des années 80, ont collaboré au numéro d'août [The Straight-up Issue, n° 257, août 2005]. Reprenant le concept du « portrait-vérité » propre aux origines d'i-D, qui consistait à photographier de vrais gens dans leurs propres vêtements, Simon et Stephen ont établi un véritable bilan de la mode street mondiale. Nick Knight a été notre rédacteur pour The

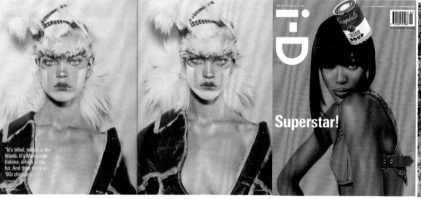

coinciding with the release of the 'King Kong' remake. The year ended with The Home Issue [No. 261, December 2005] guest collaborator being legendary image-maker Peter Saville.
During the early seventies, in my first art direction job at 'Vanity Fair', I learnt working with inspirational photographer Frank Horvat that a theme like 'Women's Liberation' or the 'European Issue' creates a focus making those particular issues special. Themes have always been an integral part of i-D's identity: often they evolved randomly, sometimes they illustrate the cover but frequently they are just made up to add to the chaos. Sometimes our themes straight-jacketed editors, but Ben Reardon embraced the concept from the moment he was made i-D's Editor in the summer of 2006. Ben, who began as an Editorial Assistant under Avril in 2003, made his editorial debut with The Horror Issue [No. 267, June/July 2006], which featured Snejana Onopka as the cover star. The ghoulish beauty on the cover of that issue was produced by Edward Enninful with a make-up extravaganza by i-D's Beauty Director, Pat McGrath and photography by Richard Burbridge.

durch die Arbeit mit dem inspirierenden Fotografen Frank Horvat, dass ein Oberthema wie „Women's Liberation" oder „European Issue" einen Fokus bildet, der die jeweiligen Ausgaben zu etwas Besonderem macht. Die Themen machten immer einen wichtigen Bestandteil der Identität von i-D aus: Oft ergaben sie sich ganz willkürlich, manchmal illustrieren sie den Titel, aber oft sind sie auch einzig dazu da, das Chaos zu verstärken. Manchmal fühlten sich unsere Redakteure durch die Themen eingeengt, aber als Ben Reardon im Sommer 2006 leitender Redakteur wurde, griff er das Konzept gleich begeistert auf. Ben, der 2003 als Redaktions-assistent unter Avril angefangen hatte, gab sein Debüt als Redakteur mit The Horror Issue [Nr. 267, Juni/Juli 2006], das Snejana Onopka auf dem Titel hatte. Die makabre Schönheit auf dem Titel dieser Ausgabe war die Kreation von Edward Enninful mit einem Make-Up, mit dem i-Ds Beauty Director Pat McGrath sich selbst übertraf, und fotografiert von Richard Burbridge.
Bens redaktioneller Ansatz bei i-D war sein weitgefächertes Interesse an Gegenwartskultur in all ihren Permutationen, und er wollte mit i-D zurück zu dessen Kernkonzept individueller Identität. Aus diesem Grund suchte er sich Flash Louis aus, einen Jungen mit einem guten Haarschnitt und einem netten Lächeln,

Nationality Issue [n° 259] en octobre 2005, dont la couverture présentait un morphing numérique du mannequin Gemma Ward réalisé à l'aide d'un scan 3D.
Le directeur de la création David Lipman a codirigé The Faith Issue [n° 260] du mois de novembre, avec en couverture l'actrice Naomi Watts photographiée par son frère Ben. Dans le dossier qui lui était consacré, Naomi déambulait dans les rues de New York avec l'assistant de Ben déguisé en singe, ce qui coïncidait avec la sortie du remake de King Kong. L'année s'est conclue sur The Home Issue [n° 261, décembre 2005], un numéro dirigé par le légendaire créateur d'images Peter Saville.
Lors de mon premier emploi de directeur artistique chez Vanity Fair au début des années 70, j'avais appris en travaillant avec le photographe charismatique Frank Horvat qu'un thème comme « L'émancipation des femmes » ou « Spécial Europe » suscite un intérêt qui rend ces numéros très particuliers. Les thèmes ont toujours fait partie intégrante de l'identité d'i-D : ils évoluent souvent de manière aléatoire, ils illustrent parfois la couverture, mais généralement, ils ne font qu'ajouter au désordre. Les rédacteurs se sentaient parfois ligotés dans une camisole de force par nos thématiques, mais Ben Reardon a adopté le concept dès sa nomination à ce poste à l'été 2006. Après avoir

Ben's editorial approach to i-D reflects his wide interest in contemporary culture — in all its permutations — and wanting to take i-D back to its core concept of individual identity. For this reason he opted for Flash Louis, a boy with a good haircut and a nice smile who he spotted on the streets of London. He looks so fresh, modern and positive on the cover of The Youth Issue [No. 271, October 2006]. As it happened, Ben's early years at i-D corresponded with another wave of youthful creativity that felt very similar in spirit to London in the early eighties. Affected by the events of 9/11, many of Ben's friends and peers, felt it was time to go back to basics. Rejecting branding and wishing to create something uniquely their own, this new tribal community began expressing themselves through subculture, fashion, photography, art, writing or film. In many ways, the tone of this new movement in London reminded me of something Caroline Baker (i-D's first Fashion Editor) wrote in the first issue; "i-D [identity] counts more than fashion. Originate, don't imitate." Designers Giles Deacon,

der ihm in London auf der Straße aufgefallen war. Er sieht auf dem Titel von The Youth Issue [Nr. 271, Oktober 2006] so frisch, modern und positiv aus.
Wie es sich ergab, fielen Bens erste Jahre bei i-D zusammen mit einem neuerlichen Ausbruch jugendlicher Kreativität, der große Ähnlichkeit mit dem Geist des London der frühen Achtziger hatte. Nach den erschütternden Ereignissen von 9/11 hatten viele von Bens Freunden das Gefühl, zum Wesentlichen zurückkehren zu müssen. Diese neue Stammesgemeinschaft hatte keine Lust mehr auf Branding, sondern wollte etwas ganz Eigenes schaffen und begann sich in Subkultur, Mode, Fotografie, Kunst, Literatur oder Film auszudrücken. In vieler Hinsicht erinnerte mich die Haltung dieser neuen Bewegung in London daran, was Caroline Baker (die erste Moderedakteurin von i-D) in unserer ersten Ausgabe geschrieben hatte: „i-D [Identität] zählt mehr als Mode. Originate, don't imitate." Die Designer Giles Deacon, Gareth Pugh, Christopher Kane und Richard Nicoll, die alle dieser Gruppe angehörten, etablierten sich nicht nur in dieser Periode, sie brachten auch London als Modemetropole zurück.
In den Achtzigern versammelten sich Style-Legenden wie Leigh Bowery, Boy George und Steve Strange in Clubs wie Blitz oder Taboo; diese neue Gruppe tummelte sich in ihrem eige-

débuté comme assistant de rédaction sous la direction d'Avril en 2003, Ben est devenu rédac' chef sur The Horror Issue [n° 267, juin/juillet 2006]. La beauté effrayante de Snejana Onopka en couverture était le fruit du travail d'Edward Enninful, avec un maquillage très original signé Pat McGrath, responsable des pages beauté d'i-D, et une photo de Richard Burbridge. L'approche éditoriale de Ben pour i-D reflète son vaste intérêt pour la culture contemporaine et toutes ses permutations, ainsi que son désir de ramener le magazine vers l'identité individuelle, c'est-à-dire son concept d'origine. Pour cette raison, Ben a choisi Flash Louis, un garçon bien coiffé et doté d'un joli sourire qu'il avait repéré dans les rues de Londres, qui paraît vraiment frais, moderne et optimiste en couverture de The Youth Issue [n° 271, octobre 2006]. Il se trouve que les premières années de Ben chez i-D ont coïncidé avec l'arrivée d'une autre vague de jeunes créatifs qui me rappelait beaucoup l'esprit londonien du début des années 80. Bouleversés par les événements du 11 septembre, de nombreux amis et pairs de Ben ont senti qu'il était temps de revenir aux sources. Rejetant le branding au profit d'un concept unique qui lui ressemble, cette nouvelle communauté tribale a commencé à s'exprimer à travers la sous-culture, la mode, la photographie, l'art, la littérature ou le cinéma. Sous

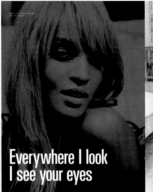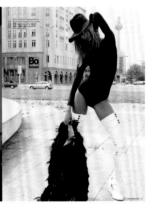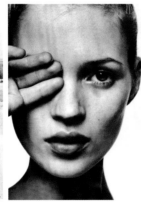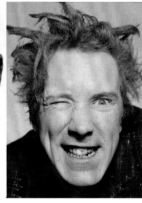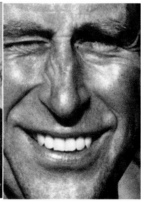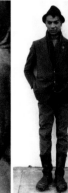

Gareth Pugh, Christopher Kane and Richard Nicoll, all part of this group, not only became established during this period but they brought the spotlight back to London as a fashion capital. In the eighties, style legends like Leigh Bowery, Boy George and Steve Strange congregated at clubs like Blitz or Taboo, this new group in London hung out in their own club called BoomBox. Some people from the eighties crossed over like iconic stylist and designer Judy Blame who works with Gareth Pugh. While subculture factions defined London in the eighties, this new generation, perhaps responding to the international diversity in London, created their own support networks. The late noughties brought a revival of sorts with Nu-Rave culture introducing new music and a new generation in London wearing fluorescent clothes and dying their hair in crazy colours, represented by The Happiness Issue [No. 270, October 2006]. Other favourite covers from the decade include beauties — Amber Valetta, Christy Turlington, Alek Wek, and the first and very colourful cover for Jessica Stam [No. 247, The New Dawn

nen Club, dem BoomBox. Einige Leute aus den Achtzigern hatten den Anschluss gefunden, zum Beispiel die legendäre Stylistin und Designerin Judy Blame, die mit Gareth Pugh arbeitet. Hatten in den Achtzigern die Splittergruppen der Subkultur London definiert, baute sich diese neue Generation, vielleicht empfänglich für die internationale Vielfalt in London, ihre eigenen Unterstützernetzwerke auf. Die späten Nullerjahre brachten so etwas wie ein Revival mit der Nu-Rave-Kultur, neue Musik und eine neue Generation, die in leuchtenden Farben und verrückt gefärbten Haaren in London herumlief, wie in The Happiness Issue [Nr. 270, Oktober 2006] zu sehen.
Zu meinen anderen Lieblingscovern aus diesem Jahrzehnt zählen die Schönheiten – Amber Valetta, Christy Turlington, Alek Wek und auf ihrem ersten, sehr, sehr bunten Titelbild Jessica Stam [Nr. 247, The New Dawn Issue, September 2004] – die das Team aus Edward Enninful, Richard Burbridge, Pat McGrath und Eugene Souleiman produzierten. Die Künstlerin Collier Schorr debütierte mit einem Titelfoto von Caio Vaz, einem jungen brasilianischen Model [Nr. 273, The We've Got Issues Issue, Februar 2007], und die Künstlerin Linder Sterling, der wir in den Achtzigern schon begegnet sind, gestaltete das Pop-Cover für die Ausgabe vom Herbst 2009 [Nr. 303].

bien des aspects, le ton de ce nouveau mouvement londonien me rappelait ce qu'avait écrit Caroline Baker (la première rédactrice mode d'i-D) dans notre numéro inaugural : « i-D [l'identité] compte plus que la mode. N'imitez pas. Inventez. » Les créateurs de mode Giles Deacon, Gareth Pugh, Christopher Kane et Richard Nicoll, tous membres de cette mouvance, se sont non seulement fait connaître au cours de cette période, mais ont aussi redonné à Londres son statut de capitale de la mode.
Alors que les icônes de la mode des années 80 telles que Leigh Bowery, Boy George et Steve Strange se retrouvaient dans des clubs comme le Blitz ou le Taboo, ce nouveau groupe de Londoniens a trouvé son propre repère : le BoomBox. On y croise certaines légendes des eighties comme la styliste et créatrice Judy Blame, qui travaille avec Gareth Pugh. Si les factions de la sous-culture définissaient Londres dans les années 80, cette nouvelle génération s'est créé ses propres réseaux de soutien, peut-être en réaction à la diversité internationale de la capitale anglaise. La fin des années 2000 a assisté à une sorte de renouveau lorsque la culture Nu-Rave a introduit à Londres une nouvelle musique prisée par des jeunes en vêtements fluo qui se teignaient les cheveux dans des couleurs improbables, comme l'a

Issue, September 2004] — produced by the team of Edward Enninful, Richard Burbridge, Pat McGrath and Eugene Souleiman. Artist Collier Schorr made her debut with a cover photograph of Caio Vaz, a young model from Brazil [No. 273, The We've Got Issues Issue, February 2007] and artist Linder Sterling, who we first met in the eighties created the pop cover for the Fall 2009 [No. 303] Issue.
The Pre-Fall 2010 covers will come out of chance surprise. Nick Knight's covers for our 30th anniversary issue with Kate Moss, Naomi Campbell and Lady Gaga still rely heavily on the magic that happens through the eye of the camera. The graphic toolbox is then opened up to add a word or more. The wink is infinite: a two-frame movie communicating a nod for those who know. Nick is one of i-D's longest-serving contributors. His first photo shoot was featured in February 1983 [No. 12, The Love & Romance Issue], and his first cover with Sade was two months later [No. 14, The All Star Issue, April 1983]. I sat down with Nick to talk about i-D, photography, magazines and the future.

Bei den Titeln bis zum Herbst 2010 werden wir uns überraschen lassen. Nick Knights Titel zu unserem 30. Geburtstag mit Kate Moss, Naomi Campbell und Lady Gaga stützen sich noch sehr auf die Magie, die durch das Auge der Kamera entsteht. Dann folgt der Griff in die grafische Trickkiste, um ein Wort oder mehrere hinzuzufügen. Das Zwinkern hat keine Grenzen: Ein Film aus nur zwei Einzelbildern kommuniziert Einverständnis zwischen denen, die Bescheid wissen.
Nick gehört zu den Mitarbeitern von i-D, die besonders lange dabei sind. Sein erster Foto-shoot stellte den Titel für Februar 1983 [Nr. 12, The Love & Romance Issue], und sein erster Titel mit Sade kam zwei Monate später [Nr. 14, The All Star Issue, April 1983]. Ich setzte mich mit Nick zusammen, um über i-D, Fotografie, Zeitschriftenmarkt und die Zukunft zu reden.

reflété The Happiness Issue [n° 270, octobre 2006].
Produites par l'équipe d'Edward Enninful, Richard Burbridge, Pat McGrath et Eugene Souleiman, les autres couvertures très réussies de la décennie ont mis à l'honneur des femmes sublimes – Amber Valetta, Christy Turlington, Alek Wek et la première couverture d'une Jessica Stam multicolore [The New Dawn Issue, n° 247, septembre 2004]. L'artiste Collier Schorr a fait ses débuts en photographiant le beau Caio Vaz, un jeune mannequin brésilien [The We've Got Issues Issue, n° 273, février 2007], tandis que l'artiste Linder Sterling, rencontrée dans les années 80, a créé la couverture pop du numéro Automne 2009 [n° 303].
Les couvertures précédant l'automne 2010 prendront les lecteurs par surprise. Les unes signées Nick Knight pour le numéro de notre trentième anniversaire avec Kate Moss, Naomi Campbell et Lady Gaga reposent encore largement sur la magie déclenchée par l'œil de l'appareil photo. La palette graphique n'intervient alors que pour ajouter un ou plusieurs mots. Le clin d'œil est infini : un film en deux images, telle une « private joke » s'adressant aux initiés.
Nick figure parmi les plus anciens collaborateurs d'i-D. Son premier shooting photo a été publié en février 1983 [The Love & Romance Issue,

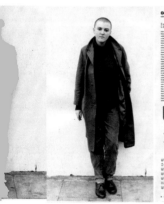 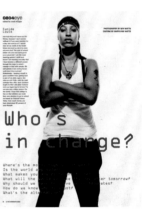 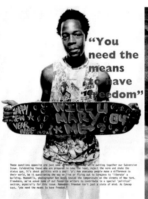 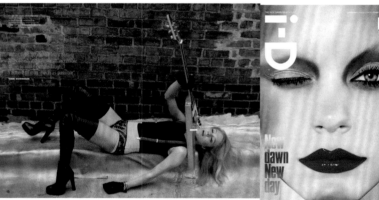

n° 12], suivi par sa première couverture avec Sade deux mois plus tard [The All Star Issue, n° 14, avril 1983]. J'ai interviewé Nick pour parler d'i-D, de photographie, de magazines et du futur.

Terry Jones in conversation with Nick Knight

Terry Jones: Explain Gemma Ward's cover to me. [The Nationality Issue, No. 259, October 2005] It wasn't a photograph?

Nick Knight: No, it was done using 3-D scanning technology, which I've been working with for a while, because it is exciting and the computer does creative things. The computer can't judge whether a reflection is a solid object, or whether that object is advancing towards or receding from the lens, so the computer approximates the data. You get a voluminous computer-generated relief map of lumps, bumps and contours and a photographic image that is applied on top of that. Basically, what you have is the computer inventing reality, which I think is quite an amusing concept.

TJ: So Gemma had to lay her face down on a scanner?

NK: No, she sits on a chair and then the scanner goes right round her, quite sci-fi like, and sends a beam right round her, which is great to film.

TJ: Did you film it?

NK: Yes, we film virtually all of our

Terry Jones im Gespräch mit Nick Knight

Terry Jones: Erklär mir mal das Cover mit Gemma Ward [The Nationality Issue, Oktober 2005]. Das war kein Foto?

Nick Knight: Nein, das habe ich mit 3-D-Scan gemacht, einer Technologie, mit der ich schon länger arbeite, weil sie spannend ist und der Computer von sich aus kreativ wird. Der Computer unterscheidet nicht, ob das, was der Scanner erfasst, ein fest stehendes Objekt ist oder ob das Objekt sich der Linse nähert beziehungsweise sich von ihr entfernt, darum schätzt der Computer die Daten. Du bekommst eine umfängliche computergenerierte Reliefkarte von Knubbeln, Hubbeln und Konturen heraus, und ein fotografisches Bild, das obendrüber gelegt wird. Im Grunde erfindet der Computer also Wirklichkeit, was ich ein sehr amüsantes Konzept finde.

TJ: Gemma hat also ihr Gesicht auf den Scanner gelegt?

NK: Nein, sie sitzt auf einem Stuhl, und dann fährt der Scanner um sie herum, ziemlich futuristisch, tastet sie mit einem Strahl rundherum ab, das ist toll zu filmen.

TJ: Hast du es gefilmt?

NK: Ja, wir filmen praktisch alle unsere Sessions. Begonnen hat das so um 1998 herum,

Terry Jones en conversation avec Nick Knight

Terry Jones : Parle-moi de la couverture de Gemma Ward [The Nationality Issue, n° 259, octobre 2005]. Ce n'était pas une photo ?

Nick Knight : Non, on a utilisé la technologie de scan 3D avec laquelle je travaillais déjà depuis un moment parce qu'elle me fascine et que les ordinateurs permettent d'être créatif. Comme l'ordinateur ne peut pas savoir si un reflet est un objet solide, ni si cet objet avance ou recule par rapport à l'objectif, il fournit des données approximatives. On obtient une volumineuse carte numérique en relief avec des bosses et des contours, et une image photographique appliquée par-dessus. En fait, l'ordinateur invente la réalité et c'est un concept que je trouve assez amusant.

TJ : Gemma a dû poser son visage sur un scanner ?

NK : Non, elle est restée assise sur une chaise pendant que le scanner tournait autour d'elle. Un peu comme dans un film de science-fiction, il émet un rayon tout autour d'elle, ce qui est d'ailleurs génial à filmer.

TJ : As-tu filmé cette séance ?

NK : Oui, nous filmons quasiment toutes nos séances. Ça a commencé vers 1998, quand Andy Knight (l'un de mes assistants) nous a fait

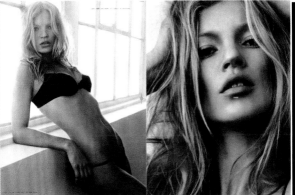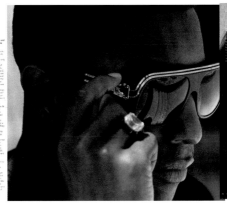

sessions. It started off around 1998 because of something that Andy Knight (an assistant of mine) said – that a photo shoot was a fantastic thing to watch and what a shame that only the seven people in the studio would ever see it. After that, we started putting a video camera on a tripod at the back of the studio, and saying to everybody: "There's a video camera, are you all okay with that?" Then they'd just forget about it and you got a very interesting, fly-on-the-wall film of what went on in the session. By the mid-nineties we were videoing regularly, and by the year 2000 we were recording on multiple cameras. First of all it was just recording everything, and then it became something that I realised had more value and therefore a purpose. With the advent of the Internet, and my SHOWstudio website, there was a place to put these films. Previously films about fashion didn't really work in cinemas, because the time cycle is too long, so this became another reason to do them.

We started this because you asked about Gemma. Interestingly, you can take the data from the 3-D scan and you can

weil Andy Knight (ein Assistent) da so etwas gesagt hat, dass es fantastisch sei, einem Fotoshooting zuzusehen, und es schade sei, dass nur die sieben Leute im Studio es je zu sehen bekämen. Danach haben wir damit angefangen, hinten im Studio eine Videokamera auf einem Stativ hinzustellen, und alle gefragt: „Da hinten steht eine Videokamera, ist euch das recht?" Irgendwann haben sie dann gar nicht mehr daran gedacht, und es kam ein sehr interessanter „Mäuschen spielen"-Film von den Vorgängen im Studio dabei heraus. Mitte der Neunziger nahmen wir regelmäßig alles auf Video auf, und ab 2000 nahmen wir mit mehreren Kameras auf. Zuerst ging es nur darum, alles mitzuschneiden, bis ich dann erkannte, dass es mehr wert war und darum eine Bestimmung hatte. Dann kam das Internet und meine Website SHOWstudio, und es gab endlich eine geeignete Plattform dafür. Filme über Mode hatten bis dahin im Kino nie wirklich funktioniert, weil sie nie wirklich aktuell sein konnten, aber jetzt gab es einen zusätzlichen Grund, sie zu machen. Wir kamen darauf, weil du nach Gemma gefragt hast. Interessanterweise kannst du die Daten des 3-D-Scans nehmen und das i-D-Cover daraus machen, wie ich es mit Gemma gemacht habe, oder du kannst es umdrehen und eine Skulptur daraus machen. Du kannst ein Objekt daraus herstellen, das du in die Hand nehmen

remarquer qu'un shooting photo était une chose fascinante à regarder et qu'il était dommage que seules les sept personnes présentes dans le studio aient la chance de voir ça. Par la suite, nous avons installé une caméra vidéo sur un trépied au fond du studio en prévenant les gens : « Il y a une camera vidéo, est-ce que ça dérange quelqu'un ? » Tout le monde oubliait sa présence et ça donnait un film un peu voyeuriste mais très intéressant sur ce qui s'était passé pendant la séance. Vers le milieu des années 90, on filmait régulièrement les shootings en vidéo, et en l'an 2000, on s'est mis à utiliser plusieurs caméras. Au début, il s'agissait juste de tout enregistrer, puis je me suis rendu compte que ces films avaient de l'intérêt, et donc un sens. Avec l'arrivée d'Internet, j'ai pu présenter ces films sur mon site SHOWstudio. Avant, les films sur la mode ne fonctionnaient pas très bien en salles parce qu'ils durent trop longtemps, mais le web nous a donné une autre raison de les tourner. Nous en parlons parce que tu m'as interrogé au sujet de Gemma. Chose intéressante, tu peux prendre les données du scan 3D et recréer la couverture d'i-D telle que je l'avais fait avec Gemma, mais aussi les manipuler pour en faire une sculpture. Tu peux créer un objet qui tient dans ta main ou aussi grand qu'un immeuble. On peut faire tout ce qu'on veut avec ça, parce

create the cover of i-D, like I did with Gemma, or you can turn it around and make a sculpture. You can make an object that fits in your hands, or you could have it the size of a building. You can do what you want with it, because it's now data, and that data can be a 360° object. The process – the physical and visual relationship with the sitter – is the same as taking a conventional photograph. I direct Gemma the same way, respond to her emotions and her spatial composition in the same way, except that instead of hitting a button and getting one view, you get a 360° view. Of course you can take it and put it on the Internet and turn it around, but you can also create statues out of it. There's nobody sculpting away at a block of marble with a hammer and chisel, but yet you end up with a physical representation of life. I think this new breed of 3-D scanning is very exciting and will bring a whole new way of looking at fashion imagery, or it might only be a blind alley. But I think that once you get people who can use it, and find excitement through it, then they'll find uses for it. I've done two or three sculptures now. The

kannst, oder du kannst es groß wie ein Haus machen. Du kannst damit machen, was du willst, weil es jetzt Daten sind, und diese Daten können ein 360-Grad-Objekt sein. Der Prozess – die räumliche und visuelle Beziehung zu deinem Modell – ist genau wie beim Fotografieren auch. Ich gebe Gemma dieselben Anweisungen, ich reagiere genauso auf ihre Stimmungen und ihre Stellungen, nur dass man nicht auf einen Knopf drückt und eine Ansicht bekommt, sondern eine Rundumsicht. Die kannst du natürlich ins Internet stellen, oder du kannst sie drehen, du kannst aber auch Plastiken daraus machen. Niemand bearbeitet mit Hammer und Meißel einen Marmorblock, aber es kommt am Ende ein greifbares, lebensechtes Abbild heraus. Ich finde, dieser neue Gebrauch von 3-D-Scannern ist sehr aufregend und wird eine ganz neue Sehweise in die Darstellung von Mode hereinbringen – kann aber auch sein, dass es sich einfach als Sackgasse herausstellt. Aber ich glaube, sobald Leute kommen, die damit umgehen können, und die die Arbeit damit spannend finden, werden sie auch Anwendungen dafür finden. Ich habe bis jetzt zwei oder drei Plastiken gemacht. Die Plastik entsteht nicht durch Fotografie, aber es ist eine Plastik auf fotografischer Basis.
TJ: Ich finde, das Erstaunliche ist, welche technologischen Neuerungen sich in so kurzer Zeit

qu'il s'agit de données et qu'elles peuvent produire un objet à 360°. Le processus – la relation physique et visuelle avec la personne assise – est le même qu'une prise de vue classique. Je dirige Gemma de la même manière, je réponds de façon identique à ses émotions et au volume qu'elle occupe dans l'espace, sauf qu'au lieu d'appuyer sur un bouton pour obtenir un cliché, on obtient une vue à 360°. Bien sûr, on peut la mettre en ligne et la manipuler, mais aussi créer des statues. Il ne s'agit pas de sculpter un bloc de marbre au burin et au ciseau, mais on se retrouve quand même avec une représentation physique de la vie. Je trouve cette nouvelle génération de scans 3D absolument fascinante et je pense qu'elle va susciter un regard entièrement inédit sur l'imagerie de mode, à moins que ça ne soit qu'un cul-de-sac. Une fois que des gens auront appris à s'en servir et à l'apprécier, je crois pourtant qu'ils trouveront des applications. J'ai déjà réalisé deux ou trois sculptures à ce jour. Elles ne sont pas reproduites à partir d'une photographie, mais générées par la photographie.
TJ : Le fait que tant de choses aient changé sur le plan technologique en aussi peu de temps me fascine. A la fin des années 90, tu faisais encore des Polaroids et le processus de création restait assez mystérieux.

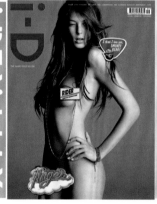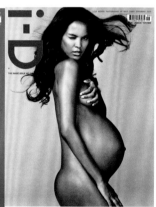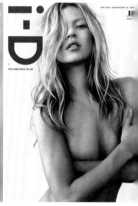

sculpture doesn't come from photography, but it is photographically based sculpture.
TJ: I think what is so amazing is that in such a short amount of time so much has changed from a technology perspective. At the end of the nineties you were still doing Polaroids and there was still that level of mystery.
NK: I started to use a 10x8 camera around 1989. The film would go off to the lab to be developed and you'd pin up the 10x8 Polaroids on the back wall, that's what my process tended to be. Maybe over a three-day period, you'd have a kind of wallpaper made up of hundreds of Polaroid images, and everybody — the model, stylist, hairdresser, make-up artist and assistants all stood in front of them and expressed their opinion. Often they saw things that I didn't see in the images. When you're in the moment of taking the pictures, you don't really perceive every detail; I think it's an emotional interplay that happens, you stop seeing at a certain point and you feel. Polaroids provided a way of, in part, scrutinising the physicality of the image and you could say, "The

ergeben haben. Ende der Neunziger machtest du noch Polaroids, und es gab immer noch diesen gewissen Grad von Unwägbarkeit.
NK: Ich fing etwa 1989 an, mit einer 10x8-Kamera zu arbeiten. Der Film ging ins Labor zum Entwickeln, und die Polaroids pinnte ich an die Wand, das war meistens meine Vorgehensweise. Nach drei Tagen oder so hatte man dann eine Art Tapete aus Hunderten von Polaroids, und jeder – Model, Stylist, Haarstylist, Visagist und die Assistenten – stand davor und konnte seine Meinung dazu äußern. Ihnen fielen auf den Bildern oft Dinge auf, die ich nicht sah. Während des Fotografierens achtest du nicht wirklich auf jede Kleinigkeit, das ist mehr ein emotionales Geben und Nehmen, und an irgendeinem Punkt hörst du auf zu sehen und fühlst stattdessen. Die Polaroids waren eine Möglichkeit, die technischen Details der Bilder zu überprüfen, man konnte sagen: „Hier ist das Licht zu hart", oder es war auch immer, und außerdem gibt es den Leuten, mit denen du arbeitest, die Möglichkeit, sich einzubringen. Mir kam das sehr entgegen, weil ich dann meine eigenen Bilder mit ihren Augen sah. Heutzutage ist das gar nicht so einfach, weil die Bilder sofort auf einem Computermonitor erscheinen. Ein Polaroid konnte ich an die Wand pinnen und zwanzig Minuten lang draufstarren, wenn ich wollte. Jetzt taucht ein Bild auf dem Monitor auf und

NK : J'ai commencé à utiliser un appareil Polaroid 10x8 vers 1989. On faisait développer la pellicule par un labo et on punaisait les tirages 10x8 sur le mur du fond. J'aimais bien travailler comme ça. Au bout de trois jours, on se retrouvait avec une sorte de papier peint composé de centaines d'images Polaroid, et tout le monde – le mannequin, le styliste, le coiffeur, le maquilleur et les assistants – venait se planter devant pour donner son avis. Souvent, ils voyaient des choses que je n'avais pas repérées dans les images. Lorsqu'on est occupé à prendre des photos, on ne remarque pas nécessairement chaque détail ; je pense qu'une interaction émotionnelle s'opère : à un moment donné, on cesse de regarder pour ressentir. Dans une certaine mesure, les Polaroids permettaient d'examiner attentivement l'aspect physique de l'image et de se dire, par exemple, « L'éclairage est trop fort ici », ce genre de choses. Cette façon de procéder encourageait aussi l'équipe à s'exprimer. Cette expérience m'a vraiment nourri parce qu'elle me permettait de voir mes propres images à travers leurs yeux. Aujourd'hui, c'est plus délicat car les images s'affichent instantanément sur un écran d'ordinateur. Avant, je pouvais accrocher un Pola au mur et le regarder pendant vingt minutes si j'en avais envie, alors que

light's too strong here," or whatever, and it was also a way of encouraging the team around you to express themselves. That for me became very nourishing because then I saw my own images through their eyes. Now it is tricky because instantly the images come up on a computer monitor. I could pin up a Polaroid and stare at it for twenty minutes if I wanted to, now an image comes up on a screen and then the next one, the next one and the next one, and to get back to that first photograph is always quite hard. You can't get back to the first one, or see the second and the fifth one at the same time, unless you're printing everything out. That is what we end up doing now - taking thirty or forty shots from the session just captured and printing all those out. Then you end up with these images almost the same size as the old Polaroids, pinned on the back wall again. So, that's opened up the process in a different way, now everybody in the studio sees exactly how the image will be more or less, on a screen as it happens even before the photographer does, because you're actually looking through the camera or looking at the

dann das nächste, und dann noch ein und noch eins, und noch mal zu diesem ersten Bild zurückzugehen ist immer umständlich. Du kannst nicht noch mal einen Blick auf das erste werfen, oder dir das zweite und das fünfte nebeneinander ansehen, es sei denn, du druckst sie alle aus. Das machen wir mittlerweile – wir nehmen dreißig oder vierzig Fotos aus der Session und drucken die alle aus. Dann hat man wieder lauter Bilder fast im Format der alten Polaroids an der Wand hängen. Das hat also den Prozess in anderer Weise geöffnet, jetzt sieht jeder im Studio ziemlich genau, wie das fertige Foto aussieht, auf einem Monitor, und zwar noch vor dem Fotografen; du guckst ja durch den Sucher oder schaust das Model an, aber du hörst die Leute darauf reagieren, ehe du überhaupt Zeit gehabt hast, es dir anzusehen und als Bild zu beurteilen; stattdessen beurteilst du es als Moment, den du durchlebst. Ich bin nicht sicher, ob das weiterhin funktionieren wird, aber es öffnet den Prozess in eine andere Richtung. Negativ betrachtet könnte man sagen, es entwertet die Rolle des Fotografen oder schmälert die Verfügungsgewalt, die der Fotograf im Vorhinein über das Bild hatte.
TJ: Es gibt nicht mehr den überraschenden Moment, wenn diese eine Polaroid-Aufnahme herauskam, die eine bestimmte Magie hatte.

maintenant, les images défilent sur l'écran les unes derrière les autres et il est toujours assez compliqué de revenir sur la première photo. On ne peut pas revenir sur la première, ni regarder la deuxième et la cinquième en même temps, sauf si on imprime tout. C'est d'ailleurs ce qu'on fait désormais : on sauvegarde la trentaine ou la quarantaine de photos qui viennent d'être prises pendant la séance et on les imprime toutes. On se retrouve avec des images qui font presque la même taille que les anciens Polaroids, puis on les punaise sur le mur du fond. Simplement, la méthode est différente. Aujourd'hui, tout le monde en studio voit exactement à quoi l'image ressemblera plus ou moins, sur un écran dès qu'elle est prise, avant même que le photographe ne la voie puisqu'il est occupé à regarder à travers l'objectif ou à observer le mannequin. Il entend les réactions des gens avant d'avoir pu évaluer le résultat sous forme d'image, et non sous la forme d'un moment à vivre. Je ne sais pas si on va continuer à travailler ainsi, mais ça ouvre le processus d'une manière différente. Si on regarde le revers de la médaille, on peut se dire que cette méthode dévalue le rôle du photographe ou lui retire le pouvoir qu'il avait auparavant sur l'image.
TJ : On n'a plus la surprise de découvrir le Polaroid et la magie qu'il recélait.

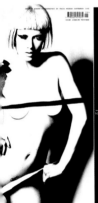
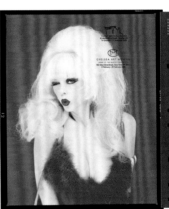
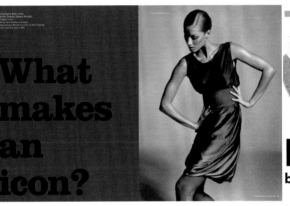

What makes an icon?

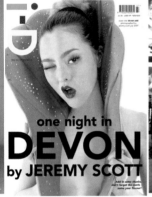

one night in DEVON by JEREMY SCOTT

model but you are hearing people reacting to it before you've had the time to take it in and evaluate it as an image, as opposed to evaluating it as a moment you're living through. I'm not sure that's how it will continue to work, but it does open up the process in a different way. If you look at it in a negative way, you might say that it devalues the role of the photographer or takes away the power the photographer had over the image beforehand.
TJ: You no longer have the surprise when you got that one Polaroid shot and there was magic in it.
NK: It's a different time now and I think things are changing. There is a re-evaluation of fashion and imagery and the use of fashion imagery. Because of the Internet, people now talk a lot about fashion film, and whether that will replace fashion photography. We're in a transition period that's almost akin to when painting went to photography; I should imagine there are huge discussions now about print versus film. I think that fashion film has something new to offer, which is a better understanding of the clothes. I think it's a medium that is certainly

NK: Heute sind andere Zeiten, und die Dinge ändern sich. Es gibt ein Neubewerten und Umdenken in der Abbildung von Mode und der Verwendung dieser Bilder. Wegen des Internets reden jetzt alle vom Modefilm und darüber ob er die Modefotografie ablösen wird. Wir sind in einer Übergangsphase, so ähnlich wie der des Übergangs von Malerei zur Fotografie; ich rechne damit, dass es noch Riesendiskussionen über Print versus Film geben wird. Ich glaube, der Modefilm hat etwas Neues anzubieten, nämlich, dass die Kleidungsstücke besser zu erfassen sind. Das Medium steckt ja noch in den Kinderschuhen, darum kann man schlecht eine definitive Aussage dazu machen. Es eignet sich auf jeden Fall besser für das Internet, weil man bewegte Bilder von Kleidung zeigen kann, die ja für die Bewegung gedacht ist, daraus folgt wahrscheinlich, dass ein bewegtes Bild geeigneter ist, Mode darzustellen, als ein statisches Bild.
TJ: Was i-D angeht, denke ich definitiv in diese Richtung.
NK: Das ist die Basis dessen, was wir gerade sehen. Ich glaube, die Modefotografie ist eine aussterbende Art.
TJ: Ich glaube, dass der Einfluss und der Wert von Print als einem greifbaren Medium, im Gegensatz zum Internet, das ein flüchtiges Medium ist, eher noch steigen wird. Ich glaube,

NK : L'époque est différente et je pense que les choses sont en train de changer. On réévalue la mode, son imagerie et l'utilisation qui en est faite. Avec Internet, les gens parlent désormais beaucoup du film de mode en se demandant s'il finira par remplacer la photo de mode. C'est une période de transition qui s'apparente presque à l'époque où la photographie a supplanté la peinture ; j'imagine que cela donnera lieu à de grands débats entre les défenseurs de la photo et ceux de la vidéo. Je pense que le film de mode va apporter quelque chose de nouveau, à savoir une meilleure compréhension des vêtements. Ce support en est encore à ses premiers balbutiements, donc difficile d'émettre un avis définitif sur la question. Il convient certainement mieux au medium qu'est Internet parce qu'on peut créer un support animé pour les vêtements, qui sont justement conçus pour bouger. En conséquence, la meilleure façon de présenter la mode repose probablement sur une image en mouvement et non sur une image fixe.
TJ : C'est exactement ce que j'envisage pour i-D.
NK : Et c'est la base de ce qui se passe actuellement. Je pense que la profession de photographe de mode vit ses dernières années.
TJ : Pourtant, je crois que le pouvoir et la valeur du support imprimé, par opposition à Internet,

in its infancy, so it's hard to make a definitive opinion. It certainly is better for the medium of the Internet, because you can make something that moves for clothes, which are designed for movement, so it probably follows that the best way of showing fashion is through a moving image rather than a still image.

TJ: It's definitely how I'm thinking for i-D.

NK: That's the basis of what we're seeing now. I think the fashion photographer probably is a dying breed.

TJ: I think that the power and value of print as a physical medium, as opposed to the Internet, which is a transient medium, will only increase. I think that there's still a lot to be explored. In 1980, I got involved with this company called Catalyst and we did this hour-long magazine on a VHS tape, but it was very hard to make that work. Today that idea can be made in someone's bedroom, so I think we're getting closer to that idea of a moving magazine.

NK: In terms of what's going to happen in the future and seeing how people will live in this world, I have three children all in their teens who don't

die Möglichkeiten sind noch lange nicht ausgelotet. 1980 hatte ich mich mit einer Firma zusammengetan, Catalyst, und wir machten ein einstündiges Magazin auf VHS, aber es funktionierte nur sehr bedingt. Heute kann man diese Idee bei irgendwem im Schlafzimmer umsetzen, darum glaube ich, wir kommen dem bewegten Magazin sehr viel näher.

NK: Was in Zukunft passieren wird und wie Menschen in dieser Welt leben werden – ich habe drei Kinder, alle unter zwanzig, die an Zeitschriften überhaupt keinen Blick verschwenden. Für sie besteht tatsächlich kein Grund, in eine Zeitschrift zu sehen, denn Zeitschriften werden als langsam und schwerfällig wahrgenommen. Wenn du eine Zeitschrift aufschlägst, spricht sie nicht mit dir und du kannst sie nicht interaktiv nutzen. Es gibt nichts zu hören, nichts bewegt sich, und nichts verändert sich. Aber wenn du ins Internet gehst, redest du plötzlich mit deinen Freunden, und du lädst Filme herunter, und es ist interaktiv, die Dinge passieren live. Es ist einfach eine völlig andere Welt.

TJ: Ich glaube trotzdem an den Wert von etwas Greifbarem, einem Album oder einer Zeitschrift, etwas, das man sich später noch einmal ansehen kann. Ich glaube, es gab eine Art, Informationen zu sammeln, bei der man einen Großteil davon tatsächlich im Kopf spei-

medium transitoire, ne vont faire qu'augmenter. Selon moi, il reste encore beaucoup de choses à explorer. En 1980, j'ai travaillé avec la société Catalyst à la création d'un magazine d'une heure sur cassette VHS, mais c'était très compliqué à réaliser. Aujourd'hui, n'importe qui pourrait faire ça dans sa cuisine. Voilà pourquoi je pense qu'on se rapproche du concept de magazine animé.

NK : En ce qui concerne l'avenir et notre futur rapport au monde, j'ai trois enfants adolescents qui ne lisent jamais la presse. En fait, ils n'ont aucune raison de le faire, puisque les magazines sont considérés comme « lents ». Quand on ouvre un magazine, il ne se met pas à vous parler et vous ne pouvez pas interagir avec lui. Il n'y a aucun son, aucune animation, tout est statique. Tandis que sur Internet, on peut discuter avec ses amis, télécharger des films, c'est interactif et tout se passe en direct. C'est un monde complètement différent.

TJ : J'estime pourtant que le support physique a toujours de la valeur, comme un album ou un magazine que l'on peut relire. Cette manière de découvrir les informations permettait en fait d'en mémoriser une grande partie. Aujourd'hui, les gens font de même avec l'ordinateur.

NK : Je n'agis vraiment pas dans un but intéressé en disant que la photographie s'apprête à céder la place à la vidéo, mais je crois que c'est la vérité.

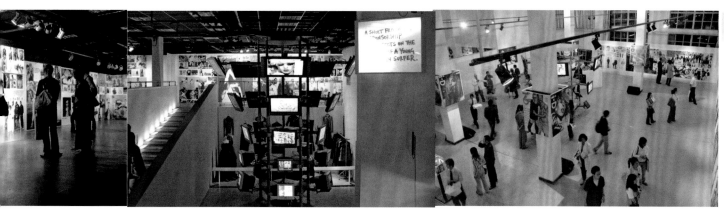

look at magazines at all. There's actually no reason for them to look at magazines, because magazines are perceived as slow. You open a magazine and it doesn't speak to you and you can't interact with it. There's no noise, nothing moves and nothing changes. But you go to the Internet and all of a sudden you're speaking to your friends and you're downloading films, and it's interactive, and things are going live. It's just a whole different world.

TJ: I still think there's value in something physical, like an album or magazine that you can look back to. I think there was this way of collecting information and actually holding a lot of it in your brain. Today I think people are using the computer to collect and hold information.

NK: I don't have any particular axe to grind in saying that photography is on the way out and films are on the way in, but I think it's the truth.

TJ: I think that gadgets like this little Flip are amazing; I mean for me they're like the new Polaroids.

NK: You see, that's the thing: if I said to you to come over here with a still camera you wouldn't have done it,

cherte. Ich glaube, heute benutzen die Leute Computer, um Informationen zu sammeln und zu speichern.

NK: Ich nehme das nicht persönlich, wenn ich sage, dass Fotografie auf dem absteigenden und Filme auf dem aufsteigenden Ast sind, aber ich glaube, es stimmt.

TJ: Ich finde technische Spielereien wie diese kleinen Flip-Videokameras erstaunlich, ich meine, für mich sind das die neuen Polaroids.

NK: Siehst du, das ist es eben: Wenn ich gesagt hätte, komm und bring eine Fotokamera mit, hättest du es nicht gemacht, aber eine Videokamera macht es dir sehr viel leichter.

TJ: So was benutze ich schon seit 1986, seit ich meine erste Videokamera in die Finger bekam.

NK: Ja, aber jetzt bist du viel relaxter.

TJ: Total.

NK: Es ist sehr schwierig, wieder dazu zurückzukehren. Bei Fotografen wie William Klein zum Beispiel hatte man immer das Gefühl, dass sie blitzschnell auf Neuerungen reagierten. Alles wirkte wie eine Revolution. Das ist längst nicht mehr so; ich habe eher das Gefühl, Leuten ein Medium aufzuzwingen, bei dem schon alle Knochen krachen und das sich nur noch dem Tod entgegenschleppt.

TJ: Aber auf einer Flip wirst du nie die Energie eines William Klein einfangen.

TJ : J'adore les gadgets comme ce petit caméscope Flip ; pour moi, ce sont un peu les nouveaux Polaroids.

NK : Tu vois, c'est exactement ça. Si je t'avais dit de venir avec un appareil photo, tu ne l'aurais pas fait, alors que prendre ton caméscope te semble naturel.

TJ : J'utilise ce genre d'appareil depuis 1986, quand j'ai acheté ma première caméra vidéo.

NK : Mais tu es un peu plus à l'aise avec ça maintenant.

TJ : Tout à fait.

NK : Il est très difficile de revenir en arrière. Des photographes comme William Klein, par exemple, donnaient l'impression de suivre la rapidité du changement. C'était comme une petite révolution. Ce n'est plus le cas aujourd'hui ; autant essayer d'imposer aux gens un medium tout détraqué qui vivrait ses derniers instants.

TJ : Avec ce Flip, on ne pourra pourtant jamais retrouver l'énergie d'un William Klein.

NK : Mais on trouvera autre chose. Je pense qu'il faut regarder l'avenir avec enthousiasme.

TJ : Je crois qu'il faut vivre avec son temps.

NK : Oui, et cela devient un débat parmi ceux qui ne font rien. Les gens qui créent se lancent parce qu'ils en ont envie. S'ils veulent créer des robes et les présenter sur Internet, ou recourir à la vidéo plutôt qu'à la photo, peu importe : ils

but with a video camera it's much more accessible to you.
TJ: I've been using this sort of thing since 1986 when I got hold of my first video camera.
NK: But you're kind of more relaxed now.
TJ: Totally.
NK: It's very hard to go back to that way. With photographers like William Klein, for example, you had the feeling they were going with that speed of change. It all felt like a revolution. It doesn't anymore; it just feels like you're trying to force people into a medium that is actually creaking, dying and on its last legs.
TJ: But you'll never catch the energy of a William Klein on a Flip video camera.
NK: But you'll catch something else. I think we have to be enthusiastic about the future.
TJ: I think you have to live in the moment.
NK: Yes, and that becomes a debate for people who aren't actually doing stuff. People that are doing it get on with it because they want to do it. So if they want to create dresses and put

NK: Nein, aber du fängst dafür etwas anderes ein. Ich glaube, wir sollten der Zukunft mit Enthusiasmus begegnen.
TJ: Ich denke, man muss im Jetzt leben.
NK: Ja, und das wird dann eine Debatte für Leute, die nicht wirklich damit arbeiten. Leute, die damit arbeiten, machen es einfach, weil sie Lust dazu haben. Und wenn sie Kleider entwerfen und sie ins Internet stellen wollen, oder lieber mit Film als mit Fotografie arbeiten wollen, ist es ihnen egal, sie fragen nicht lange, sie machen es einfach. Mein Sohn, der im Alter von zwölf Jahren Filme schneidet, bedient sich aus Quellen, die er auf seinem Laptop hat oder woher auch immer, und mixt fröhlich alles miteinander. Er stellt sich nicht die Frage nach der Legitimität von Fotografie oder danach, ob das Medium sich verändert oder stirbt. Es ist ihm egal; es hat für ihn keinerlei Relevanz. Ich im Alter von 51 Jahren schleppe seit 25 oder 30 Jahren die Last der Geschichte der Fotografie mit mir herum, weil es eine Leidenschaft von mir war. Außerdem bin ich vorbelastet durch die Erkenntnis, dass das Medium sich verändert, darum halte ich es für elementar, jede persönliche oder romantisierte Vorstellung von der Fotografie von Negativen, Dias, Abzügen, Büchern und was sonst noch, beiseite zu lassen. Die Leute, die heute kreativ arbeiten, Jugendliche, lassen

ne demandent pas la permission, ils se contentent d'agir. Mon fils, qui fait déjà du montage à l'âge de douze ans, est ravi de télécharger des sources vidéo sur son ordinateur portable ou autre et de les monter toutes ensemble. Il ne remet pas en question la validité de la photographie et ne se demande pas si ce medium est en train de changer ou de mourir. Il s'en fiche ; cela n'a strictement aucune importance à ses yeux. A cinquante-et-un ans, et aujourd'hui depuis 25 ou 30 ans, je suis vraiment marqué par l'histoire de la photographie parce que c'est l'une de mes passions. Je suis aussi un peu accablé en me rendant compte que ce medium change. Il est donc essentiel que je me débarrasse de toute notion personnelle ou romantique sur la photographie, comme le négatif, les transparences, les tirages, les albums, etc. Ces choses ne freinent pas les créatifs actuels, c'est-à-dire les ados. Cela ne leur pose pas de problème car ils se contentent d'agir.

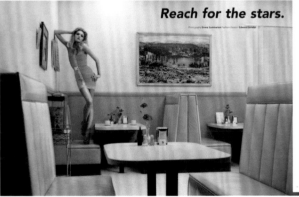
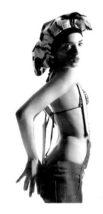
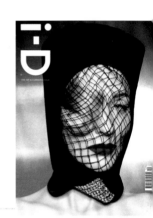

them out on the Internet, or do films rather than photography, they don't care, they don't ask, they just do it. My son, who edits films at the age of twelve, is quite happy to grab sources from his laptop or from wherever it is and mix them all together. He doesn't question the validity of photography or whether the medium is changing or dying. He doesn't care; it's not relevant to him at all. At the age of fifty-one, and for 25 or 30 years now, I've been really weighed down with the history of photography because it's been a passion of mine. I'm also slightly burdened with the realisation that this medium is changing, so I think it is really fundamental that I remove any personal or romanticised notions I have of photography such as, the negative, transparencies, prints, books, whatever. These things don't impede the people creating work now, who are in their teens, or whatever, they don't have an issue with that because they just do it.

sich von solchen Dingen nicht behindern, sie haben da keine Probleme, weil sie es einfach machen.

Looking back over the years it's amazing how many variations the challenge of the wink and smile has given us. The face, most times, is a blank canvas that becomes a collaboration between the star and the photographer, who, together with the stylists, hair and make-up artists, generates a cover image that reflects a moment in time.

The i-D cover has become a collectable. Some covers have iconic status instantly, while others reveal themselves upon reflection years later. All of them are unique. As I was going through all the covers, there are favourites that clocked in my brain as always being memorable, but then there were others I'd forgotten about like The Born Again Issue [No. 86, November 1990]; the US Issue [No. 131, August 1994] featuring Naomi Campbell and Kate Moss together or The Streaker Issue [No. 221, June 2002]. I have different favourites for different reasons, such as The Elevator Issue [No. 191, October 1999], The Art Issue [No. 28, August 1985] or The Wuli Dancing Issue [No. 9, November 1982]. Some caused problems at the time but are seen in a different

Es ist schon erstaunlich, wenn man sich ansieht, wie viele Lösungsvarianten für die Aufgabe „Zwinkern und Lächeln" im Lauf der Jahre zusammengekommen sind. Das Gesicht ist zumeist eine leere Leinwand, die zu einer Kollaboration zwischend dem Star und dem Fotografen wird, der zusammen mit den Stylisten, Haarstylisten und Visagisten ein Titelbild entstehen lässt, das einen bestimmten Zeitgeist wiedergibt.

i-D-Cover sind mittlerweile Sammelobjekte. Einige Titel werden sofort zur Ikone, während andere sich erst im Rückblick erschließen. Alle von ihnen sind einzigartig. Als ich die vielen Titelbilder durchging, begegnete ich den Favoriten wieder, die sich für immer in mein Gehirn eingebrannt hatten, aber auch solchen, an die ich mich nicht erinnern konnte, wie The Born Again Issue [Nr. 86, November 1990]; The US Issue [Nr. 131, August 1994] mit Naomi Campbell and Kate Moss zusammen, oder The Streaker Issue [Nr. 221, June 2002]. Ich habe verschiedene Favoriten aus ganz verschiedenen Gründen, wie The Elevator Issue [Nr. 191, Oktober 1999], The Art Issue [Nr. 28, August 1985], oder The Wuli Dancing Issue [Nr. 9, November 1982]. Einige machten bei ihrer Entstehung Probleme, wirken aber ganz anders, wenn man sie heute neu entdeckt. Andere bringen eine Flut von Erinnerungen zurück, etwa

L'incroyable variété engendrée au fil des années par le défi du clin d'œil et du sourire est absolument fascinante. Dans la plupart des cas, le visage devient une toile vierge consacrée à la collaboration entre la star et son photographe, qui aux côtés des stylistes, des coiffeurs et des maquilleurs, produit une image pour une couverture reflétant un moment précis dans le temps.

Les couvertures d'i-D sont devenues des objets de collection. Certaines accèdent instantanément au statut d'image culte, tandis que d'autres, après réflexion, se révèlent bien des années plus tard. Chacune est unique. En revenant sur toutes ces couvertures, j'ai retrouvé celles que mon cerveau avaient enregistrées parmi mes préférées et les plus inoubliables, mais j'en avais oubliées certaines, notamment celles de The Born Again Issue [n° 86, novembre 1990], The US Issue [n° 131, août 1994] avec Naomi Campbell et Kate Moss, ou The Streaker Issue [n° 221, juin 2002]. J'ai plusieurs couvertures préférées pour plusieurs raisons, comme The Elevator Issue [n° 191, octobre 1999], The Art Issue [n° 28, août 1985] et The Wuli Dancing Issue [n° 9, novembre 1982]. Celles qui avaient provoqué des problèmes à l'époque se redécouvrent sous une lumière différente aujourd'hui. D'autres font ressurgir un flot de souvenirs, comme la couverture « Fast forward »

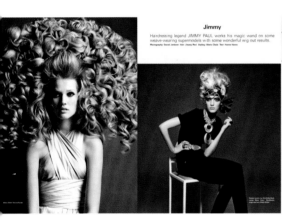
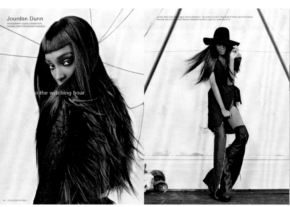
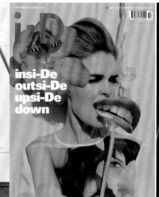
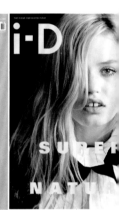

light when rediscovered today. Others bring back a flood of memories; such as Carter Smith's 'Fast forward' cover [The Forward Issue, No. 180, October 1998] which was done while we were working on the 'Fashion and Cinema' project at the Stazione Leopolda in Florence. I like its nice clean dynamic. Blown up on canvas, the combined talent and energy of all involved has elevated i-D cover art to something money can't buy. I told Tricia when we had the first issues stacked up in our hallway that they would become collectors' items. I never wanted to make a magazine for landfill. Type and letterform have always been my focal interest. I still have my early student type books, where I would trace letters with a Rapidograph or sharp pencil and memorise the type names. I was very fortunate to have two great mentors — Richard Hollis and Ivan Dodd — who created the foundation for my rebellious energy. The basis of all of i-D's typography is owed to them. Richard Hollis, the head of The West of England Art College, encouraged my lifelong love of handmade, lo-tech graphic tools and allowed me to see

Carter Smiths 'Fast forward'-Titel [The Forward Issue, Nr. 180, Oktober 1998], der während der Arbeit an unserem 'Fashion and Cinema'-Projekt in der Stazione Leopolda in Florenz entstand. Mir gefällt die nette, saubere Dynamik. Auf Leinwand hochgezogen, haben das vereinte Talent und die vereinte Energie aller Beteiligten die Cover Art von i-D zu etwas gesteigert, das mit Geld nicht zu bezahlen ist. Als wir die ersten Ausgaben in unserem Flur gestapelt hatten, sagte ich zu Tricia, sie würden zu Sammlerstücken werden. Ich wollte nie ein Magazin für die Müllkippe machen.

Schriften und Buchstabenformen waren immer mein Hauptinteresse. Ich habe noch immer meine Schriftmusterbücher aus dem Studium, wo ich Buchstaben mit einem Rapidograph oder einem harten Bleistift nachzog und die Namen der Schriften auswendig lernte. Ich hatte das Privileg, zwei wunderbare Mentoren zu haben – Richard Hollis und Ivan Dodd –, die mir ein solides Fundament für meine rebellische Energie gaben. Die Basis für die gesamte i-D-Typografie ist ihnen zu verdanken. Richard Hollis, der Direktor des West of England Art College, förderte meine Liebe zu handgemachten grafischen Low-Tech-Werkzeugen und öffnete mir die Augen für das Mögliche. Ich habe schon oft gesagt, dass die Art Colleges Orte sein sollten, an denen man experimentiert und

de Carter Smith [The Forward Issue, n° 180, octobre 1998] réalisée pendant que nous travaillions sur le projet « Fashion and Cinema » à la Stazione Leopolda de Florence. J'aime son dynamisme épuré. Agrandis sur toile, le talent et l'énergie combinés de toutes les personnes impliquées ont hissé la couverture i-D au rang d'œuvre d'art que l'argent ne peut acheter. En voyant les premiers numéros empilés dans notre entrée, j'avais dit à Tricia qu'ils deviendraient un jour des objets de collection. Je n'ai jamais eu envie de faire un magazine pour qu'il finisse à la décharge.

Je suis avant tout passionné par la typographie et les caractères. J'ai conservé mes manuels de typographie d'étudiant, où je dessinais les lettres au Rapidographe ou avec un crayon bien taillé et mémorisais les noms des polices. J'ai eu l'immense chance d'avoir deux mentors exceptionnels, Richard Hollis et Ivan Dodd, pour façonner mon énergie rebelle. On leur doit toutes les typographies d'i-D. Richard Hollis, directeur du West of England Art College, a attisé mon amour de toujours pour les outils graphiques low-tech faits main et m'a initié au champ des possibles. J'ai souvent dit que les écoles d'art devaient être des lieux d'expérimentation permettant de faire des erreurs, parce qu'on doit connaître les limites avant de pouvoir les repousser. J'ai eu le privilège d'apprendre

what was possible. I have often said that art colleges should be a place to experiment and make mistakes, because it is necessary to know the limits before you can stretch them. Learning by my mistakes was a privilege I had when I was given my first design studio experience with Ivan Dodd, who taught me the finer rules of typography, and very importantly, with Beatrix Miller during my tenure at British Vogue between 1972 and 1977. I've tried over the years to give the same opportunity to people at i-D.

Looking through the credits on each cover re-enforces the creative web that i-D has always fostered. The teaching process is continuous, with many i-D staffers starting their careers with work experience and ending up as editors. Steve Male came to work on the Fiorucci sticker project when I needed an illustrator, and by the end of the eighties he had used these skills to produce a string of graphic covers when we had no photographic winks. Avril Mair came to i-D for work experience. Two years later she was made Editor, a post she held for ten years. Edward Enninful was cast as a

Fehler macht, weil es notwendig ist, die Grenzen zu kennen, ehe man sie durchbricht. Aus meinen Fehlern zu lernen war ein Privileg, das mir zuteil wurde, als ich erste Erfahrungen in einem Designstudio bei Ivan Dodd sammelte, der mir die Feinheiten der Typografie näherbrachte, und, auch sehr wichtig, durch meine Arbeit mit Beatrice Miller während meiner Zeit bei der britischen Vogue zwischen 1972 und 1977. Ich habe in all den Jahren immer versucht, den Leuten bei i-D ähnliche Möglichkeiten zu schaffen.

Die Durchsicht der Cover-Credits macht klar, dass i-D sein kreatives Netzwerk immer weiter ausgebaut hat. Dieser Prozess des Weitergebens ist nicht abgeschlossen. Viele aus dem i-D-Stall begannen ihre Laufbahn als Praktikanten und endeten als Redakteure. Steve Male kam, als ich für die Arbeit an den Fiorucci-Stickern einen Illustrator brauchte, und hatte Ende der Achtziger sein Können bei einer Reihe von grafischen Covern bewiesen, als wir noch keine fotografischen Zwinkertitel hatten. Avril Mair kam als Praktikantin zu i-D. Zwei Jahre später wurde sie zur Redakteurin befördert und hielt diesen Posten für zehn Jahre. Edward Enninful war als Model für ein Shooting gecastet worden und trieb sich so lange im Büro herum, bis er erst Junior Fashion Editor und später Fashion Director wurde; in seinen

de mes erreurs lors de ma première expérience en atelier de création avec Ivan Dodd, qui m'a enseigné les règles plus subtiles de la typographie, et surtout auprès de Beatrix Miller en travaillant pour le Vogue anglais entre 1972 et 1977. Au fil des années, j'ai essayé d'offrir les mêmes opportunités aux gens d'i-D.

Il suffit de lire la liste des personnes ayant contribué à chaque couverture pour comprendre qu'i-D n'a jamais cessé de développer son réseau créatif. Le processus d'apprentissage continue, de nombreux collaborateurs d'i-D ayant débuté leurs carrières comme stagiaires pour finir rédacteurs. Steve Male nous a rejoints lorsque j'ai eu besoin d'un illustrateur pour le projet d'autocollants Fiorucci, et à la fin des années 80, ses talents lui ont permis de produire toute une série de couvertures graphiques dès que nous ne disposions pas de clins d'œil photographiques. Avril Mair a débuté chez i-D en tant que stagiaire ; deux ans plus tard, elle était nommée rédactrice, un poste qu'elle a occupé pendant dix ans. Edward Enninful a été recruté comme mannequin pour une séance photo ; il passait si souvent dans nos bureaux qu'il est devenu rédacteur junior en mode, puis rédacteur des pages mode, produisant plus d'une centaine de couvertures i-D pendant ses 19 ans de présence au magazine. Quand je reviens sur

 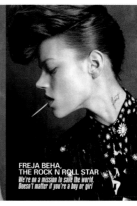

THE AIREST OF THEM ALL

model for a shoot, hung out in the office, became a Junior Fashion Editor, then Fashion Director and has produced more than 100 i-D covers over his 19 years at the magazine. When I look at the thread that has run through all my work at i-D over the past 30 years it is this sense of collaboration — the concurrent series of creative relationships with many talented people — that has made it all so worthwhile. Talent breeds talent, and I wait for the next generations who will enter the i-D family…

Daydreaming. Terry must wake up and stop daydreaming. Jones the daydreamer. That was constant on my school report, no matter the beatings, the verbal batterings or the bribes ("your mother will be very disappointed"). No one ever told me back in the sixties that this would be my day job. And today I could officially retire.

i-D has reached its 30th birthday and I've reached my 65th. With my life partner Tricia we watched over three decades of an idea that started when we talked at home one morning. Picking Tricia out on the university dance floor was without a doubt the best choice of

mehr als 19 Jahren bei dem Magazin hat er über 100 i-D-Cover produziert. Wenn ich den roten Faden sehe, der sich durch meine gesamte Arbeit bei i-D in den vergangenen dreißig Jahren zieht, dann ist es dieses Gefühl, gemeinsam an etwas zu arbeiten — die fortgesetzte Serie kreativer Beziehungen mit vielen talentierten Leuten —, das das Ganze befriedigend gemacht hat. Talent zeugt Talent, und ich warte schon auf die nächsten Generationen, die zur i-D-Familie stoßen werden …

Tagträumerei. Terry muss achtgeben, anstatt vor sich hin zu träumen. Jones, der Tagträumer. Das war eine Konstante auf meinen Schulzeugnissen, an der weder Schläge, noch Schimpferei oder der Appell an mein besseres Ich („Deine Mutter wäre ja so enttäuscht") etwas änderten. In den Sechzigern hat mir nie jemand gesagt, dass ich es irgendwann beruflich machen würde. Und mittlerweile könnte ich offiziell in Rente gehen.

i-D feiert seinen 30. Geburtstag, und ich habe meinen 65. erreicht. Meine Lebensgefährtin Tricia und ich blicken auf drei Jahrzehnte einer Idee zurück, die entstand, als wir uns eines Morgens zu Haus unterhielten. Dass ich mir Tricia an der Uni auf der Tanzfläche geangelt habe, war ohne jeden Zweifel die beste Entscheidung meines Lebens. Unsere Arbeitsbeziehung beruht auf gegenseitigem Respekt,

le fil rouge qui relie tout mon travail chez i-D au cours des 30 dernières années, je me rends compte que c'est ce sens de la collaboration – la série simultanée de relations créatives entre autant de gens talentueux – qui fait toute la valeur du magazine. Le talent engendre le talent, et j'ai hâte de voir à l'œuvre les futures générations qui entreront dans la famille i-D…

La rêverie. Terry doit se réveiller et arrêter de rêvasser. Jones le rêveur. Voilà un commentaire qui revenait constamment sur mes bulletins scolaires, malgré les raclées, les insultes ou les chantages (« ta mère va être très déçue »). Dans les années 60, personne ne m'a jamais dit que j'en ferai un jour mon métier. Et aujourd'hui, je pourrais officiellement prendre ma retraite. i-D célèbre son 30e anniversaire et je fête mes 65 ans. Avec ma compagne Tricia, nous sommes revenus sur trois décennies d'existence d'une idée née en discutant un matin à la maison. Repérer Tricia sur la piste de danse de l'université est sans aucun doute la meilleure chose que j'aie faite de toute ma vie. Notre relation de travail repose sur le respect mutuel, la confiance et le dialogue, avec un « n'oublie pas que sourire, c'est bon pour la santé ! »

Je me rends compte que la mémoire a besoin d'une expérience sensorielle pour être

my life. Our working relationship is built on mutual respect, trust and dialogue with a 'don't forget smiles are good for your health!'

Memory, I find, needs a sensorial experience to be triggered. Talking to many contributors for this book, it's incredible how often the request to see the cover to jolt the brain has been necessary. Some people have worries that it's the drink, the drugs, the mobile microwaves that pop out our brain cells, or just the ageing process. I like to think it's a combination of information overload and lack of brain exercise. Computers are replacing our memory banks and are endangering our intuitive skills. Studies in Asia, where Internet access has been most prolific, already show signs that very special human skills - to think laterally and three dimensionally - need more cultivation. i-D needs to retain human endeavour and the combined skills of creative individuals to open people's eyes to the possibilities that have not been over exploited. The exchange of ideas is another essential remit that needs to be filtered and infiltrated into the mainstream.

Vertrauen und Dialogbereitschaft mit einem „Vergiss nicht, Lächeln ist gut für die Gesundheit!"

Das Gedächtnis, finde ich, braucht den Anstoß durch eine sensorische Erfahrung. Bei meinen Gesprächen mit vielen Mitarbeitern für dieses Buch hat es mich erstaunt, wie oft es notwendig war, sich ein Cover anzusehen, um dem Gedächtnis auf die Sprünge zu helfen. Manche Menschen haben die Befürchtung, dass es Alkohol, Drogen oder herumschwirrende Mikrowellen sind, die unsere Gehirnzellen killen, vielleicht auch einfach das Alter. Ich glaube, es liegt an einer Kombination aus Informationsüberflutung und mangelndem Gehirntraining. Computer ersetzten unseren körpereigenen Datenspeicher und gefährden unsere intutiven Fähigkeiten. Studien in Asien, wo der Internetzugang am flächendeckendsten ist, zeigen bereits, dass sehr spezielle menschliche Fähigkeiten – das Querdenken und dreidimensionale Denken – wieder mehr kultiviert werden müssen. i-D muss sich den menschlichen Impuls erhalten, und die kombinierten Fähigkeiten einzelner Kreativer, um den Menschen die Augen für Möglichkeiten zu öffnen, die noch nicht völlig ausgeschlachtet wurden. Der Austausch von Ideen ist ein weiterer essenzieller Aufgabenbereich, der gefiltert und in den Mainstream eingeschleust sein will.

recouvrée. En parlant avec de nombreux contributeurs du magazine pour réaliser ce livre, on m'a très souvent demandé de revoir telle ou telle couverture pour en faire remonter le souvenir. Certains s'inquiètent : est-ce dû à l'alcool, à la drogue, aux micro-ondes qui détruisent les cellules du cerveau, ou simplement à l'âge ? Je préfère blâmer la surcharge d'informations et le manque d'entraînement cérébral. Les ordinateurs remplacent nos réservoirs de souvenirs et menacent nos capacités intuitives. Des études menées en Asie, où les gens sont particulièrement accros à Internet, indiquent déjà que certaines capacités spécifiquement humaines – penser latéralement et en trois dimensions – exigent d'être cultivées. i-D doit préserver l'effort humain et les talents conjugués des individus créatifs pour ouvrir les yeux du public sur des possibilités qui ne sont pas encore surexploitées. L'échange d'idées constitue une autre contribution essentielle qui doit être filtrée et infiltrée dans la société.

Les compétences des imprimeurs et des fabricants de papier deviennent plus précieuses à l'heure où une simple pression sur une touche de clavier permet de transmettre les informations par voie numérique. L'impression est un procédé physique dont j'adore les imperfections quand on le pousse

 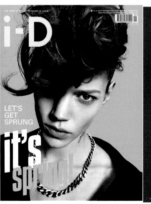 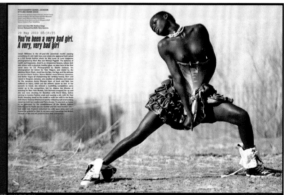

The skills of printers and paper makers become more valuable as the press of a button on a keyboard can now transmit digital information. Print is a physical process and I love the imperfections that come when the process is stretched to extreme tolerance. I often like to test technicians' skills to the max. Print, I believe, will have a renaissance for collectors, like modern music makers who are rediscovering the precious qualities of analogue equipment and 12-inch vinyl. Digital allows us an alien perfection that airbrushes reality to give an illusion that photography always alludes to. At 'Vogue' we had three full-time re-touchers, slimming and smoothing, to keep the truth a secret. We don't get any younger, except surgically or digitally. Today every photographer knows how to cheat reality and artistically relies on the skill of lights, technology and the modern machines that take the image from the camera to the page. Using the technological possibilities of the future to support the ideas that can be collected into physical print is still the desire.

Das Können von Druckern und Papierherstellern ist heute mehr denn je gefragt, wo man nun durch ein paar Klicks auf einer Computertastatur digitale Informationen übertragen kann. Drucken ist ein physischer Prozess, und ich liebe die kleinen Fehler, zu denen es kommt, wenn der Prozess bis an seine Grenzen getrieben wird. Es macht mir oft Spaß, die Fähigkeiten der Techniker maximal zu beanspruchen. Ich bin sicher, dass Gedrucktes eine Renaissance bei Sammlern erleben wird, genau wie moderne Musikproduzenten die unschätzbaren Qualitäten von analogem Equipment und 12-Inch-Vinyl wiederentdecken. Digitalisierung erlaubt uns eine unirdische Perfektion, die die Realität dermaßen schönt, dass die Perfektion erreicht wird, die die Fotografie immer anstrebt. Bei Vogue hatten wir drei Vollzeitretuscheure, die verschlankten und glätteten, um die Wahrheit zu verschleiern. Es gibt keine ewige Jugend, es sei denn digital oder chirurgisch. Heute weiß jeder Fotograf, wie er die Realität austrickst und bedient sich künstlerischer Mittel wie Licht, Technologie, und moderner Maschinen, die das Bild von der Kamera auf die Seite bringen. Die technologischen Möglichkeiten der Zukunft zu nutzen, um die Ideen zu unterstützen, die in das materielle Druckerzeugnis eingehen, treibt uns immer noch an.

jusqu'à ses dernières limites. J'aime souvent éprouver les compétences des techniciens. Je crois que le support imprimé va vivre une renaissance auprès des collectionneurs, à l'instar des musiciens d'aujourd'hui qui redécouvrent les qualités inestimables du matériel analogique et du disque vinyle. Le numérique nous apporte une perfection d'un autre monde qui repeint la réalité pour créer une illusion à laquelle la photographie n'a toujours fait qu'allusion. Chez Vogue, nous avions trois retoucheurs photo à temps plein, pour amincir les corps et lisser les rides, pour que la vérité reste un secret. On ne rajeunit pas, sauf par voie chirurgicale ou numérique. Aujourd'hui, le moindre photographe sait comment tromper le réel et s'appuie artistiquement sur l'éclairage, la technologie et les machines modernes pour transférer directement l'image de l'appareil photo à la page. Le désir reste pourtant le même : se servir des possibilités technologiques du futur pour défendre des idées recueillies sur un support imprimé physique.

Graphiquement, j'essaie de créer une image à partir de la vie, et capturer l'énergie de cet instant, c'est obtenir un résultat. Je pense qu'il ne faut rien prendre trop au sérieux ; l'irrévérence est saine et rares sont les choses sacrées. J'ai toujours aimé le contraste visuel

I try to create an image with life graphically, and to capture the energy of that moment is to get a result. I don't believe in taking anything too seriously, irreverence is healthy and few things are sacred. I have always liked the visual contrast that illustrative type could add to the cover and pages inside so the graphic toolbox in my Instant Design studio was developed from the concept: how to D.I.Y. on no budget. Everything at the start of i-D was handmade. Prints were made in the basement darkroom and cut by scalpel or torn by hand (much to the dismay of some photographers). Handmade separations, mis-registration, colour manipulation, blurring and other distortions were all chaotically controlled. Graphic design should have a look of immediacy and speed. I am sure the next wave of gadgets will widen the possibilities of distributing and receiving communication.
What began for me 30 years ago — as a diversion to commercial layout work — is now a business, but the magazine's original concept to be an alternative voice to people with new ideas and innovative views stays constant. Time

Ich versuche, grafisch ein lebendiges Bild zu schaffen, und wenn ich die Energie dieses Moments einfange, habe ich, was ich wollte. Ich halte nichts davon, Dinge allzu ernst zu nehmen, Respektlosigkeit ist gesund, und nur weniges ist heilig. Ich mag den visuellen Kontrast, den eine illustrative Typographie dem Titelbild und den Seiten im Heft hinzufügen kann, darum folgte das grafische Instrumentarium in meinem Studio International Design dem Konzept: Selbermachen kostet nichts.
In den Anfängen von i-D war alles handgemacht. Die Abzüge machten wir in der Dunkelkammer im Keller und zerschnitten sie mit Skalpellen oder zerrissen sie einfach (zur Verzweiflung vieler Fotografen). Farbauszüge, Fehldrucke, Farbmanipulationen, Unschärfe und andere Verzerrungen waren alle chaotisch-kontrolliert. Grafikdesign sollte nach Unmittelbarkeit und Schnelligkeit aussehen. Ich bin mir sicher, die nächste Generation technischer Spielereien wird die Möglichkeiten der Verbreitung und dem Erhalt von Informationen erweitern.
Was für mich vor 30 Jahren als kleine Abwechslung von meinen kommerziellen Layoutjobs begann, ist heute eine Firma, aber unsere ursprüngliche Idee, Leuten mit neuen Ideen und innovativen Sichtweisen ein alternatives Forum zu bieten, ist gleich geblieben. Zeit und

que la typographie illustrative peut apporter à la couverture et aux pages intérieures. Voilà pourquoi les outils graphiques de mon studio Instant Design ont été conçus à partir du concept « comment faire les choses soi-même sans aucun budget ». Aux débuts d'i-D, tout était fait main. Les photos étaient développées dans ma chambre noire à la cave, découpées au scalpel ou déchirées à la main (au grand désarroi de certains photographes). Les séparations manuelles, les erreurs de mise en page, la manipulation des couleurs, les flous et autres distorsions étaient tous contrôlés de manière chaotique. Le graphisme doit donner un sentiment d'immédiateté et de rapidité. Je suis sûr que la prochaine génération de gadgets étendra les possibilités de diffusion et de réception de la communication.
Ce qui a commencé pour moi voilà 30 ans – pour me distraire d'un travail de mise en page commerciale – est aujourd'hui une véritable entreprise, mais le concept original du magazine n'a pas changé : offrir une voix alternative pour les gens aux idées inédites et aux opinions innovantes. Le temps et l'histoire diront ce que nous avons accompli, mais je suis fier qu'i-D ait toujours exprimé ce que nous sommes, ce que nous aimons et où nous allons en tant que culture. Les couvertures d'i-D ont toujours

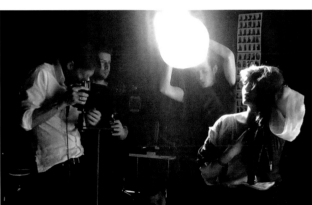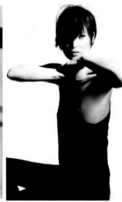

and history will look back at what we've accomplished, but I am proud that i-D has always expressed who we are, what we like and where we are going as a culture. i-D covers have always aimed to catch the visual graphic that tags the brain in an instant with a wink showing 'I am alive'. The most important point about i-D, or any magazine for that matter, is that it is a mirror of its time. I believe i-D is always progressing, evolving and looking into the future. As each issue closes, that end always marks a new beginning. Embracing the future without fear is always the next challenge.

Every end at i-D is just the start of a new beginning.

Geschichte werden erweisen, was wir erreicht haben, aber ich bin stolz darauf, dass i-D immer zum Ausdruck gebracht hat, wer wir sind, was wir mögen, und wo wir uns als Kultur hinbewegen. i-D-Covern ist es immer gelungen, die visuelle Grafik zu erwischen, die dem Gehirn mit einem Augenzwinkern blitzschnell zeigt: „Ich lebe". Das Entscheidende an i-D, wie eigentlich an jedem Magazin, ist, ein Spiegel seiner Zeit zu sein. Ich glaube, i-D wird sich weiter fortentwickeln und in die Zukunft orientieren. Immer, wenn eine Ausgabe abgeschlossen ist, markiert das Ende einen neuen Anfang. Sich ohne Furcht auf die Zukunft einzulassen, ist immer die nächste Herausforderung.

Bei i-D ist jedes Ende nur der Anfang eines Neubeginns.

cherché à saisir le graphisme visuel qui s'imprime en un instant dans le cerveau, avec un clin d'œil prouvant que « je suis vivant ». La chose la plus importante pour i-D, ou tout magazine à cet égard, c'est d'être le miroir de son temps. Je pense qu'i-D ne cesse de progresser, d'évoluer et de regarder vers l'avenir. Le bouclage d'un numéro marque à chaque fois un nouveau départ. Etreindre le futur sans en avoir peur, c'est toujours le prochain défi.

Chaque bouclage d'i-D n'annonce qu'un nouveau départ.

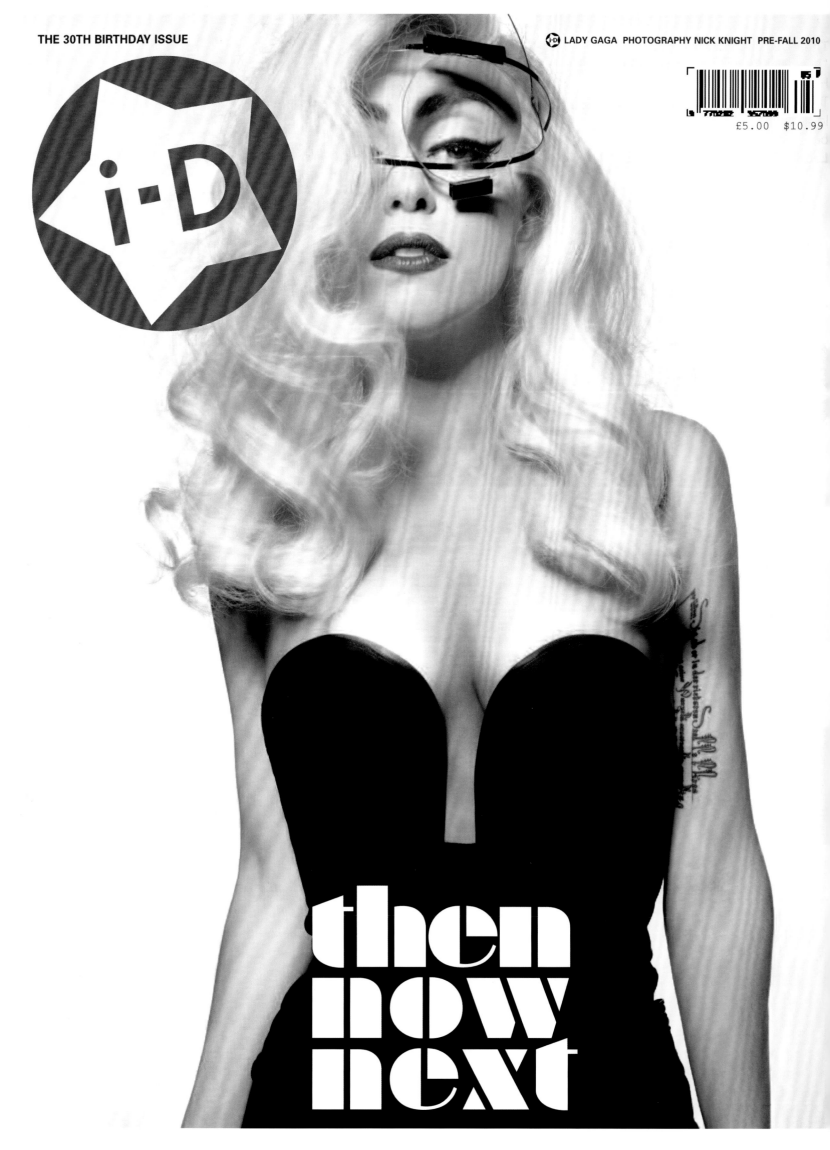

£5.00 $10.99

then now next

The 30th Birthday Issue, No.308, Pre-Fall 2010
"Nick Knight is our Andy Warhol. I think he is the great artist of our time.
He embraces technology, fashion, photography, video, art, sculpture.
There isnt a medium that Nick Knight has not mastered. He's the most
lovely person who is so full of life and love and creativity and endless,
boundless passion."
Lady Gaga

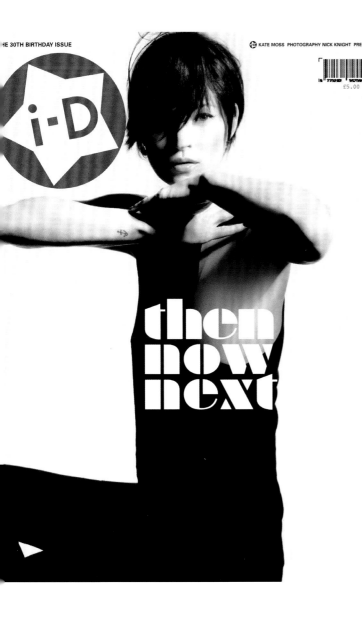

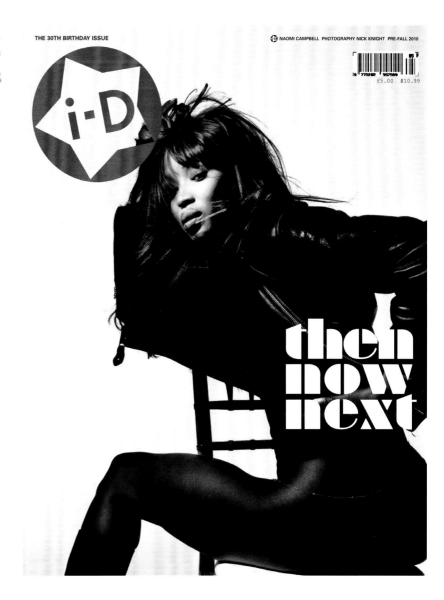

"It's difficult for me to pick an absolute favourite. I always find that within a year there's a new favourite. I love the graphic strength of the Jessica Stam cover [The New Dawn Issue, No. 247, September 2004]. I love the Kate Moss and David Sims cover [The Survival Issue, No. 149, February 1996] and I love Matt Jones's Chloe Sevigny cover [The Dynamic Issue, No. 194, January / February 2000]. I also love a lot of the early graphic covers, in particular the Scarlett/True Brit cover, Judy Blame's collage and the smiley wink that Stephen Male did... there's just so many..." Over the years I have had the privilege to work with many talented photographers at the start of their careers and they and the cover stars have created the ingredients that make each cover artwork.

Terry Jones, i-D Founder

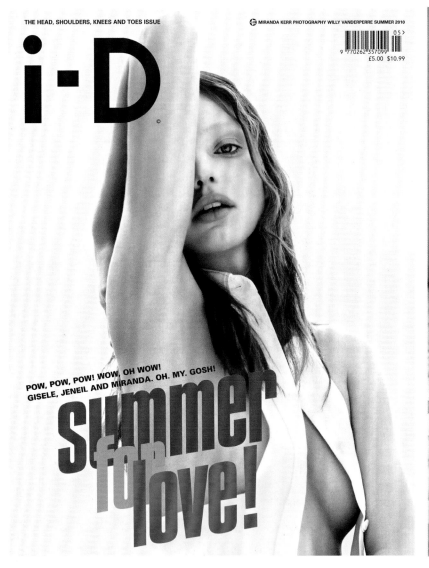 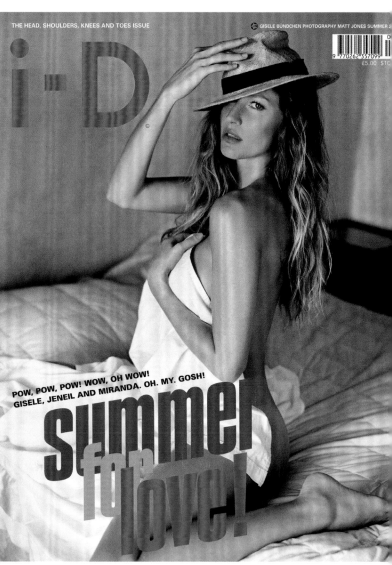

"I believe in the next generation, I believe in youth. I'm obsessed with street fashion, it's how I started, reporting from the streets. The fashion industry will not progress unless we find the new, so I always work with a few young photographers and designers..."

Edward Enninful, i-D Fashion Director

The Head, Shoulders, Knees and Toes Issue, No. 307, Summer 2010
"It was a surprise because we were just doing an editorial and the team suggested a cover try. When they finally said they were going to do it, I was like "Yes!" Adrian said, "Elly, you need to practice your wink!" So I was practicing my wink for days during fashion week. Every time they had a camera on me I was, like "jigga jigga ha..." (winks) trying to do something just to practice and get it. Finally we did it and it was amazing."
Jeneil Williams, Cover Star

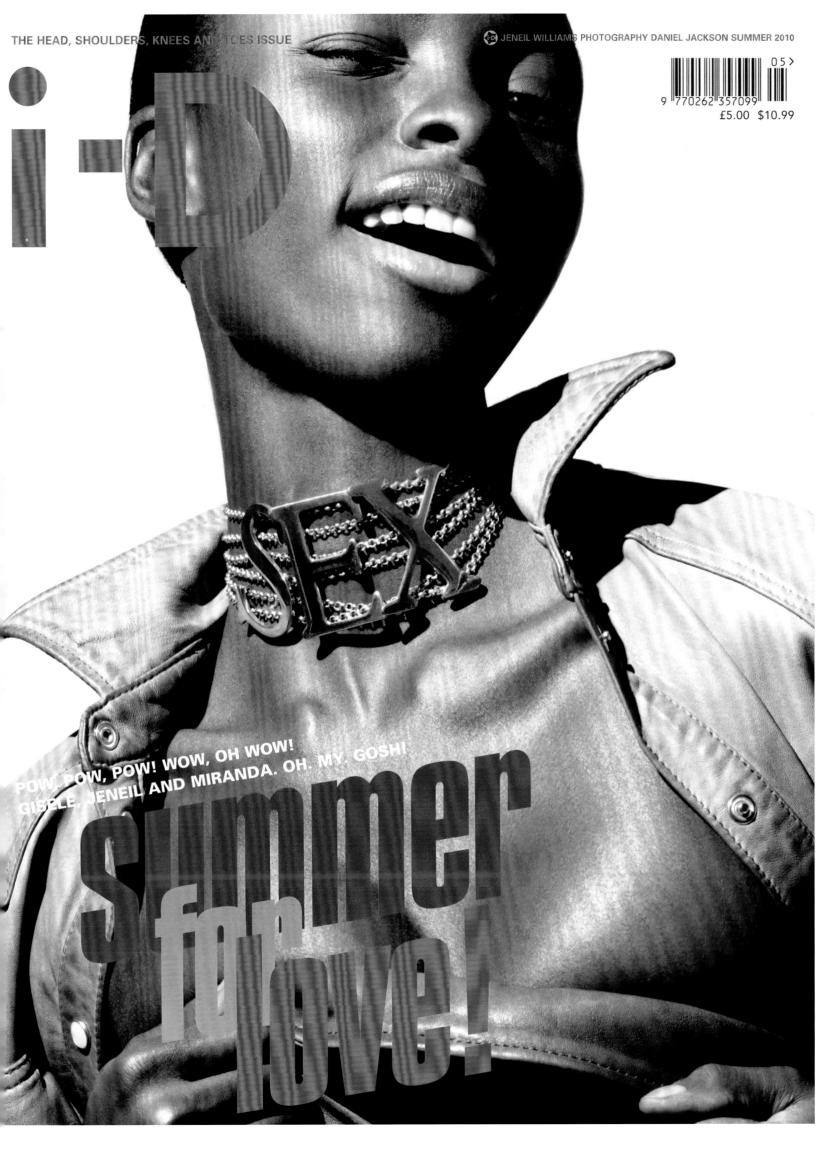

JENEIL WILLIAMS PHOTOGRAPHY DANIEL JACKSON SUMMER 2010

i-D

9 770262 357099
05 >
£5.00 $10.99

POW, POW, POW! WOW, OH WOW!
GISELE, JENEIL AND MIRANDA. OH. MY. GOSH!

Summer for love!

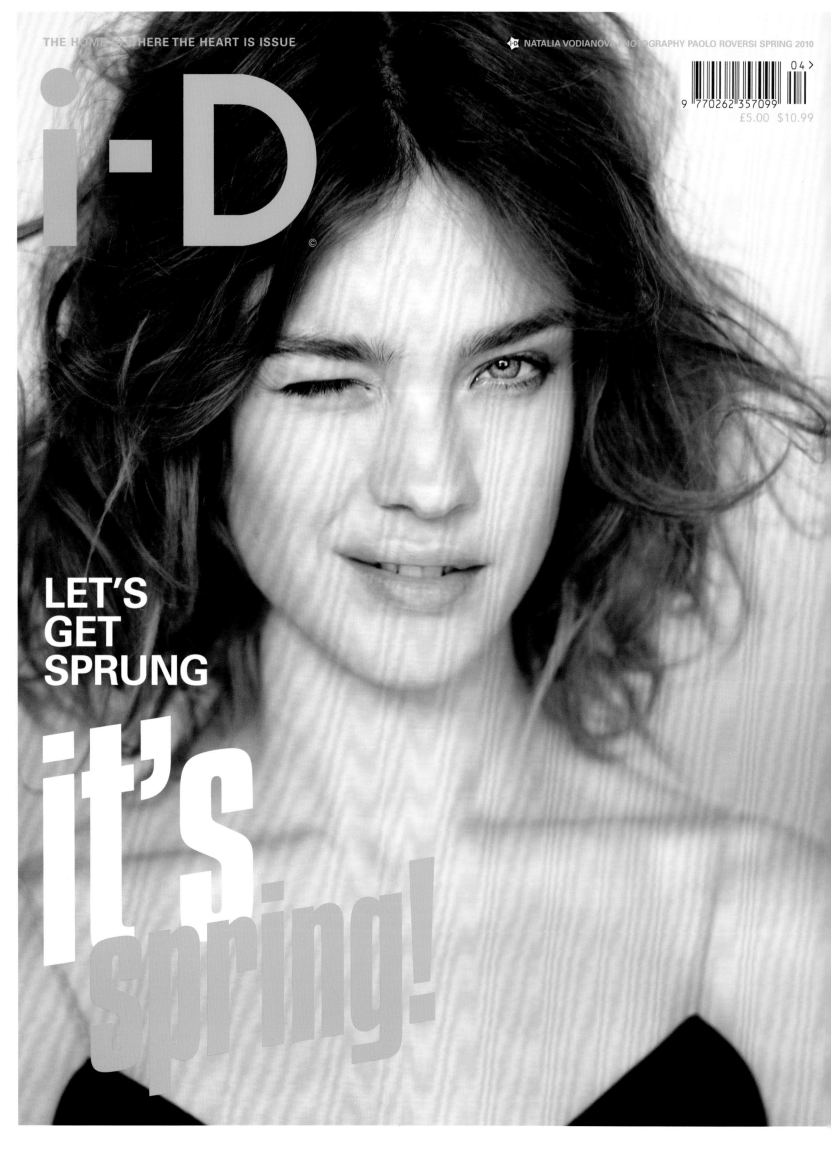

THE HOME IS WHERE THE HEART IS ISSUE

NATALIA VODIANOVA PHOTOGRAPHY PAOLO ROVERSI SPRING 2010

04

9 770262 357099

£5.00 $10.99

i-D

LET'S
GET
SPRUNG

it's spring!

"I was really thrown in the deep end at i-D. It was a question of sink or swim. I was painfully shy when I started so it was an amazing growing experience. I remember sitting with Corinne Day and all of these people, having to act like a grown up but really being a child, having just left school... Looking back on that now, I realise how young I really was. I remember the fear every night, the fear of failure or the fear that things were not going to work out. The nice thing is when you are doing something at that age people are really rooting for you. There were a lot of photographers behind me, along with Terry and Tricia Jones from i-D. I was able to make mistakes and learn from them, whereas I don't think people are able to do that now..."

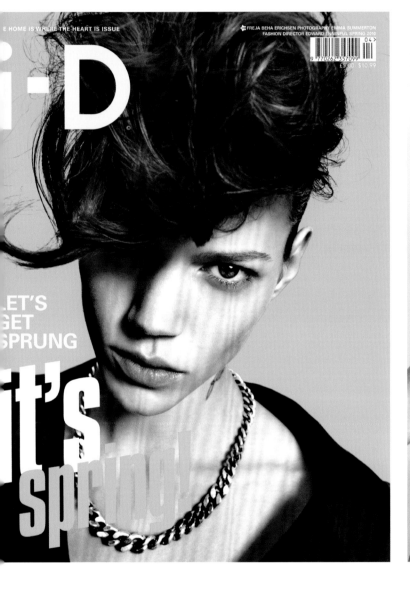

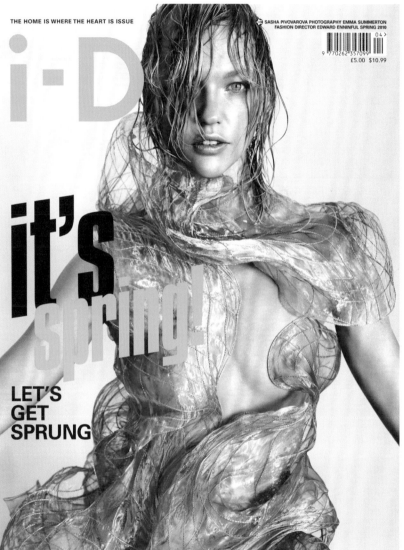

Terry Jones in conversation with Emma Summerton

Terry: How did your photographic career start?

Emma: By accident actually. I moved out of home when I was sixteen and worked as a hairdressing apprentice but had to leave because I was allergic to everything. I was then a waitress before I decided I wanted to do something creative and studied Fine Art in Sydney at the National Art School. I fell into photography. It was pretty basic – 35mm, black and white, darkroom; nothing super technical, just very art based. When I graduated I blagged my way into assisting a fashion photographer, despite never having put fashion and photography together. I went for an interview with the photographer and I didn't realise what he did, but he shot for 'Vogue' Australia.

What was his name?

Tony Notarberardino. He became my boyfriend. I was his first assistant for six years, full time. He is technically amazing. I learned everything I know in that time. The interview I had with him was quite funny because I thought, "Oh no, I've blagged my way this far and now they're going to ask me technical questions and I don't know anything. Instead he asked me what magazines I read and I said, "I don't read magazines." I'd never seen i-D, I'd

never seen Italian 'Vogue', I wasn't in that world. I was more into still life and portrait photography. When I started working with Tony, I realised that it was possible to be creative and make a living at the same time. It was like a revelation. Then, when I saw magazines that came out of Europe and England, I realised there was this whole other level of photography that I didn't even have a clue about. When it came time for me to stop assisting and start shooting, I packed everything up and moved to London.

Where was your work first published?
I shot five portraits for Australian 'Vogue' before I left. Then my first published work was for 'Nylon' in New York.

How did you start with i-D?
My career with i-D started with Edward Enninful, my guardian angel. I joined Edward's sister Akua's photographic agency. Akua liked my work and showed it to Edward who also liked it. Our first shoot for i-D was in Prague with Lily Cole. We had a wonderful time and took some great pictures.

What was your first cover for i-D?
I've got a really terrible memory but I think it was Gemma Ward [The Offspring Issue, No. 280, September 2007]. We shot Gemma in New York and we shot the cover right at the end of two days shooting at the Chelsea Hotel. We shot her on the rooftop and in a bedroom and it was great.

Did she have any problem winking?
No, she was a great winker. It's always the first question you ask the girls, "Come on then, show me your wink. Have you been practising?" Gemma was a really good winker.

Both being Australian, were you able to crack a joke?
Yes, I guess so. We share that laidback attitude and understanding of each other's humour. It was a really special moment because she hadn't done an i-D cover before, so for both of us it was really important. We were both really excited. Gemma was really blossoming into a woman and wanted to make it sexy, beautiful and innocent at the same time. I went and grabbed the flowers from Tony's apartment because he lives in Chelsea. I just put them over her head and she transformed into this beautiful, blooming, gorgeous creature. I think she was very excited and really happy to be doing it.

Do you have any other favourite cover moments?
Shooting Kate Moss for the cover of The !*#? Issue [No. 282, November 2007] is one of my favourites.

What was it like shooting Kate?
Amazing, she goes into character and her own little world and is really there for you and really there for the picture. For this shoot, Sam McKnight put that amazing fringed blonde wig on her.

Did she play dizzy?
Not really, she's almost in her own universe. It must be weird to be Kate, with all eyes on you and so much attention. I would go crazy. I don't know how she does it... although doesn't she have a famous saying like, 'Never complain, never explain'? And it's true; she goes into the moment and goes into the pictures and really gives it everything and has no inhibitions and no vanity, which is quite amazing considering who she is and what she does. But, she'll go anywhere for the picture, so I can only think that it's no vanity because that's what makes us closed off to the moment, but she's very in it, so it was great.

What was it like shooting Lily Donaldson and Gemma Ward for the cover of The Boyz II Men Issue [No. 284, February 2008]?
Edward and I were shooting them for Italian 'Vogue' in 29 Palms and in between we shot this cover in Edward's room, which was great. It's always fantastic to find yourself in a random situation shooting an i-D cover. They're really sweet girls and I think they're really good friends. Then there was the Raquel Zimmerman cover [The Who's That Girl Issue, No. 285, March 2008], which we shot around the same time in a theatre in LA.

How did you feel about KAWS drawing over your cover [The Stepping Stone Issue, No. 289, July 2008]?
The KAWS incident. That's right, we shot Sasha Pivovarova around the same time. We stopped at a drive-in somewhere between 29 Palms and LA and shot Sasha in Comme des Garçons. I wasn't happy with KAWS drawing a big bubble over Sasha's head.

What did you think about the final outcome?
The final outcome was fantastic. It was really cute. I just didn't like not being able to see Sasha's face.

What other models do you enjoy working with?
Freja Beha is amazing. She's really incredible, calm, interesting and just totally great in front of the camera. For The Home Is Where The Heart Is Issue [No. 306, Spring 2010] we styled her in four different characters, and it's quite amazing how she transformed from being boyish and quite tough to really pretty and girly. We did two cover tries with her, one where she looks like a boy with a quiff and one where she's this sexy summer girl with loose curly hair. She's quite a chameleon. Then we did Sasha. We'd been shooting Sasha for Italian 'Vogue' for a couple of days and decided to do a cover try for i-D on her and she was great. She's quite a quiet, strange creature, quite a mysterious one. I can't work her out. I don't know how to explain Sasha; she's from another planet maybe.

Where did she grow up?
She's Russian. Her English is pretty good though. She's an artist and she does a lot of drawing. She just did a fairytale book with Karl Lagerfeld that she illustrated. She's quite an interesting girl. I think there's this whole other side to her that's a creator and modelling is something that happened by accident. At some point I think she'll become a total artist and live this bohemian, creative existence and not have to be someone else's muse; she'll just do her own thing. I think these girls travel a lot and work really hard and I think it can probably get to the point where you're giving so much and you're moving around so much that you have to give something back to yourself. I don't know how they do it.

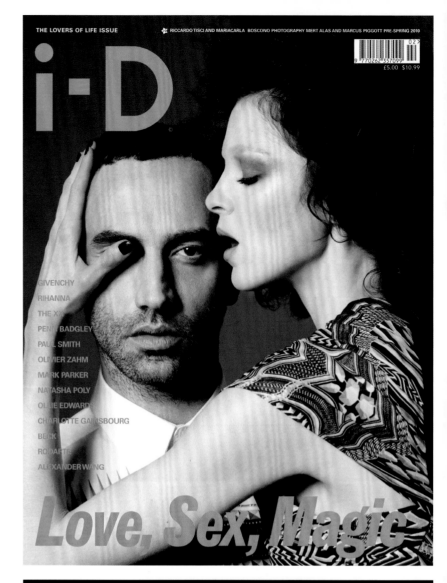

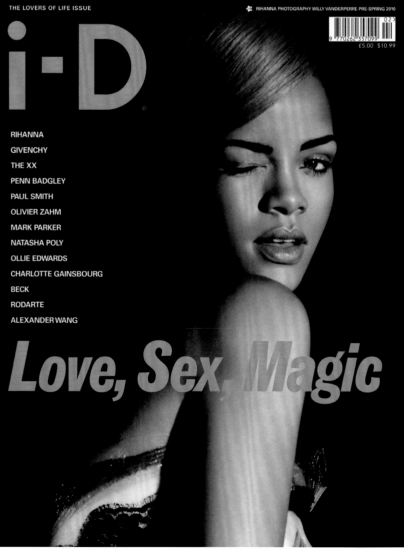

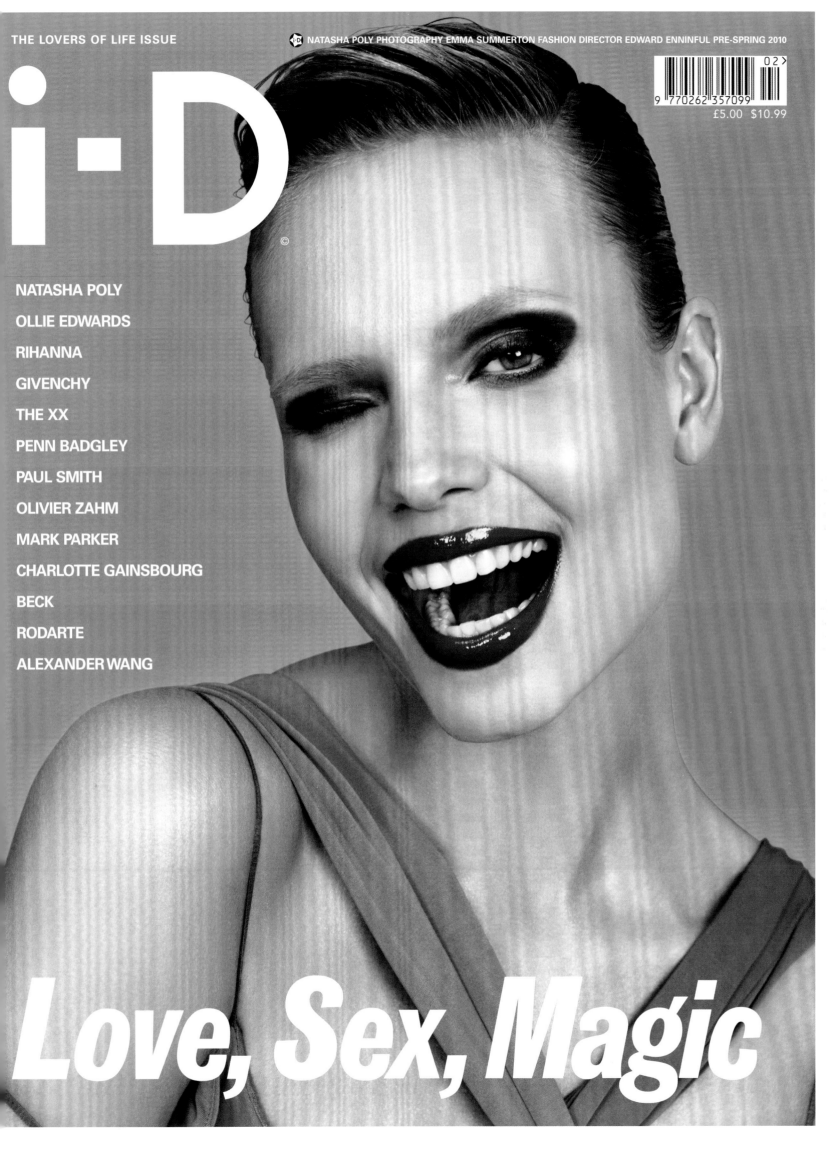

i-D

NATASHA POLY

OLLIE EDWARDS

RIHANNA

GIVENCHY

THE XX

PENN BADGLEY

PAUL SMITH

OLIVIER ZAHM

MARK PARKER

CHARLOTTE GAINSBOURG

BECK

RODARTE

ALEXANDER WANG

Love, Sex, Magic

i-D

SUPER
NATURE

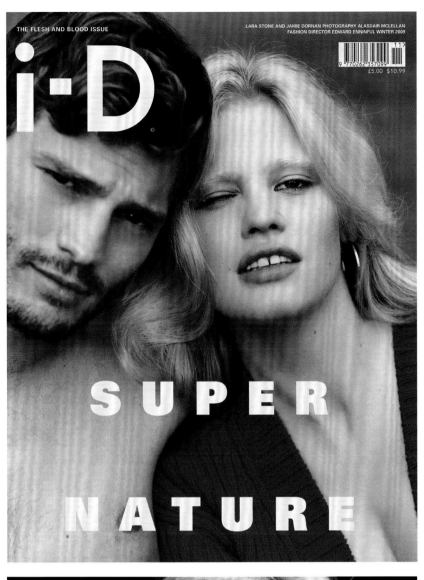

The Flesh and Blood Issue, No. 304, Winter 2009
"These models are totally unbeatable. They were supermodels when I was growing up. They are all mothers and incredibly professional and at the top of their game, flying in from everywhere to make the shoot happen. The fact that they agreed to do this together was like a dream come true for me. The shoot was so much fun because they were practically like sisters with each other. Plus I have shot Claudia several times and adore her."
Kayt Jones, Photographer and i-D LA Editor

The Flesh and Blood Issue No. 304, Winter 2010
"When I shoot a cover for i-D, I always like to do something very fresh and very natural, like the picture I shot of Georgia Jagger for the Winter 2009 Flesh and Blood Issue. The first cover I did for i-D was Kirsten Owen for The Anarchy Issue [No. 82, July 1990]. She was not winking, she was almost crying and it was a special cover. I'm very happy with my Natalia Vodianova cover [The Home is Where the Heart is Issue] because I think that Natalia looks like a really young, young girl. She is a young girl, but she is a mother with three children, but she looks like a child herself, and I like that."
Paolo Roversi, Photographer

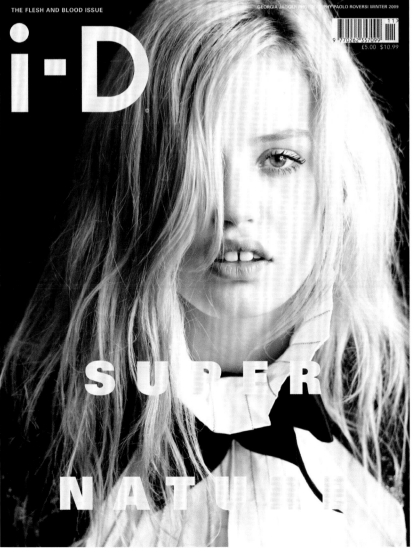

The Inside/Outside Issue, No. 303, Fall 2009
"In 1585, the word 'wink' was defined as "a very brief moment in time" and the subsequent nineteenth century invention of the camera helped mechanise the capture of those moments forever. This cover photograph is the visual equivalent of a three minute single – Tim Walker took this photo at the very end of the day, it was a now or never moment – the last roll of film, the last daylight, the last outfit. I was wearing a Richard Nicoll dress that had a Linder photomontage printed head to toe, you can see another woman's face on the dress, captured in her brief moment forty years ago. Her body becomes my body every time I wear the dress.
When I make photomontages, I sometimes realise that hours have slipped by and all I have succeeded in achieving is to substitute one cut out flower for another, each discarded with equal dissatisfaction.
I wonder then, what is the point of what I do? Rose is a rose is a rose, as Gertrude Stein said. For this cover, in the true spirit of 1976, the mouth and the flower fell into place almost immediately, without hesitation or undue consideration. The rose and the cut out mouth found their places within Tim's portrait of me and my glue stick positioned the ephemeral elements permanently in situ.
Some butterflies are guilty of auto-mimicry for their survival. Their wings can look like owl eyes when viewed from below or their blue wings mimic the skies through which they fly. This serves the survival of both the model and the mimic. In the twenty-first century, I lose track of who the models are and what the mimics are, although the survival of the fittest seems as brutal as ever. On the evening before this cover shot was taken, the future of i-D magazine was suddenly in jeopardy – the savage financial recession of 2009 threatened closure. On the day, we all worked for free and worked quickly, shooting within the new economic restraints. i-D magazine was important to me as a young artist, it showed me what a secretary in Hull wore on her day off and how a boy in Wigan tied his shoelaces. National anthropology and auto-mimicry were documented, stapled together and sent out to the provinces – it was a discussion in which we could all join in. Brief moments in British time were captured and disseminated and art historians now, thankfully, have somewhere to look for the history that happened outside the gallery walls in the 1980s.
And happily, as in fairytales, butterflies survive, i-D survives and as the famous lepidopterist Nabokov wrote, about nature and art, "Both were a form of magic, both were a game of intricate enchantment". On we all go together."
Linder Sterling, Artist

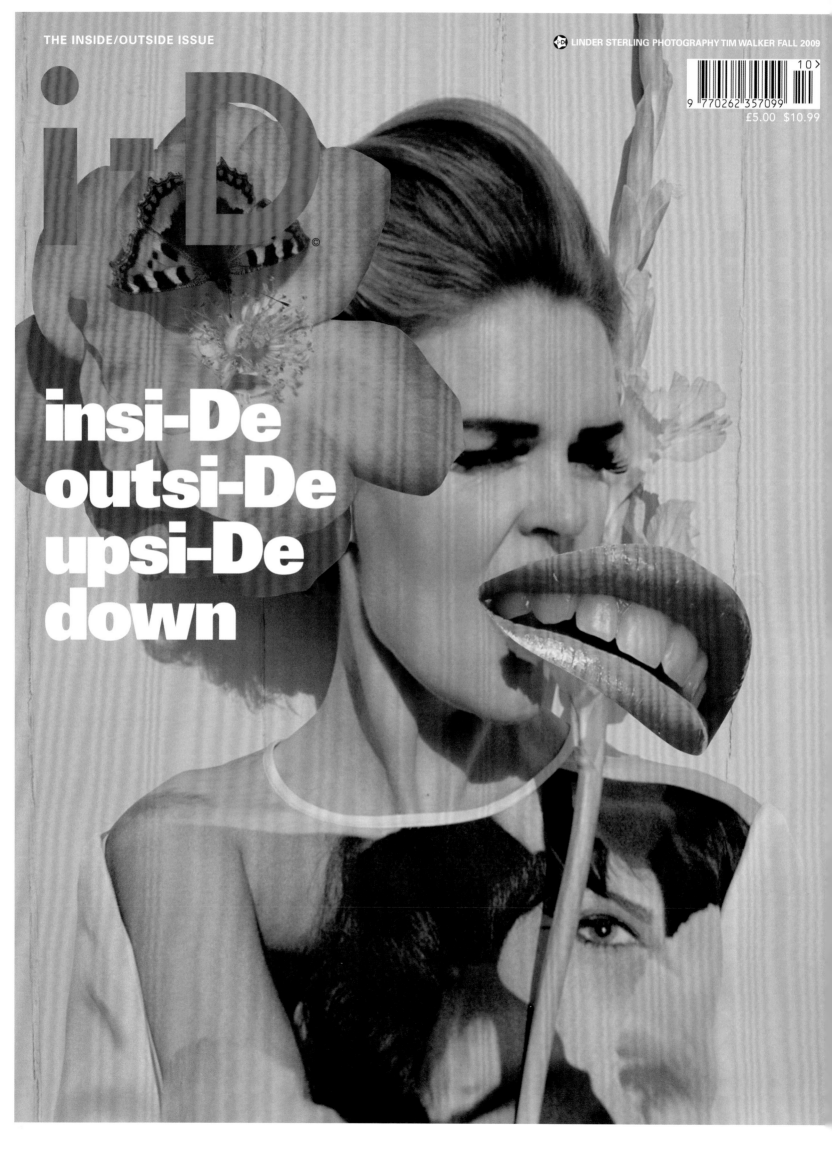

LINDER STERLING PHOTOGRAPHY TIM WALKER FALL 2009

£5.00 $10.99

i-D ©

insi-De
outsi-De
upsi-De
down

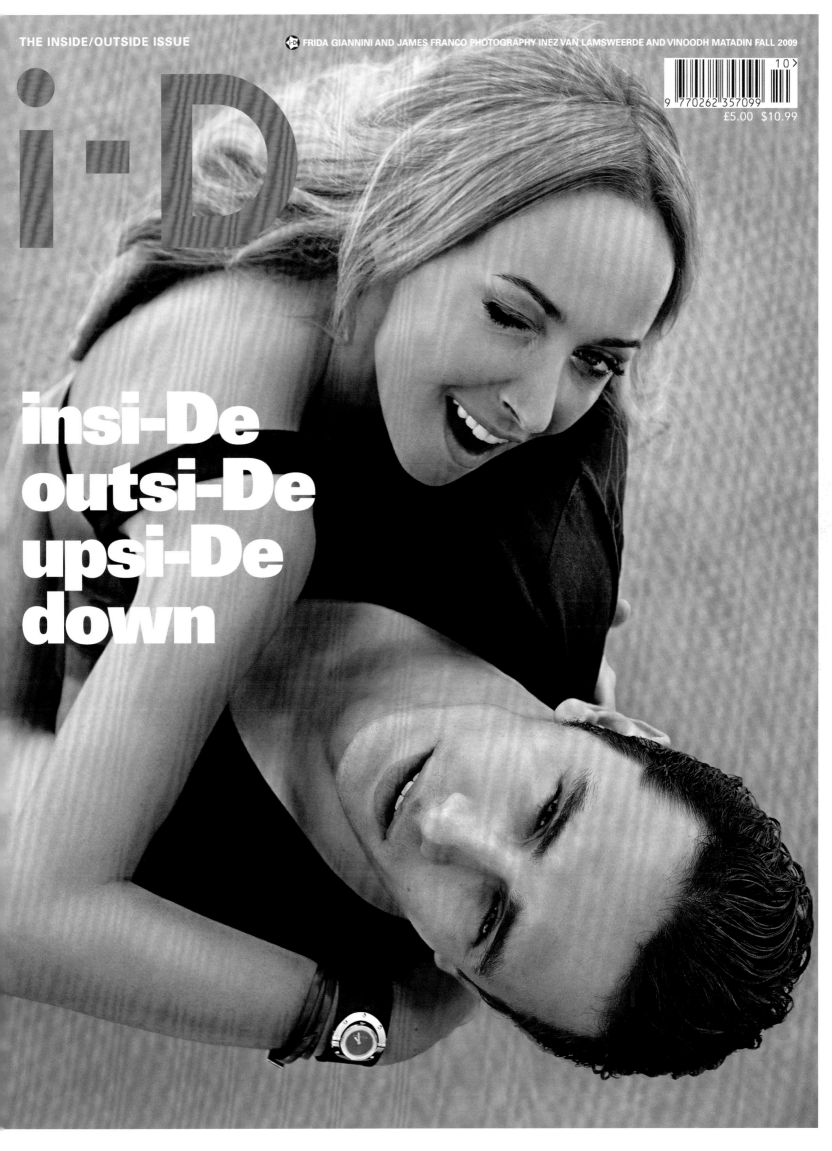

i-D

£5.00 $10.99

insi-De
outsi-De
upsi-De
down

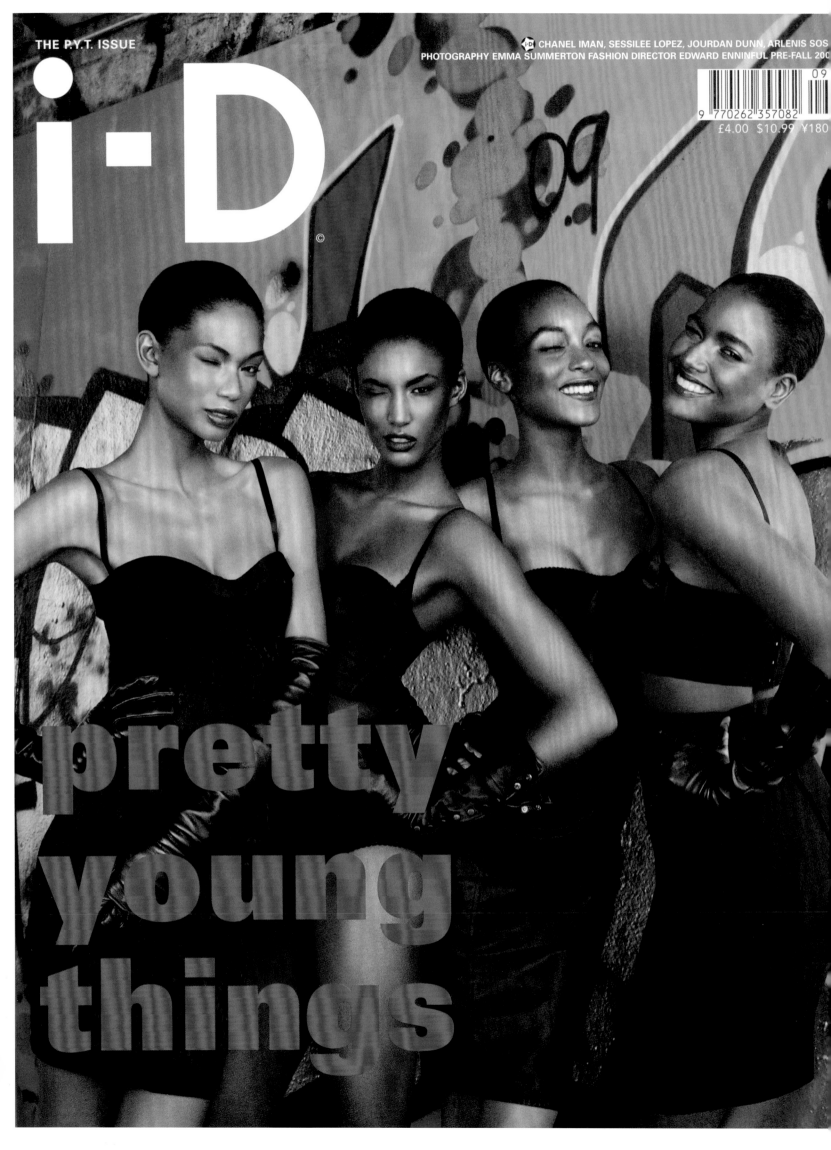

THE P.Y.T. ISSUE

i-D

CHANEL IMAN, SESSILEE LOPEZ, JOURDAN DUNN, ARLENIS SOS
PHOTOGRAPHY EMMA SUMMERTON FASHION DIRECTOR EDWARD ENNINFUL PRE-FALL 200

09

9 770262 357082

£4.00 $10.99 ¥180

pretty
young
things

The Pretty Young Things Issue, No. 302, Fall 2009

"When I shot my i-D cover I had an amazing time with
the girls... It was a day where we were giving our
personalities, energy and love to the story. I also love
working with Edward and Emma. Edward is an amazing
human being who is very professional and cares about
you and your job. Emma; she's so friendly and cool, she
laughs with you, she jumps, she does everything that
you do just to make you feel confident with her. Each
one of the team is aware of how hard the job
sometimes is and yet it is because of them that it can
be simple, easy and fun! You don't have to think too
much about anything – when you have been through the
fun time of the make-up and the hair party that we had
on this shoot – oh God, such a fun time! It's time to
give your best, to give your widest smile, time to
dance, time to be yourself for the camera. That's what
i-D is showing to people in this story... us four girls –
as we are."
Arlenis Sosa, Cover Star

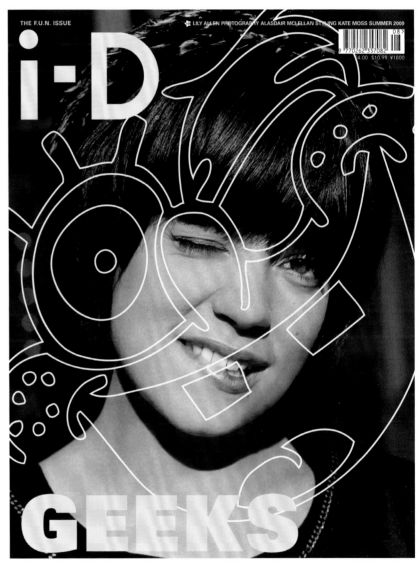

The Pretty Young Things Issue, No. 302, Fall 2009

"Shooting for i-D was such an amazing experience. We
all had so much fun. The entire team worked extremely
hard on the cover. We even shot the cover twice and
worked from 7am to 2am the next day non-stop. It
wasn't like work though, because time truly does fly
when you're having fun! Edward Enninful was the first
stylist ever to let me pick anything I wanted to wear for
the shoot, so of course, I picked the lingerie. It was
important to him that we all felt beautiful and sexy, so
we got a chance to truly show who we are as
individuals. Emma is so cool and easy going! During the
entire shoot, we were like girlfriends who knew each
other forever, just gossiping and laughing. The other
girls were super cool as well. We had just a little too
much fun working, because after having such a great
day, Arlenis and I hurried to our car to get to the
airport for our flight back to New York, but we got
stuck in traffic and missed our plane! How about that?"
Sessilee Lopez, Cover Star

The F.U.N Issue, No. 301, Pre-Fall 2009

"SpongeBob SquarePants is a sponge who lives under
the sea in Bikini Bottom, so the most interesting part of
creating a 6 page fashion feature for i-D was figuring
out how on earth our lovable sea sponge could possibly
end up wearing new season Tom Ford. As a result the
high spec photo real artwork, which was specially
created by the Nickelodeon US creative team, is a true
fashion story. SpongeBob wins the coveted 'Fry Cook of
the Year' Award for his dedication and flair in flipping
Krabbie Patties at the Krusty Krab. For the second time
in his life, SpongeBob enters the spotlight and becomes
a celebrity, spending the day being styled for his debut on
the red carpet. After trying Tom Ford and Marc Jacobs
SpongeBob settles on a sailor theme and wears vintage
Jean Paul Gaultier for his time to shine. A lot of love
and care from both sides of the Atlantic went into the
creation of the four fashion images and the two Sponge-
Bob covers. We're proud to have them on our wall."
Nickelodeon

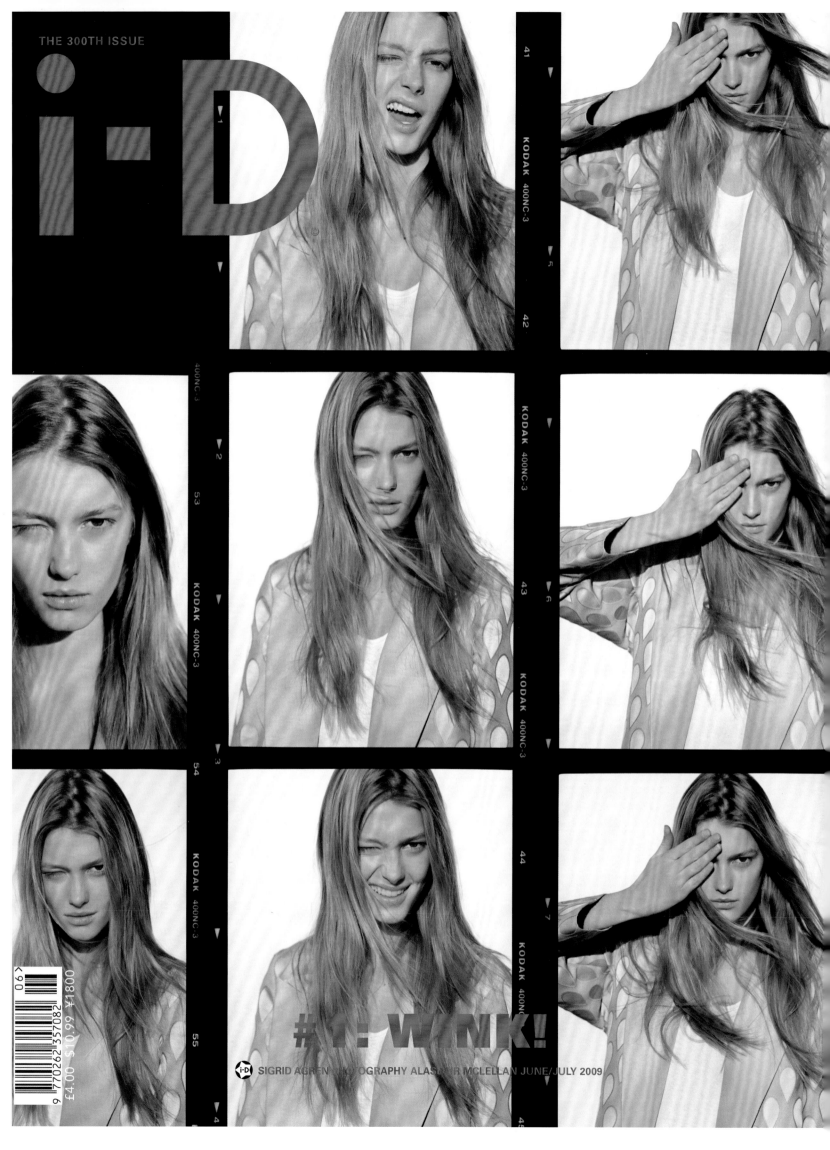

THE 300TH ISSUE

i-D

#1: WINK!

SIGRID AGREN PHOTOGRAPHY ALASDAIR MCLELLAN JUNE/JULY 2009

£4.00 $10.99 ¥1800

9 771262 357082

The 300th Issue, No. 300, June / July 2009
"There were five iconic models in this shoot, each of whom had a very distinct beauty. All agreed to shoot nude and we shot in one day at a studio in LA. We did cover tries for all the girls: Liberty, Devon, Tasha, Jessica and Bridget. We didn't know in advance which would be the cover, and there was just something about Tasha's – plus she was the only girl on the shoot not to have had an i-D cover before. Tasha was very raw and focused – her sexuality and vulnerability made the picture really strong."
Kayt Jones, Photographer and i-D LA Editor

The 300th Issue, No. 300, June / July 2009
"I was so excited and honoured to be included in the 300th issue. i-D had been on my mind a lot, as a good friend of mine, photographer Shawn Mortensen had been trying to set up a shoot for me with i-D for a few months, though scheduling had delayed it. The morning I was to shoot for the 300th issue, I learned of the death of Shawn. I went to work, but kind of dazed and angry and very sad. Kayt was great and I had a great shoot with her but had many mixed emotions – maybe she even captured some of that vulnerability in our pictures. That is one day I'll never forget and I remind myself to attempt to be as spirited as Shawn was and embrace creativity as always. R.I.P Shawn. xx"
Tasha Tilberg, Cover Star

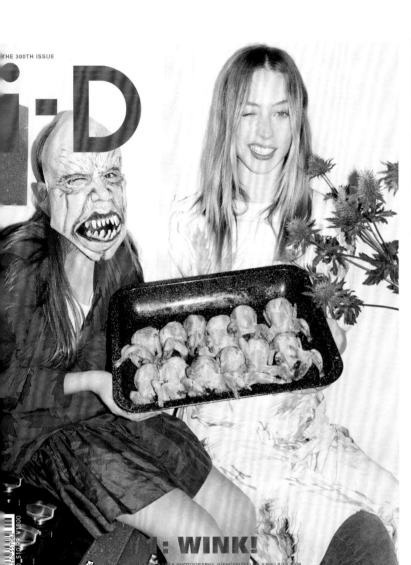

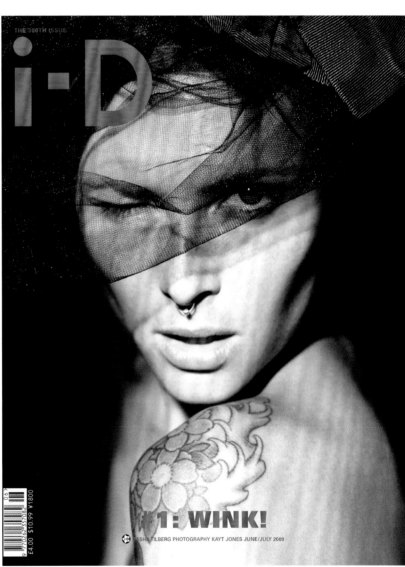

The 300th Issue, No. 300, June / July 2009
"Lovely food, lovely company!"
Raquel Zimmerman, Cover Star

The Resourceful Issue, No. 299, May 2009
"I shot Chanel in New York in 2008 and the vampire craze was just ramping up – there must have been something in the air. I love Chanel and shot her in Karl Lagerfeld's travelling pavilion in Central Park. She had a great energy to match her amazing looks and was super-excited to be doing her first i-D cover."
Kayt Jones, Photographer and i-D LA Editor

i-D

Creating a
fashion
environment
without
skimping on
the sparkle!

D-i-Y

CHANEL IMAN Photography KAYT JONES MAY 2009

£4.00 $10.99 ¥1800

i-D ©

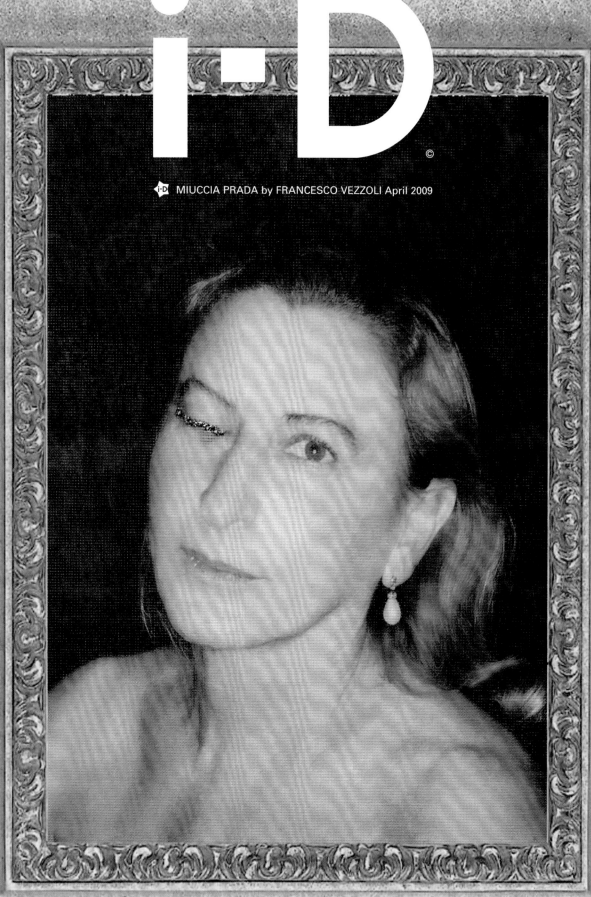

i-D MIUCCIA PRADA by FRANCESCO VEZZOLI April 2009

04 >

£4.00 $10.99 ¥1800

i-D

"i-D all the way, baby!"
— LILY DONALDSON

SPECIAL COLLECTORS ISSUE · 12 FASHION COVERS

FEATURING: KATE MOSS GRACE CODDINGTON NAOMI CAMPBELL AGYNESS DEYN YASMIN LE BON JOURDAN DUNN DAISY LOWE CECILIA CHANCELLOR
ALICE DELLAL LILY DONALDSON STELLA TENNANT ALEK WEK ERIN O'CONNOR SUSIE BICK LILY COLE JENY HOWORTH ELIZA CUMMINGS AND TWIGGY

Cover Star LILY DONALDSON Photography SØLVE SUNDSBØ Fashion Director EDWARD ENNINFUL March 2009

£4.00 $10.99 ¥1800

i-D

"Feel the fear and do it anyway."
— AGYNESS DEYN

SPECIAL COLLECTORS ISSUE · 12 FASHION COVERS

FEATURING: KATE MOSS GRACE CODDINGTON NAOMI CAMPBELL AGYNESS DEYN YASMIN LE BON JOURDAN DUNN DAISY LOWE CECILIA CHANCELLOR
ALICE DELLAL LILY DONALDSON STELLA TENNANT ALEK WEK ERIN O'CONNOR SUSIE BICK LILY COLE JENY HOWORTH ELIZA CUMMINGS AND TWIGGY

Cover Star AGYNESS DEYN Photography SØLVE SUNDSBØ Fashion Director EDWARD ENNINFUL March 2009

£4.00 $10.99 ¥1800

i-D

"I love i-D! It's sooo LONDON!"
— JOURDAN DUNN

SPECIAL COLLECTORS ISSUE · 12 FASHION COVERS

FEATURING: KATE MOSS GRACE CODDINGTON NAOMI CAMPBELL AGYNESS DEYN YASMIN LE BON JOURDAN DUNN DAISY LOWE CECILIA CHANCELLOR
ALICE DELLAL LILY DONALDSON STELLA TENNANT ALEK WEK ERIN O'CONNOR SUSIE BICK LILY COLE JENY HOWORTH ELIZA CUMMINGS AND TWIGGY

Cover Star JOURDAN DUNN Photography SØLVE SUNDSBØ Fashion Director EDWARD ENNINFUL March 2009

£4.00 $10.99 ¥1800

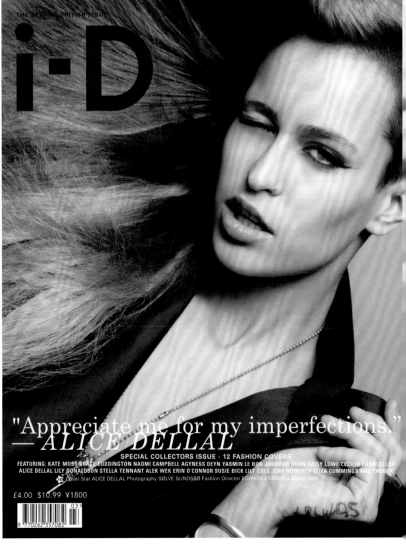

i-D

"Appreciate me for my imperfections."
— ALICE DELLAL

SPECIAL COLLECTORS ISSUE · 12 FASHION COVERS

FEATURING: KATE MOSS GRACE CODDINGTON NAOMI CAMPBELL AGYNESS DEYN YASMIN LE BON JOURDAN DUNN DAISY LOWE CECILIA CHANCELLOR
ALICE DELLAL LILY DONALDSON STELLA TENNANT ALEK WEK ERIN O'CONNOR SUSIE BICK LILY COLE JENY HOWORTH ELIZA CUMMINGS AND TWIGGY

Cover Star ALICE DELLAL Photography SØLVE SUNDSBØ Fashion Director EDWARD ENNINFUL March 2009

£4.00 $10.99 ¥1800

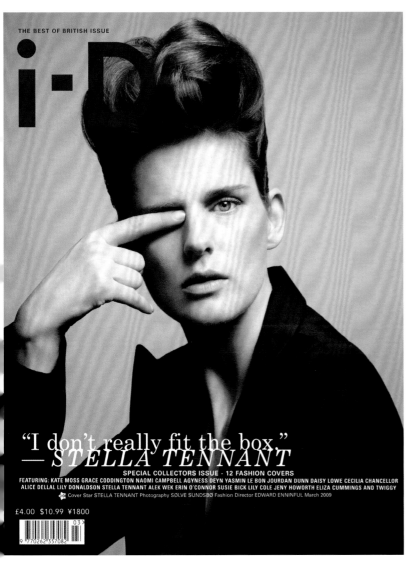

i-D

"I don't really fit the box."
— *STELLA TENNANT*

SPECIAL COLLECTORS ISSUE - 12 FASHION COVERS
FEATURING: KATE MOSS GRACE CODDINGTON NAOMI CAMPBELL AGYNESS DEYN YASMIN LE BON JOURDAN DUNN DAISY LOWE CECILIA CHANCELLOR
ALICE DELLAL LILY DONALDSON STELLA TENNANT ALEK WEK ERIN O'CONNOR SUSIE BICK LILY COLE JENY HOWORTH ELIZA CUMMINGS AND TWIGGY
Cover Star STELLA TENNANT Photography SØLVE SUNDSBØ Fashion Director EDWARD ENNINFUL March 2009

£4.00 $10.99 ¥1800

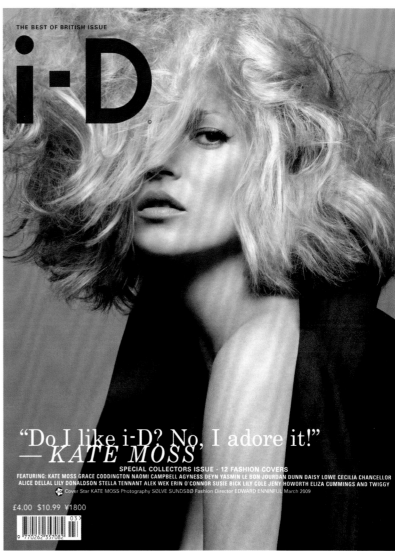

i-D

"Do I like i-D? No, I adore it!"
— *KATE MOSS*

SPECIAL COLLECTORS ISSUE - 12 FASHION COVERS
FEATURING: KATE MOSS GRACE CODDINGTON NAOMI CAMPBELL AGYNESS DEYN YASMIN LE BON JOURDAN DUNN DAISY LOWE CECILIA CHANCELLOR
ALICE DELLAL LILY DONALDSON STELLA TENNANT ALEK WEK ERIN O'CONNOR SUSIE BICK LILY COLE JENY HOWORTH ELIZA CUMMINGS AND TWIGGY
Cover Star KATE MOSS Photography SØLVE SUNDSBØ Fashion Director EDWARD ENNINFUL March 2009

£4.00 $10.99 ¥1800

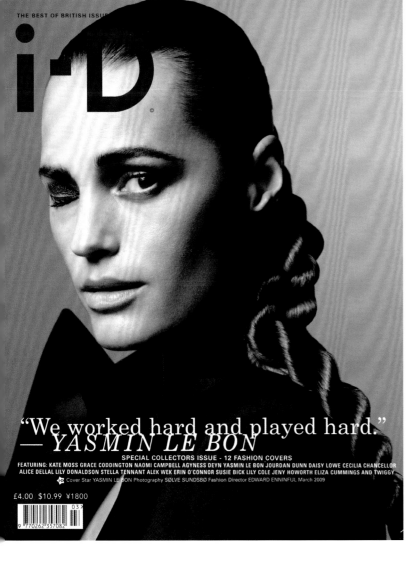

i-D

"We worked hard and played hard."
— *YASMIN LE BON*

SPECIAL COLLECTORS ISSUE - 12 FASHION COVERS
FEATURING: KATE MOSS GRACE CODDINGTON NAOMI CAMPBELL AGYNESS DEYN YASMIN LE BON JOURDAN DUNN DAISY LOWE CECILIA CHANCELLOR
ALICE DELLAL LILY DONALDSON STELLA TENNANT ALEK WEK ERIN O'CONNOR SUSIE BICK LILY COLE JENY HOWORTH ELIZA CUMMINGS AND TWIGGY
Cover Star YASMIN LE BON Photography SØLVE SUNDSBØ Fashion Director EDWARD ENNINFUL March 2009

£4.00 $10.99 ¥1800

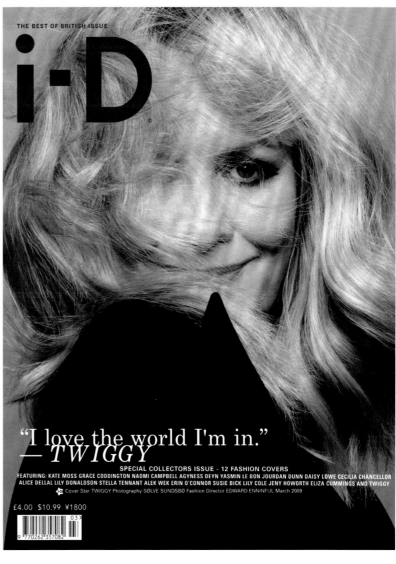

i-D

"I love the world I'm in."
— *TWIGGY*

SPECIAL COLLECTORS ISSUE - 12 FASHION COVERS
FEATURING: KATE MOSS GRACE CODDINGTON NAOMI CAMPBELL AGYNESS DEYN YASMIN LE BON JOURDAN DUNN DAISY LOWE CECILIA CHANCELLOR
ALICE DELLAL LILY DONALDSON STELLA TENNANT ALEK WEK ERIN O'CONNOR SUSIE BICK LILY COLE JENY HOWORTH ELIZA CUMMINGS AND TWIGGY
Cover Star TWIGGY Photography SØLVE SUNDSBØ Fashion Director EDWARD ENNINFUL March 2009

£4.00 $10.99 ¥1800

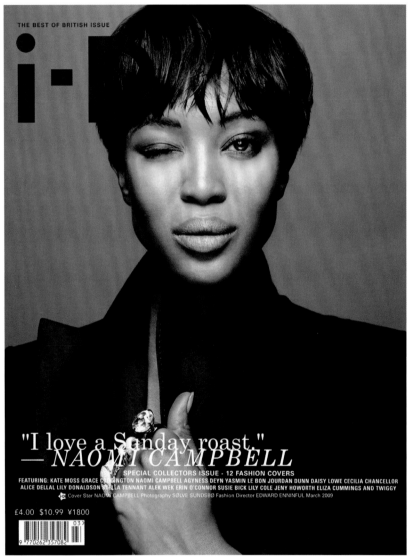

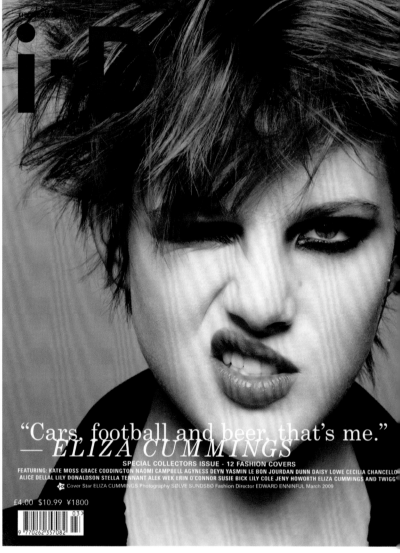

The Best of British Issue, No. 297, March 2009
"This was shot at 5am with Sølve Sundsbø and Edward Enninful in New York. I was ill with the flu, but we did it. I didn't want to let Edward down. We shot from 11pm till 5.30am, then I got on a flight to London straight after! Edward is so special and when he has a vision you will do anything to accommodate him. I've worked with him so many times and no two shoots look the same. I absolutely love working with him, and Terry Jones for giving photographers and stylists a platform to grow and the artistic freedom to express themselves. He is groundbreaking."
Naomi Campbell, Cover Star

The Best of British Issue, No. 297, March 2009
"It was fucking great, I loved shooting the cover, I love i-D and I love Edward Enninful!"
Eliza Cummings, Cover Star

The Best of British Issue, No. 297, March 2009
"I left modeling ten years ago so that I could concentrate on raising my twin boys and spend time waiting for my rock star husband to come back from tour. Tori Edwards who, owns TESS, told me that Edward Enninful wanted to shoot me for i-D. I was a little ambivalent as it was so long since I had stepped into that harsh, unforgiving light. But the man behind the camera was Sølve Sundsbø – the dream photographer – and there are some things in life you just don't say 'No' to! This feeling was only exacerbated when I peeped through the door of Sølve's studio and saw the great Kate Moss smoking a fag and having her make-up done. Then Twiggy walked past. Two of the greatest icons of their generations. It reminded me of a Robert Altman movie as I spent the next fifteen minutes hyperventilating in the loo. Later I watched Kate work. We are old friends and I've seen her in action many times before but once again I was staggered by her ability to transcend her surroundings. To watch Kate

The Best of British Issue, No. 297, March 2009
"The Best of British cover was shot in New York just before Christmas and outside the studio it was snowing like crazy. I was so excited to get to work that day. Edward Enninful and Sølve Sundsbø are such an explosive pair, they conjure up so many beautiful images together whilst making everyone giggle hysterically. They made me feel like a real woman that day... It was the first time I'd really felt like one. What a wonderful feeling! Thanks i-D!"
Daisy Lowe, Cover Star

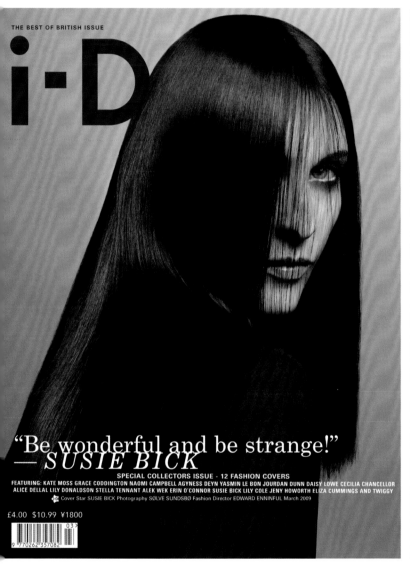

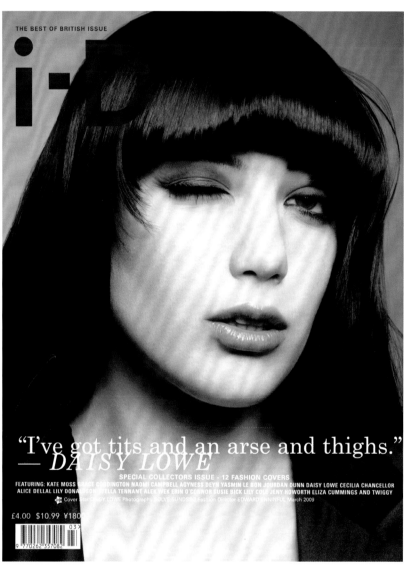

before the camera is a rare privilege. She is a true and a great artist. A near divine energy pours out of her – and once again I was reminded of the great Marilyn Monroe. Later, I had my hair done by six hairdressers, each specialising in the sacred hairdressing skills – brushing, combing, cutting, extensions, applying hairspray etc. – all lauded over by the legendary Luigi Murenu. Edward then took me into a room the size of an aircraft hangar full of the most beautiful clothes in the world, waved his arm and said, 'Take your pick!' A coterie of assistants spent the next hour attempting to prize me into various feathered and sequined dresses. In walked Edward and very diplomatically said, 'She looks beautiful in her bra and pants'. And that's how they shot me. I've never had photos taken where I've looked so good. This is a testament to the talents of this extraordinary team of people."
Susie Bick, Cover Star

The Manhood Issue, No. 296, February 2009
"I told Ann and Boyd this was going to be the fastest shoots either of them had ever done; all I needed was for them to fall in love for fifteen minutes – job well done Boyd!"
Matt Jones, Photographer and i-D New York Editor

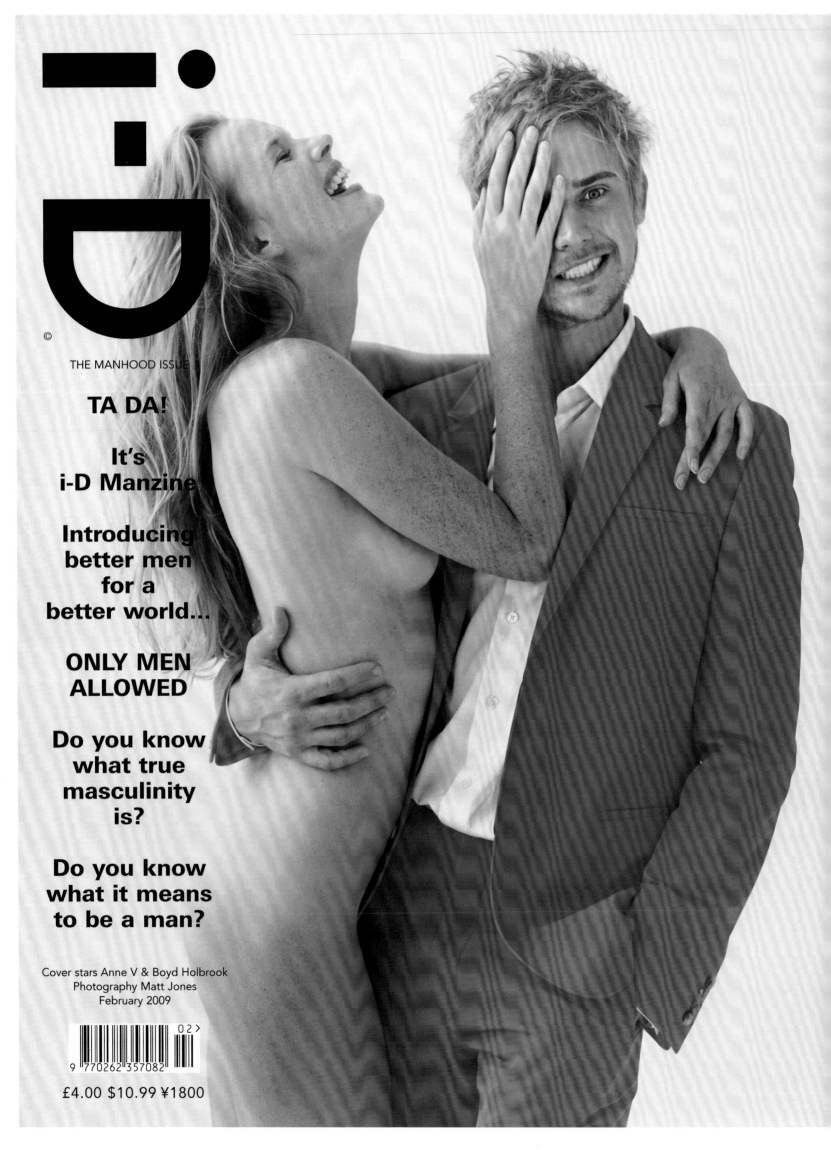

i-D

©

THE MANHOOD ISSUE

TA DA!

It's i-D Manzine

Introducing better men for a better world...

ONLY MEN ALLOWED

Do you know what true masculinity is?

Do you know what it means to be a man?

Cover stars Anne V & Boyd Holbrook
Photography Matt Jones
February 2009

£4.00 $10.99 ¥1800

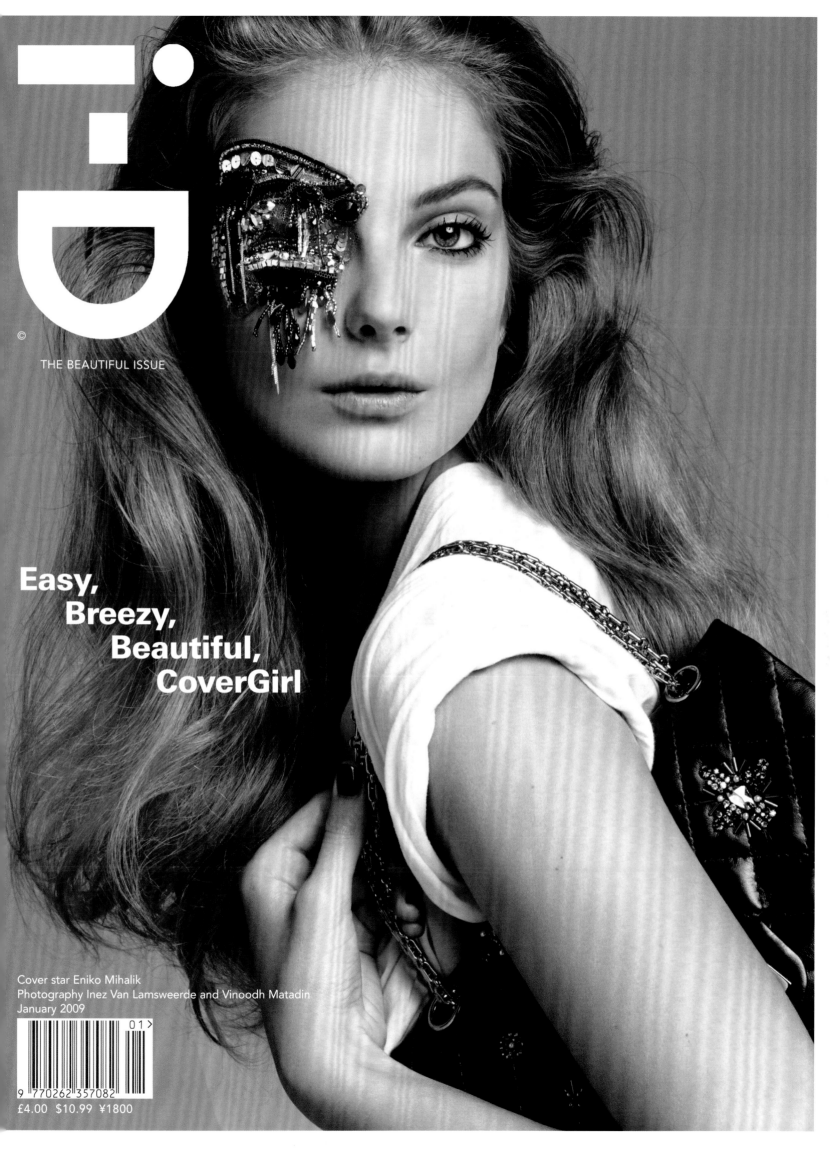

i-D

THE BEAUTIFUL ISSUE

Easy,
Breezy,
Beautiful,
CoverGirl

Cover star Eniko Mihalik
Photography Inez Van Lamsweerde and Vinoodh Matadin
January 2009

01 >

£4.00 $10.99 ¥1800

9 770262 357082

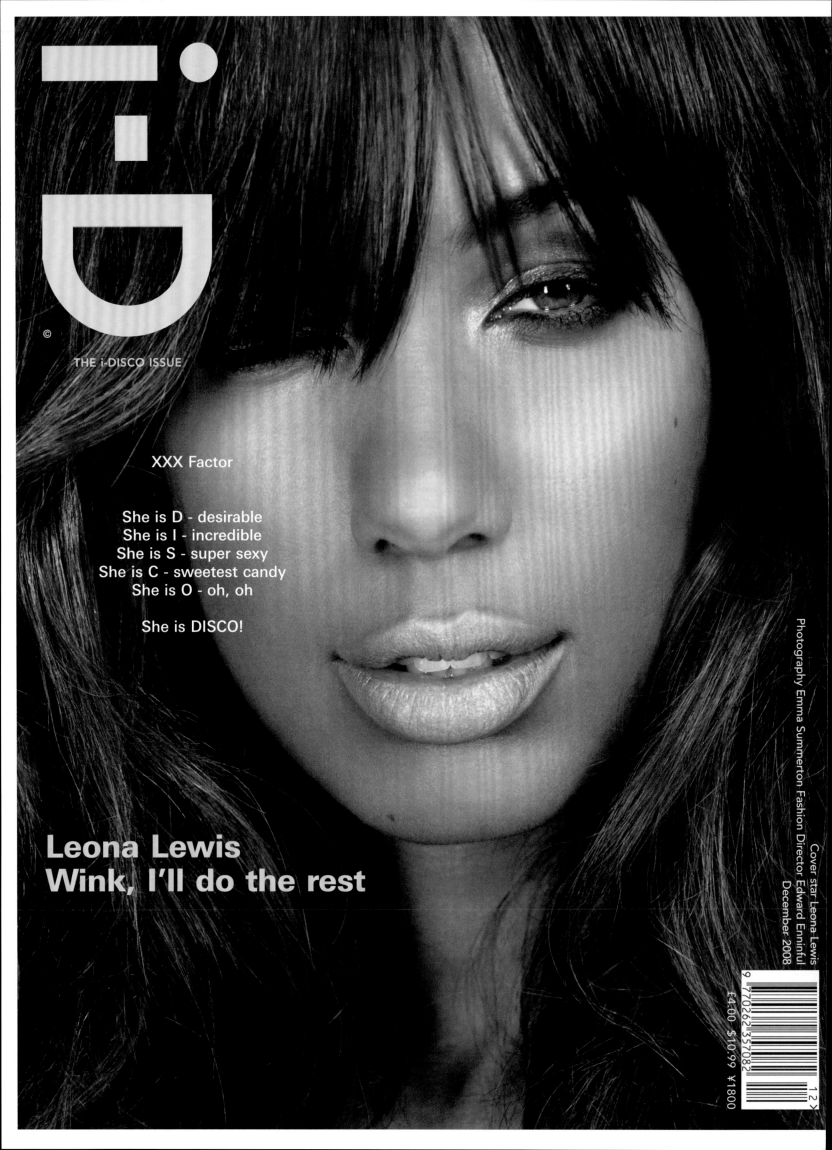

i-D

THE i-DISCO ISSUE

XXX Factor

She is D - desirable
She is I - incredible
She is S - super sexy
She is C - sweetest candy
She is O - oh, oh

She is DISCO!

Leona Lewis
Wink, I'll do the rest

Cover star Leona Lewis
Photography Emma Summerton Fashion Director Edward Enninful
December 2008

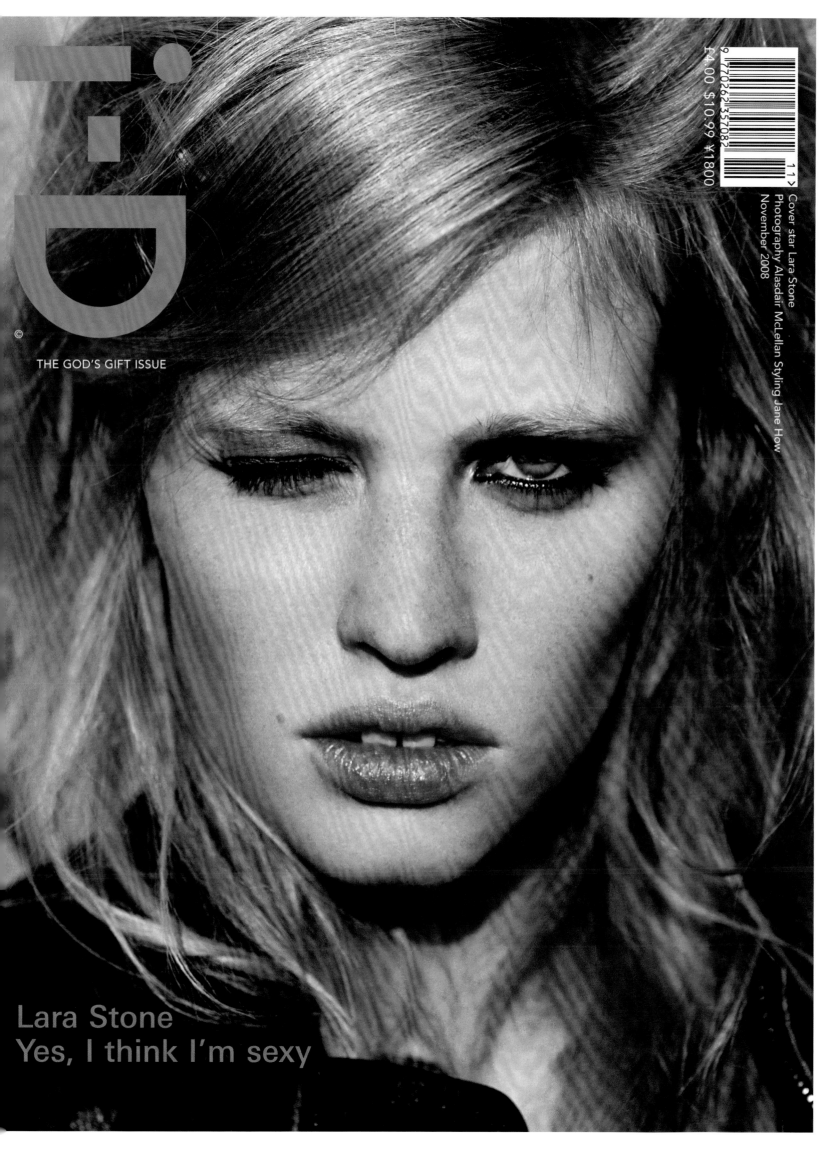

The Beautiful Issue, No. 295, January 2008
"When I started modelling I didn't know any of the magazines, nor most of the designers, or the important people in fashion. The first time I ever went to Paris, all I knew was that I was really excited. I started to do castings, started to Google people and things, so I would know who's who and what they do. At the agency they have all the magazines that their models shot for. That's where I first saw i-D and it soon became one of my favourites. I thought it was such a cool, big thing to be in it, so of course I was really happy to shoot a cover after three years of waiting. I think the day we shot it, was the day I realised why all the cover girls have one eye closed. I never thought about it before. I started to practice my wink in the mirror but soon Peter Philips helped me out and put the flittered lace on my eye. I was a bit nervous but when I saw the first try I just went, 'Wow, it's beautiful!'. I was really, really happy and proud in a way. One thing I 'ticked off' my list with a big smile."
Eniko Mihalik, Cover Star

The To Die For Issue, No. 291, September 2008
"I love working with Edward Enninful and i-D. Edward has championed my career from the very beginning and we work really well together. All his shoots are fun. I always feel really comfortable working with him. He pulls a great team together, so you feel especially confident and can be yourself. As for the images... OMG! They are amazing and some of my all time favorites."
Jourdan Dunn, Cover Star

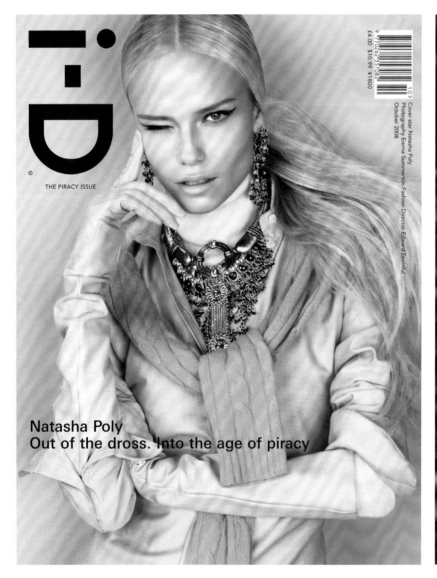

Natasha Poly
Out of the dross. Into the age of piracy

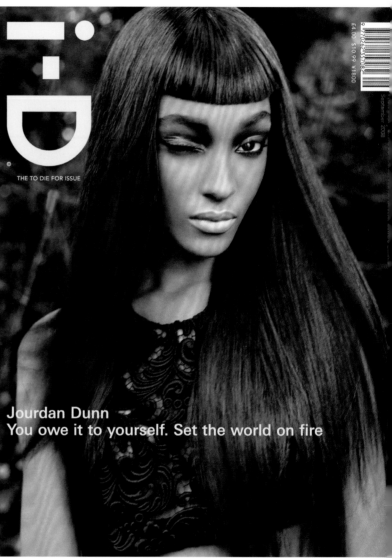

Jourdan Dunn
You owe it to yourself. Set the world on fire

The Artisan Issue, No. 290, August 2008
"This was so special to me. I remember I first worked for Yves Saint Laurent when I was seventeen and then being asked to be the face of the YSL for autumn/winter 2008, almost two decades later, and shooting this cover with Stefano...it was very overwhelming and incredible. It was the same year we lost Yves, but I had heard he was really happy to hear that I was the face of the ads. Stefano made the cover so incredibly modern and classic and elegant. I asked him 'What am I going to wear?' and he said 'Nothing!' He had this vision, he is so amazing and a close friend. I really loved working with Inez and Vinoodh too. I love being directed and they just knew exactly what they wanted and got it so quickly. It was an honour to do this. I love this cover."
Naomi Campbell, Cover Star

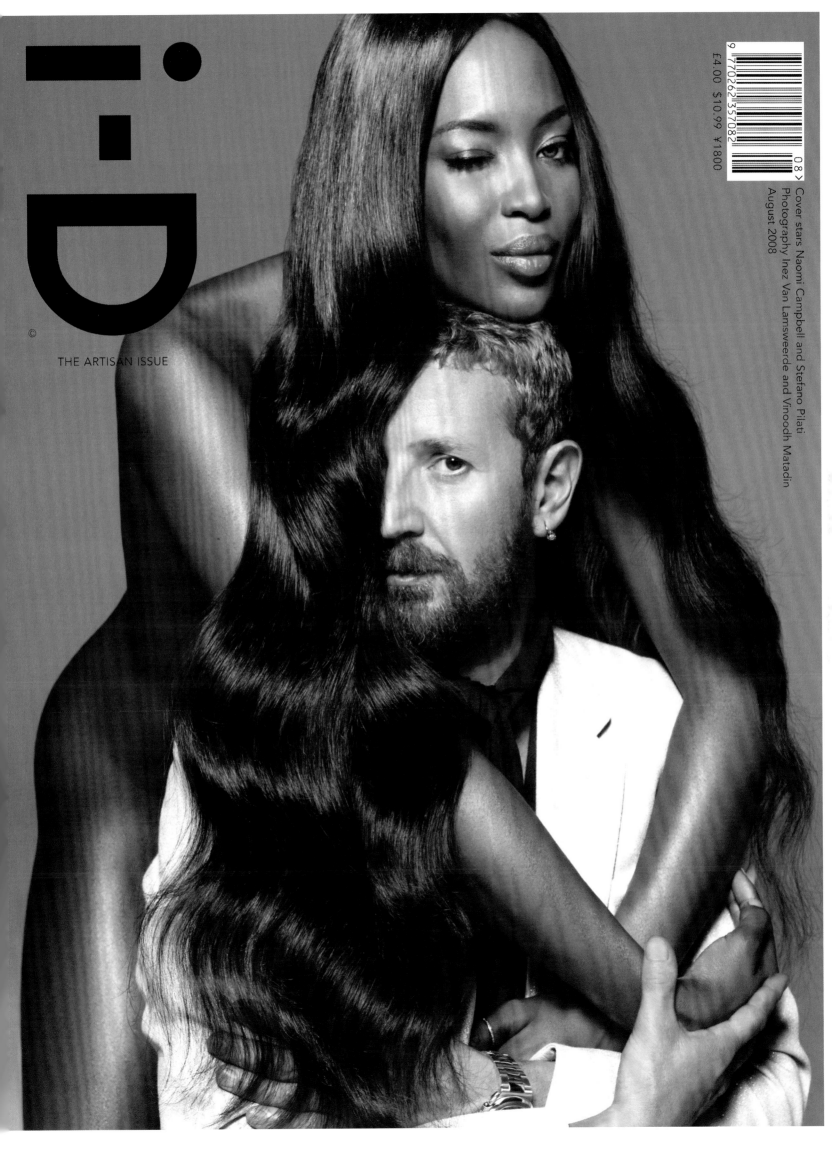

i-D

©

THE ARTISAN ISSUE

£4.00 $10.99 ¥1800

9 770262 357082

08 >

Cover stars Naomi Campbell and Stefano Pilati
Photography Inez Van Lamsweerde and Vinoodh Matadin
August 2008

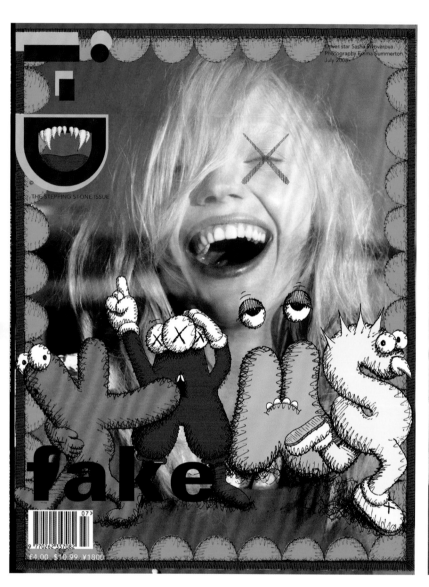

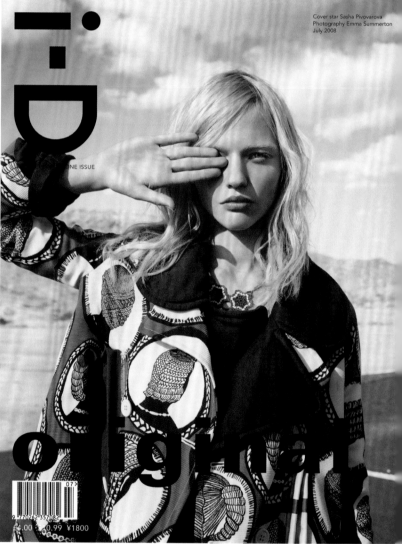

The Stepping Stone Issue, No. 289, July 2008
Working on The Stepping Stone issue with i-D was
simply my best print design experience to date!
KAWS, Artist

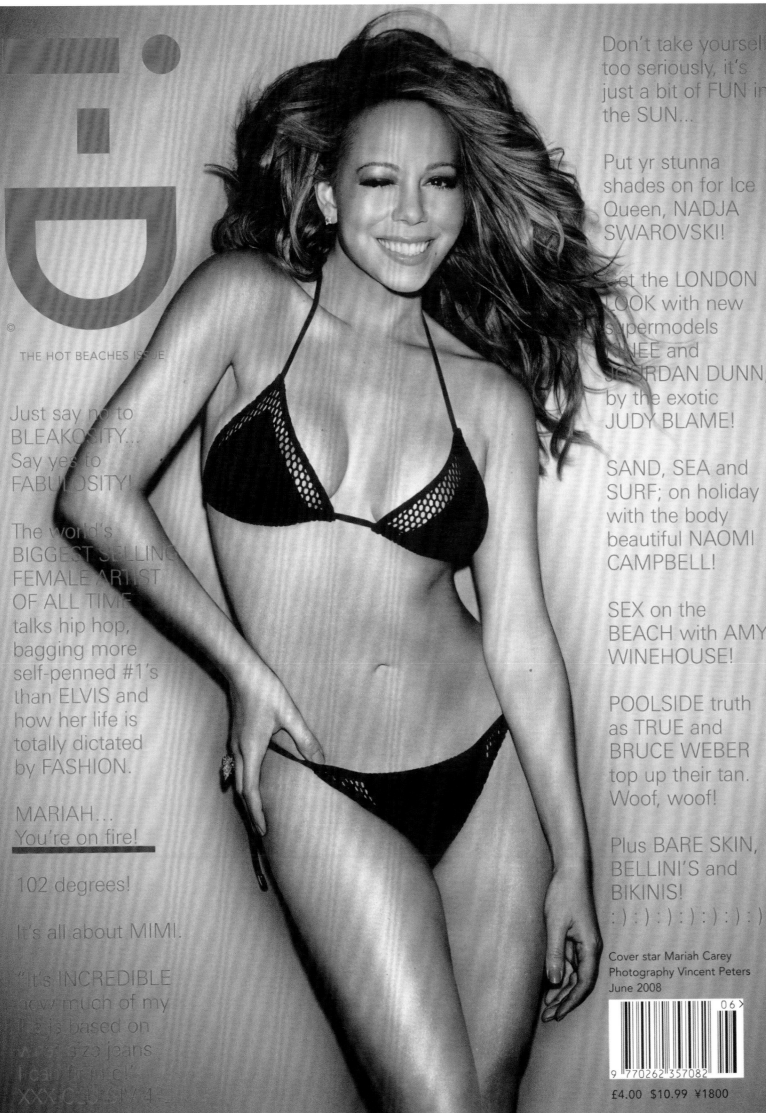

i-D

THE HOT BEACHES ISSUE

Just say no to BLEAKOSITY... Say yes to FABULOSITY!

The world's BIGGEST SELLING FEMALE ARTIST OF ALL TIME talks hip hop, bagging more self-penned #1's than ELVIS and how her life is totally dictated by FASHION.

MARIAH... You're on fire!

102 degrees!

It's all about MIMI.

"It's INCREDIBLE to know much of my life is based on what size jeans I can fit in!" XXXCLUSIVE!

Don't take yourself too seriously, it's just a bit of FUN in the SUN...

Put yr stunna shades on for Ice Queen, NADJA SWAROVSKI!

Get the LONDON LOOK with new supermodels JENEE and JOURDAN DUNN, by the exotic JUDY BLAME!

SAND, SEA and SURF; on holiday with the body beautiful NAOMI CAMPBELL!

SEX on the BEACH with AMY WINEHOUSE!

POOLSIDE truth as TRUE and BRUCE WEBER top up their tan. Woof, woof!

Plus BARE SKIN, BELLINI'S and BIKINIS!
:):):):):):)

Cover star Mariah Carey
Photography Vincent Peters
June 2008

9 770262 357082

06>

£4.00 $10.99 ¥1800

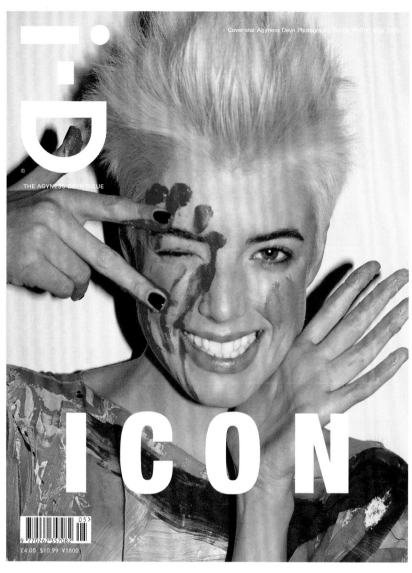

i-D

THE AGYNESS DEYN ISSUE

Cover star Agyness Deyn Photography Walter Pfeiffer May 2008

ICON

£4.00 $10.99 ¥1800

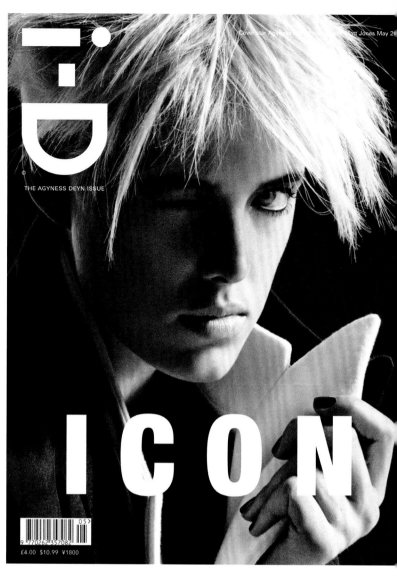

i-D

THE AGYNESS DEYN ISSUE

Cover star Agyness Deyn Photography Matt Jones May 2008

ICON

£4.00 $10.99 ¥1800

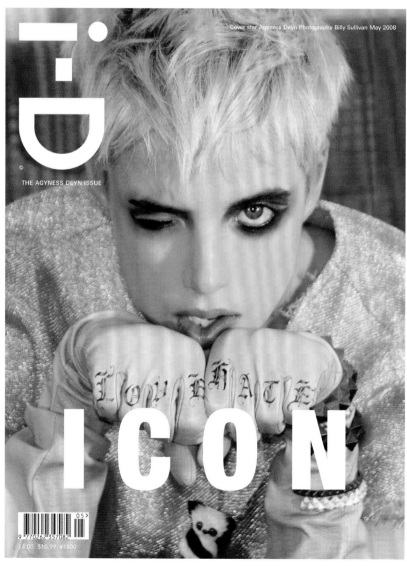

i-D

THE AGYNESS DEYN ISSUE

Cover star Agyness Deyn Photography Billy Sullivan May 2008

ICON

£4.00 $10.99 ¥1800

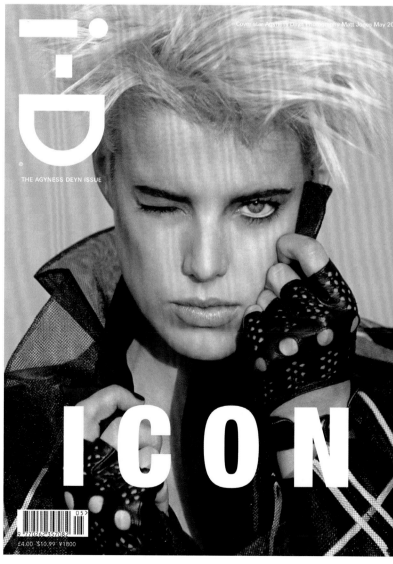

i-D

THE AGYNESS DEYN ISSUE

Cover star Agyness Deyn Photography Matt Jones May 2008

ICON

£4.00 $10.99 ¥1800

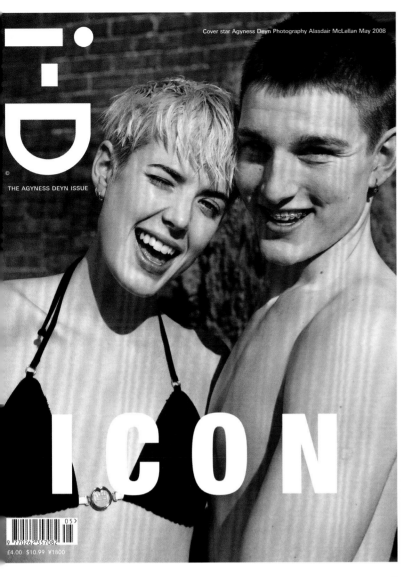

Cover star Agyness Deyn Photography Alasdair McLellan May 2008

The Agyness Deyn Issue, No. 287, May 2008
"It was just plain fun; I was playing in my studio with my friend Louie and he brought Agyness and Lorie along."
Billy Sullivan, Photographer

The Agyness Deyn Issue, No. 287, May 2008
"When I arrived in London, they told me, 'Agyness doesn't feel well; she has an eye infection, so we have to postpone the shooting,' which was scheduled for the following day. I was only here for three days – all I could do was shopping instead of working. On my last day in London I got a call, saying that it was now possible, but only two hours, so we hurried down to South London and this colourful house. I felt terrible after it was done. I thought that was the worst shooting of my life, but I got quickly into another mood when Dean [Langley, former i-D Art Director] told me that I have the cover!"
Walter Pfeiffer, Photographer

"i-D covers were not really planned, of course they were, but we did not know for sure what would be that months cover until they left the building for the repro house and even then, there was still time for change. I loved this process. The team would question Terry and Terry would question the team, always pushing for what we hoped would be something fresh, often solving the problem with minutes to go. There was no real design formula or template, just the wink to keep things constant. Covers would change when it felt right, the design was always a progression. After ten years working at i-D this process produced a lot of covers. It's difficult to list favorites, each cover has its' own story to tell, and it was always the current issues' cover that was your favorite. But there were some covers where the ideas or working behind them stand out from the rest.
For The Nationality Issue [No. 259, October 2005] we were stuck between two cover options, Nick Knight pushing for one, editorial pushing for another. We ended up running them both on the same cover – one as the main image with the other taking the place of the picture box in which the logo was usually shown.
Turning the cover photo on its' side for The Happiness Issue [No. 270, October 2006] as a take on the old A4 format covers. Not telling M&M there was a possibility of a second cover for The Feminine Issue [No. 252, March 2005] until the last day of working on a collaboration issue with them. I'm sure Terry was testing how much they really wanted their ornate version of the cover to run. It did. Giving first covers to artists Wolfgang Tillmans, Collier Schorr, Walter Pfeiffer and Francesco Vezzoli, with the latter sewing the eye up of Miuccia Prada for The Pleasure and Pain Issue [No. 298, April 2009]. On The Couples Issue cover [No. 279, August 2007] we wanted to use a Terry Richardson shot of a real couple kissing that so perfectly illustrated the theme, but it had no clothing credit, so going against advertising expectations Terry ran the cover. Giving KAWS The Stepping Stone Issue cover [No. 289, July 2008] to mess with and publishing it with a limited run. It's now a highly sought after collectors issue. Running The !#*? Issue [No. 282, November 2007] with Kate Moss asking the question "You want me to say who I am?" Starting The Who's That Girl Issue cover [No. 285, March 2008] with one cover shot which we had in place the entire issue only to swap it for the shot we featured inside, Terry deciding this after having lunch on the last day of production. It pissed everyone off, but it was the better cover. Giving the relatively unknown model Agyness Deyn four covers and an entire issue in May, 2008 [The Agyness Deyn Issue, No. 287]. For The Best of British Issue [No. 297, March 2009] we started with one cover and then ending up with twelve. After working on a cover idea based on a contact sheet with Alasdair McLellen, I suggested it for the 300th issue cover [The 300 Issue, June/July 2009]. Also on the table was an idea from Juergen Teller, and a last minute cover from Kayt Jones. Each of them were great images. I worked up all three knowing that we could only run one. Terry liked all three so we ran all three. Raquel Zimmerman holding a tray of quails about to be roasted for her dinner by Juergen Teller, I thought was maybe pushing it too far. It wasn't. Allowing us to ask the makers of SpongeBob SquarePants to draw over Lily Allen and to make their own i-D logo for The F.U.N Issue covers [No. 301, August 2009] was pretty special. And printing "would you like to enlarge your penis" from the title of a spam email that was bombarding the office that week on the spine of The Boys ll Men Issue [No. 284, February 2008] gave everyone something to talk about that month, which is what it is all about."
Dean Langley, Former Art Director

i-D

©

THE GENDER AGENDA ISSUE

GOOD GIRL
GONE BAD

Cover star Rinko Kikuchi
Photographed by Matt Jones
April 2008

IF IN DOUBT,
WINK,
PEACE AND POUT!

Gemma Ward

Lily Donaldson

Gemma and Lily
Photography: Emma Summerton. Fashion Director: Edward Enninful. February 2008

Lean and mean is in,
We're nice girls who'd like to talk...

THE WHO'S THAT GIRL ISSUE

Fashion,
fashion &
even more
fashion.
It's time
to think
wink.

Cover Star Raquel Zimmerman Photographed by Emma Summerton March 2008

The Gender Agenda Issue, No. 286, April 2008
"Between 7am and 10am was the only allocated time to shoot Rinko. I'd seen her the night before and told her that I didn't want her putting any make-up on before I arrived. She was still in bed with her Gizmo doll. She is one of the coolest girls I've ever photographed. She doesn't edit herself at all; she's just totally natural."
Matt Jones, Photographer

The Who's That Girl Issue, No. 285, March 2008
"Los Angeles dream."
Raquel Zimmerman, Cover Star

Terry Jones in conversation with Francesco Vezzoli

Terry: You're responsible for two iconic i-D covers, Cate Blanchett [The Art & Commerce Issue, No. 283, December 2007] and Miuccia Prada [The Pleasure & Pain Issue, No. 298, April 2009]...
Francesco: I'm flattered because both are women [Cate Blanchett and Miuccia Prada] who always make very specific choices. And I have to say they weren't easy to get, but I'm glad that they accepted to work with me.
How did you get them to agree to do a cover?
The Cate Blanchett cover I have to credit on behalf of my former companion Matthias Vriens. He shot a very iconic image and we had to shoot very quickly because, of course, Cate was incredibly busy, as she should be, being one of the best actresses in the world. I had met Cate before, but I'd never worked with her and everyone was blown away by her timing, her availability, and by her willingness to play along with us. That's what led us to capture such an original image. She had no fears in letting us play with her image. I thought that was very flattering.
Did you shoot Cate as part of a larger art project?
Yes, I basically got Cate to do something that she'd never done before. You could equally say that I did that with Miuccia in a way too because not so much changing specifics in the photograph, but I think a pretty daring picture and that's why I liked it and that's why I credit Matthias for the great job he did, but as well what Cate did for me during the performance was unusual because she is very great in movies and she is very great acting in the theatre, that was more like being an actor in her theatrical and intellectual provocation, she accepted to play along so that was great. Equally Miuccia accepted to be naked. I thought that was very special as well. I thought because she was Miuccia Prada and because she was on the cover of i-D, she should wear nothing but herself.
How did her husband react?
He was fine with it. Before sending it to you, we showed him two versions of the cover, one of which was way more daring than the other. Out of respect for Miuccia, I showed her and her husband all the options and he said we should go for the more daring image, which we did. So I think they not only believe in modernity in the intellectual standing of their company, but even in the other behaviours of their life. They have a lot of respect from me.
When did you first become aware of i-D?
A long, long time ago. When I was in high school, i-D was a medium through which I could gain access to a form of culture to which I aspired to belong, but of course living in a provincial city in the North of Italy, I could not belong to because there wasn't such a reality. Basically I came to London not so much to be an artist, but because I was infatuated with club culture. I wanted to meet DJs and I wanted to meet the club kids defining the history of worldwide culture.
What was your favourite club at that time?
Do you remember the DJ called Fat Tony?
Absolutely.
Tony was one of my best friends and I basically followed him around like a groupie. Tony introduced me to Danny Rampling who took us out for some great evenings at the Milk Bar. I also used to go to this club called Solaris and I was there the first year the Ministry of Sound opened, which was amazing. I remember this club called Quiet Storm. Do you remember that one?
I never went there.
That was a bit too fancy for you. Not too fancy but too Joujis. You would prefer more real situations. Last night I was in a club in Milano and I bumped into Princess Julia. When Julia used to play Queer Nation in Covent Garden that was my favourite club ever. I used to go there when I was about 21 or 22, and Julia used to play the best music.

i-D

©

THE ART & COMMERCE ISSUE

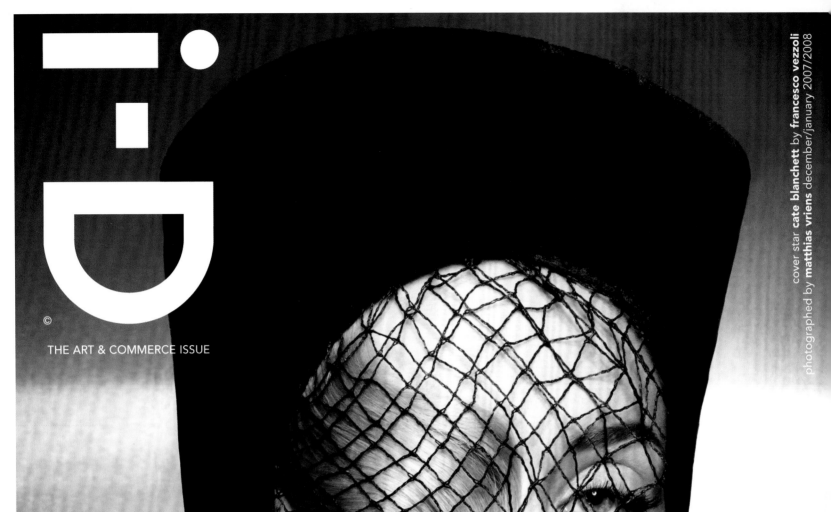

cover star **cate blanchett** by **francesco vezzoli**

photographed by **matthias vriens** december/january 2007/2008

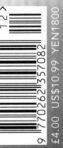

£4.00 US$10.99 YEN1800

i-D

THE !*#? ISSUE

You want me to say who I am?

i-D ©

THE WORLD WIDE WEB ISSUE

cover star **naomi campbell** photographed by **mario sorrenti** october 2007

Don't be scared of it because it's cool

£4.00 US$9.99 YEN1800

9 770262 357082

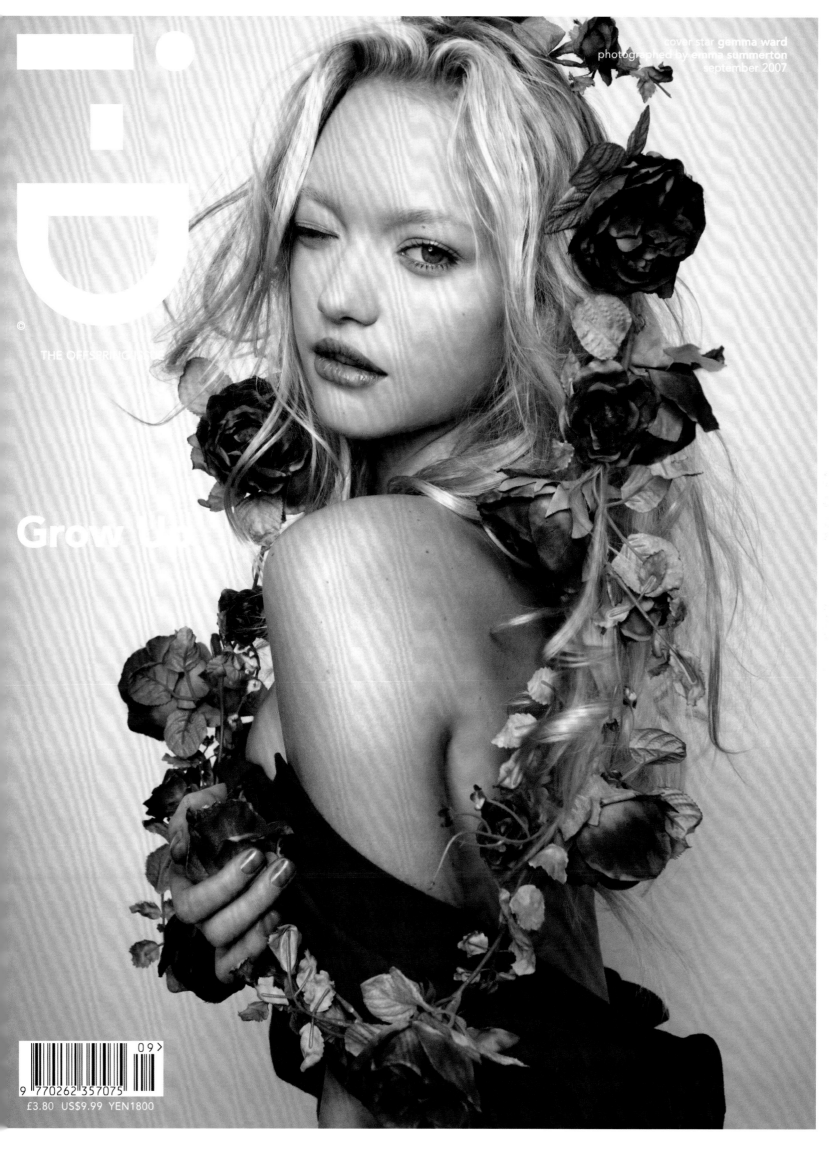

i-D

cover star gemma ward
photographed by emma summerton
september 2007

THE OFFSPRING ISSUE

Grow Up

The Art Issue, No. 283, December 2007
"Cate Blanchett needed to stay close to the Beverly Wilshire Hotel, so we rented a room in the old Chanel storage space across from the hotel on Rodeo Drive and set up a mini studio there. While it wasn't glamorous, it did the trick. Elizabeth Stewart styled the shoot. She found this forties' felt dish hat with a veil. I placed it in front of my face and pretended to be Hannibal the Cannibal, but when I looked in the mirror the hat resembled an Alexander McQueen creation, and I loved it. I showed it to Danilo, our hairdresser, and asked him if he could create a flame of hair over her left eye to be held in place by the veil, as an alternative to the i-D wink. When I was ready to shoot, Cate asked me what I wanted for mood. I told her she looked like Marlene Dietrich so she should go in that direction. Then, within seconds, she froze her face and became Marlene Dietrich. I have never seen anything like it and I had the picture in less than three frames."
Matthias Vriens, Photographer

The World Wide Web Issue, No. 281, October 2007
"I didn't realise I was going to be nude in this one, but again Mario Sorrenti knew what he wanted and he didn't want clothes! I love the images that Mario gets of me, I felt like a bad girl but still with some softness and always very tasteful. I remember he told me he wanted to use one of the images for his exhibition in China and I thought they would never let him have an image like that in China, but they did!"
Naomi Campbell, Cover Star

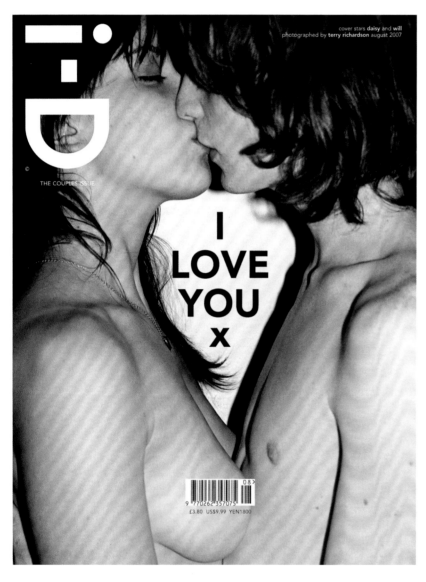

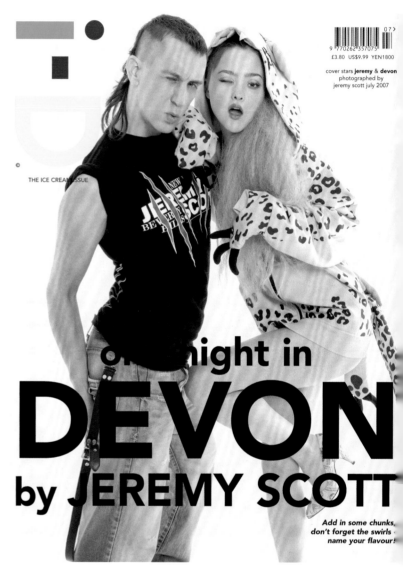

The Couples Issue, No. 279, August 2007
"It was the second time I'd ever been to New York and we shot in the Lower East side at Terry's studio. It was boiling hot and Terry had this poor fellow jumping around and dancing his arse off without a break for a couple of hours, like a DJ and his hype man. I felt natural and relaxed with Daisy Lowe in front of the camera at the time, but I remember one of our friends' calling us "fucking perverts!" on seeing it in print for the first time (in front of Daisy's mother!). It's documentation of an incredible period of my young life and I'm proud to have shared that."
Will Blondelle, Cover Star

The Ice Cream Issue, No. 278, July 2007

"I was the first designer to put Devon on the catwalk. She's been in many of my shows and we have been photographed together by all kinds of photographers, but I'd never shot her myself. So this cover session was the first time we had worked together in quite a while, because she was doing more film work. We shot pieces from my archives, which I had not seen in a while and dated back to the very earliest shows I did with Devon. All of this made for a very magical experience. At one point, Devon and I went into our own little world, speaking together in less words and more shared thoughts. We would shoot a look, go rummage through

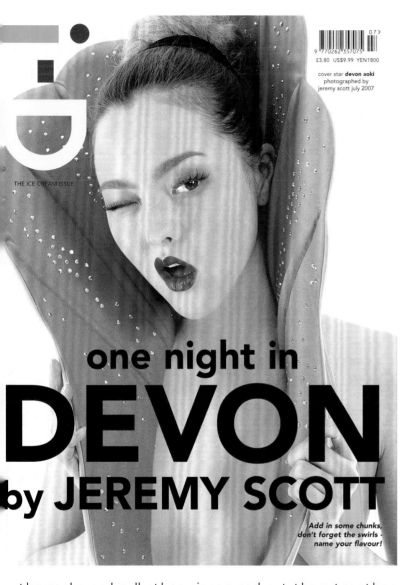

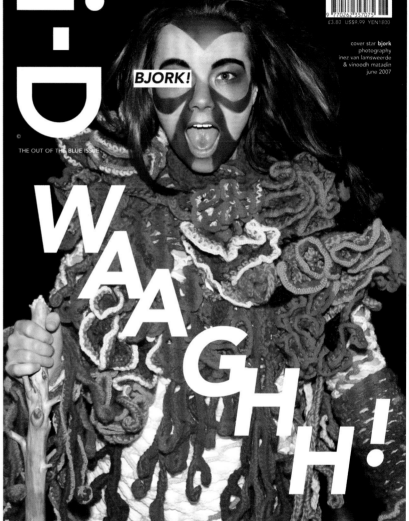

the racks and pull other pieces and put them together. Devon would change her hair herself, and maybe ask for a different shade of lipstick. Then we would shoot another look. Devon, being the pro that she is, had already been on the cover of i-D a few times, and was used to the wink, but I kept getting confused if I was winking with the correct eye, and as I was flipping over from behind to in front of the camera to pose in the photo it confused me even more. But in the end, we got the shot. That was the first time a designer photographed himself wearing his own designs for the cover of i-D, or any other magazine for that matter!"

Jeremy Scott, Designer and Photographer

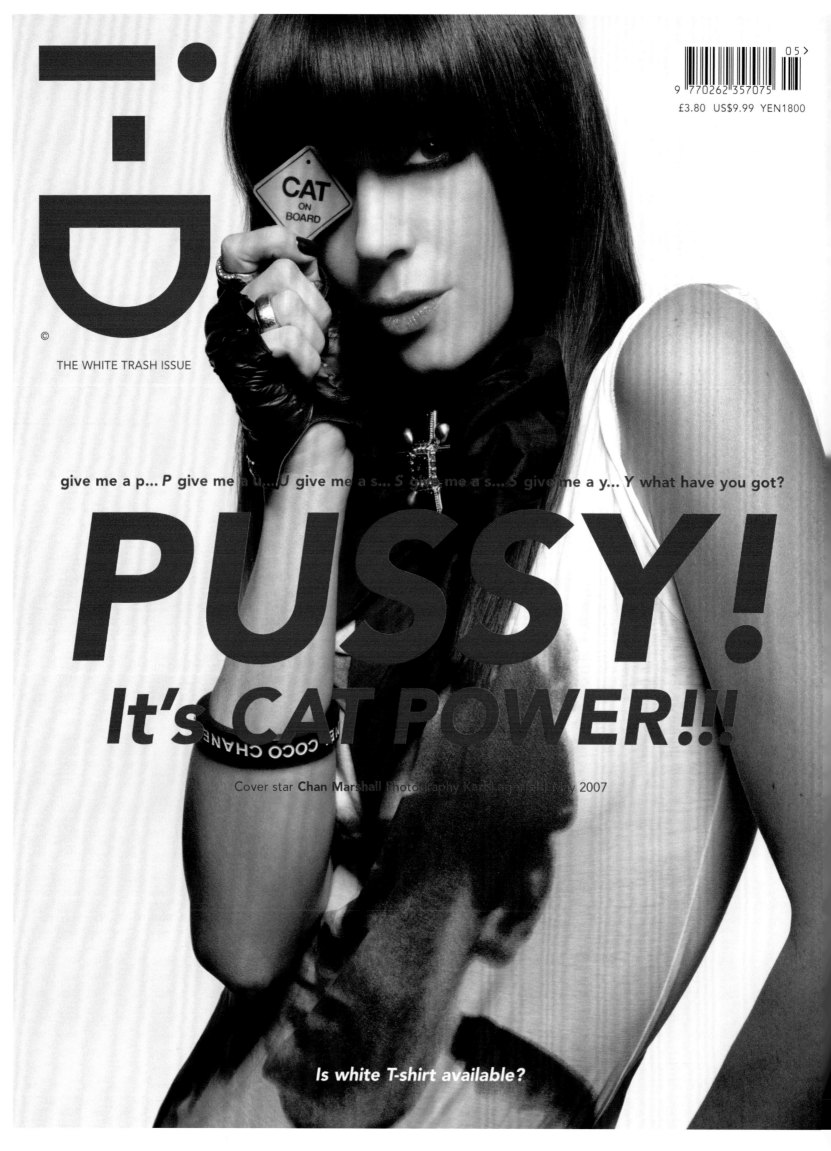

i-D

© THE WHITE TRASH ISSUE

CAT ON BOARD

give me a p... *P* give me a u...*U* give me a s... *S* give me a s...*S* give me a y... *Y* what have you got?

PUSSY!

It's CAT POWER!!!

Cover star **Chan Marshall** Photography Karl Lagerfeld May 2007

Is white T-shirt available?

05
9 770262 357075
£3.80 US$9.99 YEN1800

i-D

THE TISSUE ISSUE

Red is the new black.

cover star clemence poesy photographed by paolo roversi april 20..

9 770262 357075

04

£3.80 US$9.9. YEN1800

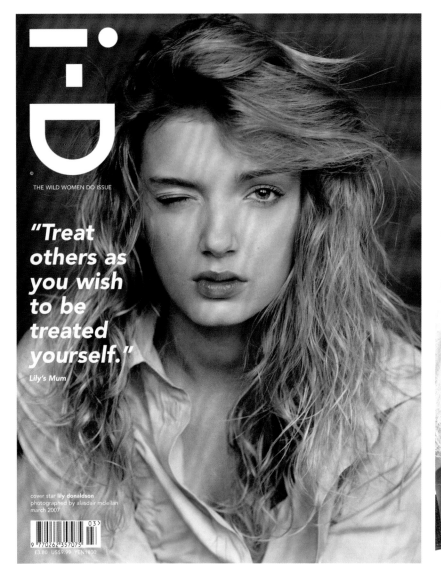

THE WILD WOMEN DO ISSUE

"Treat
others as
you wish
to be
treated
yourself."

Lily's Mum

cover star lily donaldson
photographed by alasdair mclellan
march 2007

£3.80 US$9.99 YEN1800

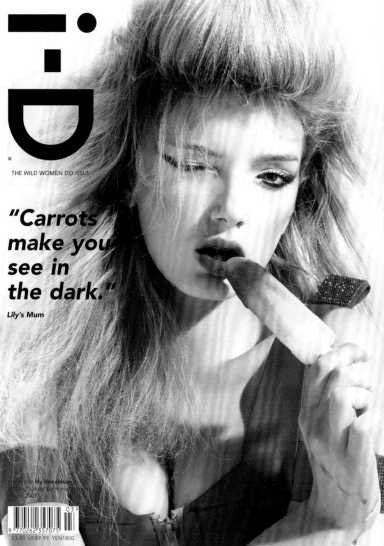

THE WILD WOMEN DO ISSUE

"Carrots
make you
see in
the dark."

Lily's Mum

cover star lily donaldson
photographed by mariano vivanco
march 2007

£3.80 US$9.99 YEN1800

The We Got Issues Issue, No. 273, February 2007
"I didn't know how to blink with only one of my eyes, so
all the pictures that Collier took were very funny, When
we saw that there was no way for me to do it, I had
the idea of putting my hand over my face, making the
peace and love sign. That was the picture, that was the
cover... I stayed really happy!"
Caio Vaz, Cover Star

88

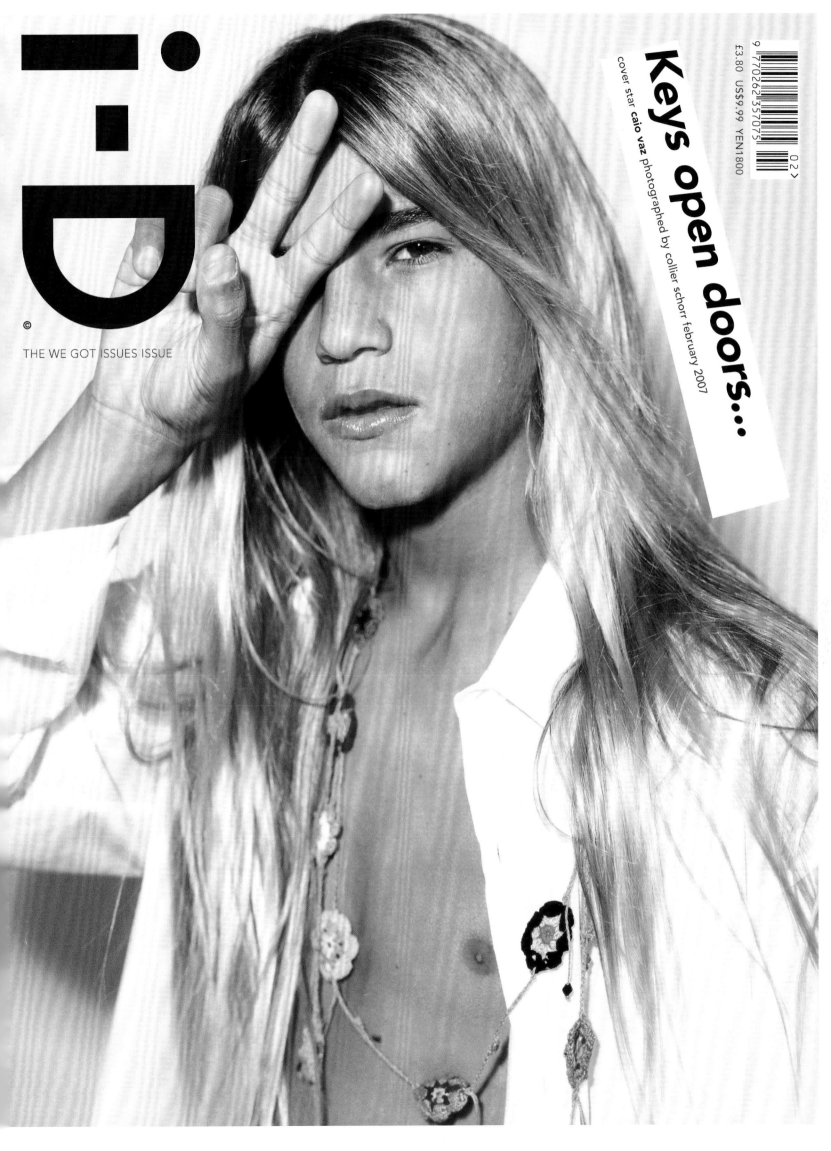

i·D

©

THE WE GOT ISSUES ISSUE

£3.80 US$9.99 YEN1800

02

cover star **caio vaz** photographed by collier schorr february 2007

Keys open doors...

CASSIE

Oh my GOSH

£3.80 US$9.99 YEN1800

9 770262 357075 12 >

VISER ISSUE

P.DIDDY

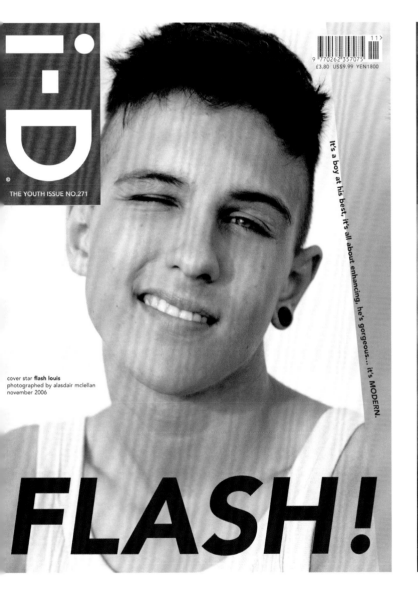

i-D

THE YOUTH ISSUE NO.271

It's a boy at his best, it's all about enhancing, he's gorgeous... It's MODERN.

cover star **flash louis**
photographed by alasdair mclellan
november 2006

FLASH!

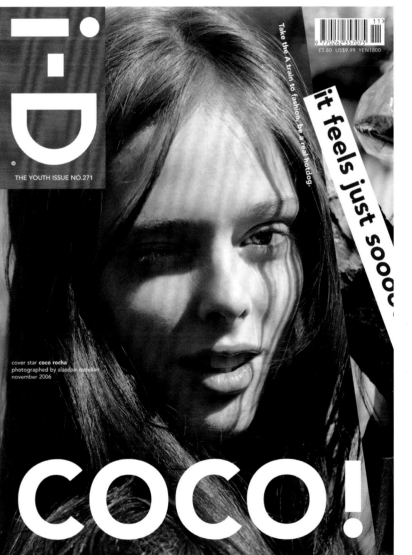

i-D

THE YOUTH ISSUE NO.271

Take the A train to fashion, be a real hotdog.

it feels just sooo

cover star **coco rocha**
photographed by alasdair mclellan
november 2006

COCO!

The Youth Issue, No. 271, November 2006
"This was an iconic shoot for me. I had such a great time working with Alasdair McLellan and Olivier Rizzo and it is one of my favourite covers I've done. This was also one of the first interviews I did and was honoured to be touted by i-D as the new face of fashion."
Coco Rocha, Cover Star

i-D

©

THE HAPPINESS ISSUE NO.270

happiness is what I call fashion!

Angela Lindvall photographed by Richard Bush October 2006

£3.80 US$9.99 YEN1800

9 770262 357075

10>

The Wealth Issue, No. 269, September 2006
"My favourite i-D cover would have to be my first ever
of Claudia Schiffer. It was so exciting to have an i-D
cover and a landmark moment for me without a doubt!
Also shooting Kate Moss for i-D was a great moment.
Others that stick in my mind are Devon Aoki by Paolo
Roversi, Jessica Stam by Richard Burbridge, L'il Kim by
Steven Klein and Laura Foster by David Sims."
Emma Summerton, Photographer

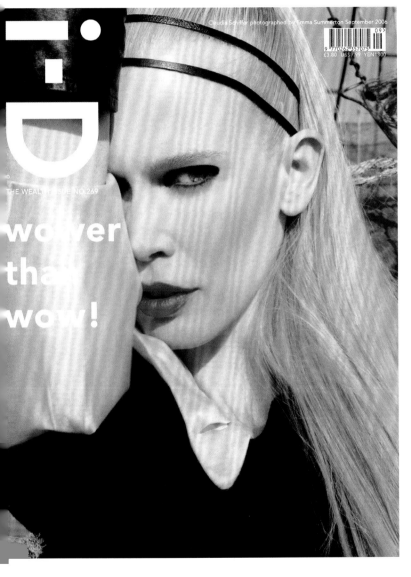

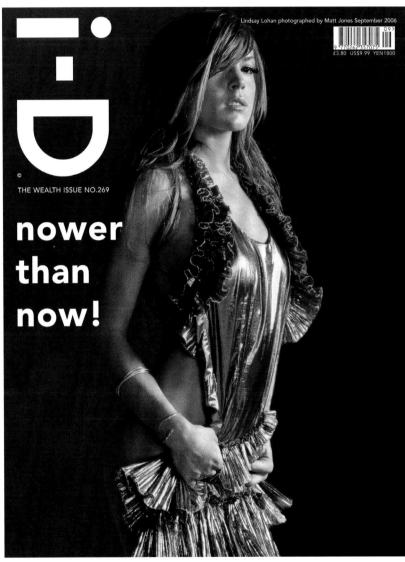

The Health Issue, No. 268, August 2006
"I don't know what to say about Beyonce; there's
something about her that's quite breathtaking – it's
everything about her – I'm trying to put my finger on
it. She's like no one else I've ever photographed.
She was simply amazing."
Matt Jones, Photographer

Beyoncé Knowles photographed by Matt Jones August 2006

i-D

©

THE HEALTH ISSUE NO.268

beyond

£3.80 US$9.99 YEN1800

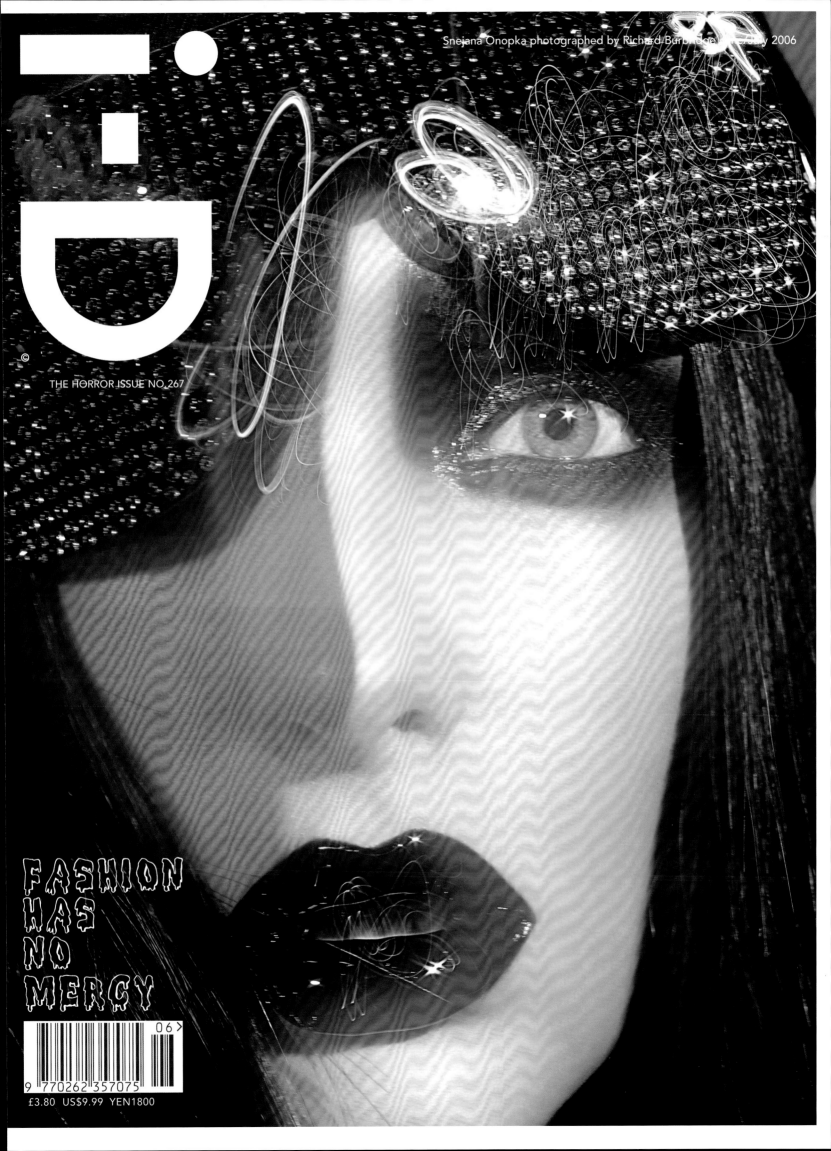

i-D

Snejana Onopka photographed by Richard Burbridge in early 2006

THE HORROR ISSUE NO. 267

FASHION
HAS
NO
MERCY

06>

9 770262 357075

£3.80 US$9.99 YEN1800

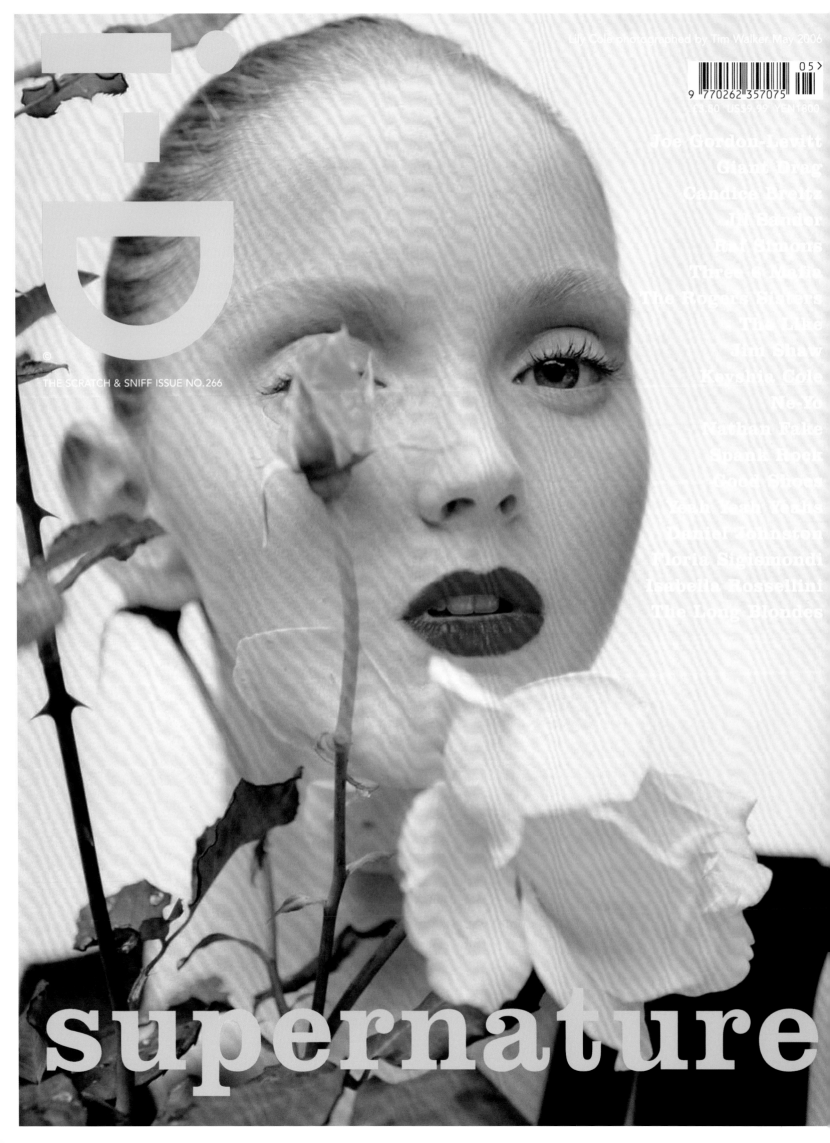

i-D

© THE SCRATCH & SNIFF ISSUE NO.266

Lily Cole photographed by Tim Walker, May 2006

9 770262 357075

£3.80 US$9.99 YEN1600

05

Joe Gordon-Levitt
Giant Drag
Candice Breitz
Jil Sander
Raf Simons
Three 6 Mafia
The Rogers Sisters
The Gits
Jim Shaw
Keyshia Cole
Ne-Yo
Nathan Fake
Spank Rock
Good Charlotte
Yeah Yeah Yeahs
Daniel Johnston
Floria Sigismondi
Isabella Rossellini
The Long Blondes

supernature

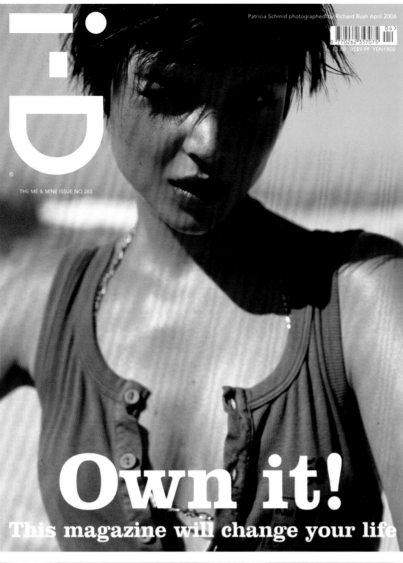

The Me & Mine Issue No. 265

Patricia Schmid photographed by Richard Bush April 2006

Own it!
This magazine will change your life

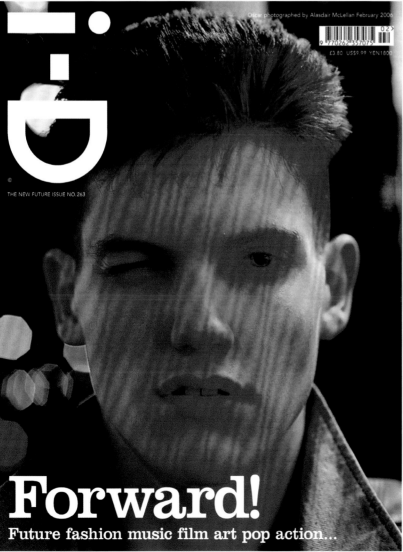

The New Future Issue No. 263

Oscar photographed by Alasdair McLellan February 2006

Forward!
Future fashion music film art pop action...

The Horror Issue, No. 267, June/July 2006
"The beautiful Snejana transformed! Black eyes, black mouth, stunning. Based on the Dior show, autumn/winter 2006."
Pat McGrath, Beauty Director, i-D

The Scratch and Sniff Issue, No. 266, May 2006
"I love i-D. As a London girl I grew up familiar with its cutting-edge stories and iconic imagery, so I was honoured to join the women (and men) who've managed to blink their way onto a cover! This cover was shot with Tim Walker and Edward Enninful who are always a joy to work with and the flower-covered-eye was an idea made spontaneously one sunny London day!"
Lily Cole, Cover Star

Terry Jones in conversation with Richard Bush and Sarah Richardson

Terry: What was the first cover you worked on together for i-D?
Richard: The first cover we worked on was with Patricia Schmid in Africa for The Me & Mine Issue [No. 265, April 2006].

Fantastic location...
RB: Yes, there were great white sharks and freezing cold water for us to contend with!
Sarah: Well, the freezing cold water only became a problem when everyone decided to go swimming and then the model didn't want to get in the shower even though it was hotter than the sea.
RB: Oh yes, we had all sorts of drama on that shoot.

Was she a character?
SR: She was a character, yes.
RB: It was still a great shoot though.

After that you both worked together on the Angela Lindvall cover [The Happiness Issue, No. 270, October 2006].
SR: Yes, that was three or four years ago now. It was Angela's third or fourth cover for i-D.
RB: That was a great shoot because Angela just came into her own and created something quite extraordinary for the camera.
SR: It was so instantaneous, wasn't it?
RB: Yes, that's how a lot of i-D covers tend to happen, as happy accidents. We shot in the middle of the Californian desert, right in the middle of nowhere and I remember being very spooked watching Angela walking up the road in those incredibly high heels.
SR: Oh yes.
RB: We were shooting on this really long, straight, deserted road and this hillbilly came by as if out of nowhere.
SR: We were a little freaked out, because Angela was wearing these amazing shoes Nicholas Kirkwood had made for us, those really big ones from one of his first collections. She also had this little dress on and I think it freaked a few people out to see her dressed like that in the middle of the Palmdale desert.

There are some weird people in the desert. She could have been accosted.
RB: The dress she was wearing was made entirely of rubber and poor Angela was really sweating.
SR: Yes, she was wearing a full-on rubber outfit. I remember she came up with the idea of starting a company to take very rich women out to the desert and dressing them in rubber so they'd lose weight.

Fantastic. That's a great idea.
RB: It was a good business plan, but unfortunately it didn't work.

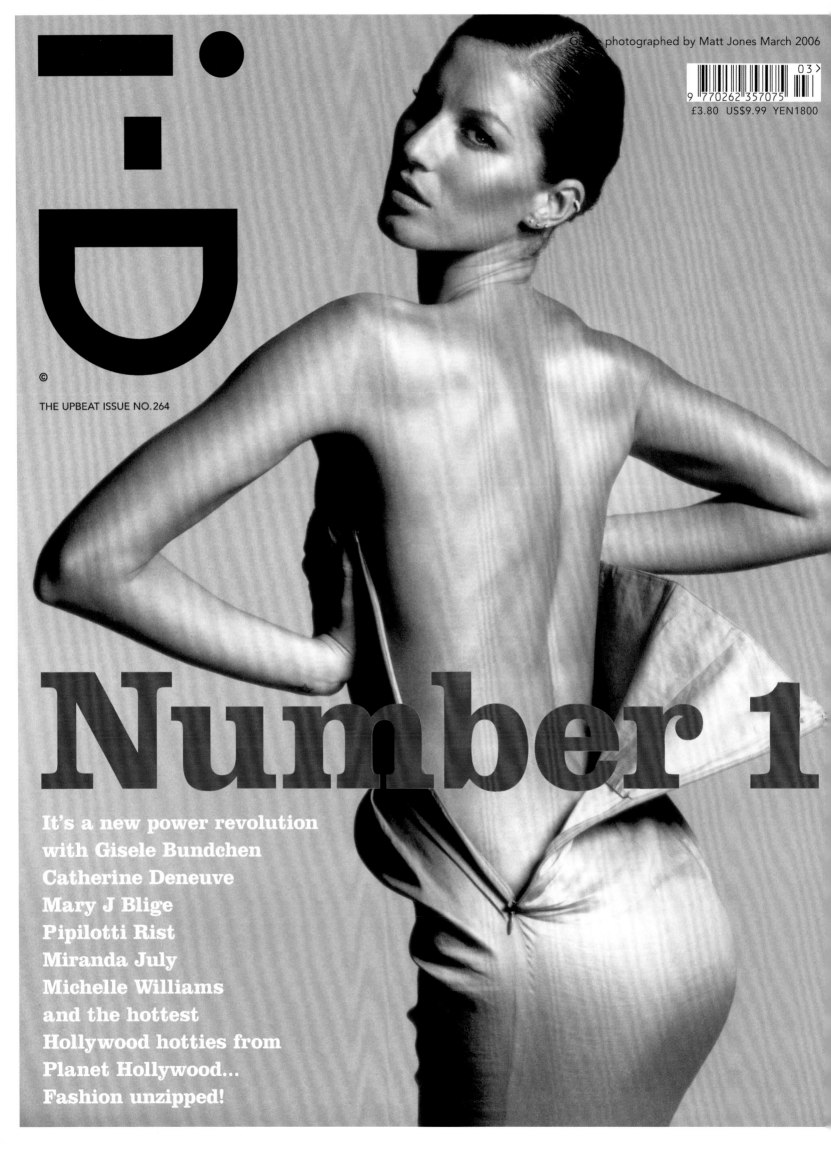

i-D

Gisele photographed by Matt Jones March 2006

£3.80 US$9.99 YEN1800

©

THE UPBEAT ISSUE NO. 264

Number 1

It's a new power revolution
with Gisele Bundchen
Catherine Deneuve
Mary J Blige
Pipilotti Rist
Miranda July
Michelle Williams
and the hottest
Hollywood hotties from
Planet Hollywood...
Fashion unzipped!

The Upbeat Issue, No. 264, March 2006
"Gisele is wonderfully opinionated; there's no doubt who's the boss in the room!"
Matt Jones, Photographer

The Home Issue, No. 261, December 2005
"I was super proud to be on the cover of i-D. Looking back it was a risk to put me on the cover; especially back then. I wouldn't say I was particularly stylish. I just rocked up in my Adidas hoodie and didn't take much styling or direction, but to be fair it was a great shoot and made a brilliant cover".
Lady Sovereign, Cover Star

Lily Donaldson photographed by Richard Burbridge January 2006

£3.80 US$9.99 YEN1800

THE SKIN ISSUE NO.262

It's Magnetic

Eyes!
The first look at new season beauty

Mouth!
Frances Bean Cobain speaks out

Teeth!
Winter glamour bites back

Nose!
Sniff up next year's brightest popstars, artstars and future icons

Lady Sovereign photographed by Alasdair McLellan December 2005

£3.80 US$9.99 YEN1800

THE HOME ISSUE NO.261

My England

The Skin Issue, No. 262, January 2006
"Sparkling. Movement; Lily was perfect! The make-up was based on the spring/summer 2006 Yohji Yamamoto show."
Pat McGrath, Beauty Director, i-D

The Faith Issue, No. 260, November 2005
"My assistant at the time, Chris, was dressed in a ridiculous Ape suit for the shoot. Naomi and he were bouncing on a trampoline. Somehow, even though Chris is a big guy, Naomi managed to continually double bounce him. Problem was, we were shooting on a roof top eleven stories high, over one of New York's busiest streets. In the manic seconds to capture the shot, I told him to toughen up. Looking back we were lucky Chris was not Chris 'the flying Ape' who landed in traffic! Things you do to get the shot."
Ben Watts, Photographer

i-D

Naomi Watts photographed by Ben Watts November 2005

9 770262 357075

11

£3.80 US$9 ¥800

THE FAITH ISSUE NO.260

True faith

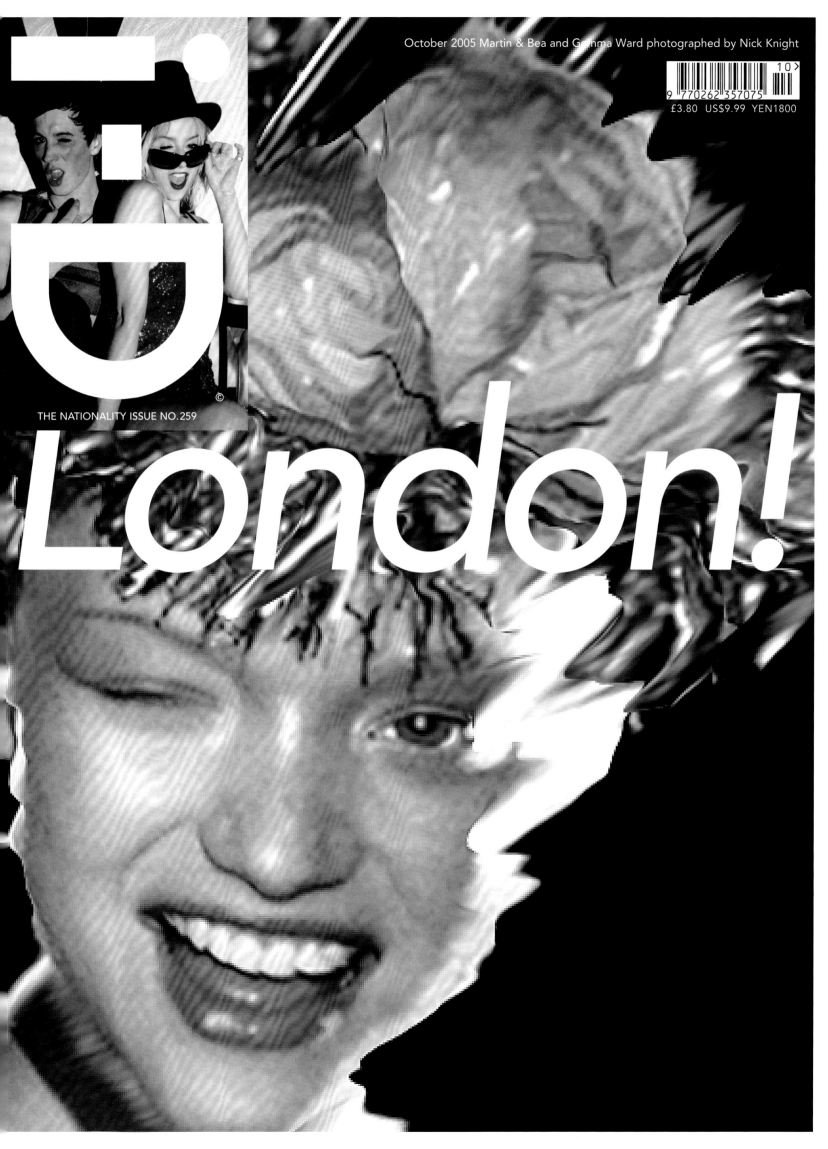

October 2005 Martin & Bea and Gemma Ward photographed by Nick Knight

£3.80 US$9.99 YEN1800

THE NATIONALITY ISSUE NO.259

©

London!

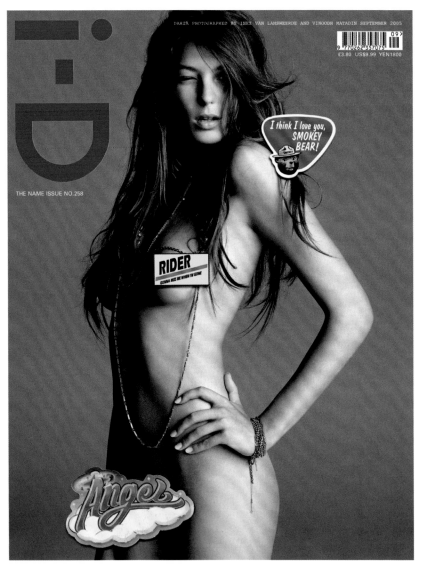

I think I love you, SMOKEY BEAR!

THE NAME ISSUE NO.258

RIDER

£3.80 US$9.99 YEN1800

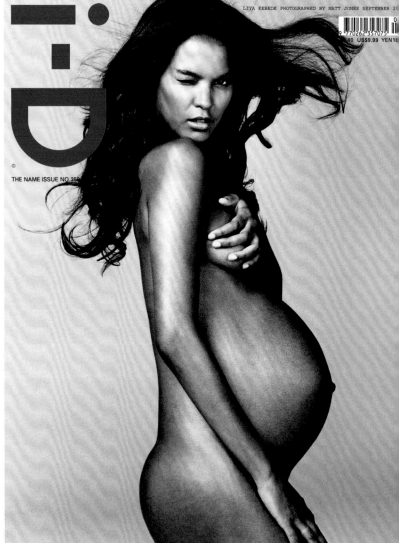

THE NAME ISSUE NO.258

.80 US$9.99 YEN18

The Iconic Issue, No. 258, September 2005
I shot my second cover with Matt Jones when I was pregnant [The Name Issue, No. 258, September 2005]. It was my first nude photo shoot, but because I was pregnant it felt different. I still have the picture. It's one photograph that I've actually framed. I love that picture; there's so much beauty in that picture."
Liya Kebede, Cover Star

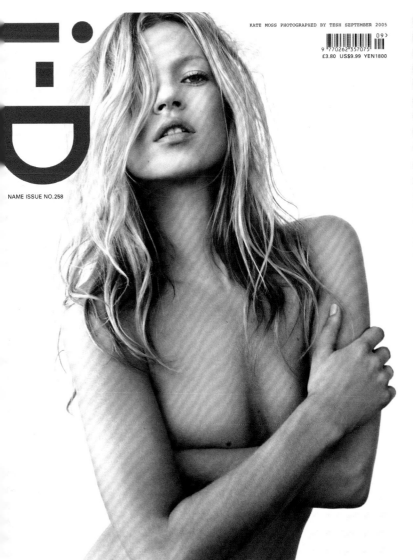

KATE MOSS PHOTOGRAPHED BY TESH SEPTEMBER 2005

£3.80 US$9.99 YEN1800

NAME ISSUE NO.258

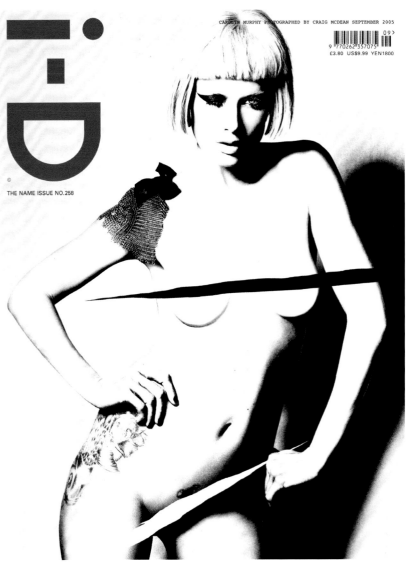

CAROLYN MURPHY PHOTOGRAPHED BY CRAIG MCDEAN SEPTEMBER 2005

£3.80 US$9.99 YEN1800

THE NAME ISSUE NO.258

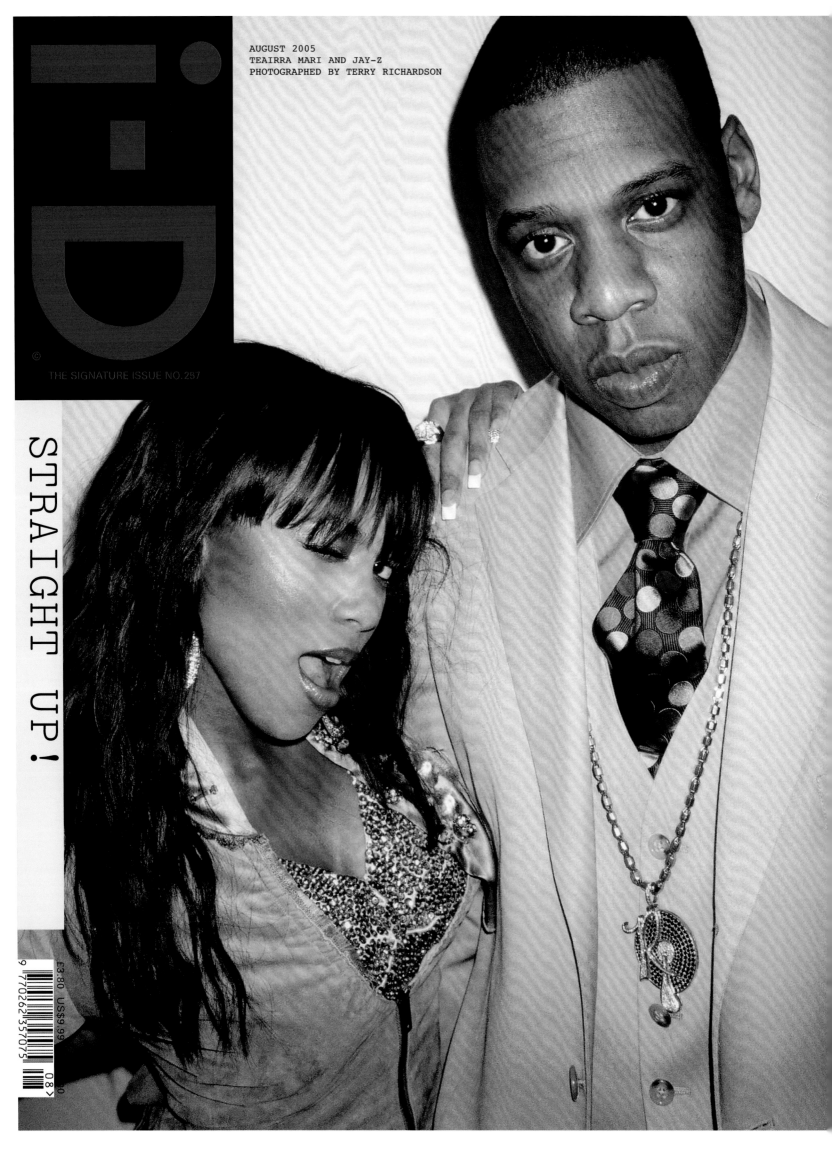

i-D

AUGUST 2005
TEAIRRA MARI AND JAY-Z
PHOTOGRAPHED BY TERRY RICHARDSON

THE SIGNATURE ISSUE NO. 257

STRAIGHT UP!

£3.80 US$9.99

9 770262 357075

08 >

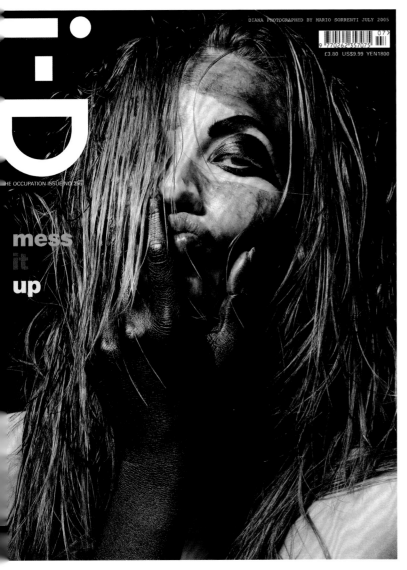

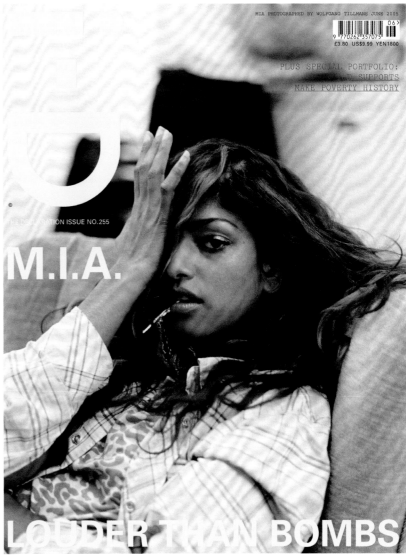

Terry Jones in conversation with
Mario Sorrenti

Terry: What is your favourite cover of i-D?
Mario: The cover I shot of Diana Dondoe for The Occupation Issue [No. 256, July 2005]. That's my favourite.
How did you get Diana so dirty?
I think it was just grease. We put black grease on her face and we just kept putting more and more on. Then we put it in her hair and it just got wilder and crazier and I was telling her to go more and more crazy. I think she even went home like that. I don't even know how she got the oil off!
You're bad.
Yes but she loved it. Then I got a nasty phone call from her boyfriend saying, "How could you do that to my girlfriend? You're a loser.'
That's really funny. Who did the make-up?
Linda Cantello and Bob Recine did the hair.

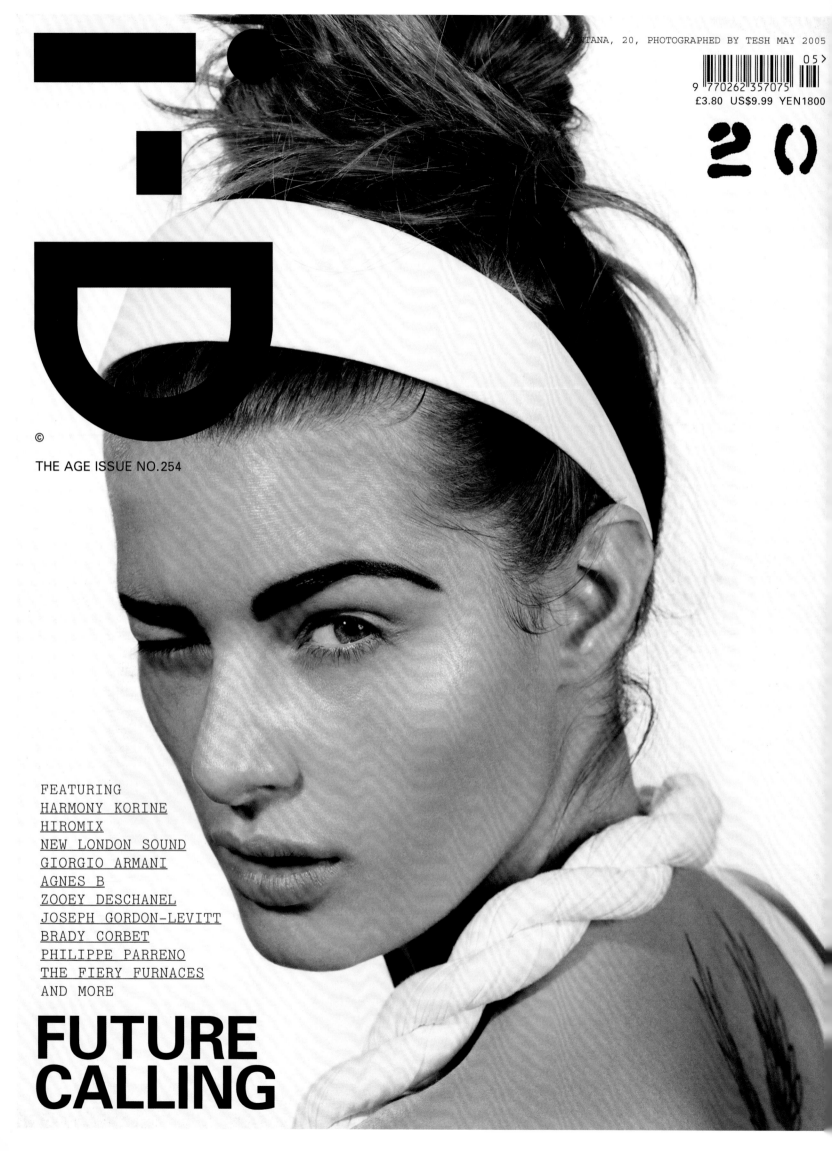

TANA, 20, PHOTOGRAPHED BY TESH MAY 2005

05 >

9 770262 357075

£3.80 US$9.99 YEN1800

20

©

THE AGE ISSUE NO.254

FEATURING
HARMONY KORINE
HIROMIX
NEW LONDON SOUND
GIORGIO ARMANI
AGNES B
ZOOEY DESCHANEL
JOSEPH GORDON-LEVITT
BRADY CORBET
PHILIPPE PARRENO
THE FIERY FURNACES
AND MORE

FUTURE CALLING

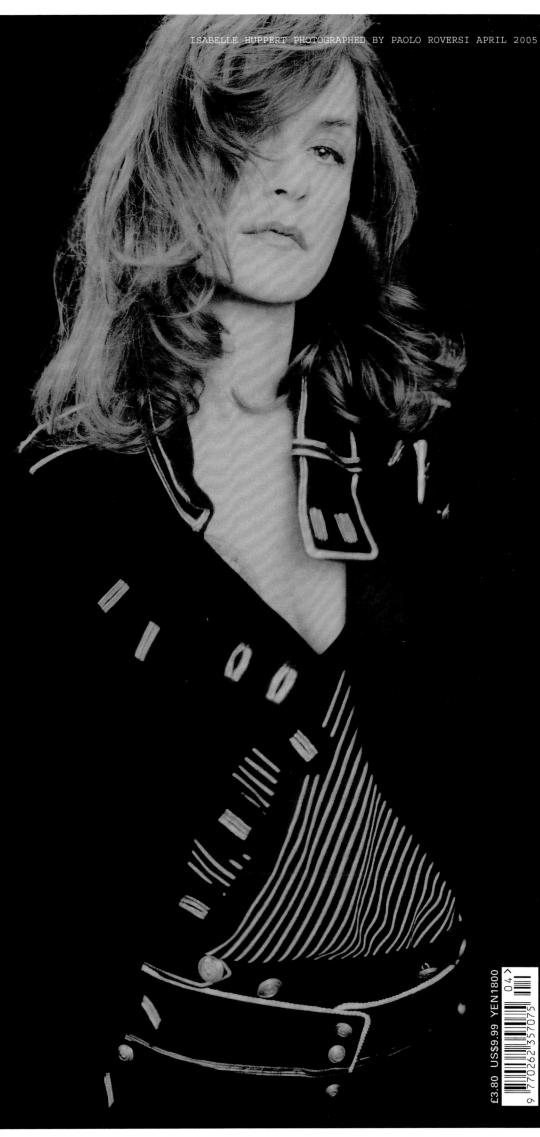

ISABELLE HUPPERT PHOTOGRAPHED BY PAOLO ROVERSI APRIL 2005

i-D

THE MIGRATION ISSUE NO.253

ESCAPE

ISABELLE HUPPERT
PARIS
NICOLAS GHESQUIÈRE
NEW YORK
FISCHERSPOONER
LONDON
JAMIE BELL
RIO
PETE DOHERTY
BERLIN
JACKI-YO
TOKYO
LISYONEY
JUNYA WATANABE
LOS ANGELES
RORY CULKIN
CAPE TOWN
AND MORE
MOSCOW
SHANGHAI
MARRAKECH

£3.80 US$9.99 YEN1800

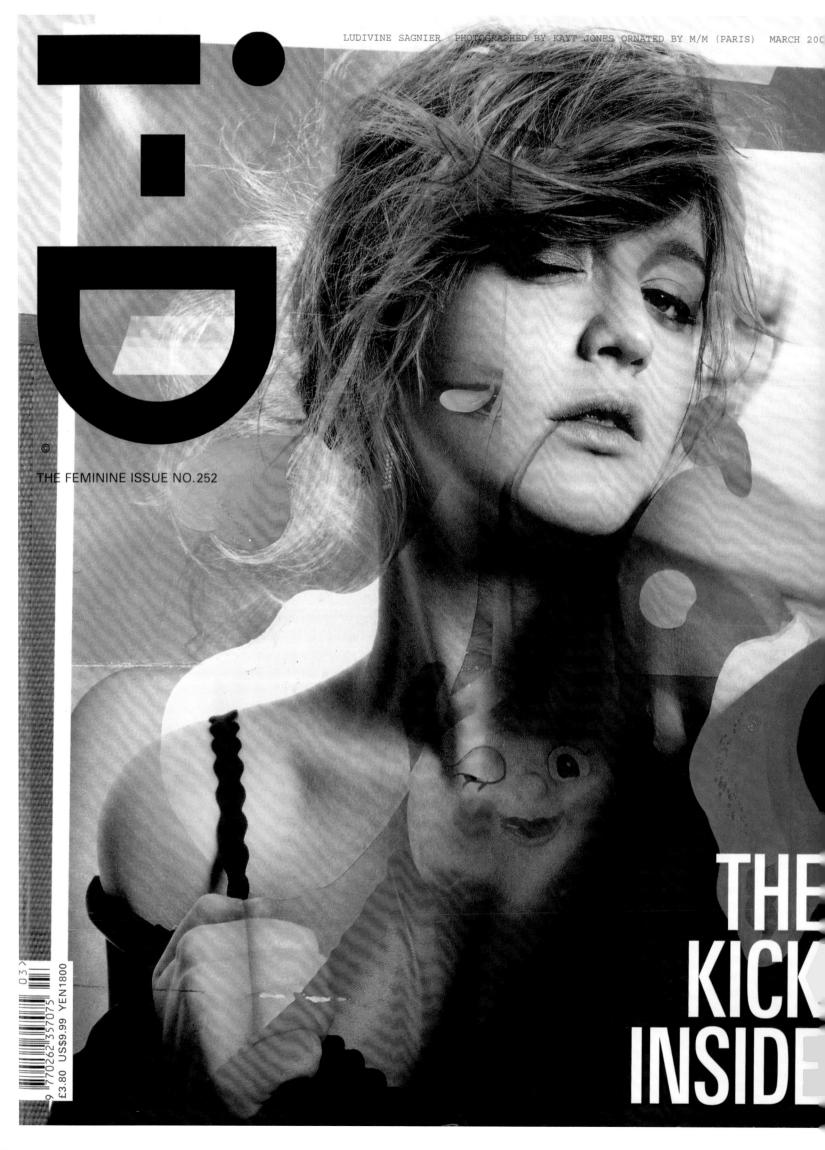

i-D

©

THE FEMININE ISSUE NO. 252

THE
KICK
INSIDE

£3.80 US$9.99 YEN 1800
9 770262 357075
03

The Masculine Issue, No. 251, February 2005
This was the start of Volume Two, which was to cover our next 250 issues. It looks like a fresh start, and the graphics have picked up on the early issues. Alasdair McLellan did a great portrait of Jack McElhone, who reflects fresh talent and a fresh start. It is important to have a cover that is ambiguous, because we have equally male and female readership, but one that is still strongly i-D. This cover marks the theme of identity, which we were to explore throughout the 25th anniversary year. The hidden eye is the hidden side of the personality.
Terry Jones, i-D Founder

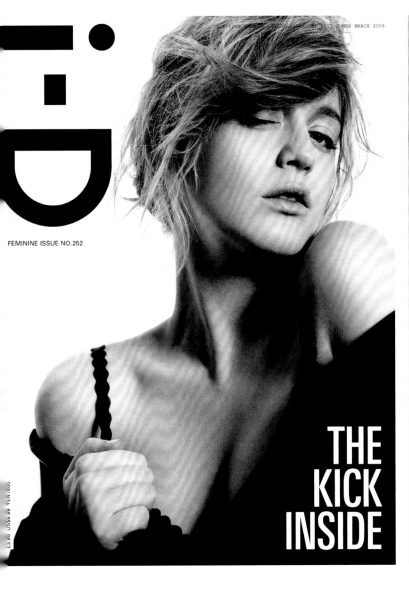

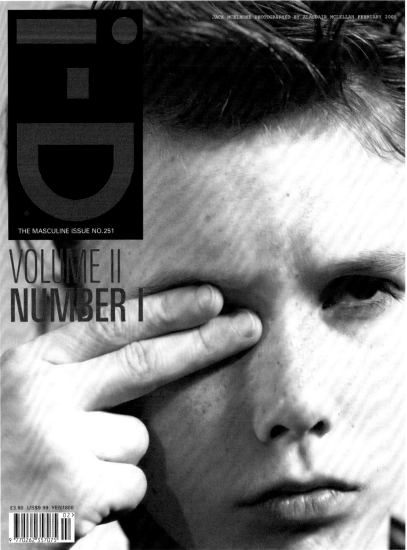

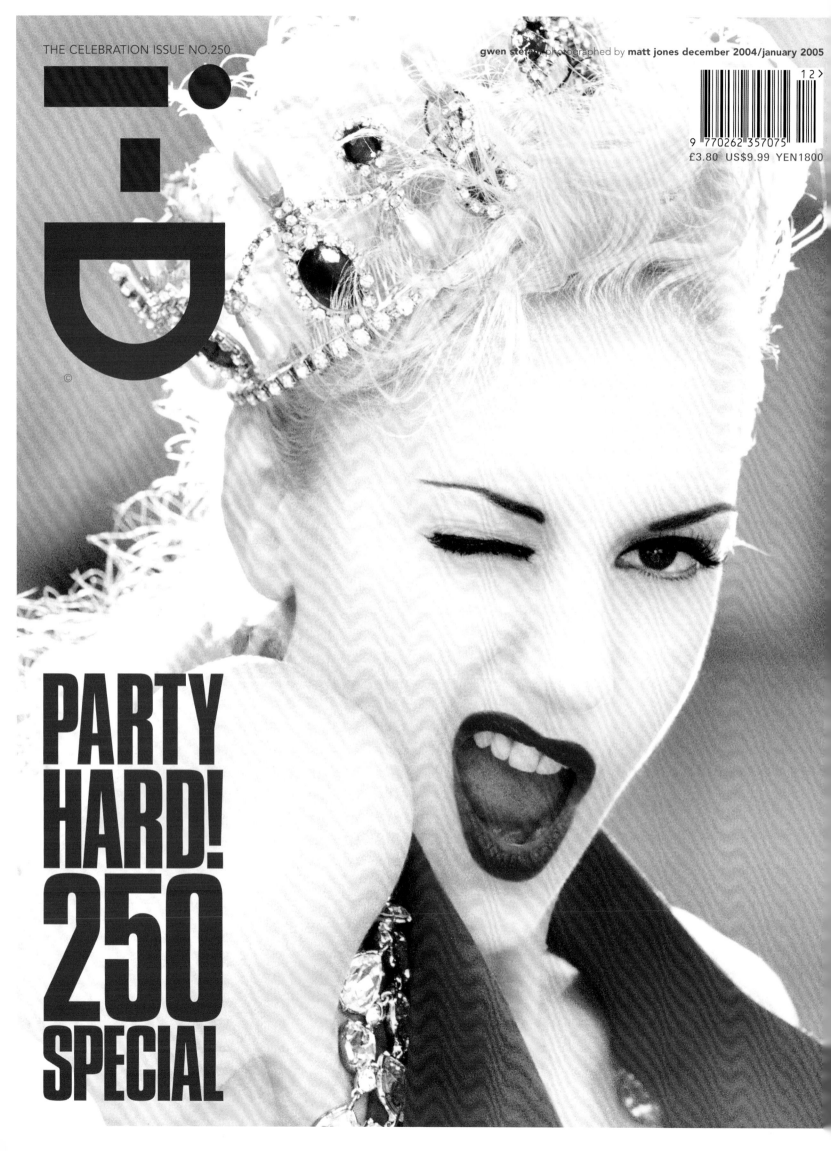

gwen stefani photographed by **matt jones** december **2004**/january **2005**

9 770262 357075

12 ›

£3.80 US$9.99 YEN1800

i-D

©

PARTY HARD! 250 SPECIAL

The Celebration Issue, No. 250, December/January 2004
"Shooting Gwen Stefani in couture in Kentish Town, being serenaded by fans from neighbouring council estates. It was the 250th Special."
Matt Jones, Photographer

The New Dawn Issue, No. 247, September 2004
"We shot the i-D photos at night because Pat McGrath, Edward Enninful, Richard Burbridge and I had such conflicting schedules. Night was the only time we could get together!"
Jessica Stam, Cover Star

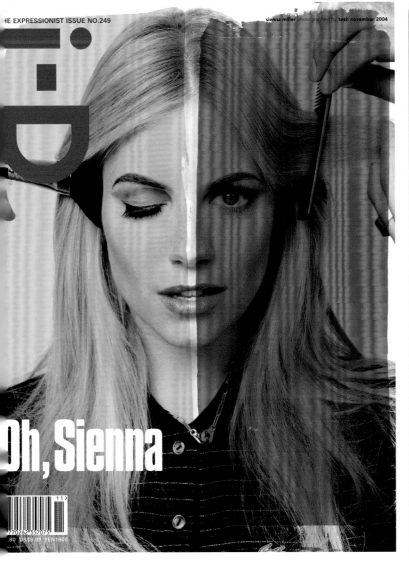

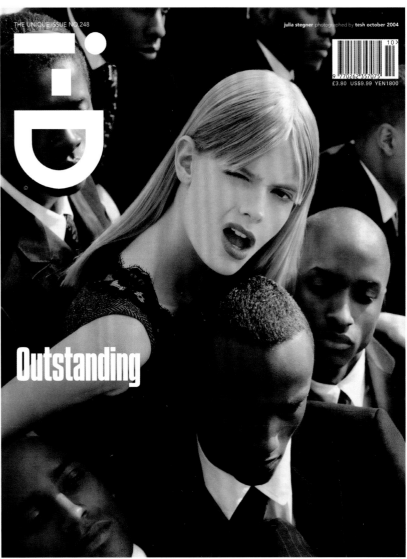

The New Dawn Issue, No. 247, September 2004
This is an outstanding graphic cover. Pat McGrath, our genius beauty director, did the make-up for Jessica Stam – and it is all make-up to achieve this effect. It just jumped off the stand. The issue was significant because it was the start of a new fashion season, a new era, a sunrise issue. We were looking at the eastern influence which a lot of the fashion designers had looked to for their new collections. It was a strong theme and we kept it running throughout the issue including an article about Chinese contemporary art and also a striking fashion story using the actress Maggie Cheung.
Terry Jones, i-D Founder

The New Dawn Issue, No. 247, September 2004
"Wham! Bam! Thank you Stam! This was all about the power of colour. I remember being on holiday and seeing this on news stands… I lived!"
Pat McGrath, Beauty Director, i-D

i-D

©

New dawn New day

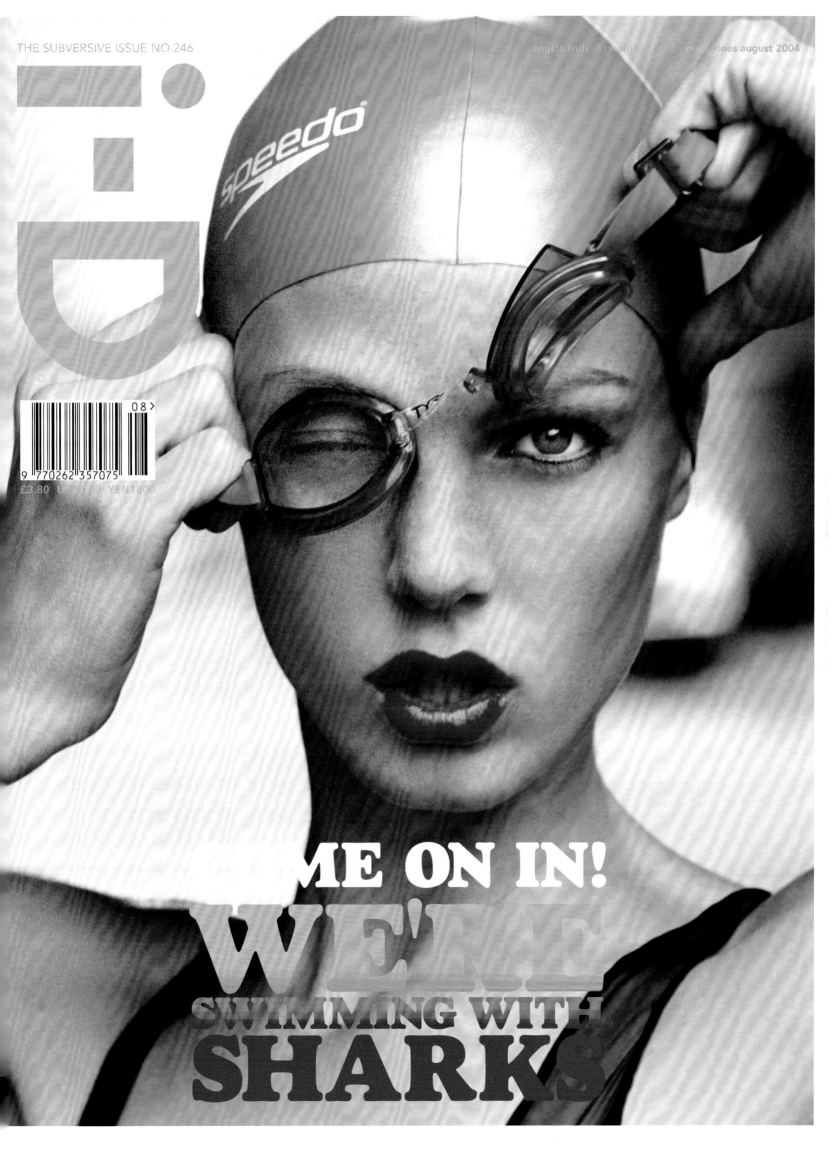

i·D

9 770262 357075

08>

£3.80 U 89 YEN1800

ME ON IN!

WE'RE

SWIMMING WITH

SHARKS

The Subversive Issue, No. 246, August 2004
"My favourite cover is this one shot with Matt Jones on the streets of the Lower West Side in New York City. I was wearing a swimming cap and goggles on my head with red lips. It was very Newton'esque... My fave!"
Angela Lindvall, Cover Star

The Subversive Issue, No. 246, August 2004
"This shot of Angela Lindvall was inspired by one of the more surreal evenings of my life, while sitting with Bob Evans in his (now burnt down) projection room following a screening of *Marathon Man* "bloopers". Bob dug out a favourite of his and Helmut Newton's 60s porn film called *Peaches*."
Matt Jones, Photographer

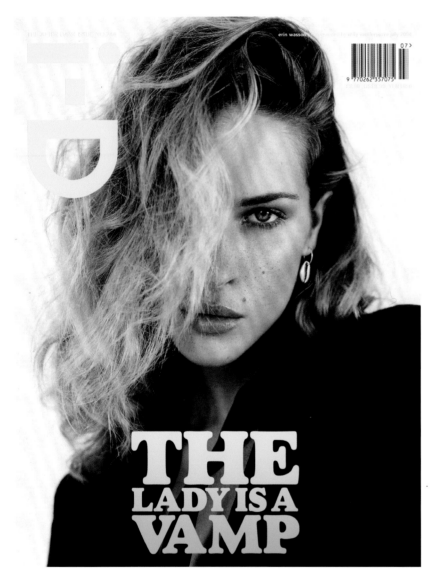

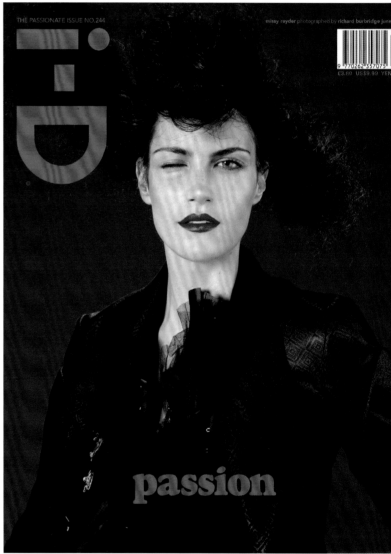

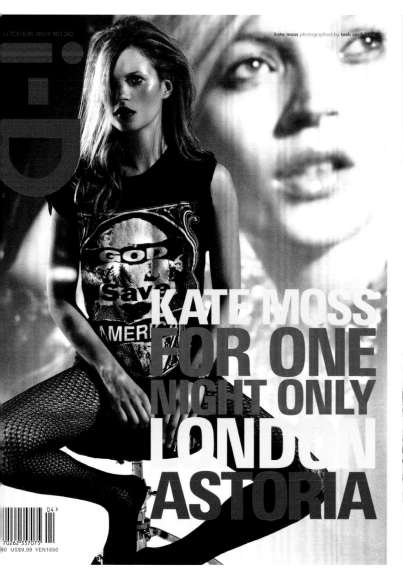

LOCATION ISSUE NO.242

kate moss *photographed by* **tesh** april 2004

i-D

KATE MOSS
FOR ONE
NIGHT ONLY
LONDON
ASTORIA

70262 357075
80 US$9.99 YEN1850
04>

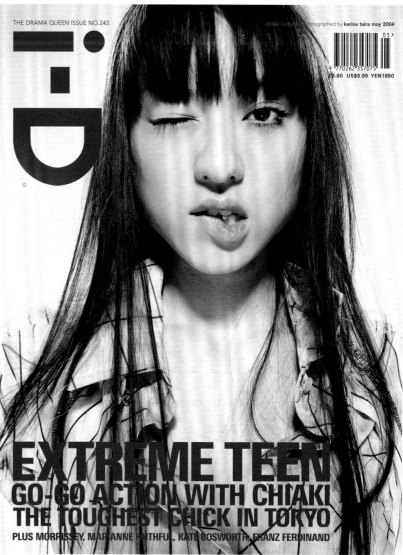

THE DRAMA QUEEN ISSUE NO.243

chiaki kuriyama *photographed by* **karina taira** may 2004

9 770262 357075
£3.80 US$9.99 YEN1850
05>

i-D

EXTREME TEEN
GO-GO ACTION WITH CHIAKI
THE TOUGHEST CHICK IN TOKYO
PLUS MORRISSEY, MARIANNE FAITHFUL, KATE BOSWORTH, FRANZ FERDINAND

Terry Jones in conversation with Alasdair McLellan

Terry: When did you first start working with i-D?
Alasdair: In 2000 I took some club pictures in Harvey Nichols in Leeds…
Then I met Simon Foxton and we did a few things for the March 2001 issue
(The Renaissance Issue, No. 207). My story with Simon involved spray-painting confectionary like Twix and Malteasers onto the models, it was
Simon's idea, and that was the start of me contributing to i-D.

When did you decide to become a photographer?
I was given a camera when I was thirteen. I had some friends round our
house one day and we just started taking pictures of each other – girls and
boys – it was really fun. From then I thought photography might be a nice
job to do.

Did you go to college?
Yes, I did an art foundation course and focused mostly on photography, I
liked drawing and quite liked graphic design but I didn't really like painting. I
just liked taking photographs. I thought it was really fascinating how you
could make a world up through photography, you could do anything you
wanted so long as you got clothes in it. I went to university and studied

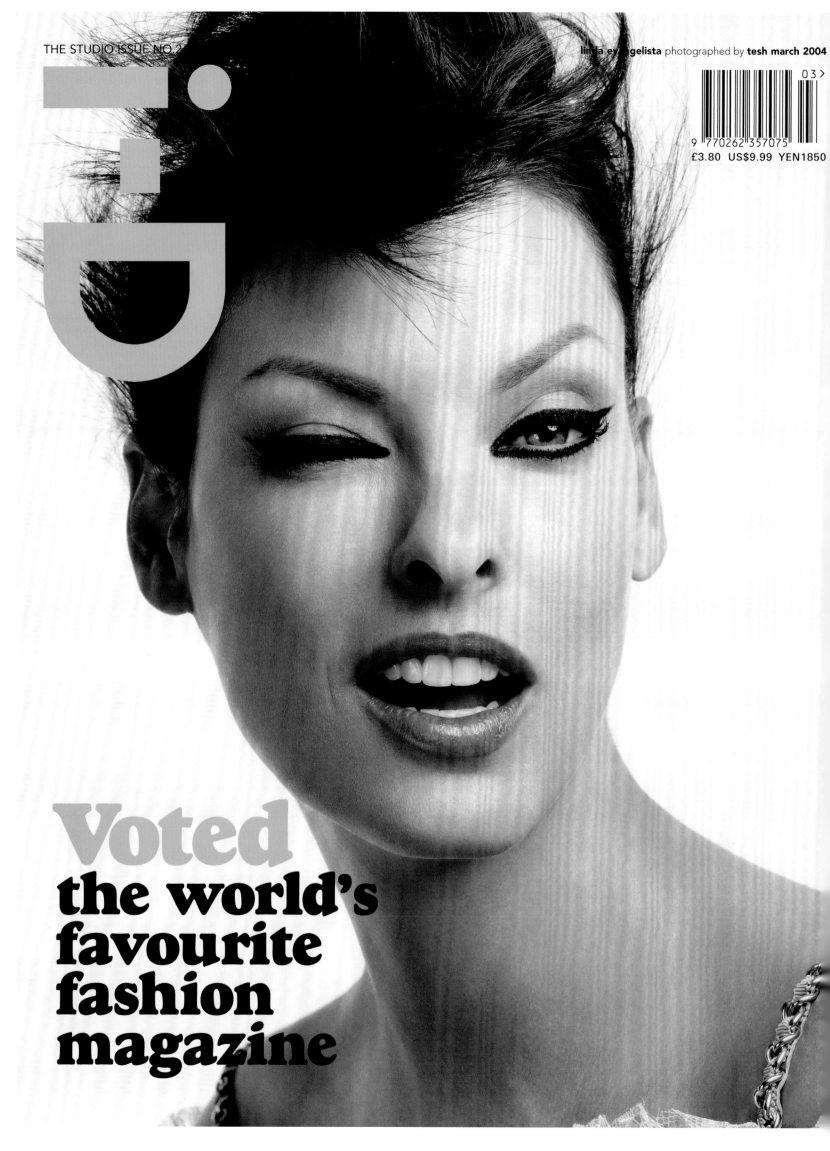

linda evangelista photographed by **tesh march 2004**

03 >

9 770262 357075

£3.80 US$9.99 YEN1850

Voted
the world's
favourite
fashion
magazine

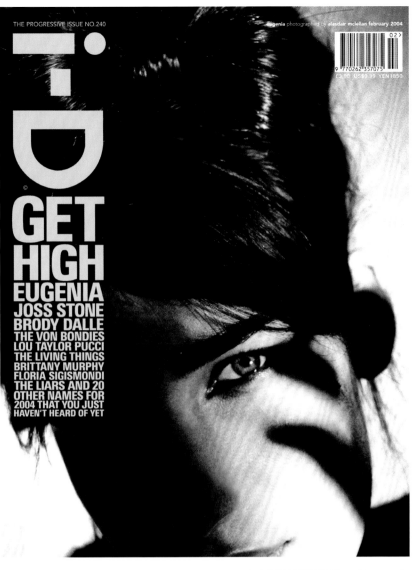

THE PROGRESSIVE ISSUE NO.240

eugenia photographed by alasdair mclellan february 2004

£3.80 US$9.99 YEN1850

i-D

GET HIGH

EUGENIA

JOSS STONE
BRODY DALLE
THE VON BONDIES
LOU TAYLOR PUCCI
THE LIVING THINGS
BRITTANY MURPHY
FLORIA SIGISMONDI
THE LIARS AND 20
OTHER NAMES FOR
2004 THAT YOU JUST
HAVEN'T HEARD OF YET

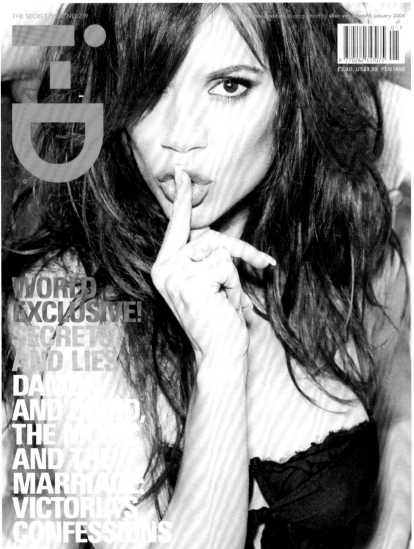

THE SECRET ISSUE NO.239

...beckham photographed by ellen von unwerth january 2004

£3.80 US$9.99 YEN1850

i-D

WORLD
EXCLUSIVE!
SECRETS
AND LIES
DAVID
AND VICTORIA,
THE KISS
AND THE
MARRIAGE:
VICTORIA'S
CONFESSIONS

photography, during which time I got a lot of rubbish pictures out of my system. After that I went back to what I did when I was thirteen, which was taking pictures of my mates. I guess that's still how I approach photography today. I think it's important to have that personal feeling to your pictures, like you're photographing someone rather than somewhere or a piece of clothing.

What's changed since you started?
It's been an amazing decade, but what's changed? I don't think that much. I still approach photography from how I always approached it. I like my pictures to feel personal — it's like photographing a friend.

Has your choice of camera changed?
I still shoot film, I think I'm one of the few photographers who still manages to do that, but I guess I don't use as much 35mm as I used to. I use a lot of 120 now, 67 format. The camera's not changed in ten years. I'm still using the same camera.

Are you ever tempted by digital?
No. I think everyone's pictures tend to look the same on digital. I don't mind shooting digital; I just don't like the end result. It doesn't have the same feeling. There's something weird about it. It takes a long time to make a digital photo look as good as film. The negative is so great because you've got everything you need to make a great picture. I still have a digital processor, but I scan the print in and then retouch from that. But you've got such a great start with the print, whereas with the digital file you've got to put all these curves on it, make it look good. You're constantly going back and forward and it takes a lot longer. I don't think the cost is that different. But, I don't feel that the overall feel of it is as nice. I also feel like everyone gets involved when you shoot digital and everyone's paying attention to the screen and not looking at the girl. I feel they're all looking at the screen going 'oh, that's amazing, but the hair doesn't look quite right, so I should go and change it, but by that point the moment's kind of gone. Whereas, if they were shooting on film they wouldn't necessarily be seeing that moment on screen, so they might pay attention to the hair not looking good because they'd be right there with me, rather than at the screen.

How was your shoot with Lily Allen?
Lily was great. I've shot her once before and she really liked the pictures. Then Ben Reardon asked me to shoot Lily for the cover of i-D. Originally we were going to shoot in her house and around where she lives in North London, but then I got this phone call from Kate Moss saying, 'I'm with Lily now, I'll style her.' We didn't have a stylist, because I didn't really want to use one but Lily said, 'I'm with Kate; Kate wants to style me,' so we all went to Paris and Kate Moss styled Lily. Kate had loads of her own clothes and obviously Kate's a style icon, so she put Lily in some of her own clothes. It was great fun; that was a great day. We had a lovely day at the Ritz in Lily's room.

Tell us a bit more about the shoot?
We did a few pictures outside because it was a lovely day. We were a bit worried because there was a whole sea of paparazzi outside the Ritz. Kate already knew what she wanted to put Lily in for the cover and we thought if we go outside the paparazzi are just going to get us and Kate said, 'Don't worry, I'll get rid of the paparazzi,' so Kate went out before us and of course all the paparazzi followed her. So we were free to shoot Lily, but then we did end up getting papped and I think for about a week I was the new love interest in Lily's life, because they had a picture of me with my arm around her, which made it onto the internet, so I think for a week I was Lily's new boyfriend.

What's so special about shooting a cover for i-D?
Everyone wants to shoot a cover for i-D because it's so iconic. It's probably the best cover concept for a magazine ever. An i-D cover shoot is always good fun — winks should be fun. But it's amazing how many models can't wink. I always think you really want a wink though because when you cover it up with hair or do something over the eye, that's a cop-out; it should be a genuine wink. I enjoyed shooting the Lara [Stone] cover most, she's always really good fun.

Was that your first cover for i-D?
No, the first cover I shot was of the model Eugenia with Olivier Rizzo. We did sixties inspired big hair thing, with a big bow. It was fun. Then I photographed a boy for the cover of the Masculine issue, he was twelve at the time. That was nice too, he was a great kid. He'd just come out of a film with Ewan McGregor and there's always something really great about photographing youth; they've always got a lot of energy. He was brilliant.

Who would you like to see on the cover of i-D in the future?
I guess someone unexpected, like some great new footballer or great new boxer who's got a great face; someone that signifies the times. There's this great kid who plays for Arsenal's youth team, who's very good. But a young Steven Gerrard or Wayne Rooney would have been perfect and I did constantly strive to get them to do it, but they're just not interested. I think an English face like that on an i-D cover would be iconic. Most of the time, and rightly so, i-D covers are models. I think models don't get used enough; I don't love the celebrity culture that's paved its way. I think there's always something great about i-D's early nineties covers, where it's an amazing picture of Linda Evangelista, just healthy, gorgeous and wonderful. Anything like that I'd like to see, just one of those people that have got great faces.

What are your favourite covers?
I really loved the early nineties. It was when I was just getting into photography. I remember being at college and seeing Corinne Day and David Sims' pictures. That had a huge impact on me. It was great to see models like Linda Evangelista and Kate Moss coming through, it felt like there was a great spirit.

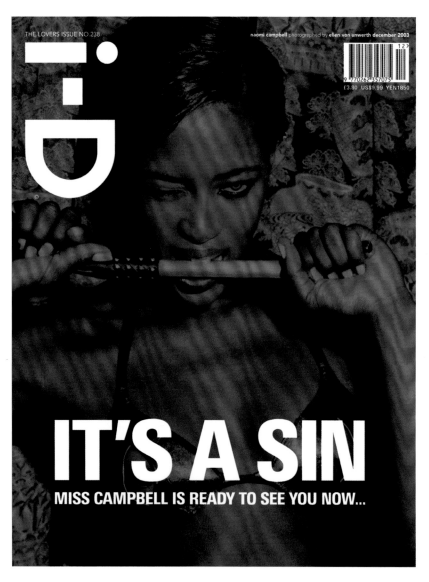

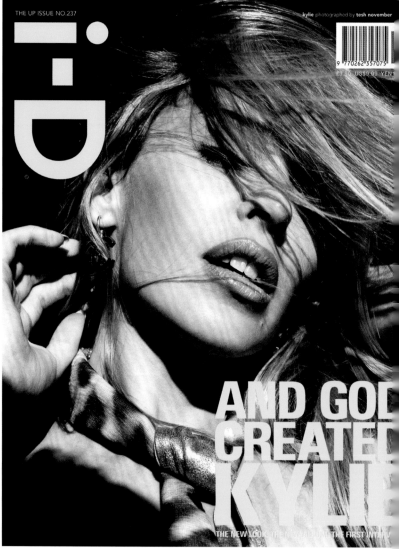

The Lovers Issue, No. 238, December 2003
"This shoot was hilarious. It was me showing my girly side. It was great, we shot into the night and it's where I first met Agyness Deyn. It's always a pleasure shooting with Ellen. I remember they asked me if I would take my hair extensions out and they were so surprised that I did, but you gotta do what you've gotta do to make the picture. It was actually a really fun weekend."
Naomi Campbell, Cover Star

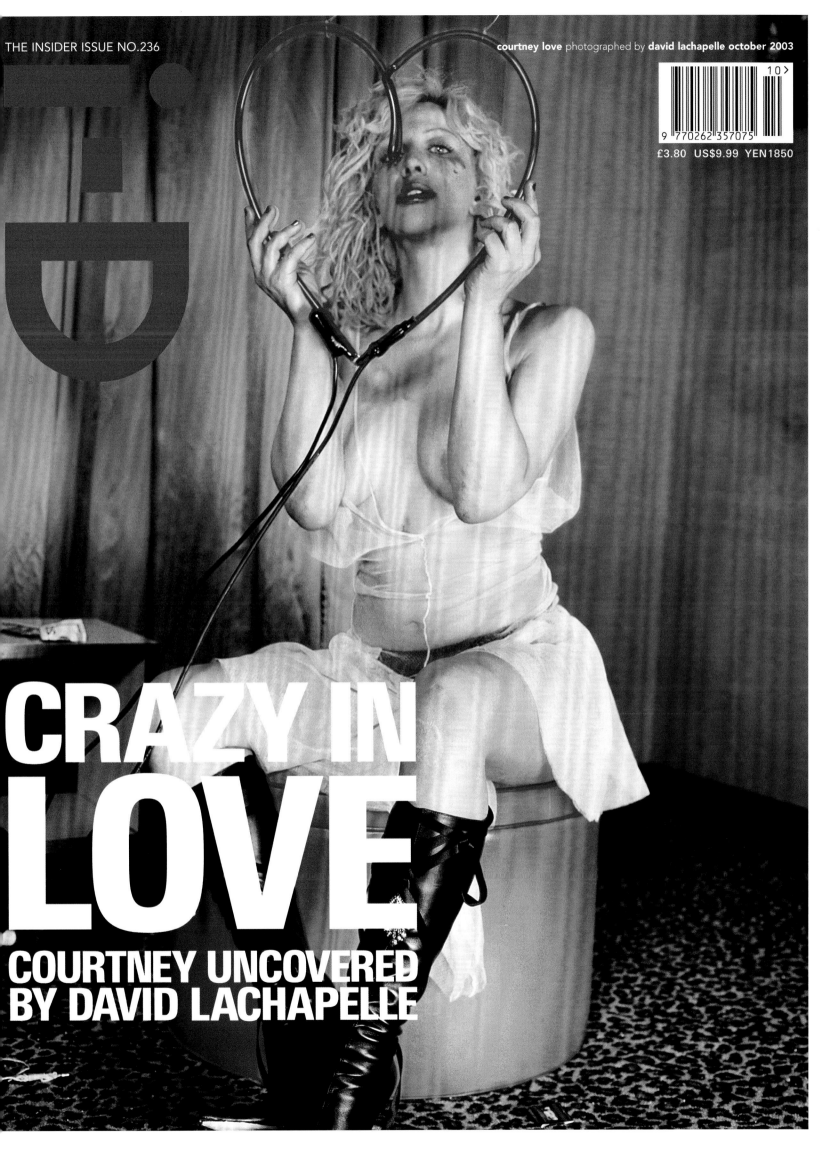

courtney love photographed by david lachapelle october 2003

10>

£3.80 US$9.99 YEN1850

CRAZY IN
LOVE

COURTNEY UNCOVERED
BY DAVID LACHAPELLE

The Straight Up Issue, No. 234, August 2003
"My cover was shot in a forest just outside London. Will Turner had tackled me earlier for a picture and we'd gotten my hair all messed up with leaves. Ellen liked it so we left them in."
Louise Pederson, Cover Star

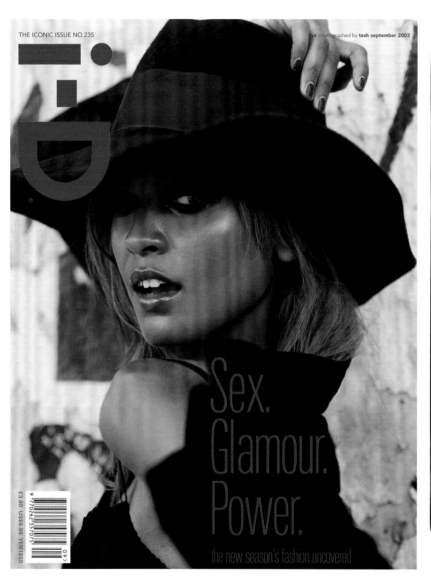

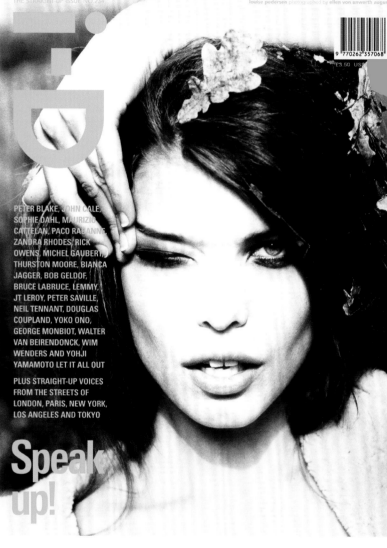

THE ICONIC ISSUE NO.235

liya photographed by **tesh** september 2003

Sex.
Glamour.
Power.

the new season's fashion uncovered

THE STRAIGHT-UP ISSUE NO.234

louise pedersen photographed by ellen von unwerth augus

PETER BLAKE, JOHN CALE,
SOPHIE DAHL, MAURIZIO
CATTELAN, PACO RABANNE,
ZANDRA RHODES, RICK
OWENS, MICHEL GAUBERT,
THURSTON MOORE, BIANCA
JAGGER, BOB GELDOF,
BRUCE LABRUCE, LEMMY,
JT LEROY, PETER SAVILLE,
NEIL TENNANT, DOUGLAS
COUPLAND, YOKO ONO,
GEORGE MONBIOT, WALTER
VAN BEIRENDONCK, WIM
WENDERS AND YOHJI
YAMAMOTO LET IT ALL OUT

PLUS STRAIGHT-UP VOICES
FROM THE STREETS OF
LONDON, PARIS, NEW YORK,
LOS ANGELES AND TOKYO

Speak
up!

The Iconic Issue, No. 235, September 2003
"This cover photographed by Tesh is actually one of my favourite covers. It was very exciting, very sexy and very beautiful. We shot it in Berlin and I wore a blonde wig, which was kind of crazy, but looked really beautiful.
Liya Kebede, Cover Star

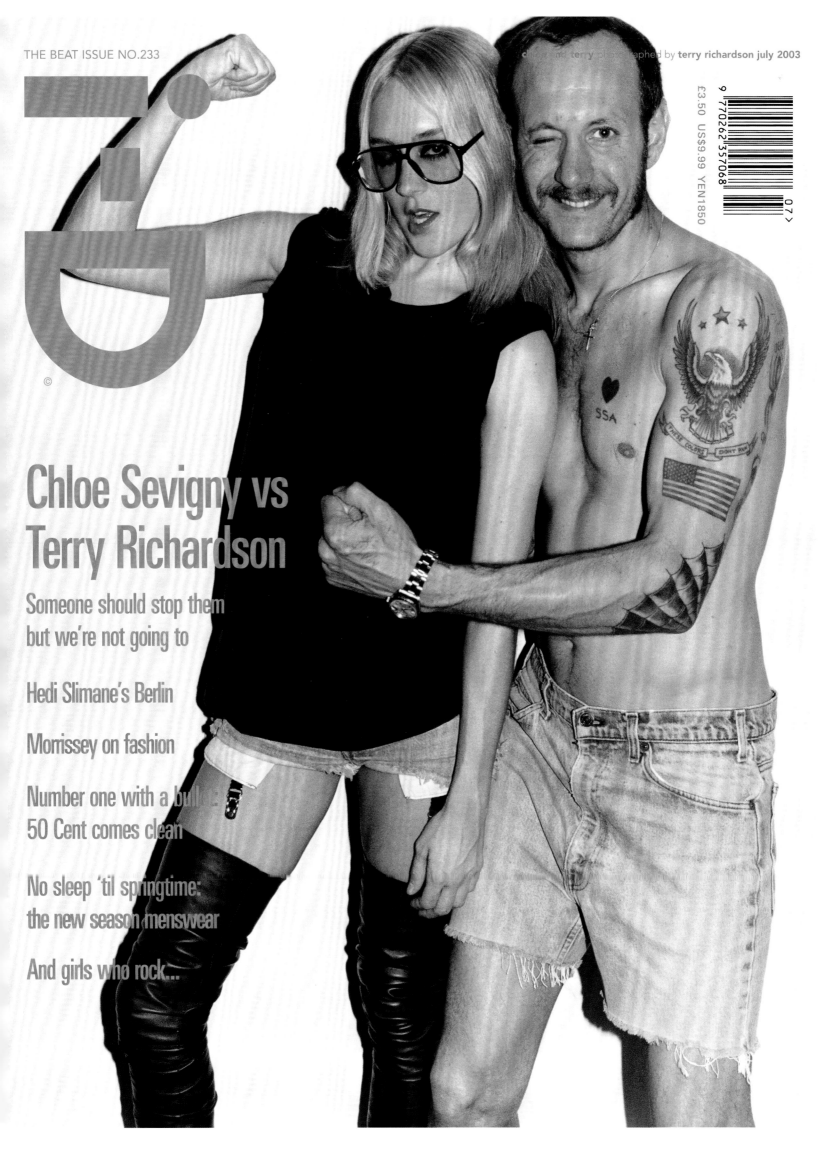

THE BEAT ISSUE NO.233

i-D.

©

chloe and terry photographed by **terry richardson july 2003**

£3.50 US$9.99 YEN1850

9 770262 357068

07

Chloe Sevigny vs Terry Richardson

Someone should stop them
but we're not going to

Hedi Slimane's Berlin

Morrissey on fashion

Number one with a bullet:
50 Cent comes clean

No sleep 'til springtime:
the new season menswear

And girls who rock...

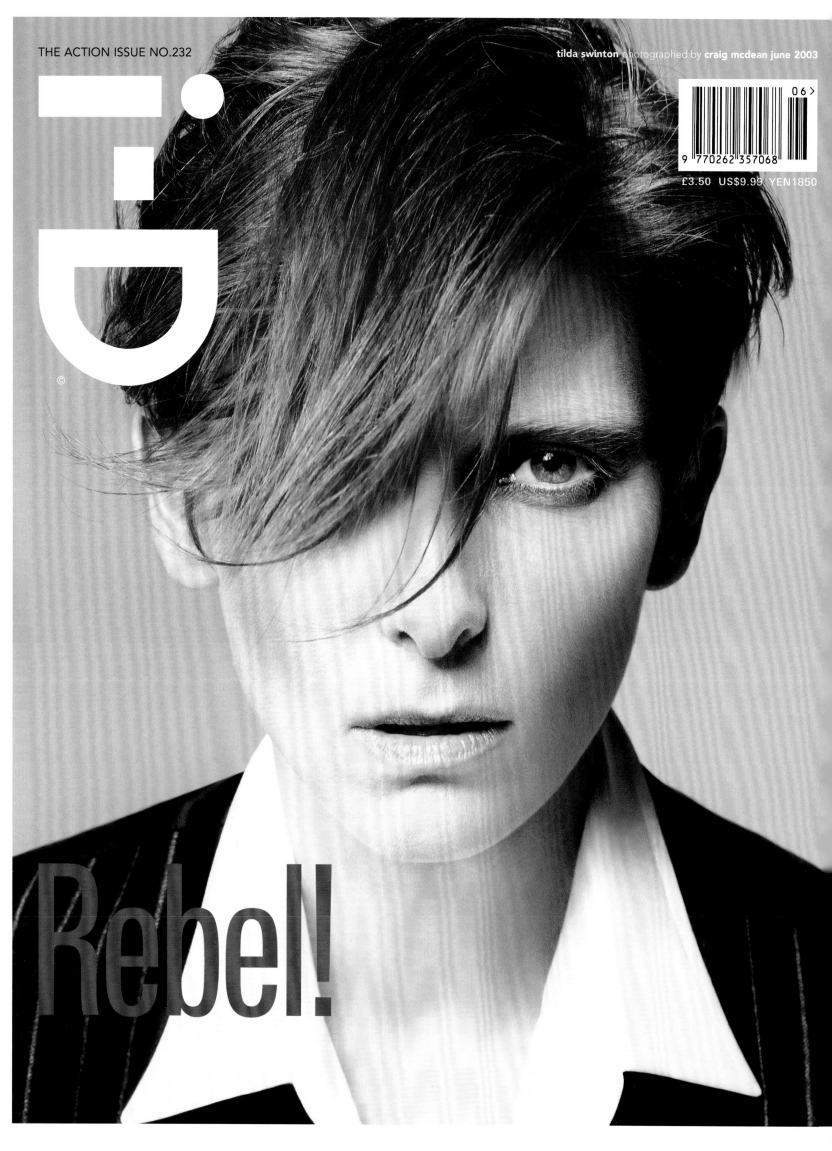

THE ACTION ISSUE NO.232

tilda swinton photographed by **craig mcdean** june 2003

£3.50 US$9.99 YEN 1850

9 770262 357068

06 >

i·D

Rebel!

The Action Issue, No. 232, June 2003
The cover shot is of Tilda Swinton, an older woman with a really strong presence. This was our 'Rebel' issue and was very timely with the start of the Iraq war. Inside, we had a 'Not In Our Name' section curated by Tricia. The issue was a fantastic response to the war, with people putting their voices into print. We felt there was very little being done explicitly in the fashion industry, although people felt the same way about the events going on around them. We are against any war, but in particular the Iraq war because it was so unnecessary and has created more problems that it has solved. It is not a normal theme to run in a fashion magazine, and we had an amazing response.
Terry Jones, i-D Founder

The Beach Issue, No. 229, March 2003
"The photo shoot was on Saint Barths, which is one of my favourite islands. The location was breathtaking and the team were so much fun. I remember thinking how funny it was that I am a blonde, but for the shoot I wore a jet black wig!"
Dewi Driegen, Cover Star

The Physical Issue, No. 231, May 2003
"My memories from my i-D cover shoot are just how fun and free it was! We literally threw on some clothes and went out to the Tuileries in Paris and I just went wild. The theme was 'Let's get physical', so I tried to mix the vibe of this beautiful scenery in Paris with some physical, high fashion poses. I couldn't be happier with how it turned out! I'll always remember the day!"
Jessica Miller, Cover Star

The Artistic Issue, No. 228, February 2003
"I love this cover because of the soup tin! I've always tried to collect anything with Campbell's on it... within reason of course, because Warhol is so expensive! It was a great collection that Philip Treacy did and I loved all the hats from this collection. Michael Boadi did the hair on this and again he was model booker, art director, everything! We love Michael, he was so much more than a hairdresser. He had such passion and always gave 110%."
Naomi Campbell, Cover Star

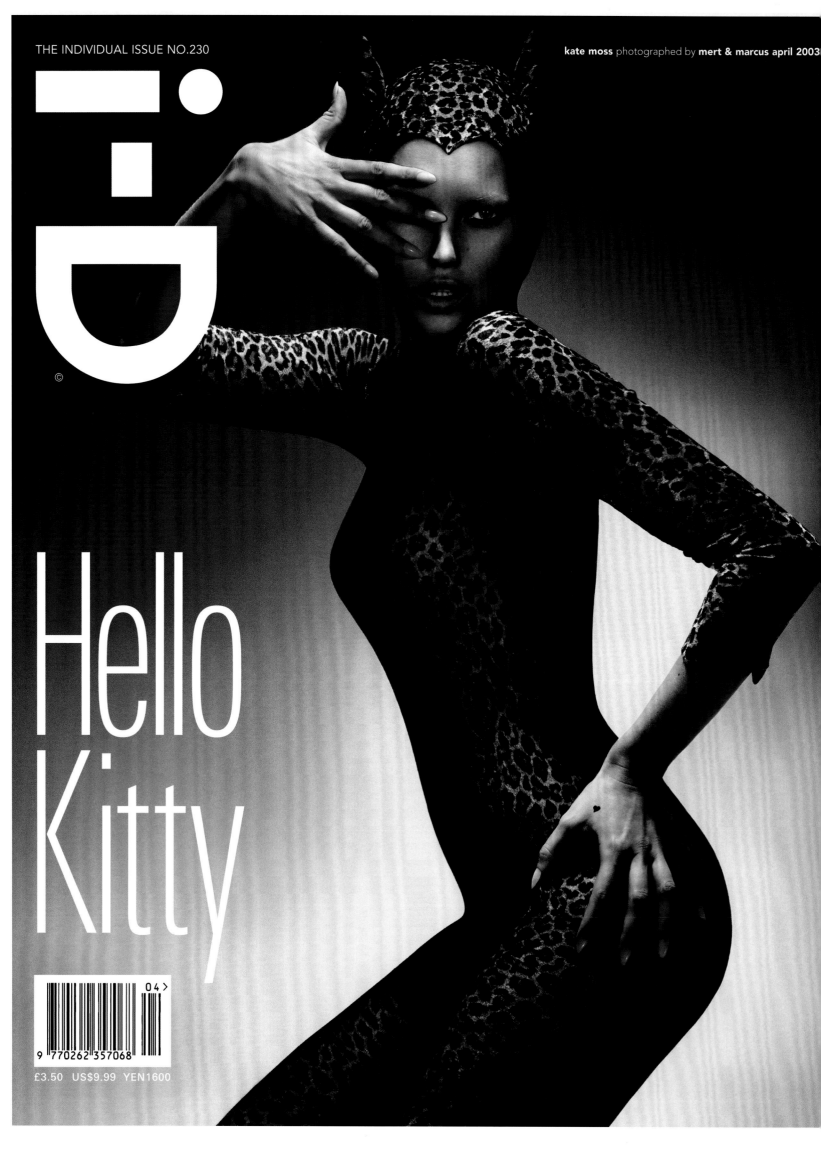

THE INDIVIDUAL ISSUE NO.230

kate moss photographed by mert & marcus april 2003

Hello Kitty

9 770262 357068

04 >

£3.50 US$9.99 YEN1600

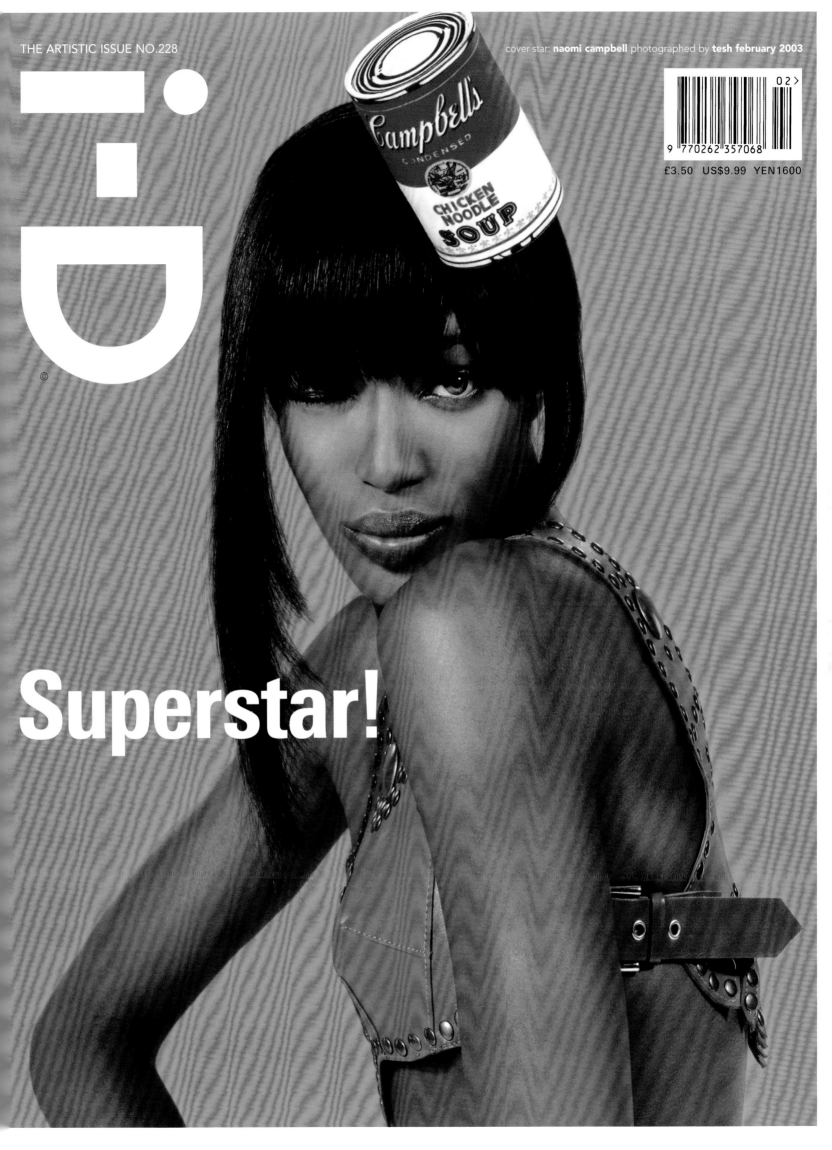

cover star: **naomi campbell** photographed by **tesh february 2003**

02>

9 770262 357068

£3.50 US$9.99 YEN1600

i-D

Superstar!

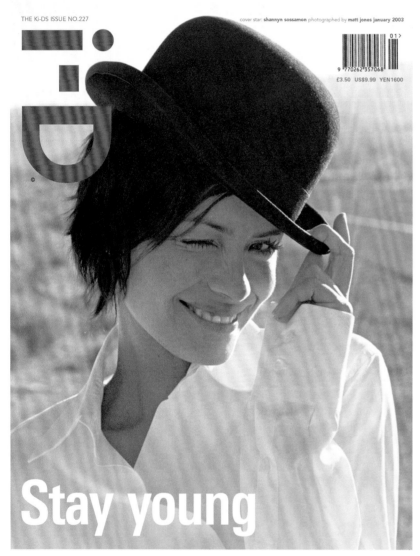

THE Ki-DS ISSUE NO.227 cover star: **shannyn sossamon** photographed by **matt jones january 2003**

£3.50 US$9.99 YEN1600

Stay young

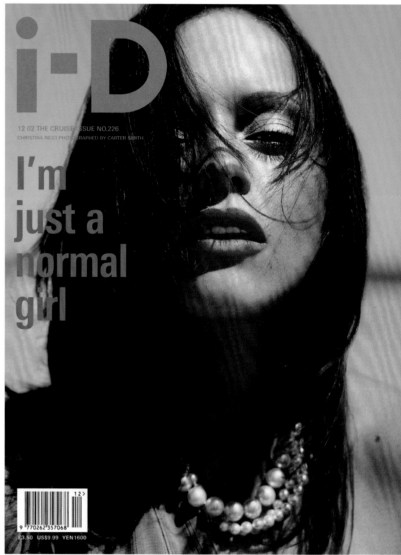

12 02 THE CRUISE ISSUE NO.226

CHRISTINA RICCI PHOTOGRAPHED BY CARTER SMITH

I'm just a normal girl

£3.50 US$9.99 YEN1600

The Ki-Ds Issue, No. 227, January 2003

"I'd met Shannyn Sossamon before and we'd hit it off, so we decided to take a road trip from LA back to her parents' house in Reno. This picture was taken at six in the morning and anyone who knows me, knows that I am notoriously crap before 10am and a large cup of coffee!"

Matt Jones, Photographer

The Cruise Issue, No. 226, December 2002

"We shot that cover on Coney Island. It was on a freezing fall day. We ate cheese fries to keep warm. Christina was up for it though, she would have done anything we asked her to. It was about the third or fourth shoot Christina and I had done together that year and we just had fun. I love the way she looks in that picture because SHE was having so much fun when we took it. That's how I remember it anyway..."

Carter Smith, Photographer

The Substance Issue, No. 224, October 2002
"Graphic! Black! Amber!"
Pat McGrath, Beauty Director, i-D

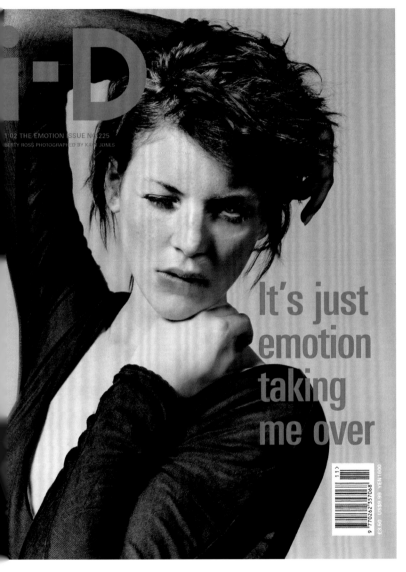

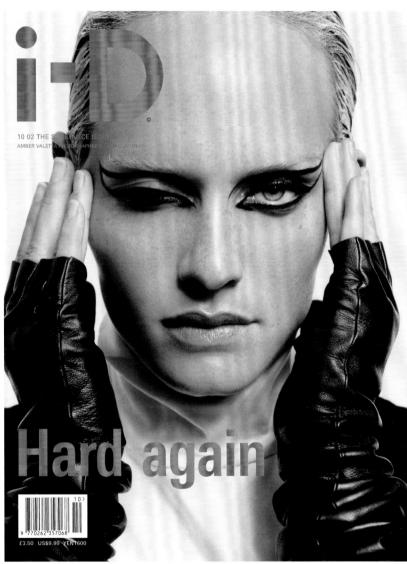

The Emotion Issue, No. 225, November 2002
"Liberty Ross is an incredible model. We shot the story in London, and in Paris in a studio that I love that used to be Peter Lindbergh's studio. I think Liberty has classic movie-star looks and quality, with a real sense of how to create a role in front of the camera. I would always tell her she should go into acting, something she is now doing. I've shot Liberty many times since then; she's become something of a muse to me, and now that we both live in LA, one of my best friends too."
Kayt Jones, Photographer and i-D LA Editor

The Emotion Issue, No. 225, November 2002
"Kayt and I had been shooting together lots around the time we did this cover – we started the shoot in Paris and finished it in London. Apart from it being such fun to do (Kayt and I basically playing around, doing what we love and do best) it's one of those covers that seems to be referenced on almost every shoot I've done since – 'Can we do the hair like this?', 'We want a similar attitude...' It's funny to look back on because since then both Kayt and I have got married, had babies and moved to Los Angeles where we are now best friends and spend most weekends together!"
Liberty Ross, Cover Star

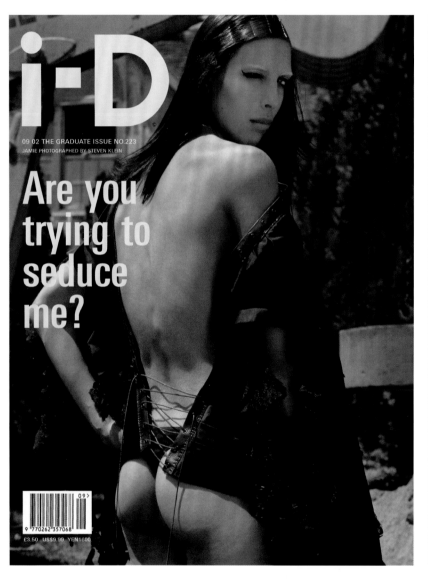

i-D

09 02 THE GRADUATE ISSUE NO.223
JAMIE PHOTOGRAPHED BY STEVEN KLEIN

Are you
trying to
seduce
me?

£3.50 US$9.99 YEN1600

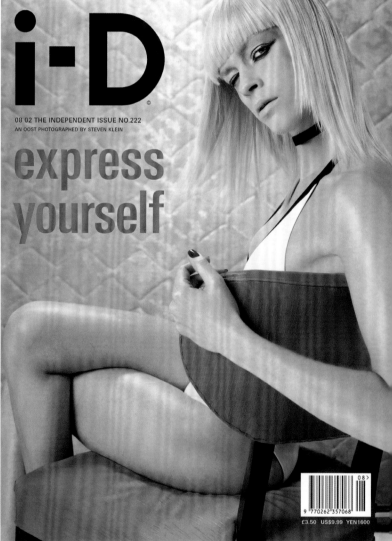

i-D

08 02 THE INDEPENDENT ISSUE NO.222
AN OOST PHOTOGRAPHED BY STEVEN KLEIN

express
yourself

£3.50 US$9.99 YEN1600

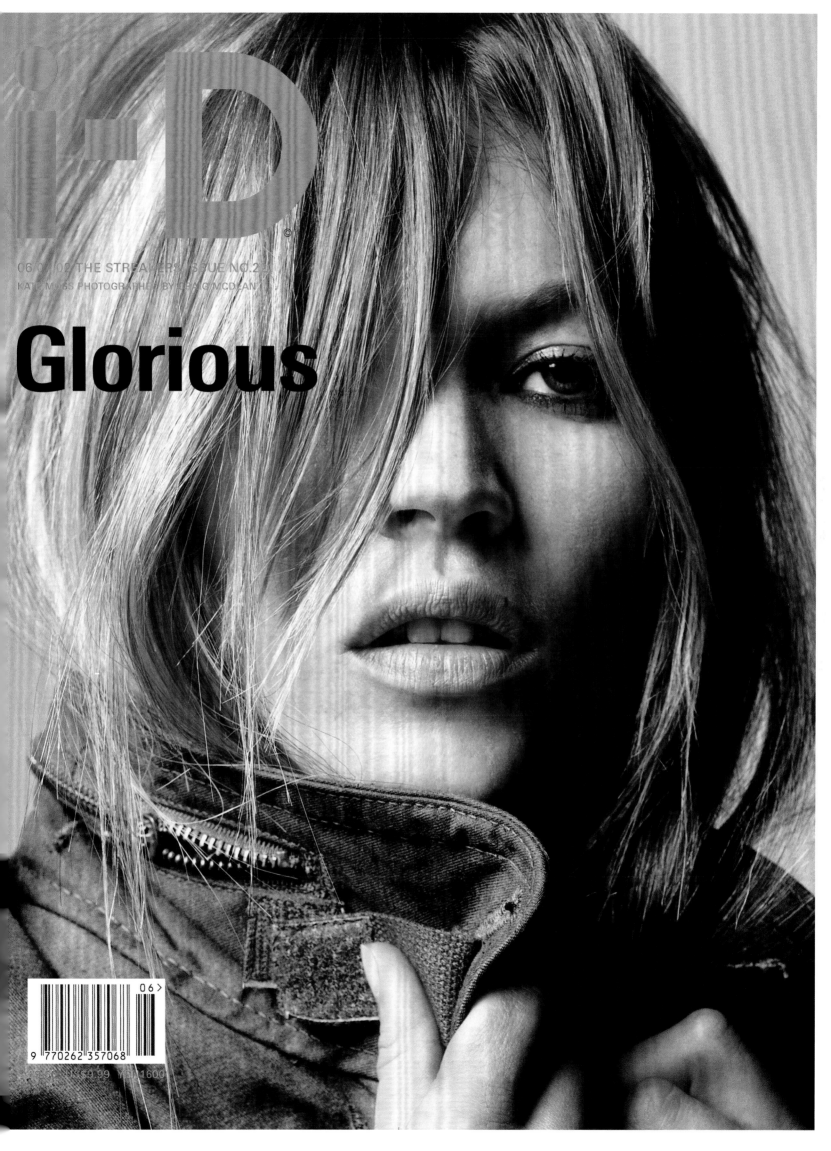

i-D

06/07/02 THE STREAKERS ISSUE NO.2
KATE MOSS PHOTOGRAPHED BY CRAIG MCDEAN

Glorious

06>

9 770262 357068

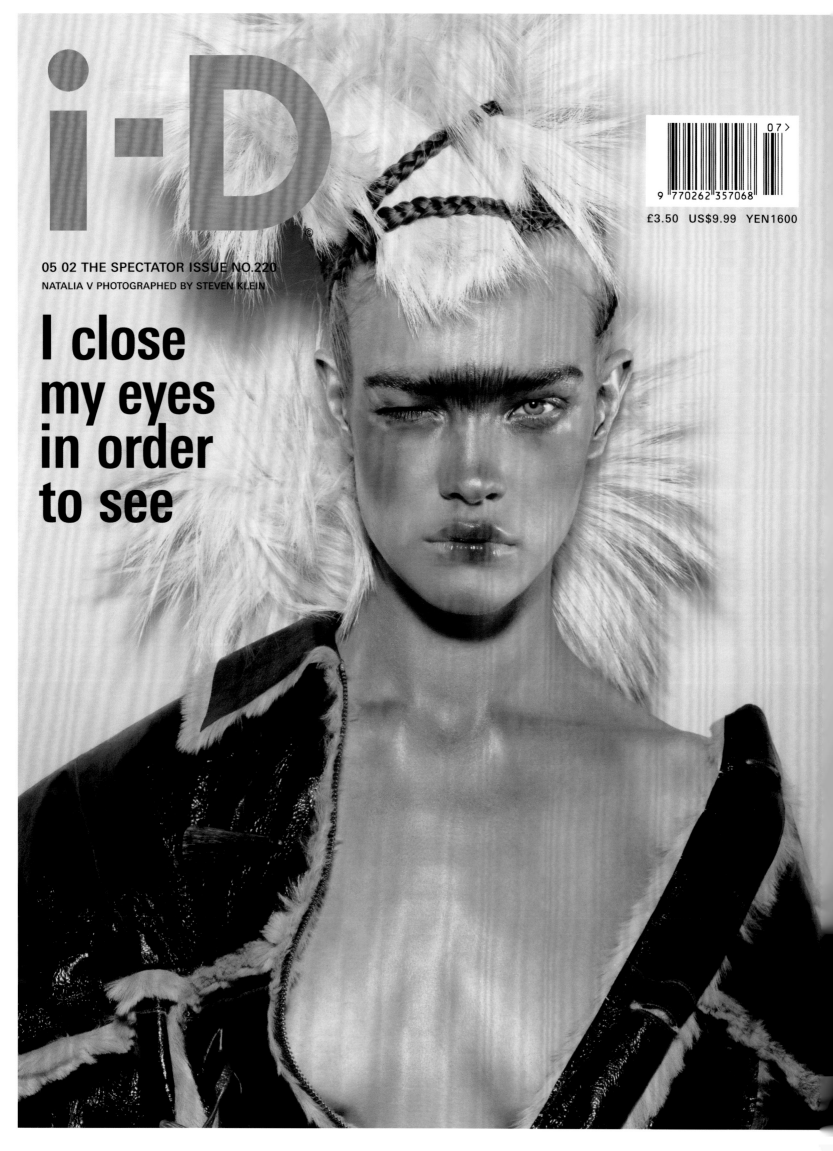

i-D©

05 02 THE SPECTATOR ISSUE NO.220
NATALIA V PHOTOGRAPHED BY STEVEN KLEIN

I close my eyes in order to see

£3.50 US$9.99 YEN1600

9 770262 357068

07>

The Spectator Issue, No. 220, May 2002
"Natalia Vodianova: powerful, tribal beauty from the Galliano show."
Pat McGrath, Beauty Director, i-D

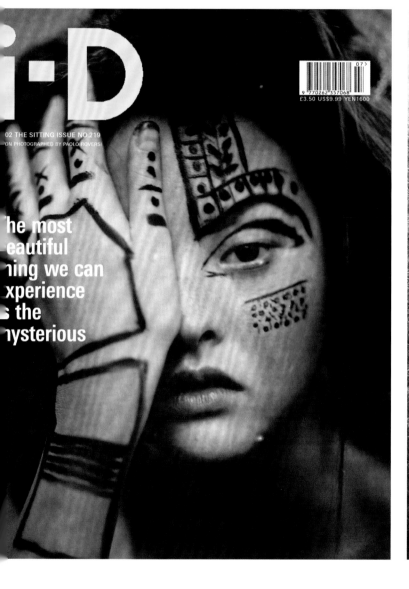

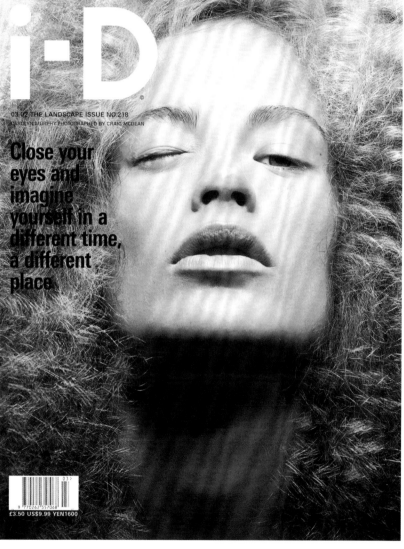

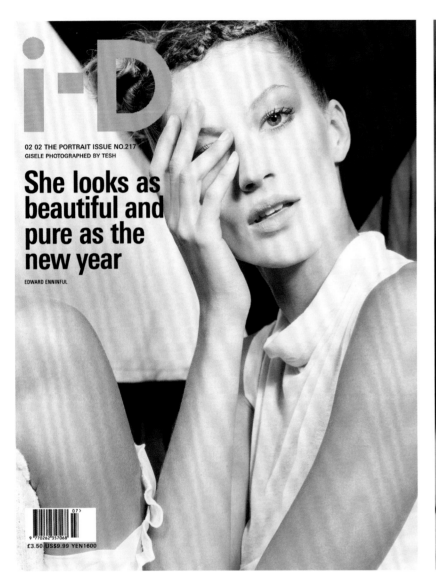

i-D

02 02 THE PORTRAIT ISSUE NO.217
GISELE PHOTOGRAPHED BY TESH

**She looks as
beautiful and
pure as the
new year**

EDWARD ENNINFUL

£3.50 US$9.99 YEN1600

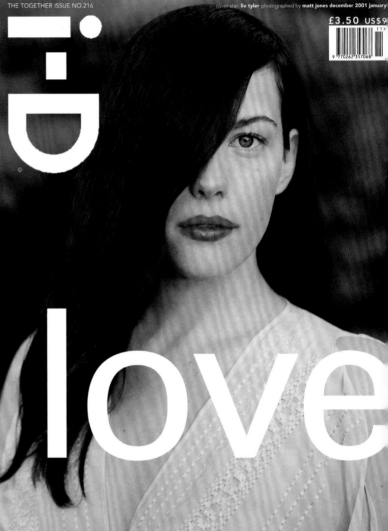

cover star: **liv tyler** photographed by **matt jones december 2001 january**

£3.50 US$9

i-D

love

The Together Issue, No. 216, December/January 2002
"Liv introduced me to Woodstock – one of my favourite
places in the world."
Matt Jones, Photographer

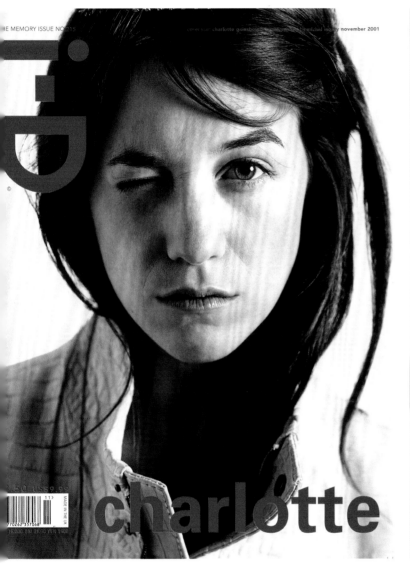

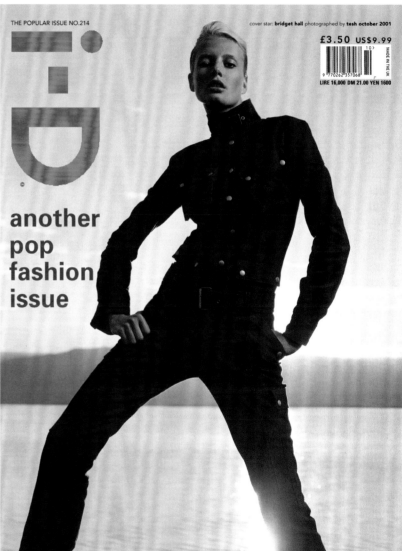

The Bedroom Issue, No. 213, September 2001
"This was one of the last photo shoots Aaliyah did before she was killed in a plane crash. She was so young; it was crazy. The cover came out days after the accident; it was already at the printers when she died. I remember hearing the news and not believing it."
Matt Jones, Photographer

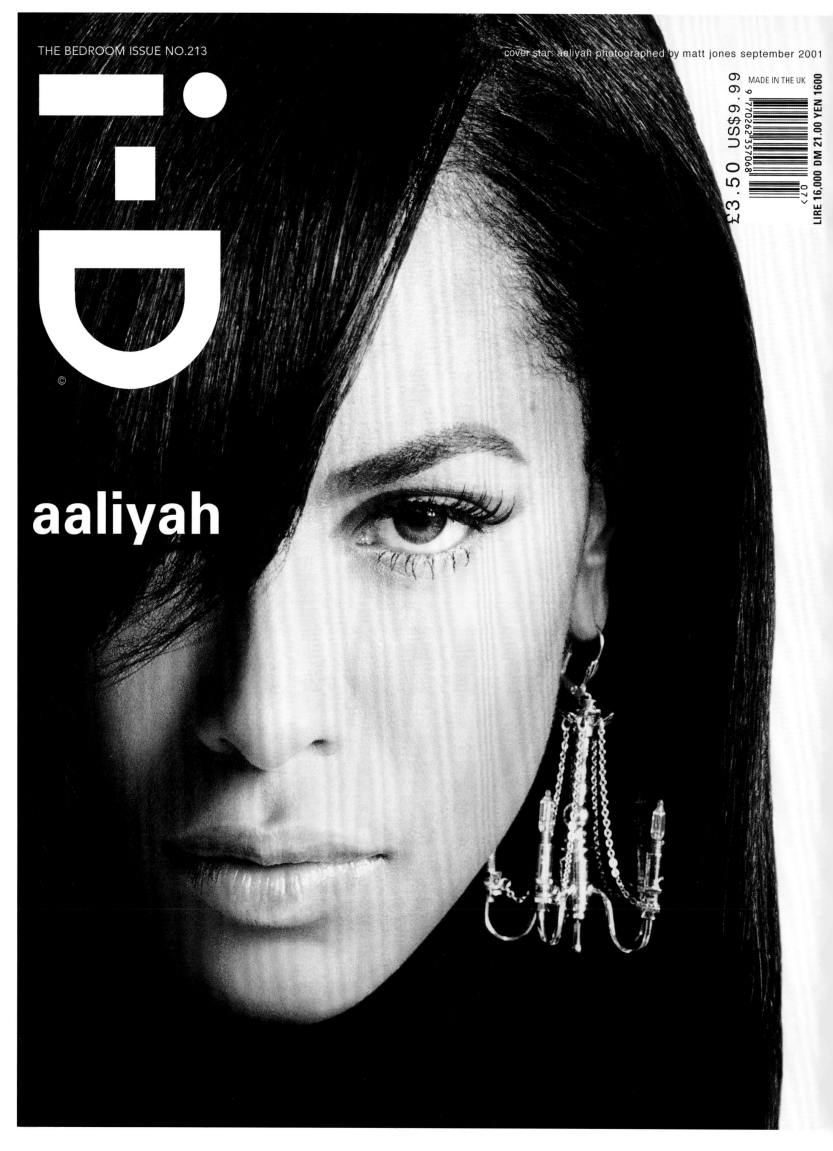

MADE IN THE UK

£3.50 US$9.99 LIRE 16,000 DM 21.00 YEN 1600

9 770262 357068

07>

i-D

©

aaliyah

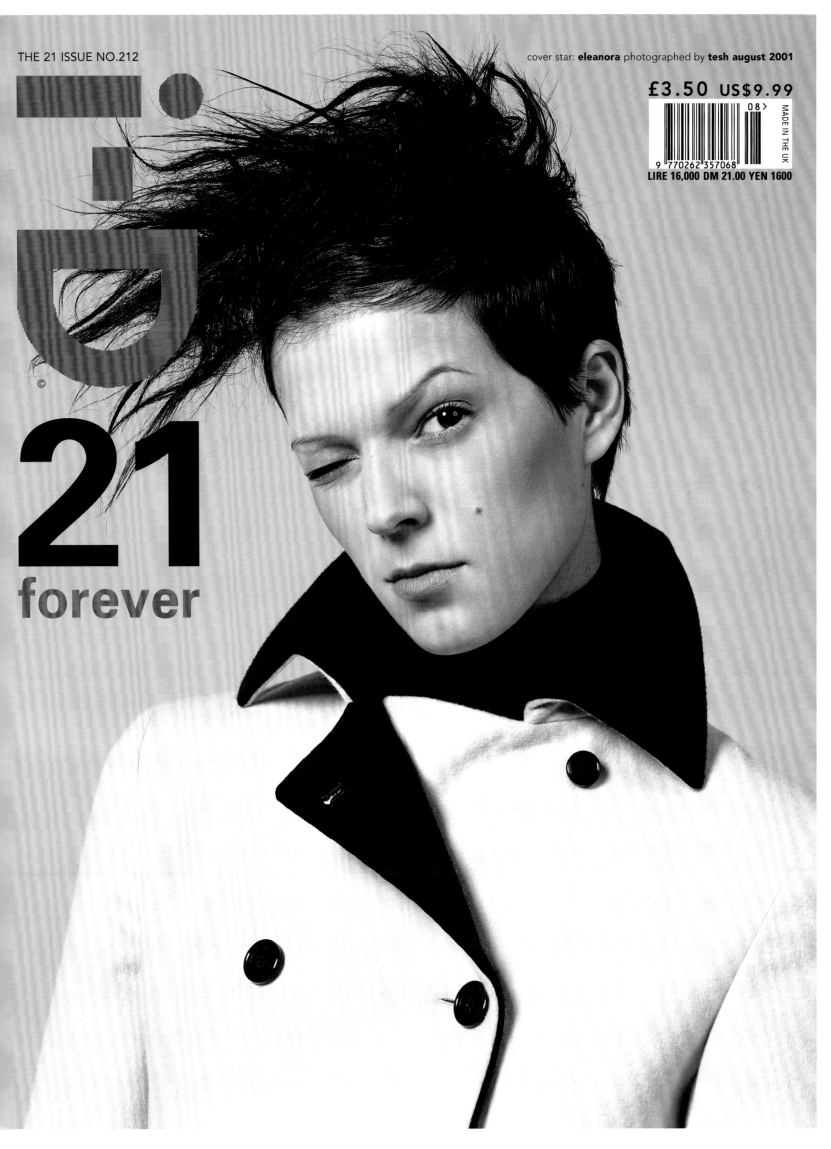

cover star: **eleanora** photographed by **tesh august 2001**

£3.50 US$9.99

MADE IN THE UK

9 770262 357068

08>

LIRE 16,000 DM 21.00 YEN 1600

21
forever

THE MAN AND BEAST ISSUE NO.211

cover stars: tom and john ford photographed by terry richardson july 2001

i-D

©

MADE IN THE UK

£3.50 US$9.99

LIRE 16,000 DM 21.00 YEN 1600

9 770262 357068

tom and john

The Man and Beast Issue, No. 211, July 2001

"I was sleeping when the doorbell rang. It was Terry Richardson, I was so happy to see him I jumped up and down wagging my tail, but then I did that when anyone was at the door. Terry had come to photograph Tom for an i-D cover. At some point during the session, Terry said, "What about John in the photo?" At first I was thrilled at the attention, but then I thought, "No way, this is Terry Richardson, if he doesn't get naked and show his bits in front of the camera he will certainly expect me to." I wasn't that kind of dog. At first the shot of Tom and me together wasn't working, so Terry

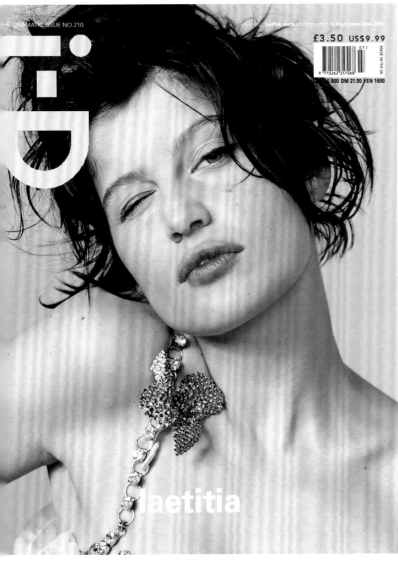

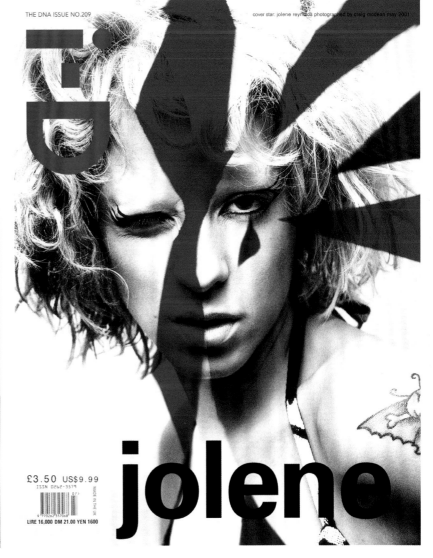

said, "John, open your mouth a little, it's sexier." The thought of me doing full on Linda Evangelista was so preposterous, I burst out laughing.
FLASH! It was done."
John Buckley-Ford, Cover Star

The Cinematic Issue, No. 210, June 2001
"Laetitia Casta was already a huge star in France, but not so well known in the UK. My first two covers had just sort of happened, but this was one that I knew from the beginning I wanted to be a cover. We went to Paris to shoot and Laetitia was amazing, an ideal of French femininity. She had just been selected as a symbol of the French Republic by the Mayor's association of France! The shoot was very playful. She was alternately girly and very boyish. The fact that she was so raw and unselfconscious spoke of her tremendous confidence and generosity. Everything she said was adorable; she just had this way about her that had everybody falling in love with her. I couldn't quite believe anyone could be that cute."
Kayt Jones, Photographer and i-D LA Editor

The DNA Issue, No. 209, May 2001
"Super-cool Jolene. I've always loved her music."
Pat McGrath, Beauty Director, i-D

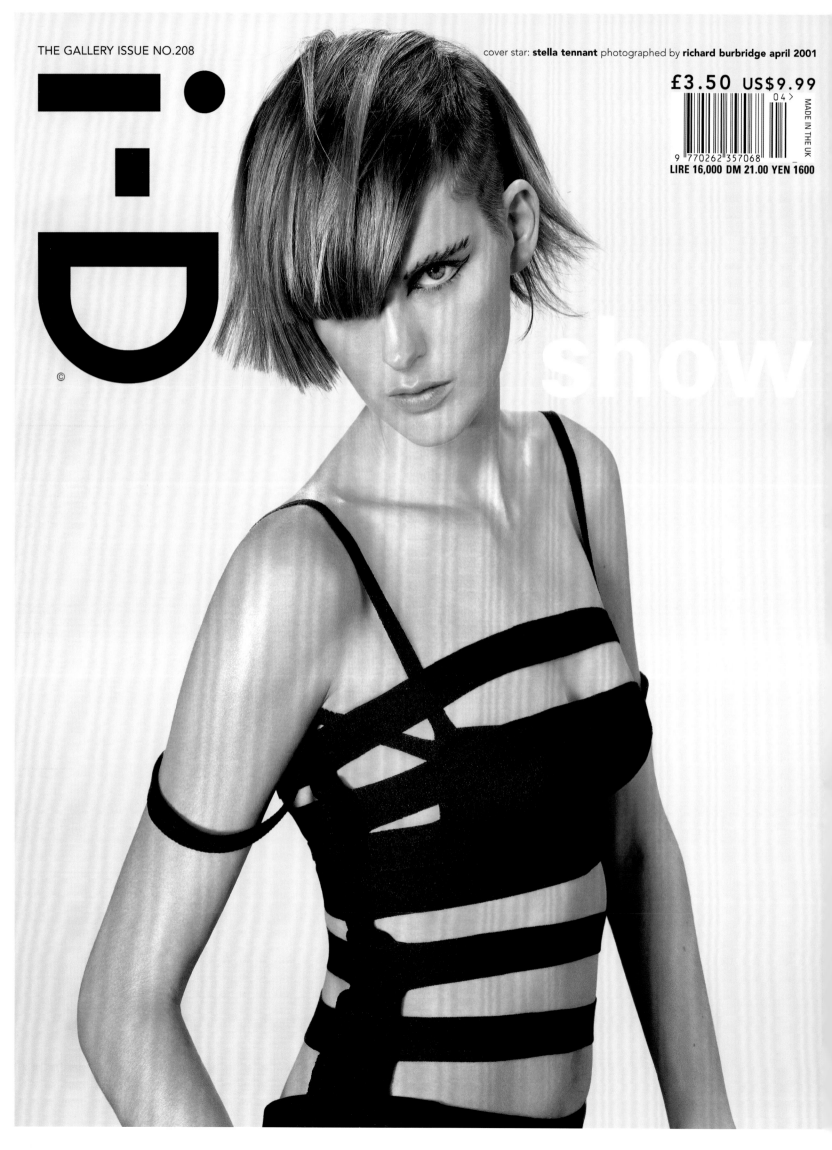

i-D
©

show

£3.50 US$9.99

04>

MADE IN THE UK

9 770262 357068

LIRE 16,000 DM 21.00 YEN 1600

The Gallery Issue, No. 208, April 2001
"Sexy Stella! We shot this in a studio in New York.
I remember how amazing Stella's body looked after
her second child."
Pat McGrath, Beauty Director, i-D

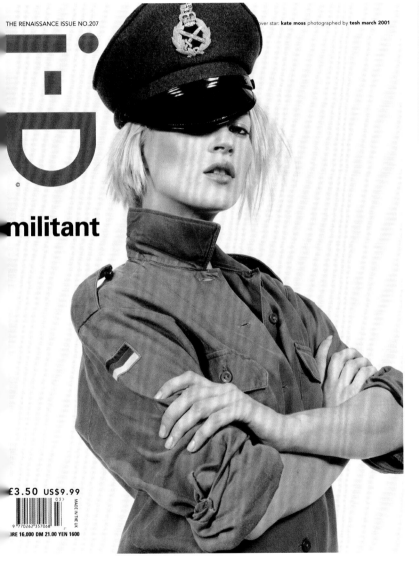

THE RENAISSANCE ISSUE NO.207

cover star: **kate moss** photographed by **tesh march 2001**

i-D

militant

£3.50 US$9.99

IRE 16,000 DM 21.00 YEN 1600

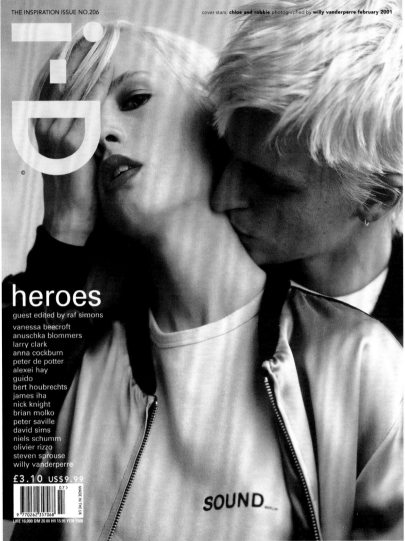

THE INSPIRATION ISSUE NO.206

cover stars: **chloe and robbie** photographed by **willy vanderperre february 2001**

i-D

heroes

guest edited by raf simons

vanessa beecroft
anuschka blommers
larry clark
anna cockburn
peter de potter
alexei hay
guido
bert houbrechts
james iha
nick knight
brian molko
peter saville
david sims
niels schumm
olivier rizzo
steven sprouse
willy vanderperre

£3.10 US$9.99

LIRE 16,000 DM 20.00 HFI 15.95 YEN 1500

SOUND

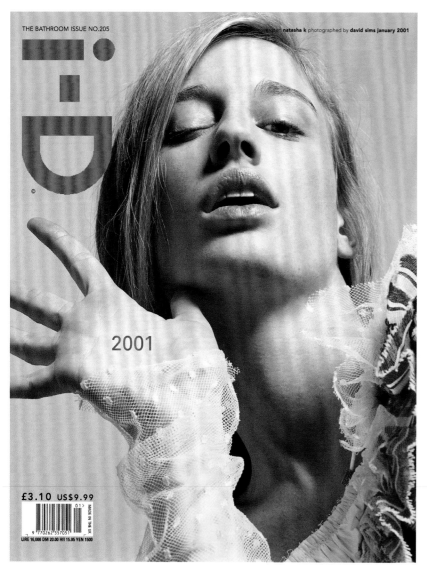

THE BATHROOM ISSUE NO.205

cover star **natasha k** photographed by **david sims** january 2001

i-D

2001

£3.10 US$9.99

LIRE 16,000 DM 20.00 Hfl 15.95 YEN 1500

MADE IN THE UK

9 770262 357051

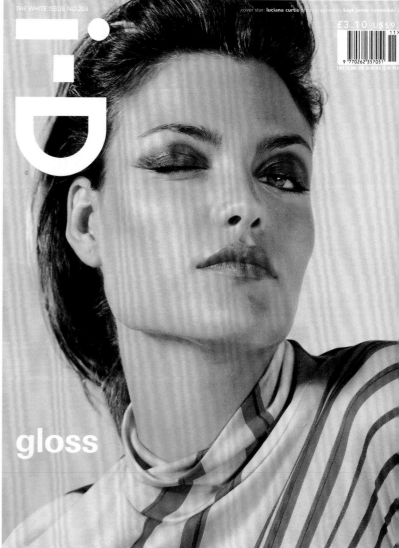

THE WHITE ISSUE NO.203

cover star: **luciana curtis** photographed by **kayt jones** november

£3.10 US$9

i-D

gloss

9 770262 357051

The White Issue, No. 203, November 2001
"We shot a fashion story for *Harper's Bazaar* Far East.
I really liked Luciana, a brilliant Brazilian model, and just
decided to do a cover try for i-D. She had a great wink!"
Kayt Jones, Photographer and i-D LA Editor

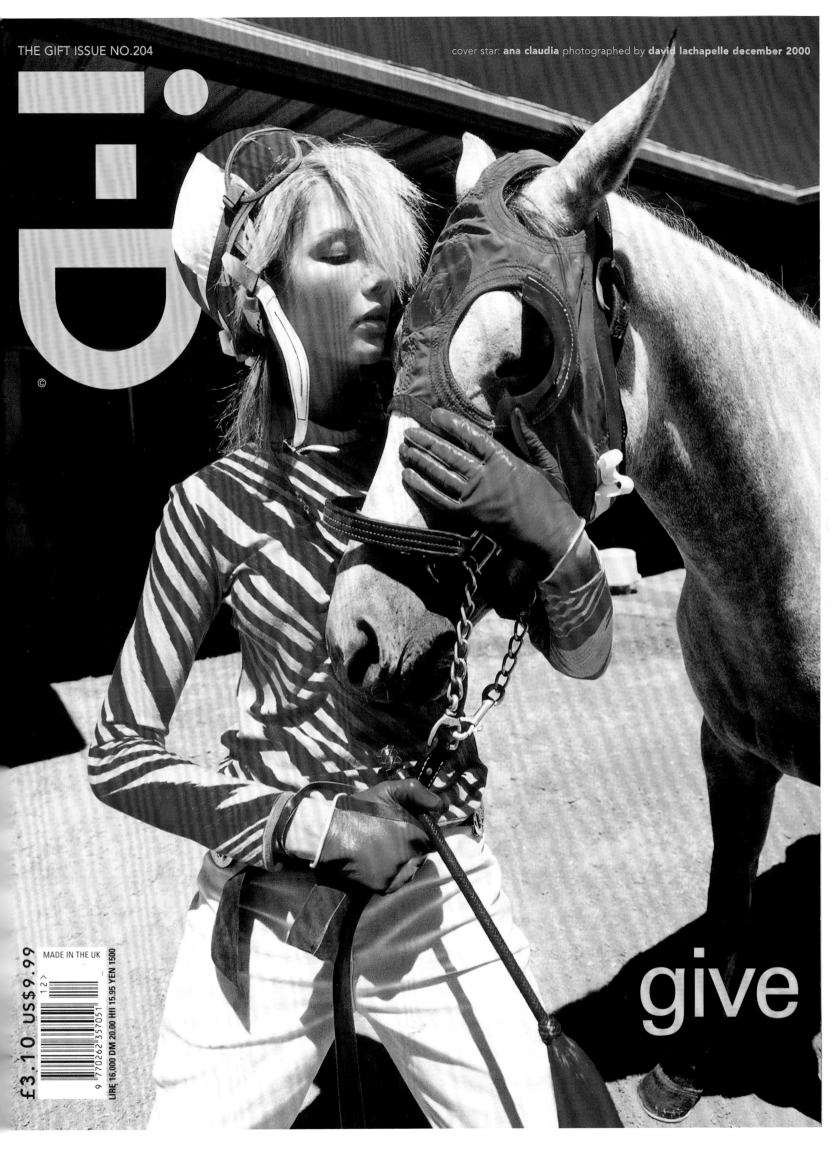

i-D

give

£3.10 US$9.99

MADE IN THE UK

LIRE 16,000 DM 20,00 HFl 15.95 YEN 1500

9 770262 357051

cover star: **björk** photographed by **mert alas and marcus piggott september 2000**

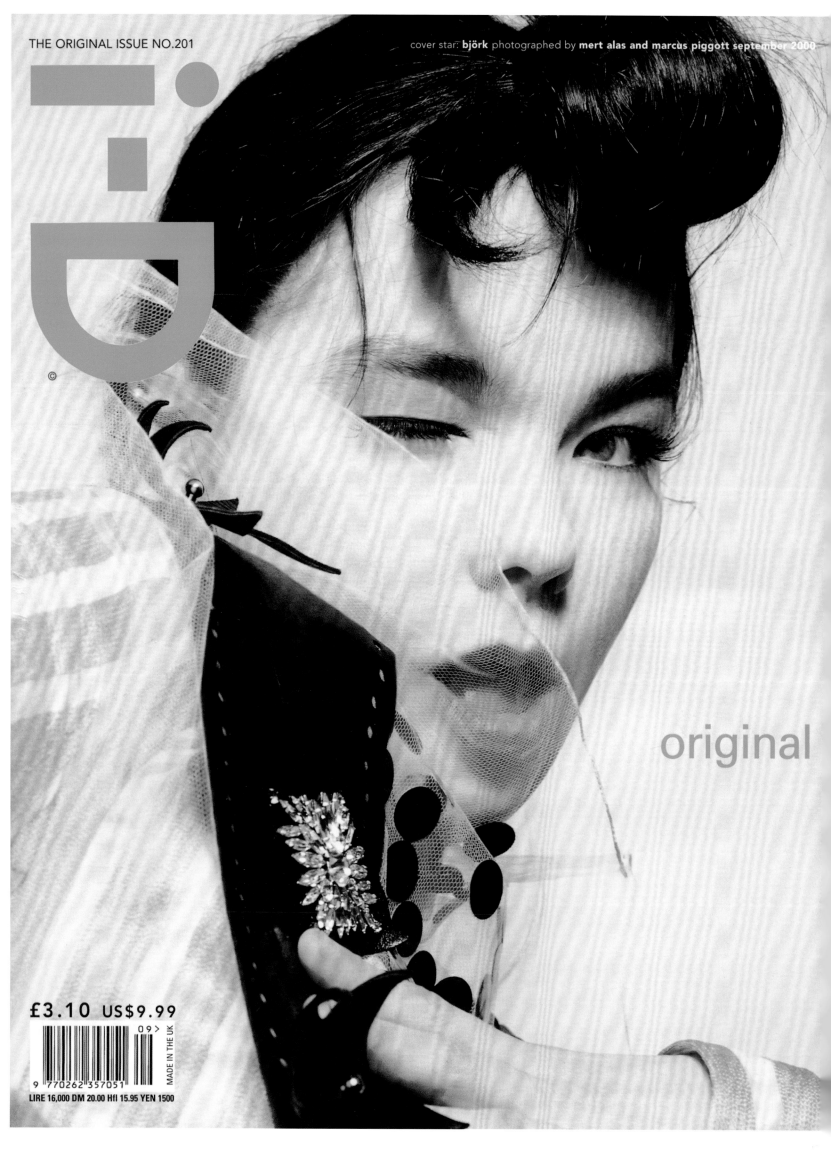

original

£3.10 US$9.99

09>

MADE IN THE UK

9 770262 357051

LIRE 16,000 DM 20.00 Hfl 15.95 YEN 1500

i·D

MADE IN THE UK

centred

£3.10 US$9.99

08>

MADE IN THE UK

LIRE 15,500 DM 20.00 Hfl 15.95 YEN 1500

FASHION MAGAZINE N° 200

i-D

©

heart

£3.10 US$9.99

9 770262 357051

07 >

MADE IN THE UK

LIRE 15,500 DM 20.00 Hfl 15.95 YEN 1500

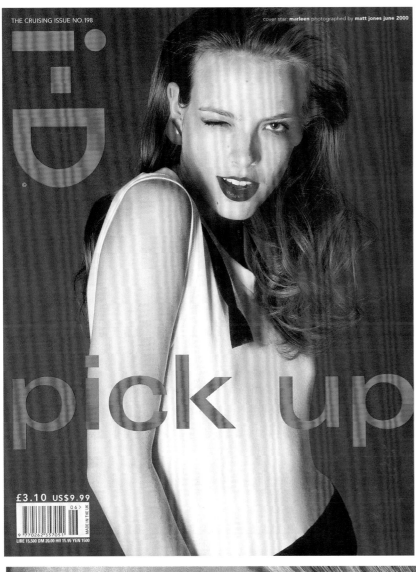

THE CRUISING ISSUE NO.198

cover star: marleen photographed by matt jones june 2000

i-D

pick up

£3.10 US$9.99

LIRE 15,500 DM 20.00 HfI 15.95 YEN 1500

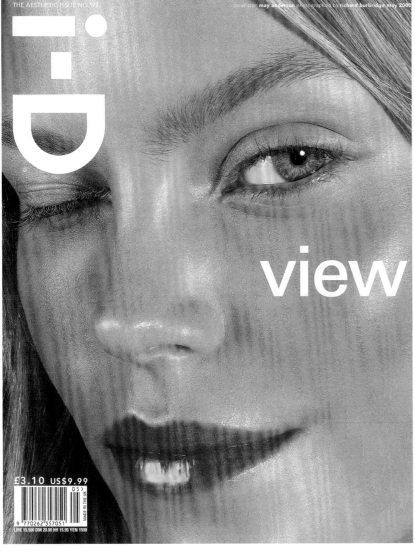

THE AESTHETIC ISSUE NO.197

cover star: may anderson photographed by richard burbridge may 2000

i-D

view

£3.10 US$9.99

LIRE 15,500 DM 20.00 HfI 15.95 YEN 1500

Terry Jones in conversation with Jeremy Scott

Terry: Tell me about the first cover you worked on for i-D...
Jeremy: I styled the cover for The Cruising Issue (No. 198, June 2000).
We shot in New York and Matt Jones, who was the photographer, asked me
whom I wanted to shoot and I choose Marlene.

What was so special about Marlene?
Marlene was fabulous. She was a model I used in all my shows. She was
Russian and she was a young, cool, pretty girl. So we shot her in New York
and at the same time Matt shot a portrait of me, which ran as a feature in
the same issue. That was my first cover.

What did you dress Marlene in?
Pieces from my own collection. You don't see the clothes so well because
she's making a gesture, but she was wearing a white T-shirt with a bowtie
printed on. I think it was a bowtie undone, like the silhouette of a bowtie.
So, that was the first cover.

What was the portrait of you like?
I remember we added a really curly weave into the back of my hair so I had a
really curly mullet. It was just a headshot. I think it was a sepia colour. Matt
shot me in Paris prior to that. I've been shot for i-D a lot actually. There was
one time in my bed and one time with a Pierrot mask and there was once a
shoot in the Bastille with Mark Borthwick. And of course Shawn Mortensen
photographed me for the nude issue wearing an Indian headdress and a
'Peace' T-shirt. Those are just a few of the shoots I can remember...

The Heartbeat Issue, No. 199, July 2000
"The flawless Alek Wek. I was obsessed with the
contrast of the white beauty mark and eyeliner against
her skin. It was so powerful."
Pat McGrath, Beauty Director, i-D

The Aesthetic Issue, No. 197, May 2000
"I remember being super excited and honoured to be
asked to do this cover. Working with Pat McGrath and
Richard Burbridge was amazing. As ridiculous as it
sounds, I never thought it could be so difficult to get
the perfect wink!"
May Anderson, Cover Star

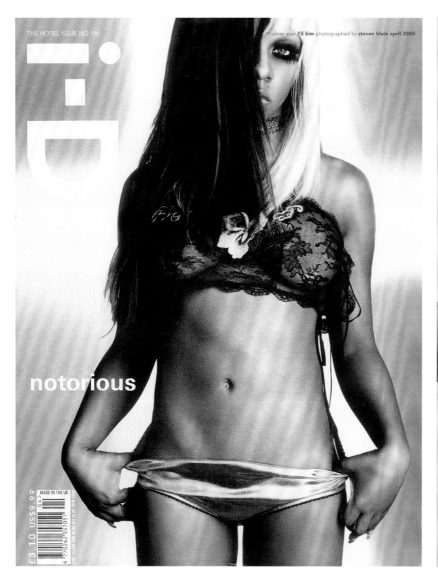

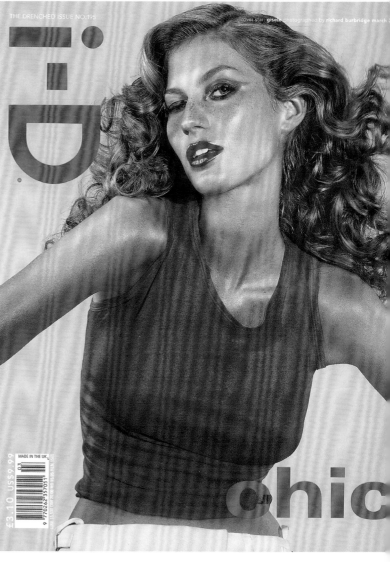

The Hotel Issue, No. 196, April 2000
"Steven Klein shot this on the day before Christmas Eve in New York. We started at 3pm and didn't finish until 5am. We love Lil' Kim...she looked MAJOR!"
Pat McGrath, Beauty Director, i-D

The Dynamic Issue, No. 194, January/February 2000
"We drove up to Connecticut to Chloë's mum's house, where she was staying with Harmony at the time. It was Halloween and it was the first time I'd experienced it in the American suburbs! The ripped T-shirt belonged to Cathy Dixon, the stylist. When the cover happened it was just one of those magic moments; a couple of frames and I knew we had it."
Matt Jones, Photographer

The Dynamic Issue, No. 194, January 2000
There is a real romance to this cover, we took a bit of a risk with is. We used soft lighting, as opposed to hard graphics, to try to get the feeling of the dawn of the millennium. It felt right for the January cover and stood out on the stands. We weren't following any rules, but it felt real and represented a new age of innocence with a soft dynamic. Chloë Sevigny represented a new age of innocence with a soft dynamic. She represented a new kind of look, a feminine vibe and not synthetic. We wanted to explore all aspects of beauty, not just the contrived. We made decisions about these shots totally from the gut. The fortunate thing about being the publisher is that my decisions don't have to be analysed.
Terry Jones, i-D Founder

cover star: **chloe sevigny** photographed by **matt jones** january/february 2000

i-D

©

dynamite

£2.80 US$7.50

01

MADE IN THE UK

9 770262 357044

IRE 13,500 DM 18.00 Hfl 14.95 YEN 1500

The Elevator Issue, No. 191, October 1999
"Iconic Guinevere; porcelain perfection with a shot of red. This was based on the Louis Vuitton show from that season."
Pat McGrath, Beauty Director, i-D

The 1.9.99 Issue, No. 190, September 1999
"Christy Turlington looking ultra swim fresh."
Pat McGrath, Beauty Director, i-D

The Wisdom Issue, No. 193, December 1999
"Awwwwe, Matt Jones... He was a baby when he shot this cover with me! The cover and the inside images are some of my favourite from my career. Matt has a great eye and affect on his subjects, which is why we're still shooting together 13 years later! i-D is just as relevant and cool today as it's always been, and lets be honest...what girl working in this business doesn't hope for an i-D cover?!"
Milla Jovovich, Cover Star

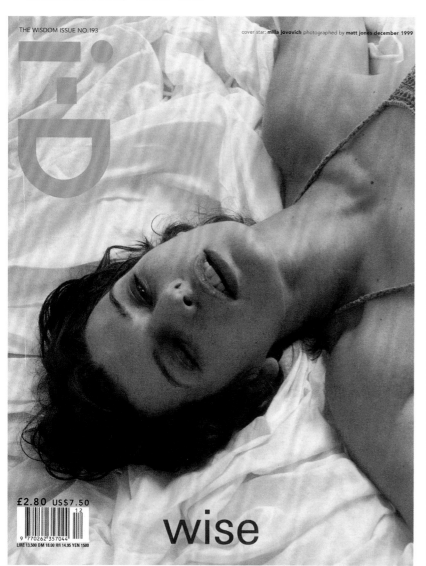

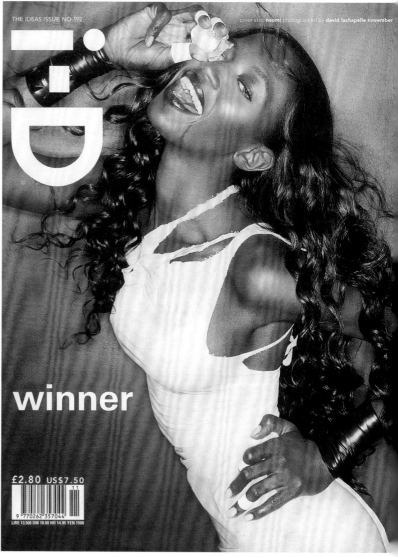

The Ideas Issue, No. 192, November 1999
"This whole shoot was hilarious! I was in a boxing ring and David LaChapelle wanted me to put my heel on the boxer's tummy and I scratched him by accident (all in the name of art) then he wanted to sue us! This was shot at 4am in David's studio. Shooting with David is like theatre. It's a whole world built around you and you have to get into character. The whole shoot and everyone involved were so great. When you're enthusiastic and the energy is great it doesn't matter what time it is."
Naomi Campbell, Cover Star

The Audible Issue, No. 189, August 1999
"It was about Oluchi looking afro-centric. A minimal version of black female beauty in the seventies."
Pat McGrath, Beauty Director, i-D

The Audible Issue, No. 189, August 1999
"This is a classic Richard Burbridge shot. By this time we had moved to single-word cover-lines, and 'Soul' epitomises this fantastic image. It was Oluchi's first ever cover shot. It is strong, and felt so right this was her first season on the catwalk. At the time, there was still a reluctance to use black models in magazines. We thought it was very important not to segregate people and our covers tried to represent diversity in the broadest sense. I was working on i-D about 80 per cent of the time by this point, and the magazine had grown. It was perfect-bound, a huge move from the first editions, which were held together with staples."
Terry Jones, i-D Founder

cover star: **guinevere** photographed by **craig mcdean october 1999**

i-D

©

£2.80 US$7.50

10

9 770262 357044

LIRE 13,500 DM 18.00 Hfl 14.95 YEN 1500

uplift

THE 1.9.99 ISSUE NO.190

cover star: **christy turlington** photographed by **richard burbridge september 1***

i-D

wink

£2.80 US$7.50

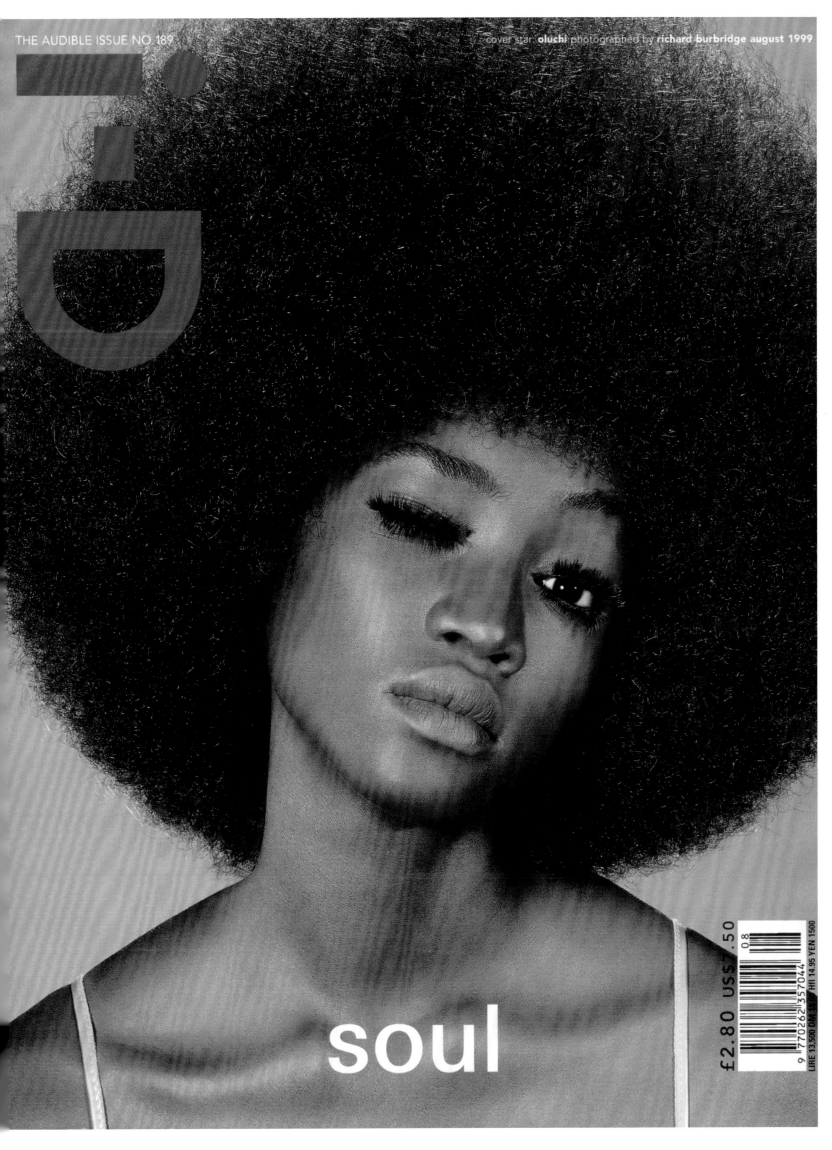

THE AUDIBLE ISSUE NO 189

cover star: **oluchi** photographed by **richard burbridge august 1999**

i-D

soul

£2.80 US$7.50

08

LIRE 13.500 DM 9.80 Hfl 14.95 YEN 1500

9 770262 357044

The Romance Issue, No. 188, July 1999
"David Sims... I remember this cover because all I kept thinking was, "Dude you're getting really close with that camera!'"
Bridget Hall, Cover Star

Terry Jones in conversation with Max Vadukal

Terry: Tell me about the cover you shot of Heidi Klum [The Skin & Soul Issue, No. 186, May 1999]?
Max: We were shooting a campaign for Victoria's Secret in Jamaica. It was at a great hotel, right behind Ralph Lauren's beach retreat, so we decided to do something for i-D off the back of it. The stylist had some extra credits and Heidi was totally open to it. The pictures were a lot of fun. After doing eighteen pages of static beauty shots for Victoria's Secret, it was really exciting to let go. I think it ran in i-D as a seven or eight-page story. The layout had little pictures in it as well.

We stole the cover lines off men's magazines.
Yes, 'Loaded' and other lads' magazines.
We also used a few cover lines from women's magazines like 'Cosmoworld'.
Really? That was such a fun shoot, really creative, not too planned. Everything is so controlled now. I had a piece in The Guardian recently and Andrew Pulver, the film critic, asked me, 'What's your biggest regret?' and I said "Digital". On a shoot in the past a photographer and his team used to walk out with their secrets. Can you imagine Helmut Newton or Richard Avedon's world being created when you've got twenty people gawking at a computer screen? Those guys would never have created half the images they created. Back then it was all about the secrets you walked out with.

Do you remember the first picture you had published?
Yes, I was trawling around London with this German guy, Thomas Degen, at the time. Thomas took me around some clubs, he had a real buzz about him and I think it was something from one of those snaps that [were published]. But the first real picture was of my friend, Chick, the alligator wrestler. Do you remember him? He ended up getting more British 'Vogue' covers than me and he wasn't even trained as a photographer!

What got you into photography?
My father took me away from school when I was really young. He used to sell old photographic equipment to the East African coast so I grew up in Kenya for nine years. I missed about three or four years of school. We were always travelling, so I was schooled at home and I didn't get a properly steady schooling until I was about nine. We always had telescopes and all kinds of photographic gear in the back of our van. My father was a very keen amateur. I remember the first camera I used was a Pentax Spotmatic and it was hidden in my father's cupboard. I would take it out once in a while and take pictures of the garden and then put it back. After a month the roll would finish and when he came to take pictures, he'd say, "Strange, I don't remember finishing this roll of film..." So he dropped the film in to the lab and it would take ages to process and be really quite expensive. Then he saw the photographs of the garden and said, "Okay, what are you doing with my camera? You only have to ask and I'll give it to you so you can take pictures."

How did you start working for i-D? Did you just turn up at the i-D office?
I think so, yes. There was a very open feeling to the industry at that time. It wasn't hard to see people. Now it's impossible to see anyone. Back then I just turned up at i-D unannounced...

And I said, "I've got a job for you."
Yes, I'm pretty sure that's what you did. I remember I was really into some books you'd done at that time. I didn't understand what a magazine really was back then, but I knew that you were quite revolutionary because you had done these covers for British 'Vogue', which were very grainy. They were quite risky covers really. During that period of photography for those magazines it was really daredevil work. You were definitely the person I needed to see, so I guess I just showed up.

And I said, "I'm working on this book of contemporary erotic photography [Private Viewing, New Leaf Books], can you go to New York for me?"
I almost got arrested for that, coming back to London carrying Robert Mapplethorpe pictures. That was wonderful going to New York and meeting all those photographers. The highlight was meeting Peter Hujar and Robert Mapplethorpe. I knew Robert's reputation was for these dark, erotic, homosexual pictures, but I didn't realise how relaxed he would be. He had a loft on Bond Street and it was painted black, everything was black and right in the middle was a long tramway of boxes of prints that you could just shuffle through. He said, 'Just go ahead and pick out what you need.' I still haven't seen half of those pictures published. There were some very, very extreme pictures in those boxes...

There were a few pictures that even I couldn't publish.
No, you couldn't, but Robert was really, really laidback, so I picked out some pictures and I was feeling very, very terrified because frankly, I'm not an editor. At that stage there was no way I could have known what to pick. I said, "Robert, I can't really pick these, you have to tell me what you think is appropriate for Terry's book." So, he went and shuffled through the pictures...

I remember you came back from that trip to America with a portfolio.
I did, yes, I shot my best friend on the streets of New York and I do believe it was the way everything started.

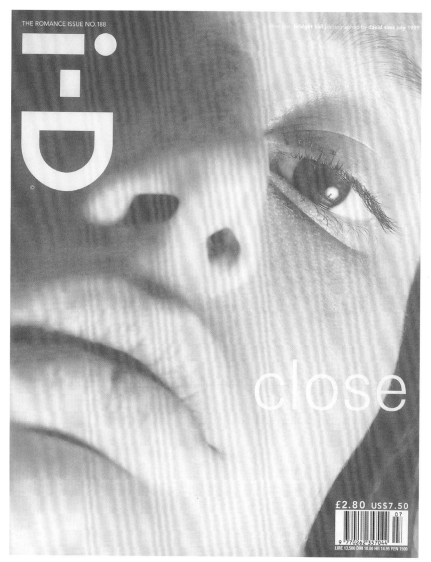

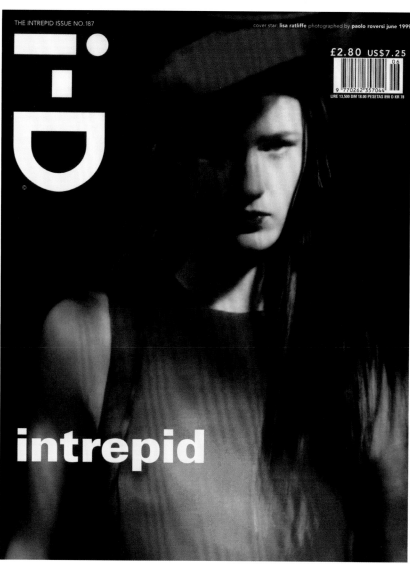

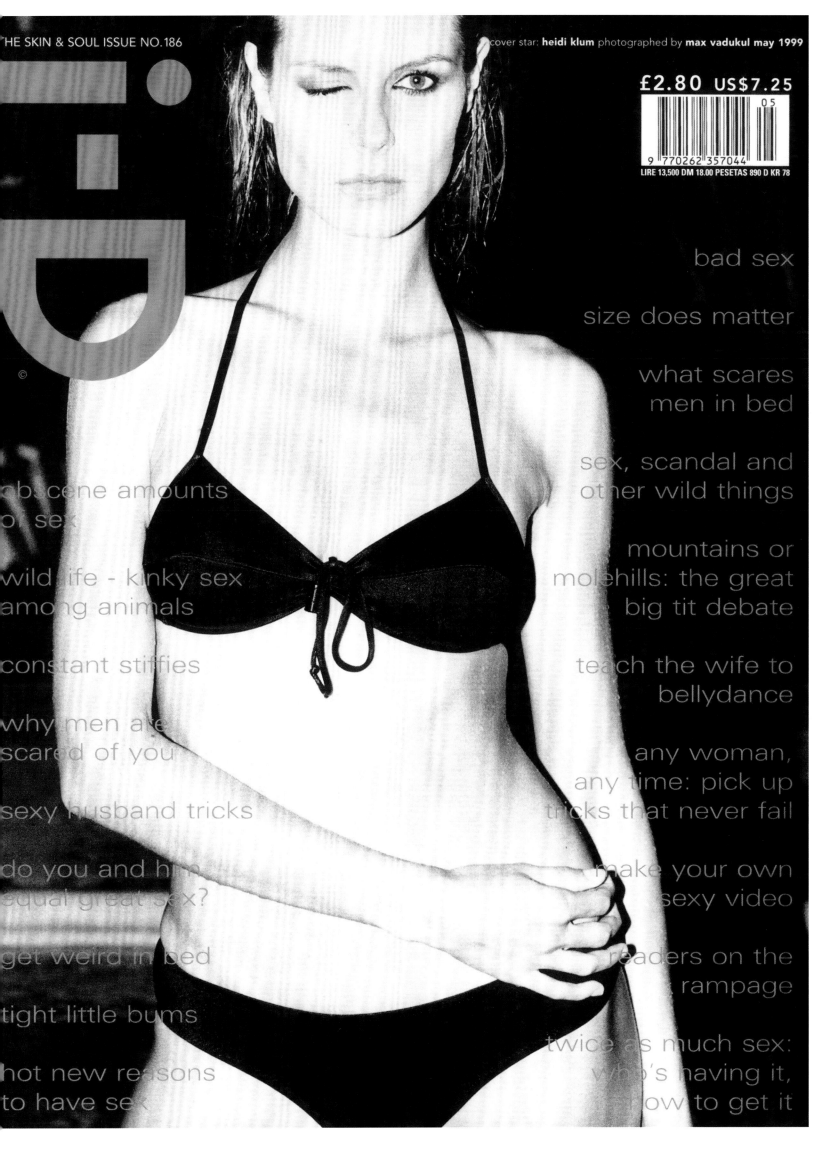

i-D

©

THE SKIN & SOUL ISSUE NO.186

cover star: **heidi klum** photographed by **max vadukul may 1999**

£2.80 US$7.25

05

9 770262 357044

LIRE 13,500 DM 18.00 PESETAS 890 D KR 78

bad sex

size does matter

what scares
men in bed

sex, scandal and
other wild things

obscene amounts
of sex

mountains or
molehills: the great
big tit debate

wild life - kinky sex
among animals

constant stiffies

teach the wife to
bellydance

why men are
scared of you

any woman,
any time: pick up
tricks that never fail

sexy husband tricks

do you and him
equal great sex?

make your own
sexy video

get weird in bed

readers on the
rampage

tight little bums

twice as much sex:
who's having it,
how to get it

hot new reasons
to have sex

The Serious Fashion Issue, No. 185, April 1999
"I channelled future clinical beauty on the stunning Colette, based on the Hussein Chalayan show that season."
Pat McGrath, Beauty Director, i-D

The Kinetic Issue, No. 184, March 1999
"Perfectly, flawlessly nude Amber Valetta."
Pat McGrath, Beauty Director, i-D

The Kinetic Issue, No. 184, March 1998
"The perfect wink! This was the start of Richard's Burbridges many covers. I was concerned that his covers monopolised the coming months as they were so easily defined but he just kept coming through. Around that time we were making a transition on the newsstand from a 'style' to more serious 'fashion' publication and these covers were a perfect vehicle to enable this. And it's easy to see now that any repetitiveness was the strength. They were very pop and defined that era."
Kate Law, Art Director

The Emergency Issue, No. 183, January/February 1999
"We had access to the circus school behind Hoxton Square and spent most of the day asking Mel C to do strenuous and undignified activities with various bits of performance equipment. She was good to work with and happily threw herself at anything we suggested. When it came to do the cover I set up a 5x4 camera with a soft box directly above the camera, a cross between a passport booth and a snapshot camera, albeit slightly better quality. Having only a finite amount of film loaded, probably about 16 sheets, I decided to cut out the most problematic element in the set up: myself. To get a good wink in 16 shots meant there was little room for error, so I gave Mel the shutter release and told her to do it herself. I acted as assistant, changed the slides and cracked the jokes. It meant that the timing in every shot was perfect and the imposition of carrying out an action for someone else was removed. The shot is straightforward and natural, partly as a result of the subject having been given control."
Donald Christie, Photographer

Terry Jones in conversation with Richard Burbridge

Terry: When did you first become aware of i-D?
Richard: I remember buying i-D in London, although I didn't live in London at the time, and simultaneously recognising the magazine and Nick Knight. I knew about a third of the people who worked for i-D at the time, but I didn't know the other two thirds so it was educational on three levels.

Were you studying at the time?
Yes, I was a student. I don't know how I first got to hear about i-D but I still have all my early issues. I remember buying a fold out issue once that I particularly loved. Was that issue two or three?

That would have been The Grown Up Issue [No. 30, October 1985]. It was A3 landscape, so it was outsized. We made it double the size of what we normally did, an extravagance. What got you into photography?
Recognising I had an ability to do it at a young age, recognising that I could be an individual through it because nobody else around me was doing it. Photography was also my ticket to a journey that enabled me to move out of my childhood town and move to London, move to art school and move to New York. I saw it as a sort of passage.

What was your first cover for i-D?
My first cover was Amber Valletta [The Kinetic Issue, No. 184, March 1999]. It was really significant because I'd worked with Pat McGrath and Eugene Souleiman when I started my career in London and then when I came to New York we lost touch. My first i-D cover was three years after I'd said goodbye to them, so it was a reunion for all of us.

After Amber, you shot a run of covers for i-D...
Yes. Amber was on the edge of her supermodel stardom and I had the freedom to take her picture for a magazine that wasn't dictated to by outside forces. With i-D, I could take the picture I wanted. It was also important to me, living in New York, to have a cover without copy all over it. I don't even think there were any words on the cover apart from 'i-D'. It was fairly radical. I haven't looked at it for a little while but I think it was pretty special for everyone. It was shot at some ridiculous time in the morning. I think Edward left the shoot at some point to fly back to London and by the time we got to shooting Amber I think he'd probably landed in London before we'd even got the shot. It was one or two in the morning.

Are there any other i-D covers that particularly stand out in your mind?
My Christy Turlington cover was a memorable one [The 1.9.99 Issue, No. 190, September 1999]. I think I've shot her since, but at the time I shot Christy she had pretty much stopped modelling. I wasn't part of that 90s photography/supermodel scene and I don't know why she agreed to do it, but she did. I just did the wink and that was it. It was a super fast shoot and unlike most of the covers where there's some manipulation to the wink, Christy could perfectly control every muscle in her face and she nailed the wink in every shot.

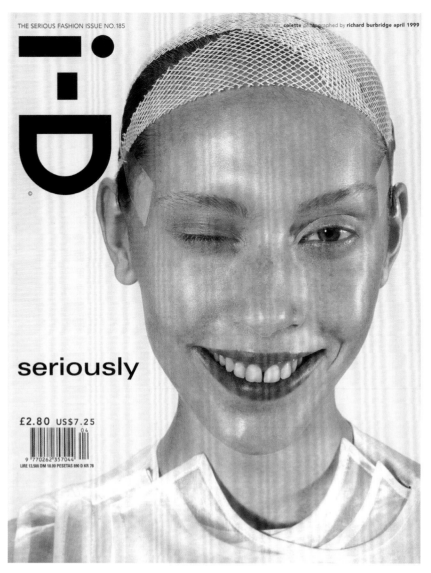

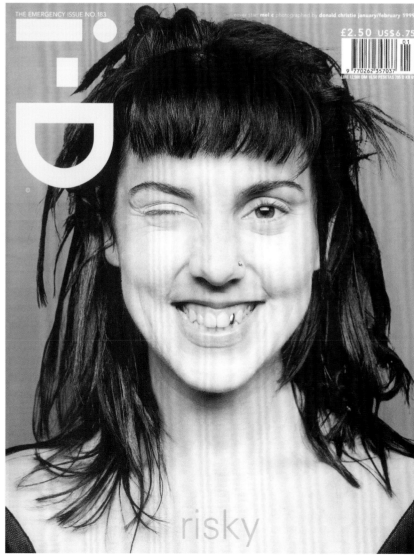

i-D

©

kinetic

£2.80 US$7.25

03

9 770262 357044

LIRE 13.500 DM 18.00 PESETAS 890 D KR 78

i-D

©

front

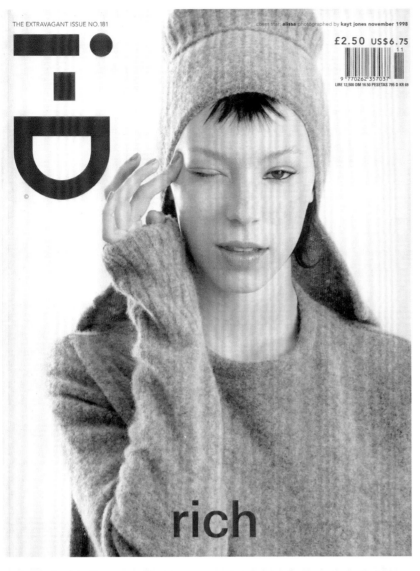

THE EXTRAVAGANT ISSUE NO.181 cover star: *alissa* photographed by kayt jones november 1998

£2.50 US$6.75

i-D

rich

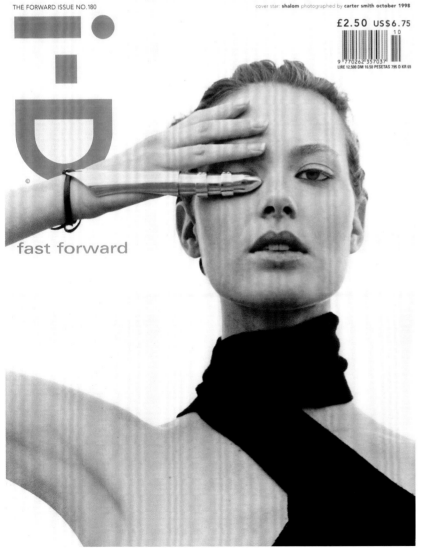

THE FORWARD ISSUE NO.180 cover star: shalom photographed by carter smith october 1998

£2.50 US$6.75

i-D

fast forward

When shooting covers, do you find the wink an asset or a hindrance?

The wink was always a challenge as a concept. I broke that challenge a number of times because, and I don't know if you know this, but a lot of the girls' winks were actually created by me, not the model. I remember when Edward realised what I was up to I felt a watershed of relief. In the past I know you've killed covers where the wink wasn't good enough and you even told me once that one girl I shot looked stoned, but some girls literally can't wink or they can but only with the wrong eye. I remember the moment when Edward found out, he was almost in awe and disbelief that the pressure was off. I think Amber's wink was probably real.

What about the Oluchi cover [The Audible Issue, No. 189, August 1999]? That was an amazing cover.

With Oluchi I let the team do their own thing and then I hope to get the best picture I can with what they do. Quite often I have to get it really quick to keep them happy too.

You've also shot Gisele for the cover of The Drenched Issue [No. 195, March 2000]…

Yes, Gisele brought her dog and all the rest on that shoot, but she takes her dog to all the shoots. Going back to Oluchi, that was really interesting because the concept at the time was something I didn't really understand and I didn't understand the language they were using. Quite often my covers are fairly straightforward in composition. I've seen other photographers shoot i-D covers with much more imagination than mine. Mine have always pretty much been portraits. But there have been times, I think Oluchi is a good example, where I had to find an angle to make the wink look good, so I think Oluchi's got her head tilted back. I remember Stella Tennant being really nervous about winking [The Gallery Issue, No. 208, April 2001], so I used a length of her hair as a solution to cover the eye. I remember that I was quite pleased with the idea that I could create a wink just by dropping the hair. I'm not sure if that was the first time that had been done, but it seemed to be a really exciting solution at the time.

What about Jessica Stam, was her wink real or constructed?

I can't remember… I think it was constructed, but constructed with a lot of love and care. I'm very careful to hide the evidence. I would never want a wink to look wrong or fake, so there's a certain amount of construction that goes into the picture in order to change and move the face.

How do you manage today without Polaroids?

I manage, but there are a number of negative things about not using Polaroids. You now have to direct this whole group of people that are using the photographer's tools, looking at the computer and having access to the computer in a way they never would have before. What I'm trying to say is that the computer now is not just the photographer's tool, anyone in the studio can turn to it and want a close-up of this or that and I think sometimes there's a huge void of motivation now. The effort that people put into pictures, the chance, the fun, the moment, the spontaneity, all that stuff is compromised big time. One of the things that I love about i-D is that you gave photographers freedom, which was really appreciated. i-D's inconsistency gave it its voice. You never knew what an i-D cover would turn out like, whether it would be half colour and half black and white or whatever. The wink was the only unifying factor and now with digital that's gone. Everybody's publishing bland, banal things. I think photography as a medium has lost so much. As a photographer I went to the shoot with a choice and although I still have a choice of lighting, of the profile, of the exposure of the picture etc everything's just become a bit too evened out. It's time to distinguish again.

In what way?

What's always been good is that there's an irony with i-D. I remember coming to you as a really young photographer. I'd spent every single penny I had, I'd begged and borrowed to present a story to you. You acted negatively towards my shoot because it seemed extravagant to you. I remember coming out of the i-D studio and thinking that I'd given everything, every single penny because I saw i-D as where I wanted to be. I saw it as a place where I was going to get to where I wanted to be. So, for me, to sacrifice everything was a worthwhile gamble, but it backfired, because I shot on 8x10 and I was a young photographer and your response was that it wasn't 'i-D enough'. There's an irony in that i-D created this desire in me to impress you and I think it has remained. There's a standard set by Nick Knight and some of the other early contributors where we knew the quality of the magazine was what it was, but we always took pictures to surpass that quality. I like the way my work looks on your cover, but the quality that I was always striving for was way better than i-D. Why shoot 8x10 for i-D that's printed like newsprint? I don't think you particularly cared about quality, perhaps you'd rather more of a throw away picture or a more utilitarian kind of picture. But, there were so many photographers that you encouraged that were doing the opposite. I don't think you encouraged them to do 8x10, but we all were.

I always wanted i-D to provide a contrast to my days at Vogue, where we'd shoot 10x8. For me it was about getting the image and sometimes the intensity of a 10x8 can't be duplicated with a motor drive 35mm. I've always liked this contrast.

For me, i-D represented a platform to celebrate a part of culture that hadn't been in print before. For me to shoot a skinhead on an 8x10 camera was a metaphor for how much we valued the skinhead. I wanted to document the skinhead story with Edward with the same quality or reverence as high fashion or couture. I think that was the appealing thing.

Do you remember the first time you shot Alek Wek?

I still think it was outrageous that we did a black skinhead.

It was a great story.

Yes but so simple as well. It seemed so appropriate to i-D. The trouble is that there are a number of magazines that I respect, but there are also a tonne of magazines that don't have that distinction and are drowning everybody.

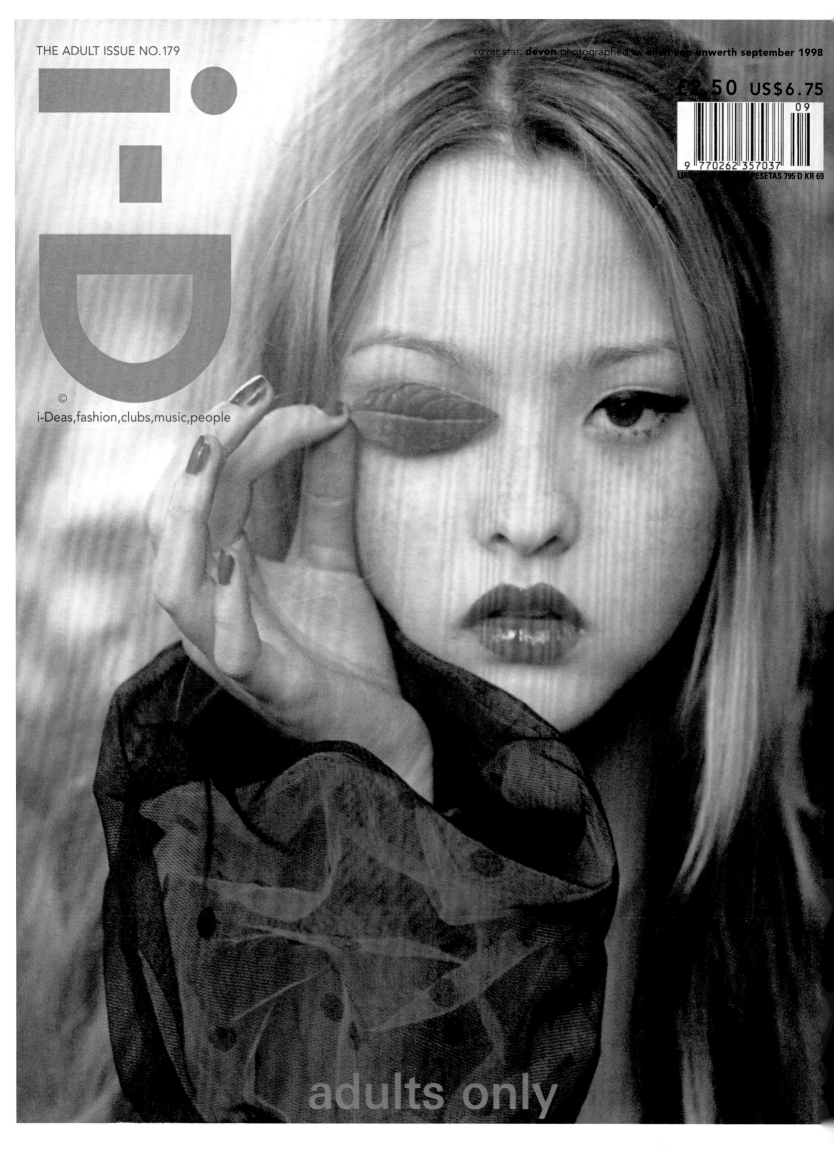

i-D

©

i-Deas,fashion,clubs,music,people

£2.50 US$6.75

LIRE... PESETAS 795 D KR 69

9 770262 357037

adults only

The Extravagant Issue, No. 181, November 1998
"We shot in Sadie Cole's art gallery in London. I used to shoot a lot in art galleries, mostly because they were cheap studios and inspiring locations. It was my first cover try and getting the cover felt like a huge deal. I was really chuffed."
Kayt Jones, Photographer and LA Editor

The Adult Issue, No. 179, September 1998
"Ellen blazed a trail for a series of props replacing winks but I loved this of Devon."
Kate Law, Art Director

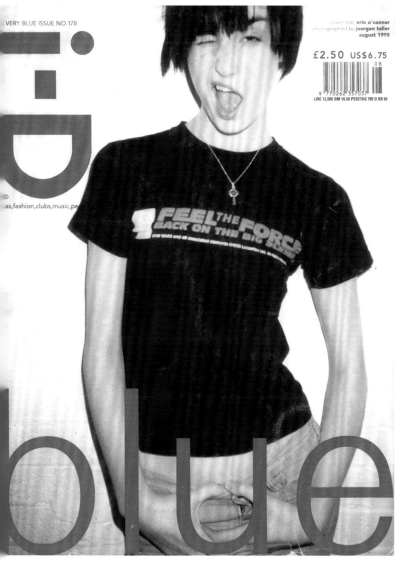

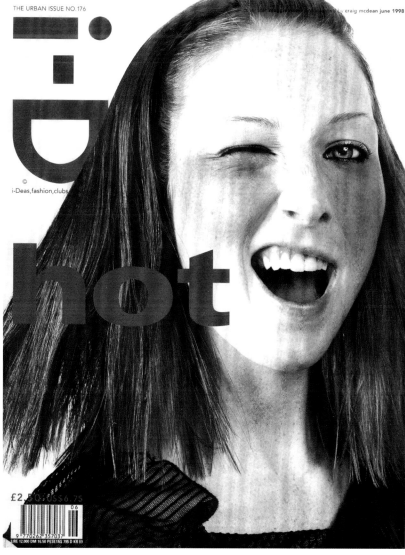

The Very Blue Issue, No. 178, August 1998
"My first i-D cover was photographed by Juergen Teller. I arrived in a pair of ancient cords I'd been wearing throughout college and an old vintage T-shirt emblazoned with 'FEEL THE FORCE'. He decided he wanted to shoot me exactly as I was – fresh face and wonky hair. My choice of outfit proved symbolic that day as the whole creative team decided I looked comfortable and happy being in my own skin. Juergen wanted real beauty and by letting my personality shine we didn't need embellishment."
Erin O'Connor, Cover Star

The Supernatural Issue, No. 175, May 1998
"I had always been the biggest fan of Kirstin Owen. It was so much fun to do this story."
Pat McGrath, Beauty Director, i-D

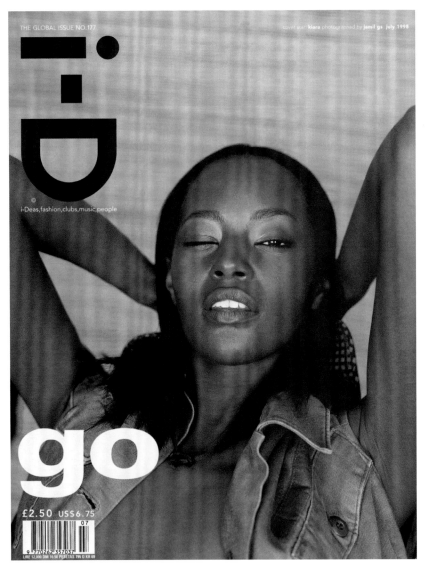

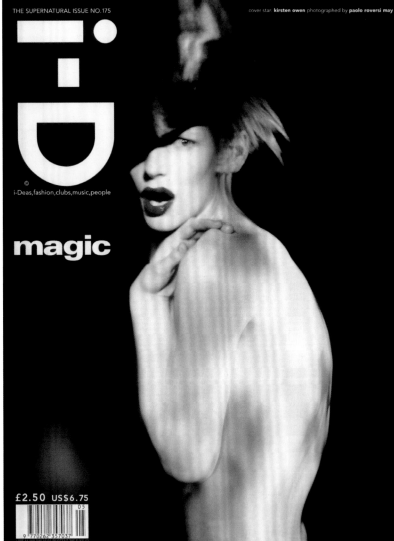

The Global Issue, No. 177, July 1998
"I read i-D as a kid and found it inspiring."
Jamil GS, Photographer

The World Class issue, No. 174, April 1998
"I loved this for its flat graphic and cartoon quality, reflected in later and current covers."
Kate Law, Art Director

The World Class Issue, No. 174, April 1998 & The Heartbreak Issue, No. 199, July 2000
"The creative freedom on set at i-D is something that resonates with me to this day. The entire team – editors, photographers, stylists, make-up artists and hair stylists – were some of the most inspiring people that I've worked with throughout my career. Both of my i-D covers celebrate the woman that I am. And both were such fun, cool experiences. I love winking for i-D!"
Alek Wek, Cover Star

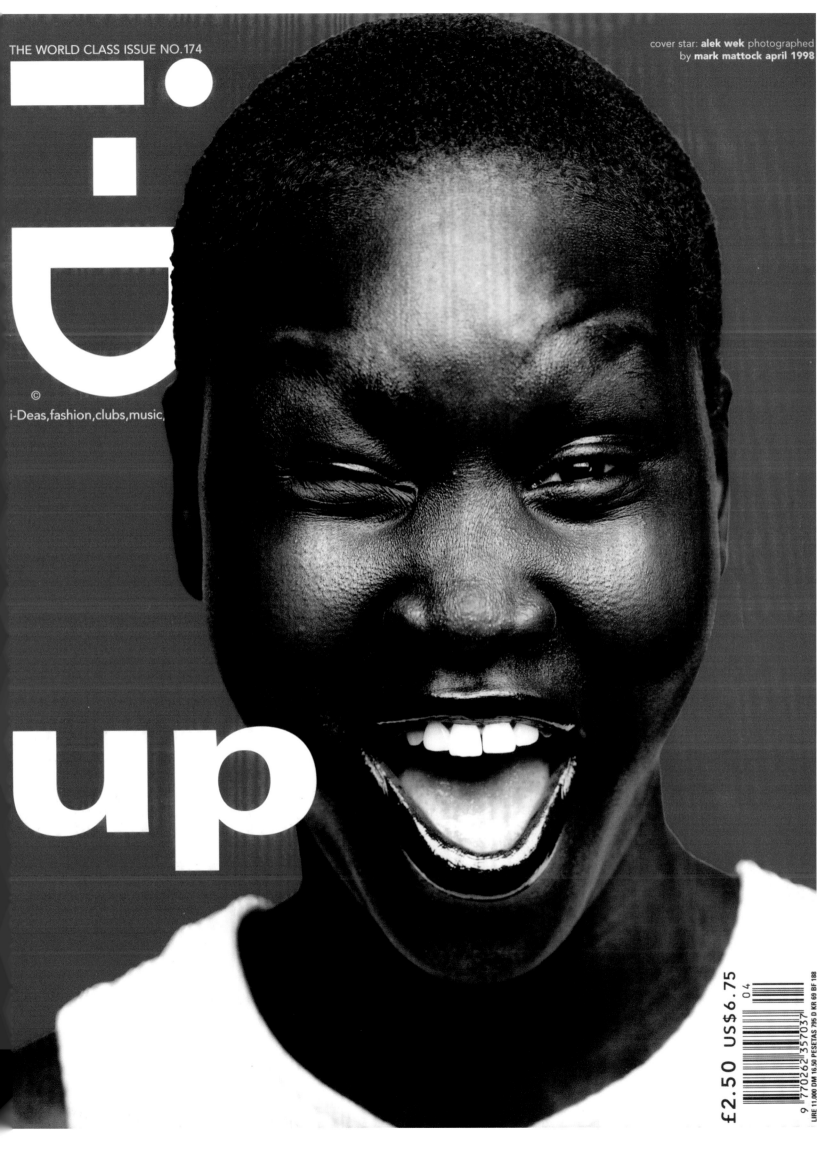

i-D

©
i-Deas,fashion,clubs,music,

up

cover star: **alek wek** photographed
by **mark mattock april 1998**

£2.50 US$6.75

04

9 770262 357037

LIRE 11.000 DM 16.50 PESETAS 795 D KR 69 BF 188

The Active Issue, No. 172, January/ February 1998
"We shot this in Michael Boadi's living room. Elfie, who shot this, used to model in the Helmut Lang shows; another model who went behind the camera. I love Michael, he was everything on the shoot: the model booker, the art director and the hairdresser! Michael was always everything! I felt really comfortable in his house. He had a vision and he executed it well."
Naomi Campbell, Cover Star

The Active issue, No. 172, January/February 1998
"I fought and lost the battle to run an alternative Stephen Sprouse cover this month, [The Active Issue, No. 172, January/February 1998] in the belief that this was too commercial and was pushing for the more experimental alternative. Experience and time has proved me wrong and I now like this for it's unadulterated simplicity, it was commercial but such covers buy us creative freedom elsewhere."
Kate Law, Art Director

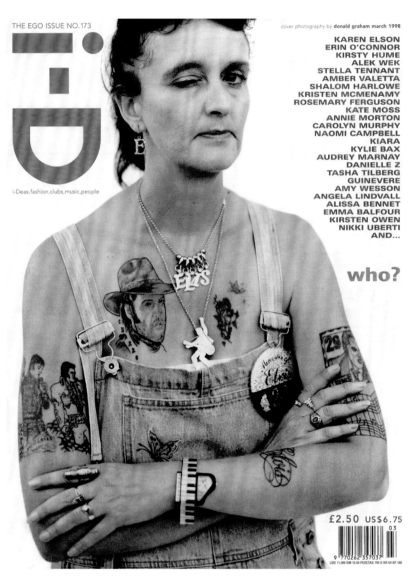

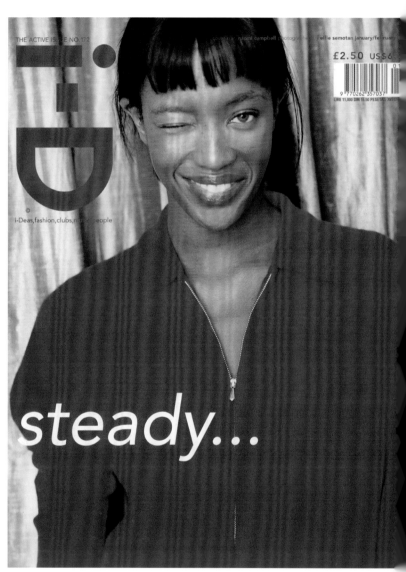

The Ego Issue, No.173, March 1998
"I was in the midst of a wonderful assignment for i-D, shooting 'found beauty' in the American South. We had arrived at Graceland in Memphis, Tennessee and were enthralled by the carnival atmosphere and the mass of devotees paying homage to Elvis Presley, the King. As I walked along the line that stretched for blocks, I came across a singularly unusual woman adorned with Elvis earrings, multiple necklaces and no less than seven Elvis tattoos. Here was an individual defining her devotion in such an inexplicable, but wondrous way; a truly unique, but deeply personal vision of beauty."
Donald Graham, Photographer

The Outrage Issue, No. 171, December 1997
"Simple and Caravaggesque. Reflected i-D's direction at the time, stripped of any detail and distracting elements."
Kate Law, Art Director

£2-20 US$5.75

12

9 770262 357006

CAN $6.95 FRANCS 38 LIRE 9,700 DM 14,90 PESETAS 1200 KR 59

i-D

IDEAS, FASHION, CLUBS, MUSIC, PEOPLE

intrigue

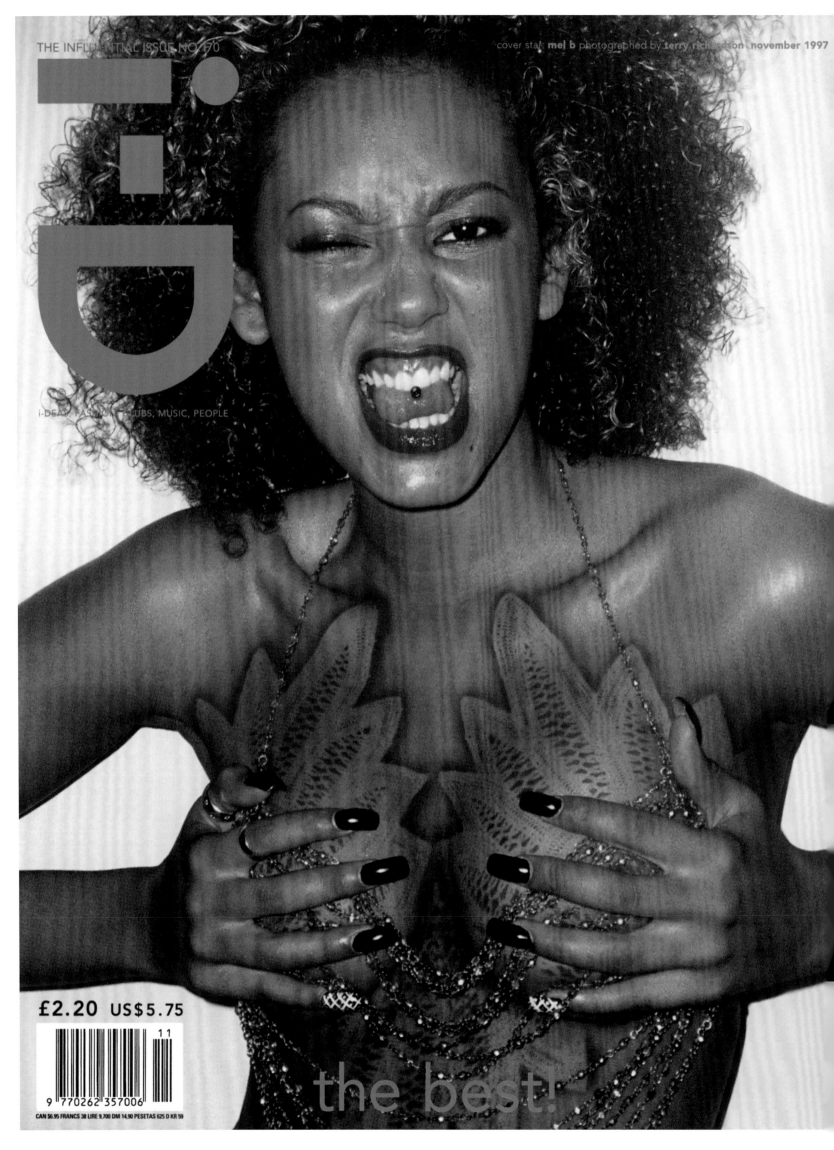

THE INFLUENTIAL ISSUE NO. 170

cover star: **mel b** photographed by **terry richardson** · november 1997

i-DEAS, FASHION, CLUBS, MUSIC, PEOPLE

£2.20 US$5.75

the best!

9 770262 357006

11

CAN $6.95 FRANCS 38 LIRE 9,700 DM 14,90 PESETAS 625 D KR 59

The Influential Issue, No. 170, November 1997
"I love this cover by Terry Richardson because it is so
funny. This was the height of the Spice Girls' rise to
fame and all the girls were doing cover-shots, but Mel B
was outstanding, totally different and certainly
outshone everything else on the newsstands at the
time. We were inverting the Spice Girls phenomenon.
Mel B had to get permission from her management to
be photographed like this, as the group were so heavily
controlled, but her managers were delighted with the
result. The timing was important – this cover came out
a month after Princess Diana died. Each i-D cover is
unique; it is like a present, and the wink is unique to us."
Terry Jones, i-D Founder

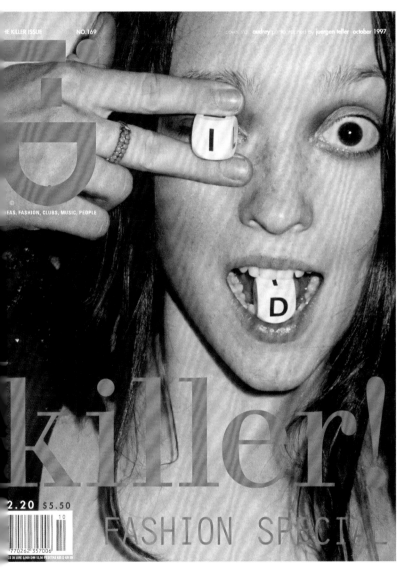

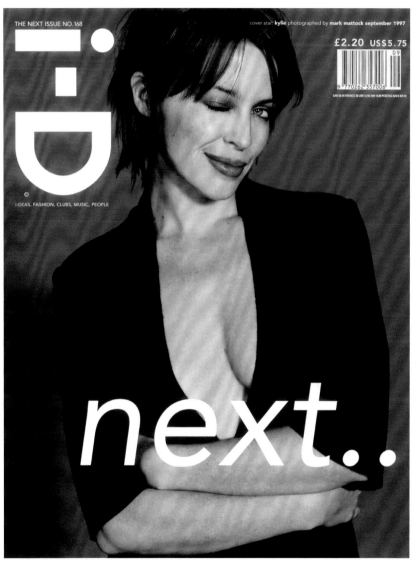

The Killer Issue, No. 169, October 1997
"The unfortunate timing of this cover [The Killer Issue,
No. 169, October 1997] meant that at the time of
going to press, Diana died. It was quite eerie that,
further to the obvious inappropriateness of the cover
line, this was reinforced by the 'D' and 'I' on the dice,
obviously intended to spell i-D. Not a huge seller, I seem
to remember."
Kate Law, Art Director

The Next Issue, No. 168, September 1997
"We had the idea to do this cover, [The Next Issue,
No. 168, September 1997] with a single word cover
line, defying conventional wisdom that says it's the
cover lines that sell issues. The outcome was
circulation figures were not affected and the issue
stood out dramatically on the news stand. It definitely
sparked a distinct phase of non-design stripped of
unnecessary design elements, later deployed by other
publications especially ones launching around this time."
Kate Law, Art Director

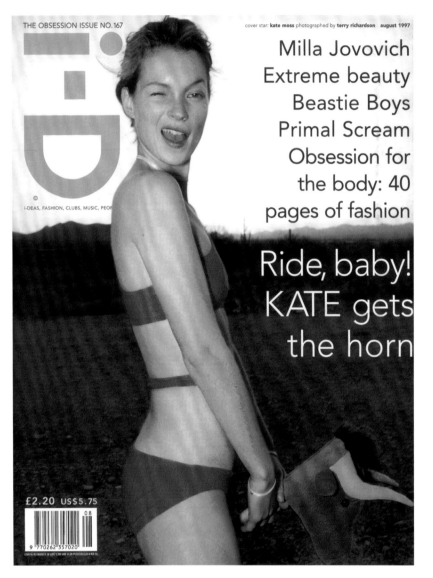

cover star: **kate moss** photographed by **terry richardson** august 1997

i-D

© I-DEAS, FASHION, CLUBS, MUSIC, PEOPLE

Milla Jovovich
Extreme beauty
Beastie Boys
Primal Scream
Obsession for
the body: 40
pages of fashion

Ride, baby!
KATE gets
the horn

£2.20 US$5.75

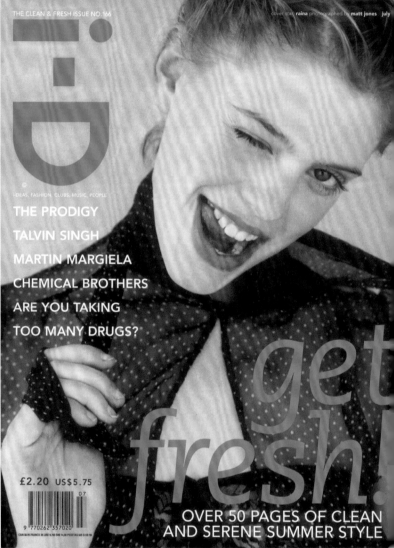

THE CLEAN & FRESH ISSUE NO.166

cover star: **raina** photographed by **matt jones** july

i-D

© I-DEAS, FASHION, CLUBS, MUSIC, PEOPLE

THE PRODIGY
TALVIN SINGH
MARTIN MARGIELA
CHEMICAL BROTHERS
ARE YOU TAKING
TOO MANY DRUGS?

get
fresh!

£2.20 US$5.75

OVER 50 PAGES OF CLEAN
AND SERENE SUMMER STYLE

The Clean and Fresh Issue, No. 166, July 1997
"My second cover was with Raina. I think at that time I
felt most comfortable photographing people I knew."
Matt Jones, Photographer

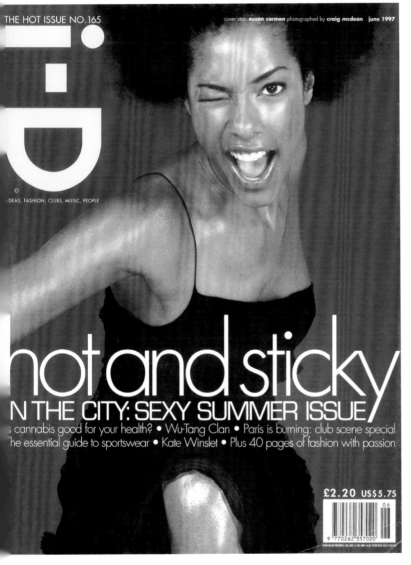

cover star: **susan carmen** photographed by **craig mcdean** june 1997

i-D

©

-DEAS, FASHION, CLUBS, MUSIC, PEOPLE

hot and sticky
N THE CITY: SEXY SUMMER ISSUE

s cannabis good for your health? • Wu-Tang Clan • Paris is burning: club scene special
he essential guide to sportswear • Kate Winslet • Plus 40 pages of fashion with passion

£2.20 US$5.75

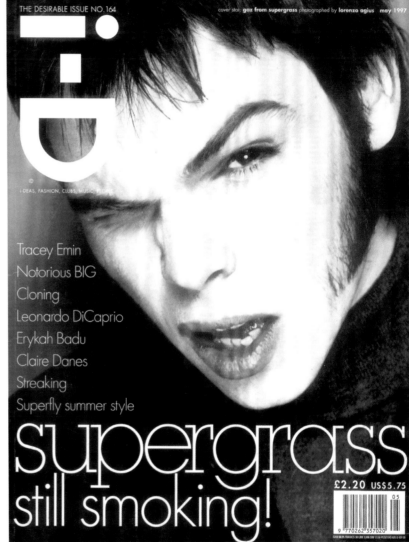

cover star: **gaz from supergrass** photographed by **lorenzo agius** may 1997

i-D

©

i-DEAS, FASHION, CLUBS, MUSIC, PEOPLE

Tracey Emin
Notorious BIG
Cloning
Leonardo DiCaprio
Erykah Badu
Claire Danes
Streaking
Superfly summer style

supergrass
still smoking!

£2.20 US$5.75

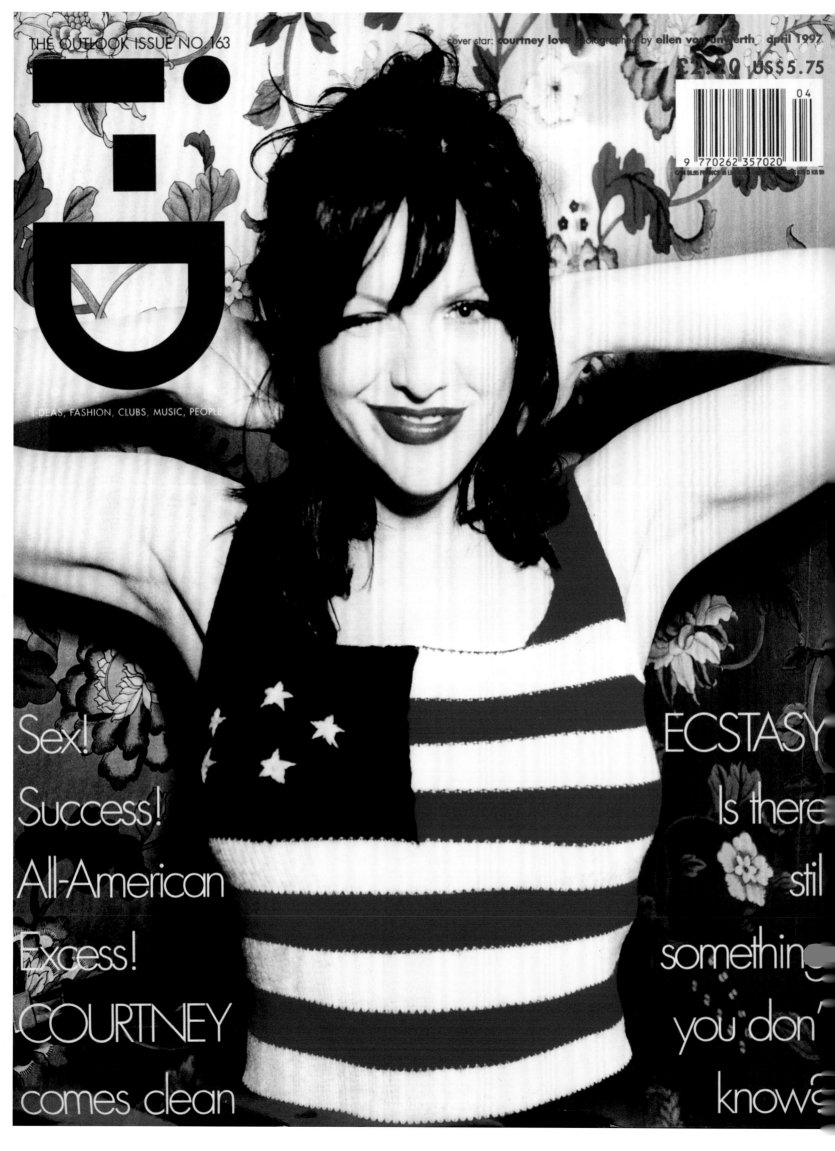

THE OUTLOOK ISSUE NO. 163

cover star: **courtney love** photographed by **ellen von unwerth** april 1997

£2.20 US$5.75

9 770262 357020

04

i-DEAS, FASHION, CLUBS, MUSIC, PEOPLE

Sex!

Success!

All-American

Excess!

COURTNEY

comes clean

ECSTASY

Is there

still

something

you don't

know?

THE NEW BEAUTY ISSUE NO: 162

cover star: **sharleen from texas** photographed by **craig mcdean** · march 1997

SPECIAL BEAUTY ISSUE

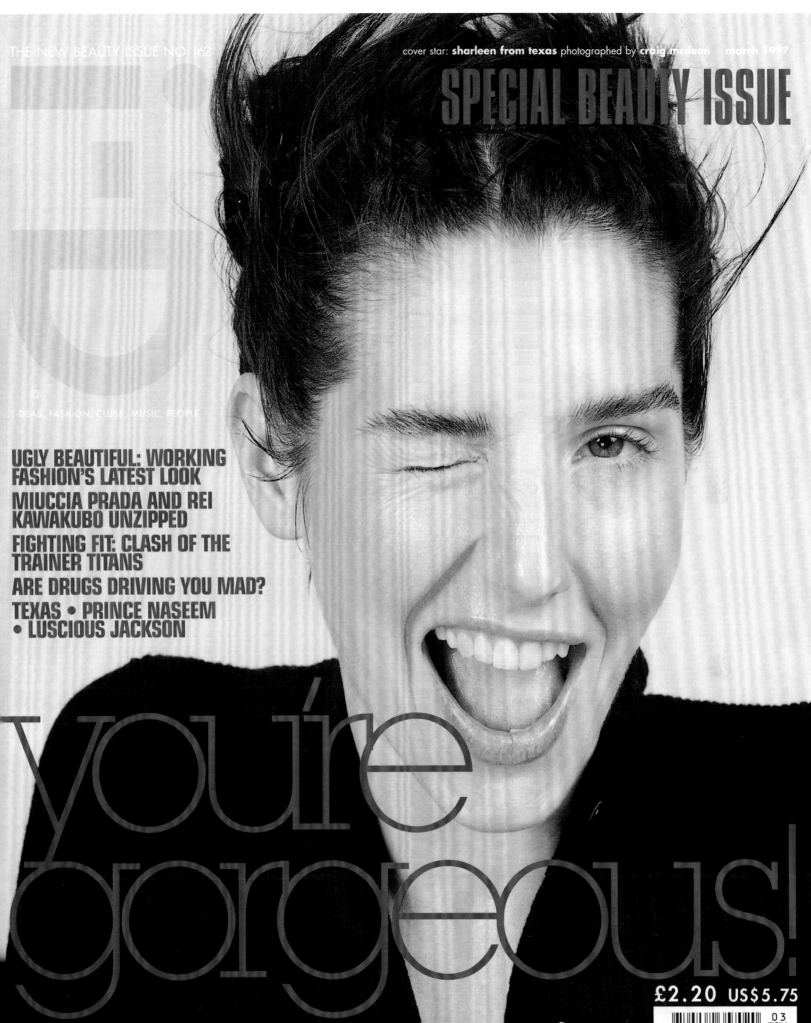

i DEAS, FASHION, CLUBS, MUSIC, PEOPLE

UGLY BEAUTIFUL: WORKING FASHION'S LATEST LOOK

MIUCCIA PRADA AND REI KAWAKUBO UNZIPPED

FIGHTING FIT: CLASH OF THE TRAINER TITANS

ARE DRUGS DRIVING YOU MAD?

TEXAS • PRINCE NASEEM • LUSCIOUS JACKSON

you're gorgeous!

£2.20 US$5.75

03

9 770262 357020

CAN $6.95 FRANCS 38 LIRE 9,000 DM 13,50 PESETAS 625 D KR 59

PUTTING ON FASHION'S FRESH NEW FACE

The New Beauty Issue, No. 162, March 1997

"In the 80s I was only earning £28 a week as a trainee hairdresser but I still managed to buy my copy of i-D at Glasgow's Queen Street station on my train journey home to Balloch. You couldn't get i-D in Balloch! God, I studied them cover to cover; every word, look, pose. I would go back to i-D again and again from the pile I saved at the side of my bed. Fast forward to 97 and I was asked to do a cover try for i-D. It was strange when something you know so well suddenly has you thinking, 'SHIT! How do I wink? I can't wink, I've never been able to wink.' I remember turning up at the studio and there was Pat McGrath, who I'd known since 1989, when she first did my make-up, Eugene Souleiman who'd cut my hair before, and Edward Enninful who I also knew. Then Craig McDean walked in. It was the first time I'd worked with him. Instantly he and Pat went into a discussion about my eyebrows, it was all gonna be about the eyebrows. Who am I to argue with this lot? Eugene pinned all my hair back, I had about 4 boxes of pins in it. Edward let me wear my own top but pulled and pinned it into the perfect shape, and then Pat began on the eyebrows, drawing and sculpting them within an inch of their life, then spraying me with the finest oil. I looked like some kinda futuristic droid, it was amazing. I remember standing in front of Craig thinking, 'Oh no, the wink', but he made the whole thing so effortless and fun. I loved it and love working with Craig! They are one of the all time great teams and continue to be, as does i-D."
Sharleen Spiteri, Cover Star

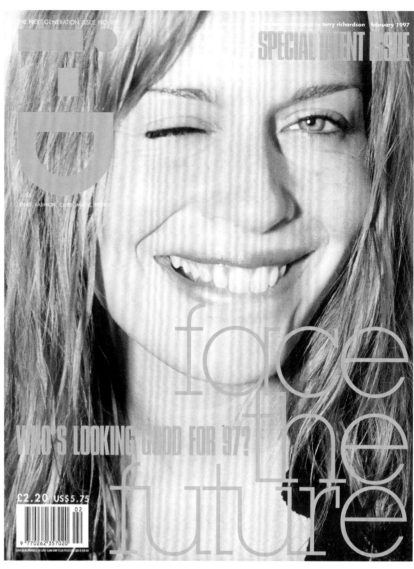

The Undressed Issue, No. 159, December 1996

"As it was The Undressed Issue, I wanted to keep it very cheeky. I took it on my first trip to New York before I moved there. I remember being really excited and running to FedEx to pick up the package when the issue arrived. Jamie Rishar was friends with Michael Boadi, who did the hair and that's how I met her because I was staying with him at the time. It came together in a very casual way; I think I did just two rolls of film. I shot it in black and white transparency, which I'd never used before and was using on a recommendation. I was working for Max Vadukul at the time as a studio assistant."
Matt Jones, Photographer

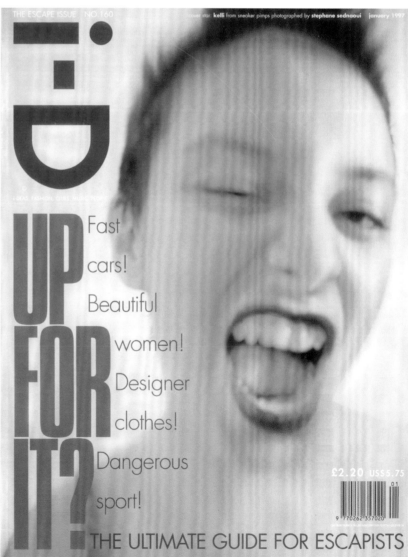

©
i-DEAS, FASHION, CLUBS, MUSIC, PEOPLE

unzip!
THE UNDRESSED ISSUE
DO WE HAVE TO SPELL IT OUT?

£2.20 US$ 5.75

9 770262 357020

THE ENERGISED ISSUE NO.158

cover star: **angela lindvall** photographed by **juergen teller november 1996**

FASHION SPECIAL
INTRODUCING NEW YORK'S NEW COOL

i-D

i-DEAS, FASHION, CLUBS, MUSIC, PEOPLE

OCEAN COLOUR SCENE IS DRUG TESTING TAKING THE PISS? HEAD RUSH: SPORT'S NEW HARD LINE THIS THUG'S LIFE: THE LEGACY OF TUPAC EVAN DANDO ON OASIS BOMBING THE BASS IN BOSNIA

pure sexy!

JUERGEN TELLER SHOOTS TO SCORE

£2.20 $5.75

9 770262 357020

FRANCS 38 LIRE 9,000 DM 13,50 PESETAS 625 D KR 59

The Energised Issue, No. 158, November 1996
"My first cover was taken at the very beginning of my career, my first job ever in fact with Juergen Teller. We were just playing around on the street in London and the picture became the cover. It was the beginning of a lot for me. Thanks i-D!"
Angela Lindvall, Cover Star

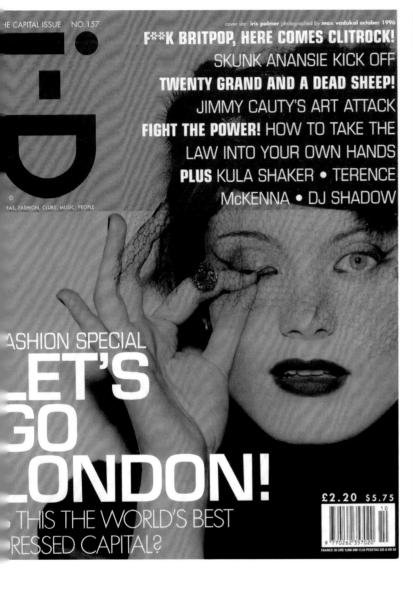

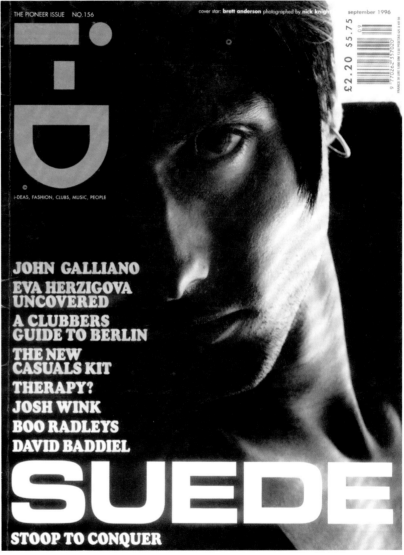

The High Summer Issue, No. 155, August 1996
"Our legendary beauty Naomi Campbell, fresh-faced for summer.
I remember we laughed and giggled all day; we had a ball!"
Pat McGrath, Beauty Director, i-D

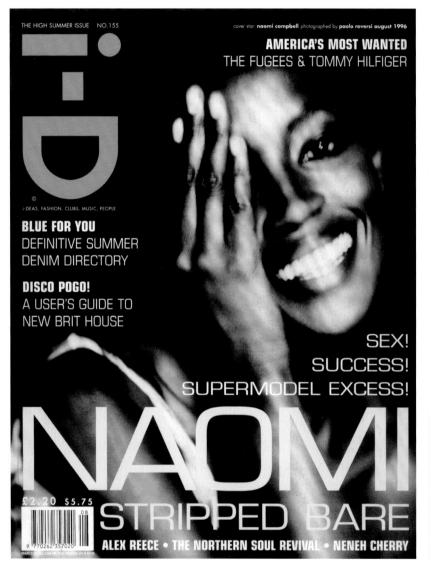

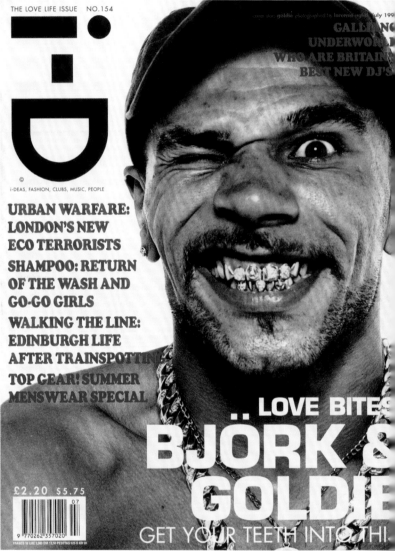

The High Summer Issue, No. 155, August 1996
"It was great working with Paolo (Roversi). I love the
way he shoots; it's always so beautiful, the textures...
He makes you look flawless. I couldn't believe that he
was going to shoot me! It was great to say I was
shooting an i-D cover with Paolo."
Naomi Campbell, Cover Star

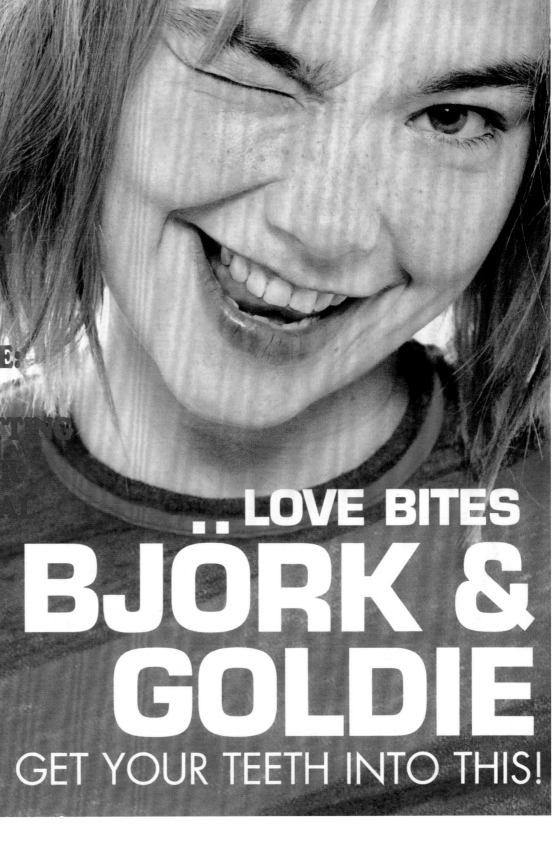

THE LOVE LIFE ISSUE NO.154

cover star björk photographed by lorenzo agius july 1996

GALLIANO
UNDERWORLD
WHO ARE BRITAIN'S
BEST NEW DJ'S?

©

i-DEAS, FASHION, CLUBS, MUSIC, PEOPLE

URBAN WARFARE: LONDON'S NEW ECO TERRORISTS

SHAMPOO: RETURN OF THE WASH AND GO-GO GIRLS

WALKING THE LINE: EDINBURGH LIFE AFTER TRAINSPOTTING

TOP GEAR! SUMMER MENSWEAR SPECIAL

.. LOVE BITES

BJÖRK & GOLDIE

GET YOUR TEETH INTO THIS!

£2.20 $5.75

9 770262 357020

07

FRANCS 38 LIRE 9,000 DM 13.50 PESETAS 625 D KR 59

The Fresh Issue, No. 151, April 1996

"I had always admired Lorraine Pascal. She had this amazingly contagious smile. She also makes exceedingly good cakes!"
Pat McGrath, Beauty Director, i-D

Terry Jones in conversation with David Sims

Terry: Can you remember your first cover?
David: God, no…

What about your first cover with Gisele?
I can remember that [The Cheeky Issue, No. 182, December 1998]. She was young, spirited and quite cheeky; the same girl she is now really, except she wasn't quite as rich back then!

After Giselle you photographed the American model Bridget Hall for The Romance Issue [No. 188, July 1999]?
Yes. You didn't like that cover at the time, did you?

It was certainly different…
When I said to you that the shot was close enough to kiss, I think that swung it.

It was like a self-portrait.
God no, that's perverse.

Your cover of Kate Moss was a classic [The Survival Issue, No. 149, February 1996]
Yes, that was a good one.

That was more than a good one. Was that your first i-D cover?
Yes, I think it might have been. Kate was very young at the time, wasn't she?

She was very young and I remember she couldn't wink.
No, I don't think she could, hence the fingers over the eye.

You also photographed Natalia Vodianova very early on in her career…
I did, yes, but we lost touch. I shot her in Iceland for a make-up brand. We haven't done any editorial together for a long time…

What were the first pictures you contributed to i-D?
Portraits I shot of friends. Do you remember those? I handed them in to Nick Knight who was Art Director at the time and then I went away on a two-month trip and when I came back they'd been published. They were the first pictures I'd ever had published. I was so excited.

Terry Jones in conversation with Kate Moss and Edward Enninful

Terry: Do you remember your first i-D cover?
Kate: I remember the third cover [The Survival Issue, No. 149, February 1996], David Sims found a way for me to cover one eye without winking because I look a bit weird when I wink. The third cover's not the only cover I didn't wink on. But I did wink on the cover with Naomi in New York at night – the black and white one [The Us Issue, No. 131, August 1994]. We were photographed by Steven Klein leaving a club in the Meatpacking District in New York, but we didn't actually go out. We'd been working all day and then shot that very late at night.
Edward: Do you remember how all the trannies were shouting over at us, 'That's not Kate and Naomi!' and then they saw the limos waiting and they changed their minds and were like 'Whoa!!!'
K: Yes. That was so funny! It was back when all the trannies occupied The Meatpacking District, before the fashion pack officially arrived. I can't believe they closed down Jackie 60 – it's all gone!

What other covers are you winking on?
K: The hobbyhorse cover shot by Terry Richardson [The Hobbyhorse Issue, No. 167, August 1997]. I'm winking on that, aren't I? I can't really wink though because my whole face screws up, it's a bit of a problem. I really like the cover shot by Craig McDean where my wink is over my eye because of my winking instability [The Streaker Issue, No. 221, June 2002]. That was a turning point. It's a theme that carried on throughout my i-D cover career! The next cover went back to the hand [The Individual Issue, No. 230, April 2003]. And the one after that was a rock 'n roll story that went back to the hair over one eye, as was the next one with Tesh that saw me naked with the hair in the face again [The Name Issue, No. 258, September 2005].

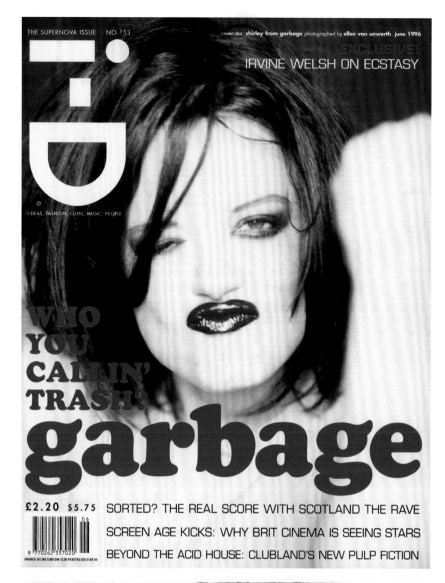

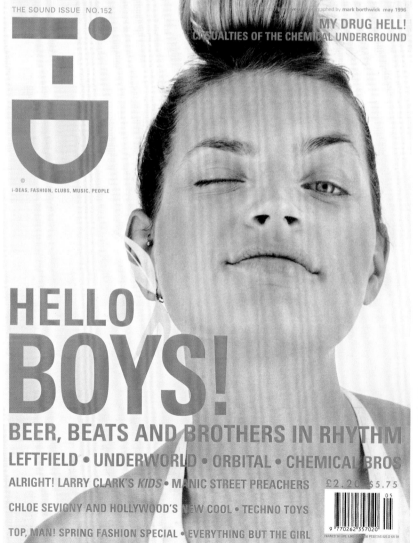

cover star: lorraine pascale photographed by craig mcdean april 1996

i-DEAS, FASHION, CLUBS, MUSIC, PEOPLE

YOUNG GUNS GO FOR IT!
Northern Uproar, Ash and the new sonic youth

GENERATION ECSTASY

TIME TO STOP TAKING THE PILL?

Flashback! The new Acid reign

What are drug-free clubbers on?

£2.20 $5.75

BOMBING THE BASS: RAVING ON BOSNIA'S FRONTLINE

MALCOLM MCLAREN • FATHER TED • HOW TO BE OASIS

PLUS MORE THAN TWENTY PAGES OF THIS MONTH'S TOP POP!

9 770262 357020

FRANCS 38 LIRE 9,000 DM 13,50 PESETAS 625 D KR 59

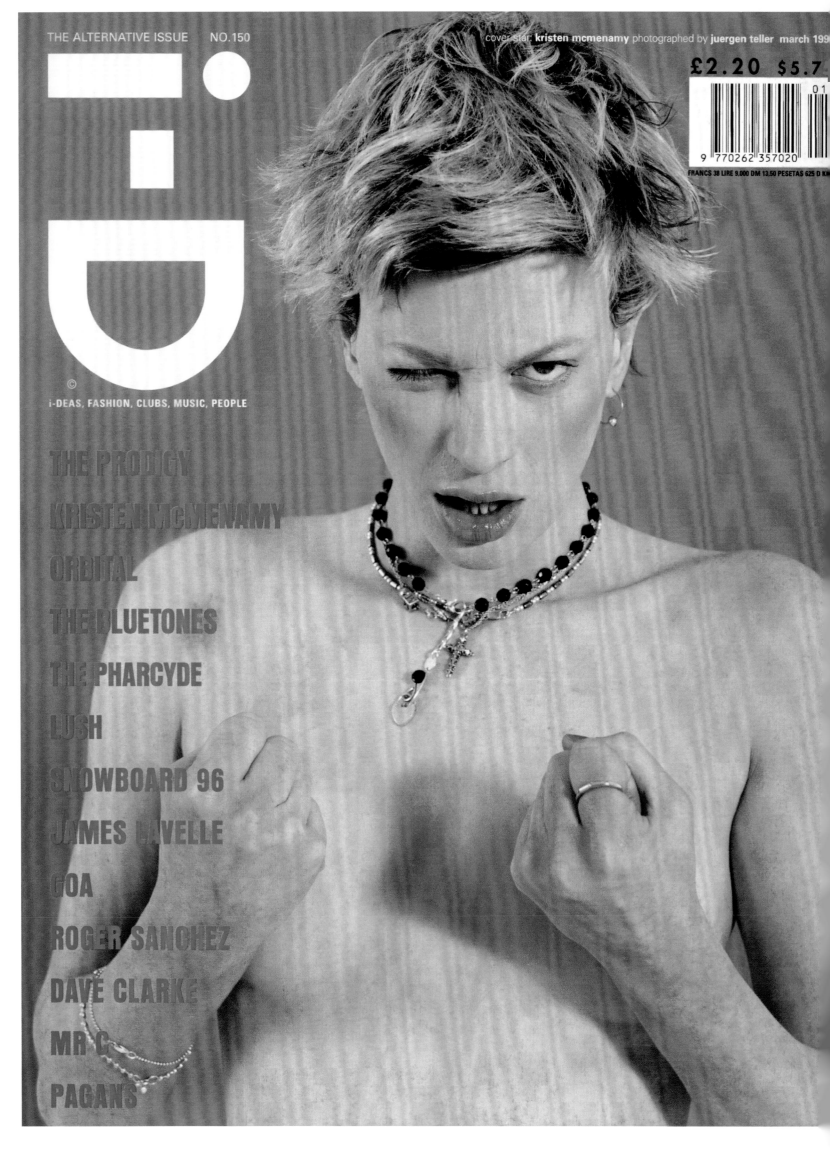

THE ALTERNATIVE ISSUE NO.150

cover star: **kristen mcmenamy** photographed by **juergen teller** march 199

£2.20 $5.7

9 770262 357020
FRANCS 38 LIRE 9.000 DM 13,50 PESETAS 625 D KN

i-D

i-DEAS, FASHION, CLUBS, MUSIC, PEOPLE

THE PRODIGY

KRISTEN McMENAMY

ORBITAL

THE BLUETONES

THE PHARCYDE

LUSH

SNOWBOARD 96

JAMES LAVELLE

GOA

ROGER SANCHEZ

DAVE CLARKE

MR C

PAGANS

THE SURVIVAL ISSUE NO.149

cover star: **kate moss** photographed by david sims february 1996

i-D

i-DEAS, FASHION, CLUBS, MUSIC, PEOPLE

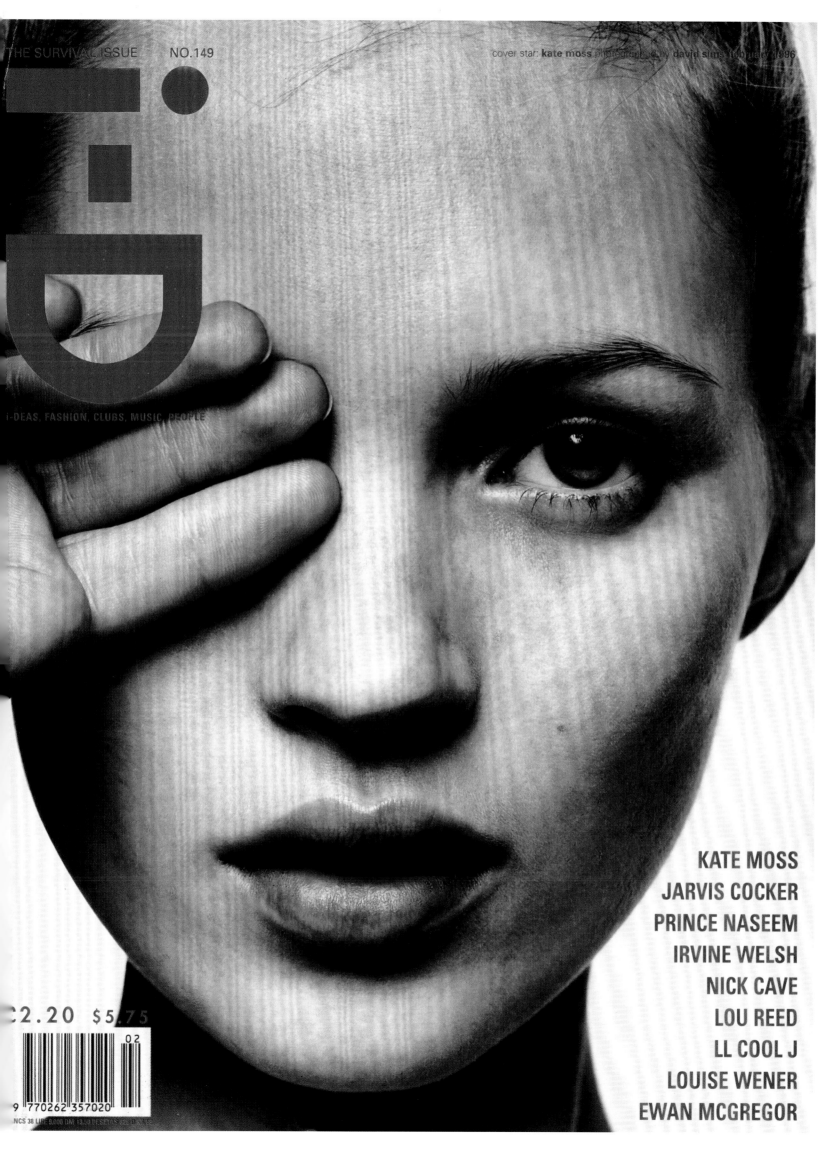

KATE MOSS
JARVIS COCKER
PRINCE NASEEM
IRVINE WELSH
NICK CAVE
LOU REED
LL COOL J
LOUISE WENER
EWAN MCGREGOR

£2.20 $5.75

02

9 770262 357020

NCS 38 LIRE 9,000 DM 13,50 PESETAS 625 DKR 55

The Alternative Issue, No. 150, March 1996

"Juergen Teller and I used to work together in the mid 1990's during the grunge period. Along with David Sims and Corinne Day, he was helping to redefine the era with his paired down, honest photography. Taking his cue from Helmut Newton, Juergen had the ability to draw out a woman's raw sexuality whilst still retaining a sense of everyday reality. When we shot Kristen McMenamy for The Alternative Issue, I decided to bring only jewellery because I was fed up with designer clothes at the time. Kristen had a huge bruise on her shoulder, which Juergen and I both loved. I scrolled 'Versace' on her chest because at that time Versace represented the ultimate in high glossy glamour, the opposite of everything we were in London. This remains, for me, one of the truest, most honest i-D covers of the magazine's history."

Edward Enninful, Fashion Director i-D

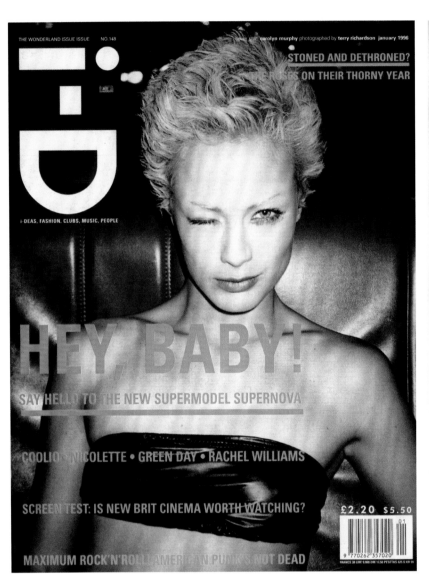

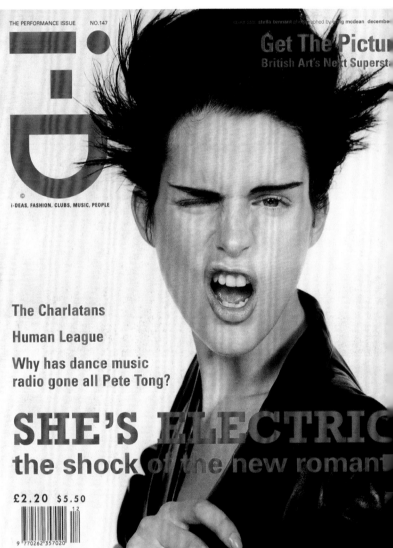

The Wonderland Issue, No. 148, January 1996

"Terry Richardson and I used to shoot a lot of crazy stories early on in his career. For a couple of years he was the only photographer I would work with. We would often shoot after 6pm in hustler/ junkie populated Times Square, graveyards in Brooklyn or hotel rooms in LA. This cover of Carolyn Murphy was her first for any magazine. We caught her at a very exciting period in her career – she was starting her ascendancy to supermodel status. It was very exciting to watch. We portrayed her as a streetwise Mia Farrow."

Edward Enninful, Fashion Director i-D

The Performance Issue, No. 147, December 1995

"So happy to work with Stella again. I was always obsessed with her eyebrows."

Pat McGrath, Beauty Director, i-D

180

The Fifteenth Birthday, Issue No. 145, October 1995
"Another cover, which was a graphic concept, was the 15th birthday issue. I thought it would be great if we could do a mirror on the cover, as the content was full of people who were relevant in art, fashion and music, from Damien Hirst to Blur to John Galliano. I thought it was safest to have a cover whereby whoever picked up the issue was on the cover. I pushed the boat out to do a full silver blocking on the cover, which meant that it had to go to the printers three weeks before the content. It was a hugely successful issue, and it was as mirrored as it could get using print. I also loved the way it would mark. The more people would

REAL ISSUE ISSUE NO.146

i·D

cover star : emma balfour photographed by craig mcdean november 1995

£2.20 $5.50

9 770262 357020

, FASHION, CLUBS, MUSIC, PEOPLE

SUPERSONIC YOUTH!

MENSWEAR MAKE SOME NOISE

Goa Trance The New Acid House?

Teenage Kicks With Larry Clark's Kids

Smack's Back: Why Is Heroin Hip Again?

Made In The UK: British Fashion Strikes Back

The Rise Of Ione Skye The Return Of St Etienne

The Real Issue, No. 146, November 1995
"The super cool Emma Balfour."
Pat McGrath, Beauty Director, i-D

FAMOUS FOR FIFTEEN YEARS

£2.20 $5.50

9 770262 357020

SPECIAL BIRTHDAY ISSUE

handle it, the more it would scratch and degrade. The aging of the silver was part of the idea. We used the same graphic idea of just the logo when we did the 200th issue [August 2000], that was again reminiscent of Issue 1. I'm still having to explain 'Why the wink?' and draw it out as a closed eye, open eye, smile. I did it yesterday for a contributor. It's great that it's still a bit of a mystery."
Terry Jones, i-D Founder

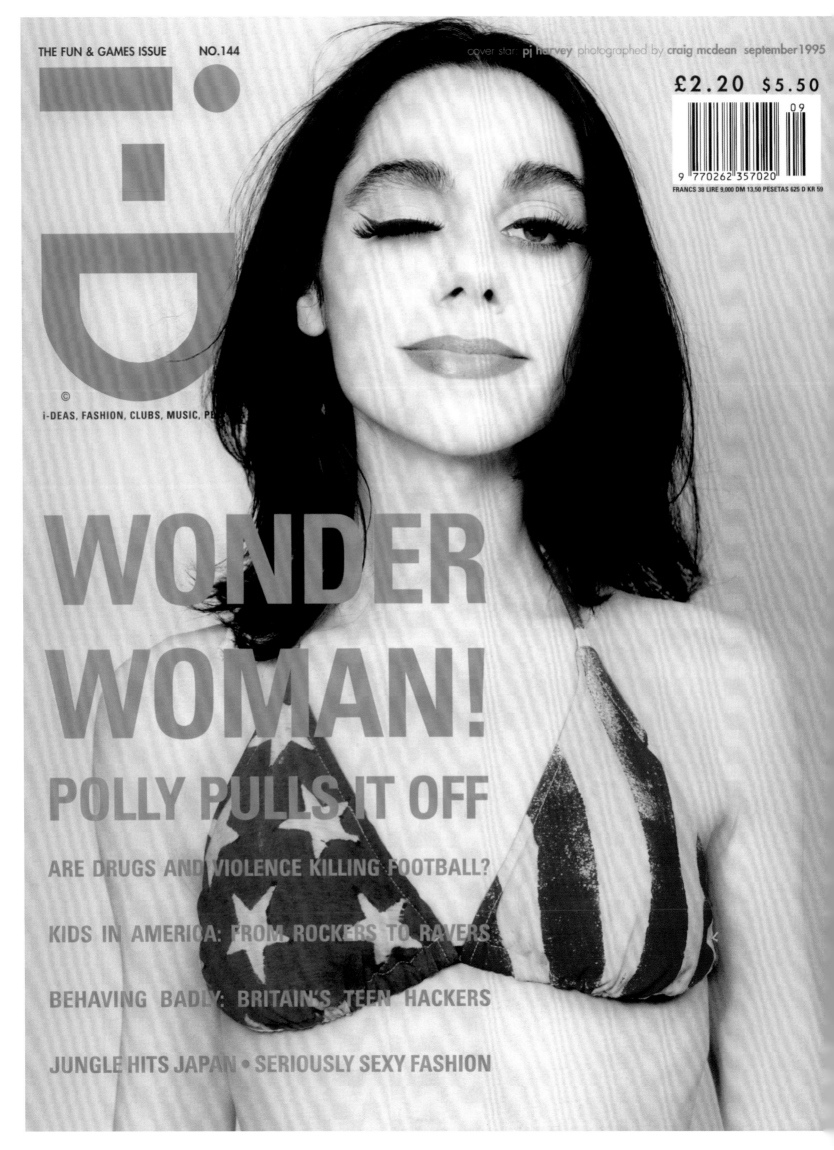

THE FUN & GAMES ISSUE NO.144

cover star: **pj harvey** photographed by **craig mcdean** september 1995

£2.20 $5.50

9 770262 357020 09

FRANCS 38 LIRE 9,000 DM 13,50 PESETAS 625 D KR 59

i:D

©

i-DEAS, FASHION, CLUBS, MUSIC, PE

WONDER WOMAN!

POLLY PULLS IT OFF

ARE DRUGS AND VIOLENCE KILLING FOOTBALL?

KIDS IN AMERICA: FROM ROCKERS TO RAVERS

BEHAVING BADLY: BRITAIN'S TEEN HACKERS

JUNGLE HITS JAPAN • SERIOUSLY SEXY FASHION

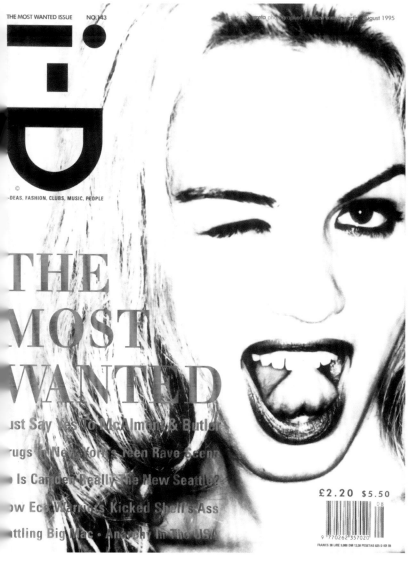

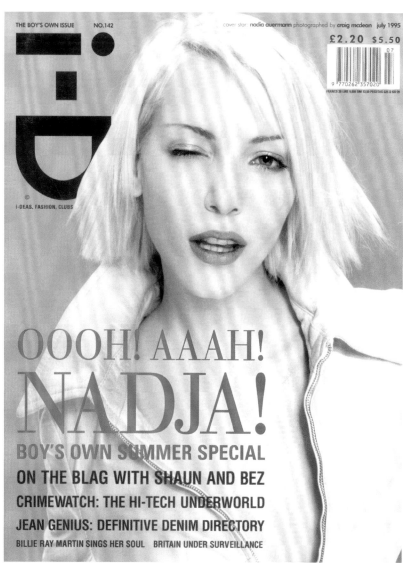

The Boy's Own Issue, No. 142, July 1995
"Nadja was the ultra-platinum beauty. Such a pleasure
to work with and such a fashion icon."
Pat McGrath, Beauty Director, i-D

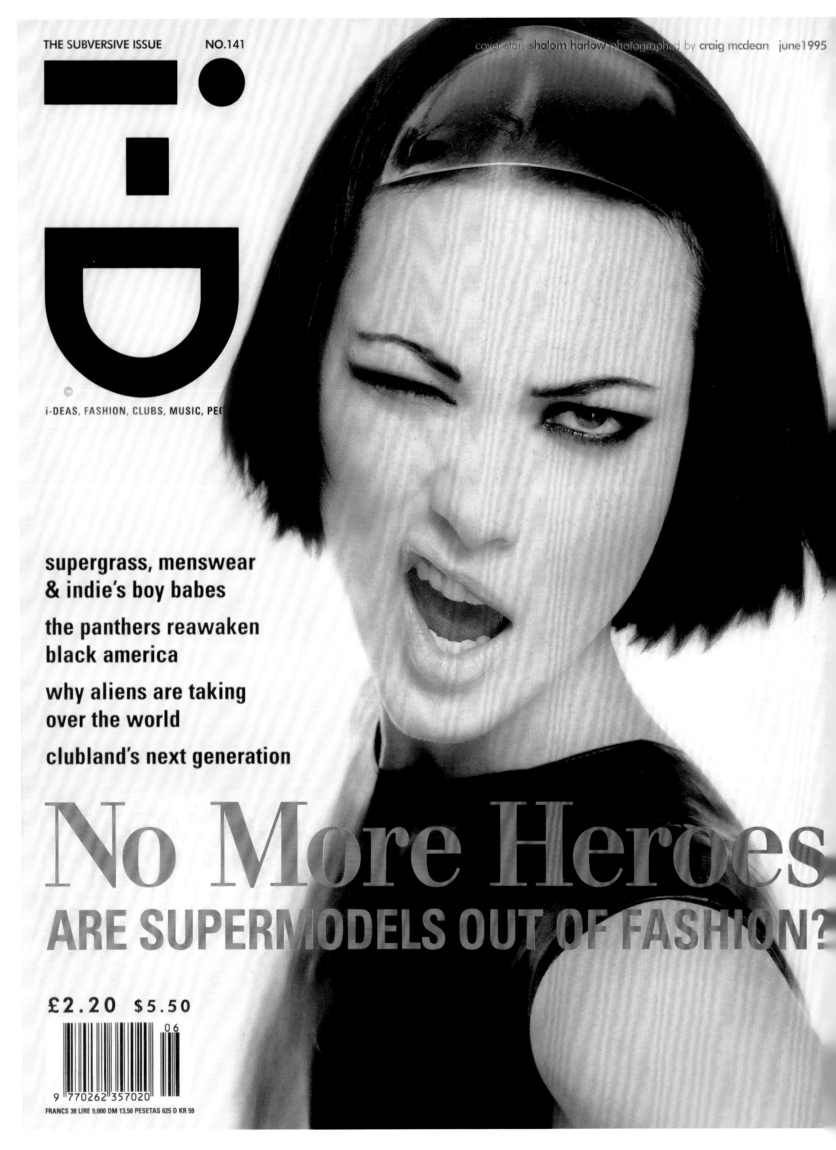

THE SUBVERSIVE ISSUE NO.141

cover star: shalom harlow photographed by craig mcdean june1995

i-D

© i-DEAS, FASHION, CLUBS, MUSIC, PE(

supergrass, menswear
& indie's boy babes

the panthers reawaken
black america

why aliens are taking
over the world

clubland's next generation

No More Heroes
ARE SUPERMODELS OUT OF FASHION?

£2.20 $5.50

06

9 770262 357020

FRANCS 38 LIRE 9,000 DM 13,50 PESETAS 625 D KR 59

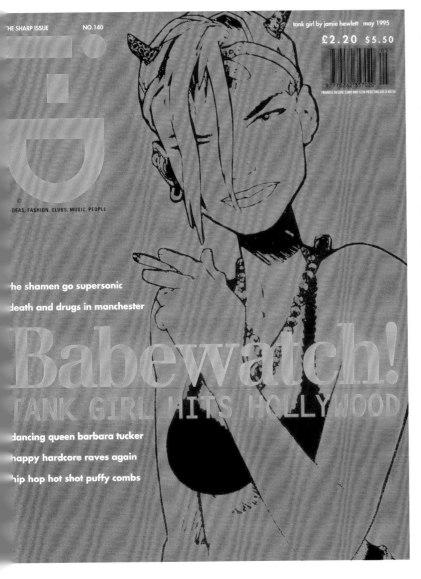

THE SHARP ISSUE NO.140 tank girl by jamie hewlett may 1995

i-D

£2.20 $5.50

FRANCS 38 LIRE 9,000 DM 13.50 PESETAS 625 D KR 59

i-DEAS, FASHION, CLUBS, MUSIC, PEOPLE

the shamen go supersonic

death and drugs in manchester

Babewatch!
TANK GIRL HITS HOLLYWOOD

dancing queen barbara tucker

happy hardcore raves again

hip hop hot shot puffy combs

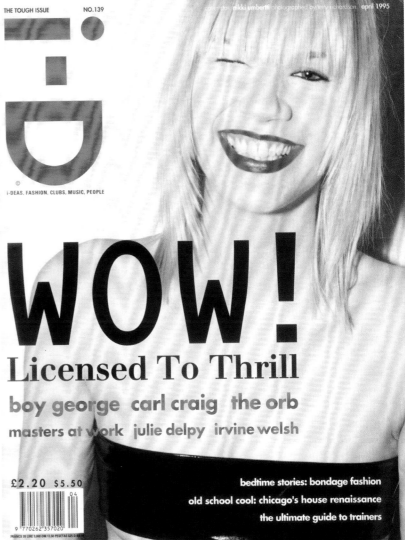

THE TOUGH ISSUE NO.139 nikki umberti photographed by terry richardson april 1995

i-D

i-DEAS, FASHION, CLUBS, MUSIC, PEOPLE

WOW!
Licensed To Thrill
boy george carl craig the orb
masters at work julie delpy irvine welsh

£2.20 $5.50

bedtime stories: bondage fashion

old school cool: chicago's house renaissance

the ultimate guide to trainers

9 770262 357020

FRANCS 38 LIRE 9,000 DM 13.50 PESETAS 625 D KR 59

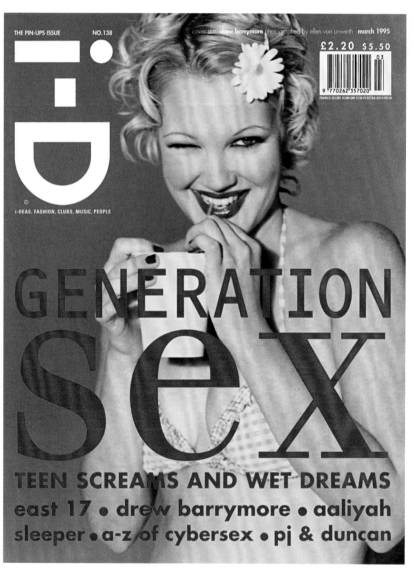

THE PIN-UPS ISSUE NO.138 cover star: drew barrymore photographed by ellen von unwerth march 1995
£2.20 $5.50

i-D

i-DEAS, FASHION, CLUBS, MUSIC, PEOPLE

GENERATION Sex

TEEN SCREAMS AND WET DREAMS

east 17 ● drew barrymore ● aaliyah
sleeper ● a-z of cybersex ● pj & duncan

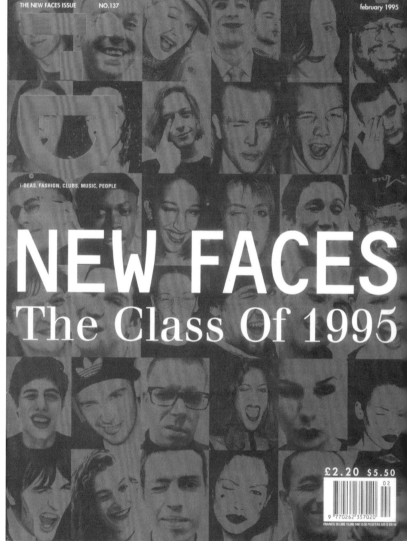

THE NEW FACES ISSUE NO.137 february 1995

i-DEAS, FASHION, CLUBS, MUSIC, PEOPLE

NEW FACES
The Class Of 1995

£2.20 $5.50

THE FUTURE ISSUE NO.136

cover star kiara photographed by dean January 1995

i-DEAS, FASHION, CLUBS, M

THIS IS THE FUTURE!

life in cyberspace

the black dog • policing the internet

future shock fashion • cyborgfeminism

a guy called gerald • techno subversives

£2.20 $5.50

9 770262 357020

01

FRANCS 38 LIRE 10,000 DM 13,50 PESETAS 625 D KR 59

The Future Issue, No. 136, January 1995
"Flawless Kiara was absolutely stunning! I gave her blade-runner eyes using a crazy mix of shimmers. It was so much fun."
Pat McGrath, Beauty Director, i-D

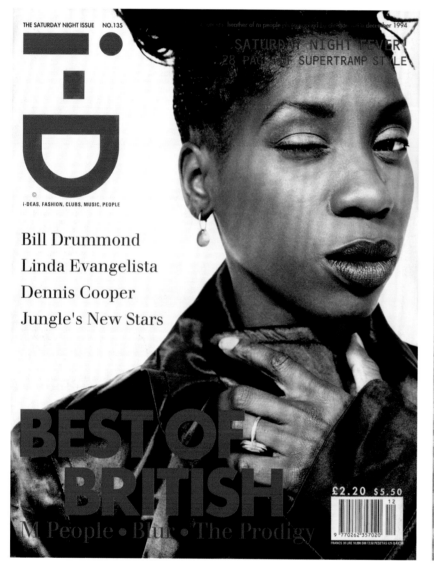

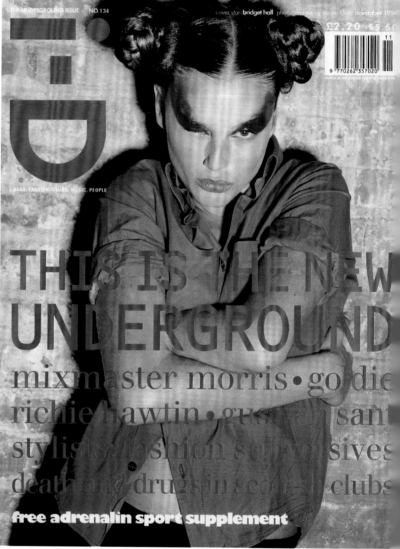

The Visionary Issue, No. 133, October 1994
"London always produces some of the best girls, Twiggy, Kate Moss, etc. Stella Tennant is one of them for sure; she has style with attitude and class! Suede was pretty hot at the time (great hair cut). We did a double winking for that one. Pat McGrath and Guido Palau were already very inspiring. We used to laugh and smoke a cigarette a lot back then...plus tea. Without trying to be nostalgic I do miss this period of lightness, the future was brighter."
Jean-Baptiste Mondino, Photographer

The Visionary Issue, No. 133, October 1994
"This was my first time working with Stella Tennant. I also remember being really excited about working with Jean-Baptiste Mondino."
Pat McGrath, Beauty Director, i-D

THE VISIONARY ISSUE NO. 133 cover stars: **brett anderson** and **stella tennant** photographed by jean baptiste mondino **OCTOBER 1994**

£2.20 $5.50

9 770262 357020

FRANCS 38 LIRE 10,000 DM 13,50 PESETAS 625 D KR 59

©

i-DEAS, FASHION, CLUBS, MUSIC, PEOPLE

FASHION'S FRESH VISION

quentin tarantino
luscious jackson
liza bruce
steve albini
billion dollar babewear
art terrorism
jungle chic
the new mods

suede
The Art Of Falling Apart

THE STREET ISSUE NO.132

cover star: **björk** photographed by ellen von unwerth **SEPTEMBER 1994**

i-D

© i-DEAS, FASHION, CLUBS, MUSIC, PEOPLE

INTERNATIONAL STREET FASHION SPECIAL

paranoia in cyberspace

the future for football

Massive Attack

Shed Seven

Rebel MC

the best disco dancing
guide in the world

public enemy

Chuck D in the dock

russell simmons

Hip hop's top dog

the drum club

Trance tripping in Tokyo

£2.20 $5.50

björk!

A Night Out With Miss World

09

9 770262 357020

FRANCS 38 LIRE 10,000 DM 13.50 PESETAS 625 D KR 59

i-DEAS, FASHION, CLUBS, MUSIC, PEOPLE

Rage Against The Machine
drop the bomb on Britain

Timothy Leary
from inner space to cyberspace

american dream
KATE, NAOMI & NEW YORK'S URBAN COOL

Nine Inch Nails
sex & death & rock'n'roll

Grateful Deadheads
on America's hippy trail

Joie Lee
Spike's smart sister

£1.95 $4.95

08
9 770262 357013

FRANCS 35 LIRE 7,100 DM 13,00 PESETAS 595 D KR 53

Plus... Laurie Anderson • ambient California • Marc Jacobs • Pavement • The Prodigy • rollin' with rollerblades

Terry Jones in conversation with Steven Klein

Terry: What is your favourite cover of i-D?
Steven: The cover I shot of Kate Moss and Naomi Campbell [The Us Issue, No. 131, August 1994] because it documents a time in history and it was shot close to my studio in the Meatpacking District, New York. I like my Alexander McQueen cover too, with Jamie Bochert with her back out [The Graduate Issue, No. 223, September 2002].

Tell me about the Kate and Naomi shoot.
We shot in the Meatpacking District in New York. At the time the Meatpacking District was not like it is today; there weren't all the clubs, boutique hotels and stores there are today.

It smelt of beef.
Yes, there was the meatpacking and at night it was quite dangerous. There were all these transvestites that used to work the streets at that time. When we were shooting Kate and Naomi – it wasn't a big production or anything – all of a sudden there were like fifteen or twenty transvestites surrounding us. At first they didn't believe it was really Kate and Naomi; they thought they were impersonators. Once they realised, they were egging them on and kept shouting at Naomi, "Swing them in" and all that kind of stuff. It would never happen today because of how the whole area has changed.

Tell me about your cover shoot with L'il Kim [The Hotel Issue, No. 196, April 2000].
I only had half an hour to shoot L'il Kim because even though she arrived in the morning, she had to have her footbath and toe manicure, so she took almost fifteen hours to get ready for the camera and then I shot her for maybe twenty minutes.

You also photographed Veronica Webb for the cover [The Urgent Issue, No. 124, January 1994]....
That was my first cover I did with Edward Enninful. I was quite honoured to shoot that one.

That was also Veronica's first cover.
Yes, that was her first cover, my very first cover and my first time working with Edward. You know your covers, Terry!

I don't remember them all.
Yes you do; you know them all.

The US Issue, No. 131, August 1994
"Kate was living with me at this point, in-between my place and Christy Turlington's. We were really close at this time and having lots of fun in New York. We shot this in the Meatpacking District and all the trannies were going crazy! This is when Pat McGrath entered my life too. It was great to be shooting this for i-D, a British magazine, it always feels special when you're doing it for England."
Naomi Campbell, Cover Star

The US Issue, No. 131, August 1994
"I remember shooting until three or four in the morning. We shot it in the Meatpacking District in New York and there were crowds in the street screaming Kate and Naomi's name. It was hysterical!"
Pat McGrath, Beauty Director, i-D

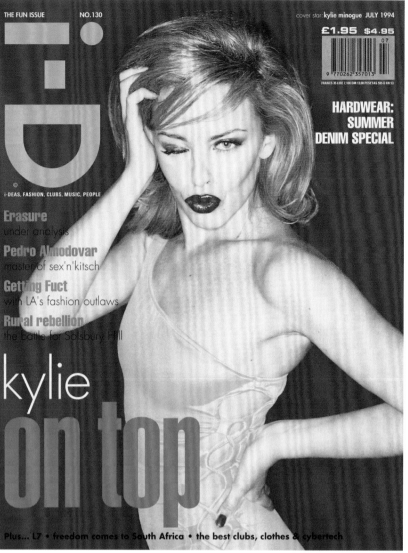

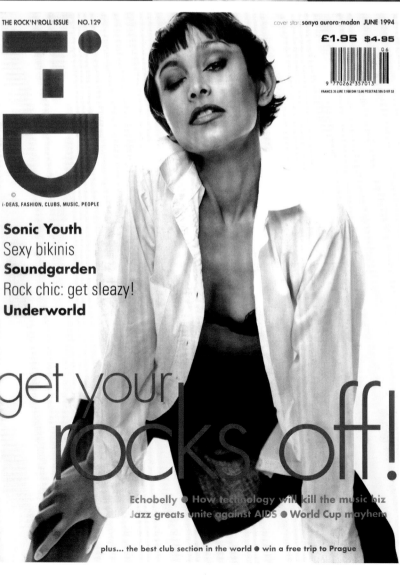

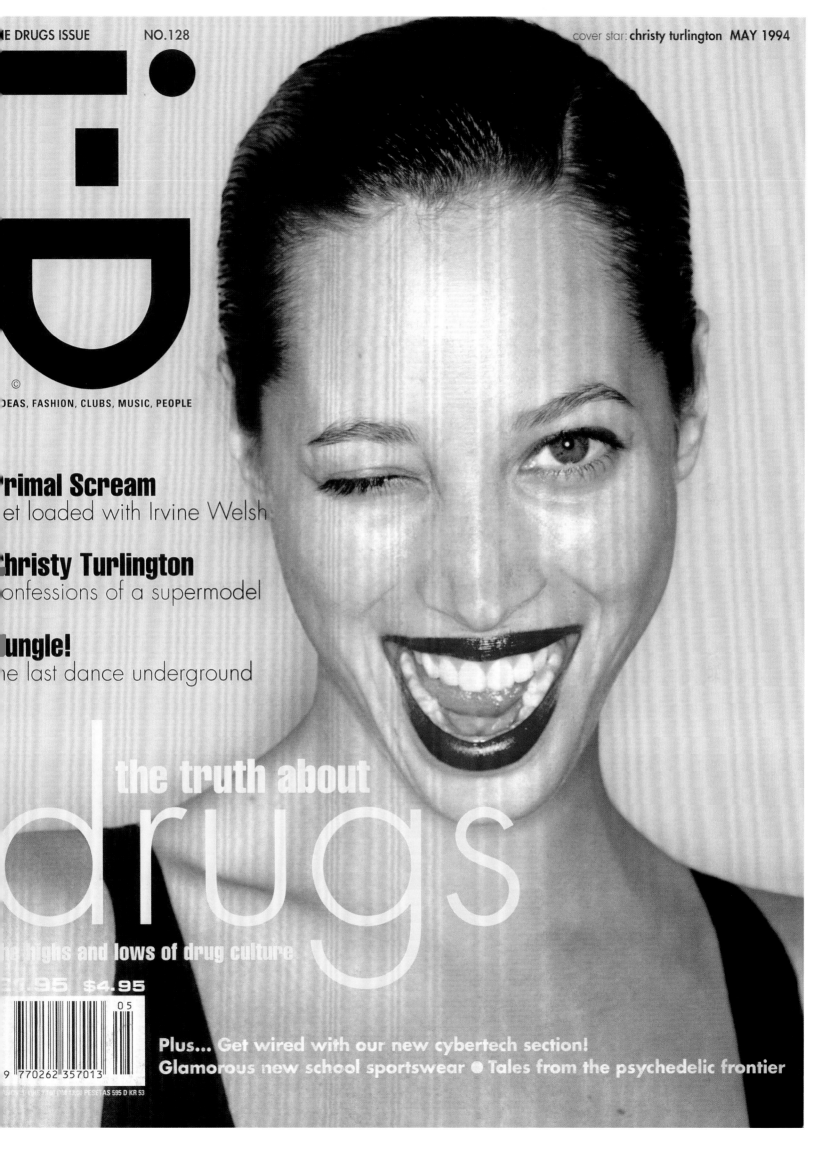

i-D

©

DEAS, FASHION, CLUBS, MUSIC, PEOPLE

rimal Scream
et loaded with Irvine Welsh

hristy Turlington
onfessions of a supermodel

ungle!
he last dance underground

the truth about
drugs

highs and lows of drug culture

95 $4.95

05

9 770262 357013

Plus... Get wired with our new cybertech section!
Glamorous new school sportswear ● Tales from the psychedelic frontier

THE SEX ISSUE

i-D

©

i-DEAS, FASHION, CLUBS, MUSIC, PEOPLE

127 april 1994

i-D

cover star: courtney love

what our generation really thinks about sex

the naughty guide to smut

rap wars: men vs. women

saucy, silly, sleazy

SEX!

with Courtney Love

£1.95 $4.95

9 770262 357013 04

FRANCS 35 LIRE 7,100 DM 13,00 PESETAS 595 D KR 53

plus... jean colonna's fashion extravaganza
glamorous manchester • senser • knickers!

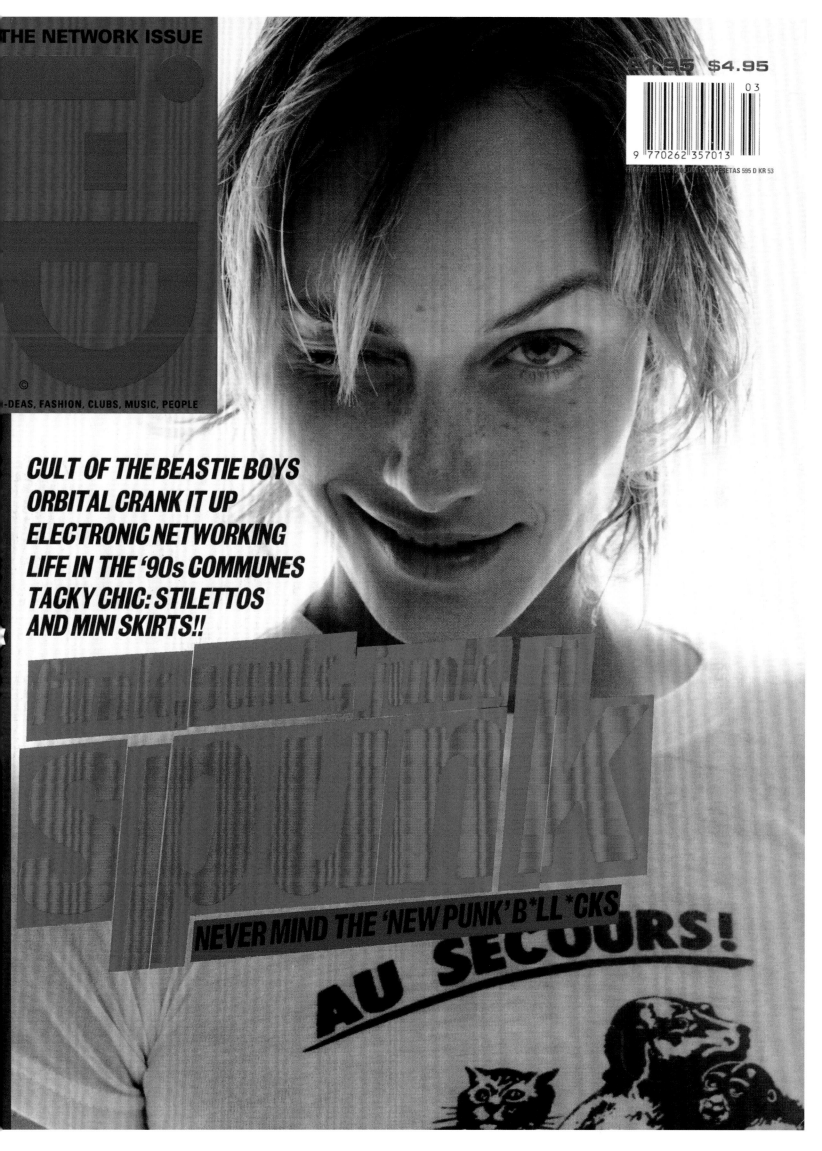

"Amber Valetta was the first supermodel I ever worked with. I remember being so nervous before meeting her. We just couldn't believe we were working with her. I will always have a special place in my heart for Amber."
Pat McGrath, Beauty Director, i-D

Terry Jones in conversation with Scott King

Terry: Do you remember your first day in the i-D studio?
Scott: Yes, I couldn't cut a straight line. I'd just left college and Stephen (Male) really liked my college work and sent me over to your house. Then you terrified me by saying, 'Ok, you can start work now.' I remember thinking if you gave me a job then I'd go and spend my last £8 on booze to celebrate, and then start work in a week or two. But you said, 'No, you can start now.' I remember having to cut out some proofs. You said you were going out and all I had to do – the only thing I had to do – was cut out eight pieces of paper in a straight fashion. You came back and it looked like I'd used a pair of kid's scissors and I was blind!

I remember. But I kept you on. What did you work on after that?
For about three weeks I went to your studio at Sherriff Road everyday. We worked together on the party you held at the Hacienda in Manchester as part of i-D Now and then I started working as a graphic designer at i-D full-time.

Who was on the i-D team at the time?
Kate Law had just left Camberwell College of Art and came in to i-D for a work placement. She did an illustration made out of cut metal. Because she was quite hot we gave her a work placement and she's still there. It turned out Kate went to college with a friend of mine. I think that was often the way with i-D – there was always a social connection somewhere. I didn't work on any covers initially. We always had to go to Latent Image and sit there. I remember these incredibly complex plotting systems... I never understood what they did. The scanning and all that kind of stuff was well beyond anything I could do. You always designed the covers and I only ever got involved when you were away.

You worked on The Drugs Issue [No. 128, May 1994]...
I'd been working at i-D just over a year by this stage. Previously we'd been doing all these trashy, punky graphics but you had definitely had enough, so for this issue you cleaned it all up. This was the first cover of a new period. A beautiful woman [Christy Turlington] and a beautiful wink. The type's not bad either. This was a new look for i-D that carried on for quite some time.

Do you remember the Kylie Minogue cover [No. 132 September 1994]?
Yes, we used this kind of heavy, Ultra Bold Gill I think it was, typeface. I don't know where the idea came from, but I remember this cover was a rescue job. We weren't happy with the picture of Kylie so you decided to put fluorescent pink behind her head and tint her with fluorescent pink too. It's obviously not a pantone... But it became a good cover that started out really not very good at all...

What other covers did you work on?
The Saturday Night Issue with Heather Small [No. 135, March 1995] was a good cover because it tapped into Douglas Coupland's book, Generation X. I remember you and I getting quite excited about the combination of a Serif font and old and new together. It looked really, really good. At the time, we also did a few covers with a big typeface over the image without destroying it. The worst thing about being a young designer at the time was every time I thought I'd found or learnt a formula, when I tried to reapply it, it never worked. For example the Carolyn Murphy cover we did in January 1996 [The Wonderland Issue, No. 148] is a version of that and was absolutely fucking awful, whereas the same thing on The Saturday Night Issue works beautifully. Similarly with the Kristen McMenamy cover in 1996 [The Alternative Issue, No. 150, March 1996]. At the time I remember thinking it was a really crap cover, but looking at it today it's not actually, it looks really modern still.

What other i-D covers stand out in your memory?
I really remember the Tank Girl cover [The Sharp Issue, No. 140, May 1995]. We had this poxy drawing, that was really thin and crap and you duplicated it, which seems obvious now, and moved it around a little bit. I just did a book with a young designer and he had no idea that you could put 4% cyan in black but that's exactly the kind of thing I learnt working with you. Fire engine red works with blue every time.

What came next?
The Shirley Manson cover [The Supernovembra Issue, No. 153, June 1996]. The Shirley cover was really the end of my relationship with i-D. I've never talked about this, but you went away and before you went you told me that when you came back you were going to take full artistic control. So I decided that before you came back I was going to change everything, so I changed the whole magazine. I changed all the type, everything. It's what I imagined Nova would look like now. I was very proud of it actually, even though it led towards the end.

Was that the very last cover you worked on?
It wasn't the very last one I did, but it was the beginning of the end. I think we worked on two more covers together. The last cover I did with you was the Brett Anderson cover by Nick Knight [The Pioneer Issue, No. 156, September 1996]. That was a very, very good cover. A slight part of me was relieved when I left because I had no idea what to do with that cover. You turned it round, you actually turned the image around and I'd been trying for five days to make it work as a cover and you did it in a flash.

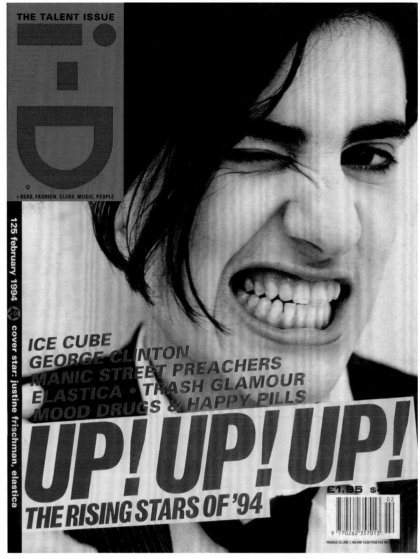

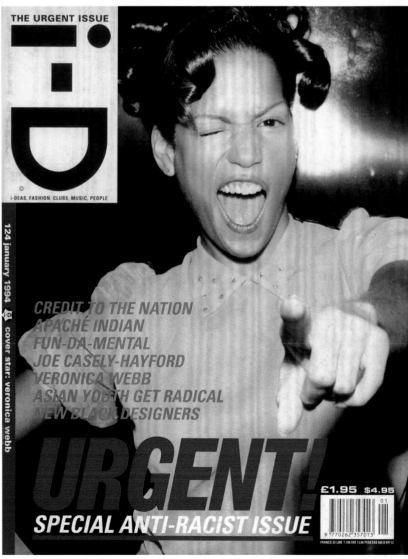

i-DEAS, FASHION, CLUBS, MUSIC, PEOPLE

LOVE IT!

KATE MOSS TELLS ALL

SNOOP DOGGY DOGG

MALCOLM McLAREN•PULP

HELMUT LANG•TIM ROTH

THE RETURN OF THE SUIT

£1.95 $4.95

9 770262 357013

FRANCS 35 LIRE 7,100 DM 13,00 PESETAS 595 D KR 53

THE HARD ISSUE

i·D

i-DEAS, FASHION, CLUBS, MUSIC, PEOPLE

©

122 november 1993

cover star: linda evangelista

XTRA HARD!

BAD GIRLS: SHAVED, PIERCED, TATTOOED

RIGHT SAID FRED
PJ HARVEY/FRESH PRINCE
FUTURE SOUND OF LONDON
SCOOTERS RIDE AGAIN!/THE NEW RAP POETS

£1.95 $4.95

9 770262 357013

11

FRANCS 35 LIRE 7,100 DM 13.00 PESETAS 595 D KR 53

The New Look Issue, No. 121, November 1993
"This shoot came quite early on in my career and was the first time I shot in a studio. My friend Jason 'Travis' Evans offered to help out. I knew he had a red shower curtain so I asked him to bring it along as a backdrop. We set up some contraption and had light coming through the shower curtain. The other people on the shoot were Edward Enninful, Pat McGrath and Michael Boadi. After waiting for hair and make-up, I finally started shooting. After a few shots, Jason noticed a wind machine, which we quickly used and totally fucked up the hair. In retrospect, Michael was a good sport about it. I haven't used a wind machine since, and I haven't done another cover for i-D."
Stefan Ruiz, Photographer

The New Look Issue, No. 121, October 1993
"Tania Court was always an obsession of Edward Enninful's and mine."
Pat McGrath, Beauty Director, i-D

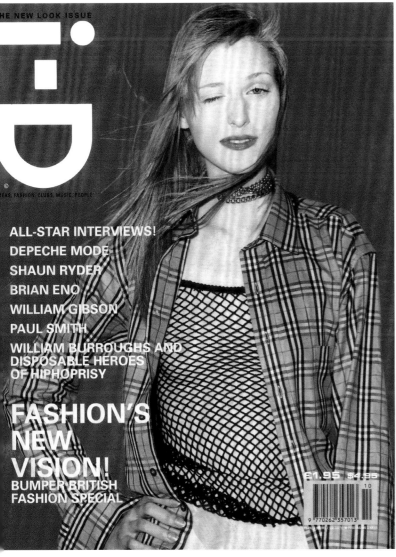

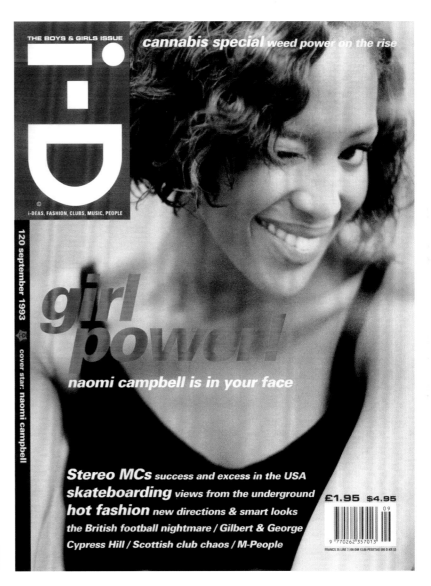

The Hard Issue, No. 122, November 1993
"Linda Evangalista was the supermodel of the time, and this is a great shot of her looking young and fresh, rather than made-up. Juergen Teller, who took the shot, was in the early stages of his career, which he started with i-D. Edward Enninful, who is still Fashion Director for i-D, created the look. He was only about 19. It contrasts with the other pictures of Evangelista of the time. The picture is straightforward, and we had moved into block-type graphics, making the type work as a layer over the top of the image. We always had a hook and "Xtra Hard!" summed up this issue. i-D was an international household name by this time, and our team was growing ever stronger."
Terry Jones, i-D Founder

The Boys & Girls Issue, No. 120, September 1993
"This cover is so special to me. It was shot by Jenny Howarth who is a good friend of mine and a huge model at the time, who also went behind the camera. I first met Jenny in 1985 on a shoot with Michael Roberts and Isabella Blow. It was the first time I met Edward Enninful too, so it means so much to me. I call this my Whitney Houston hair! I remember we shot this in Paris and it was like the start of a new family. It means so much because both Jenny and Edward are very important people in my life."
Naomi Campbell, Cover Star

The Festival Issue, No. 119, August 1993
"I had worked many, many times with Gillian Gilbert and Steven Morris from New Order. We always had a blast!"
Pat McGrath, Beauty Director, i-D

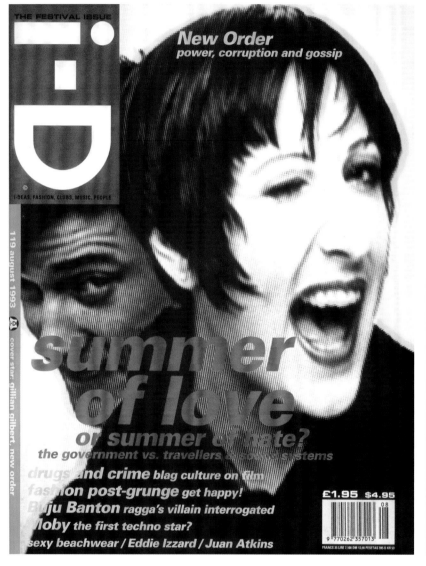

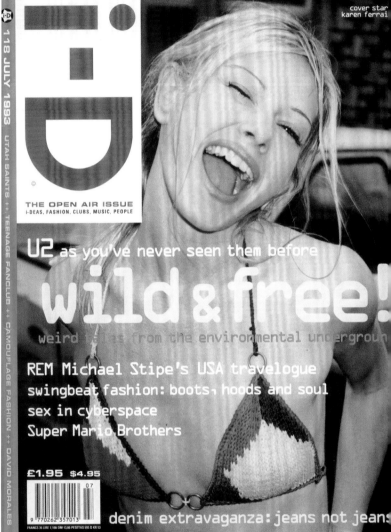

The Festival Issue, No. 119, August 1993
"I had worked with Stephen Morris and Gillian Gilbert from New Order before, so I had a reasonable expectation of what was going to happen. They would be late, which they were and Gillian would faff over the clothes, which she did. I decided to use my time constructively. So once the lighting was set up I laid out two poly boards behind the cove and went to sleep. The shoot was easy and quick, I managed to get a spark of energy out of them (they were the laid back half of New Order) and, since they have neither patience nor tolerance towards photographs or photographers the shoot was over quite quickly. The resulting images were then rephotographed from a TV screen."
Donald Christie, Photographer

The Europe Issue, No. 116, May 1993
"Bjork is an absolute delight. I remember we all sang opera together that day."
Pat McGrath, Beauty Director, i-D

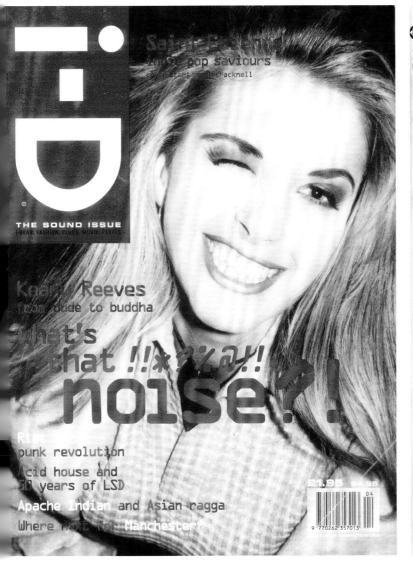

i·D

THE SOUND ISSUE
I-DEAS, FASHION, CLUBS, MUSIC, PEOPLE

Saint Etienne
more pop saviours
cover star: sarah cracknell

Keanu Reeves
from dude to buddha

what's
that !!*%@!!
noise?!

Ride
punk revolution
Acid house and
50 years of LSD
Apache Indian and Asian ragga
Where next for Manchester?

£1.95 $4.95

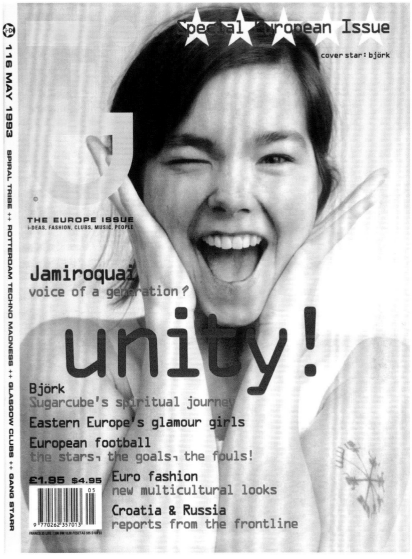

Special European Issue

cover star: björk

116 MAY 1993 SPIRAL TRIBE ++ ROTTERDAM TECHNO MADNESS ++ GLASGOW CLUBS ++ GANG STARR

THE EUROPE ISSUE
I-DEAS, FASHION, CLUBS, MUSIC, PEOPLE

Jamiroquai
voice of a generation?

unity!

Björk
Sugarcube's spiritual journey
Eastern Europe's glamour girls
European football
the stars, the goals, the fouls!

£1.95 $4.95

Euro fashion
new multicultural looks
Croatia & Russia
reports from the frontline

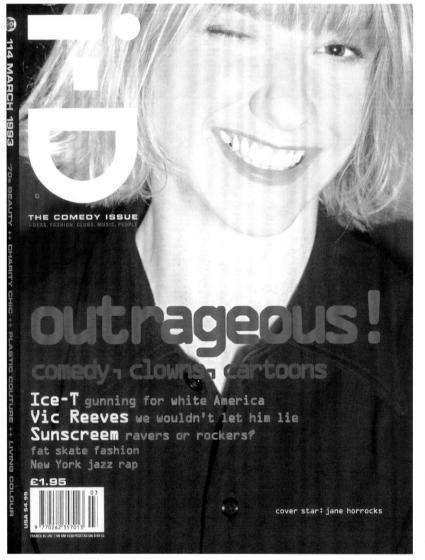

114 MARCH 1993

'70s BEAUTY ++ CHARITY CHIC ++ PLASTIC COUTURE ++ LIVING COLOUR

i-D

THE COMEDY ISSUE
i-DEAS, FASHION, CLUBS, MUSIC, PEOPLE

outrageous!
comedy, clowns, cartoons

Ice-T gunning for white America
Vic Reeves we wouldn't let him lie
Sunscreem ravers or rockers?
fat skate fashion
New York jazz rap

£1.95

USA $4.95

cover star: jane horrocks

FRANCS 35 LIRE 7,100 DM 13,00 PESETAS 595 D KR 53

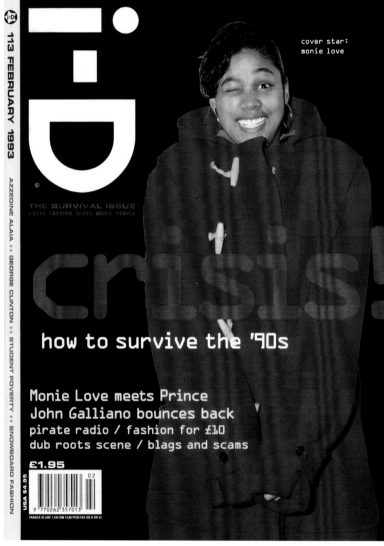

113 FEBRUARY 1993

AZZEDINE ALAIA ++ GEORGE CLINTON ++ STUDENT POVERTY ++ SNOWBOARD FASHION

i-D

cover star:
monie love

THE SURVIVAL ISSUE
i-DEAS, FASHION, CLUBS, MUSIC, PEOPLE

crisis!
how to survive the '90s

Monie Love meets Prince
John Galliano bounces back
pirate radio / fashion for £10
dub roots scene / blags and scams

£1.95

USA $4.95

FRANCS 35 LIRE 7,100 DM 13,00 PESETAS 595 D KR 53

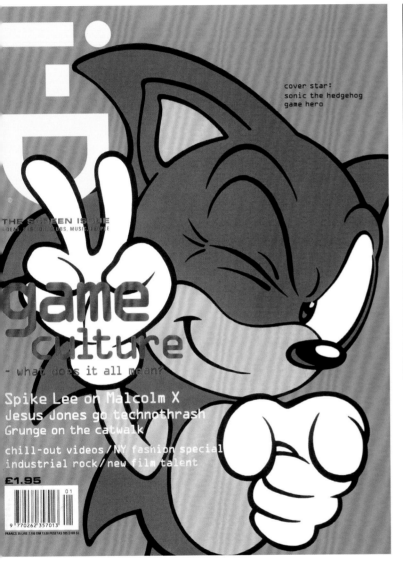

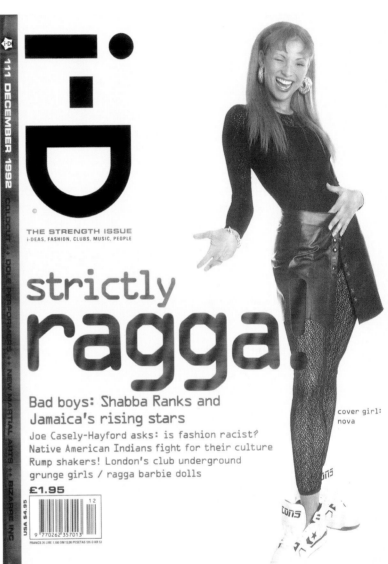

The Strength Issue, No. 111, December 1992
"I'll always remember my first i-D cover. We shot this at the Royal College of Art. Nova was a friend of mine."
Pat McGrath, Beauty Director, i-D

i-D

110 NOVEMBER 1992

BRITISH TECHNO ++ 808 STATE ++ GARY CLAIL ++ RAGGA DANCING

©

THE SEXUALITY ISSUE
i-DEAS, FASHION, CLUBS, MUSIC, PEOPLE

let's talk about

sex!

sexuality special

Chat! Salt-N-Pepa
Argument! i-D's Sex Forum
Riot! queer fanzines
the new pornography / fetish wear
sexy fashion / feminism now
A-Z of safe sex

cover girl
holly davi

£1.95

Plus! Free 28-page talent supplement*

* UK editions only

9 770262 357013

11

FRANCS 35 LIRE 7,100 DM 13,00 PESETAS 665 D KR 53

The Parade Issue, No. 108, September 1992
"My favourite cover was issue 108 as this shot was totally unplanned and was a kind of happy accident. IIt was only when I was in the darkroom some weeks later I noticed Nora Kryst was giving the so important i-D wink which has managed to elude my camera on many an occasion and I am sure the same is true for many a contributing smudger to this day."
Eddie Monsoon, Photographer

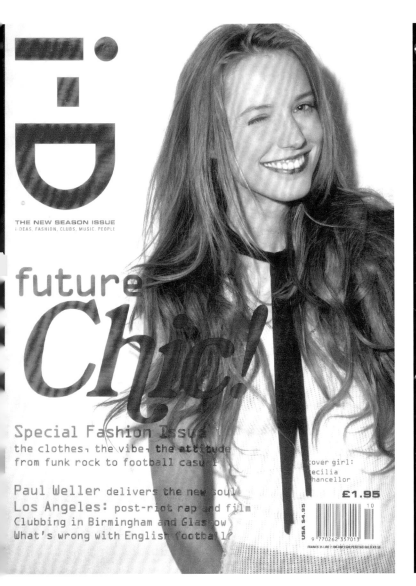

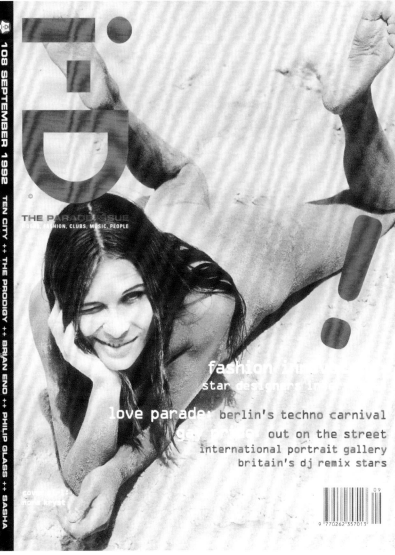

The New Season Issue, No. 109, October 1992
"Despite having copious amounts of extra hair, I think this picture is really natural and I love it. Out of all the covers I did, it is still my favourite. Edward (Enninful) has always been supportive of my career and he's always fun to work with."
Cecilia Chancellor, Cover Star

The Parade Issue, No. 108, September 1992
"I totally love this cover. Eddie (Monsoon) took such a cool photo, but then I do always look like that when the sun is shining bright. Edward (Enninful) loved the cover too and was totally proud of it being the first ever 'whole body' cover. Eddie and I used to go out together, that's why we were in Thailand. From the same holiday, Eddie did a very cool collage of Polaroids for The Sex Issue in November 1992. I also remember a shoot with Judy Blame, called 'JUST SAY NO', for The Activism Issue in April 1992. Judy's head was shaved and his whole face and head were painted in red lipstick. It was excellent! Eddie and I lived together for about three years at the beginning of the 90s. We had a lot of fun. I used to love popping by the i-D office; it was such a cool place to hang out."
Nora Kryst, Cover Star

i-D

107 AUGUST 1992 TERENCE McKENNA ++ THE SUGARCUBES ++ LIVERPOOL CLUBS ++ CARL COX

THE ARTIST ISSUE
i-DEAS, FASHION, CLUBS, MUSIC, PEOPLE

cover girl:
beatrice dalle

artcore
- why art isn't boring

PUBLIC ENEMY: the riots and the remixes

The Orb: the art of chilling
Black art rewrites history
The street art underground
Art fashion/Summer T-shirts

£1.95

USA $4.95

08

9 770262 357013

FRANCS 35 LIRE 7,100 DM 13,00 PESETAS 665 D KR 53

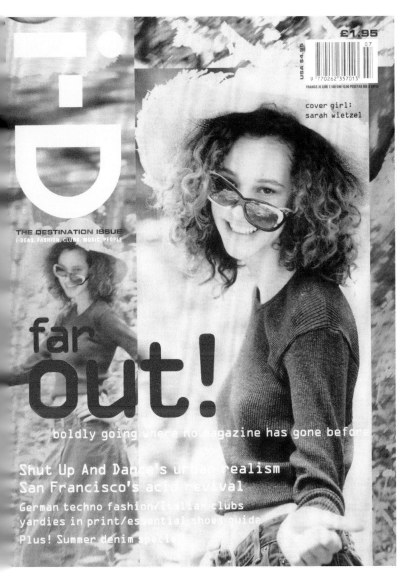

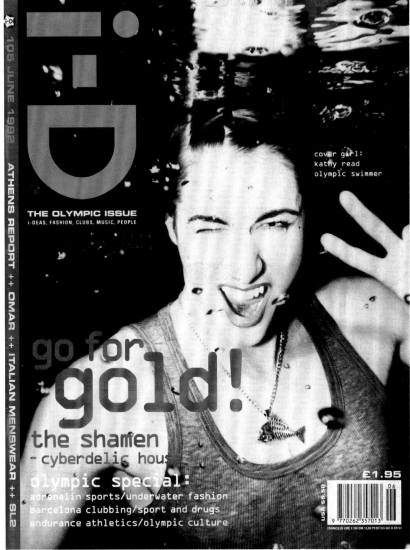

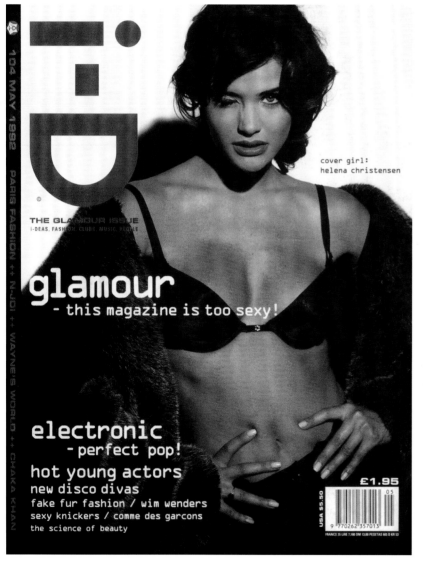

104 MAY 1992

cover girl:
helena christensen

THE GLAMOUR ISSUE
i-DEAS, FASHION, CLUBS, MUSIC, PEOPLE

PARIS FASHION ++ N-JOI ++ WAYNE'S WORLD ++ CHAKA KHAN

glamour
- this magazine is too sexy!

electronic
- perfect pop!

hot young actors
new disco divas
fake fur fashion / wim wenders
sexy knickers / comme des garcons
the science of beauty

£1.95

USA $5.50

05

9 770262 357013

FRANCS 35 LIRE 7,100 DM 13.00 PESETAS 665 D KR 53

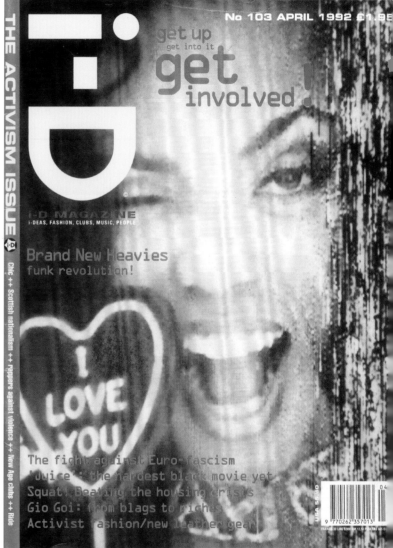

No 103 APRIL 1992 £1.95

get up
get into it
get
involved !

i-D MAGAZINE
i-DEAS, FASHION, CLUBS, MUSIC, PEOPLE

THE ACTIVISM ISSUE

Chic ++ Scottish nationalism ++ rappers against violence ++ New Age clubs ++ Ride

Brand New Heavies
funk revolution!

I
LOVE
YOU

The fight against Euro-fascism
'Juice' - the hardest black movie yet
Squat! Beating the housing crisis
Gio Goi: from blags to riches
Activist fashion/new leather gear

04

9 770262 357013

FRANCS 35 LIRE 8,900 DM 12.50 PESETAS 665 D

No 102 MARCH 1992 £1.80

FRANCS 33 LIRE 6,900 DM 12,50 PESETAS 665 D KR 49

i-D

©

i-D MAGAZINE
i-DEAS, FASHION, CLUBS, MUSIC, PEOPLE

future now!

the science of
fashion: 14-page
photo special with
Joe Casely-Hayford
Duffer Of St George
Dirk Bikkembergs
Bella Freud
Jean Colonna
Romeo Gigli
Martin Margiela
Veronique Leroy
Christopher Nemeth

Inner City
and Detroit's new techno generation

David Cronenberg
the horror of 'Naked Lunch'

International cyberpunks/Techno art
Holographic fashion/Ragga Twins

USA $5.50

03

9 770262 357006

No 100 JANUARY 1992 £1.80

i·D

i-D MAGAZINE
i-DEAS, FASHION, CLUBS, MUSIC, PEOPLE

neneh cherry
strictly personal

think.
positive!
be aware if you dare

100th issue special

action on AIDS:
positive responses from fashion, music, film,
photography, sport and activism.

pull-out club supplement:
new directions in clubland

free condom inside!

THE POSITIVE ISSUE · The Orb ++ angry performers ++ Shades Of Rhythm ++ condom guide

USA $5.50

9 770262 357006

01

FRANCS 33 LIRE 6,500 DM 12,50 PESETAS 665 D KR 49

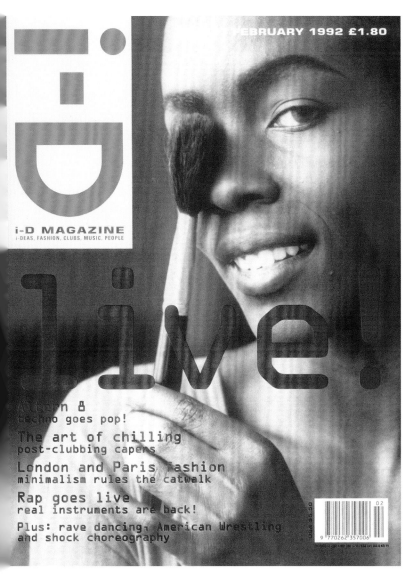

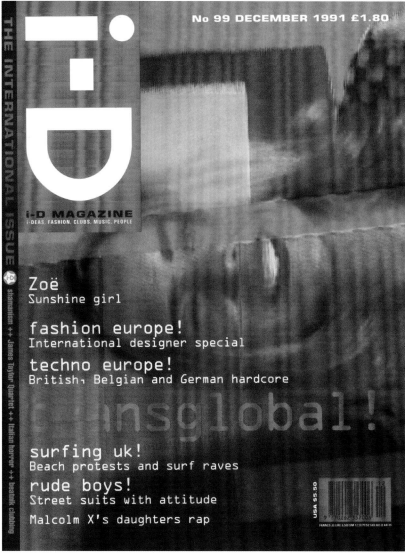

i·D

i-D MAGAZINE
i-DEAS, FASHION, CLUBS, MUSIC, PEOPLE

FEBRUARY 1992 £1.80

live!

Altern 8
techno goes pop!

The art of chilling
post-clubbing capers

London and Paris fashion
minimalism rules the catwalk

Rap goes live
real instruments are back!

Plus: rave dancing, American wrestling
and shock choreography

USA $5.50

i·D

THE INTERNATIONAL ISSUE

shamanism ++ James Taylor Quartet ++ Italian horror ++ beatnik clubbing

i-D MAGAZINE
i-DEAS, FASHION, CLUBS, MUSIC, PEOPLE

No 99 DECEMBER 1991 £1.80

Zoë
Sunshine girl

fashion europe!
International designer special

techno europe!
British, Belgian and German hardcore

transglobal!

surfing uk!
Beach protests and surf raves

rude boys!
Street suits with attitude

Malcolm X's daughters rap

USA $5.50

i-D Japan

"i-D Japan came about after Tokyo publishers U.P.U. called in 1992 and wanted to do a Japanese edition of i-D. They introduced me to a number of photographers, who they felt were the best to contribute to i-D at that time, including Takashi Homma. The first cover was shot by Takashi with Kyon Kyon, who was the biggest Japanese music star at the time. I wanted to make an extreme statement for the first cover and suggested doing a meter high red wig. On the day of the shoot, Kyon Kyon, who spoke English, loved i-D and could do a brilliant wink, put on the wig with white face makeup, which we then cropped in on for the super graphic cover image. I said to Takashi, "I'm sure you got that in the first shot." Three hours and a bunch of rolls later, which were watched by her management, we called it a wrap. Takashi was delighted to see the cover was the first shot on the first roll.

Takashi and I went on to collaborate on many things; he did the cover for Issue 2 and a number of fashion stories for i-D Japan, and then came to London, partly to improve his English and enjoy club life, and to work as a regular photographer for i-D. When we were in Florence for the i-D Now exhibition in 1992, Takashi shot his only UK cover with two models that were there for Romeo Gigli. Then he went from strength to strength to being one of the top artistic photographers in Japan today.

Even with i-D Japan Issue 1 I was already taking liberties with traditional characters of Japanese typography, which wasn't the fashion but I just loved the aesthetic of traditional Japanese alphabets. We would try and find words that used the letters I liked. I have absolutely no idea what the cover lines they put in meant, but they always look good. Another cover was inspired by my fascination for Zen archery – the model's holding the string of a bow – which was a device to help the girl keep her right eye closed while the open eye contacted with the photographer. It was a bit like a Japanese version of the water pistol idea [The Out Already Issue, No. 10, December 1982], finding something that makes you close your eye.

i-D Japan existed for about 18 months because by the time the magazine was up and going, the finance bubble had burst and Japan was already going through a tough time economically. I was involved for a year going one week a month to Japan and working with the studio there. One of the girls who was in the studio came to London and worked with me here, whilst another girl, Hiromi, who was my assistant, translator and shadow at every meeting, ended up marrying Adam Howe the stylist, who has also been responsible for some i-D covers."

Terry Jones, i-D Founder

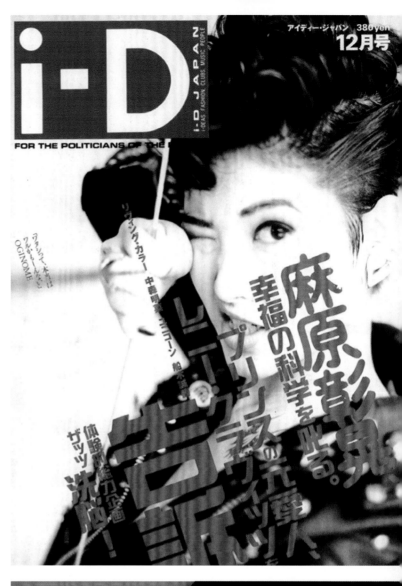

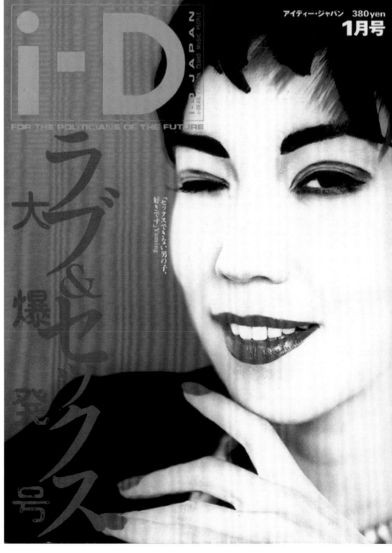

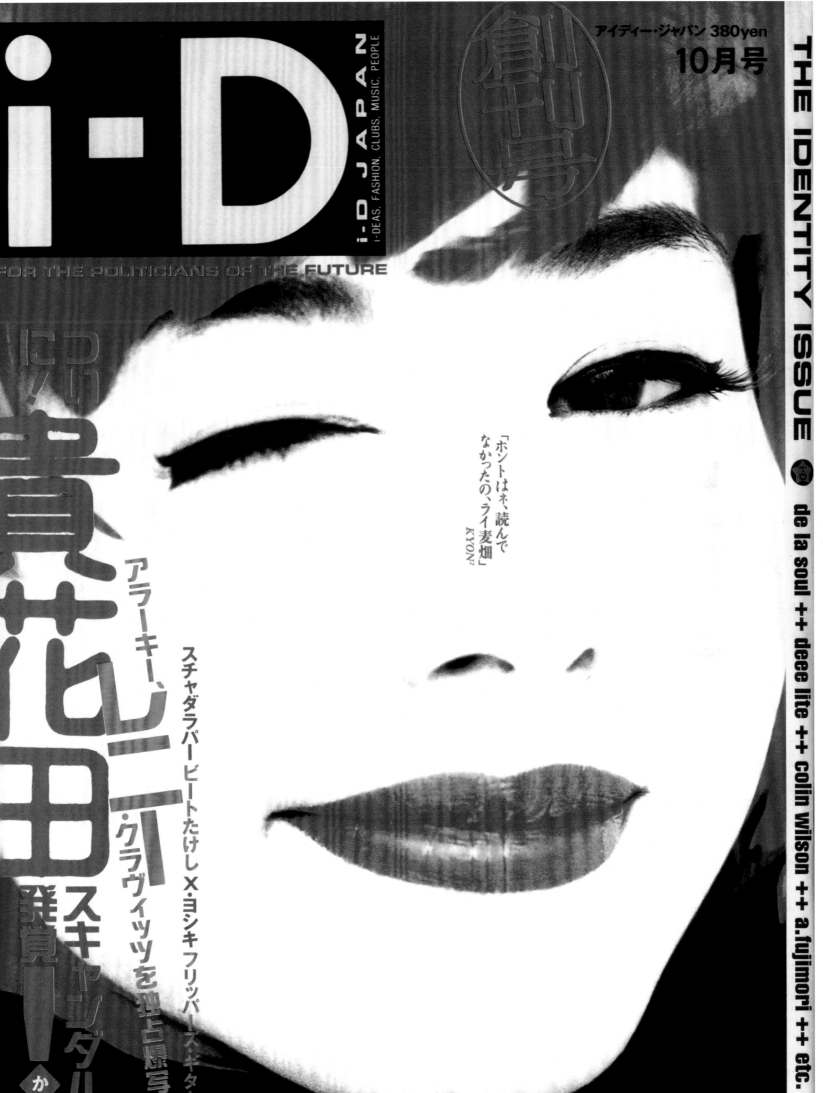

i-D

i-D JAPAN

i-DEAS. FASHION. CLUBS. MUSIC. PEOPLE

FOR THE POLITICIANS OF THE FUTURE

創号

アイディー・ジャパン 380yen

10月号

THE IDENTITY ISSUE

de la soul ++ deee lite ++ colin wilson ++ a.fujimori ++ etc.

「ホントはネ、読んで
なかったの、ライ麦畑」
KYON²

祝・貴花田発覚!!

アラーキー、レニー・クラヴィッツを独占爆写!

スチャダラパービートたけし×ヨシキ フリッパーズ・ギター

スキャンダル（か）

THE HYPERREAL ISSUE
i-D
Bizarre Inc ++ Sabrina Johnston ++ electric cars ++ Vic Reeves

i-D

No 98 NOVEMBER 1991 £1.80

i-D MAGAZINE
i-DEAS, FASHION, CLUBS, MUSIC, PEOPLE

Jungle Brothers
Flip out on film

Stussy
New clothes, new direction

Viva Cuba!
The other side of Havana

Liverpool clubs
What the hell is going on?

Sandra Bernhard
real wild woman

OUT OF THIS WORLD

supernaturalists, techno games and technicolour fashion

USA $5.50

9 770262 357006 11

FRANCS 33 LIRE 6.500 DM 12.50 PESETAS 665 D KR 49

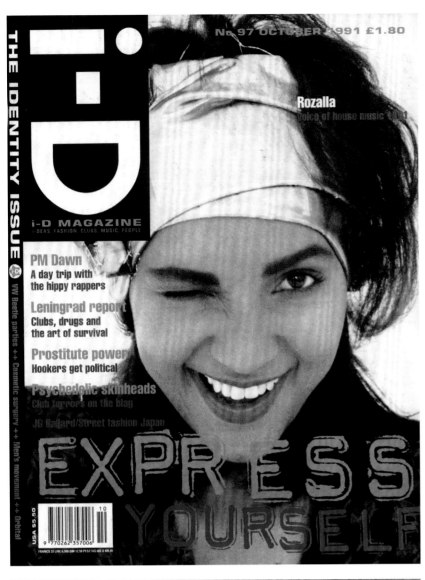

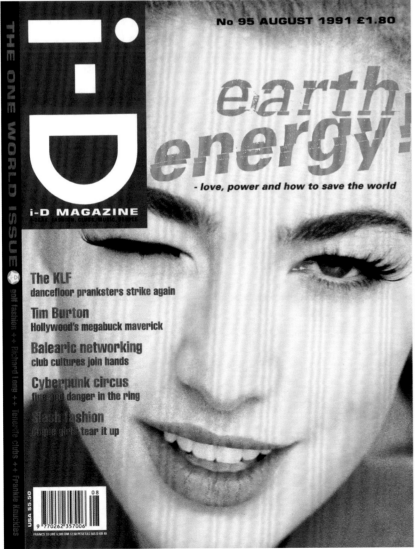

The Identity Issue, No. 97, October 1991
"I remember this photo well as it was my first ever cover. I recall the choice for the cover was a choice between a model, and myself and I remember thinking 'Well it will definitely be the model then!' I was so thrilled when I realised i-D had chosen me. How did I find out? When I saw the copies on a magazine stand, stopped still and screamed. I actually still have the photo framed in my living room."
Rozalla, Cover Star

The One World Issue, No. 95, August 1991
"This is a chance for me to mention how grateful I am to Nick Kamen, and the numerous other beautiful men, who came to me with their beautiful women."
Mark Lebon, Photographer

Terry Jones in conversation with
Edward Enninful

Terry: What was the first cover you worked on at i-D?
Edward: My first cover was Rozalla (The Identity Issue, No. 197, October 1991), shot by Hugh Stewart. Rozalla was the Zambian singer, who had just released, Everybody's Free (To Feel Good).

Which photographer have you worked on the most covers with?
Probably Richard Burbridge or Craig McDean. I styled twelve covers with Tesh, twelve with Richard, and loads of covers with Craig.

What is you favourite Craig McDean cover of i-D?
I've got my favourite Craig i-D cover framed on my wall – Shalom Harlow, The Subversive Issue, No. 141, June 1995). Me, Craig, Pat McGrath and Eugene Souleiman went to Paris when the whole grunge thing was happening. We didn't have any money and we all stayed on in Paris after the shows to shoot Shalom and Nadja Auermann but they were so busy our shoot got cancelled. Didier Fernandez who looks after Linda Evangelista and all the girls was so kind he flew all of us back and gave us all the girls to redo the cover.

Amazing.
Incredible, isn't it? Didier's still around. We did that and we did Nadja. All these covers, so many stories. A lot of the ideas back then came from Pat – it was very beauty-led. She'd say, 'I want to do amber eyes' or 'I want to do Colette Pechekhonova at the Hussein Chalayan show.' One cover I remember is Oluchi Onweagba, The Audible Issue, No. 189, August 1999). We started shooting in New York around 4pm or 5pm and later that night I had to catch a flight back to London. Seven hours later I got off the plane and they were still shooting – that's dedication.

Why were they taking so long?
They couldn't get the look. They tried straight hair, curly hair, make-up, no make-up and finally Oluchi was so fed up, she said, "I have this afro in my

bag," and she put it on her head and that is one of i-D's most memorable covers.

That was Oluchi's first cover.
It was Oluchi's first cover and a personal favourite, a real personal favourite. I think it's so iconic. I'll tell you a Diana Ross story, you'll like this, Diana Ross saw the Oluchi cover and had been hunting Pat and me down. I got a call one day from MAC inviting us to do a shoot with Diana based on the i-D cover because she loved it so much. She said she loved it so much she carried the picture of Oluchi around with her in her bag. That was funny. Gisele tells the best stories about her covers. The first cover she did with David Sims, she was a baby, she was so young. The second cover she was starting to become a recognised model and she was getting a little theatrical – that was with Tesh. For her third cover with Richard Burbridge she was sexy. And for her fourth cover she was a woman, which was the one Matt Jones shot. Now she's a mother, and she's on the cover again, once again photographed by Matt. I think after Kate and Naomi, Giselle has had the most i-D covers. She's so stunning.

What other i-D covers do you love?
I love the cover of The New Dawn Issue with Jessica Stam.

Which girls had their first covers with i-D before their careers took off?
So many! Carolyn Murphy, Naomi Campbell, Alek Wek, Jourdan Dunn… my God the list goes on and on. Oluchi, Gisele… Gisele had come to London to do tests when we shot her David Sims cover. She hadn't taken off yet. That was the same story with so many of the girls.

What makes a great i-D cover?
There's always something quite tongue-in-cheek about an i-D cover. The best ones have been the ones that are quite graphic, but always contain a certain amount of humour. Of course, it's always great when you capture a girl or pop star before she hits mainstream success. Though you also want to define success at the same time and capture a girl at a stage of becoming a woman as opposed to being a girl.

Like the cover of Devon Aoki and the leaf for The Adult Issue [No. 179, September 1998]?
Exactly. Devon had just turned eighteen and we captured her at a very specific point in her life. Ellen von Unwerth and I went into the forest and shot it. I haven't seen Devon in so long. I'd love to see her again. Devon is one of those girls you get obsessed with.

Which girls would you like to see on magazine covers today?
I love Natasha Poly. I think she's really stunning. And I love Freja Beha and Sasha Pivovarova. I think we should do Liya Kebede for the cover. I know we have done Liya before, but what a beauty. I recently shot her for American Vogue, she's so beautiful.

How did you and Pat McGrath start working together?
I'd been at i-D a couple of years and I was working with Craig McDean, who'd just finished assisting Nick Knight. We were doing a story about plastics for i-D and Michael Boadi said, 'You have to meet this girl, her name's Pat McGrath.' At the time Pat was a music make-up artist in her early twenties who wanted to move into fashion. So we all met at Judy's house, where I was living at the time and we did our first shoot together and then our second shoot and that was it. We all started out together. It's amazing, isn't it? I love the fact that Pat won't work for any other magazine. She'll only work for i-D.

How did Eugene Souleiman come into the picture?
I was working with Eugene and Craig before I was working with Pat. They became such a good team and they rose up. We all kind of came together. I love Eugene, I see him a lot now, and I speak to him a lot.

He's so mellow now.
Can you believe it? He was crazy. London was very much about teams back then. There was David Sims, Guido Palau and Dick Page, Corinne Day, James Brown and Glen Luchford and Mario Sorrentti and Camilla Nickerson.

Did you have a favourite cover before you started working with i-D?
Yes. I loved the first two covers by Judy Blame [The Madness Issue, No. 34, March 1986 and The Surreal Issue, No. 57, April 1988]. I was like 'Oh my God!' Then I saw Visions. That's one of my favourite fashion stories ever. Do you remember Visions? The story Judy did with all the newspapers. I nearly died when I saw that.

You styled covers with Juergen Teller as well?
Yes, we worked together on the Kristen McMenamy cover and we did this amazing story with all the girls.

What about Steven Klein?
Yes, I did a few covers with him too – Veronica Webb with Anna Cockburn [The Urgent Issue, No. 124, January 1994], Kate and Naomi walking through the Meatpacking District in New York [The Us Issue, No. 131, August 1994] and then there was an Armani cover that he did of the girl in the chair [The Independent Issue, No. 222, August 2002]. I did a McQueen cover with Steven too, with Jamie Bochert [The Graduate Issue, No. 223, September 2002], who's back again. Steven's done some good covers. Then there's that amazing L'il Kim cover with Patti Wilson [The Hotel Issue, No. 196, April 2000].

How did you meet Patti Wilson?
This is the most amazing story. I'd just started at i-D when Barry from Zed called me and said, 'There's this American stylist called Patti Wilson, she works for a magazine called Vibe, she's shooting a story with a photographer called Steven Klein and she needs help prepping clothes from London. For some reason I agreed to do it. So, I collected all these clothes for Patti and sent them to her and that's how we met. I used to stay with her in New York all the time and I got her into i-D. I love Patti, she's an original.

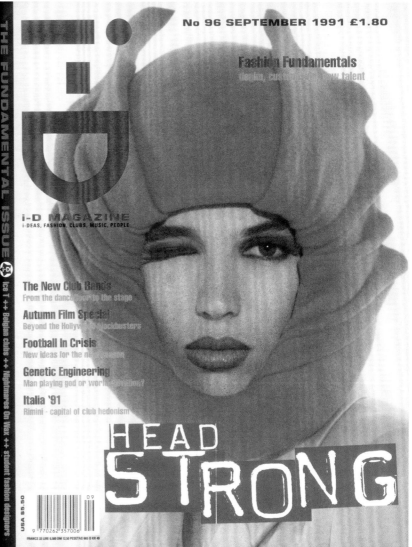

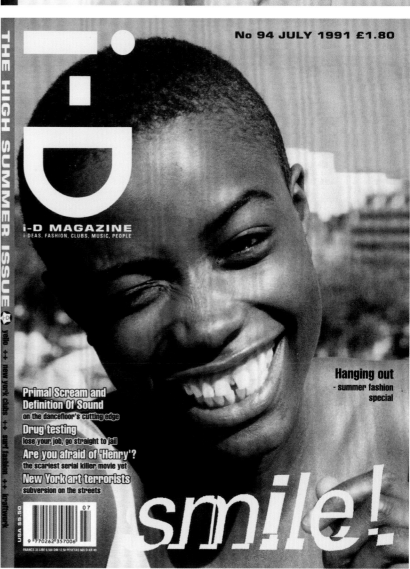

No 93 JUNE 1991 £1.80

i-D

i-D MAGAZINE
IDEAS. FASHION. CLUBS. MUSIC. PEOPLE

THE TRAVEL ISSUE

i-D () london – new york – paris – tokyo – italy – iD – $70 (francisco – berlin

Jean Paul Gaultier
backstage at his Paris show

Christopher Walken
film gangster is 'King Of New York'

Berlin clubs
are East and West still divided?

T-shirts
i-D's summer holiday selection

Flowered Up / Mock Turtles

let's go!

alternative holidays,
transglobal fashion
and circus travellers

Adeva
sexy
house
music

USA $5.50

06

9 770262 357006

FRANCS 33 LIRE 6,500 DM 12,50 PESETAS 665 D KR 49

Terry: What was the first cover you styled for i-D?
David: My first i-D cover was Kylie Minogue [The Love Life Issue, No. 90, March 1991], shot by Robert Erdmann. I can remember it really well. It was a black and white cover. Kylie was really big at the time, she'd just finished Neighbours and just released I Should Be So Lucky. She was about to change her image, which was a real turning point for her. For the cover shot she wore a black PVC bustier and long black gloves. It was a really, really cool shoot. I still have the Polaroids. Judy Blame art directed it and it was just incredible. It turned things around for Kylie.

What was your relationship with Judy at the time?
I was Judy's assistant and then he promoted me, so the jobs he couldn't or wouldn't do, he gave to me, and the jobs that he wanted a hand with, he directed and I styled.

What was it like working with Kylie?
Kylie was brilliant. We're still friends now. After that I went on to style two videos for her and yes, I still see her. She's great. I guess we're around the same age.

The Love Life Issue, No. 90, March 1991
"David Thomas, the stylist, remembers Kylie already being very in control of her own image, and that she was sitting there [in the studio] looking at, and editing contact sheets because she already owned the copyright. She was incredibly intelligent person that way for all [of her] pictures. But those [contact sheets] were printed from negatives, but in Paris at the time people used to put pin pricks in transparencies, the colour ones. I remember going to 'Vogue Hommes' and the art director was in hysterics because he'd sent some Jean-Paul Goude pictures out to some actor, who's name I can't remember, who'd returned them with pin holes through them [so they couldn't be

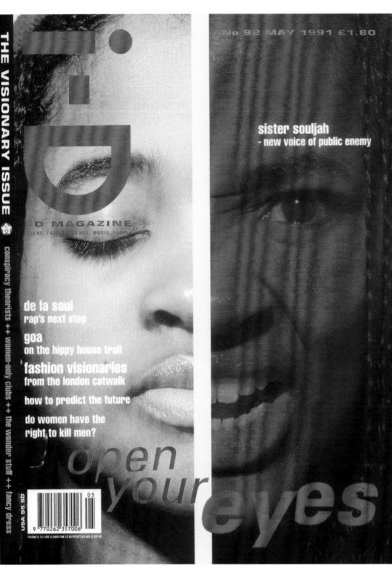

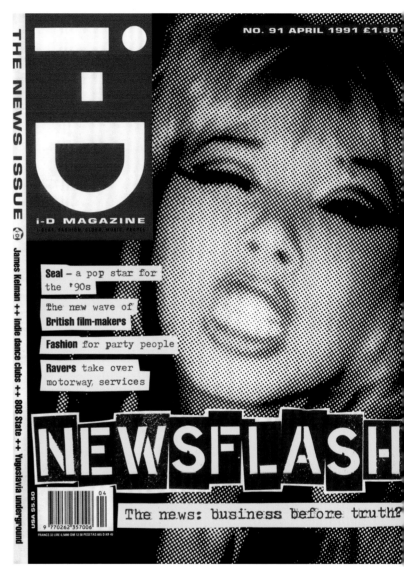

What else do you remember from the shoot?
My main memory is Kylie sitting editing film. It was before photographers owned the rights to their pictures, so any time Kylie had her picture taken she took full control of her image. She would review the film and any pictures she didn't like, she cut out with a pair of scissors. So any picture you saw of Kylie during that time had been approved directly by Kylie herself. I've never seen anyone have so much control or be so into their image. She was way ahead of everyone else.

What are you doing now?
I live in Los Angeles and I'm still styling, it's probably my twenty-second year of styling.

used]. In a funny way, it is fantastic because now with digital it is so creepy that you can't kill it off. You can trash a file but it is very hard to control. I was told I was going to do a cover of Kylie Minogue; I didn't know who she was and I didn't know that soap opera [Neighbours] she was on that everyone else knew, I just took the picture, which is probably the intelligent way to do it, sometimes I think it is better when you don't know the person's history. Everyone knows too much history now. Kylie didn't have control of this picture and she didn't ask to see it. I don't like the light in this image because I think it is too glamourous. She says it is her favourite picture ever."
Robert Erdmann, Photographer

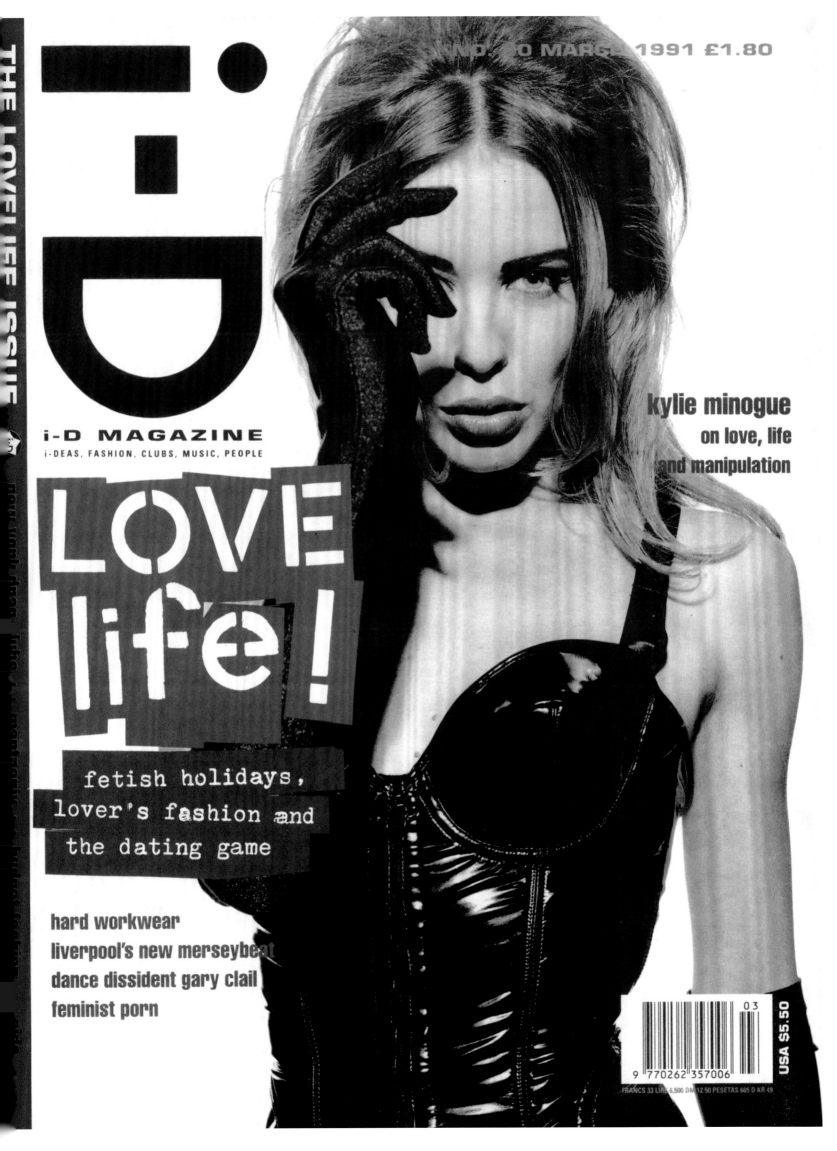

NO. 90 MARCH 1991 £1.80

i-D

i-D MAGAZINE
i-DEAS, FASHION, CLUBS, MUSIC, PEOPLE

LOVE life !

fetish holidays,
lover's fashion and
the dating game

kylie minogue
on love, life
and manipulation

hard workwear
liverpool's new merseybeat
dance dissident gary clail
feminist porn

03

USA $5.50

9 770262 357006

FRANCS 33 LIRE 6,500 DM 12 50 PESETAS 665 D KR 49

The Communication Issue, No. 89, February 1991
"Most photographers at this time either did their own printing, or got someone special with a darkroom to do it for them. Whilst I love and appreciate the skill of the darkroom, I was living too much at the time to bother. So I loved it when I was able to shoot with the 35 mm black and white film. You would shoot, pull the film out of the canister and it was done. This cover was shot on Polaroid 35 mm film."
Mark Lebon, Photographer

The Communication Issue, No. 89, February 1991
"I turned up for the shoot not really knowing what to expect. Thinking that it would be a full on shoot, I was surprised when we just walked out onto the street in front of Mark Lebon's studio and he took a handful of Polaroids and that was it; no hair, no make-up, no stylist. I've never been enamoured with the photo as it's not the best picture I've ever had taken, but it is on the cover."
Michelle Legare, Cover Star

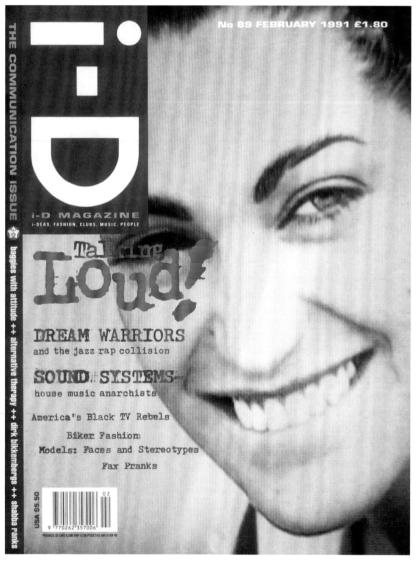

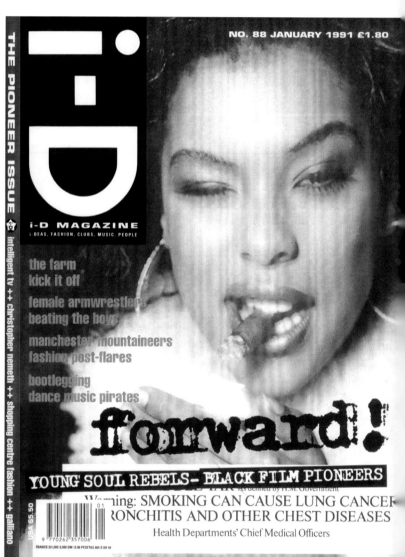

i-D

NO. 87 DECEMBER 1990 £1.80

i-D MAGAZINE
i-DEAS, FASHION, CLUBS, MUSIC, PEOPLE

**adamski
talks back**

**acting up
the new gay militants**

surveillance
who's bugging who?

sex toys
computer age orgasms

Just do it!

USA $5.50

9 770262 357006

12

FRANCS 33 LIRE 5,900 DM 12.50 PESETAS 665 D KR 49

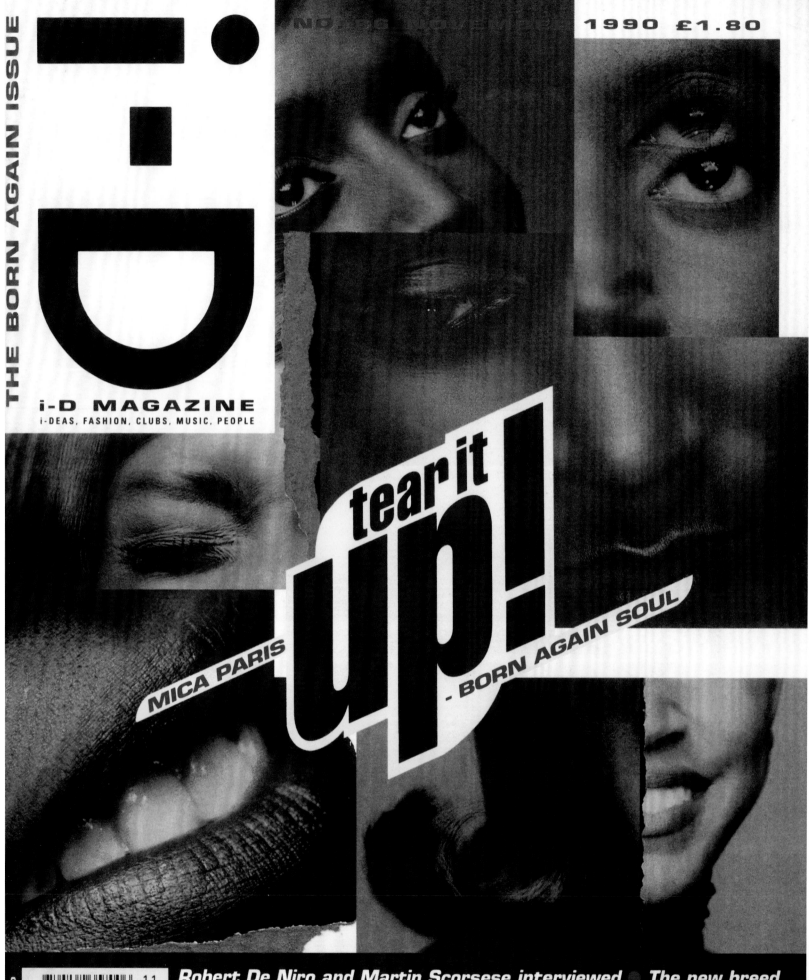

i-D

THE BORN AGAIN ISSUE

i-D MAGAZINE
i-DEAS, FASHION, CLUBS, MUSIC, PEOPLE

1990 £1.80

tear it up!

MICA PARIS

— BORN AGAIN SOUL

USA $5.50

9 770262 357006

11

FRANCS 33 LIRE 5,900 DM12.50 PESETAS 665 D KR 49

Robert De Niro and Martin Scorsese interviewed ● **The new breed of trainers** ● **Cult watching - protecting the spiritual consumer** ● **Bruce Sterling and William Gibson - from cyberpunk to steampunk** ● **Permaculture - gardening as guerilla warfare** ● **Phil 'Reflecting Skin' Ridley - sick as a frog?** ● **i-Spy Fashion - Radical Modernists**

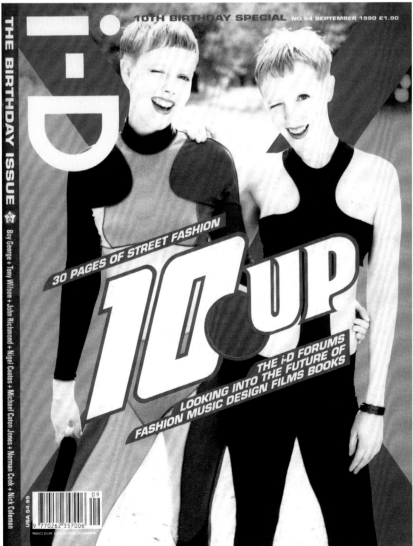

"Lady Miss Kier, of the band Dee Lite, had a fantastic sound. I think she must have been very infuential on Lady Gaga, if you listen to Lady Gaga's stuff today. I can remember going to the i-D office on Curtain Road and John Godfrey, i-D's Editor at the time, playing Dee Lite non-stop, which was great because you can listen to Dee Lite a million times and it still doesn't lose any of its greatness."
Nick Knight, Photographer

The Anarchy Issue, No. 82, July 1990
"For the anarchy shoot, Paolo wanted me to cry. I tried hard but I couldn't. I thought of sad things but I still couldn't cry. Paolo gave me his mother's dress to wear. It was silk and had a flowery print. I fell in love with the dress. Paolo said, "Bouge Pas" and I didn't move. I heard the sound of his 8x10 Deardorff... click. The light from the windows coming into the studio was grey and shiny. The magic shoot. It was black outside and bright in the studio. I don't remember much else."
Kirsten Owen, Cover Star

Terry Jones in conversation with Craig McDean

Terry: What was your first shoot for i-D?
Craig: I shot Mica Paris for The Born Again Issue [No. 86, November 1990]. I initially shot her on film, but the film didn't turn out that good or something happened to the film... I can't remember... but I'd already ripped all the Polaroids up and thrown them in the bin so Nick Knight, [then Picture Editor of i-D] had to pick all the pieces out and piece them back together as a picture. Maybe the original I shot was so bad that it looked better ripped up. I can't remember!
Did Nick give you a hard time about that?
No, not at all. It was my first cover and it was kind of poignant that we'd ripped it all up and then we had to piece it back together. I remember pulling the pieces out of the black bin liner and Nick saying, 'This is a great cover; it's genius,' so that was it.
What i-D cover did you shoot next?
I think it was Amber Le Bon. I also shot Stella Tennant and Shalom Harlow. They were two of my favourite covers because they were so graphic. I loved the black headband that Eugene Souleiman made. I think I liked it so much I copied it when I photographed Stella Tennant. I also really loved the Guinevere van Seenus cover... was it a red Louis Vuitton dress she was wearing? That was really good. I think it was on the front cover of an i-D book as well.
Back in the 90s, how did a cover shoot for i-D come about?
The covers I shot for i-D were always shot on the back of something else. We would be on a shoot and then at the end of the day, we would say, "Let's do an i-D cover." We always waited until the last minute to say to the model, "By the way, can you stay and do an i-D cover?" And you know what, no one ever refused. Everyone wanted to be on the cover of i-D. I'd have people calling me up and asking, "Why haven't I got an i-D cover? Can we do an i-D cover at the end of our next shoot?" I always used to say, "We can try." We always tried at the end of every shoot.
What was it like photographing Shalom Harlow for the cover?
It's really hard to go back and draw time on them. All I remember is that I was with Pat McGrath and Eugene Souleiman at a studio with Edward Enninful. I couldn't tell you if I shot her in England or New York. I can't even remember where we shot it!
Edward, Pat, Eugene and you were like the four musketeers at the time...
Yes, we were. We've been called other things than the four musketeers, but yes definitely.
What has been your favourite cover of all time?
I have three favourites. I love the Guinevere van Seenus cover, I love the Shalom Harlow cover and I love the Stella Tennant cover. I think those are my three favourites. Obviously the first cover I shot is important; the fact that we made it was genius. You printed it on matte paper, I remember. Didn't you also change the format of the magazine for that issue? I remember being quite sad not to have had a cover of the old format.
The old format was smaller.
Yes, I really wanted to have a cover in the smaller format, but c'est la vie.
What was the first fashion story you shot for i-D?
One of my very first portraits for i-D was J.G.Ballard. I remember his typewriter, his very cruddy curtains and his garden. He also rode a unicycle. I also photographed Vic Reeves and I shot a boxing story for you.
Are you still doing sports photography?
No. I wish I had been at the Winter Olympics; it would've been great. It's really funny, I just got back from Berlin — I first went in 1986 and 1989 — and I was just there now. I want to shoot a whole story there. I'm so inspired by it. Being a photographer, you usually go to LA, New York, Paris, but going to Berlin was so inspiring; there's so much art going on. It's just a great place. I want to spend a week there and photograph the architecture; it's so inspiring to find new cities; go to Nova Scotia or places like that. I used to do that a long time ago, but I haven't done it in a while.
Why did you decide to become a photographer?
To get out of Manchester. As a kid I loved the National Geographic and all those great Magnum photographers. I admired them so much. Especially

i-D MAGAZINE i-DEAS, FASHION, CLUBS, MUSIC, PEOPLE NO. 83 AUGUST 1990 £1.80

i-D

super nature

The Happy Mondays in Ibiza

Thailand — party paradise

Richard 'Hardware' Stanley + Soho + the new modernists

THE PARADISE ISSUE

Postponing death – can we live to 150? ● NLP – the power of persuasion ● The green movement – too successful for its own good? ● New British black comedy ● Positively pregnant fashion ● Fashion: black is back

i-D MAGAZINE
i-DEAS, FASHION, CLUBS, MUSIC, PEOPLE NO. 82 JULY 1990 £1.80

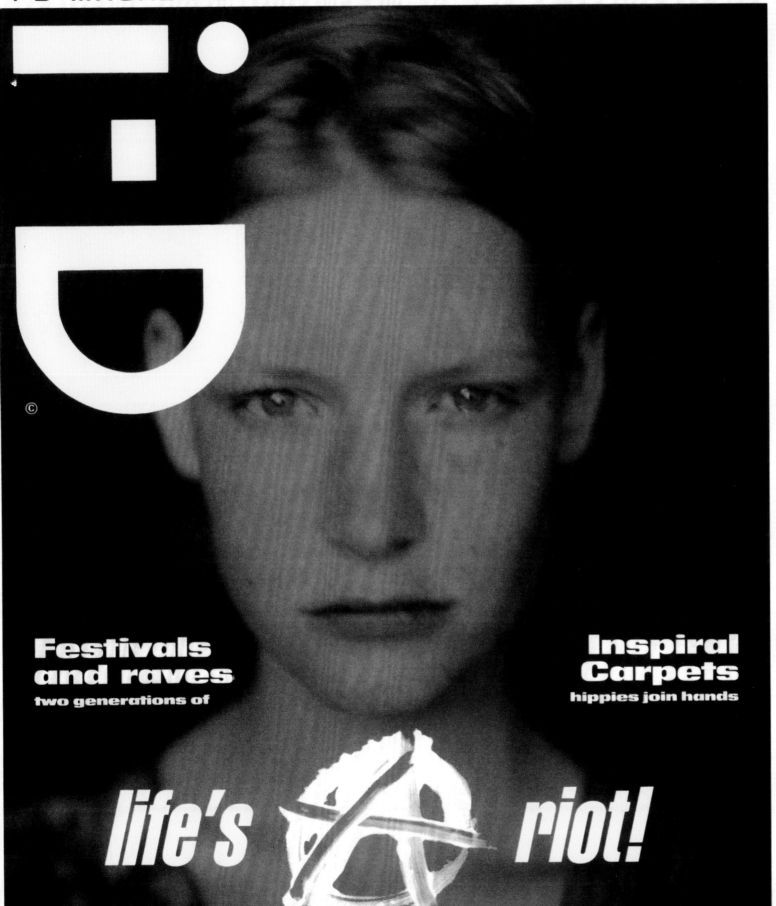

**Festivals
and raves**
two generations of

**Inspiral
Carpets**
hippies join hands

life's riot!

USA $4.95

9 770262 357006

07

FRANCS 33 LIRE 5,900 DM 12 PESETAS 665 D KR 49

Anarchists — in the poll tax front line ● *Anarchic chic* ●
Office sabotage — how to get your own back ● *The other
side of Eastern Europe — punks, skateboards and acid
house* ● *The house sound of Sheffield* ●

people like Don McCullin. Growing up and looking at all those greats like Sebastião Salgado really inspired me, as did loving imagery basically.

Your fashion work is quite like war photography.
I think it's a definite war Terry; a different war, you pick your battles. It's usually a hair or a make-up war. But, that's how I got interested. It was in Blackpool and I really hated it and then I loved the fashion photography of the eighties. And I loved what Nick was doing and what a lot of other photographers were doing. I also loved all the old Cartier-Bresson, all those people like Lartigue.

Did you study photography?
Yes, I did a course in general art in Manchester and then I went to Blackpool and studied photography. I also watched a lot of New Wave films from France and basically just smothered myself with knowledge. I was always willing and wanting to learn and also desperate to get out of Cheshire, where I lived. I never thought I would become a fashion photographer; I was more interested in portraits. It just so happens that the only way to make money when I was living in Blackpool was to shoot models for their model cards. I didn't want to work in a bar, so I used to shoot on the weekends for a Manchester modelling agency and then all of a sudden I was shooting fashion full-time.

That was before you worked with Nick Knight?
Oh yes, I was still at college trying to make some money. All my friends would work in a bar at night but I wanted to print at night because my place was too bright during the day so I used to print all night. Subsequently, I got banned from using all the cameras at college. I never returned them because I was shooting models on the weekend when the camera was meant to be back; this was the bane of my life.

How long did you work with Nick?
Maybe three years. I was never really happy living in Blackpool and I knew that when college finished there would be a flood of people trying to find jobs assisting photographers in London, so I decided to leave early and find a job. I'd gone down to London to visit Nick a few times and helped him out for nothing. Charlotte [Knight, Nick's wife] told me that Nick had no jobs, no work. But then when I arrived in London all of a sudden Nick said, "You can come and assist me." I don't even look at it as assisting; it was like Nick helped me to get somewhere else in life and he's still my mentor now. No one likes to be anyone's assistant. But Nick's never selfish; he always pushes you.

He said he gave you a hard time.
Oh, he did. It was such a hard time, but it's okay, it's good to have a hard time. It's hard to judge yourself, but to have someone else to judge you is great… Nick never ridicules. He's never told me to give up photography, which is good. He was a great teacher of a lot of things, not only photography but life itself. Sometimes we never even talked about photography.

You've lived in New York for fifteen years now, how is that?
I never planned to live in New York but I came for work and never left. Now I could never leave, because I have a family here and a place here and I've established myself. It's always good to get out for a bit though and go somewhere else. I don't want to become complacent and New York can make you like that, it can make all your values wrong, so you have to be very careful of living here or you can become too involved in the whole machine. That's why I want to go back to Berlin. I want to do things that I want to do. I want to do my next book. You have to push yourself otherwise you're driven by all the wrong reasons in America.

Are cars still a passion of yours?
I still have a fondness for driving cars. I think the problem is that driving a 1970s Challenger around Long Island doesn't have the same appeal as it did a few years ago. With the rise of global warming etc, you're kind of looked down upon. You're driving this gas-guzzling monster around; it sounds great and it looks great, but you feel this slight guilt. Maybe I'll put one of those green engines in it to make me feel better. A friend of mine has converted an old Porsche and put a green engine in it, it doesn't sound the same though…

Do you still have a motorbike?
Yes, I have a few motorbikes, but I think Tabatha [Craig's wife] would like me to give them up. I used to race motor cross so I still enjoy going on motor cross bikes, which I ride in the sand pits. After a while you lose your nerve to ride the things, but I still love them, yes. The freedom of a bike is major.

The Dangerous Issue, No. 80, May 1990
"The picture reflects the cover story about pollution created by Judy Blame and Mondino. By this time, our editorial had broadened and this issue dealt with social and environmental issues, so the shot reflects the brilliant story inside. This was partly a response to Margaret Thatcher's politics at the time. It was intentional, as we moved into a new decade. We were not just dealing with the façade of fashion. There was political awareness underneath that, and we were tackling pollution and racism, and covering topics such as alternative medicine."
Terry Jones, i-D Founder

The Dangerous Issue, No. 80, May 1990
"The pollution story with Judy Blame was such a great moment,. We didn't have cell phones, the Internet or money. The fashion world was still free of perfumes, shoes and handbags. This cover was pure attitude and London was a great school for me. Being able to work with Ray Petri and Judy Blame was a gift."
Jean-Baptiste Mondino, Photographer

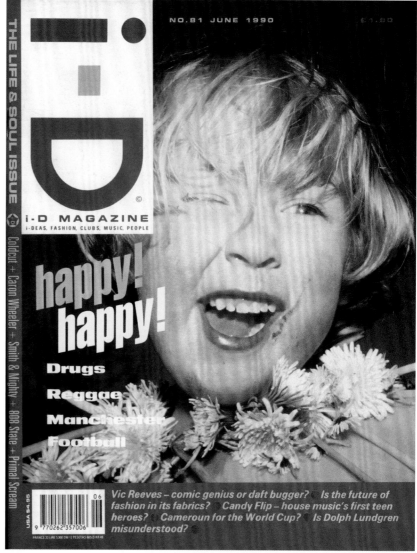

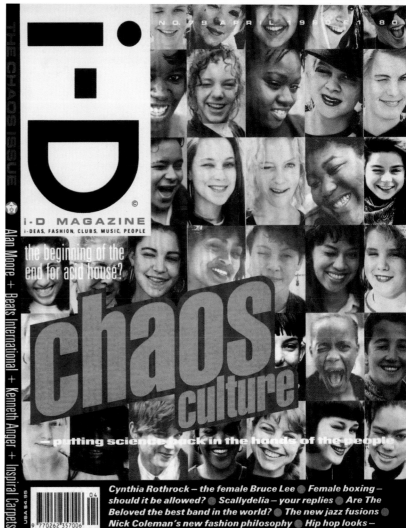

i·D

NO 80 MAY 1990 £1.80

i-D MAGAZINE

i-DEAS, FASHION, CLUBS, MUSIC, PEOPLE

©

Warning!
This magazine is dangerous

fashion fallout
– poisonous looks

Water – is it safe to drink? ● Julian Clary, the man behind the make-up ● 'The Krays' and the Kemps – can pop stars act? ● Monie Love and the changing face of rap ● Viking Combat – have martial arts gone mad? ● Hip hop fashion adopts the suit ● The man behind 'The Toxic Avenger' ●

USA $4.95

05

9 770262 357006

FRANCS 33 LIRE 7,000 DM 12 PESETAS 665 D KR 49

i·D

NO. 78 MARCH 1990 £1.80

THE HIGH SPIRITS ISSUE

Victoria Wilson-James

i-D MAGAZINE
i-DEAS, FASHION, CLUBS, MUSIC, PEOPLE

KLF + Martin Margiela + Lloyd Cole + David Hare

high
spirits!

BRAIN MACHINES, HEALING AND PSYCHIC WARFARE

Boy George is born again ● *Global fashion – Antwerp, Tokyo, Melbourne, Paris and London* ● *The Rocky Horror Show returns* ● *Hanif 'My Beautiful Laundrette' Kureishi – the buddha of suburbia* ●

THE GOOD HEALTH ISSUE

Pedro Almodovar + Joe Smooth + Mannie Greenwald + Rays Wonder

i-D

NO. 77 FEBRUARY 1990 £1.80

i-D MAGAZINE
i-DEAS, FASHION, CLUBS, MUSIC, PEOPLE

Electribe 101
— the band of the '90s, already?

Scallydelia

after the happy mondays,
the stone roses,
the inspiral carpets;
what next?

sex and the spiritual orgasm

02

9 770262 357006

Health Clubs – the amusement arcades of the future/ Designer foods that alter your mind and body/ Fashion catwalk report 1990 – a picture of health?/ Suckerball – Rollerball meets ice hockey/ Billy Boy's rising star/ The new fashion entrepreneurs

FRANCS 33 LIRE / OOS DM 12 PESETAS 855 D KR 45

Lisa Stansfield + Jim Jarmusch + Everything But The Girl + Report From Belfast

i-D MAGAZINE

i-DEAS. FASHION. CLUBS. MUSIC. PEOPLE

NO. 76 DECEMBER 1989/JANUARY 1990 £1.80

Queen B
— the future of rock'n'roll?

up TIME
THE NEW REALITY

0 74470 74518 1

12

FRANCS 33 LIRE 7,000 12 PESETAS 665 D KR 49 USA $4.95

INSi-DE

Soul II Soul — the success story continues/ Natural Uppers And Legal Highs/ Street jeans report — what you're wearing now/ John Richmond and his fashion manifesto/ Cyberspace — science fiction becomes science fact/ Goodbye to the '80s — a decade of i-Deas

The Dangerous Issue, No. 80, May 1990
"The picture reflects the cover story about pollution. By this time, our editorial had broadened and this issue dealt with social and environmental issues, so the shot reflects the brilliant story inside. This was partly a response to Margaret Thatcher's politics at the time. It was intentional, as we moved into a new decade. We were not just dealing with the façade of fashion. There was political awareness underneath that, and we were tackling pollution and racism, and covering topics such as alternative medicine. By this time we were stocked in WH Smith – the first cover of ours they stocked was Madonna, though they didn't know who she was."
Terry Jones, i-D Founder

The Politics Issue, No. 74, December 1989

"Liza Minnelli was on a junket; it was a comeback for her. It was one of those five-, ten-minute things in a hotel room. When I started taking pictures, I wanted to connect with people, personally. I would be one of 20 photographers she would have to deal with. Most photographers would try to become control freaks in that situation, but I decided to be an out of control freak. I didn't set up lights and I was using a camera with a motor drive. I didn't look through the lens; I just waved it around in a chaotic fashion hoping to get a reaction out of her. That didn't work, so I tried another ploy, which was to remind her that when her

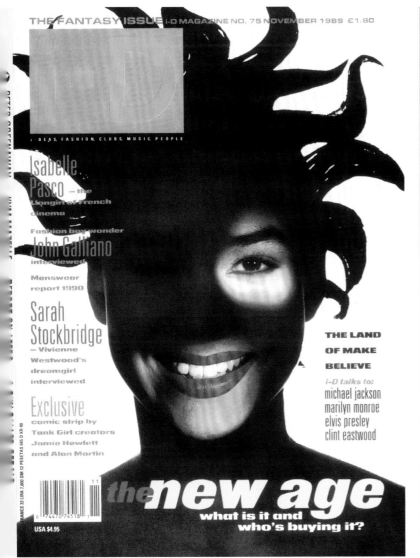

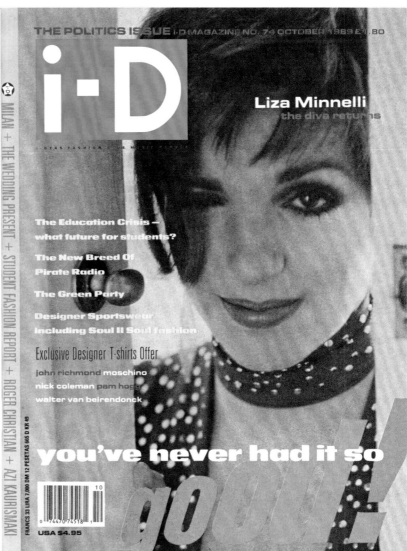

mother died, she tried to sue my dad. My father was an infamous guy because he did plastic surgery, and he looked after Judy Garland. That didn't work either, so I finally asked her to come to the door and said, "give us a wink and say goodbye". I like the photograph because the camera is looking down on her which makes her look vulnerable."
Mark Lebon, Photographer

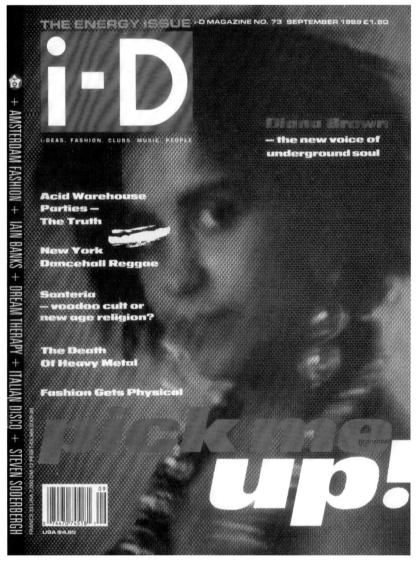

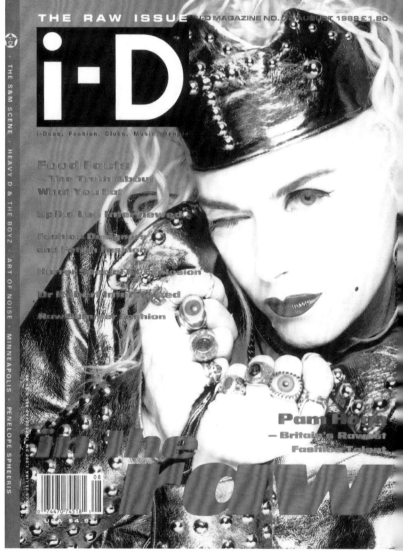

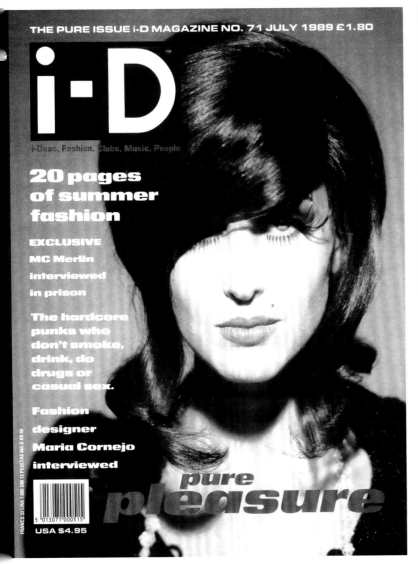

i-D

i-Deas, Fashion, Clubs, Music, People

**20 pages
of summer
fashion**

**EXCLUSIVE
MC Merlin
interviewed
in prison**

**The hardcore
punks who
don't smoke,
drink, do
drugs or
casual sex.**

**Fashion
designer
Maria Cornejo
interviewed**

pure
pleasure

USA $4.95

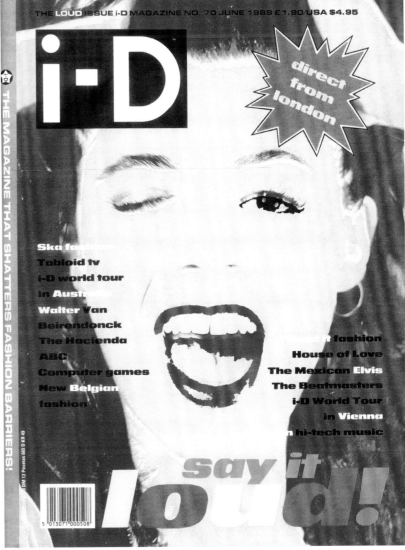

i-D

direct
from
london

THE MAGAZINE THAT SHATTERS FASHION BARRIERS!

Ska fashion
Tabloid tv
i-D world tour
in Austra
Walter Van
Beirendonck
The Hacienda
ABC
Computer games
New Belgian
fashion

fashion
House of Love
The Mexican Elvis
The Beatmasters
i-D World Tour
in Vienna
hi-tech music

say it
loud!

The Rich Issue, No. 69, May 1989

"Working for i-D has been a rewarding, fun and sometimes frustrating experience over the years, I remember working very hard to produce the blue story and cover for issue 69 with Judy Blame and being lucky enough to have Miss Kate Moss modeling only for us to open the issue and discover the art department had decided to crop her head out of the shoot? Nice legs though..."
Eddie Monsoon, Photographer

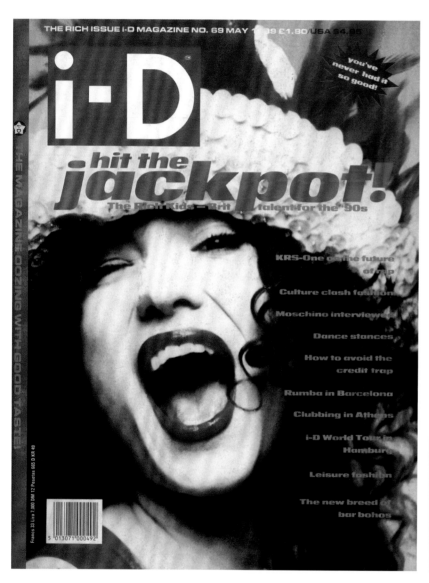

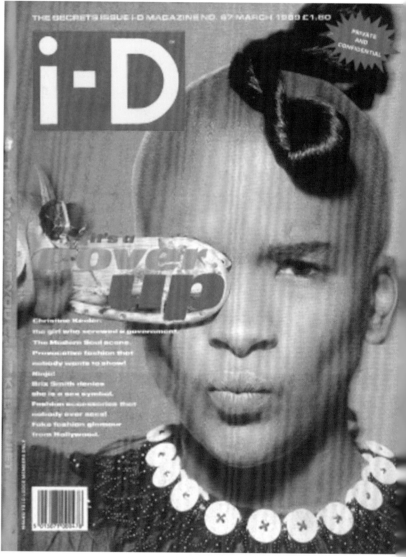

The Power Issue, No. 68, April 1989
"This cover is my very beautiful wife Charlotte. I think she's on the front cover of i-D three times. I photographed Charlotte and it was a birthday present I gave her. I took her to Paris for her birthday and on the plane I gave her the first proof of that cover, "Here you are darling. Happy Birthday." We didn't get married for some years after that. I had to have a couple of children before I got married."
Nick Knight, Photographer

£1.80

i-D ™

THE MAGAZINE WITH PULLING POWER!!

positive power!
beef it up!

kills all
known
germs dead

Lira 7000 DKR 49.00 Pesetas 665 DM 12

5 013071 000485

Asian power Tokyo power Paris power Black power Religious power Metal power

THE EARTH ISSUE i-D MAGAZINE NO. 66 FEBRUARY 1989 £1.80/USA $4.25

i-D

THE TRENDIEST FASHION ORGAN ON EARTH!

earthy!

Francs 35 Lira 7,600 DM 12 PESETAS 655 D KR 5350

5 013071 000461

high street fashion pagan rites and earth magic raw hide fashion

lisa stansfield asian style brash green UK fashion recycled artists

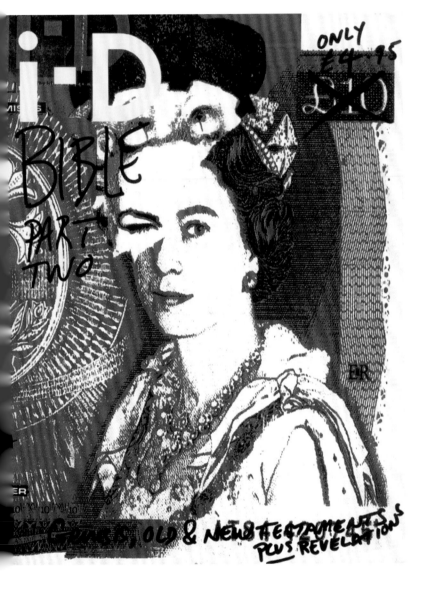

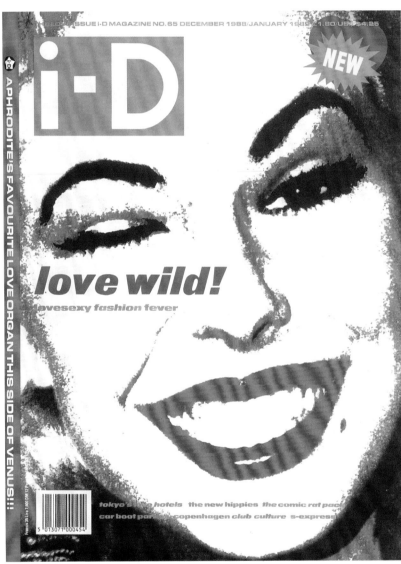

The Love Issue, No. 65, December 1988

"I remember buying my first copy of i-D No. 2 from the local, indie record shop in Oxford, my home town. It opened my eyes to a world I wanted to be part of and inspired my teenage years. Fast forward a few years and I am assisting Mark Lebon and working on many an i-D shoot. This was my introduction to the magazine and how I first started working for i-D as a photographer. Beth Summers gave me my first commission to cover the Saint Martins fashion graduates collections and this turned out to be the first of many shoots Beth and I produced together including a couple of my early covers."

Eddie Monsoon, Photographer

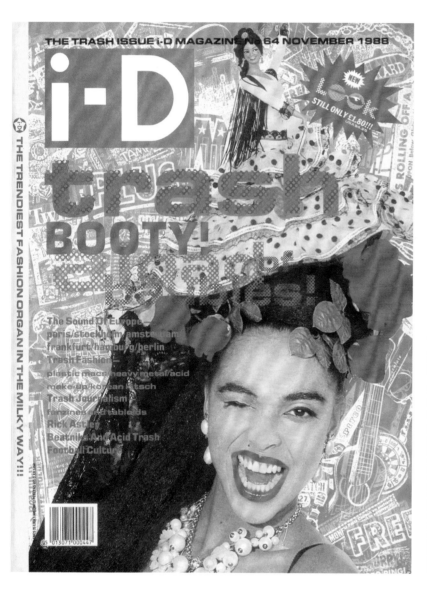

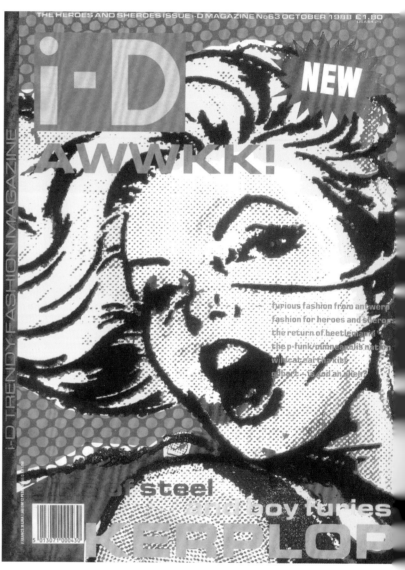

Terry: What was your first cover for i-D?
Eugene: I think it was Cleopatra Jones photographed by Norman Watson for
The Adventure Issue [No. 61, August 1988].
What is your most memorable i-D cover?
The Stella Tennant cover, the one where her hair's flying up against a white
background [The Performance Issue, No. 147, December 1995]. I loved the
energy of it, the orange lips and that shock of black hair. I think I worked on
the Sharleen Spiteri cover as well [The New Beauty Issue, No. 162, March
1997]. And that gorgeous cover Craig McDean shot when he first started
out, with the French actress, Beatrice Dalle, out of Betty Blue... In fact, I
think it was the first time I ever worked with Craig.
How many i-D covers have you worked on?
I've done a lot; I've worked on about twenty.
What was Beatrice Dalle like?
Gorgeous, stunning.
Have there been any divas?
No, they're all nice with me, believe it or not.

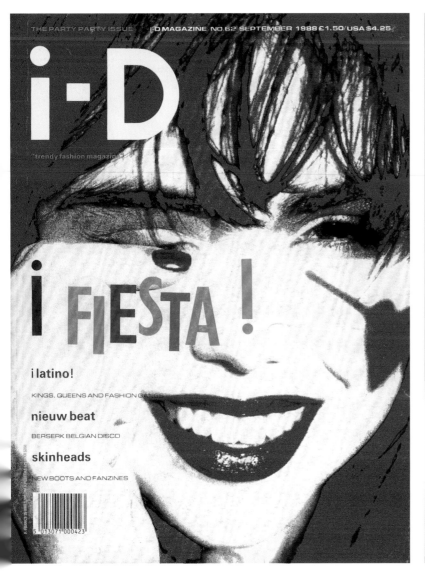

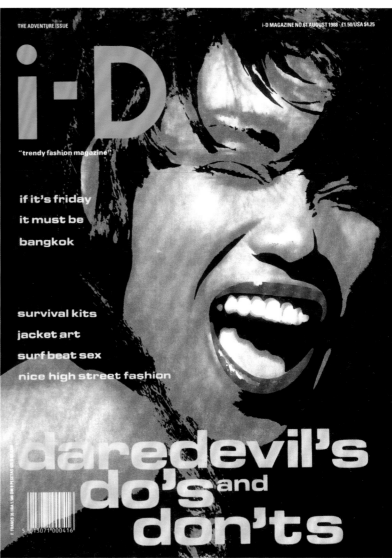

Have you ever damaged anyone's hair?
No, I've never done that. I'm a lover, not a hater.
Can you recall any funny stories over the years?
There are always funny moments, especially with Pat McGrath, Craig
McDean and Edward Enninful around. Too much personality in one room!
Who are your favourite designers?
Yohji Yamamoto and Haider Ackermann. I like designers whose clothes you
look at and you know immediately who designed them. I don't like designers
that change their aesthetic a lot. A really good designer should evolve. I
don't like to see designers swap and jump from one thing to another. I like
to see a signature throughout their work. When you look at Yohji or you
look at Comme des Garçons, Azzedine Alaïa, Stella McCartney or Pheobe
Philo, you know it's them, which I like a lot.
How do you think fashion has changed since you started?
Things are moving much faster now than they ever have. I think it's
important to step back and look at what you've done in an intelligent way
and push it forward, rather than being nervy and just scrabbling on to the
next thing. I'd like to see people being a little more precious and concise. I'd
like to see handbags go and shoes. I'd love that; I'd love it to be about
clothes again. I'd love to see just two collections a year as well.

THE GRADUATION ISSUE

i-D MAGAZINE NO.60 JULY 1988 £1.50/USA $4.25

i-D

"trendy fashion magazine"

know it all!

john waters

pool hustlers

hip students

five star

acid jazz

paris fashion

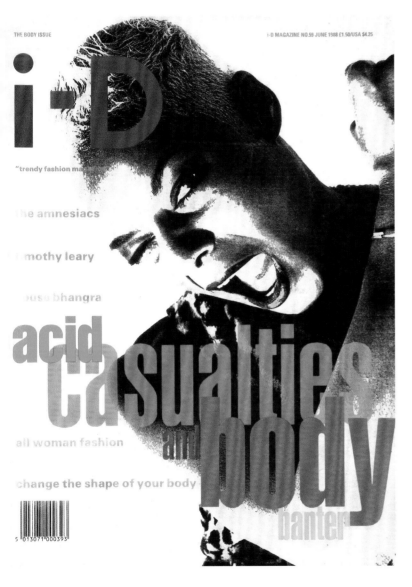

i-D MAGAZINE NO.59 JUNE 1988 £1.50/USA $4.25

i-D

"trendy fashion ma

the amnesiacs

mothy leary

usu bhangra

acid
Casualties and body

all woman fashion

change the shape of your body

panter

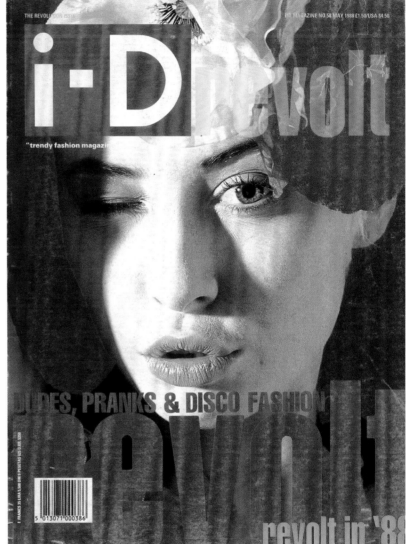

I-D MAGAZINE NO.58 MAY 1988 £1.50/USA $4.50

i-D revolt

"trendy fashion magazi

DUDES, PRANKS & DISCO FASHION

revolt

revolt in '88

THE SURREAL ISSUE

i-D MAGAZINE NO.57 APRIL 1988 £1.50/USA $4.50

i-D ™

"trendy fashion magazine

fashion !?

who's
dreaming
what now
?

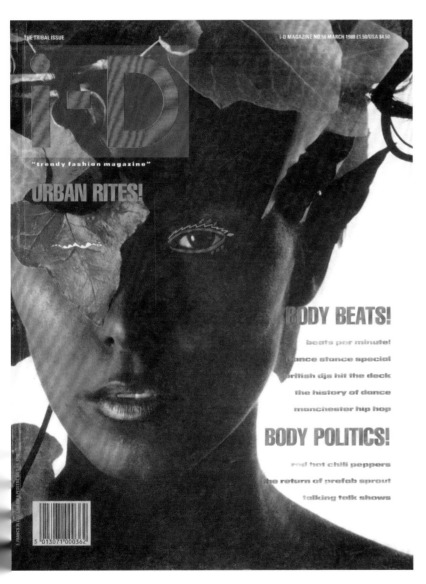

i-D MAGAZINE NO.56 MARCH 1988 £1.50/USA $4.50

i-D

"trendy fashion magazine"

URBAN RITES!

BODY BEATS!

beats per minute!

dance stance special

british djs hit the deck

the history of dance

manchester hip hop

BODY POLITICS!

red hot chili peppers

the return of prefab sprout

talking talk shows

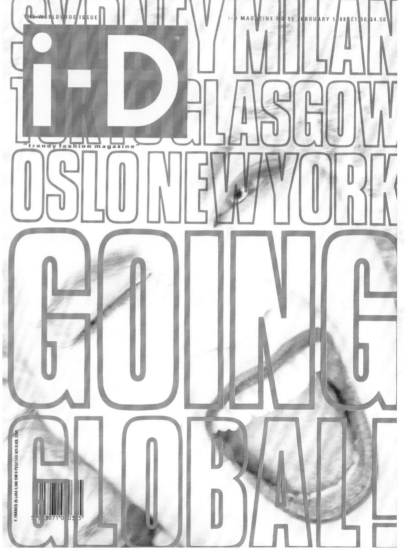

i-D MAGAZINE NO 55 FEBRUARY 1988 £1.50/$4.50

i-D

"trendy fashion magazine"

SYDNEY MILAN
GLASGOW
OSLO NEW YORK
GOING
GLOBAL!

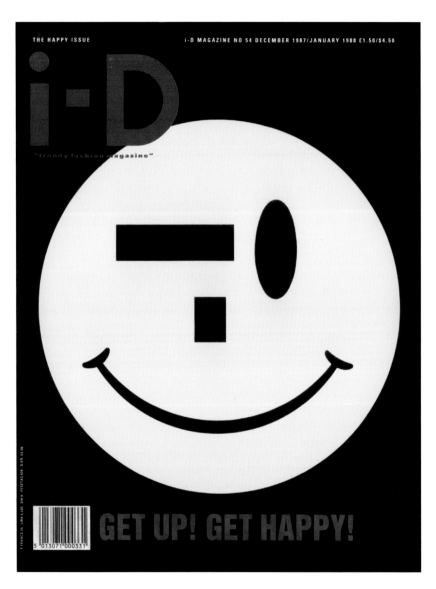

THE HAPPY ISSUE

i-D MAGAZINE NO 54 DECEMBER 1987/JANUARY 1988 £1.50/$4.50

i-D

"trendy fashion magazine"

GET UP! GET HAPPY!

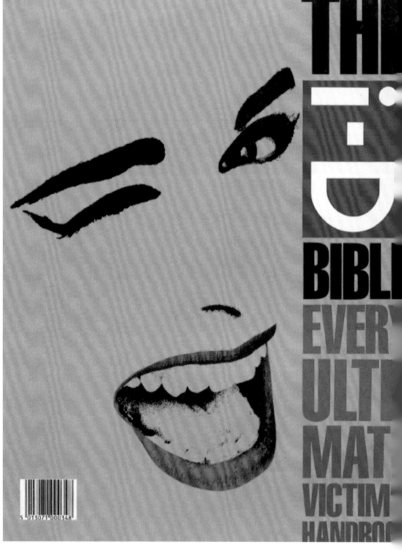

THE i-D

BIBL

EVER
ULTI
MAT
VICTIM
HANDBOO

The Fear Issue, No. 53, November 1987

"I met a Japanese student who was the sweetest dolly daydream I'd ever seen. Maybe I was in love with her just a bit... Anyway, time to shoot the cover and I invited her to the shoot where I styled her in devil's horns and badges that had arrived through the post unrequested. I loved them. They said things like, "Fuck me like a sinner." The shoot was delicious and the picture would be one of the first times we clashed with our new distributor WH Smith. They hated the cover and wanted the inflammatory wording painted out – not sure how this was done as there was no digital re-touching in those days."

Caryn Franklin, Former i-D Co-Editor

The New Brit Issue, No. 52, October 1987

"Alice wasn't a model, but she is a direct descendent of our first Prime Minister [Sir Robert Walpole]. In this photo, Alice and her brothers are all on top of one another and tickling each other. There is nothing like pushing everyone's heads together. The image is all about the family and the power of the group, which is something I believe in. We almost became a family, but that is another story."

Mark Lebon, Photographer

i-D

"trendy fashion magazine"

HOP TO IT!
RABBIT! RABBIT! RABBIT!

ESSENTIAL MENSWEAR
BOYS FOR
THE GIRLS
CARI-COUTURE ON THE
STREETS OF LONDON

CALENDAR
GIRLS
20 YEARS
OF FIORUCCI
CURTIS
MAYFIELD

5 013071 000300

The Boy's Own Issue, No. 51, September 1987

"I was 17 when I did that picture and I was definitely still in school. I used to do modelling as a teenager during school holidays. You know, I was 13 and did pictures with tons of make-up on to make me look 25. One of my friends was Claudia Sarne, who was the daughter of Tanya Sarne, who owned Ghost. Claudia and I did a little fashion show for Ghost at Lynn Franks. We were 16. Caryn Franklin, from i-D was there and she asked for my name and number. You know how some shoots these days have big concept meetings? For this they had this idea with bunny ears and tattoos. I just showed up, put on the ears and bustier, and snap, it was done in an hour. It was very cool.

I remember all those covers from the age of 13, which would have been 1983. When I was a teenager, I used to buy i-D magazine and 'The Face' and keep little piles in my bedroom. These magazines were a part of my teenage years. I remember the Buffalo Boys, Ray Petri and the men who wore kilts. I even went to Taboo at the

The Holiday Issue, No. 50, August 1987

"Here we have Sara Stockbridge in Vivienne Westwood. Again, a cover where she did a fantastic wink because she was very animated in front of the camera and partly because she was biting her tongue rather gently in that shot."

Nick Knight, Photographer

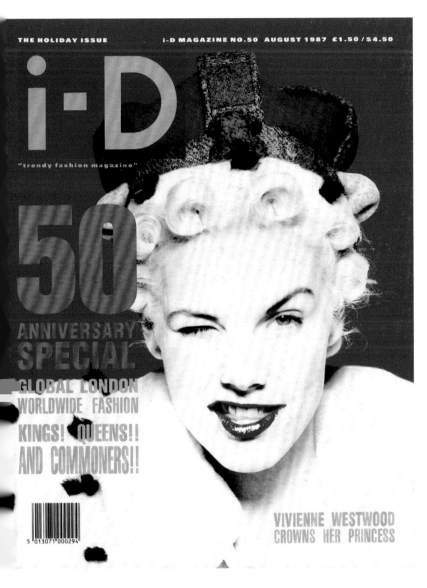

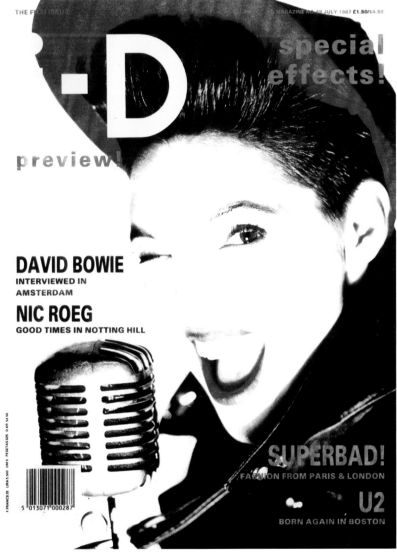

time. I was probably too young to be there, but f*** it. Not long after my i-D cover appeared, I was on the Kings Road and I saw this guy walking down the street wearing one of those black nylon bomber jackets with the orange lining that everyone bought from Kensington Market. He had my cover safety-pinned to the back of his jacket. For me, that cover was the coolest thing I've ever done."

Rachel Weisz, Cover Star

The Plain English Issue, No. 48, June 1987

"It was always a blast to shoot Leigh Bowery. When Robert Violette's book on Bowery came out I was so surprised to see how much Leigh had been documented, because at the time I just thought of him as a club kid and a bit of a druggie. But actually he was amazing at so many things; making himself an icon for the few years he lived in London. The first time I photographed him it was in his "outer space look", where he and Trojan paraded around day and night looking like Krishna or Vishnu. I then shot him in my studio for a series of greeting cards; he dressed as a Christmas pudding for Christmas and in bed with bottles of pills for a get-well card. The pig face was totally a Leigh concept and very powerful. I will never forget seeing him at a bus stop in a man's wig and a dirty old raincoat, having just come from Lucian Freud's studio, where Lucian had just painted him so brilliantly nude and bald. I wish more eccentric talented and amusing people like Leigh Bowery still graced the planet."

Johnny Rozsa, Photographer

Terry Jones in conversation with Val Garland

Terry: How did you become a make-up artist?
Val: I kind of fell into it. I was badgered into being a make-up artist by friends of mine. I used to wear tonnes of make-up myself. I was a punk, I was a new romantic… I used to wear loads and loads of make-up. And people kept saying to me 'You should do make-up'. I was a hairdresser at the time and one day on a shoot the make-up artist didn't turn up so the photographer said, 'You've got to do the make-up Val,' and that's how my career started.

What is your favourite cover of i-D?
My favourite cover of i-D would have to be the Leigh Bowery cover [The Plain English Issue, No. 48, June 1987] but there are so many others. I love the Devon Aoki cover where she's got the leaf over her eye [The Adult Issue, No. 179, September 1998], that always stood out, but there have been so many amazing covers. I love them all.

Terry Jones in conversation with Derek Ridgers

Terry: When did you first start working for i-D?
Derek: I have no exact recollection of the date but I'm pretty sure I came to see you in the autumn of 1980, most probably whilst my Skinhead show was on because that had a lot of publicity. I left the meeting with the first two copies of i-D, so I guess that would be about right?

What do you remember from the meeting?
I remember being in a sunny upstairs room and being extremely impressed by your enthusiasm about i-D. But, I have to say; I was slightly under-whelmed by the way photographs were used in those first couple of issues of i-D. I guess one of my problems would have been your PUNK! book. My feeling was that, at the time, the photographs very much took second place to the design and overall fanzine concept of the magazine. I felt it didn't quite suit my style at that point.

I'm sorry you felt that way…
Obviously, if I'd had the foresight and the good sense to look a little deeper and think a little harder, I would have felt differently. But making erroneous and usually very rash decisions has been my lifelong way, unfortunately.

What shoots do you remember doing for i-D?
To be honest, this was one of the strangest jobs I ever did and it probably confirmed my conviction that fashion photography was never likely to be my strongest suite. Early in 1992, Beth Summers [Former Fashion Editor of i-D] suggested I should shoot a fashion spread for i-D and shoot it in the same style as I had been shooting my documentary club portraits. After my initial misgivings about i-D proved to be so comprehensively wide of the mark, I was very eager to work for you, so I jumped at the chance. I really loved taking the photos. The models were not really models at all but some club girls that Beth already knew and was friends with. They were all great and full of character and attitude. Some of the shots were taken during the day in some empty Soho clubs and some were taken on an empty floor of the same building i-D was in at the time, on Curtain Road. My problem was, I really didn't have a clue what was going on regarding the clothes and the styling. It looked to me like Beth had been to a few charity shops and jumble sales and bunged a whole load of disparate stuff together and I thought the whole thing looked like a dreadful, disjointed mess. It was something that always bothered me about that shoot. But gradually, over the years, the clothes in those photos have started to look more and more right. And these days, when I go to fashionable nightclubs, I notice plenty of kids dressed like that. Most of them, in fact. So I guess Beth was way ahead of her time. I just couldn't see it at the time!

The Good Sport Issue, No. 47, May 1987
Nick Knight: Tess is a young girl who had the same sort of androgynous look that I still really like. I think this is a girl who we met on the tube. Simon Foxton and I saw her on the tube and thought she looked great, she looked like a boy, fantastic and we used her for this, I think I'm right in saying that.
Terry Jones: There were two shots, the one with the wink inside and then that one, which had more animation.
NK: A bit of flash and a bit of tungsten mixed together.

The Pop Issue, No. 46, April 1987
"Anybody who knows Grace Jones will know the power of this woman: enormously powerful physically, the sexual, social presence she is in a room. We went to photograph her in her hotel and I think she quite liked the look of my assistant, Andy. I might be completely wrong, but she looked like she was going to eat Andy for a while, bless him. Obviously Jean-Paul Goude did the most amazing graphic work of her and I was thrilled to photograph her."
Nick Knight, Photographer

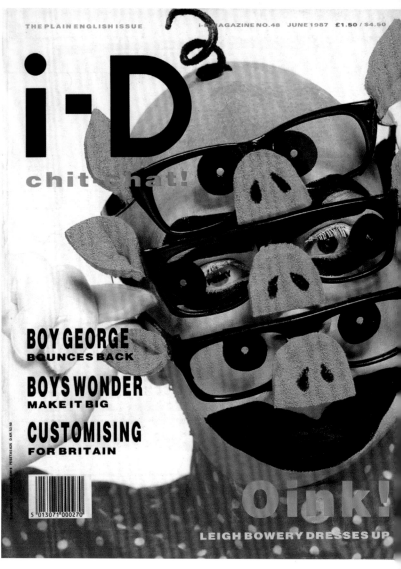

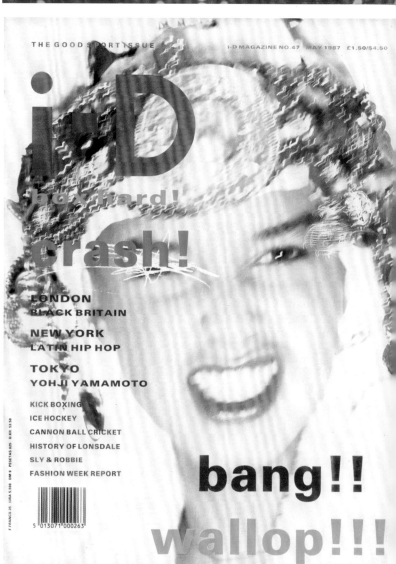

THE POP ISSUE i-D MAGAZINE NO.46 APRIL 1987 £1.50/$4.50

i-D

music!

pop life!

GRACE JONES

BOUND TO BE PERFECT

MALCOLM MCLAREN

FALLS IN LOVE

RICHARD BUTLER CLEANS UP

SIX CULTS FOR 87

RUPERT EVERETT OPENS HIS MOUTH

BEAUTY SPECIAL
A POP GLOSSARY FOR THE 80's
NEW YORK REPORT
ANDY WARHOL'S LAST SUPPER

5 013071 000256

Terry Jones in conversation with Dylan Jones

Terry: What was the first cover you worked on as Editor of i-D?
Dylan: Sade was the first, Smiley was the last.

How did the cover with Sophie Hicks [The e=mc2 Issue, No. 16, June 1984] happen?
In the early 80s, some of i-D's covers were shot as proper covers, others would happen by accident. Some even happened on shoots where the person who was meant to be on the cover didn't end up on the cover, but someone else did instead! Judy Blame, Vivienne Westwood, Rachel Weisz – that was Rachel Weisz' first cover [The Boy's Own Issue, No. 51, September 1987].

It was, yes. She was still a schoolgirl.
This is the cover I remember Kate Flett getting really angry about. I had a huge row with you over this.

Why?
Because it's filthy... Kevin Davies took the photos and he was even more furious than I was, because it looks like you'd spilt tea on it, actually you probably did spill tea on it! I remember Kate Flett was in the newsagents and two girls came in and picked up this cover and said, "Look, it's covered in tea; they really don't try do they," and she went for them apparently. Terrible cover Terry, awful. I remember where we were when we did it because Jo and I were working with Stephen Male on the 'Smiley' cover at the time.

What other covers are memorable to you?
Sade, Madonna, Sophie Hicks... I can remember all of these photo shoots. They're all coming back to me.

What about the Isabella Rossellini cover [The Metropolitan Issue, No. 45, march 1987]?
The Isabella Rossellini cover happened because I knew Fabrizio Ferri, who was going out with her at the time. This was a paparazzi shot wasn't it?

Wasn't it during the MTV Total Access fashion show?
Yes, up in Newcastle. I remember because this is the story we did with Nick Knight and Simon Foxton, which was the MA1 flying jacket with all the Russian paraphernalia on it. We'd just been to Russia and come back with all these badges and posters. I remember we spent about six months walking around London with photographs of Lenin on our MA1 flying jackets.

Do you remember Scarlett [the cover star of The Head to Toe Issue, No. 8, October 1982]? She's now doing homeopathic healthcare and organic gardening.
Obviously. From the door of Cha Cha's to homeopathic gardening. That was the Soho shoot, it was the rebirth of Soho, which was in February 1986 and we shot it in November 1985.

It was Ellen von Unwerth's first story.
Yes, it was Swing Out Sister, Paolo Hewitt and a whole bunch of other people shot in Bar Italia. It sounds like a cliché now, but that was the first time that we'd done Soho again.

You've also appeared in i-D yourself over the years...
Yes, that was a long time ago. I remember I was photographed with a hat for The Olympic Issue [No. 105, June 1992]. I was wearing big track pants and a pair of basketball shoes and a fedora. I've no idea who that is [points at The Dramatic Issue, No. 39, August 1986]... I don't know anything about that cover and I was working at i-D at the time!

That was Naomi Campbell's first cover.
But she's blue Terry.

We did her in negative.
I don't remember that cover at all. I never knew that was Naomi Campbell, but there we are. It looks more like Avatar.

That's probably where James Cameron got his inspiration!
You were twenty-five years before your time...

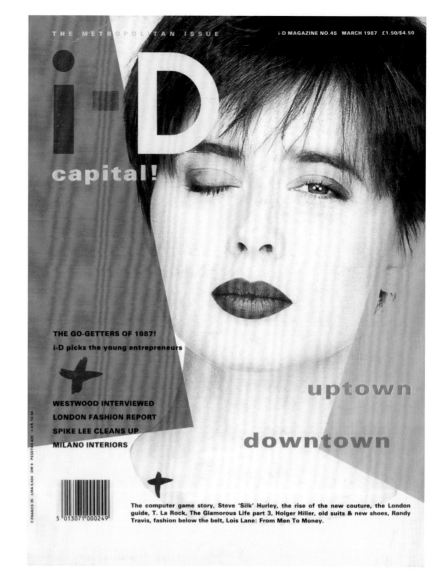

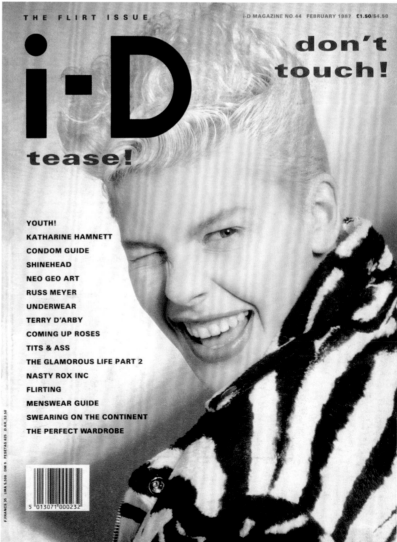

i-D

scoop!

i-D'S TOTAL ACCESS FASHION SHOW!

TOM WAITS

JANET STREET-PORTER

JIM JARMUSCH

THE INDIE SCENE

JEAN-JACQUES B

ANTHONY HOPKIN

GLENYS KINNOCK

i-DEAL IMA

i-D'S

exclusive!

THE MEDIA ISSUE

5 013071 000195

THE INDISPENSABLE DOCUMENT OF FASHION STYLE AND IDEAS

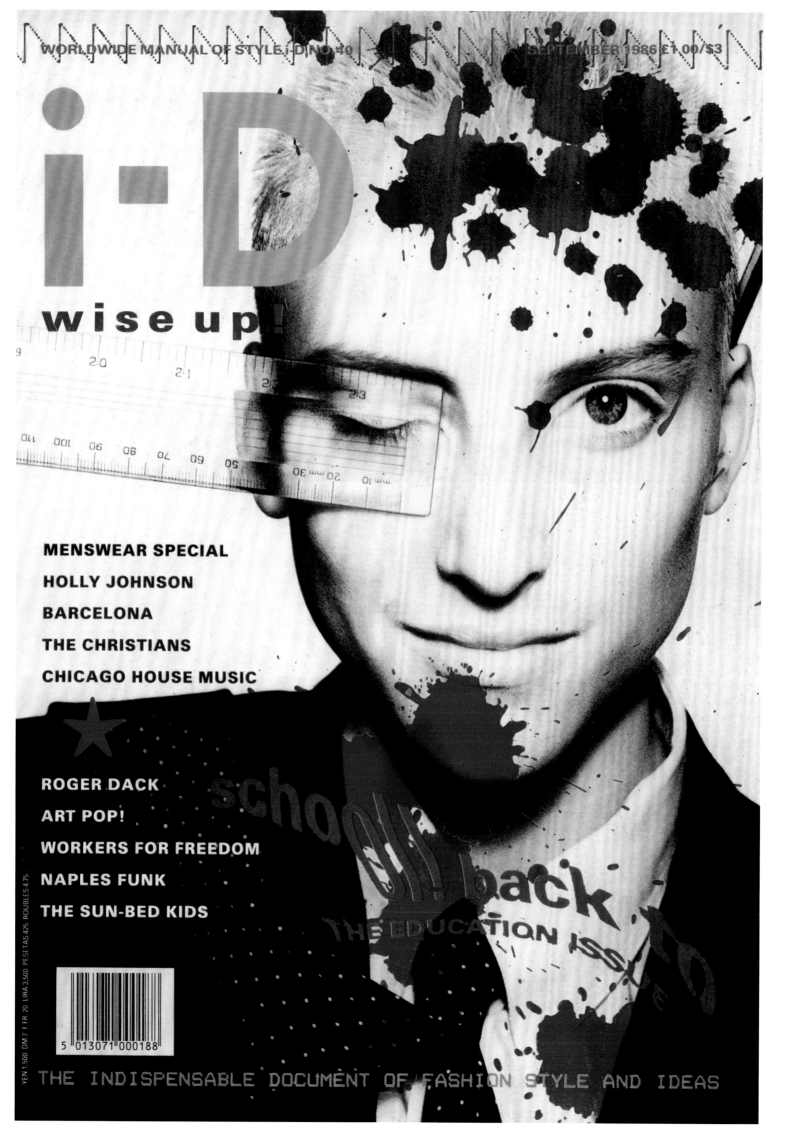

i-D

wise up!

MENSWEAR SPECIAL

HOLLY JOHNSON

BARCELONA

THE CHRISTIANS

CHICAGO HOUSE MUSIC

ROGER DACK

ART POP!

WORKERS FOR FREEDOM

NAPLES FUNK

THE SUN-BED KIDS

back

THE EDUCATION ISSUE

YEN 1,500 DM 7 F FR 20 LIRA 3,500 PESETAS 425 ROUBLES 4.75·

5 013071 000188

THE INDISPENSABLE DOCUMENT OF FASHION STYLE AND IDEAS

The Comic Book Issue, No. 43, Dec/Jan 1986/87
"That is a Scottish girl named, Mickey. It was a Betty Boop story and she was brilliant. What I love about that is that Terry used to manipulate the cover art and not tell me. It didn't bother me because it made it so much better. It becomes a very interesting, sort of precursor to digital manipulation. I am not sure digital is very much a part of the world of i-D. I think it is part of the world of other magazines, as in "get it in the frame and put it on the page". The cover is so much better because it has been manipulated, the hyper contrast worked. It is very brutal, very direct raw lighting, strict yet very simplistic. Plus the cover doesn't say anything about the model, so there is no celebrity, no personality involved, which is fabulous."
Robert Erdmann, Photographer

The Beauty Issue, No. 42, November 1986
Nick Knight: This is Angie Hill, who used to go out with John Richmond for a while.
Terry Jones: The mother of Phoenix.
NK: Right. Just another one of these people that brings so much life to the whole thing and was photographed in my front room actually, back in Petersham.
Nick Knight, Photographer

The Beauty Issue, No. 42, November 1986
"The Beauty Issue is another cover that started life as a black and white photo. Angie Hill, the cover girl, looks so fresh and natural; I think that's why I was inspired by the baby postcard for the colours. I had never seen a baby with lavender eyes?"
Moira Bogue, Former i-D Art Editor

The Photographic Issue, No. 38, July 1986
Nick Knight: Around this time, I started working for Yohji Yamamoto and my life was completely fulfilled because I had international high fashion [in Paris] with Mark Ascoli, Yohji and Peter Saville and in England I had Simon Foxton, you and i-D. Ann Scott was a model with Z Agency, which was really good at finding new, young faces. She was on their books. At that time Z Agency had the most interesting models and those were the models we tended to use for Yohji, which were often models Mark had found on the street. I think Ann Scott was on Z Agency's books. I'd love to speak to her and find out what she's up to, I believe that she's a very strong writer now.
Terry Jones: Simon is in touch with her through Facebook, we wonder whether her tattoos have increased.
NK: I think they probably have. She kind of felt at the time that she was drifting, looking for something, I guess we probably all were.
Nick Knight, Photographer

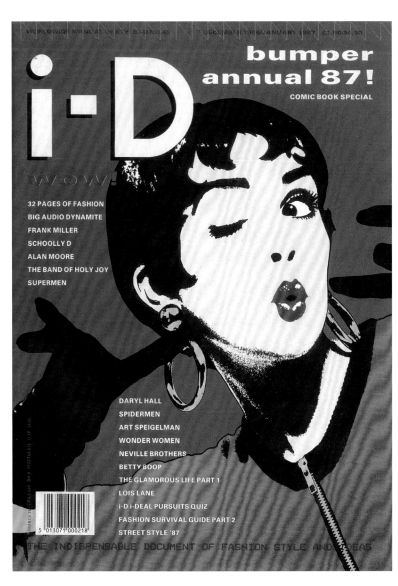

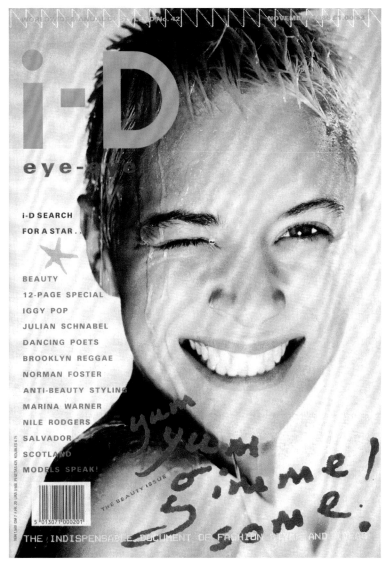

The Education Issue, No. 40, September 1986
Nick Knight: Amanda King was a dancer for Michael Clark. Out of all the dancers who Michael was working with at the time, I think she was his main dancer, a tiny, little girl and an amazing dancer. She just had this beautiful face; big eyes and we worked quite a bit with Amanda and did quite a lot of things with her.
Terry Jones: We were doing The Education Issue and you did the ruler. I mean at that point our themes were quite abstract. I don't think we had the theme before, I think you did the ruler and then we decided to call it The Education Issue.
Nick Knight, Photographer

The Media Issue, No. 41, October 1986
"Muriel Gray is a TV presenter and broadcaster. I think we were trying to go fake paparazzi style."
Nick Knight, Photographer

The Magic Issue, No. 36, May 1986
"I was always very intrigued by girls who looked like boys, always liked girls who look like boys."
Nick Knight, Photographer

The Cool Issue, No. 33, February 1986
"Nick Knight photographed Corinne Drewery with the perfect wink and style of the i-D logo. This was a black and white image, which we coloured up on the computer. Drewery was performing the club circuit at the time; she had not even been signed and Swing Out Sister were unknown. It was the perfect time to capture her, and really reflects our mood in the mid-eighties. This issue stood out on the stands, and marks a time that people remember. We were experimenting as we went on. We were at the early stage of using Scitex scanning, hand-manipulating the graphics on a Xerox machine. I had lost track of circulation figures by then; we were established by this time."
Terry Jones, i-D Founder

WORLDWIDE MANUAL OF STYLE i-D No. 39 AUGUST 1986 £1.00/$3

i-D
act!

THE METHOD

CATHY TYSON

EDINBURGH
FESTIVAL

PANINARI

TOKYO

GILBERTO GIL

THE FRINGE

✝

RICHMOND/CORNEJO

BRIGHTON

30 YEARS OF
YOUTH CULTURE

THE MUSICAL

P-FUNK

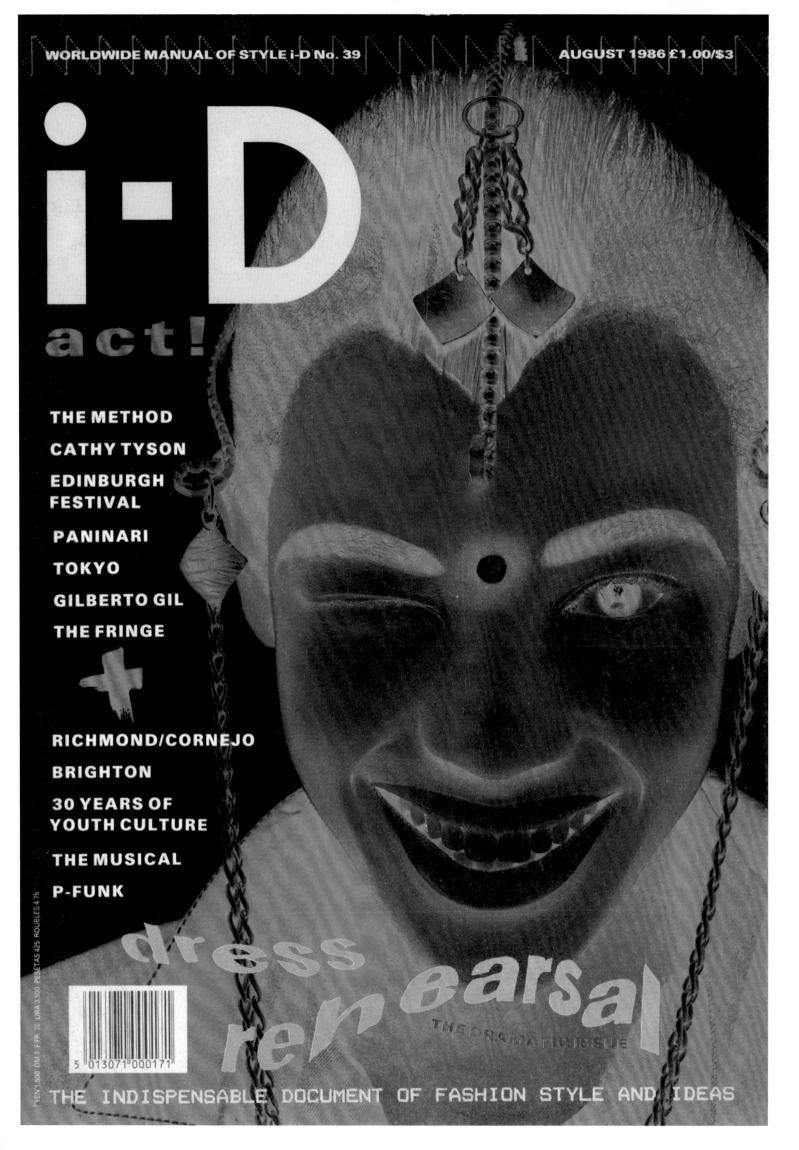

dress rehearsal
THE DRAMATIC ISSUE

THE INDISPENSABLE DOCUMENT OF FASHION STYLE AND IDEAS

YEN 1,500 DM 7 F FR 20 LIRA 3,500 PESETAS 425 ROUBLES 4.75

5 013071 000171

i-D

shoot!

ALEX COX

LIVERPOOL

KLAUS KINSKI

THE COMMUNARDS

LARRY FUENTE

THEN JERICO

POST MODERNISM

TOSCANI

JOCKEY SILKS

BRIAN GRIFFIN

watch the birdy!

THE PHOTOGRAPHIC ISSUE

YEN 1,500 DM 7 F FR 20 LIRA 3,500 PESETAS 425 ROUBLES 4.75

5 013071 000164

THE INDISPENSABLE DOCUMENT OF FASHION, STYLE AND IDEAS

The Dramatic Issue, No. 39, August 1986

"Naomi is this young girl who came to see me from Beth Ann Hardison. As opposed to Mickey or Kathy Kanada, when you met Naomi you knew she was going to be something. But in those days, it wasn't like, "oh, let's make sure we don't get her to do very much and manipulate her career, then what we're gonna do is make sure she does an i-D cover and then springboard her to French or Italian Vogue, then we'll make sure she gets a Gucci campaign and then we'll make sure for one show she gets an exclusive". This cover is a discovery that really was amazing, but maybe not amazing enough at the time to have it be her face, so Terry turned it into a black and white. It is an interesting artifact because it is of Naomi, and she wasn't good enough yet to say, "let's do a cover with Herb Ritts". She's just this spotty girl, but she's fabulous, and oops she is the right girl, so let's do something to the picture but let's just do it really simplistically. I think the best things in i-D are those things that stay simplistic."
Robert Erdmann, Photographer

The Dance Issue, No. 35, April 1986

"You'd think I'd remember someone's foot being that close to someone's face, but none of us could remember whose foot that was, so this cover is all about memory. Akure is half Nigerian and half English, and that is Caryn Franklin's foot in the picture. Frances Hathaway introduced MAC cosmetics to the U.K. with this cover. This is a lost cover, because no one has a copy of it. Akure lives in L.A. now, and I was speaking with her the other day and she has [the issue] in a box in her mother's garage in Croyden. Akure remembers more than I do about the shoot. She remembers sitting on the bus coming to Battersea to see me. I have very little memory of the actual days I shot any of these covers so I've had to piece it all together. It was so innocent then, we didn't think about what was at stake with a cover, for Terry the stakes were probably high. We were all so naïve, because you could say, "let's do a cover on Akure", and everyone would say, "okay", and then it just became a cover. It was a very naïve time, an innocent time, but I don't think Terry was innocent. He couldn't have been innocent considering everything he'd done before. When we [shot] these covers we didn't feel like we were part of some insider club, we were just going to a studio and doing an i-D cover. At the time, Guido Palau and I weren't allowed in to the Wag Club in London because we were too naf. Which was fine, because you shouldn't be able to get into any old club. Anybody can get in to Disneyland. I do think things need to turn around a bit, because things can be too democratic. This whole Facebook, YouTube free knowledge, free access is wrong. You should have to pay a price to be involved in things. I think access should be difficult, that is what makes it interesting. If it is free, it is no longer interesting."
Robert Erdmann, Photographer

The Madness Issue, No. 34, 1986

"That cover was a big transition for all involved, because each of us was stepping out from what we knew. This was Judy's first job as a stylist. Up to then the only stylist I'd worked with was Ray Petri. Judy was a jewelry designer who'd been living, for a year or so, in a cupboard in my flat, but he totally understood my aesthetic. Letting go of the photography was the next step for me to becoming a fully conceptual photographer who represented people, so I woke up that morning and decided that the model should take the pictures. I owed Jenny Horwath so much for the inspiration she'd given me that she actually took that cover shot. I wanted to support her wish to start taking pictures and to give her some payback for her thankless task of being in front of the camera. Jenny took the fashion pictures on the inside pages of that issue. I felt happier in the promotion of talent re-presenting people who were really talented and wanted to be re-presented to a wider audience."
Mark Lebon, Photographer

The Cool Issue, No. 33, February 1986

"This is one of my all time favourite covers. The photo, colour treatment and graphics are stark, simple and classic with an i-D twist. The repro house used to get very nervous when I would go in to work on a cover with the head technician, who by the way, was the only one working on a computer screen! The bosses would pass by every 20 minutes or so, nervously hovering about, trying to will me out of the building. Time spent on the cover was a gift to i-D and in those days computers were much slower."
Moira Bogue, Former i-D Art Editor

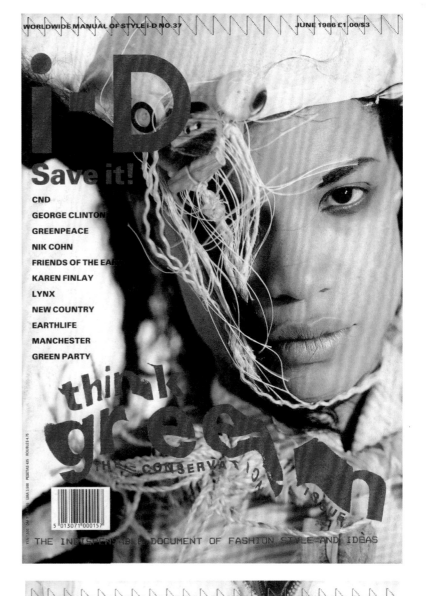

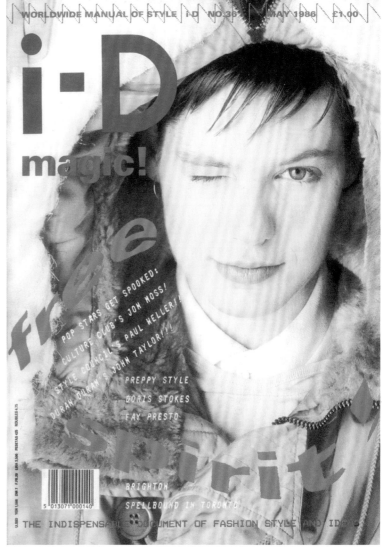

WORLDWIDE MANUAL OF STYLE i-D NO.56 APRIL 1988 £1.00

i-D

DANCE SPECIAL

APRIL CONFi-DE

SPUTNIK SPEAK OUT

DEGUILLE GETS DOWN

STEP ON IT

MICHAEL CLARKE

CAUGHT CLUBBING

SAFE SEX GUIDE?
i-D GOES DANCING

5 013071 000133

THE INDISPENSABLE DOCUMENT OF FASHION STYLE AND IDEAS

WORLD'S I DIMENSIONAL JOURNAL OF STYLE i-D NO.34 MARCH 1986 £1.10

i-D

THE MADNESS ISSUE

PASSION, FASHION AND TOTAL MADNESS

MARCH CONFI-DE
**LYDON
ON LAGER**

**KELLY
ON MONEY**

**GAULTIER
ON GIRLS**

PASSION VICTIMS!

013071 000126

THE INDISPENSABLE DOCUMENT OF FASHION STYLE AND IDEAS

i-D MAGAZINE No. 33 FEBRUARY 1986 £1.00

i-D

THE COOL ISSUE

Cool out sister!
Vivienne Westwood
Paul Rutherford
Fashion survival guide

CHILL OUT

U S$3 YEN 1.500 DM 7.5 F FR 20 LIRA 4.600 4.75 ROUBLES

Plus music, fashion, style + soho cool

THE INDISPENSABLE DOCUMENT OF FASHION STYLE AND IDEAS

i-D MAGAZINE No. 32 DECEMBER/JANUARY 1986 £1.00

i-D

The Jet Set Issue

IN SIGHT

OUTER LIMITS

THE INDISPENSABLE DOCUMENT OF FASHION STYLE AND IDEAS

WORMANDANESTYLE

the spectator issue

i-D MAGAZINE No. 31 NOVEMBER 1985 £1.00

i-D

the indispensable document
of fashion style & ideas

ONE EYED

MONSTER!

5 013071 000096

NEW SEASON OF ENTERTAINMENT....WITH LOTS OF CHUNKY BITS!!

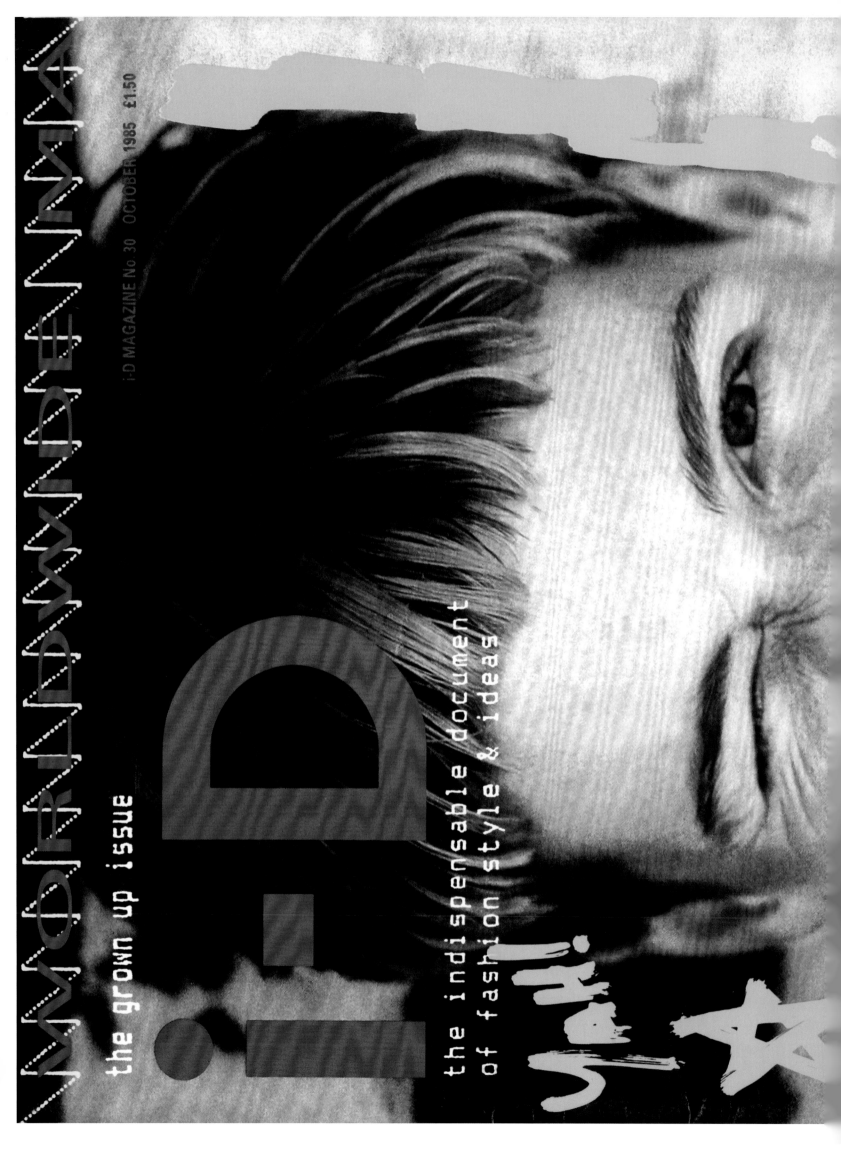

NORMADWDENMA

i-D MAGAZINE No 30 OCTOBER 1985 £1.50

i-D

the grown up issue

the indispensable document
of fashion style & ideas

The Grown-up Issue, No. 30, October 1985
"A couple of years after meeting Jenny, she became a famous model known for her minimal, natural look and cropped – less than in inch – hair, bleached almost white. On the day we did this picture, Jenny's hair was longer, her roots were showing and she was wearing no makeup. The idea for the photograph came from the street, because at that time in London it was all about the street. What I loved about i-D was it had this appreciation of people on the street, who created fashion from their own imagination, and not the industry. Sue Clowes had designed these clothes where she had made a frottage of the floor of her studio and printed on top of it. That frottage symbolised the street. So we shot this in the street. There was a sense in me that I just wanted to get down and dirty and be able to shoot a cover of someone with their head in the gutter. Jenny was literally lying in the gutter, near New Cavendish Street. It is a moment of total confidence and belief in being."
Mark Lebon, Photographer

The Grown Up Issue, No. 30, October 1985
"This was for our fifth-birthday issue. Jenny Howarth, the model on the front, was one of the first supermodels. She became famous for her cropped, bleached hair. But she was babysitter for our children, and that's how she looks on this cover; the girl-next-door, fresh-faced look. It's a very personal image for me. This was a one-off A3 format, and the news trade hated it, even though we folded it in half. We were manipulating type and using basic graphic tools – and the photocopier in the office. No-one else was using graphics in our way. It was saddle-stitched rather than perfect bound, because it was cheaper, but, aesthetically, I liked it."
Terry Jones, i-D Founder

The Health & Efficiency Issue, No. 29, September 1985
"Caryl Dolores was great, a fantastic girl. Got to a London airport, met William Faulkner and he cut her hair in the airport and then we shaved her head for the cover. Shaving girl's heads for the cover of i-D became a bit of a thing, which Caryn Franklin will testify to."
Nick Knight, Photographer

The Health and Efficiency Issue, No. 29, September 1985
"This cover featured a bald woman with no clothes on. It was a great shot that had been sent in to i-D on spec. As Fashion Editor, I remember looking through the credits and questioning the need for a stylist's credit, as the model was wearing no clothes. 'Ah well,' said stylist Paul Frecker when I phoned him to discuss. 'I should have a stylist's credit because styling is just as much about knowing what to leave off as it is about knowing what to add.' We agreed that this was Paul's moment as a stylist and even though it looked to the untrained eye like he had done nothing at all... those of us in the know were in on the real deal. There had been a lot of thinking going on about adding nothing and for that he deserved a credit."
Caryn Franklin, Former i-D Co-Editor

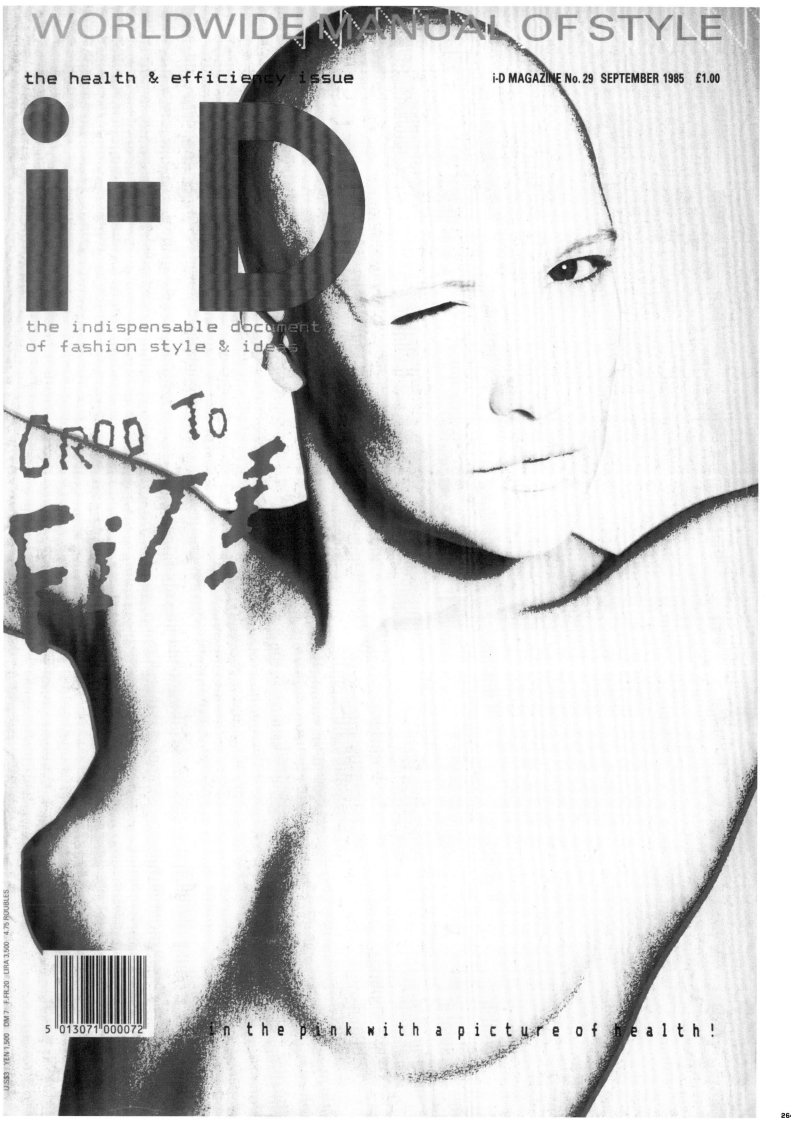

WORLDWIDE MANUAL OF STYLE

the health & efficiency issue

i-D MAGAZINE No. 29 SEPTEMBER 1985 £1.00

i-D

the indispensable document
of fashion style & ideas

CROP TO FiTi

in the pink with a picture of health!

U.S.$3 YEN 1,500 DM 7 F.FR.20 LIRA 3,500 4.75 ROUBLES

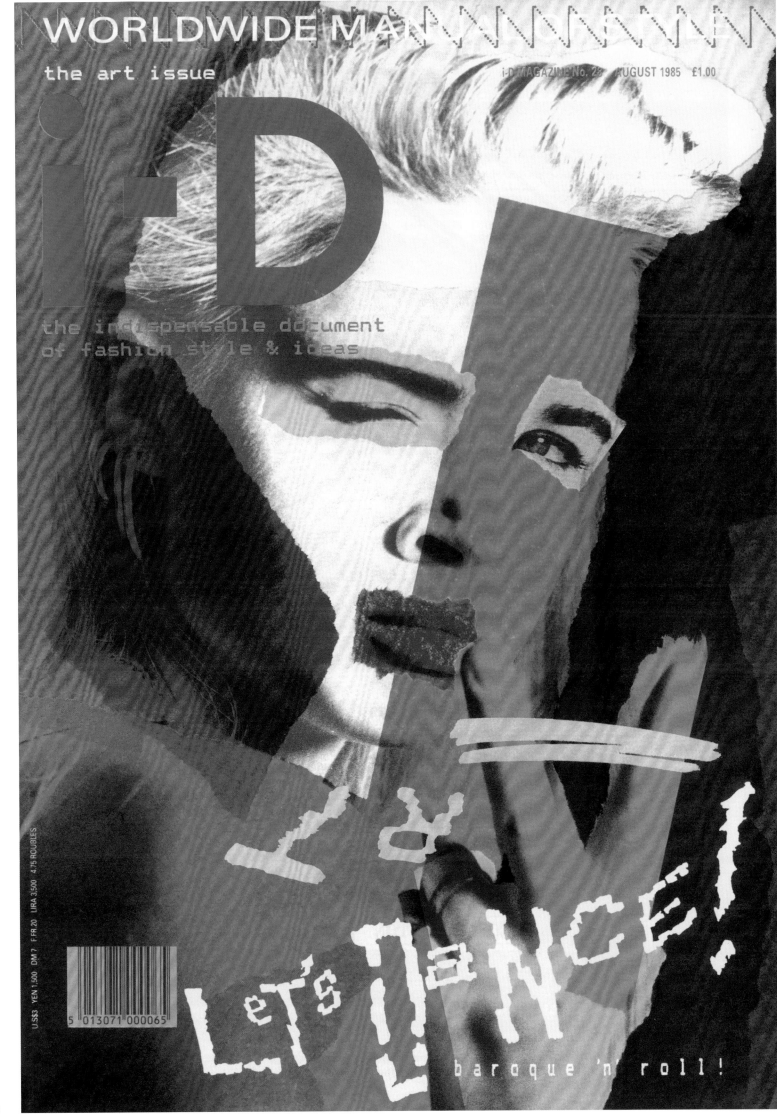

WORLDWIDE MANUFACTURE

the art issue

i-D MAGAZINE No. 28 AUGUST 1985 £1.00

i-D

the indispensable document
of fashion style & ideas

LET'S DANCE!

baroque 'n' roll!

U.S.$3 YEN 1.500 DM 7 F.FR 20 LIRA 3.500 4.75 ROUBLES

5 013071 000065

WORLDWIDE MANUAL OF STYLE

the love-in issue

i-D MAGAZINE No. 27 JULY 1985 £1.00

i·D

the indispensable document
of fashion style & ideas

KISS THIS

Street Wise And Looking Kool

U.S.$3 YEN 1,500 DM7 F.FR.20 LIRA 3,500 ROUBLES 4.75

5 013071 000058

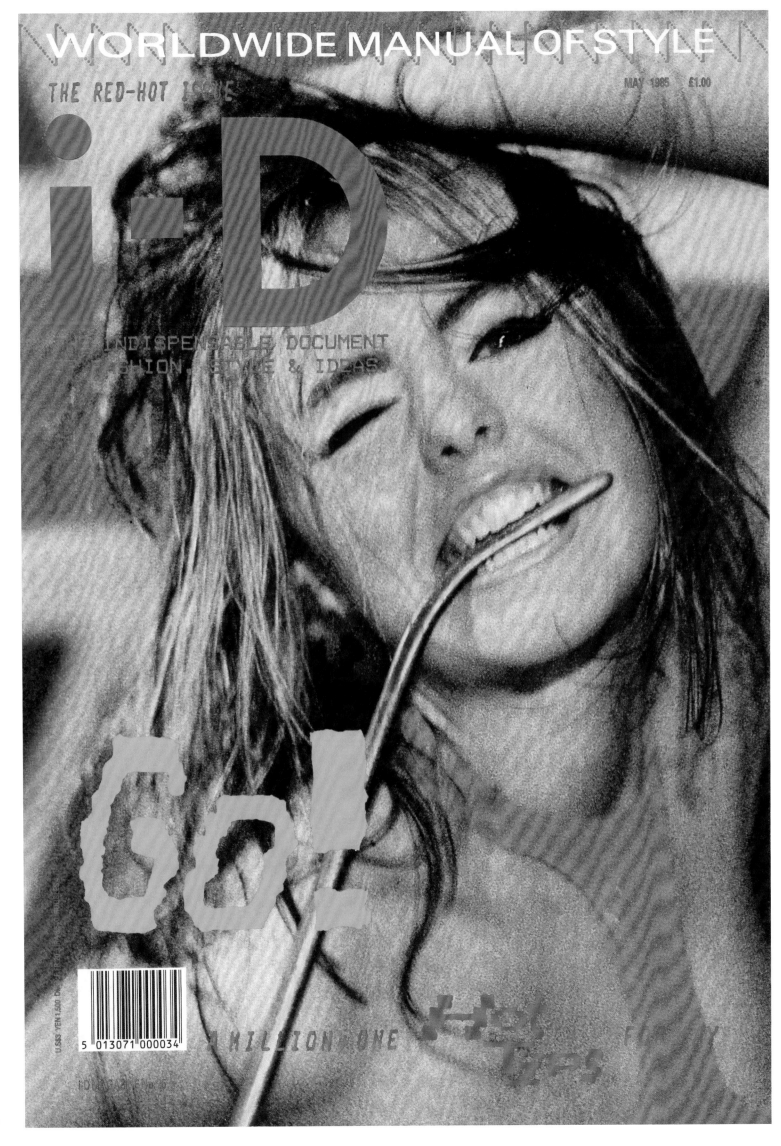

WORLDWIDE MANUAL OF STYLE

THE RED-HOT ISSUE

MAY 1985 £1.00

i-D

THE INDISPENSABLE DOCUMENT
FASHION, STYLE & IDEAS

The Cool Issue, No. 33, February 1986
"Corinne Drewery from Swing Out Sister just had such a brilliant wink and smile. For a photographer, this is the time where you really are penniless. You've got absolutely nothing to your name; no money and you're just living off your photography. For the early i-D stuff, I was living on £50 a week, which I was earning by working for the New Musical Express and photographing people like George Clinton. They'd send over these people, but I wasn't really interested in that early, black music scene coming across from America. I'd get paid by the NME to do it and you'd use the money from NME to fund a shoot for i-D, because i-D never had any money. It was really kind of hand-to-mouth. This was the world I was living in, so it's a perfectly good transcript of that."
Nick Knight, Photographer

The Cool Issue, No. 33, February 1986
"Nick Knight photographed Corinne Drewery with the perfect wink and style of the i-D logo. This was a black and white image, which we coloured up on the computer. Drewery was performing the club circuit at the time; she had not even been signed and Swing Out Sister were unknown. It was the perfect time to capture her, and really reflects our mood in the mid-eighties. This issue stood out on the stands, and marks a time that people remember. We were experimenting as we went on. We were at the early stage of using Scitex scanning, hand-manipulating the graphics on a Xerox machine. I had lost track of circulation figures by then; we were established by this time."
Terry Jones, i-D Founder

The Jetset Issue, No. 32, December/January 1985/86
"Sometimes I was allowed to go to the repro' house and mess with the colour, or add colour to the cover shot. Here we added cyan to the eye and enhanced the red in the lips. It is part of a black and white 'outer limits' travel story by Nick Knight and Simon Foxton. The bold styling of the photos, and the theme of space travel lent itself magnificently to a bit of wild and free layout by Tim, my then apprentice (another illustrator turned graphic designer). However, Nick did not appreciate our enthusiasm. For him it was the last straw and the next time he submitted a fashion story he was in charge of the layout!"
Moira Bogue, Former i-D Art Editor

The Jetset Issue, No. 32, December/January 1985/1986
"This is a girl called Kate, who just had the most beautiful face. I can't remember where I met Kate."
Nick Knight, Photographer

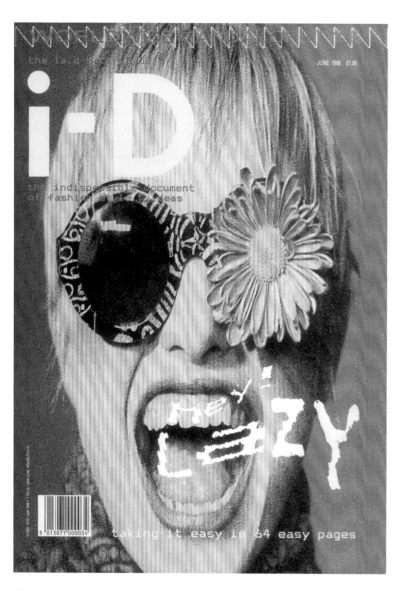

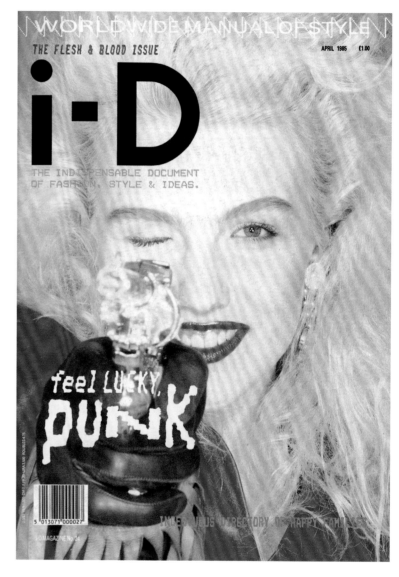

The Gourmet Issue, No. 22, February 1985
"The two girls are Helen Campbell, someone I'd been having a relationship with for quite some years and her friend, whose name I've very sadly forgotten. They both had Siouxie Sioux, jet-black hair and pale faces. I wanted to reproduce the open eye, shut eye and smile with the chain rather than their lips. We connected their noses by this chain, which kind of made a wink."
Nick Knight, Photographer

The Flesh and Blood Issue, No. 24, April 1985
"This is a girl called Katie Westbrook. She was just a great, striking blonde girl. I've got no idea where I saw her, but it would have been in the street somewhere, and I just went up to her and said, "You're amazing, do you want to...""
Nick Knight, Photographer

The Money Issue, No. 18, September 1984
"Sherron was a dancer, a fantastic girl with bright orange hair, completely full of life. Just a ball of energy that I'd met in a club. She was one of those people you meet in clubs, on the street, at concerts or wherever it was, basically anybody who you liked the look of, who you thought, "Christ! They look exciting," instead of having no reason to go and talk to them, you automatically had this reason, being a photographer and working for i-D, you'd just say, "You look fantastic. Can I photograph you?""
Nick Knight, Photographer

The Art Issue, No. 28, August 1985
Nick Knight: "This is Lizzie Tear, who again was another great girl you would see around town and want to photograph them. Did we cut that up or did we tear it up? I can't remember what we did now."
Terry Jones: "We'd overlaid all these on the computer originally. I had the black and white photograph scanned at Latent Image. They'd just got the Scitex scanner, which cost Colin Fitzgerald a fortune. He'd stretched himself to the limit to have the first or second one in London. I spent eight hours putting all of the Andy Warhol-inspired layers of colour and it was such a massive file that I got a call in the morning that [the cover] was meant to go to print and the file had corrupted. So, we had an hour to redo it, which we did with tissue paper. Moira and Tim in the art department recreated the whole thing with tissue paper, scanned it conventionally and Colin never forgave me for it. From his side, it was the most expensive cover, ever."
Nick Knight, Photographer

The Love-In Issue, No. 27, July 1985
"People don't say enough about Caroline Baker [the stylist], who knew so much. We were like kids compared to her, she had already done all these amazing things for 'Nova' and she had all that experience working with Hans Feuer with all that telephoto, long lens and back lit stuff. She is a person people do not worship enough. This is a good cover because it is so graphic and it is an uncomplicated and fun solution to how do you cover the left eye. Which is very good for neophytes. Terry was very smart because he was introducing a brand but he was giving people total freedom. If the idea of the brand is simply to have the left eye closed then everyone is being put on the same page. It's not like branding for Bazaar. There is unbelievable freedom but it's really strict. And as we were so incredibly naïve and childlike, [the i-D cover] was like a puzzle to be solved. Instead of worrying about "would it sell", "would it be a cover", we just had a puzzle to solve each time."
Robert Erdmann, Photographer

The Red Hot Issue, No. 25, May 1985
"I don't know how she ended up with a poker in her mouth. I don't know who thought that one up, but somehow she ended up with a poker in her mouth. Maybe because it was, The Red Hot Issue. That was quite handy because Patsy and I went on to have quite a reasonable working relationship for a short period in time."
Mark Lebon, Photographer

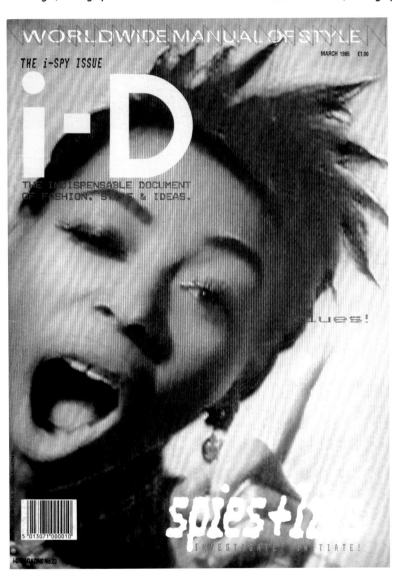

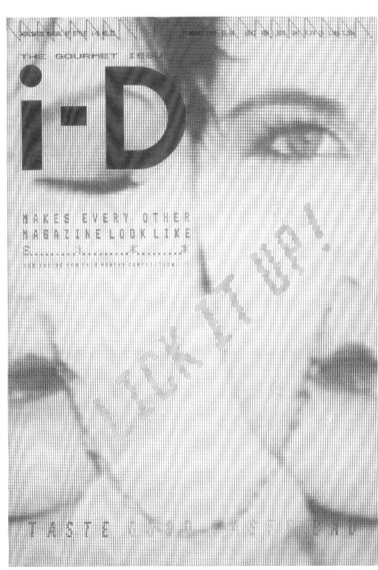

The Inside Out Issue, No. 19, October 1984
"Anna Pigalle was a singer, another club girl, who used to go out with Alex McDowell, who I believe is one of the three people, with Terry, who started i-D magazine: there was Terry, Perry and Al. We shot that, which was heavily influence by Paolo Roversi, and his colour gels."
Nick Knight, Photographer

The All Star Issue, No. 14, April 1983
"The Sade issue was the first issue I worked on when I arrived at i-D in late 1983. The issue was a turning point for i-D, because not only was it portrait and not landscape, but it was an image of someone who was escaping the London club scene. This was not only Sade's attempt at going for the big time, it was i-D's too. This was Sade's first ever cover, at least six months before The Face, and I loved it because it looked like a Fiorucci ad. I'd just come back from two weeks in Japan with ex-Blitz kid Stephen Linard, and remember encouraging him to have his picture taken with his pink ghetto blaster – the one that caused such consternation when we spent three hours on a stopover at Moscow airport. At that time everyone I knew ended up in the magazine..."
Dylan Jones, Former i-D Editor

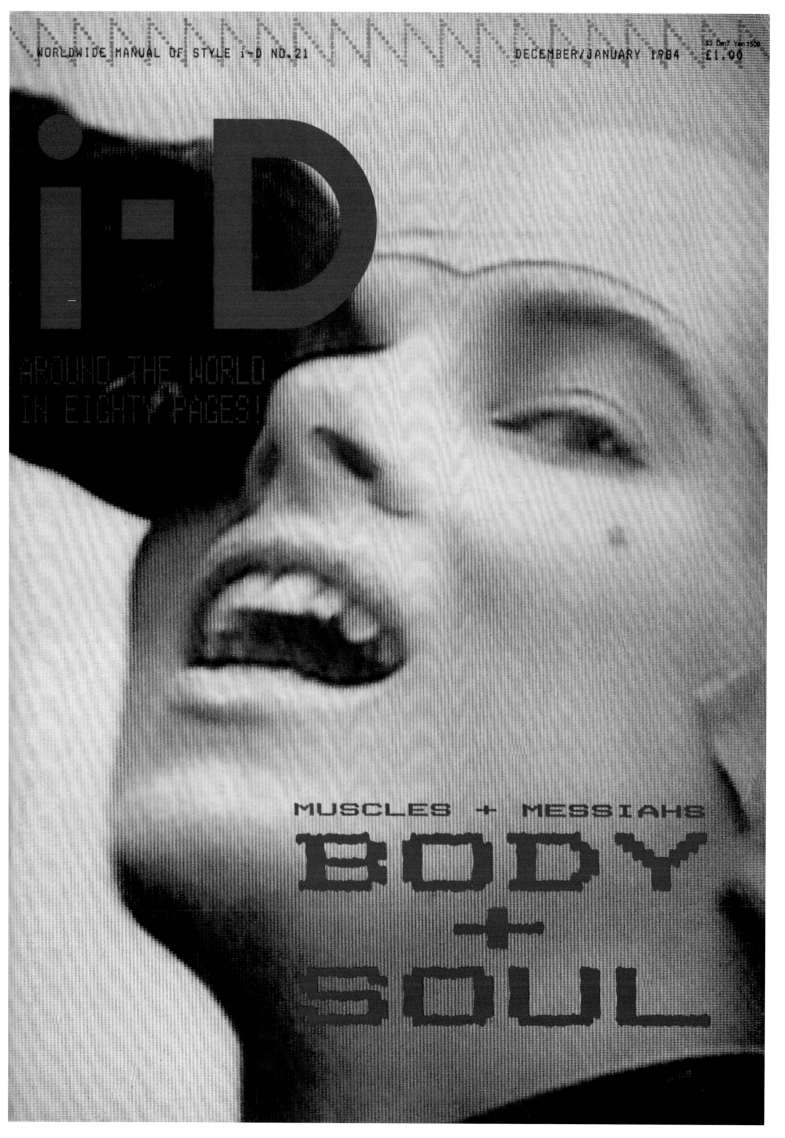

i-D

AROUND THE WORLD
IN EIGHTY PAGES!

MUSCLES + MESSIAHS

BODY
+
SOUL

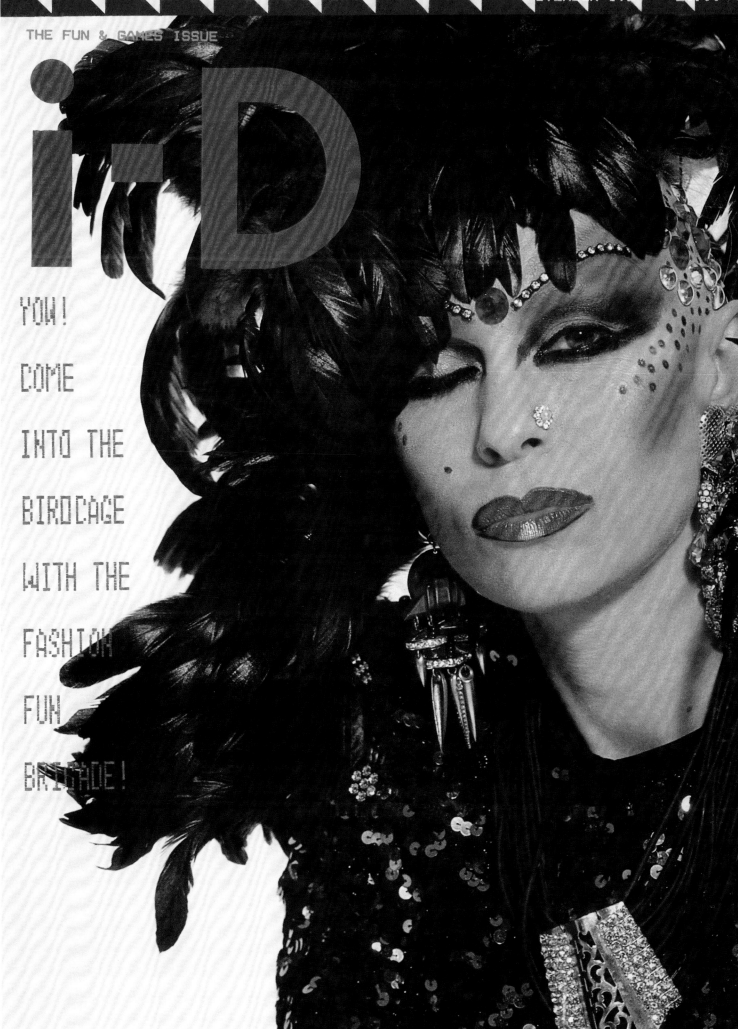

WORLDWIDE MANUAL OF STYLE i-D NO.20 NOVEMBER 1984 £1.00

THE FUN & GAMES ISSUE

i-D

YOU!
COME
INTO THE
BIRDCAGE
WITH THE
FASHION
FUN
BRIGADE!

The Language Issue, No. 17, July/August 1984
"This was very important shoot for me, not only were the pictures inside all about challenges with loads of pages all with different stylists and people, but the challenge of the cover was about co-ordinating the release of a pop song with a record cover, my brother James' new, and amazingly awful, one and only rap single called Sexify You, which promoted himself as a hair dresser. The deal was that Jo Kelly was the girl in the video and for me it was about actually being able to have a cover girl in a pop promo and I actually managed to pull it off. The [cover and single] both came out at the same time, sadly it didn't help James' singing career. His tonality was definitely challenging, bless his soul, I think it was the only cover we ever shot together."
Jo Kelly, Cover Star

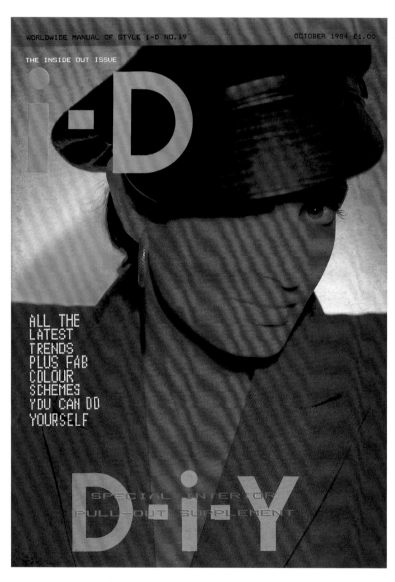

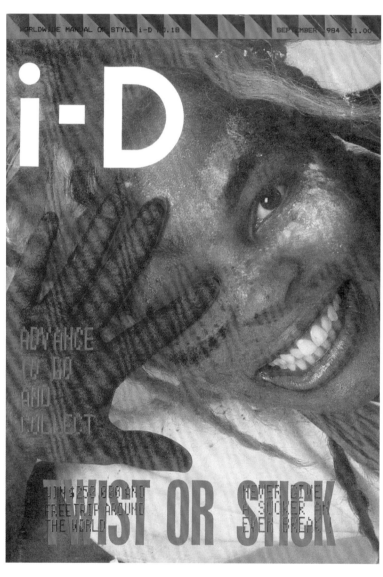

The All Star Issue, No. 14, April 1983
"The Sade issue was the first issue I worked on when I arrived at i-D in late 1983. The issue was a turning point for i-D, because not only was it portrait and not landscape, but it was an image of someone who was escaping the London club scene. This was not only Sade's attempt at going for the big time, it was i-D's too. This was Sade's first ever cover, at least six months before 'The Face', and I loved it because it looked like a Fiorucci ad. I'd just come back from two weeks in Japan with ex-Blitz kid Stephen Linard, and remember encouraging him to have his picture taken with his pink ghetto blaster – the one that caused such consternation when we spent three hours on a stopover at Moscow airport. At that time everyone I knew ended up in the magazine..."
Dylan Jones, Former i-D Editor

The All Star Issue, No. 14, April 1983
"That cover was shot in a photographic studio at the end of Sherriff Road. Which is where Terry lived and where the i-D offices were. Sade came down to have her photograph taken, so we took lots of photographs of Sade, who was absolutely beautiful and completely charming as a persona. I've remained in love with her ever since. The one thing that I didn't know, and hadn't realised, was that i-D is a wink all the way through and nobody had told me, or Sade, for that matter, that she had to wink. What Terry did in the end was chose one photograph, where she blinked by mistake and shut both eyes and then he composited it in, in a kind of police photo-fit kind of way with one shut eye and one open eye, nose and mouth."
Nick Knight, Photographer

The Out Already Issue, No. 10, December 1982
"The wink and smile really worked as we forced the wink with a squirt in the eye. Moira Bogue, on the cover, was our Art Editor. It was all about declassification. We were still not accepted by the news trade at this point because of our landscape format. Our circulation increased to about 15,000, and we had a lot of support from Virgin, who were selling the magazine, but we were running up debts. My house was filled with boxes containing the magazine. But i-D was known worldwide; people from the US, Japan, and Italy were buying it, primarily through fashion stores. You were on the global guest-list if you knew about i-D as we were doing world tours and i-D nights."
Terry Jones, i-D Founder

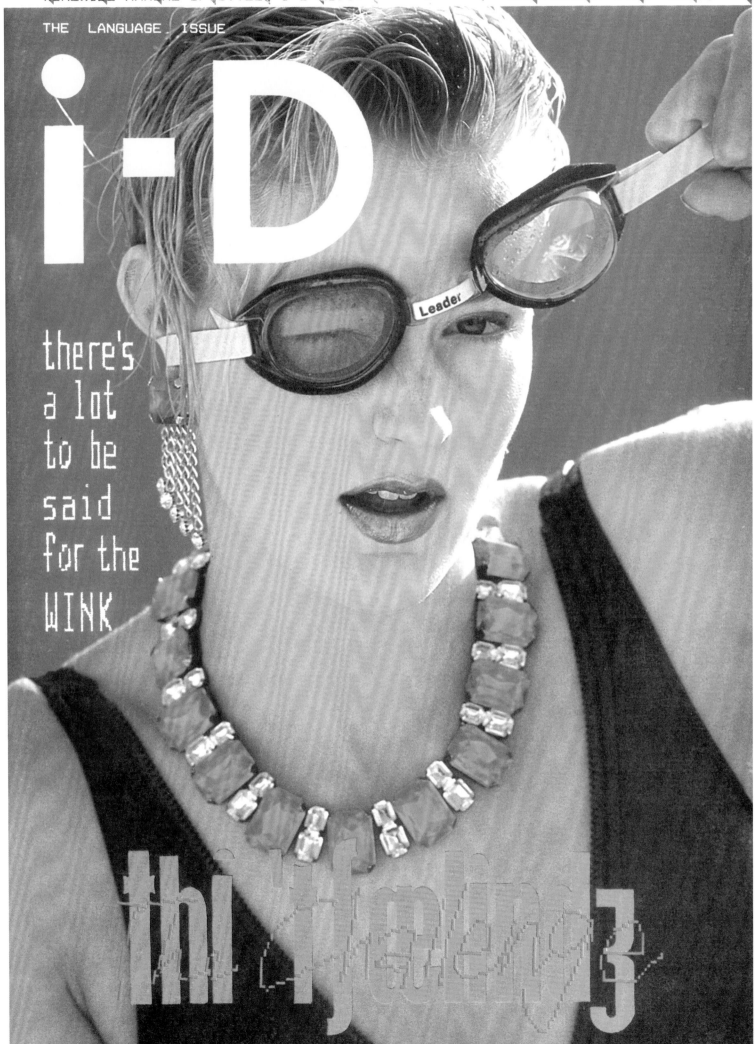

THE LANGUAGE ISSUE

i-D

there's
a lot
to be
said
for the
WINK

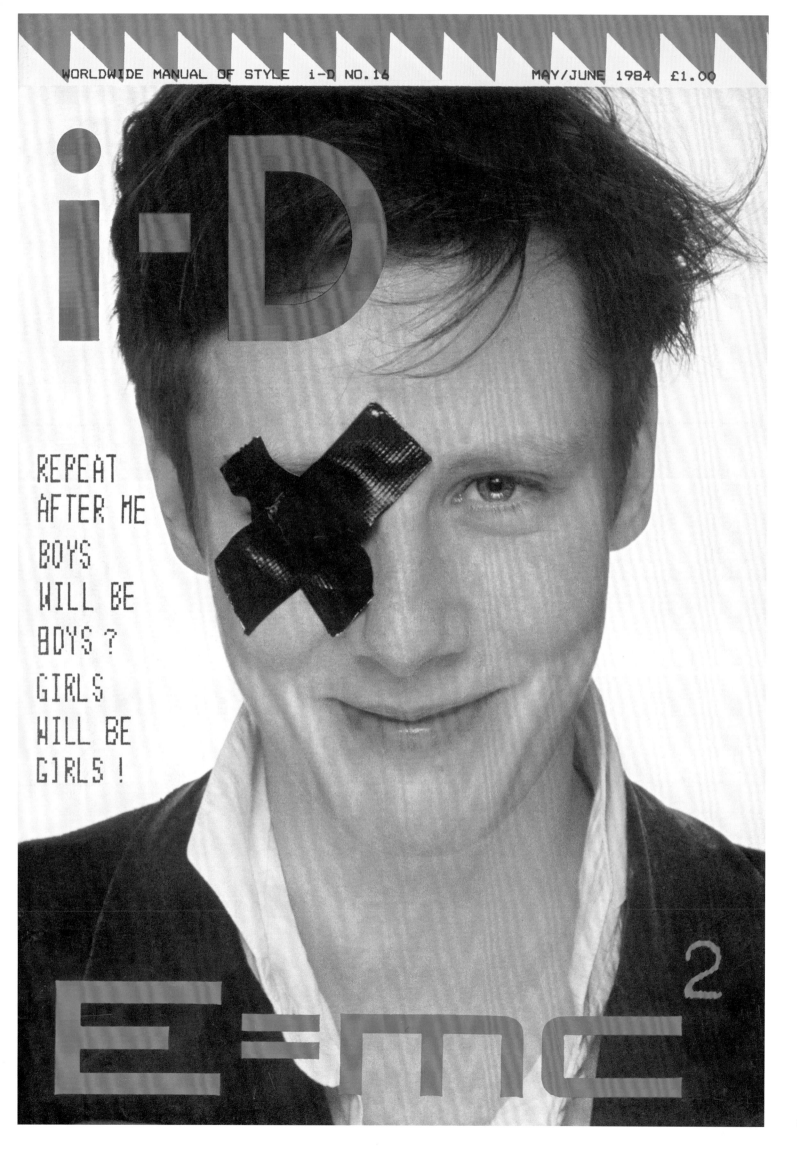

i-D

REPEAT
AFTER ME
BOYS
WILL BE
BOYS ?
GIRLS
WILL BE
GIRLS !

$E=mc^2$

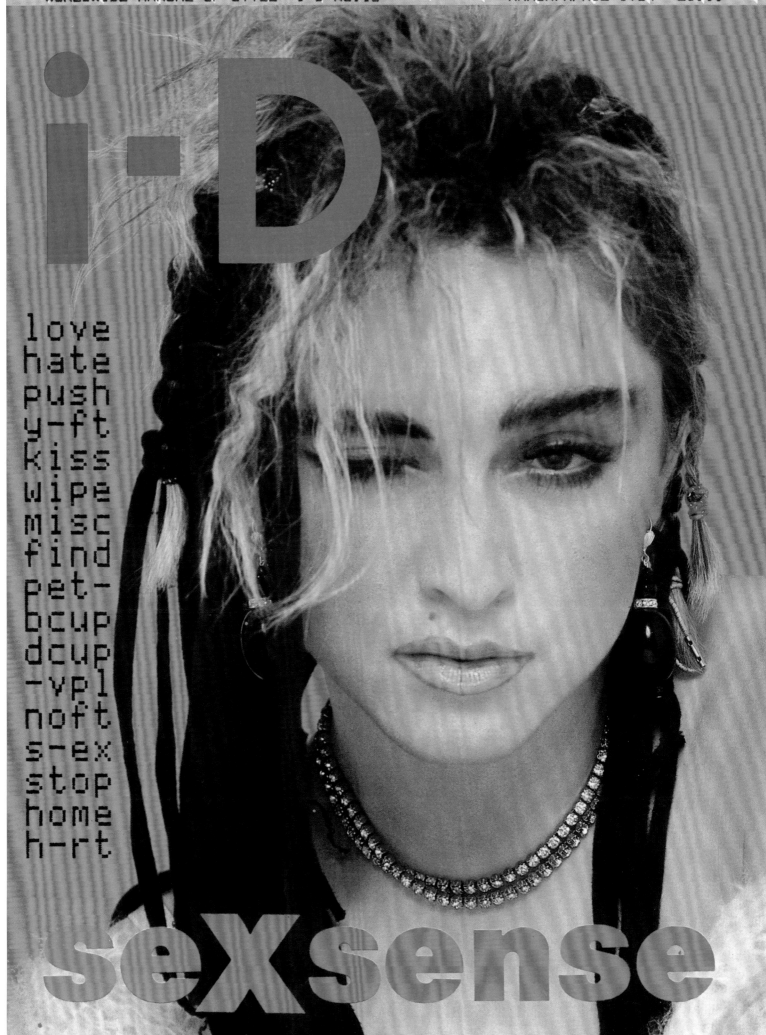

i-D

love
hate
push
y-ft
kiss
wipe
misc
find
pet-
bcup
dcup
-vpl
noft
s-ex
stop
home
h-rt

sexsense

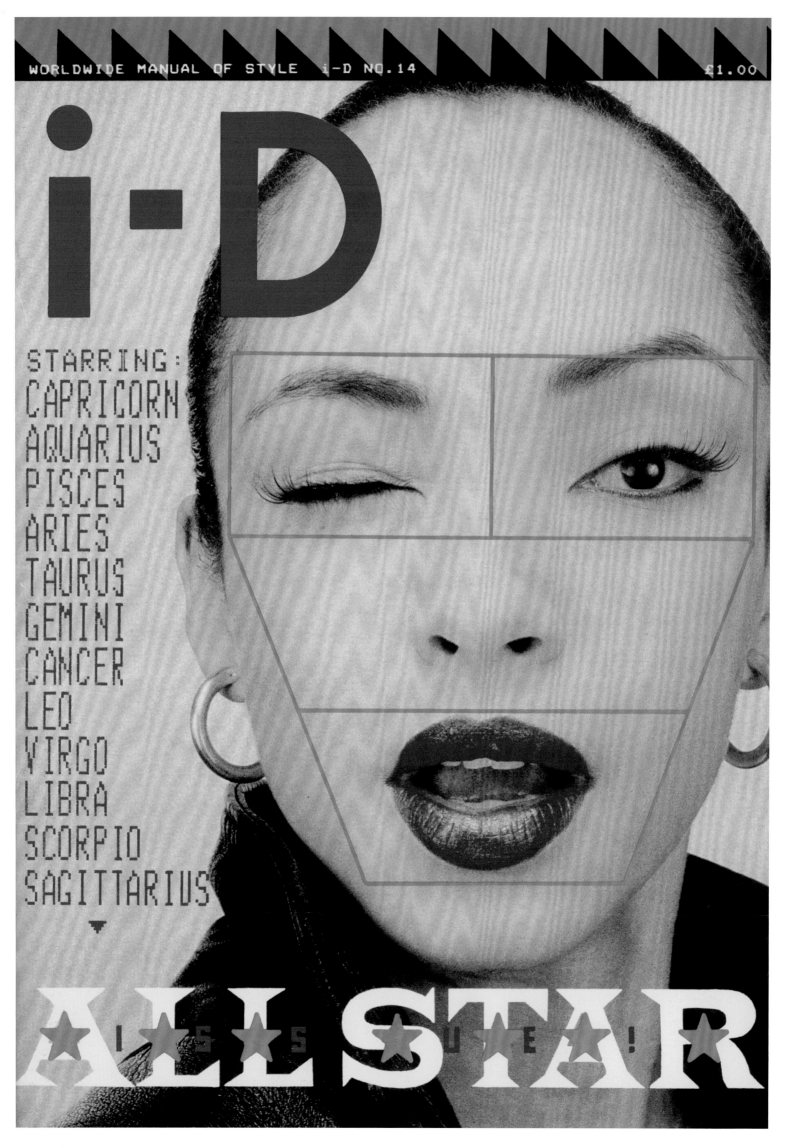

i-D

STARRING:
CAPRICORN
AQUARIUS
PISCES
ARIES
TAURUS
GEMINI
CANCER
LEO
VIRGO
LIBRA
SCORPIO
SAGITTARIUS

ALLSTAR

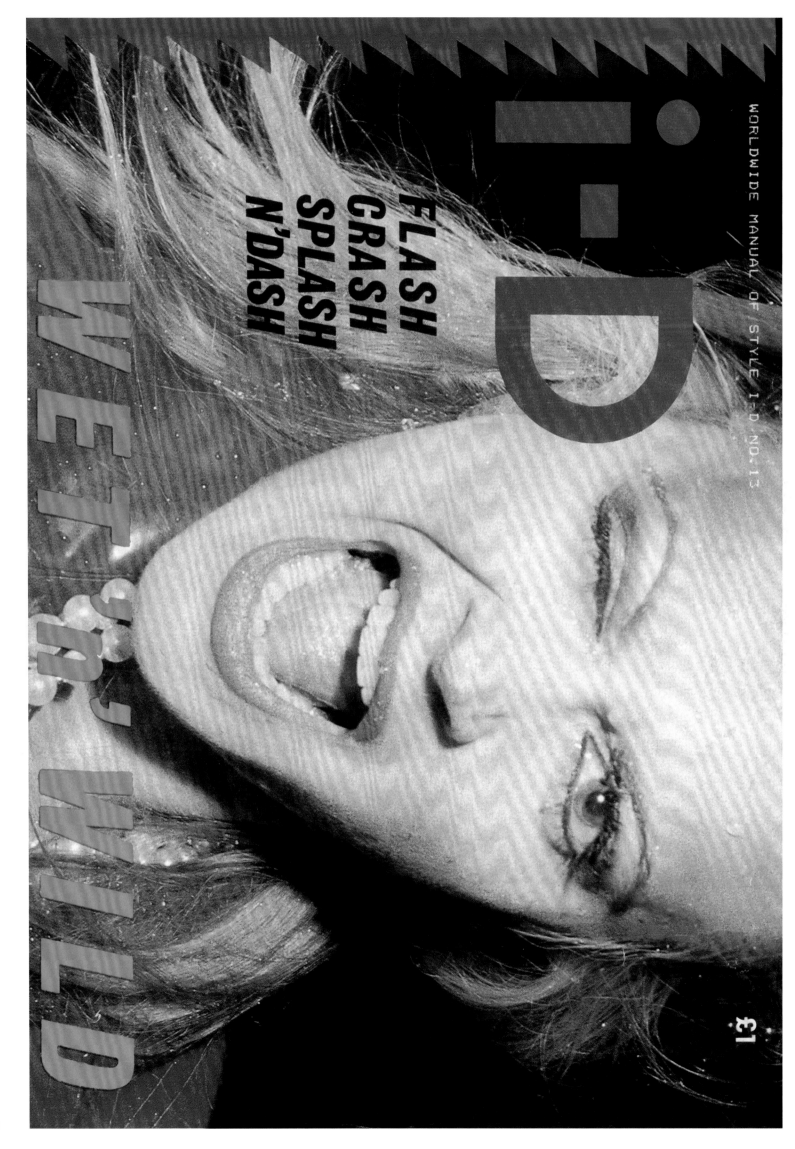

i-D

WORLDWIDE MANUAL OF STYLE i-D NO.13

FLASH
CRASH
SPLASH
N'DASH

WET 'R WILD

£1

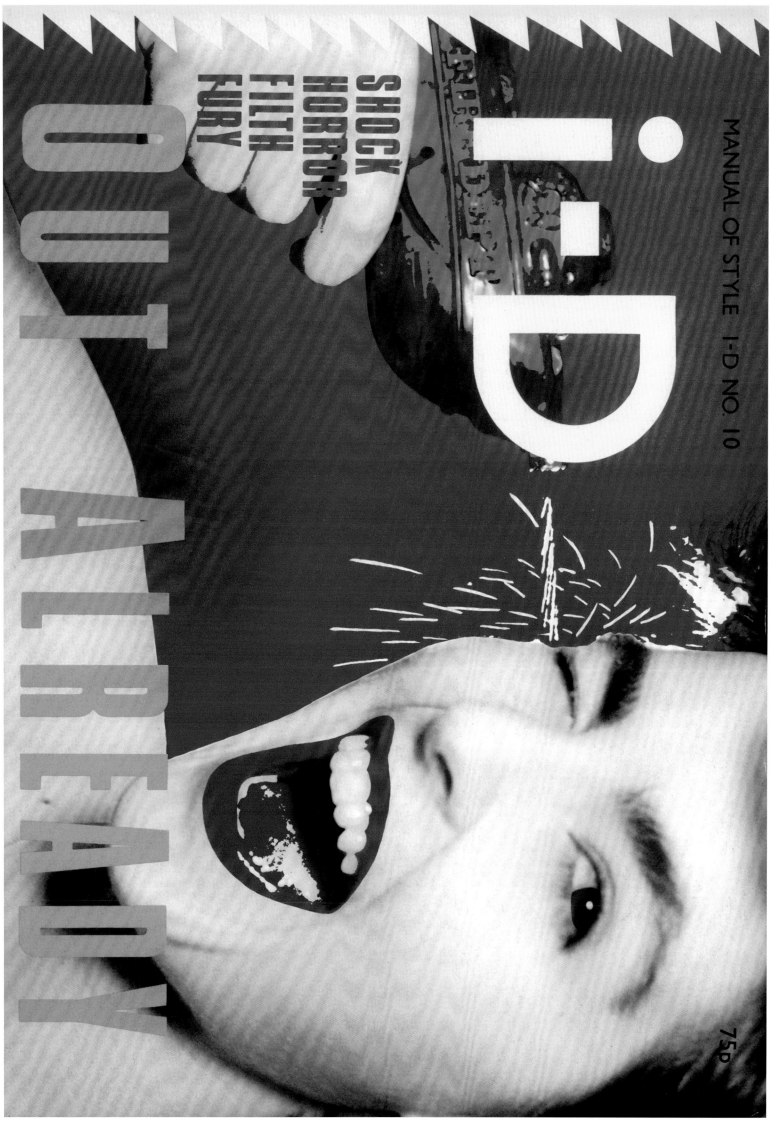

i-D

SHOCK
HORROR
FILTH
FURY

OUT ALREADY

75p

i-D

POWER
CRIME
SPORT
ETC
ETC...
PLUS+

WULI DANCING

75p

Terry Jones in conversation with Scarlett

Terry: Your first cover [The Head to Toe Issue, No. 8, October 1982] is Nick Knight's favourite cover.

Scarlett: It's a lot of people's favourite cover. Good old Thomas Degen. I'm not often gob-smacked but I really am to look at this cover again after all these years.

You did a good wink.

I know. How fabulous is that? No lines, not a wrinkle in sight, unlike now. When was that photo taken? It must be 1982.

1982/1983... You were working at Antenna, the hair salon on Kensington Church Street at the time.

I was only there a short while. My memory is appalling. I think I was still running Cha Cha at the time. I first appeared in issue two of i-D in a picture in Kensington Market with Helen Carey – how funny! And then there must have been other bits and pieces, but this cover was the fabulous one.

What did you do after Cha Cha's?

Cha Cha closed down, so Michael and I looked for another club and eventually took over the upstairs bar at Ronnie Scott's. It was only for a short period of time, short but fun, though much more low key. Cha Cha just became too big a thing. Me, Judy Blame and Michael started it for a laugh, so we had somewhere to go. Judy used to say, "It'll be fun, we'll just lounge around on sofas and drink vodka," in that fabulous Judy Blame way. But then he ran off with the coat check money – that's quite a famous story – and took over the bar at Heaven. So Michael and I carried on Cha Cha on our own. All these people went there but it wasn't a big thing for us, it was just our life. We were having fun like so many other people. I remember in those days you could go to a different club every night run by somebody you knew or run by somebody who knew somebody that you knew. If you were eighteen or nineteen, life was just a big old social whirl.

You had a great wardrobe.

I had a great wardrobe but none of it cost any money. Jumble sales were fabulous in those days, as were second-hand shops. You could pick something up for 20–50 pence. If it was a pound it was expensive but you'd just pin it on, belt it, do something bonkers. Everyone we knew made clothes, so we all swapped. I was hairdressing at the time, hairdressing and doing the club.

Who did your hair for the cover?

Ross Cannon did my hair, the most brilliant hairdresser of the time. Ross was really the star of Antenna, despite Simon Forbes taking all the glory. When Ross left Antenna he opened a salon in Kensington Market.

Who did your braids?

Simon did those...

Simon also did the hair for the Madonna cover [The Sexsense Issue, No. 15, May 1984].

Did he? I remember Jeremy Healy and Kate were doing Hazy Fantazy at the time and they'd both just dreaded their hair. Nobody had seen such a thing in their life before and I remember Simon, telling me to, 'Pump Jeremy for information about how they do their hair' and I told Jeremy about what Simon had said and we laughed. But, we were long gone by then, long gone.

After then Mark Lebon shot you for the cover of The Madness Issue [No. 34, March 1986]...

Yes, Ross was still doing my hair at that point. Ross was responsible for all the bizarre wigs we used for that shoot, all the funny flowers, autumn based make-up and cardboard eyes. I can't remember what my hair was like at the time. It probably had some little number going on. It was never just plain shaved; there was always some story, buildings or an installation shaved in the side. For the cover I was wearing a beret and a cardboard eye. The wink was the cardboard eye. I like that cover.

It's Mark's favourite i-D cover.

I like it a lot. I like it because people don't know it's me.

So, your club days are long finished then?

Long, long finished. We did a few warehouse parties back in 1985/86, maybe even 1988, I can't remember. And I did a little stint in the bar upstairs at Heaven, but I was bored of it all by then. Also I was drinking and that really wasn't doing me any favours. I haven't had a drink for twelve years now. So yes, I'd had enough of clubbing. I didn't start it as a career or to make money, I started it to have fun and when it wasn't fun anymore there wasn't much point doing it.

Was Heaven the last club you worked at?

Yes, I finished in 1988. The bizarre thing about it was I was working at Heaven on a Thursday night and I was also gardening three days a week for my first gardening job. I was living this complete double life, and everybody thought I was completely bonkers except for the British artist Donald Urquhart. He really encouraged me to take the gardening job. He said, "You love it and need a change. Go and do gardening."

So, you did?

I was working at this charity called Macro that did the gardens for elderly folk in Camden. We'd tend and maintain, they just wanted a cup of tea and a bit of a chat. So it was really a delightful job to have. After that I worked for Camden Council. I was based in Waterlow Park and I thought how fabulous, but of course it was 1988 and Waterlow Park wasn't great at all. I was one woman among twenty-three men and it was absolute sexist crap. I spent most of my time picking dog shit up off the roundabouts, cutting grass on the verges of council estates, picking syringes out of hedges and working with men who called me, 'The Girl'. Three months into the job I said to them, "How rude you all are. I've learnt all twenty-three of your names and you can't learn mine." I stuck at it for six months more then I left. It

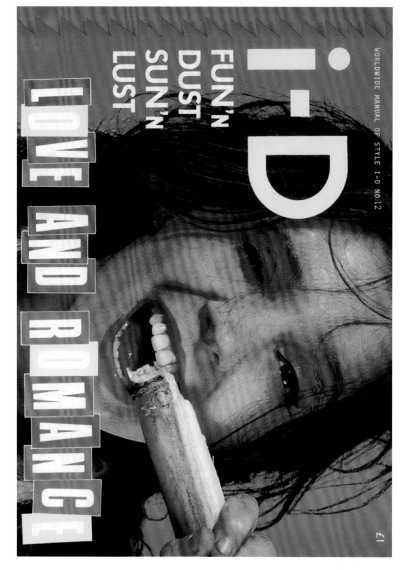

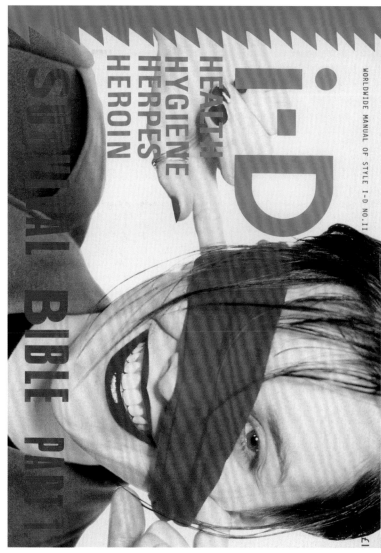

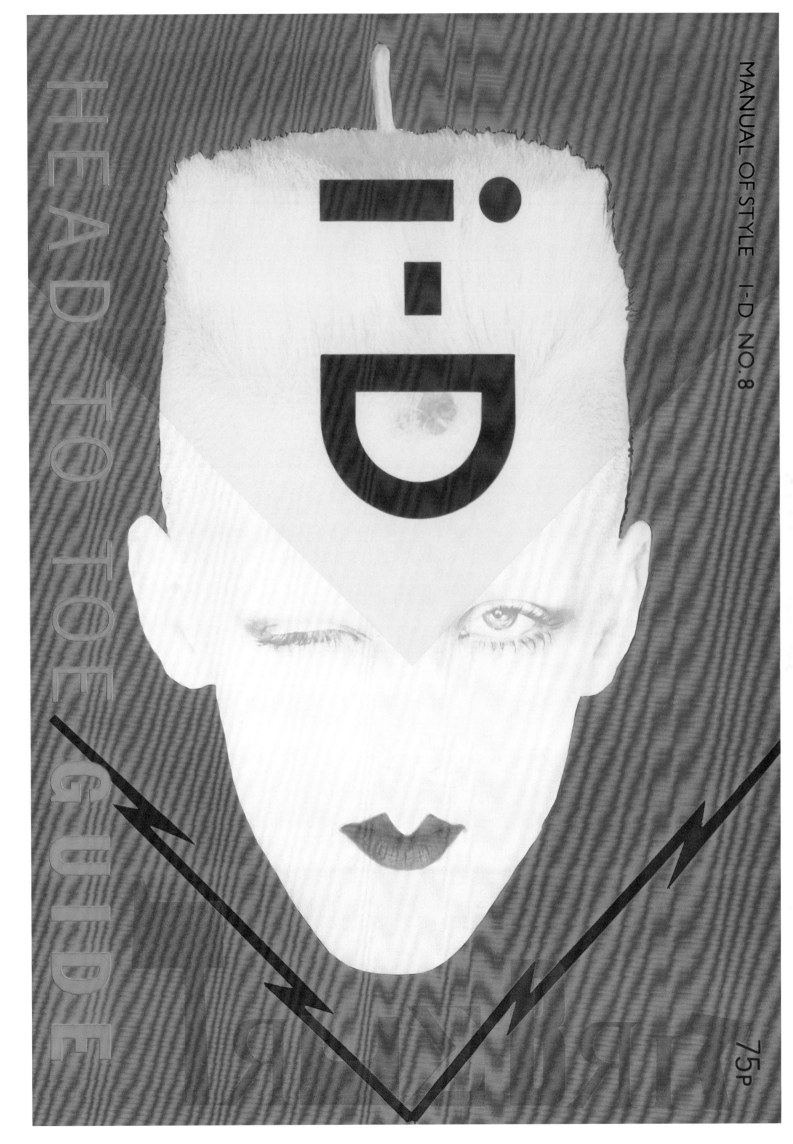

i:D

HEAD TO TOE GUIDE

75P

ruined my enjoyment of gardening, which I didn't want it to do. So I put my name down for an allotment. I was already growing vegetables in the tiny back garden of my tiny flat. I was doing square foot gardening, although I didn't know that was what it was called at the time. I put my name down for the allotment in 1988 and in 1997 I finally got it. I've had it ever since. So all the veg moved from my back garden up there and life has been marvellous ever since.

Gardening is the new fashion.
I'm doing community gardening now because I hurt my arms and I don't have the strength to be a gardener. I can't hold shears and I have to be careful with the wheelbarrow. But I know that gardening is healing and I am a healer.

What healing do you do?
I'm a qualified Reiki healer. I did have a little practice going but when I wasn't very well, I stopped.

Where did you learn?
I learnt privately. Alan Billington, who was one of my club friends from the 80s, taught me. I bumped into him after many years and he'd become a Reiki master. I was always interested in Reiki. I'd had some very strong healing in 1995 when I was in a real crisis and I knew it was brilliant. I

The Love and Romance Issue, No. 12, February 1983
"I found Sophie whilst shooting a group called the Sex Beatles for the 11th issue of i-D. The cover photo was done in a studio. To get a photo of Sophie winking, chewing on a stick of sugar cane and smiling was quite a challenge. As far as I remember, Sophie did her own make-up and hair. As usual, the individual I was photographing was also the stylist."
James Palmer, Photographer

The Health and Herpes Issue, No. 11, January 1983
"When I was forming The Smiths I worked in a shop called X Clothes, which was the first store in Manchester to sell i-D. I remember one cover really impressed my friends, and me because the girl in the picture looked so cool. Around the same time I became friends with Matt Johnson from The The and he offered to let me stay at his place in London if ever I needed it. When I went to London to try and get The Smiths a deal on Rough Trade I turned up at Matt's place and was amazed that the girl who opened the door (Matt's girlfriend) was the girl on the i-D cover. Fiona and I have since travelled the world on buses and planes, shared sofas, apartments and lives. She is Godmother to one of my children and is still one of my closest friends. Weird what a picture can do."
Johnny Marr, Musician and Guitarist of The Smiths

studied with him very intensely for a long period. It wasn't one of those 'go and learn it' in a weekend things. I did my qualifications in 2000 and then I treated friends and did little bits here and there and I always enjoyed it. I guess after I'd hurt my arms I thought this is the opportunity to put into practice what I'd learnt and start my own practice. Then I got unwell, so I stopped. Now is the time to start again, because now is a time of new beginnings. I'm doing community gardening, which is brilliant. And I'm specialising in food growing, which is my thing. So twenty years later, after all those people thought I was bonkers, I'm suddenly in this very 'fashionable' field and I know my subject very well.

What's your wardrobe like today?
Well, it's very mixed, because of course I have the gardening clothes and then I have the home clothes and the going out clothes, but I don't go out so much now...

You still look great.
Thank you. I try to. I always get told I look glamorous on the allotment and I think, 'Bless you' because I'm in my gardening clothes, but you've got to keep up a standard. You've got to have your lipstick on and you've got to wear your nice wellies, and a pair of gloves that match the wellies. You've got to have a little bit of style even when you're gardening.

The Head to Toe Issue, No. 8, October 1982
"Scarlett O'Horror was working as a hairdresser at Antenna on Kensington Church Street. She was also well known on the London nightlife scene at the time. I photographed her in various looks in the 80s and did a short horror movie and music video with her. When she came to visit me in Munich in 1980, she and her style caused crowds to gather and stare at her. 25 years on and I met her in London in 2007. Now she is Scarlett the heavenly healer."
Thomas Degen, Photographer

The In Future Issue, No. 7, September 1982
"I found Kate at Kensington Market, I think. There is a full-length portrait of her in the content of the issue, on page 23. The cover photo was done in the back garden of the i-D house and fair bit of improvisation was required."
James Palmer, Photographer

The Sweat is Best Issue, No. 6, August 1981
"The Japanese girl used to work at Mifune, the first Japanese restaurant in Munich. It was a free make-up job by my friend Rupi Sinds, who was experimenting with tribal make-up at that time."
Thomas Degen, Photographer

The Out Already Issue, No. 10, December 1982
"Steve Johnston took this picture one afternoon when we had the studio to ourselves. We made a makeshift backdrop to lean against the photocopier (did we even have a photocopier?!), in a tiny space of about 4' x 4'. We had to crouch down so as not to spray water all over the artwork boards. I put on some eyeliner and bright red lipstick, filled the water pistol and squirted my winking eye madly while Steve took a few shots. I vaguely recollect being under the impression that the water pistol shot was just a test run, so when Terry told me he was actually going to use it I wasn't sure whether to be pleased or dismayed!"
Moira Bogue, Cover Star and Former i-D Art Editor

The Wuli Dancing Issue, No. 9, November 1982
"I can't remember why we ended up using a 1950s picture postcard for this cover... Perhaps Terry just came across the image of a girl winking and thought it would work nicely. Over the years my Mum has convinced herself that it's me on the cover and now my kids also try to persuade me she is right ... but it's not true!"
Moira Bogue, Former i-D Art Editor

The Head to Toe Issue, No. 8, October 1982
"The Head to Toe Issue was great to work on. Terry wanted a 'True Brit' theme and his ideas translated with ease onto the designed page, representing historical and global influences on fashion and culture with layers of wallpaper torn away to reveal historic imagery. I was so excited by the end result. Ideas, words, images and design were really beginning to synchronise. Scarlett was the perfect 'True Brit' cover girl; a symbol of individual self-expression and a face that was hard and soft, male and female, tribal and universal. A beauty not dictated by a dreamlike fantasy of glamour but by a gutsy, street-level urbanism – truly eccentric and eclectic."
Moira Bogue, Former i-D Art Editor

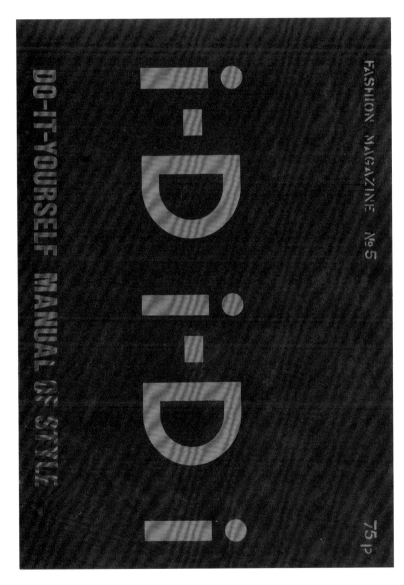

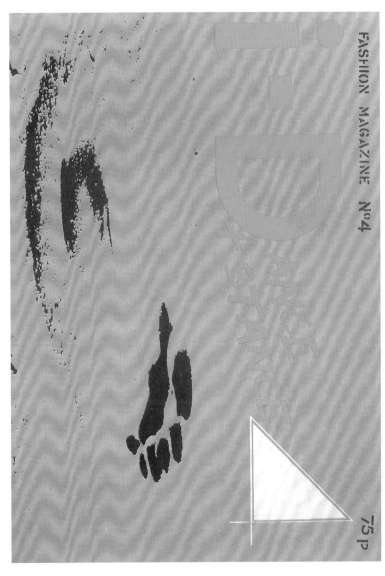

The Out Already Issue, No. 10, December 1982
"Moira worked at i-D and was great at winking. Steve Johnson our resident photographer (who regularly picked up the phone with the word's 'i-D hand built by butchers,' he hated having his pictures cut) had photographed Moira with a water pistol. We all decided the image was a bit fresh faced and it needed some punch. Someone had a tabloid paper and we decided to steal their front page 'SHOCK HORROR FILTH AND FURY,' for ourselves."
Caryn Franklin, Former i-D Co-Editor

The i-Deye Issue, No. 3, January 1981
"For me this issue was all about The Scars, a great young Scottish band that for a few minutes were competing with U2. We did a gold flexi-disc inside – which was very forward thinking at the time – and a misguided fashion shoot with the band. I still regret that this was my last issue as Co-Editor of i-D. After this cover I left to focus on my graphics venture, Rocking Russian Design. But working in the attic at Terry's house was the best, it felt as though you were watching history in the making."
Alex McDowell, Former i-D Co-Editor, RDI, Production Designer, Immersive Designer, Producer

The Star Issue, No. 2, November 1980
"Scrubber, the girl on the back cover, worked at the place where i-D was printed at the time. I liked her statement in the like/dislike section. She said, 'I don't like hitchhiking in the rain, because it ruins my hairdo.'"
Thomas Degen, Photographer

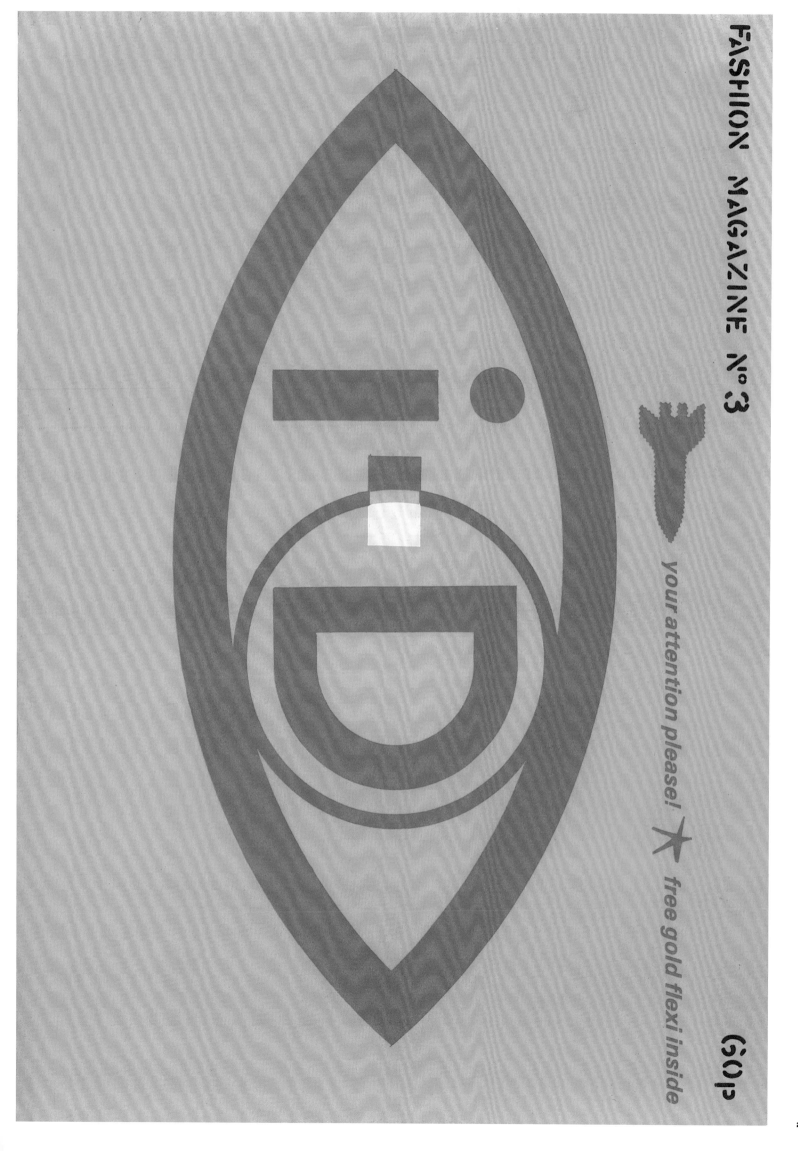

your attention please!

free gold flexi inside

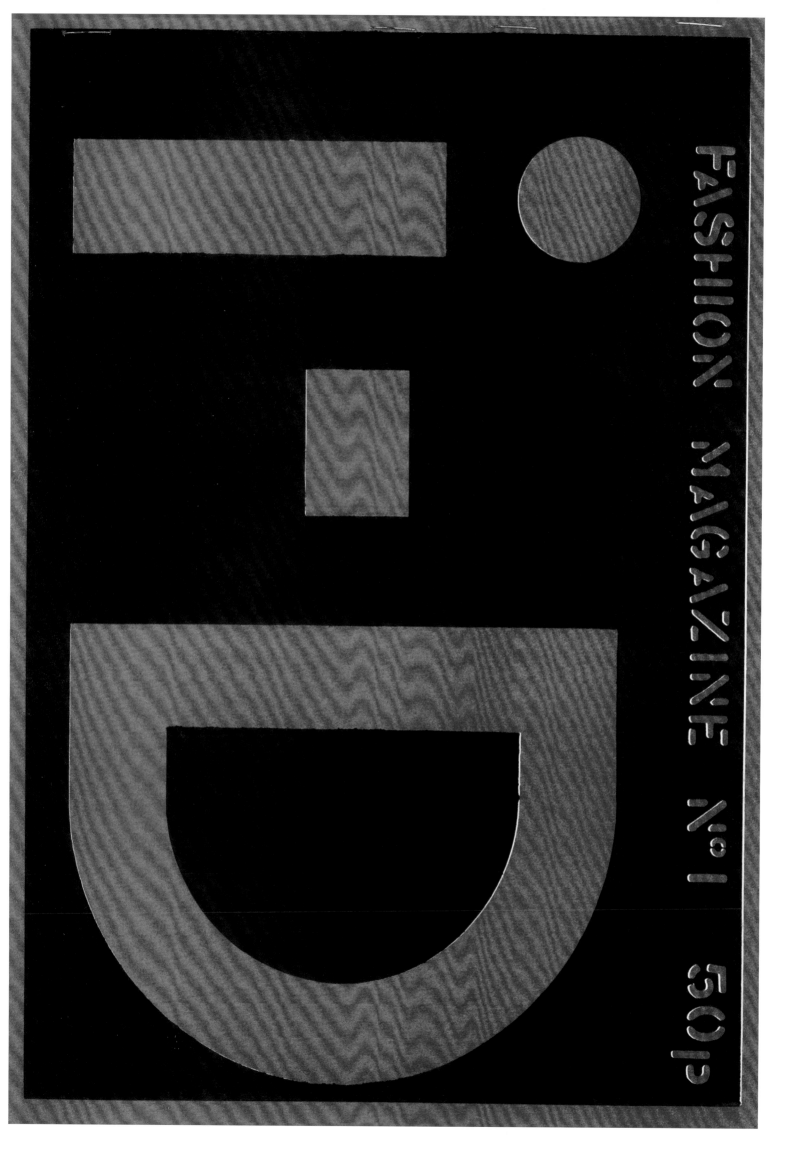

The One Issue, No. 1, August 1980

"It was iconic, a wink and a smile before people knew why we were doing a wink and smile; a graphic face rather than a human face. It was a response to the formality of magazines at the time, reflecting the anti-culture vibe of punk and the beginning of the New Romantics in the eighties. This was a two-colour cover made from a printed silk screen, stapled together. WH Smith refused to rack it because they said that the staples were a health hazard. We distributed the copies a print run of 2000, out of the back of our car, and through various kiosks and music outlets. We put it together in my house, by hand. Nothing was type-set, it was all glued down from the type writer. No one had seen anything like it before."

Terry Jones, i-D Founder

ST
I-D

DIESEL®
FOR SUCCESSFUL LIVING

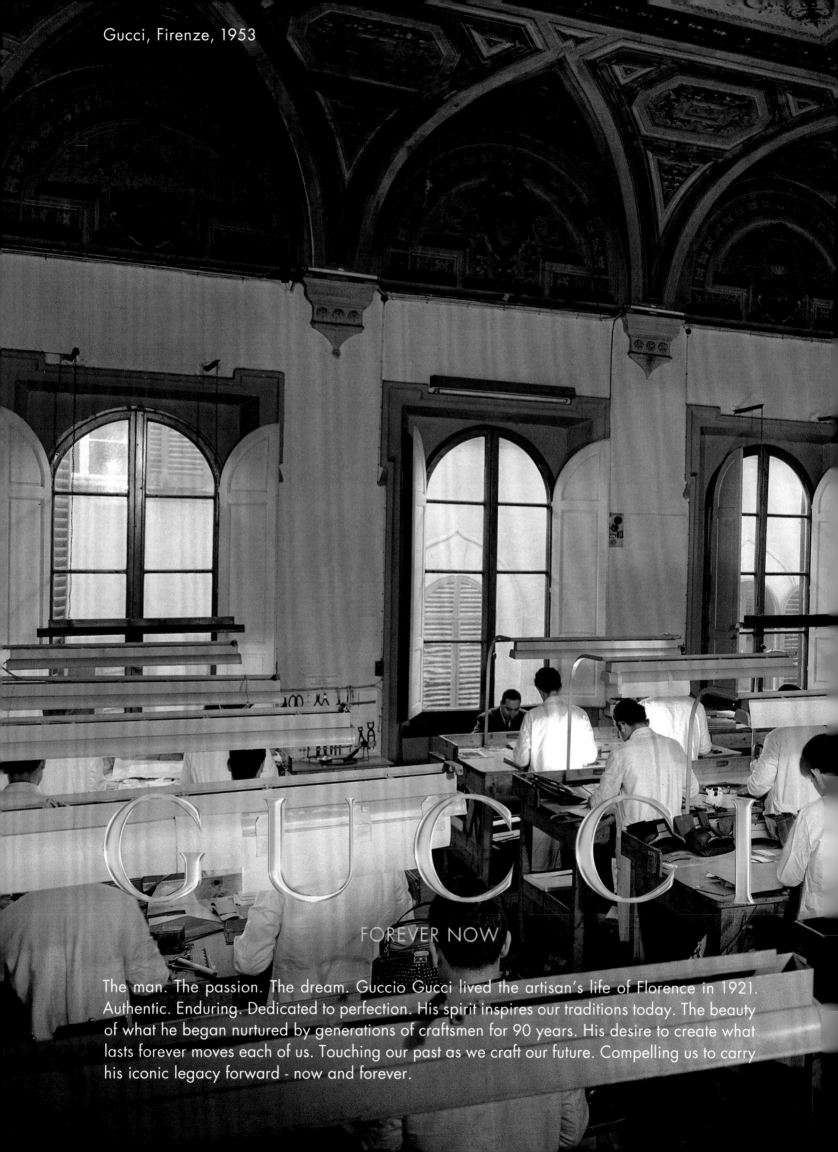

Gucci, Firenze, 1953

GUCCI

FOREVER NOW

The man. The passion. The dream. Guccio Gucci lived the artisan's life of Florence in 1921. Authentic. Enduring. Dedicated to perfection. His spirit inspires our traditions today. The beauty of what he began nurtured by generations of craftsmen for 90 years. His desire to create what lasts forever moves each of us. Touching our past as we craft our future. Compelling us to carry his iconic legacy forward - now and forever.

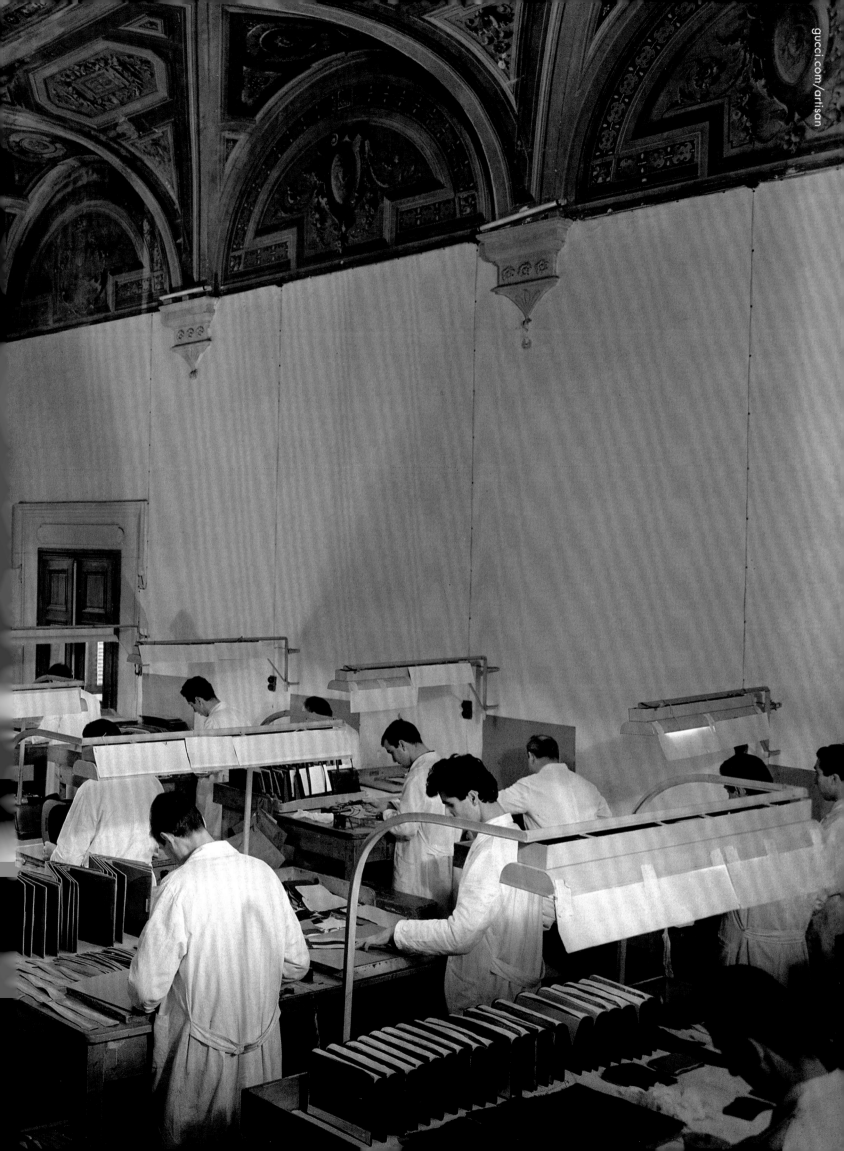

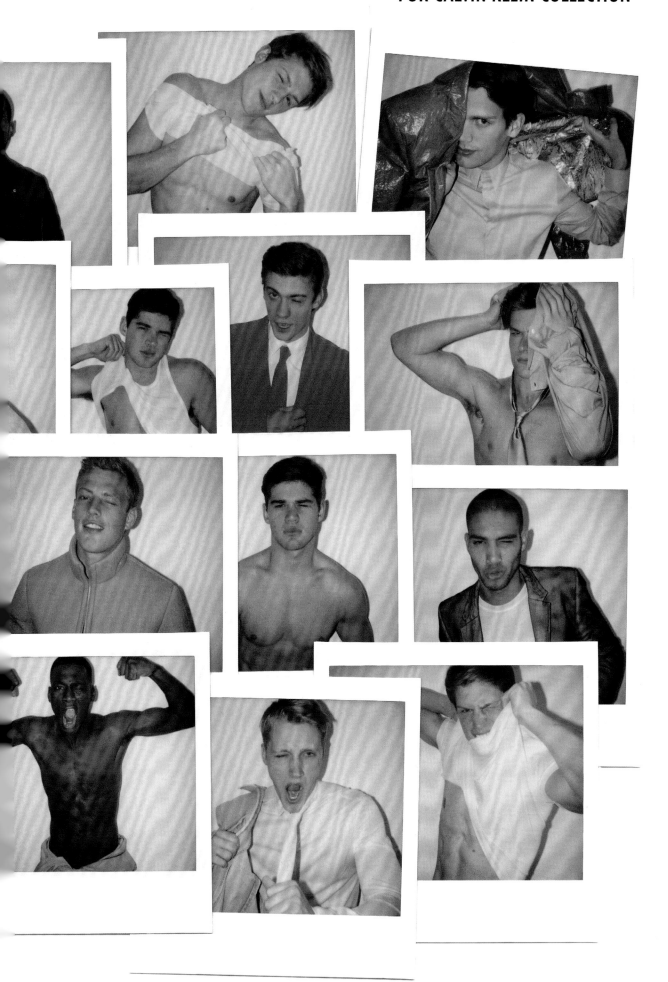

photography Ellen Nolan

'When I left home my mother gave me this chair from our kitchen.
It became Doris' chair. Doris was my first employee – she sat at a machine making
buttonholes in the shirts. String marks are still visible on the back of the
chair from where she tied her cushion.'

'Today I still use this chair in my kitchen.'
MARGARET HOWELL

MARGARET
HOWELL

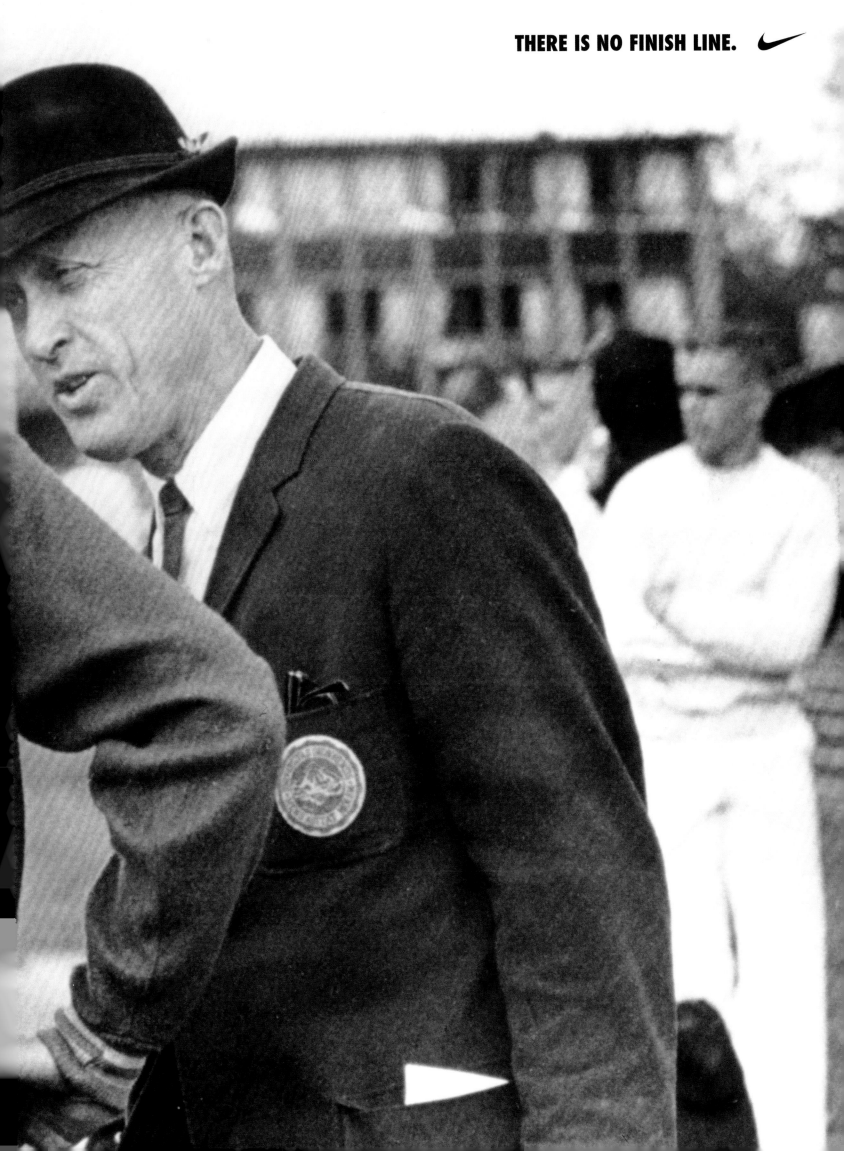

THERE IS NO FINISH LINE.

PRINGLE
OF SCOTLAND

RAF SIMONS

15 YEARS

44843
HOODED JACKET IN RASO GOMMATO, RUBBERIZED COTTON SATIN. TWO ZIP-FASTENING
POCKETS ON THE FRONT AND CHEST. CONTRASTING NYLON TAPES INSIDE THE HOOD
THAT CAN BE FOLDED AWAY AND FIXED TO FORM A RAISED COLLAR. FLEECE LINING.
VELCRO® BANDS AT CUFFS. SNAP FASTENING BAND AT COLLAR. ZIP FASTENING WITH
CONTRASTING NYLON TAPE EDGING.

STONE ISLAND

WINK
TO CLOSE AND OPEN THE EYELID OF ONE EYE DELIBERATELY,
AS TO CONVEY A MESSAGE, SIGNAL, OR SUGGESTION.

STONE ISLAND

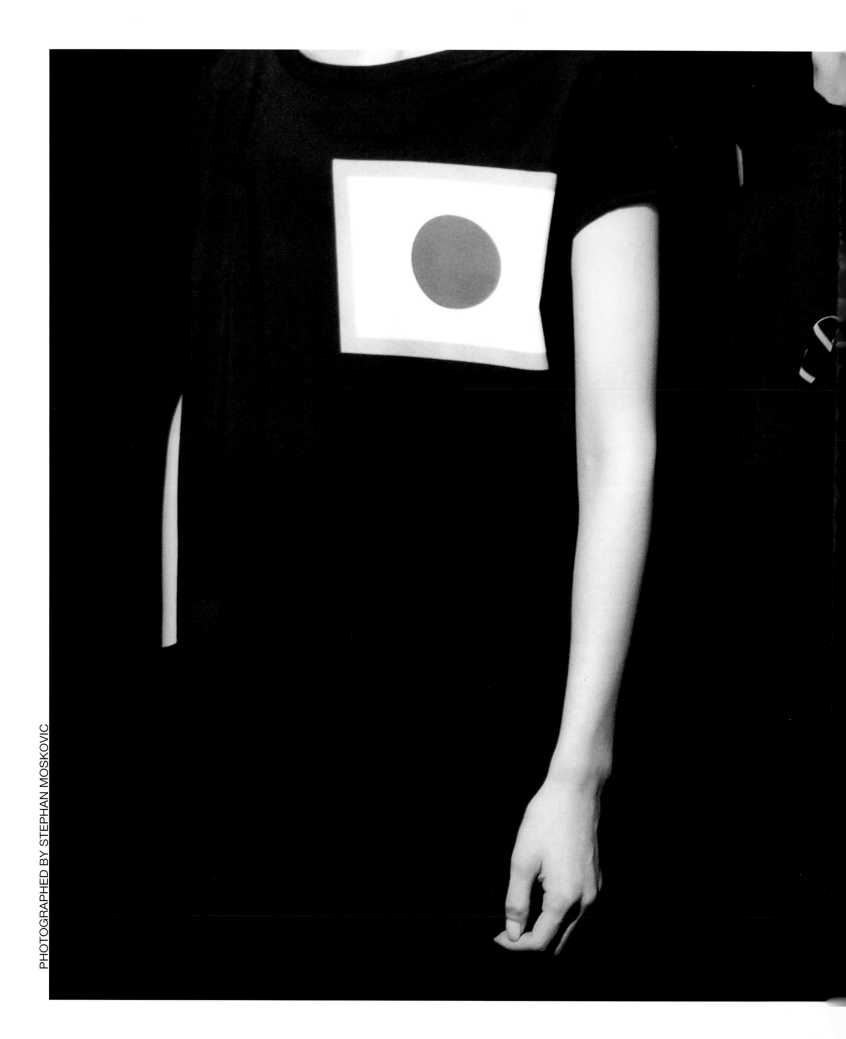

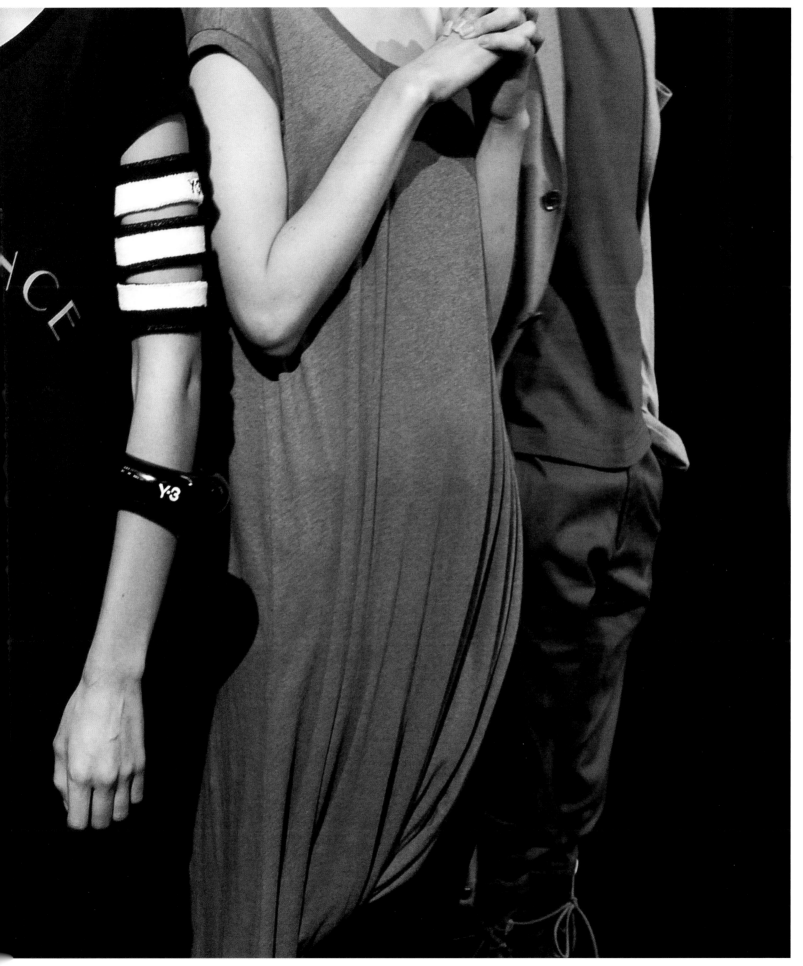

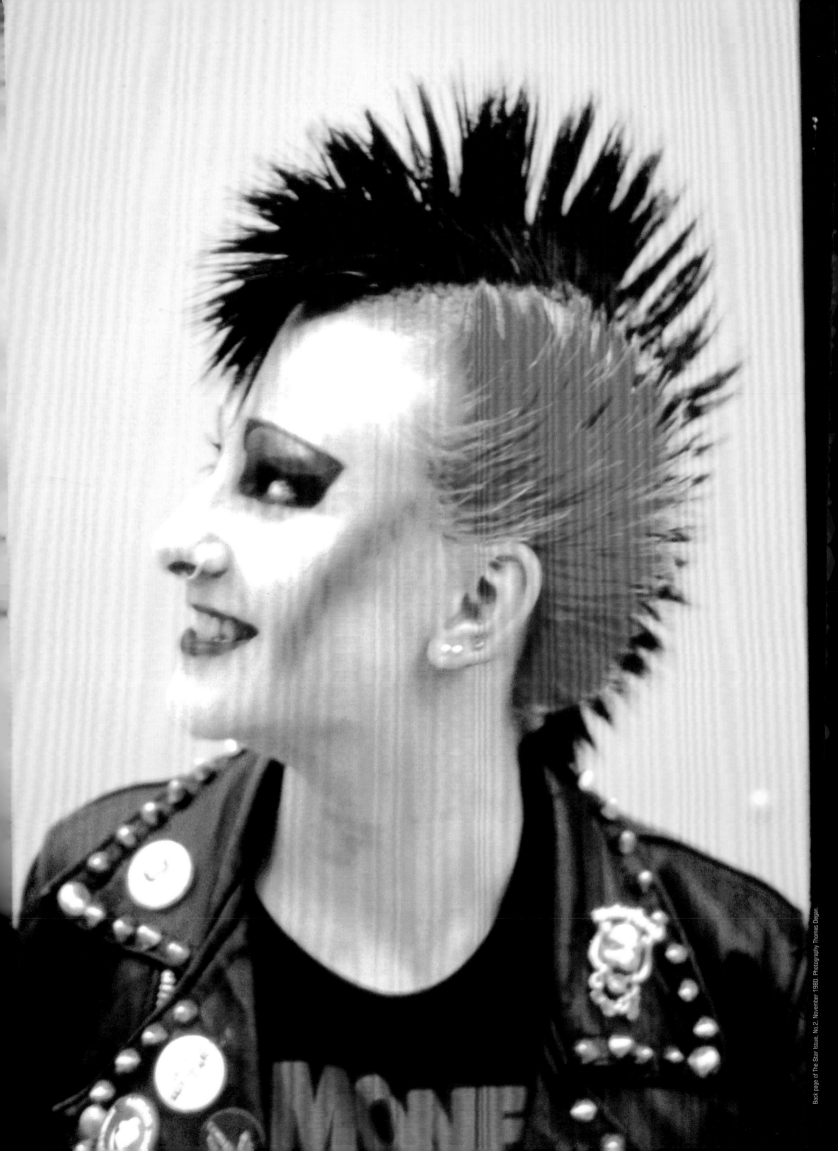

Back page of The Star Issue No.2, November 1980. Photography Thomas Degan.

BIOGRAPHIES

Alasdair McLellan, Photographer
Alasdair McLellan first became involved with i-D shooting club culture in Leeds in the late nineties. Born in 1974, he bought his first camera when he was thirteen and was inspired to pursue a career in photography when he began taking pictures of friends as a teenager. McLellan went on to study photography in Nottingham. Having completed his degree, he moved to London, met stylist Simon Foxton and shot his first fashion story for i-D. He cites his most memorable i-D cover as the one he shot with Lily Allen for The F.U.N Issue in Summer 2009. Styled by Kate Moss at The Ritz in Paris, the hotel was surrounded by paparazzi and McLellan was mistakenly identified as Allen's new beau. McLellan is also a regular contributor to 'Fantastic Man', 'Self Service', 'Arena Homme Plus', French, British and Russian 'Vogue' and 'L'Uomo Vogue'. He has also worked on advertising campaigns for Alexander McQueen, Emporio Armani, Topman and Aquascutum. Alasdair believes that photography should be personal and loves the fact that you can create any world you desire through its medium.

Alastair McKimm, Stylist
Alastair McKimm is a Belfast born and bred stylist. After studying fashion design at Nottingham Trent, Alastair moved to London and on his third day in the city, knocked on the door of the i-D offices and inquired about a job. The old fashioned door-to-door sales technique worked in his favour and McKimm was invited to assist Fashion Director Edward Enninful. His first shoot as a freelancer was a double page spread in i-D. McKimm now lives and works in New York and contributes to publications including Italian, Chinese and Japanese 'Vogue', 'Purple', 'V', 'Numéro' and 'Numéro Homme' and many advertising campaigns for both print and television including DKNY, Nike, Alexander Wang, Helmut Lang, Diesel, Tommy Hilfiger, Louis Vuitton, Stella McCartney, Gap and Levi's. In addition he has consulted with a range of top designers on their seasonal shows, including Costume National, CNC, Ohne Titel, Cerruti, Graeme Armour, Alexander Wang, and J Mendel. Alastair is a Contributing Editor to i-D and Fashion Director of 'The Last Magazine', his signature style is grunge/goth glamour and he styled Agyness Deyn for one of the multiple covers for The Agyness Deyn issue of i-D, May 2008 with photographer Matt Jones.

Alix Sharkey, Journalist
Alix Sharkey is a freelance journalist specialising in pop culture and fashion. Born in 1956, Alex studied design and art history at university. He joined i-D in 1981, became co-editor and left in 1989. Since then he has written a weekly column for the Independent from 1992 to 1995, worked as news editor for MTV Europe and as a BBC TV presenter; he is currently a contributing editor for British 'GQ' and 'Ocean Drive'. His book about Belgian fashion designer Dries Van Noten, 'DVN 1-50', was a best seller, and his work has appeared in various anthologies of journalism, including the 'Bedside Guardian', 'Material Man', 'Meaty, Beaty Big & Bouncy: An Anthology of Rock Writing' and most recently, 'Transculturalism: How The World Is Coming Together' [2004]. He lives in Miami Beach and is currently finishing his debut novel, 'The Marabout'.
www.alixsharkey.com

Andrew Macpherson, Photographer
Andrew Macpherson was surrounded by fashion and glossy magazines from an early age. Born in London in the early sixties, his mother owned a couture dress shop and his father was a racing car driver. At thirteen an inspiring teacher opened his eyes to the idea of photography as a career. After expulsion from school at fifteen, Macpherson started his career making tea in an old-fashioned photo production house in Fleet Street. By the time he was twenty, he had five years of experience and he began assisting photographers such as Lord Snowdon, Horst, Fabrizio Gianni and Ed White. He soon met Amanda Harlech, who was then Junior Fashion Editor of 'Harper's Bazaar' and they started shooting together. Macpherson contributed to i-D, 'The Face', 'The Sunday Times' and 'Jill' during this time and was then commissioned by British 'Vogue', French 'Vogue' and 'Vogue' Italia. He has also photographed advertising campaigns for the likes of Levi's, Diesel Jeans and Ray Ban. Macpherson now lives in Los Angeles; his love of the city inspired a shift from fashion to entertainment photography and he now describes himself as an American Photographer. At the start of the 90s, Macpherson contributed two covers to i-D, the first of Christy Turlington for The Paradise Issue [No.90, May 1990] and another of R&B singer, Adeva for The Travel Issue [No.93, June 1991].
macfly.com

Angus Ross, Photographer
British photographer Angus Ross specialises in music, beauty and fashion. His first work for i-D was the submission of a test shoot, "I will never forget that shoot," Ross reminisces, "I used an oil based smoke machine for the first time and it left a ghastly residue all of the studio floor." This led to more editorial work with i-D and a cover shoot of model, Kayla for The Pure Issue in July 1989. Angus has since shot music stars including Janet Jackson, Take That and Soul II Soul and contributed to magazines including British 'Vogue', 'Elle' UK, 'Marie Claire' and 'The Face'. His commercial clients have included Saatchi & Saatchi, Vidal Sassoon, Jaegar and Marks & Spencer. Today, Ross is inspired by originality and authenticity in art.

Benn Watts, Photographer
Benn Watts was born in London in 1967. He moved to Australia as a young boy and studied at Sydney College of Art and Design before moving to New York in 1995. Watts has photographed advertising campaigns for brands such as Nike, Kodak and Apple and worked for many major publications of note including i-D. Ben has released two books, 'Big Up' and 'Lickshot', both of which document his love of street culture, celebrity, hip hop and fashion in the form of lo-fi scrapbooks. Watts' first shots for i-D were of festival-goers at Lollapalooza, contributing to the magazine's long legacy of straight-up photography. His first cover was of his younger sister Naomi Watts for The Faith Issue in November 2005. For the shoot, Ben photographed Naomi with a man dressed in a fancy dress costume gorilla suit in homage to her role in the blockbuster Hollywood movie King Kong.
www.bennwatts.com

Billy Sullivan, Photographer
Billy Sullivan is an American artist who was born in Brooklyn and attended New York's High School of Art and Design and School of Visual Arts. As a multi-disciplinary artist Billy has built up an extensive portfolio of paintings, photographs, pastel and ink drawings. Sullivan shot Agyness Deyn for her namesake issue in May 2008. One of six covers by different photographers, Sullivan's cover featured the model wearing tattooed Sylvia B. gloves. Having started his career shooting friends from the downtown New York art, nightclub and fashion scenes, Billy now focuses on portraits and still life, identifying Andy Warhol as a major influence on his work. His art has been featured in a number of exhibitions worldwide, including a solo exhibition at Nicole Klagsbrun Gallery in New York and is in permanent collections at many notable institutions, including MOMA and The Metropolitan Museum of Art also in New York.

Caryn Franklin, Journalist
Caryn Franklin is a fashion commentator who started her career as co-editor of i-D in the early 80s. Caryn has since been a presenter, producer and director, but is probably is best known for her 12-year stint on the BBC's 'Clothes Show' which had weekly UK audiences of 13 million. She also co-hosted Clothes Show Live for 20 years. Caryn has written for a variety of publications as well as authoring four books and lecturing in colleges and universities. She has also produced documentaries on designers including Vivienne Westwood, Philip Treacy, Agnès b and Matthew Williamson. Her own shows include 'Style Bible', 'The Frock and Roll Years' and 'Style Academy'. Franklin now runs a fashion consultancy and has been co-chair of Fashion Targets Breast Cancer, for 15 years as well as a patron of the Eating Disorders Association (Beat). Caryn co-founded All Walks Beyond The Catwalk with Erin O'Connor and Debra Bourne, an initiative which promotes diversity.

Christian Witkin, Photographer
Christian Witkin was born in Manchester to a Dutch mother and American father, artist Jerome Witkin. He led a nomadic lifestyle, moving from city to city, until his parents divorced in 1972. Witkin then lived in Amsterdam until 1984 and is now based in New York City, having made his transatlantic move at seventeen to study Fine Art and Photography at Syracuse University. Following his degree, Witkin assisted some of the biggest names in the business, including Annie Leibovitz, Bruce Weber and Peter Lindberg. He went on to launch his professional career in the summer of 1993 and has since made photographic contributions to publications such as i-D, 'Vogue', 'W', 'Harper's Bazaar', 'The Sunday Times' and 'Vanity Fair'. Witkin has also shot numerous advertising campaigns for brands including Nike and GAP. His commercial and editorial work has earned him several awards and he has exhibited in galleries all over the world. Witkin also has an impressive folio of personal work exploring a diverse range of subject matter, including an in-depth study of Thai ladyboys. In December 1994 he shot Heather Small for the cover of The Saturday Night Issue of i-D.
christianwitkin.com

Collier Schorr, Photographer
Collier Schorr was born and raised in Brooklyn. Her iconic images examine established ideas of gender, youth and identity referencing such diverse topics as Nazi ideals and wrestling. Attending the School of Visual Arts in eighties New York, Schorr went on to build an impressive catalogue of exhibitions and extensive bibliography. Her work has been displayed in many notable institutions including the Museum of Modern Art in New York and Guggenheim, Berlin. As well as i-D, Schorr's editorial contributions include shoots for 'Vogue Hommes International' and 'Purple'. The nature of her work made her the perfect choice to shoot androgynous Brazilian model Caio Vaz for the cover of The We Got Issues Issue of i-D [No. 273, February 2007]. Collier had a retrospective at London based gallery Modern Art in 2010.
collierschorr.com

Corinne Day, Photographer
Corinne Day made her name as a photographer in the 90s when she photographed Kate Moss for the cover of 'The Face'. The shoot was Kate's first major editorial. She was styled by legendary stylist Melanie Ward, topless, with a Native American headdress. The picture changed the perception of fashion photography and helped coin the phrase 'grunge'. Compared to Nan Goldin and Larry Clark, Day's photography blurs the boundaries between real life and the staged, with locations and casting often being her friends in their natural environments. In 1993 she photographed Moss for British 'Vogue' in American tan tights and a pink vest with fairy lights strung up on the wall, and for the cover of i-D during the same year in an oversized knitted jumper, the sleeves stretched to the knees, with bare legs and a royal blue cover wash. Day continued to work for i-D, collaborating with stylist Panos Yiapanis in numerous iconic fashion images. In 2000, Day published her book, 'Diary', a highly personal visual documentation of her life and friends. She has contributed editorial work to publications, including i-D, 'The Face', British, Paris and Italia 'Vogue' and her work has featured in exhibitions at the V&A Museum, National Portrait Gallery, Tate Modern and Saatchi Gallery. Day has also been the subject of the BBC documentary, 'Corinne Day Diary'. Shot over a 10-year period by Corrine Day's boyfriend, Mark Szaszy, the film focused on such uncompromising material as her friends' drug-taking habits, and her own life-threatening illness. In her own words, "Photography is getting as close as you can to real life, showing us things we don't normally see. These are people's most intimate moments, and sometimes intimacy is sad."

Craig McDean, Photographer
Craig McDean is a British fashion photographer and filmmaker originally from Middlewich, near Manchester. Craig first started taking pictures of his rocker friends as a teenager, before moving to London to assist Nick Knight. Craig's first cover of i-D featured a ripped up Polaroid of Mica Paris for The Born Again Issue in November 1990. Something went wrong with the film and Craig had to pick the pieces of Polaroid out of the bin to create the cover, which he describes as "genius". McDean has since shot a massive 22 covers for i-D, as well as being a regular contributor to 'Vogue Italia', British 'Vogue', 'Another', 'W' and 'Harper's Bazaar'. McDean's advertising campaigns include Gucci, Giorgio Armani, Emporio Armani, Yves Saint Laurent, Calvin Klein and Jil Sander and his inspirations include "everyone and everything". Craig published his debut book, 'I Love Fast Cars', a collection of photographs celebrating the world of drag racing in 1999. His favourite i-D covers are both ones he shot, Stella Tennant for The Performance Issue in December 1995 and Shalom Harlow for The Subversive Issue in June 1995. Craig is currently based in New York.

David Bailey, Photographer
David Bailey shot to fame in the 1960s, when he became one of the first photographers to gain the same notoriety as the celebrities he photographed. Born in London's East End in 1938, Bailey served his National Service with the Royal Air Force in Malaysia in 1957 before assisting London fashion photographer John French. Bailey soon branched out on his own and began shooting for British, French, American 'Vogue' and 'Vogue Italia'. He is widely accredited with capturing the 'swinging London' of the 1960s. Bailey's first contribution to i-D was a shot of Sophie Hicks for the cover of The E=mc² Issue in June 1984. In 1964, Bailey released a collection of poster prints called 'Box of Pin Ups' that featured photographs of celebrities including The Beatles, Terence Stamp and notorious East London gangsters The Kray Twins. He has also photographed album sleeves for artists including The Rolling Stones, Marianne Faithful, M.I.A and Paul Weller. David has directed commercials and documentaries and was awarded The Golden Lion at Cannes Film Festival in 1987 for his 'Greenpeace Meltdown' commercial. In 2001, Bailey was awarded a CBE.
davidbaileyphotography.com

David LaChapelle, Photographer
David LaChapelle was born in Connecticut in 1969, studied fine art at North Carolina School of the Arts before moving to New York, where he enrolled in the Art Students League and the School of Visual Arts. LaChapelle's career took off in the 80s, when he attracted the attention of Andy Warhol and the editors of 'Interview' magazine, who offered him his first professional job as a photographer. Since then, David has shot some of the world's most familiar faces, including Lil' Kim, Madonna, Elizabeth Taylor, Tupac Shakur and Lady Gaga. Having built up an impressive catalogue of his signature vivid and colourful photography, LaChapelle expanded his work to include music videos, live theatrical events and documentary films. His stage work includes Elton John's Las Vegas spectacular 'The Red Piano', which ended its five-year run in Las Vegas in 2009. David has directed many music videos including Christina Aguilera's Dirty, Amy Winehouse's 'Tears Dry On Their Own' and Britney Spears' 'Everytime'. LaChapelle and his burgeoning interest in film led him to make the short documentary 'Krumped', an award-winner at Sundance from which he developed the feature film RIZE. The film was released to huge critical acclaim, and was chosen to open the 2005 Tribeca Film Festival in New York City. LaChapelle's work has also featured in exhibitions at the Palazzo delle Esposizioni and Palazzo Reale in Italy, the Barbican in London, and The Helmut Newton Foundation in Berlin. He has shot three covers for i-D, Naomi Campbell for The Ideas Issue in November 1999, Ana Claudia for The Gift Issue in December 2000 and Courtney Love for The Insider Issue in October 2003. David continues to be inspired by a variety of subject matters, from art history to street culture.
lachapellestudio.com

David Sims, Photographer
David Sims is a world-renowned British photographer. An avid surfer, when he's not travelling the world shooting for the world's top fashion magazines, David can be found hitting the surf in Cornwall, where he lives with his family. David began his photographic career assisting photographers Robert Erdmann and Norman Watson. His first editorial contribution to i-D was a series of portraits of his friends. In 1993, 2000 and 2001 Sims signed

one-year exclusive contracts to 'Harper's Bazaar' (USA). In 1994 he was awarded the Young Fashion Photographer of the Year award by the Festival de la Mode and held his first exhibition in London. Sims' pictures also appear in the permanent collections at the Tate Modern and the Victoria & Albert museum. Sims' first 1-D cover (The Survival Issue, No. 149, February 1996) starred a young Kate Moss, covering one eye with her hand. Today, Sim's continues to be a regular contributor to 1-D, as well as 'W', 'L'Uomo Vogue', 'Arena Homme Plus', 'Vogue Homme International', British 'Vogue' and 'Dazed & Confused'. His advertising clients have included Jil Sander, Balenciaga, Calvin Klein, Marc Jacobs, Prada, Rimmel and Burberry.

Derek Ridgers, Photographer
Derek Ridgers is a British photographer who documented the rise of the Blitz Kids, the New Romantics, Hell and Taboo in London in the late 70s, early 80s. Derek originally trained as a graphic artist and worked in the advertising industry for over a decade, where his clients included a camera manufacturer. After testing out one of their products, Derek traded in advertising for photography and went on to become one of London's most influential club photographers. A founder of the straight-up style of photography, Derek's pictures of the punks, hippies, ravers, goths and new romantics around Soho and the Kings Road appeared in the 'NME', 'The Face', 'The Independent', 'Time Out', 'Loaded' and 'The Sunday Telegraph'. Today Derek's work is the subject of a research project at the University of the Arts London. In April 1991, Derek Ridgers' photograph of model Moni, appeared on the cover of The News Issue of 1-D. derekridgers.com

Donald Christie, Photographer
Donald Christie was born in Stirling, Scotland in 1960. A self-taught photographer, he studied Fine Art at Newcastle Polytechnic, specialising in film, video and sound. After completing his degree, Christie moved to a squat in London and started work as a runner in the pop promo industry before moving into photography. Donald initially specialised in reportage and portraiture before moving into fashion photography in the early 90s. Christie is a regular contributor to 1-D, his work has appeared on the cover twice. The first time in August 1993 for The Festival Issue and the second time for The Emergency Issue in January 1999, starring Spice Girl, Mel C. Christie is involved in a series of projects with charities and voluntary organisations such as teaching photography to elderly people, and to men with severe learning difficulties. He also travelled to East Jerusalem to work with an ophthalmic hospital. Christie is currently completing an MA in Art and Media Practice at The University of Westminster. And is working on collaborative projects with musicians and sound artists, including Icarus, Kim Hiorthøy, Massive Attack and Janek Schaefer. donaldchristie.com

Donald Graham, Photographer
Donald Graham is an internationally renowned fashion, portrait and fine art photographer. Graham began his career as a fashion photographer in Paris, before moving to New York and Los Angeles to work in editorial, advertising, film,

music and portraiture. Graham has won awards for his advertising work from Nikon, Hasselbad and the American Society of Magazine Photographers amongst others. His images are part of the permanent collections of both the Metropolitan Museum of Art in New York and the International Centre of Photography. Graham shot La Vera Chapel at Graceland to commemorate the twentieth anniversary of Elvis' death for the cover of 1-D's The Ego Issue in March 1998. Truly cosmopolitan; Graham now divides his time between New York, Los Angeles and Taos, New Mexico. donaldgraham.com

Dylan Jones, Editor
Dylan Jones studied design and photography at Central Saint Martins School of Art, before establishing himself as a journalist and securing the position of Editor of 1-D in 1984. Now Editor of British 'GQ', prior to this Jones was the Editor-At-Large of 'The Sunday Times,' and an editor at 'The Observer', 'Arena' and 'The Face'. He has written and edited several books, including an international best-selling biography of Jim Morrison, 'Dark Star'; 'iPod, Therefore I Am' and 'Cameron on Cameron', a series of interviews with the Conservative leader. He has won the BSME Editor of the Year award seven times, once for his work on Arena and five times for GQ. A notable face during the New Romantic era, during his tenure as editor at 1-D, Dylan took the 1-D club nights to a global platform with 'The 1-D World Tour' and his memorable covers include Sade, Swing Out Sister and Grace Jones.

Eamonn McCabe, Photographer
Eamonn McCabe is one of the world's most popular and respected photographers in art, fashion, sport and music. Born in London in 1959, McCabe worked on the very first issue of 1-D, as an assistant to Steve Johnson shooting straight-ups against a wall on the King's Road. McCabe soon started shooting for 1-D, 'The Face' and 'Arena', and by the age of 25 was a regular contributor to British 'Vogue', 'Elle', 'Marie-Claire', 'Vanity Fair' and 'Interview'. In 1985, McCabe shot two covers for 1-D, The Eye Spy Issue starring Carol Thompson and The Spectator Issue featuring Blair Booth. He later went on to shoot commercials and a short fashion piece for Channel 4, winning the coveted title of British Fashion Photographer of the Year in 1989. In 1990 McCabe moved to New York where he lives with his partner and two children. McCabe published his first book, 'Ice', a collection of glacial landscapes in Iceland in 1997.

Eddie Monsoon, Photographer
Eddie Monsoon began his photographic career assisting photographer Mark Lebon. He soon became involved with the Buffalo movement, spearheaded by stylist Ray Petri and was introduced to legendary stylist Judy Blame, who he went on to photograph and collaborate with in his work. Monsoon was a regular contributor to 1-D throughout the 1980s and 90s. Monsoon shot five covers for 1-D between 1988 and 1992.

Elfie Semotan, Photographer
Elfie Semotan is one of Austria's most famous fashion photographers. Born in Upper Austria in 1941, Elfie graduated from the school of Fashion Design Hetzendorf in Vienna in 1960 and moved to Paris, where she worked as a model for seven years. On returning to Vienna, Semotan began work as a professional photographer, shooting for 1-D, British 'Vogue', 'Elle', 'Esquire', 'Marie Claire' and

'Harpers Bazaar'. In 1986, Semotan began a long-standing collaboration with Helmut Lang, confirming her status as a prolific member of Austria's avant-garde. Semotan photographed Naomi Campbell for the cover of The Active Issue of 1-D in January 1998. Her work has since been exhibited in the Semper Depot and the WestLicht Gallery in Vienna. Semotan published her first book 'Hair' in 1997. She currently lives and works between New York, Vienna and Jennersdorf. semotan.com

Ellen von Unwerth, Photographer
Ellen von Unwerth was born in Frankfurt in 1954. She started her career as a model before becoming a photographer in 1986. Ellen has since established herself as one of the most prominent female fashion photographers and directors working today. Her photographs focus on the erotic and feminine and lend themselves perfectly to fashion photography. Ellen's work has been exhibited all over the world and appeared in 'Vogue', 'W', 'Interview', 'Details' and 'The Face' to name just a few. A regular contributor to 1-D, Ellen has shot ten covers including Kylie Minogue, Bjork, Drew Barrymore, Courtney Love and Victoria Beckham. Her advertising work includes campaigns for Victoria's Secret, H&M, Guess, Diesel and Chanel. Ellen has also directed short films for Azzedine Alaïa and Katherine Hammet and music videos for Duran Duran, Salt'n'Pepa and Christina Aguilera. To date six books of her work have been published.

Emma Summerton, Photographer
Emma Summerton's first contribution to 1-D was a shoot with Lily Cole, styled by Edward Enninful in Prague. "It was a great beginning to be working with such fantastic people in a magical city; we had a blast," she remembers. The Australian born photographer studied Fine Art at the National Art School in Sydney then worked as a photographic assistant for five years. She moved to London in 1998 and assisted Turner Prize nominated artist Fiona Banners. "The people I work with constantly inspire me," Emma says. "As do art, music, films, books, fabulous fashion and, of course, great models who transform in front of the camera." Emma's favourite 1-D cover is the first cover she shot for the magazine, which was Claudia Schiffer styled by Edward Enninful for The Wealth Issue in September 2006. Emma describes the shoot as a landmark moment in her career, adding, "shooting Kate Moss for 1-D was a great moment also!" As well as contributing to 1-D, Summerton has shot editorial work for British, Italian, Nippon and American 'Vogue' and commercial projects for clients including Yves Saint Laurent, Miu Miu and Jaeger.

Eugene Souleiman, Hair Stylist
Eugene Souleiman is one of the world's most influential hairstylists. Born in Harrow in 1961, Eugene's career began in 1982 when he became an apprentice hairdresser. Following this he worked closely with Trevor Sorbie for ten years and held top positions at Bumble and Bumble, L'Oreal and Vidal Sassoon. Souleiman often works in partnership with make-up artist Pat McGrath. The pair have worked on sixteen 1-D covers together. Souleiman has also worked on runway shows for Alexander McQueen, Lanvin, Yohji Yamamoto, Prada, Miu, Miu, Calvin Klein, Dolce & Gabbana, Jil Sander, Louis

Vuitton and Dries Van Noten to name a small few. While Souleiman's groundbreaking hair styles have graced the pages of international publications including 1-D, 'Vogue Italia', British, French and American 'Vogue', 'Self Service', 'Harper's Bazaar', 'Another' and 'W'. For five years he has been working on an ongoing collaboration with artists, Jake and Dinos Chapman on 'The Art of Chess' exhibition, styling the hair of individual chess figures. He is also global creative director for Wella Professionals worldwide. Souleiman is currently based in New York, but works extensively in London, Milan, New York and Paris.

Fabrizio Ferri, Photographer
Fabrizio Ferri is an internationally renowned fashion photographer. Born in Rome in 1952, Ferri began taking pictures as a young boy, documenting life around him. In 1973 he moved into fashion photography and his work has since featured in 'American Photo', 'Elle Décor', 'Esquire', German and British 'Vogue', 'Vogue Italia', 'Glamour', 'GQ', 'Harper's Bazaar' and 'In Style'. While his advertising clients have included Bulgari, Estee Lauder, Levi's, L'oreal, Oscar de la Renta and Salvatore Ferragamo. In March 1997, Ferri shot Isabella Rossellini for the cover of The Metropolitan Issue of 1-D. As well as a successful career in photography, Ferri owns two large rental studios, two restaurants, the clothing company Industria Collection and a resort on Pantelleria in Sicily. Fabrizio is also a director of two short films: Aria (1997) and Prélude starring ballerina Alessandra Ferri and Sting (1998). Both of which won the 1998 Premio RaiSat Show Award at the 55th Mostra Internazionale del Cinema in Venice. In 2000, he directed Carmen, which won the Best Live Performance Award in Dance Screen2002, hosted by Monaco Dance Forum. Today, Ferri divides his time between Milan and New York with his wife and two daughters.

Francesco Vezzoli, Artist
Francesco Vezzoli is a contemporary Italian artist, working in tapestry, paint, performance and film. Born in Brescia, Italy in 1971, Vezzoli graduated from Central St Martin's with a BA in Fine Art in 1995, and moved back to Milan where he set about establishing himself as a working artist. Embracing multimedia techniques, Francesco draws on a range of disciplines from embroidery to photography and video installations. Vezzoli's work unites pop icons, auteur cinema, art history and politics. His work has been exhibited all over the world and has been presented at the prestigious Venice, Whitney, Shanghai, Istanbul and Sao Paulo Art Biennials. Fascinated by the iconicity of female identity, Vezzoli interviewed and stitched a tapestry of Miuccia Prada for the cover of 1-D's Pleasure and Pain Issue, in April 2009. He has also collaborated with the likes of Gore Vidal, Roman Polanski, Natalie Portman and Lady Gaga.

Guido Hildebrand, Photographer
Swedish photographer Guido Hildebrand's first contribution to 1-D was photographing model Camilla for the cover of The Trash Issue in November 1988. "I was so impressed by 1-D's style and great articles I knew I wanted to work for them," Hildebrand remembers. "Some of the covers were just stunning." Hildebrand launched his own rental studio complex and meeting spot for creative visual communication, Delight

Studios, in Stockholm six years ago. During which time Hildebrand has produced commercial work for brands including Persol Eyewear and editorial for magazines such as Io 'Donna'. Hildebrand is currently working on a personal photographic project shooting portraits of people in a village in northern Sweden. "I still have a lot to achieve," Hildebrand muses, "and that thought is what continues to make the future inspiring." Hildebrand's favourite cover of 1-D is Nick Knight's shot of Grace Jones for The Pop Issue in April 1987.

Henrik Bülow, Photographer
Henrik Bülow is a Danish fashion photographer. His work has appeared in 1-D, 'ELLE', 'Qvest' and 'Grazia'. Henrik is also a successful commercial photographer and his clients have included Saint Tropez, Hugo Boss, Coca Cola, Vero Moda and Red Cross. Bulow photographed Helena Christensen for the cover of The Glamour Issue of 1-D in May 1992, in which the supermodel wears a bra and fur coat. henrikbulow.com

Hugh Stewart, Photographer
Hugh Stewart was born and raised on a farm in New Zealand. He moved to London in his early twenties and came into the 1-D office where he met Terry Jones. "I had just moved back to London and came in and met Terry Jones who liked and published my photos of surfers at Bondi Beach." It was whilst squatting in Euston in the early 80s that Stewart first picked up a camera and started taking portraits of his friends. Stewart shot two covers for 1-D in 1991; the first in July starred Lorraine Pascale for The High Summer Issue, "I think I shot about 3 frames of Lorraine, but I do remember going into the news agent in Ladbroke Grove where I lived, with Lorraine and there she was winking at us," whilst his second was of singer, Rozalla for The Identity Issue. Hugh's work has also appeared in British, French and American 'Vogue', 'Rolling Stone', 'GQ', 'Vanity Fair' and 'Harper's Bazaar'. His photographs have been exhibited in the National Portrait Gallery in London and Canberra. Hugh lives in Sydney with his wife, two daughters and son and travels to the UK several times a year. hughstewart.com

Inez van Lamsweerde and Vinoodh Matadin, Photographers
Inez Van Lamsweerde and Vinoodh Matadin launched their international photographic career with ten pages in 'The Face' in 1994. The shoot typified van Lamsweerde and Matadin's hyper-realistic style. Now, 25 years later, with their campaigns for fashion houses such as YSL, Chanel, Balmain, Gucci, Louis Vuitton, and Chloé, and with regular publications in 'W', Vogue' and the 'New York Times', Inez and Vinoodh are amongst the most important photographers working in the world today. They are also among the very few photographers that have successfully crossed the line between fashion and art and have managed to simultaneously maintain careers in both fields. The team have lived and worked in New York since 1995 and have photographed Daria, Bjork, Stefano Pilati with Naomi Campbell, Eniko Mihalik and Frida Giannini with James Franco for the cover of 1-D.

James Palmer, Photographer
James Palmer studied photography at Manchester

Polytechnic from 1970 to 1973. After college he concentrated on music photography for a year and a highlight was the cover photography of Dr Feelgood's first classic album 'Down by the Jetty', 1975. Palmer showed his work to Terry Jones at Vogue magazine and after this he assisted Oliveiro Toscani and David Bailey for a year. Palmer then did cruise ship and travel photography, working around the world with many different nationalities of people. In 1980 Palmer became one of the main originating photographers for the first years of 1-D magazine. His real and actual street fashion work was comprehensive and prolific as can be seen in the first sixteen issues of the magazine. He did the cover photography for 1-D 7 and 12. From 1974 to 1986 Palmer's music, portrait and street fashion photography was published in numerous magazines and newspapers, including 'Time Out', the 'New Musical Express', 'Melody Maker', the 'London Evening Standard', the Australian, American 'GQ', 'Italian 100 Cose'. Since his street fashion time Palmer has been concentrating on portraits, landscape and event photography.

Jamil GS, Photographer
Jamil GS is a Danish born American photographer who studied fine art and graffiti in Copenhagen before attending Parson's School of Design in New York. Jamil launched himself as a professional photographer in the early 90s when he strated contributing to 1-D. "I used to read 1-D as a kid," he recalls. "I used to find it inspiring because it had the freshest ideas and trends from the street, before they became mainstream fashion. I wanted to contribute. During my transition from assistant to Photographer I met Terry Jones and Edward Enninful on a trip to London and offered to correspond to 1-D from New York. My first shoot was in 1994. It was my first (lousy) paid assignment, but it was exciting and fresh and the beginning of a good working relationship." jamilgs.com

Jane How, Stylist
Jane How has over twenty years of knowledge and experience in the fashion industry. One of her earliest jobs as a stylist was for the cover of The Pure Issue of 1-D in July 1989, which she also did the hair for. Since then How has used her talent for complementing her subjects with the right combination of clothes, mood, environment and accessories for a range of editorial and commercial projects. She has worked with many celebrated photographers including Nick Knight, Steven Meisel, Juergen Teller, Mario Sorrenti, Paolo Roversi, Willy Vanderperre, Alasdair McLellan, Mikael Jansson, Ryan McGinley and Cedric Buchet. Jane has been involved in the creation of iconic images for Christian Dior, Prada, Yves Saint Laurent and Missoni, as well as styling catwalk shows for Hussein Chalayan, Pucci and Martin Margiela, and has an ongoing collaboration with Stella McCartney. She is also a regular contributor to a number of international titles including 1-D, 'Purple', 'Vogue Italia', 'Self Service', 'Another', 'The New York Times' and 'W'. Jane lives in London with her partner and children.

Jean-Baptiste Mondino, Photographer
Jean-Baptiste Mondino is a photographer, music video and advertisement director. His

career began in the 70s when he became Artistic Director for advertising agency, Publicis. Mondino went on to design record sleeve art with his partner Gerald Rufin in the early '80s. During this time, he was also a DJ and composer and released a single called 'Le Danse Des Mots' in 1983. Mondino has contributed two covers to the i-D archive; the first was an image of Marni for The Dangerous Issue in May 1990 with stylist Judy Blame and the second was Suede's Brett Anderson and model, Stella Tennant for The Visionary Issue in October 1994 with stylist Zoe Bedeaux. His sitters have included Madonna, Björk, Vanessa Paradis, Neneh Cherry, Keziah Jones, Alain Bashung. His clients: Chanel, Jean-Paul Gaultier, Armani, Dior, Dolce & Gabbana, Yves Saint Laurent.

Johnny Rozsa, Photographer

Johnny Rozsa has been photographing the world's most beautiful celebrities and models since 1975. The New York resident's often contributed to i-D and his first cover was a photograph of Leigh Bowery wearing a pig mask for The Plain English Issue in 1987. It was the first time a man had appeared on i-D's cover. "He was so creative and funny and brought humour and wit to the magazine stands," Rozsa remembers. One of Rozsa's most memorable contributions to i-D, was a story on London's club kids shot entirely on Polaroids, a cutting edge technique at the time. Today, Rozsa continues to shoot, and has contributed to such magazines as 'Vogue', 'The Sunday Times', 'Ritz', 'MaxIm' and 'The New York Times'. Johnny's portraits of are part of the permanent collection at the National Portrait Gallery in London. His photographs of Leigh Bowery have been exhibited in several museums, including the Museum of Contemporary Art in Sydney, the Kunsthalle in Vienna, and the Kunstverein in Hanover. He identifies his major inspirations as the more subtle aspects of life, such as beauty and honesty. Rozsa recently produced a book called 'Untouched' published by Glitterati.
johnnyrozsa.com

Judy Blame, Stylist

Judy Blame is a stylist, jeweller, designer and art director and since the early '80s he has been designing accessories using endlessly scavenged chains, safety pins, rope, string, bottle tops, champagne corks, feathers and buttons, all being re-worked and refined into fabulous fashions. As part of the then Buffalo movement, Blame has styled, designed and art directed for numerous artists including Neneh Cherry, Björk, Boy George, Iggy Pop and Kylie Minogue, and has collaborated with designers including John Galliano, Rifat Özbek, Richard Nicoll, Jessica Ogden, Philip Treacy, Gareth Pugh, Louis Vuitton and Comme des Garcons. He has also shot editorial with photographers Nick Knight, Juergen Teller, Mark Lebon and Jean Baptiste Mondino, amongst others. His aesthetic helped define i-D's visual style throughout the 80s using his signature cut and paste collage style to full effect on covers of The Madness Issue and The Surreal Issue. Judy Blame says of his iconic name, "I wanted a lady name because everyone changed their name to one of the same sex, so I thought I'd confuse people. Judy was a nickname given to me by a friend, and Blame just sprang to mind one day. It sounds like a trashy b-movie actress from the 50's - a bleached blonde tart who

only made one film and never got anywhere - I like that."

Juergen Teller, Photographer

Juergen Teller discovered photography after a bow-making apprenticeship was cut short by an allergic reaction to wood shavings. He studied at the Bayerische Staatslehranstalt für Photographie in Munich from 1984 to 1986. In 1986 Teller moved to London where he met Venetia Scott. During their time together Teller and Scott collaborated on two i-D covers, for The Open Air Issue in July 1993 and The Killer Issue in October 1997. Teller stands out in the world of photography by his refusal to separate the commercial fashion pictures and his most autobiographical uncommissioned work. His work is subversive and unexpected; he often includes himself as the subject and favours interesting looking people over models. Exhibitions of his work have been held all over the world and his work has also been featured in numerous books, magazines and on record covers. Teller has also produced campaigns for Helmut Lang, Katharine Hamnett, Hugo Boss, Miu Miu, Yves Saint Laurent, Vivienne Westwood and Marc Jacobs. He has shot eleven covers for i-D, some of the most memorable of which include Linda Evangelista, Courtney Love, Kristen McMenamy, Justine Frischmann, Raquel Zimmerman and Christy Turlington.

Karina Taira, Photographer

Karina Taira is a Japanese American photographer and film director. Born in San Francisco in 1981, Karina attended the Art Centre College of Design in Pasadena before establishing herself as a professional photographer at the tender age of nineteen. After moving to New York, Karina was awarded the Diesel perfume campaign, which brought her to Europe and led to major editorial and advertising work in Paris, Milan, Tokyo, and London for the likes of Givenchy, La Perla, Vera Wang, Dior cosmetics, Lee Jeans and Guerlain. Taira shot 'Kill Bill' star, Japanese actress and model, Chiaki Kuriyama for The Drama Queen Issue of i-D in May 2004. Taira's work has also featured in 'Vogue Vogue Gioiello', 'Premiere, Amica,' 'Rouge' and 'Life'. She currently divides her time between homes in Paris and New York.
karinataira.com

Karl Lagerfeld, Fashion Designer

An iconic fashion designer and photographer, Karl Lagerfeld, Creative Director of Chanel, Fendi and his own label, Karl Lagerfeld, is a fashion legend. Born in 1938 in Hamburg, he moved to Paris in 1952. His creative career began aged seventeen when he won a prize from the International Wool Secretariat. Lagerfeld then began working as an apprentice for Pierre Balmain before taking up the role of artistic director at Jean Patou three years later. After leaving Patou he worked as a freelance designer, moving to Chlöe in 1963. For Karl, perfume is as important as fashion. When 'Chloe' was launched in 1975, he became the first ready-to-wear creator to develop a global perfume brand. In 1983 he became the Artistic Director at Chanel and has since created all the haute couture, read-to-wear and accessories collections for the house - totalling nine per year. Constantly searching out new experiences, he illustrated Hans Christian Andersen's tale, 'The Emperor's New Clothes', and created costumes for La Scala in Milan, the opera in Florence and the ballet in Monte Carlo. November

1999 saw the opening of his 7L bookshop, followed by Editions 7L. Lagerfeld is also an award-winning photographer shooting Chanel's international advertising campaigns himself. His photographs have appeared in some of the world's most important international magazines. For The White Trash Issue of i-D in May 2007 he photographed singer Chan Marshall.

Kayt Jones, Photographer

Kayt Jones is a photographer and filmmaker known for her cinematic fashion imagery and evocative portraiture. Born and raised in London, Jones began her career in Paris as a photo assistant, later receiving her degree in film and photography in London. Jones's editorial photography is characterised by a strong narrative component, underscoring the reciprocal creative influence between her two areas of study. Jones received the 2009 Style Award for Fashion Photographer of the Year. Her work is regularly featured in magazines including i-D, French 'Elle', 'V', 'Vs' and British 'Vogue', and has been exhibited internationally. Jones's film directorial debut came in 2008 with the short film "Foxglove", which premiered at the Locarno Film Festival, co-directed with her director husband Jay Rodan. Their most recent short film, 'The Corner', showed at 'A Shaded View on Fashion Film Festival' in Milan in 2010. Jones lives with her husband and two children in L.A. Memorable covers for i-D include Laetitia Casta and the naked supermodels (Winter Issue, 2009) Claudia Schiffer, Eva Herzigova and Helena Christensen, as well as young stars like Chanel Iman.
kaytjones.com

Kevin Davies, Photographer

Kevin Davies' first photographic job was for the 'NME'. Not long after, Davies travelled to Vienna where he bumped into i-D's Editor of the time, Dylan Jones at Gatwick Airport. "I recognised him from i-D," Davies remembers, "so I casually walked over and enquired if he was Dylan and he replied 'Might be'…" Despite the unusual meeting, the pair hit it off and Davies was soon a contributing photographer to i-D and 'The Face'. Davies shot four covers for i-D between 1987 and 1989. His first cover starred Rachel Weisz, styled by Caryn Franklin as a bunny girl, for The Boys Own Issue in September 1987. While his favourite issue is The Fear Issue, November 1987, for which he photographed Japanese model and video artist Mariko for the cover. Today Davies shoots fashion, landscape and interiors. He collaborates regularly with British milliner Philip Treacy and has documented U2 on tour. Davies cites his inspirations as his family and Ireland.

Lorenzo Agius, Photographer

Lorenzo Agius was born in Colchester in 1962. He studied photography at the University of East Anglia and worked for several years as a photographer's assistant in London, before going freelance in 1989. Specialising in advertising, portraits and still life, Lorenzo's big break came in 1996 when he shot the publicity posters for 'Trainspotting'. Agius photographed three covers for i-D, Björk and Goldie for alternating covers of The Love Life Issue in July 1996 and Supergrass frontman, Gaz Coombes for The Desirable Issue in May 1997. In 1997, his photograph of Liam Gallagher and Patsy Kensit defined Cool Britannia on the cover of

'Vanity Fair'. Since then Agius has established his reputation as one of the world's leading portrait photographers shooting celebrities including Madonna, Muhammad Ali, Johnny Depp, Angelina Jolie, Brad Pitt and Beyoncé. In 2006, Agius' retrospective exhibition 'Look At Me' was showcased at the Getty Images Gallery in London. Agius is currently working on the publicity for the new 'James Bond' movie.
lorenzo-agius.com

Magnus Unnar, Photographer

Magnus Unnar was born in Iceland in 1974. He moved to London to study at the London College of Printing before launching as a professional photographer. Unnar collaborates frequently with super stylist Nicola Formichetti and his work has appeared in 'Dazed & Confused', 'V', 'Self Service' and 'Vogue Nippon'. He has also shot advertising campaigns for H&M, Iceberg, Emilio Pucci, Tommy Hilfiger and Paul Smith. Unnar lives in Paris, London and New York and is working on a new book of his work, set to be published in the Autumn of 2010. Cassie and P Diddy were the stars of the cover shot by Unnar for The Older and Wiser Issue in December/January 2006/07.

Mario Sorrenti, Photographer

Mario Sorrenti is an Italian-born photographer who moved to New York at the age of ten. His interest in photography grew as he began to document his life through the medium. At age twenty-one Mario's career really began when he was commissioned to shoot the Obsession fragrance campaign for Calvin Klein. Mario first became involved with i-D through stylist Jane How, as he remembers, "Jane How introduced me to the magazine, and we did some stories together with artist Shannon Plumb." Since then, Mario has shot three covers for i-D, the last of which featured Naomi Campbell for The World Wide Web Issue in October 2007. Mario has worked with various fashion clients including Giorgio Armani, Hermes, Lonchamp, and Yves Saint Laurent. In 2001 he published a book called 'The Machine', a photographic study of his younger brother and fellow photographer Davide, who passed away in 1997. In addition to being held in the permanent collections at the Victoria & Albert Museum and Tate Modern in London, Sorrenti's work has been featured in numerous exhibitions at galleries and museums worldwide. Today he is inspired by "sex and the 70's," and continues to be a regular contributor to i-D.
mariosorrenti.com

Mario Testino, Photographer

Mario Testino is one of the world's most well-known and celebrated fashion photographers. Born in Peru he moved to London in 1976 after completing his university studies and in the early 1980s began his career as a photographer. During this time Testino approached i-D and began contributing to the magazine. "When I started my career, i-D was an outlet for photography that was free and experimental," he recalls. In 1984, Testino shot the cover of The Body and Soul Issue of i-D. Today he is a regularly contributor to British 'Vogue', American 'Vogue', 'Vanity Fair' and 'V'. Mario continues to shoot international celebrities as well as fashion photography. His commercial clients include Burberry, Dolce & Gabbana, Versace, Lancôme and

Michael Kors. As well as having published nine books of his work, Mario has had some of the most successful photography exhibitions in galleries and museums around the world. In 2002, The National Portrait Gallery showed a major exhibition of Testino's work, entitled 'Mario Testino: Portraits'. When he's not working, Testino is a humanitarian who works with a number of charities and recently won the Hero Award from the organisation Aid for Aids.
mariotestino.com

Mark Borthwick, Photographer

Mark Borthwick is an iconic British photographer, musician, artist and filmmaker living in Brooklyn, New York. Borthwick first shot to fame as a fashion photographer in the early 1990s. His sun-drenched photographs often incorporate nature, architecture and design, have appeared in high-end publications including i-D, 'The Face', 'Vogue Italia', 'Interview', 'Purple', 'Self Service', 'Another' and 'The New Yorker'. In May 1996, Mark photographed Guinevere van Seenus for the cover of i-D's The Sound Issue. As well as fashion photography, Borthwick has collaborated on short films with Chloë Sevigny, Mike Mills and Chan Marshall (Cat Power) and his artwork has been featured in exhibitions worldwide. The father of two children with fashion designer Maria Cornejo, Mark's main sources of inspiration include friends, collaborations, nature and silence.
markborthwick.com

Mark Lebon, Photographer

Mark Lebon's work for i-D spans three decades. Between 1984 and 1992, he shot a total of thirteen covers for the magazine, the first of which was Madonna for The Sexsense Issue in May 1984. He studied at West Surrey College of Art and Design and North East London Polytechnic and went on to produce memorable fashion editorial for magazines including i-D, 'The Face', 'Arena', 'Blitz', British 'Vogue', 'Tempo' and 'Harper's' and 'Queen'. Lebon was a key player in the 'Buffalo' aesthetic spearheaded by stylist, Ray Petri in the '80s. Lebon has created commercial campaigns for many clients including Katherine Hamnett, John Galliano, Jean-Paul Gaultier, Bodymap and Vivienne Westwood. In the mid '80s, he founded Crunch Productions Ltd, a company specialising in fashion, advertising, broadcasting and music promotion. Lebon has two sons, Tyrone and Frank.

Mark Mann, Photographer

Mark Mann is a New York based celebrity and sports photographer. Born and raised in Glasgow, Mark studied photography at Manchester Polytechnic and on graduating assisted photographers Nick Knight and Miles Aldridge. Mann relocated to New York three years later and started shooting for 'Men's Health', 'Vibe', 'Spin', 'Fortune', 'Billboard', 'Parade' and 'Complex'. Mann has photographed celebrities including Iggy Pop, Jack Black, the Black Eyed Peas, David LaChapelle, Jerry Seinfeld, Joan Jet and Rihanna. His advertising clients have included Reebok, Gillette, Vitamin Water, Ford, Chrysler and Sean John. Mann's portraits have featured in several coffee table books, including 'Rolling Stone's Tattoo Nation' and 'Hip-Hop Immortals' and were recently on display at the New Museum in

New York City. In April 1990, Mann, together with Nick Knight and Craig McDean shot the images that made up the montage cover of The Chaos Issue.
markmannphoto.com

Mark Mattock, Photographer

Mark Mattock is a British photographer. Born in 1961, Mattock studied graphic design at Central Saint Martins and on graduating went on to work with iconic Art Director Neville Brody. Mattock later became Design Director of 'Arena' magazine, but left to concentrate on his photography soon after winning the Magazine Designer of The Year Award. Mattock photographed Kylie Minogue for The Next Issue of i-D, in 1997. He has since shot for fashion magazines from British 'Vogue' to the 'Big Issue' and ads from Honda to Armani. Mattock recently took a step back from the fashion world to concentrate on personal work and fishing!
markmattock.com

Matt Jones, Photographer

Matt Jones is a London born, New York based photographer. The son of i-D founders, Terry and Tricia Jones, Matt grew up with i-D in the house and he's now based stateside as the magazine's New York Editor. Matt's first contribution to i-D was a shoot of Damien Hirst naked, taken when Matt was just nineteen years old. "I was incredibly nervous but it was my idea and Damien was very willing," Matt recalls. Jones has since shot 18 covers of i-D and his extensive celebrity portraits include Cate Blanchett, David Lynch, Barack Obama, Gwyneth Paltrow, Beyoncé and many others. His work has been exhibited internationally with two recent shows: Colette in Paris and the Oblong Gallery in London. Matt's editorial work has featured in 'GQ', 'Life', 'Esquire', 'Elle' and 'The New York Times' among others.

Matthew R Lewis, Photographer

Matthew R Lewis was born in Hertfordshire in 1959. He studied theatre design, first in North London and then at Antioch College, Ohio, before teaching himself the art of photography. A regular contributor to i-D, Lewis shot three consecutive covers for the magazine, from March 1993 to May 1993. He was also a regular contributor to 'Frieze', 'Attitude' and 'Gay Times', photographing such cultural personalities as Boy George, Leigh Bowery, Malcolm McClaren and Quentin Crisp, and in the nineties up and coming bands like Oasis. Lewis' photographic work has featured in two books, 'Fully Exposed' by Emmanuel Cooper and 'With Gilbert and George in Moscow' by Dan Farson. His work had a raw and insightful quality to it, which has been likened to that of Diane Arbus. Lewis took his own life in May 2009, aged forty-nine. His work was the subject of a posthumous exhibition called 'Of Gods and Monsters' at The Movie Poster Art Gallery in London in August 2009.
matthewrlewisportraits.co.uk

Matthias Vriens-McGrath, Photographer

Before establishing himself as one of the world's most influential fashion photographers, Matthias Vriens-McGrath worked as the Editor-in-Chief/Creative Director of 'DUTCH' magazine, the Worldwide International Creative Director of Giorgio Armani and the Senior Art Director at Gucci Group. Today, splitting his time between Los Angeles and New York, he is currently

working on project BL33N, an online t-shirt magazine project. The Dutch photographer is a regular contributor to i-D, 'Numéro', 'Numéro Homme', 'Glamour', 'Details' and 'The New York Times T Magazine'. Vriens-McGrath has shown his work in two solo shows at The Project, his gallery in New York, as well as various museums worldwide, including the Museum Modern Stockholm and the Nederlands Foto Instituut in Rotterdam. Vriens-McGrath collaborated with artist, Francesco Vezzoli on the iconic cover of Cate Blanchett for The Art and Commerce Issue of i-D, in December 2007.

Max Vadukul, Photographer
Max Vadukul is a self-taught British photographer whose powerful, thought-provoking images have graced the pages of the world's leading fashion magazines for over 20 years. Max first found fame shooting the campaign for Yohji Yamamoto in 1984. After this, Vadukul spent seven years in Paris working for French 'Vogue' and 'Egoiste' and became well known for his black and white photography. On moving to New York, he began collaborating with Tina Brown, formerly of Vanity Fair, which led to a three-year contract with 'The New Yorker' - the second contract ever given to a photographer in the magazine's 100-year history (the first was to Richard Avedon). In September 2000, Callaway published a retrospective of Vadukul's work entitled 'MAX' and Piccolo Press soon followed step in 2001 with Crazy Horse - a limited edition book featuring Vadukul's pictures of the Parisian cabaret, designed by Stephen Gan of 'Visionaire'. His work has been published most frequently in 'Vogue Italia', 'L'Uomo Vogue', French 'Vogue', 'Vogue China', 'Vanity Fair', 'Rolling Stone' and 'The New Yorker'. Vadukul lives in New York with his wife Nicoletta Santoro, the Fashion Director of Vogue China, and twins Alx and Eloise. He has shot three covers for i-D, his favourite being Angela Lindvall for the cover of The Self Issue in October 2000. Vadukal has directed four breakthrough films for the new 'A Line of Yohji' brand.
maxvadukul.com

Mert Alas and Marcus Piggott, Photographers
Mert Alas and Marcus Piggott met in 1994 and began a partnership, which would be responsible for creating some of the most graceful, immaculate images in fashion. They have shot three covers for i-D, the first of Bjork for The Original Issue in September 2000 and the second of Kate Moss, dressed as a cat, for The Individual Issue in April 2003. These two women epitomize their style of taking portraits of powerful and sophisticated women. Their most recent cover was a Givenchy special and featured model Mariacarla Boscono seductively caressing the face of Givenchy head designer Riccardo Tisci. Before meeting, Alas studied classical piano and cello in his native Istanbul and Welsh-born Piggott was living in England, where they joined forces. The duo has contributed to numerous international publications, including 'American Vogue', 'Vogue Italia', 'W', 'Pop', 'Numéro' and 'Arena Homme Plus'. Commercial clients include Louis Vuitton, Missoni, Giorgio Armani, Fendi, Miu Miu and Kenzo.

Michel Momy, Photographer
Michel Momy first started working with Terry Jones in the late 1970s, when Jones was Art

Director of British 'Vogue'. Born in France in 1947, Momy bought his first camera in Tokyo in 1973 and within two years he was shooting for 'Elle' and Façade in Paris. Momy started contributing to i-D in 1980, photographing rock stars of the time including Alan Vega from the band Suicide. Moving to New York, Momy studied film at Parson's School of Art which led to him working with a number of prominent publications, as well as shooting a controversially erotic advertising campaign for Bloomingdale's. Momy has lived in Paris since 1985, where he continues to shoot editorial and advertising campaigns for the likes of Hermès and Orange. In November 2001 he shot Charlotte Gainsbourg for the cover of The Memory Issue.
michelmomy.com

Moira Bogue, Designer
Moira Bogue was Terry Jones' first graphic design assistant at i-D. Born in Rio de Janeiro in 1960, Moira moved to London in her late teens to study graphic design. She worked as graphic designer at i-D from 1981 to 1987 and even starred on the cover of the Out Already Issue, photographed by Steve Johnston in December 1982. On leaving i-D, Moira formed a design partnership of her own, working as consultant, art director, designer and photographer. Her clients have included Conran, Next Directory, Sony Music, Hodder & Stoughton and Amouage. Since 1990 Moira has studied Japanese Ido shiatsu, reflexology, massage, herbalism and yoga. Today she works as a freelance graphic designer in London, where she lives with her husband and their two children.

Nick Knight, Photographer
Nick Knight has a long history with i-D magazine, photographing his first cover in April 1983 for The All Star Issue, featuring Sade. Since his time as Commissioning Picture Editor of the magazine Knight has shot for 'W', British 'Vogue', 'Another Man', 'Another', 'Dazed & Confused', French 'Vogue' and 'Visionaire'. He has collaborated with celebrated international designers including Yohji Yamamoto, John Galliano, Gareth Pugh and Alexander McQueen, as well as photographing advertising campaigns for Christian Dior, Lancôme, and Yves Saint Laurent. Knight has released a number of books, the first of which was Skinheads, published in 1982 and more recently, Nick Knight in 2009. Knight's work has been exhibited in notable institutions including International Centre of Photography, V&A Museum, Saatchi Gallery, Hayward Gallery and Tate Modern. Over the past decade, Knight's work has consistently championed film and moving image as the ideal medium for fashion in the digital age. Convinced of the importance of the Internet in shaping the new medium of fashion film and inspired by the creative freedom it offered, Knight founded the award-winning fashion website SHOWstudio.com in 2000.
nickknight.com

Nigel Shafran, Photographer
Nigel Shafran is a British photographer who first started shooting for i-D in the late eighties. Shafran photographed French actress Aure Attika for the cover of The Action Issue in December 1990 and went on to establish himself as a world-respected fashion photographer, with his work appearing in magazines including i-D, 'Vogue', 'Harpers Bazaar' and 'The Face'. Since then

Shafran's work has been exhibited at The Photographers' Gallery, the Victoria and Albert Museum, Tate Britain, Fig-1 and MW Projects. Today his chosen subject matter is deliberately low-key and often captures domestic, everyday occurrences such as the washing up, charity shops and car boot sales. Shafran has published five books, including 'Ruth's Book', 'Edited Photographs', 'Dad's Office' and 'Flowers for …'
nigelshafran.com

Normski, Photographer
Normski is a north London born and bred music photographer, TV presenter and journalist. Normski shot his first story for i-D in 1988, when Features Editor Beth Summers called him up to ask for contacts in the music industry for a forthcoming i-D shoot. Instead of just handing the information over, Normski offered to shoot the story himself and his initiative was rewarded with a 7-page story of Polaroids in the next issue. Normski went on to shoot Diana Brown for the cover of The Energy Issue in September 1989. His TV career kicked off in 1991 when he landed the job of presenter on dance music program 'Dance Energy' on BBC 2, which ran for five series. In September 2003, Normski exhibited his photographs of urban street culture at London's Proud Gallery, entitled 'Hip Odyssey'.
normskiphotography.com

Olivier Rizzo, Stylist
Olivier Rizzo graduated from the Royal Academy of Fine Arts in Antwerp, then assisted various Belgian designers before he started his career as a freelance stylist and creative consultant. He has produced work for numerous magazines including i-D, 'Another', 'V', 'Arena Homme Plus', 'Fantastic Man', 'Vogue Italia' and 'Love' and has worked with many top photographers including Willy Vanderperre, Steven Klein, Mert Alas & Marcus Piggott, Steven Meisel, Craig McDean, Alasdair McLellan and David Sims. Olivier has worked on catwalk shows including Prada, Miu Miu, Jil Sander, Dolce & Gabbana and Louis Vuittton, and has been involved in advertising campaigns for Prada, Raf Simons, Jil Sander, Calvin Klein, Giorgio Armani, Lanvin and Louis Vuitton. Olivier has worked on a number of covers for i-D, including styling Miranda Kerr, shot by Willy Vanderperre for the Summer For Love Issue of i-D May 2010. His first i-D cover, also with Willy Vanderperre, was of Chloe and Robbie for The Inspiration Issue of i-D February 2001, of which Raf Simons was guest editor. Remembering the experience, Olivier states, "It was very emotional, we were very close to them, and we really believed in them."

Panos Yiapanis, Stylist
Stylist Panos Yiapanis was first introduced to the fashion industry via his good friend the photographer Corinne Day. London based stylist has since made a name for himself styling editorial for publications including i-D, 'Arena Homme Plus', 'Vogue Italia', 'Love' and 'V', and working with photographers including Mert Alas and Marcus Piggott, Nick Knight, Juergen Teller, Steven Klein, Alasdair McLellan and Inez Van Lamsweerde and Vinoodh Matadin. Stylist for Givenchy and Rick Owens, Panos' dark, brooding aesthetic has established his position as one of the most exciting stylists working in the fashion industry today. Panos recently teamed

with photographer Willy Vanderperre to style pop star Rihanna and with Mert & Marcus to shoot the Givenchy special with Riccardo Tisci and MariaCarla Boscono for the Pre-Spring issue of i-D 2010.

Paolo Roversi, Photographer
Paolo Roversi was born in Italy in 1947. His love for photography blossomed on a family holiday to Spain, which resulted in the young Roversi setting up a darkroom in a vacant cellar together with the local postman, also a keen amateur snapper. In 1970, Roversi started work with Associated Press; his first assignment was to document Ezra Pound's funeral in Venice. Roversi moved to Paris in 1973, where he fell in love with fashion photography. His work has since appeared in i-D, 'Harper's Bazaar', British 'Vogue', 'Vogue Italia', 'Interview' and 'Marie Claire'. Roversi has also collaborated with commercial clients including Yohji Yamamoto, Comme des Garçons, Christian Dior and Givenchy. Roversi has shot eight covers for i-D starring Devon Aoki, Isabelle Huppert, Clemence Poesy, Kirsten Owen, Lisa Ratcliffe, Naomi Campbell, Georgia Jagger and most recently Natalia Vodianova for The Home is where the Heart is Issue, Spring 2010.
paoloroversi.com

Pat McGrath, Make-Up Artist
Pat McGrath is one of the most famous and respected make-up artists of our generation. Born in Northampton in 1966, Pat completed an art foundation, before moving to London to establish herself as a make-up artist. McGrath made her i-D debut at the start of the 90s in a 'plastic' story photographed by Craig McDean and styled by Edward Enninful, with whom she has gone on to collaborate with on a successful international level. Beauty Director of i-D, McGrath regularly collaborates on major fashion advertising campaigns for brands including Prada, Alberta Ferretti, Calvin Klein and Lanvin. While her editorial work with top photographers like Steven Meisel for Italian and American 'Vogue' continually breaks new ground. McGrath dispenses her knowledge in the expert advice pages of 'Allure'. Her celebrity clients have included Madonna, Jennifer Lopez, Oprah Winfrey, Sarah Jessica Parker and Gwyneth Paltrow. Pat currently devises the catwalk make-up for designers including Gucci, Yohji Yamamoto, Christian Dior, Dolce & Gabbana, Versace, John Galliano and Viktor & Rolf.

Patrick Demarchelier, Photographer
Patrick Demarchelier was born in 1943 in Le Havre, Normandy. He received his first camera as a present for his seventeenth birthday and set about capturing his friends, family and the occasional wedding. Patrick learnt how to retouch and develop films as he went along, and in 1975 he left Paris for New York where he began work as a freelance fashion photographer. Demarchelier's work soon captured the attention of high profile magazines and his editorial shoots have since appeared in i-D, 'Vogue', 'Harper's Bazaar', 'Elle', 'Marie Claire', 'Newsweek', 'Glamour' and 'Mademoiselle', amongst many others. Demarchelier photographed model Dewi for i-D's The Beach Issue in March 2003. His commercial campaigns include Dior, Louis Vuitton, Chanel, Ralph Lauren, Calvin Klein and Yves Saint Laurent. Demarchelier was inducted as an Officier dans

l'Ordre des Arts et des Lettres in 2007. Today he is based in New York with his wife Mia and their three children.
demarchelier.net

Patti Wilson, Stylist
Patti Wilson was born in New York. She spent her early career working as a waitress and then a hostess in a jazz club before finding work as a stylist's assistant. Patti began working for i-D in the early 90s and has since styled eight covers for the magazine, working with Ellen Von Unwerth, Terry Richardson, Steven Klein and David LaChapelle and styling celebrities and supermodels including Mel B, L'il Kim, Courtney Love, Shirley Manson and Naomi Campbell. As well as i-D, Patti is a regular contributor to 'Vogue Italia', Russian 'Vogue', 'Vogue Nippon', 'L'Uomo Vogue', 'Numéro', 'Harpers Bazaar' and 'V', working with such photographic heavyweights as Steven Meisel, Steven Klein, Peter Lindbergh, Paolo Roversi, Jean-Baptiste Mondino, Miles Aldridge and Sølve Sunsbø.

Philip Sinden, Photographer
Philip Sinden is an editorial and advertising photographer working in London, Europe and the US. Sinden first started shooting for i-D when his good friend commissioned him to shoot a fashion story with the stylist Beth Summers. "It was very different to what I was used to shooting at the time," Sinden recalls, "there were early nerves but then we worked out what we were doing and it was really exciting. We shot an eight page story with a cover try." The shoot was a success and Sinden went on to photograph model, Kathleen, for the cover of The Secrets Issue in March 1989. As well as i-D, Sinden contributed to British 'Vogue', 'Harper's Bazaar' and Condé Nast 'Traveller'. He has also shot commercial work for clients Lexus and Paul Smith. Sinden cites "family and friends" as his main source of inspiration.
philipsinden.com

Richard Burbridge, Photographer
Richard Burbridge began his career in photography in the early nineties and moved to New York in 1993, where he is still based. His first contribution to i-D was a picture of an exploding firework, after he met Nick Knight. "I went and met with Nick [Knight], who was the photo editor. Nick asked me if I would like to shoot for the magazine. I said yes." Richard has since photographed numerous i-D covers, his favourite of which being his first with Amber Valetta for The Kinetic Issue in March 1999. Burbridge collects old scientific and optical devices and his interest in science is often reflected in his photography. He is also heavily inspired by art, particularly that of Sigmar Polke. As well as i-D, Burbridge has contributed to magazines such as 'Self Service', 'Another', 'Vogue Italia' and 'V'. He has also shot commercial work for clients including MAC, Givenchy, Hermes and Louis Vuitton.

Richard Bush, Photographer
Richard Bush was born in Hampshire in 1973. He studied French at King's College London before embarking on a career in photography. Self-taught, Richard's first published work was in 'Creative Review' in December 1999. He met stylist Jane How in March 2001, which sparked his career at i-D. Today Richard works with some of the industry's leading names

and is a regular contributor to i-D, Japanese 'Vogue', 'Numéro', 'Dazed & Confused' and 'Another'. Bush also boasts campaigns with Yohji Yamamoto, Paco Rabanne Fragrance, L'Oreal Paris and L'Oreal Professional. He cites "great ideas and people" as his main source of inspiration. Bush shot two covers for i-D in 2006, Patricia Schmid for The Me and Mine Issue in April and Angela Lindvall for The Happiness Issue in October.

Robert Erdmann, Photographer
Robert Erdmann studied History of Photography at Princeton University in New Jersey. He went on to assist Helmut Newton, among other photographers, before moving to Italy to work as a stylist. Erdmann moved to London in 1984 where he set about establishing himself as a photographer; shooting fashion, as well as musicians such as Iggy Pop, Kylie Minogue, Frankie Goes to Hollywood, Simply Red and Bananarama for magazines including i-D and 'The Face'. Erdmann has shot six covers for i-D including Naomi Campbell's first i-D cover, The Dramatic Issue in August 1986. He has also contributed to French, British and German 'Vogue's', various 'Elle's', 'Marie Claire', assorted magazines at 'US Condé Nast', as well as men's magazines including British 'GQ', US 'GQ', 'L'uomo Vogue', 'Vogue Hommes' and 'Vogue Hommes International'. Erdmann is now based in Los Angeles.
roberterdmann.com

Scott King, Designer
Scott King trained as a graphic designer and became Art Director of i-D after Terry Jones gave him a job on the spot immediately after his interview. From his first day, when he struggled to cut a straight line, King went on to design some of the most memorable i-D covers of the '90s, including The Supernova Issue in July 1996, which featured a shot of Garbage front woman Shirley Manson by Ellen von Unwerth. King commented on this cover saying, "I'm sorry Terry. The picture didn't quite fit on the cover". After i-D, King briefly became Creative Director of 'Sleazenation', winning Best Cover and Best Designed Feature of the Year awards for his work there. He occasionally collaborates with the historian Matt Worley under the banner 'CRASH!'. King's work has been exhibited in galleries and museums worldwide including: The Institute of Contemporary Arts, London, Kunst-Werke Berlin, Kunstverein Munich, the Museum of Contemporary Art, Chicago and the Museum of Modern Art, New York.

Simon Foxton, Stylist
Born in 1961 in Berwick-Upon-Tweed, Simon Foxton has been contributing to i-D since the magazine featured his Central Saint Martins graduate collection in 1983. Subsequently, then fashion editor Caryn Franklin asked him if he wanted to do some styling. Foxton met up with Terry Jones, who introduced him to Nick Knight, who he has continued to collaborate with ever since. Today, he is Consultant Fashion Director for i-D magazine and is inspired by, "the same things as always; looking at people and twisting and mixing dress codes." As well as i-D, Foxton has also contributed to a number of international publications including 'The Face', 'Arena Homme Plus', 'Vogue Hommes International', 'Details', 'Fantastic Man', 'W' and 'Big

Magazine'. Foxton has also worked as Creative Consultant for commercial clients such as Levi's, Converse, Caterpillar and Stone Island. The Photographer's Gallery in London hosted his first solo exhibition in 2009. Foxton identifies his most memorable cover as the first one he styled, an image of model Kate by Nick Knight, in a pair of optician's lens trial glasses, because of its graphic strength.

Sivan Lewin, Photographer

Sivan Lewin is a photographer. She studied at The London School of Economics, the Royal College of Art and the Art Institute of Chicago. Lewin's work has been exhibited at The Photographer's Galley, The National Gallery, The V&A and The Courtauld Institute of Art and in the Nederlands Foto Institute in Rotterdam. In 1993 she was awarded the John Kobal Photographic Portrait Award. Her work has appeared in 'W', American 'Vogue', 'New York Times Magazine', 'House & Garden' and 'Elle'. In December 1992, Lewin shot model Nova for the cover of The Strength Issue of i-D. Her commercial clients include Anthropologie, Marks & Spencers, Kate Spade, Barneys New York, Bergdorf Goodman, Banana Republic and Nike. Lewin is currently based in New York.
sivanlewin.com

Sølve Sundsbø, Photographer

Sølve Sundsbø was born and raised in Norway. In 1995 he moved to London and began studying at the London College of Printing, becoming Nick Knight's assistant after just 4 months. Since then, he has become a regular contributor to publications including i-D ,'Pop', 'The Face', Italian 'Vogue', 'Numéro', 'Big', 'Visionaire', 'V', 'Interview' and 'Vogue Nippon'. His commercial clients have included Chanel, Cartier, Dior, Dolce & Gabbana, Hermès, H&M, Levis, Nike and Yves Saint Laurent. In 1999 Sundsbø was voted the best newcomer at the International Festival of Fashion in Hyères. Sølve has produced films for Nike, Gucci, Biotherm and SHOWstudio. In 2009, Sundsbø shot a staggering twelve cover stars for The Best of British Issue of i-D which he describes as "pretty hard to forget," He continues to live in London with his wife and 3 sons and is inspired by, "the same things as ten years ago: everything, everyone, everywhere, all the time."

Stefan Ruiz, Photographer

Stefan Ruiz was born in San Francisco and studied painting and sculpture at the University of California and the Accademia di Belle Arti in Venice. His passion for photography began in West Africa, where he documented Islamic influence on local art. Between 1992 and 1998, Ruiz taught art at San Quentin State prison. He went on to establish himself as a professional photographer contributing editorial work to publications including 'The New York Times' T Magazine', 'The Sunday Telegraph' and 'Vogue Italia'. Ruiz started shooting for i-D in the early 90s and continued to work with Terry Jones on advertising campaigns. He has since won awards for his work with Caterpillar, Camper, Diesel, Air France and Costume National. In October 1993, Ruiz shot Tania Court styled by Edward Enninful for The New Look Issue.
stefanruiz.com

Stéphane Sednaoui, Photographer

Stéphane Sednaoui is a French photographer and film director. Sednaoui began working as a photo journalist, portraitist and advertising photographer before finding success as a fashion and celebrity photographer in the late 80s. Celebrities photographed include Madonna, Bjork, Kylie Minogue, Charlotte Gainsbourg and Courtney Love. Sednaoui's images have graced the pages of i-D, 'Vogue Italia', 'Vanity Fair', 'The New York Times' T Magazine', 'Numéro', 'The Face' and 'Vogue Hommes International'. In the early 90s, Sednaoui decided to branch out from photography and work with film, directing music videos for Björk, Nenah Cherry, the Red Hot Chili Peppers, Smashing Pumpkins, Massive Attack, Tricky, Tina Turner, Garbage, Madonna and U2 to name a small few. Sednaoui shot singer, Kelli from the 'Sneaker Pimps', for The Escape Issue of i-D in January 1997. A compilation of Sednaoui's music videos and short films, entitled 'Work of Director: Stephane Sednaoui' was released on DVD in September 2005. Stéphane is currently working on a photographic book of Tibet.

Steve Johnston, Photographer

Steve Johnston was born in Glasgow in 1956. He attended Carlisle Art College where he initially studied painting before transferring to photography in his second year. In 1977 Johnston met Terry Jones, who was then Art Director of British 'Vogue'. Johnston was shooting The Jam for 'Vogue' and he and Terry hit it off immediately. A year later he collaborated with Jones on the iconic 'Pink Punk Book', developing the straight-up style of photography i-D is famous for today. Johnston collaborated with i-D for a few years after its launch in 1980, during which time he shot three covers for the magazine. In 1991 Johnston turned his attention to painting and is now known for his ephemeral scenes of defined figures on a minimal background.
stevejohnstonartist.com

Steven Klein, Photographer

Steven Klein studied Fine Art at the Rhode Island School of Design before turning his attention to photography in the early 90s. He has since established himself as one of the most prolific photographers working today. Based in New York, Klein produces epic fashion stories for publications worldwide, including i-D, 'W', American 'Vogue' and 'Vogue Italia'. Klein shot his first cover for i-D, starring model Veronica Webb, in January 1994. He has since shot seven covers for the magazine, his favourite being the August 1994 USA Issue capturing Naomi Campbell and Kate Moss skipping out of a nightclub in the Meatpacking District of New York. As well as his prolific career in photography, Klein has published books, created video installations and photographed high-profile advertising campaigns for the likes of Calvin Klein, Dolce & Gabbana, Alexander McQueen and Nike. His photographic work has been the subject of solo exhibitions at Deitch Gallery in New York and Gagosian Gallery, Beverly Hills.
stevenkleinstudio.com

Takashi Homma, Photographer

Takashi Homma is a celebrated Japanese photographer. Born in Tokyo in 1962, Takashi graduated from Tokyo's Nihon University and then spent six years working at Light Publicity advertising agency. He moved to London in 1991 and worked as a freelance photographer. Homma soon began shooting for i-D and photographed models Lorella and Tatiana for the cover of The Technology Issue in March 1992. A year later he returned to Tokyo and now works in both editorial and commercial photography. In 1998, Homma won the Kimura Ihei Memorial Photography Award. Takashi has published several books of work, including 'Tokyo Surburbia' in 2000. He has also taken part in exhibitions all over the world, including one at London's Hayward Gallery.

Terry Richardson, Photographer

Terry Richardson is a world-renowned fashion and celebrity photographer. Born in New York City, Terry's love of photography began at high school, photographing himself, his friends and his surroundings. Richardson has since shot ten i-D covers and even starred in one himself (The Beat Issue, July 2003), alongside Chloë Sevigny. As well as i-D, Terry is a regular contributor to 'Purple', 'Dazed & Confused', 'W', 'GQ', 'Harper's Bazaar', and British and French 'Vogue'. His commercial clients have included Gucci, Sisley, Miu Miu and Chloé, while his impressive list of celebrity subjects includes Daniel Day Lewis, Leonardo DiCaprio, Vincent Gallo, Tom Ford, Jay Z, Kanye West, Karl Lagerfeld and Pharrell Williams. Often appearing in his shoots alongside his sitters, Richardson's photographs have appeared in numerous solo and group exhibitions across the world and a number of books, most recently 'Terryworld 25th Anniversary Edition', published by TASCHEN in 2008. Terry has also shot music videos and commercials and is currently working on his first feature film.
terryrichardson.com

Tesh, Photographer

Tesh studied mathematics at the University of Sussex, before moving back to London to pursue a career in photography. His first job was as an assistant to Norman Watson, who he worked with until 1998. After meeting Edward Enninful in 2000, Tesh began shooting for i-D. He has since shot thirteen covers for the magazine, his first cover being The Renaissance Issue in March 2001, starring Kate Moss in matching military coat and cap and his most recent, starring Kate Moss again, this time naked, was for The Name Issue in September 2005. Tesh's work has appeared in a number of other publications including British 'Vogue', 'Vogue Nippon', 'Flair', 'Harper's Bazaar' and 'V'. Tesh is now based in New York.

Thomas Degen, Photographer

Thomas Degen is a freelance photographer. Born in Germany in 1955, Degen launched himself as a professional photographer in 1979. On moving to London in the early 80s he began to contribute to i-D. Thomas shot the cover of The Sweat is Best Issue of i-D, art directed by Terry Jones. This was the 6th issue of i-D ever published and cost a mere 75pence. During this time, Degen also contributed to 'Vogue'. He has since shot fashion and beauty for numerous European clients, while Degen's international photographic projects have seen him travel to Afghanistan, Africa, India, Jamaica, Japan and the USA. Degen's favourite issue of i-D is the second issue, The Star Issue, printed in November 1980, which cost 60pence.

Tim Walker, Photographer

Tim Walker is a world-renowned British photographer. Born in 1970, Walker's fascination with photography began at Condé Nast, where he undertook a years work experience and helped set up the Cecil Beaton archive. Tim won first prize in the 'Independent on Sunday' and Olympus Fashion Photography Awards in 1994 and enrolled on a photography degree at Exeter College of Art not long after. On graduating, Walker assisted Richard Avedon before branching out on his own, initially concentrating on documentary and portrait photography for UK newspapers before shooting editorial for British 'Vogue', 'W' and 'Harper's Bazaar'. Today Walker contributes to a number of high-profile international titles and regularly collaborates with stylist Jacob K and set designer Shona Heath. He has also worked with numerous advertising clients. Walker's first contribution to i-D was a photograph of Lily Cole, styled by Edward Enninful for the cover of The Scratch and Sniff Issue in May 2006. While his favourite i-D cover is the one he created with artist Linder Sterling and Richard Nicoll for the Fall 2009 issue. Walker also loves Paolo Roversi's cover starring Kirsten Owen for The Anarchy Issue, July 1990.
timwalkerphotography.com

Tricia Jones, i-D Executive Director

The 'mum' of i-D, married to the job, here since the beginning! Born in 1947, London, Tricia married Terry Jones in July 1968, the beginning of a lifetime partnership, both personal and creative. Mum to Kayt and Matt Jones who are both international photographers, Tricia started her career as an infant school teacher, teaching from 1968-1985. Involved from the very beginning of the i-D story as the "maker of pasta". Tricia looked after the students who worked on the earliest issues of i-D but her role changed and developed as the magazine grew. Special projects for i-D began in 1998 with the publication of Family Future Positive which saw Tricia as Editor for the first time; other books followed, Beyond Price (1999), Learn and Pass it On (2001) and Safe+Sound (2007). More recently Tricia was the Editor of SOUL i-D (TASCHEN, 2008), a 600-page book based on a selection from these projects, with an accompanying exhibition that continues to travel internationally. Tricia now curates the SOUL i-D section of the website, is a lover of Wales, big nature and super proud mum and grandma.
i-Donline.com

Venetia Scott, Stylist

Venetia Scott is a London-based stylist who began her career at British 'Vogue'. She went on to contribute to a number of other international publications including i-D, 'The Face', 'Vogue Italia', 'Self Service', 'Another' and 'W' and in 1999 became Fashion Director of Nova magazine. In 1997, Scott was appointed Creative Director at Marc Jacobs and Marc by Marc Jacobs. Other commercial clients include Margaret Howell, who Venetia has worked with for the last eight seasons, Calvin Klein Eternity, CK Jeans, Anna Molinari and Katharine Hamnett. Venetia has styled two covers for i-D, the first for The Open Air Issue in July 1993 and the second for The Killer Issue in October 1997, both photographed by Juergen Teller. She has shot the advertising campaign for Margaret Howell for the past eight seasons and she was commissioned to shoot the advertising for APC for Fall 2010/11.

Vincent Peters, Photographer

Vincent Peters was born in Germany in 1969. He began his photographic career taking snaps whilst travelling around Thailand in the 1980s. Moving to New York in 1989, he found work as a photographers' assistant, before focusing his attentions on fine art photography and exhibiting his work extensively across Europe. Since 1990, Peters has concentrated solely on fashion photography, contributing to publications including 'Vogue Italia', 'L'Uomo Vogue', French and British 'Vogue', 'Numéro', 'Arena', 'GQ', 'Dazed & Confused', and 'Ten'. Peters photographed pop superstar Mariah Carey for the cover of i-D's Hot Beaches Issue in June 2008. Today, he focuses mainly on celebrity and personality images and also directs short films and commercials. Peters' advertising clients have included Versace, Celine, Bottega Veneta, Armani, Miu Miu, Yves Saint Laurent, Lancôme, Guerlain, Guess, L'Oreal, Boss, Cartier, Levi's, Nike, Diesel, Victoria's Secret, DeBeers and many others.
vincentpetersphotography.com

Walter Pfeiffer, Photographer

Walter Pfeiffer is the Zurich based photographer whose portraits of friends, lovers, still life and scenery - always taken with a large dose of fun - have inspired a generation of photographers including Ryan McGinley, Terry Richardson, Wolfgang Tillmans and Juergen Teller. His publication 'Welcome Aboard, Photographs 1980-2000', brought with it a revival in the realistic photography movement at the turn of the century and since then Pfeiffer has collaborated with international magazines such as i-D, 'Butt', 'Vogue Hommes' and 'Vogue Paris'. Additionally, Pfeiffer has been the subject of numerous solo and group exhibitions. In 2008, Fotomuseum Winterthur presented 'In Love with Beauty', an unprecedented chronological overview of his work, spanning four decades from his beginnings in the early 1970s to his most recent work. An exhibition catalogue published by Steidl marked the event. His other publications include 'Cherchez La Femme!' (2007); 'Night and Day' (2007); 'Welcome Aboard 1980 - 2000' (2001); 'The eyes, the thoughts, ceaselessly wandering' (1986); and 'Walter Pfeiffer' (1970 - 1980) (1980). Spring of 2010 brings a career restrospective at Hyères 2010, the 25th annual international festival of fashion and photography. For i-D, Pfeiffer shot one of six covers for The Agyness Deyn Issue, starring the model in a burst of colour smearing paint over her face.
walterpfeiffer.com

Willy Biondani, Photographer

Brazilian born photographer Willy Biondani began shooting for i-D in the early 80s. "In the 80s I was fascinated with Terry Jones' work," Biondani remembers. "It was so free and had an incredible freshness. I needed to tell Terry how great I thought he was so I shot a photographic essay, in the 'Brazilian way' and sent it to him at i-D." Jones was impressed and Biondani went on to shoot Sylvia Ross for the cover of The Tribal Issue in March 1988. Biondani moved to Paris in 1989, where he lived for six years, shooting for i-D and 'Vogue Italia'. Biondani moved back to his native São Paulo in 1996. Inspired by, "cultures, the ways in which civilisation has developed and new possibilities," he has since shot advertising campaigns for Unilever, L'Oreal, Siemens, Nivea, Natura and GM. Biondani's favourite cover of i-D is The Happy Issue for December 1987. The cover featured the smiley face logo, which Willy believes represents the i-D spirit perfectly.

Willy Vanderperre, Photographer

Belgian photographer Willy Vanderperre studied fashion design at the Royal Academy of Fine Art in Antwerp for two years before transferring to the photography department. His first show was at Modo Bruxelea and was curated by fellow Belgians Peter de Potter and Olivier Rizzo, who he still works with regularly. Vanderperre and Rizzo collaborated on their first i-D cover, a shot of models Chloe and Robbie for The Inspiration Issue in February 2001. Willy said of this shoot, "we believed in the models, it was completely right for the time," this was also their first international magazine cover. As well as contributions to i-D, Vanderperre has also worked with 'Arena Homme +', 'Another', 'Vogue', 'V', 'Fantastic Man' and recently photographed Rihanna for the Spring issue cover and Miranda Kerr for the i-D Summer issue cover, 2010.
-

Wolfgang Tillmans, Photographer

Wolfgang Tillmans was born in Remscheid, Germany in 1968. Arriving in Britain from Germany in 1990 Wolfgang Tillmans studied in Bournemouth before moving to London where he engulfed himself in a tight-knit group of creatives, embarking on making era-defining pictures of his friends and environment. After Turner Prize glory in 2000 the noughties saw Wolfgang embrace abstraction and semi-sculptural work. Tillmans work has been featured in a number of publications and exhibitions including the major survey exhibitions at the Hamburger Bahnhof, Berlin, in 2008, the Museum of Contemporary Art, Chicago in 2006, Tate Britain in 2003, Andrea Rosen Gallery in New York, and a solo show at the Serpentine Gallery in July 2010. Featuring athletes, babies, architecture, clothing and eggs, from India to Mexico, everything here is seemingly random but as always everything here is cohesive, original, incisive and as weirdly wonderful as Wolfgang himself. His contribution to the i-D covers archive was a shot of M.I.A. for the June 2005 issue.
tillmans.co.uk

INDEX

308 **The 30th Birthday Issue** Pre-Fall 2010 Lady Gaga Photography Nick Knight 308 **The 30th Birthday Issue** Pre-Fall 2010 Kate Moss Photography Nick Knight

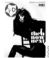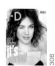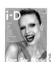

308 **The 30th Birthday Issue** Pre-Fall 2010 Naomi Campbell Photography Nick Knight 307 **The Heads, Shoulders, Knees and Toes Issue** Summer 2010 Gisele Bündchen Photography Matt Jones 307 **The Heads, Shoulders, Knees and Toes Issue** Summer 2010 Janeil Williams Photography Daniel Jackson Styling Marie Chaix 307 **The Heads, Shoulders, Knees and Toes Issue** Summer 2010 Cover Star Miranda Kerr Photography Willy Vanderperre Styling Olivier Rizzo Hair by Ben Skervin Make-up by Sally Branka 306 **The Home is Where the Heart is Issue** Spring 2010 Cover Star Natalia Photography Paulo Roversi Styling Cathy Kasterine 306 **The Home is Where the Heart is Issue** Spring 2010 Cover Star Freja Beha Photography Emma Summerton Styling Edward Enninful Hair by Ben Skervin Make-up by Mathias van Hooff 306 **The Home is Where the Heart is Issue** Spring 2010 Cover Star Sasha Pivovarova Photography Emma Summerton Styling Edward Enninful Hair by Sam McKnight Make-up by Alex Box 305 **The Lovers of Life Issue** Cover Star Riccardo Tisci and MariaCarla Boscono Photography Mert Alas and Marcus Piggott Styling Panos Yiapanos Hair by Luigi Mureno Make-up by Charlotte Tilbury 305 **The Lovers of Life Issue** Pre Spring 2010 Cover Star Natasha Poly Photography Emma Summerton Styling Edward Enninful Hair by Ben Skervin Make-up by Mathias Van Hooff 305 **The Lovers of Life Issue** Cover Star Rihanna Photography Willy Vanderperre Styling Panos Yiapanos Hair by Ursula Stephen Make-up by Karin Darnell

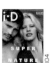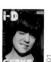

304 **The Flesh and Blood Issue** Winter 2009 Cover Stars Helena Christensen, Claudia Schiffer and Eva Herzigova Photography Kayt Jones Styling Pippa Vosper Hair by Ed Moelands Make-up by Hung Vanngo 304 **The Flesh and Blood Issue** Winter 2009 Cover Star Georgia Jagger Photography Paolo Roversi Styling Cathy Kasterine Hair by Odile Gilbert Make-up by Marie Duhart 304 **The Flesh and Blood Issue** Winter 2009 Cover Star Lara Stone Photography Alasdair McLellan Styling Edward Enninful Hair by Samantha Hillerby Make-up by Lisa Butler 303 **The Insi-De Outsi-De Issue** Art work Linda Sterling Photography Tim Walker Styling Jacob K Hair by Malcolm Edwards Make-up Sam Bryant 303 **The Insi-De Outsi-De Issue** Cover Stars Frida Giannini and James Franco Photography Inez Van Lamsweerde and Vinoodh Matadin Styling Hair by Luigi Mureno Make-up by Tom Percheux 302 **The Pretty Young Things Issue** September 2009 Cover Stars Jourdan Dunn, Chanel Iman, Arlenis Sosa and Sessilee Lopez Photography Emma Summerton Styling Edward Enninful Hair by Ben Skervin Make-up by Mathias Van Hooff 301 **The F.U.N Issue** August 2009 Cover Star Lily Allen Photography Alasdair McLellan Styling Kate Moss Hair by Luke Hersheson Make-up by Sally Branka 300 **The 300th Issue** June/July 2009 Cover Star Tasha Tilberg Photography Kayt Jones Styling Pippa Vosper 300 **The 300th Issue** Cover star Lola Photography Juergen Teller

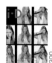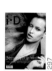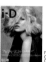

300 **The 300th Issue** Cover Star Sigrid Photography Alasdair McLellan Styling Jane How 299 **The Resourceful Issue** May 2009 Cover Star Chanel Iman Photography Kayt Jones Styling Pippa Vosper 298 **The Pleasure and Pain Issue** April 2009 Cover Star Miuccia Prada Photography Francesco Vezzoli Styling 297 **The Best of British Issue** March 2009 Cover Star Agyness Deyn Photography Sølve Sundsbø Styling Edward Enninful Hair by Luigi Mureno Make-up by Stephane Marais 297 **The Best of British Issue** March 2009 Cover Star Alice Dellal Photography Sølve Sundsbø Styling Edward Enninful Hair by Luigi Mureno Make-up by Stephane Marais 297 **The Best of British Issue** March 2009 Cover Star Daisy Lowe Photography Sølve Sundsbø Styling Edward Enninful Hair by Luigi Mureno Make-up by Stephane Marais 297 **The Best of British Issue** March 2009 Cover Star Eliza Cummings Photography Sølve Sundsbø Styling Edward Enninful Hair by Luigi Mureno Make-up by Stephane Marais 297 **The Best of British Issue** March 2009 Cover Star Jourdan Dunn Photography Sølve Sundsbø Styling Edward Enninful Hair by Luigi Mureno Make-up by Stephane Marais 297 **The Best of British Issue** March 2009 Cover Star Kate Moss Photography Sølve Sundsbø Styling Edward Enninful Hair by Luigi Mureno Make-up by Stephane Marais 297 **The Best of British Issue** March 2009 Cover Star Lily Donaldson Photography Sølve Sundsbø Styling Edward Enninful Hair by Luigi Mureno Make-up by Stephane Marais

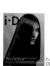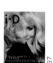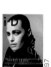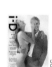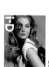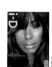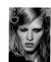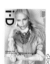

297 **The Best of British Issue** March 2009 Cover Star Naomi Campbell Photography Sølve Sundsbø Styling Edward Enninful Hair by Luigi Mureno Make-up by Stephane Marais 297 **The Best of British Issue** March 2009 Cover Star Stella Tennant Photography Sølve Sundsbø Styling Edward Enninful Hair by Luigi Mureno Make-up by Stephane Marais 297 **The Best of British Issue** March 2009 Cover Star Susie Bick Photography Sølve Sundsbø Styling Edward Enninful Hair by Luigi Mureno Make-up by Stephane Marais 297 **The Best of British Issue** March 2009 Cover Star Twiggy Photography Sølve Sundsbø Styling Edward Enninful Hair by Luigi Mureno Makeup by Stephane Marais 297 **The Best of British Issue** March 2009 Cover Star Yasmin Le Bon Photography Sølve Sundsbø Styling Edward Enninful Hair by Luigi Mureno Make-up by Stephane Marais 296 **The Manhood Issue** February 2009 Cover Star Ann Vyalitsyna and Boyd Holbrook Photography Matt Jones Styling Tina Chai Hair by Ryan Trygstad Make-up by Franchelle 295 **The Beautiful Issue** January 2009 Cover Star Eniko Mihalik Photography Inez Van Lamsweerde and Vinoodh Matadin Styling Hair by Oribe Make-up by Peter Phillips 294 **The i-Disco Issue** December 2008 Cover Star Leona Lewis Photography Emma Summerton Styling Edward Enninful 292 **The Piracy Issue** October 2008 Cover Star Natasha Poly Photography Emma Summerton Styling Edward Enninful Hair by Samantha Hillerby Make-up by Mathias Van Hooff

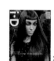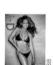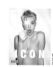

291 **The Too Die For Issue** September 2008 Cover Star Jourdan Dunn Photography Emma Summerton Styling Edward Enninful Hair by Sam McKnight Make-up by Charlotte Tilbury 290 **The Artisan Issue** August 2008 Cover Star Naomi and Stefano Pilati Photography Inez Van Lamsweerde and Vinoodh Matadin Styling Stefano Pilati Hair by Luigi Murenu Make-up by Tom Pechuex 289 **The Stepping Stone Issue** July 2008 Cover Star Sasha Pivovarova Photography Emma Summerton Styling Edward Enninful Hair by Ben Skervin Make-up by Mathias Van Hooff 288 **The Hot Beaches Issue** June 2008 Cover Star Mariah Carey Photography Vincent Peters Styling Mel Ottenberg Hair by Lew Ablahani Make-up by Keiko Takagi 287 May 2008 **The Agyness Deyn Issue** Cover Star Agyness Deyn Photography Walter Pfeiffer Styling Erika Kurihara Hair by Chi Wong Make-up by Florrie White 287 **The Agyness Deyn Issue** Cover Star Agyness Deyn Photography Alasdair McLellan Styling Kim Jones Hair by Luke HershesonMake-up by Sally Branka 287 **The Agyness Deyn Issue** Cover Star Agyness Deyn Photography Billy Sullivan Styling Lori Goldstein Hair by Teddy Charles Make-up by Ozzy Salvatierra 287 **The Agyness Deyn Issue** Cover Star Agyness Deyn Photography Terry Richardson Styling Agyness Deyn 287 **The Agyness Deyn Issue** Cover Star Agyness Deyn Photography Matt Jones Styling Alastair McKimm Hair by Kevin Ryan Make-up by Eric Polito

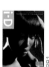

287 **The Agyness Deyn Issue** Cover Star Agyness Deyn Photography Matt Jones Styling Alastair McKimm Hair by Kevin Ryan Make-up by Eric Polito 286 **The Gender Agenda Issue** April 2008 Cover Star Rinko Kikuchi Photography Matt Jones 285 **The Who's That Girl Issue** March 2008 Cover Star Raquel Zimmerman Photography Emma Summerton Styling Edward Enninful Hair by Jimmy Paul Make-up by Mathias Van Hooff 284 **The Boyz II Men Issue** February 2008 Cover Star Gemma Ward and Lily Donaldson Photography Emma Summerton Styling Edward Enninful Hair by Danilo Make-up by Mathias Van Hooff 283 **The Art and Commerce Issue** December/January 2007/08 Cover Star Cate Blanchett Photography Matthias Vriens Styling Elizabeth Stewert Hair by Danilo Make-up by Jeanine Lobell 282 **The !s#? Issue** November 2007 Cover Star Kate Moss Photography Emma Summerton Styling Edward Enninful Hair by Sam McKnight Make-up by Val Garland 281 **The World Wide Web Issue** October 2007 Cover Star Naomi Campbell Photography Mario Sorrenti Styling Edward Enninful Hair by Orlando Pita Make-up by Tom Pechuex 280 **The Offspring Issue** September 2007 Cover Star Gemma Ward Photography Emma Summerton Styling Edward Enninful Hair by Danilo Make-up by Mathians 279 **The Couples Issue** August 2007 Cover Star Daisy Lowe and Will Blondelle Photography Terry Richardson Styling Mel Ottenberg

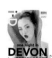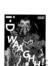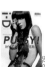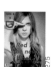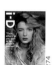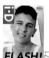

278 **The Ice Cream Issue** July 2007 Cover Star Devon Aoki and Devon and Jeremy Scott Photography Jeremy Scott Styling Jeremy Scott Hair by Jamal Hamadi Make-up by Kate Lee 277 **The Out of the Blue Issue** June 2007 Cover Star Björk Photography Inez van Lamsweerde and Vinoodh Matadin Styling Icelandic Love Corporation Hair by Christiaan Make-up by Andrea Helgadottir 277 **The White Trash Issue** May 2007 Cover Star Chan Marshall Photography Karl Lagerfeld Styling Christopher Niquet Hair by Terry Millet Make-up by Lloyd Simmonds 275 **The Tissue Issue** April 2007 Cover Star Clemence Poesy Photography Paolo Roversi Styling Marie Amélie Hair by Sam McKnight Make-up by Sam Bryant 274 **The Wild Women Issue** March 2007 Cover Star Lily Donaldson Photography Mario Sorrenti Styling Edward Enninful Hair by Recine Make-up by Linda Cantello 273 **The We Got Issues Issue** February 2007 Cover Star Caio Vaz Photography Collier Schorr Styling Monika Condrea and Erika Kunihara Hair by Hallie Bowman Make-up by 272 **The Older and Wiser Issue** December/January 2006/07 Cover Star Cassie and Puff Daddy Photography Magnus Unnar Styling Marni Senofonte Hair by Cesar Ramirez Make-up by Lena Karo 271 **The Youth Issue** November 2006 Cover Star Flash Louis Photography Alasdair McLellan Styling Kim Jones Hair by Luke Hersheson Make-up by Hannah Murray 271 **The Youth Issue** Cover Star Coco Rocha Photography Alasdair McLellan Styling Olivier Rizzo Hair by Paul Hanlon Make-up by Sally Branka

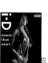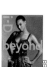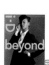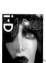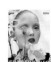

270 **The Happiness Issue** October 2006 Cover Star Angela Lindvall Photography Richard Bush Styling Sarah Richardson Hair by Bok-Hee Make-up by Troy Jensen 269 **The Wealth Issue** September 2006 Cover Star Lindsay Lohan Photography Matt Jones Styling Rachel Zoe Hair by Peter Butler Make-up by Kristofer Buckle 269 **The Wealth Issue** Cover Star Claudia Schiffer Photography Emma Summerton Styling Edward Enninful Hair by Ben Skervin Make-up by Mathias Van Hooff 268 **The Health Issue** August 2006 Cover Star Beyoncé Photography Matt Jones Styling Manna Bunini Hair by Kim Kimble Make-up by Francesca Tolot 267 **The Horror Issue** June/July 2006 Cover Star Snejana Onopka Photography Richard Burbridge Styling Havana Hair by Teddy Charles Make-up by Pat McGrath 266 **The Scratch and Sniff Issue** May 2006 Cover Star Lily Cole Photography Tim Walker Styling Edward Enninful Hair by Eugene Souleiman Make-up by Sam Byran 265 **The Me and Mine Issue** April 2006 Cover Star Patricia Schmid Photography Richard Bush Styling Sarah Richardson Hair by Deigo Da Silva Make-up by Petros Petrohilos 264 **The Upbeat Issue** March 2006 Cover Star Gisele Bündchen Photography Matt Jones Styling Edward Enninful Hair by Martin Cullen Make-up by Aaron De Mey 263 **The Future Issue** February 2006 Cover Star Oscar Photography Alasdair McLellan Styling Thom Murphy Hair by Paul Hanlon

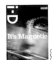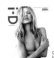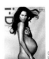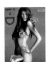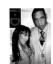

262 **The Skin Issue** January 2006 Cover Star Lily Donaldson Photography Richard Burbridge Styling Edward Enninful Hair by Guido Make-up by Pat McGrath 261 **The Home Issue** December 2005 Cover Star Lady Sovereign Photography Alasdair McLellan Styling Hair by Paul Hanlon Make-up by Sam Byrant 260 **The Faith Issue** November 2005 Cover Star Naomi Watts Photography Ben Watts Styling Beat Bolliger Hair by Bob Recine Make-up by Aaron De Mey 259 **The Nationality Issue** October 2005 Cover Star Gemma Ward Inset Martin Tomlinson and Bea Beast Photography Nick Knight Styling Jonathan Kaye Hair by Sam McKnight Make-up by Val Garland 258 **The Name Issue** September 2005 Cover Star Kate Moss Photography Tesh Styling Edward Enninful Hair by James Brown Make-up by Aaron De Mey 258 **The Name Issue** Cover Star Carolyn Murphy Photography Craig McDean Styling Tabitha Simmons Hair by Orlando Pita Make-up by Tom Pecheux 258 **The Name Issue** Cover Star Dania Photography Inez Lamsweerde and Vinoodh Matadin Styling Hair by Kevin Ryan Make-up by Gucci Westman 258 **The Name Issue** Cover Star Liya Kebede Photography Matt Jones Styling Katie Mossman Hair by Renato Campora Make-up by Gucci Westman 257 **The Signature Issue** August 1997 Cover Star Teairra Mari and Jay-Z Photography Terry Richardson Styling Andre Austin Hair by Tippi Make-up by JJ 256 **The Occupation Issue** July 2005 Cover Star Diana Photography Mario Sorrenti Styling Edward Enninful Hair by Bob Recine Make-up by Linda Cantello

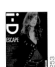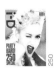

255 **The Declaration Issue** June 2005 Cover Star MIA Photography Wolfgang Tillmans Styling MIA 254 **The Age Issue** May 2005 Cover Star Isabelli Fontana Photography Tesh Styling Edward Enninful Hair by Ben Skervin Make-up by Jeannia Robinette 253 **The Escape Issue** April 2005 Cover Star Isabelle Huppert Photography Paolo Roversi Styling Nicolas Ghesquière Hair by Odile Gilbert Make-up by James Kaliardos 252 **The Feminine Issue** March 2005 Cover Star Ludivine Sagnier Photography Kayt Jones Styling Enka Kunhara Hair by James Rowe Make-up by Natsumi Watanabe 251 **The Masculine Issue** February 2005 Cover Star Jack McElhone Photography Alasdair McLellan Hair by Gareth 250 **The Celebration Issue** December/January 2004/05 Cover Star Gwen Stefani Photography Matt Jones Styling David Lamb Hair by Danilo Make-up by Lisa Butler 249 **The Expressionist Issue** November 2004 Cover Star Sienna Miller Photography Tesh Styling David Lamb Hair by Ben Skervin Make-up by Alex Box 248 **The Unique Issue** October 2004 Cover Star Julia Stegner Photography Tesh Styling Edward Enninful Hair by Ben Skervin Make-up by Lisa Butler 247 **The New Dawn Issue** September 2004 Cover Star Jessica Stam Photography Richard Burbridge Styling Edward Enninful Make-up by Pat McGrath

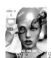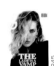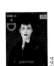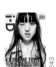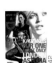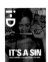

246 **The Subversive Issue** August 1997 Cover Star Angela Lindvall Photography Matt Jones Styling Katie Mossman Make-up by Angie Parker 245 **The After Dark Issue** July 2004 Cover Star Erin Wasson Photography Willy Vanderperre Styling Olivier Rizzo Hair by Luke Hersheson Make-up by Peter Philips 244 **The Passionate Issue** June 2004 Cover Star Missy Rayder Photography Richard Burbridge Styling Edward Enninful Hair by Julien d'Ys Make-up by Pat McGrath 243 **The Drama Queen Issue** May 2004 Cover Star Chiaki Kuriyama Photography Karina Taira Styling Spela Lenarcic Hair by Saburo Watanabe Make-up by Saburo Watanabe 242 **The Location Issue** April 2004 Cover Star Kate Moss Photography Tesh Styling Edward Enninful and Judy Blame Hair by Malcolm Edwards Make-up by Kay Montano 240 **The Progressive Issue** February 2004 Cover Star Eugenia Photography Alasdair McLellan Styling Olivier Rizzo Hair by Luke Hersheson Make-up by Sam Bryant 239 **The Secret Issue** January 2004 Cover Star Victoria Beckham Photography Ellen von Unwerth Styling Edward Enninful and Mark Morrison Hair by Ben Skervin Make-up by Kay Montano 238 **The Lovers Issue** December 2003 Cover Star Naomi Campbell Photography Ellen von Unwerth Styling Mark Morrison Hair by Ellin Lavar Make-up by Alex Babsky 237 **The In Issue** November 2003 Cover Star Kylie Minogue Photography Tesh Styling Edward Enninful Hair by Luke Hersheson Make-up by Karen Alder

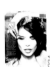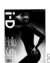

236 **The Insider Issue** October 2003 Cover Star Courtney Love Photography David LaChapelle Styling Patti Wilson Hair by James Brown Make-up by Mally Roncal 235 **The Iconic Issue** September 2003 Cover Star Liya Kebede Photography Tesh Styling Edward Enninful Hair by Sam McKnight Make-up by Lisa Butler 234 **The Straight Up Issue** August 2003 Cover Star Louise Pedersen Photography Ellen von Unwerth Styling Edward Enninful Hair by Sam McKnight Make-up by Kay Montano 233 **The Deat Issue** July 2003 Cover Star Chloé Sevigny and Terry Richardson Photography Terry Richardson Styling Heathermary Jackson Hair by Dennis Lennie Make-up by Romy Soleimani 232 **The Action Issue** June 2003 Cover Star Tilda Swinton Photography Craig McDean Styling Edward Enninful and Jerry Stafford Hair by Sam McKnight Make-up by Lucia Pieroni 231 **The Physical Issue** May 2003 Cover Star Jessica Miller Photography Matt Jones Styling Aleksandra Woroniecka Hair by Thomas Hintermeier Make-up by Kathy La Sant 230 **The Individual Issue** April 2003 Cover Star Kate Moss Photography Mert Alas and Marcus Piggott Styling Edward Enninful Hair by Michael Boadi Make-up by Charlotte Tilbury 229 **The Beach Issue** March 2003 Cover Star Dewi Photography Patrick Demarchelier Styling Havana Laffitte Hair by Michel Aleman Make-up by Dee Dee 228 **The Artistic Issue** February 2003 Cover Star Naomi Campbell Photography Tesh Styling Edward Enninful Hair by Michael Boadi Make-up by Kay Montano 227 **The Ki-Ds Issue** January 2003 Cover Star Shannyn Sossamon Photography Matt Jones Styling Havana Laffitte

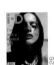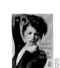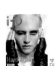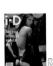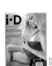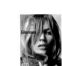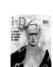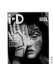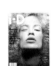

226 **The Cruise Issue** December 2002 Cover Star Christina Ricci Photography Carter Smith Styling Edward Enninful Hair by Neil Moodie Make-up by Gucci Westman 225 **The Emotion Issue** November 2002 Cover Star Liberty Ross Photography Kayt Jones Styling Belen Casadevall Hair by David Mallett Make-up by Regine Bedot 224 **The Substance Issue** October 2002 Cover Star Amber Valetta Photography Craig McDean Styling Edward Enninful Hair by Luigi Murenu Make-up by Pat McGrath 223 **The Graduate Issue** September 2002 Cover Star Jamie Bochert Photography Steven Klein Styling Edward Enninful Hair by Samantha Hair by Diane Kendal 222 **The Independent Issue** August 2002 Cover Star An Oost Photography Steven Klein Styling Brana Wolf Hair by Michael Boadi Make-up by Pat McGrath 221 **The Streaker Issue** June/July 2002 Cover Star Kate Moss Photography Craig McDean Styling Edward Enninful Hair by Guido Make-up by Aaron de Mey 220 **The Spectator Issue** May 2002 Cover Star Natalia Vodianova Photography Steven Klein Styling Edward Enninful Hair by Orlando Pita Make-up by Pat McGrath 219 **The Sitting Issue** April 2002 Cover Star Devon Aoki Photography Paolo Roversi Styling Edward Enninful Hair by Luigi Murenu Make-up by Lucia Pieroni 218 **The Landscape Issue** March 2002 Cover Star Carolyn Murphy Photography Craig McDean Styling Edward Enninful Hair by Luigi Murenu Make-up by Aaron de Mey 217 **The Portrait Issue** February 2002 Cover Star Gisele Bündchen Photography Tesh Styling Edward Enninful Hair by Ayo Laguda Make-up by Aaron de Mey

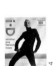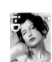

216 **The Together Issue** December/ January 2001/02 Cover Star Liv Tyler Photography Matt Jones Styling Kate Young Hair by Sally Hershberger Make-up by Romy Soleimani 215 **The Memory Issue** November 2001 Cover Star Charlotte Gainsbourg Photography Michel Momy Styling Carol Legrand Hair by Ed Moelands Make-up by Inge Grognard 214 **The Popular Issue** October 2001 Cover Star Bridget Hall Photography Tesh Styling Edward Enninful Hair by Raphael Salley Make-up by Inge Grognard 213 **The Bedroom Issue** September 2001 Cover Star Aaliyah Photography Matt Jones Styling Jason Farrer Hair by Eric Foreman Make-up by Eric Farrell 212 **The 21 Issue** August 2001 Cover Star Eleanora Photography Tesh Styling Edward Enninful Hair by Ayo Laguda Make-up by Inge Grognard 211 **The Man and Beast Issue** July 2000 Cover Stars Tom and John Ford Photography Terry Richardson 210 **The Cinematic Issue** June 2001 Cover Star Laetitia Casta Photography Kayt Jones Styling Genada Kefford Hair by Sebastian Make-up by Liz Pugh 209 **The DNA Issue** May 2001 Cover Star Jolene Reynolds Photography Craig McDean Styling Edward Enninful Hair by Eugene Souleiman Make-up by Pat McGrath 208 **The Gallery Issue** April 2001 Cover Star Stella Tennant Photography Richard Burbridge Styling Edward Enninful Hair by Eugene Souleiman Make-up by Pat McGrath 207 **The Renaissance Issue** March 2001 Cover Star Kate Moss Photography Tesh Styling Edward Enninful Hair by Michael Boadi Make-up by Inge Grognard

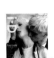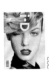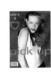

206 **The Inspiration Issue** February 2001 Cover Stars Chloe and Robbie Photography Willy Vanderperre Styling Olivier Rizzo Hair by Peter Philips and Tom Malongre Make-up by Peter Philips 205 **The Bathroom Issue** January 2001 Cover Star Natasha K Photography David Sims Styling Anna Cockburn Hair by Guido Make-up by Siobhan Luckie 204 **The Gift Issue** December 2000 Cover Star Ana Claudia Photography David LaChapelle Styling Patti Wilson Hair by Stacy Ross Make-up by Collier Strong 203 **The White Issue** November 2000 Cover Star Luciana Curtis Photography Kayt Jones Styling Katherine Alexander Hair by Rudi Make-up by Liz Pugh 202 **The Self Issue** October 2000 Cover Star Angela Lindvall Photography Max Vadukul Styling Lucy Pinter Hair by Sam McKnight Make-up by Sharon Dowsett 201 **The Original Issue** September 2000 Cover Star Björk Photography Mert Alas and Marcus Piggott Styling Hair by Michael Boadie Make-up by Alexandra Byrne 200 **The 200 for 2000 Issue** August 2000 Cover Star i-D logo Design Terry Jones 199 **The Heartbeat Issue** July 2000 Cover Star Alek Wek Photography Richard Burbridge Styling Edward Enninful Hair by Eugene Souleiman Make-up by Pat McGrath 198 **The Cruising Issue** June 2000 Cover Star Marleen Photography Matt Jones Styling Jeremy Scott Hair by Jonathan Connelly Make-up by Aaron de Mey 197 **The Aesthetic Issue** May 2000 Cover Star May Anderson Photography Richard Burbridge Styling Edward Enninful Hair by Eugene Souleiman Make-up by Pat McGrath

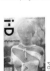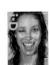

196 **The Hotel Issue** April 2000 Cover Star L'il Kim Photography Steven Klein Styling Patti Wilson Hair by Chuck Amos Make-up by Pat McGrath 195 **The Drenched Issue** March 2000 Cover Star Gisele Bündchen Photography Richard Burbridge Styling Edward Enninful Hair by Nicolas Jurnjack Make-up by Pat McGrath 194 **The Dynamic Issue** January/February 2000 Cover Star Chloé Sevigny Photography Matt Jones Styling Cathy Dixon Hair by Rick Haylor Make-up by Diane Kendall 193 **The Wisdom Issue** December 1999 Cover Star Milla Jovovich Photography Matt Jones Styling Cathy Dixon 192 **The Ideas Issue** November 1999 Cover Star Naomi Campbell Photography David LaChapelle Styling Patti Wilson Hair by Nicolas Jurnjack Make-up by Ayako 191 **The Elevator Issue** October 1999 Cover Star Guinevere Van Seenus Photography Craig McDean 190 **The 1.9.99 Issue** September 1999 Cover Star Christy Turlington Photography Tesh Styling Edward Enninful Hair by Orlando Pita Make-up by Pat McGrath 189 **The Audible Issue** August 1999 Cover Star Oluchi Photography Richard Burbridge Styling Edward Enninful Hair by Orlando Pita Make-up by Pat McGrath 188 **The Romance Issue** July 1999 Cover Star Bridget Hall Photography David Sims Styling Anna Cockburn Hair by Guido and Gary Richardson Make-up by Diane Kendal 187 **The Intrepid Issue** June 1999 Cover Star Lisa Ratcliffe Photography Paolo Roversi Styling Edward Enninful Hair by Stephen Lacey Make-up by Lisa Butler

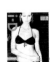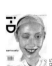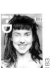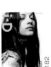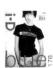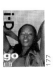

186 **The Skin and Soul Issue** May 1999 Cover Star Heidi Klum Photography Max Vadukul Styling Debbi Mason Hair by Ric Pepino Make-up by Tracie Martyn 185 **The Serious Fashion Issue** April 1999 Cover Star Colette Photography Richard Burbridge Styling Edward Enninful Hair by Eugene Souleiman Make-up by Pat McGrath 184 **The Kinetic Issue** March 1999 Cover Star Amber Valetta Photograph Richard Burbridge Styling Edward Enninful Hair by Eugene Souleiman Make-up by Pat McGrath 183 **The Emergency Issue** January/February 1999 Cover Star Mel C Photography Donald Christie Styling Merryn Leslie Hair by Jennie Roberts Make-up by Karin Darnell 182 **The Cheeky Issue** December 1998 Cover Star Gisele Bündchen Photography David Sims Styling Anna Cockburn Hair by Guido Make-up by Linda Cantello 181 **The Extravagant Issue** November 1998 Cover Star Alissa Bennet Photography Kayt Jones Styling Merryn Leslie Hair by Fernando Torrent Make-up by Nicole Jantz 180 **The Forward Issue** October 1998 Cover Star Shalom Harlow Photography Carter Smith Styling Jane How Hair by Neil Moodie Make-up by Virginia Young 179 **The Adult Issue** September 1998 Cover Star Devon Aoki Photography Ellen von Unwerth Styling Edward Enninful Hair by Bob Recine Make-up by Mary Jane Frost 178 **The Very Blue Issue** August 1998 Cover Star Erin O'Connor Photography Juergen Teller Styling Hair by Eugene Souleiman Make-up by Lucia Peroni 177 **The Global Issue** July 1998 Cover Star Kiara Photography Jamil GS Styling Jason Farrer

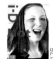 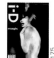 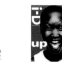 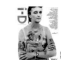 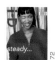 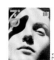 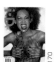

176 **The Urban Issue** June 1998 Cover Star Maggie Rizer Photography Craig McDean Styling Edward Enninful Hair by Orlando Pita Make-up by Jeffrey Lee 175 **The Supernatural Issue** May 1998 Cover Star Kirstin Owen Photography Paolo Roversi Styling Edward Enninful Hair by Eugene Souleiman Make-up by Pat McGrath 174 **The World Class Issue** April 1998 Cover Star Alek Wek Photography Mark Mattock Make-up by Aaron de Mey 173 **The Ego Issue** March 1998 Cover Star La Vera Chapel Photography Donald Graham 172 **The Active Issue** January/February 1997 Cover Star Naomi Campbell Photography Ellie Semotan Styling Edward Enninful Hair by Michael Boadi Make-up by Aaron de Mey 171 **The Outrage Issue** December 1997 Cover Star Laura Foster Photography David Sims Styling Edward Enninful Hair by Guido Make-up by Linda Cantello 170 **The Influential Issue** November 1997 Cover Star Mel B Photography Terry Richardson Styling Patti Wilson Hair by Danilo Make-up by Mathu Andersen 169 **The Killer Issue** October 1997 Cover Star Audrey Photography Juergen Teller Styling Venetia Scott Hair by Ward Make-up by Miranda Joyce 168 **The Next Issue** September 1997 Cover Star Kylie Minogue Photography Mark Mattock Styling Fiona Dallanegra Hair by Malcolm Edwards Make-up by Mary-Jane Frost 167 **The Obsession Issue** August 1997 Cover Star Kate Moss Photography Terry Richardson Hair by Johnnie Sapong Make-up by Francisco Valera

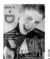 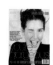 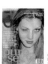

166 **The Clean and Fresh Issue** July 1997 Cover Star Raina Photography Matt Jones Styling Karl Plewka by Zaiya Make-up by Rose-Mary Swift 165 **The Hot Issue** June 1997 Cover Star Susan Carmen Photography Craig McDean Styling Edward Enninful Hair by Eugene Souleiman Make-up by Pat McGrath 164 **The Desirable Issue** May 1997 Cover Star Gaz Coombes Photography Lorenzo Agius Styling Greg Faye and Justin Laurie Hair by Lance Lowe Make-up by Jackie Tyson 163 **The Outlook Issue** April 1997 Cover Star Courtney Love Photography Ellen von Unwerth Styling Wendy Schecter Hair by Ward Make-up by Roz Music 162 **The New Beauty Issue** March 1997 Cover Star Sharleen Spiteri Photography Craig McDean Styling Edward Enninful Hair by Eugene Souleiman Make-up by Pat McGrath 161 **The Next Generation Issue** February 1997 Cover Star Annie Morton Photography Terry Richardson 160 **The Escape Issue** January 1997 Cover Star Kelli Photography Stephane Sednaoui Styling William Baker and Neil Rodgers Hair by Malcolm Edwards Make-up by Sarah Reygate 159 **The Undressed Issue** December 1996 Cover Star Jamie Rishar Photography Matt Jones Styling John Scher Hair by Michael Boadi Make-up by Rose-Marie 158 **The Energised Issue** November 1996 Cover Star Angela Lindvall Photography Juergen Teller 157 **The Capital Issue** October 1996 Cover Star Iris Palmer Photography Max Vadukal

 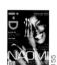 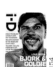 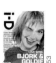 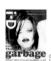 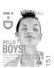 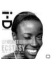

156 **The Pioneer Issue** September 1996 Cover Star Brett Anderson Photography Nick Knight Hair by Jimo Salako Make-up by Wendy Rowe 155 **The High Summer Issue** August 1996 Cover Star Naomi Campbell Photography Paolo Roversi Styling Paul Sinclaire Hair by Eugene Souleiman Make-up by Pat McGrath 154 **The Love Life Issue** July 1996 Cover Star Goldie Photography Lorenzo Agius 154 **The Love Life Issue** Cover Star Björk Photography Lorenzo Agius 153 **The Supernova Issue** June 1996 Cover Star Shirley Manson Photography Ellen von Unwerth Styling Patti WilsonHair by Sabastian Make-up by Susan Stirling 152 **The Sound Issue** May 1996 Cover Star Guinevere Van Seenus Photography Mark Borthwick Styling Jane Howe Hair by Ward Make-up by Kenny Campbell 151 **The Fresh Issue** April 1996 Cover Star Lorraine Pascale Photography Craig McDean Styling Edward Enninful Hair by Eugene Souleiman Make-up by Pat McGrath 150 **The Alternative Issue** March 1996 Cover Star Kristen McMenamy Photography Juergen Teller Styling Edward Enninful Hair by Cathy Lomax Make-up by Cathy Lomax 149 **The Survival Issue** February 1996 Cover Star Kate Moss Photography David Sims Styling Anna Cockburn Hair by Guido Make-up by Miranda Joyce 148 **The Wonderland Issue** January 1996 Cover Star Carolyn Murphy Photography Terry Richardson Styling Edward Enninful Hair by Johnnie Sapong Make-up by Francisco Valera 147 **The Performance Issue** December 1995 Cover Star Stella Tennant Photography Craig McDean Styling Edward Enninful Hair by Eugene Souleiman Make-up by Pat McGrath

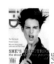 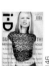 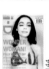 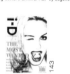 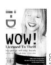 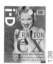

146 **The Real Issue** November 1995 Cover Star Emma Balfour Photography Craig McDean Styling Edward Enninful Hair by Eugene Souleiman Make-up by Pat McGrath 145 **The Fifteenth Birthday Issue** October 1995 Cover Star i-D Logo Design Terry Jones 144 **The Fun and Games Issue** September 1995 Cover Star PJ Harvey Photography Craig McDean 143 **The Most Wanted Issue** August 1995 Cover Star Greta Photography Ellen von Unwerth Styling Patti Wilson Hair by Ward Make-up by Suzanne Stirling 142 **The Boy's Own Issue** July 1995 Cover Star Nadja Auermann Photography Craig McDean Styling Edward Enninful Hair by Eugene Souleiman Make-up by Pat McGrath 141 **The Subversive Issue** June 1995 Cover Star Shalom Harlow Photography Craig McDean Styling Edward Enninful Hair by Eugene Souleiman Make-up by Pat McGrath 140 **The Sharp Issue** May 1995 Cover Star Tank Girl Illustration Jamie Hewlett 139 **The Tough Issue** April 1995 Cover Star Nikki Umbretti Photography Terry Richardson Styling Patti Wilson Hair by Michael Boadi Make-up by Ian Jefferies 138 **The Pin Ups Issue** March 1995 Cover Star Drew Barrymore Photography Ellen von Unwerth Styling Joe McKenna Hair by Ward Make-up by Kay Montano

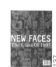 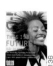 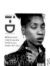 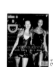 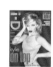 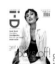 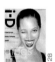

137 **The New Faces Issue** February 1995 Cover Star Class of 1995 Design Terry Jones 136 **The Future Issue** January 1995 Cover Star Kiara Photography Craig McDean Styling Edward Enninful Hair by Michael Boadi Make-up by Pat McGrath 135 **The Saturday Night Issue** December 1994 Cover Star Heather Small Photography Christian Witkin Styling Christine Fortune 134 **The Underground Issue** November 1994 Cover Star Bridget Hall Photography Steven Klein Styling Edward Enninful Hair by Dick Page 133 **The Visionary Issue** October 1994 Cover Star Brett Anderson and Stella Tennant Photography Jean Baptiste Mondino Styling Zoe Bedeaux Hair by Guido Make-up by Pat McGrath 132 **The Street Issue** September 1994 Cover Star Björk Photography Ellen von Unwerth Hair by Ward Make-up by Regine 131 **The Us Issue** August 1994 Cover Star Kate Moss and Naomi Campbell Photography Steven Klein Styling Edward Enninful Hair by Michael Boadi Make-up by Pat McGrath 130 **The Fun Issue** July 1994 Cover Star Kylie Minogue Photography Ellen von Unwerth Styling Cathy Kasterine Hair by Peter Savic Make-up by Lucia Pieroni 129 **The Rock 'n' Roll Issue** June 1994 Cover Star Sonya Aurora-Maden Photography Craig McDean Hair by Eugene Souleiman Make-up by Ellie Wakamatsu 128 **The Drugs Issue** May 1994 Cover Star Christy Turlington Photography Juergen Teller Styling Camilla Nickerson Hair by Thom Priano Make-up by François Nars

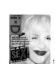 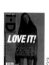 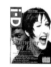

127 **The Sex Issue** April 1994 Cover Star Courtney Love Photography Juergen Teller Make-up by Roz Music 126 **The Network Issue** March 1994 Cover Star Amber Valletta Photography Craig McDean Styling Isabelle Peyrut Hair by Eugene Souleiman Make-up by Pat McGrath 125 **The Talent Issue** February 1994 Cover Star Justine Frischmann Photography Juergen Teller 124 **The Urgent Issue** January 1994 Cover Star Veronica Webb Photography Steven Klein Styling Anna Cockburn Hair by Ednis Nicholls Make-up by James Kaliardos 123 **The Smart Issue** December 1993 Cover Star Kate Moss Photography Corinne Day Styling Cathy Kasterine Hair by James Brown Make-up by Ruth Funnell 122 **The Hard Issue** November 1993 Cover Star Linda Evangelista Photography Juergen Teller Styling Camilla Nickerson Hair by Dick Page Make-up by Dick Page 121 **The New Look Issue** October 1993 Cover Star Tania Court Photography Stefan Ruiz Styling Edward Enninful Hair by Michael Boadi Make-up by Pat McGrath 120 **The Boys and Girls Issue** September 1993 Cover Star Naomi Campbell Photography Jenny Howarth Styling Edward Enninful Hair by Julien d'Ys Make-up by François Nars and Jim Breese 119 **The Festival Issue** August 1993 Cover Star Gillian Gilbert Photography Donald Christie Styling Grant Boston Hair by Michael Boadi Make-up by Pat McGrath 118 **The Open Air Issue** July 1993 Cover Star Karen Ferraii Photography Juergen Teller Styling Venetia Scott Hair by James Brown Make-up by Cathy Lomax

 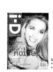 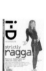

117 **The Beauty Issue** June 1993 Cover Star Kirsten McMenamy Photography Juergen Teller Styling Edward Enninful 116 **The Europe Issue** May 1993 Cover Star Björk Photography Matthew R. Lewis Make-up by Pat McGrath 115 **The Sound Issue** April 1993 Cover Star Sarah Cracknell Photography Matthew R. Lewis 114 **The Comedy Issue** Marcz 1993 Cover Star Jane Horricks Photography Matthew R. Lewis Hair by Dick Page Make-up by Dick Page 113 **The Survival Issue** February 1993 Cover Star Monie Love Photography Simon Fleury Styling Edward Enninful 112 **The Screen Issue** January 1993 Cover Star Sonic the Hedgehog Graphics Sega 111 **The Strength Issue** December 1992 Cover Star Nova Photography Sivan Lewin Hair by Michael Boadi Make-up by Pat McGrath 110 **The Sexuality Issue** November 1992 Cover Star Holly Davis Photography Simon Fleury Styling Edward Enninful Hair by Eugene Souleiman Make-up by Dick Page 109 **The New Season Issue** October 1992 Cover Star Cecilia Chancellor Photography Simon Fleury Styling Edward Enninful Hair by Eugene Souleiman Make-up by Jackie Hamilton-Smith 108 **The Parade Issue** September 1992 Cover Star Nora Kryst Photography Eddie Monsoon

 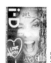 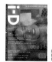 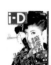

107 **The Artist Issue** August 1992 Cover Star Beatrice Dalle Photography Craig McDean Hair by Eugene Souleiman Make-up by Sharon Ives 106 **The Destination Issue** July 1992 Cover Star Sarah Wietzel Photography Nick Knight Styling Edward Enninful 105 **The Olympic Issue** June 1992 Cover Star Kathy Read Photography Craig McDean Styling Edward Enninful Hair by Hina Dohi Make-up by Kevin Ryan 104 **The Glamour Issue** May 1992 Cover Star Helena Christensen Photography Henrik Bulow Styling Johan Brun and Andrew Coombs Hair by Kirsten Weis Make-up by Kirsten Weis 103 **The Activation Issue** April 1992 Cover Star N'Dea Davenport Photography Nick Knight Styling Zoe Bedeaux Hair by Ellie Wakamatsu 102 **The Technology Issue** March 1992 Cover Star Lorella and Tatiana Photography Takashi Homma Styling Romeo Gigli 101 **The Performance Issue** February 1992 Cover Star Christie Photography Simon Martin Styling Edward Enninful Hair by Michael Boadi Make-up by Cathy Lomax 100 **The Positive Issue** January 1992 Cover Star Neneh Cherry Photography Jenny Howarth Bulling By Mark Lebon Make-up by Cathy Lomax 099 **The International Issue** December 1991 Cover Star Zoe Video Image Terry Jones Styling Johan Brun

 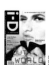 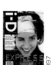 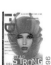 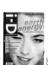 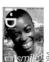

098 **The Hyper Real Issue** November 1991 Cover Star Sandra Bernhard Photography Michel Comte 097 **The Identity Issue** October 1991 Cover Star Rozalla Photography Hugh Stewart 096 **The Fundamental Issue** September 1991 Cover Star Michelle Geddes Photography Eddie Monsoon Styling Judy Blame Make-up by Lynne Easton 095 **The One World Issue** August 1991 Cover Star Elaine Irwin Photograph Mark Lebon 094 **The High Summer Issue** July 1991 Cover Star Lorraine Pascale Photography Hugh Stewart 093 **The Travel Issue** June 1991 Cover Star Adeva Photography Andrew Macpherson 092 **The Visionary Issue** May 1991 Cover Star Sister Souljah Photography Renee Valarie Cox 091 **The News Issue** April 1991 Cover Star Moni Photography Derek Ridgers Hair and Make-up by Jalle Bakke

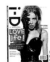 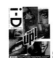 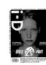

090 **The Love Life Issue** March 1991 Cover Star Kylie Minogue Photography Robert Erdmann Make-up by Charlie Green 089 **The Communication Issue** February 1991 Cover Star Michelle le Gare Photography Mark Lebon 088 **The Pioneer Issue** January 1991 Cover Star Sophie Okonedo Photography Xajer Guardians Styling Camilla Nickerson Hair by Darren Stone Make-up by Carol Brown 087 **The Action Issue** December 1990 Cover Star Aure Atika Photography Nigel Shafran Styling Melanie Ward 086 **The Born Again Issue** November 1990 Cover Star Mica Paris Photography Craig MacDean Styling Zoe Bedeaux Hair by Ken O'Rourke Make-up by Michi Nakao 085 **The Get Smart Issue** October 1990 Cover Star Lady Miss Keir Photography Nick Knight Styling Hair by Kevin Ryan Make-up by Lesley Chilkes 084 **The Birthday Issue** September 1990 Cover Stars Tasmin and Kerry Shaw Photography Nick Knight Hair by Colin Paul 083 **The Paradise Issue** August 1990 Cover Star Christy Turlington Photography Andrew MacPherson 082 **The Anarchy Issue** July 1990 Cover Star Kirstin Owen Photography Paolo Roversi 081 **The Life and Soul Issue** June 1990 Cover Star Jas Photography Brett Dee

 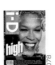 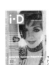

080 **The Dangerous Issue** May 1990 Cover Star Marni Photography Jean Baptiste Mondino Styling Judy Blame Hair by Mark Lopez Make-up by Christophe 079 **The Chaos Issue** April 1990 Photography Nick Knight 078 **The High Spirits Issue** March 1990 Cover Star Victoria Wilson James Photography Mark Lebon Hair by Lance Make-up by Jackie Hamilton-Smith 077 **The Good Health Issue** January/February 1990 Cover Star Billie Photography Mark Lebon Styling Anne Witchard Hair by Lance Make-up by Sharon Black 076 **The Into the Future Issue** December 1989 Cover Star Queen B Photography Imperial Eye 075 **The Fantasy Issue** November 1989 Cover Star Judith Photography Kevin Davies Styling Caryn Franklin Hair by Adam Bryant Make-up by Dick Page 074 **The Politics Issue** October 1989 Cover Star Liza Minelli Photography Mark Lebon 073 **The Energy Issue** September 1989 Cover Star Diana Brown Photography Normski Hair by Kevin Ryan Make-up by Erica 072 **The Raw Issue** August 1989 Cover Star Pam Hogg Photography Kevin Davies Make-up by Sarah Gregory 071 **The Pure Issue** July 1981 Cover Star Kayla Photography Angus Ross Styling Jane How Make-up by Frances Prescott

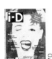 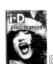 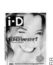 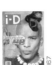 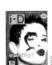 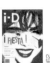

070 **The Loud Issue** June 1989 Cover Star Drena Photography Eddie Monsoon Hair by Ciona Make-up by Ciona 069 **The Rich Issue** May 1989 Cover Star Dominique Photography Eddie Monsoon Styling Nikos Hair by Kevin Ryan Make-up by Lawrence Close 068 **The Power Issue** April 1989 Cover Star Charlotte Photography Nick Knight 067 **The Secrets Issue** March 1989 Cover Star Kathleen Photography Phillip Sinden Styling Beth Summers Hair by Kevin Ryan Make-up by Jackie 066 **The Earth Issue** January/February 1989 Cover Star Lisa Stansfield Photography Phil Inkelberghe Styling Roland Mouret Hair by and Make-up by Jalle Bakke 065 **The Love Issue** December 1999 Cover Star Claudia Photography Eddie Monsoon Hair by Vanessa Kark Make-up by Vanessa Kark 064 **The Trash Issue** November 1988 Cover Star Camilla Photography Guido Hildebrand Styling Camilla Thulin 063 **The Heroes and Sheroes Issue** October 1988 Cover Star Shero Photography 062 **The Party Party Issue** September 1988 Cover Star Jade Photography Mark Lebon Hair by Fiona Make-up by Fiona 061 **The Adventure Issue** August 1988 Cover Star Cleopatra Jones Photography Norman Watson Hair by Eugene Souleiman Make-up by Vanessa Kark

 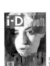 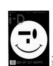 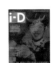

060 **The Graduation Issue** July 1988 Creative Direction Terry Jones 059 **The Body Issue** June 1988 Cover Star Karen Photography Wayne Stambler Styling Malcolm Beckford Hair by Jalle Bakke Make-up by Jalle Bakke 058 **The Revolution Issue** May 1988 Cover Star Wendy James Photography Wayne Stambler Styling Malcolm Beckford Hair by Jalle Bakke 057 **The Surreal Issue** April 1988 Design Judy Blame 056 **The Tribal Issue** March 1988 Cover Star Silvia Ross Photography Willy Biondani Styling Lica, Carla and Cric Hair by Joao Luis Make-up by Fabio 055 **The Worldwide Issue** February 1988 Cover Star Lucy Photography 054 **The Happy Issue** January/December 1987/88 Cover Star Smiley Face Logo Creative Direction Terry Jones 053 **The Fear Issue** November 1987 Cover Star Manko Photography Kevin Davies Styling Caryn Franklin Hair and Make-up by Beverley Pond Jones 052 **The New Brit Issue** October 1987 Cover Star Alice Walpole Photography Mark Lebon 051 **The Boy's Own Issue** September 1987 Cover Star Rachel Weisz Photography Kevin Davies Styling Caryn Franklin Hair by Wakamatsu Make-up by Lance

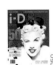 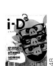 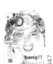 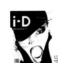 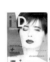 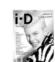 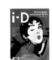 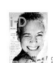

050 **The Holiday Issue** August 1987 Cover Star Sarah Stockbridge Photography Nick Knight Styling Simon Foxton Hair and Make-up by David Grainger 049 **The Film Issue** July 1987 Cover Star Elizabeth Westwood Photography Nick Knight Hair and Make-up by David Grainger 048 **The Plain English Issue** June 1987 Cover Star Leigh Bowery Photography Johnny Rozsa Styling Clive Ross 047 **The Good Sport Issue** May 1987 Cover Star Tess Photography Nick Knight Styling Simon Foxton Hair by Kevin Ryan Make-up by David Grainger 046 **The Pop Issue** April 1987 Cover Star Grace Jones Photography Nick Knight Styling Andy Knight 045 **The Metropolitan Issue** March 1987 Cover Star Isabella Rossellini Photography Fabrizio Ferri 044 **The Flirt Issue** February 1987 Cover Star Paula Thomas Photography Jamie Long Styling Robert Leech Hair by Tim Crespin Make-up by Fiona Moore 043 **The Comic Issue** January/December 1986/87 Cover Star Mickey Photography Robert Erdmann Styling Caroline Baker Hair by Hair Raisers Make-up by Carol Langridge 042 **The Beauty Issue** November 1986 Cover Star Angie Hill Photography Nick Knight 041 **The Media Issue** October 1986 Cover Star Muriel Gray Photography Nick Knight Styling Simon Foxton Make-up by Lynn Easton

 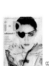 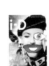

040 **The Education Issue** September 1986 Cover Star Amanda King Photography Nick Knight Styling Simon Foxton Hair by Kevin Ryan Make-up by Frances Hathaway 039 **The Dramatic Issue** August 1986 Cover Star Naomi Photography Robert Erdmann Styling Caryn Franklin Hair by Thomas Make-up by Voyski 038 **The Photographic Issue** July 1986 Cover Star Ann Scott Photography Nick Knight Styling Simon Foxton Hair by Anne Matthews Make-up by Regina 037 **The Conservation Issue** June 1986 Cover Star June Montana Photography Robert Erdmann Styling Caroline Baker Hair by Guido Make-up by Frances Hathaway 036 **The Magic Issue** May 1986 Cover Star Alice Temple Photography Nick Knight Styling Simon Foxton Hair by Kevin Ryan Make-up by Sarah Matheson 035 **The Dance Issue** April 1986 Cover Star Akure Photography Robert Erdmann Styling Caroline Baker Hair by Guido Make-up by Frances Hathaway 034 **The Madness Issue** March 1986 Cover Star Scarlett and Judy Blame Photography Mark Lebon Styling Judy Blame Hair and Make-up by Ross 033 **The Cool Issue** February 1986 Cover Star Corinne Drewery Photography Nick Knight Styling Helen Campbell Hair by Paul Kennington Make-up by Fiona Moore 032 **The Jet Set Issue** January/December 1985/86 Cover Star Kate Photography Nick Knight Styling Simon Foxton Hair by Anne Matthews Make-up by Sarah Matheson 031 **The Spectator Issue** November 1985 Cover Star Blair Booth Photography Eamonn McGabe Styling Hair by Helen Frampton Make-up by Timothy Metz

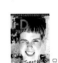 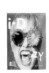 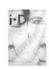 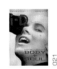

030 **The Grown Up Issue** October 1985 Cover Star Jenny Howarth Photography Mark Lebon 029 **The Health and Efficiency Issue** September 1985 Cover Star Caryl Dolores Photography Nick Knight Styling Paul Fraser Hair by and Make-up by William Faulkner 028 **The Art Issue** August 1985 Cover Star Lizzy Tear Photography Nick Knight Styling Hair and Make-up by William Faulkner 027 **The Live In Issue** July 1985 Cover Star Kathy Kanada Photography Robert Erdmann Styling Caroline Baker Hair by and Make-up by Kay Montano 026 **The Laidback Issue** June 1985 Cover Star Elissa Karin Photography Martin Brading Styling Caroline Baker 025 **The Red Hot Issue** May 1985 Cover Star Patsy Kensit Photography Mark Lebon Styling Caroline Baker Hair and Make-up by William Faulkner 024 **The Flesh and Blood Issue** April 1985 Cover Star Katie Westbrook Photography Nick Knight Styling Helen Campbell Hair by Jackie Make-up by Tracie Martyn 023 **The i-Spy Issue** March 1985 Cover Star Carol Thompson Photography Eamonn McGabe Styling Carol Thompson 022 **The Gourmet Issue** February 1985 Cover Stars Helen Campbell and Jane Colvin Photography Nick Knight Hair by Anne Matthews Make-up by Lyn Easton 021 **The Body and Soul Issue** January/December 1984/85 Cover Star Mary Emma Photography Mano Testino

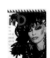 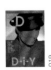 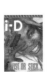 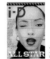

020 **The Fun and Games Issue** November 1984 Cover Star Jane Khan Photography Monica Curtain 019 **The Inside Out Issue** October 1984 Cover Star Anne Pigalle Photography Nick Knight 018 **The Money Issue** September 1984 Cover Star Sherron Photography Nick Knight Make-up by Paul Gobel 017 **The Language Issue** July/August 1984 Cover Star Jo Kelly Photography Mark Lebon Styling Mitzi Lorenz Hair by Kay Montano Make-up by James Cuts 016 **The e=mc2 Issue** June 1984 Cover Star Sophie Hicks Photography David Bailey 015 **The Sexsense Issue** May 1984 Cover Star Madonna Photography Mark Lebon 014 **The All Star Issue** April 1983 Cover Star Sade Photography Nick Knight 013 **The Wet 'n' Wild Issue** March 1983 Cover Star L A Photography Steve Johnston 012 **The Love and Romance Issue** February 1983 Cover Star Sophie Photography James Palmer 011 **The Health and Herpes Issue** January 1983 Cover Star Fiona Skinner Photography Steve Johnston

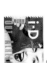

010 **The Out Already Issue** December 1982 Cover Star Moira Bogue Photography Steve Johnston 009 **The Wild Dancing Issue** November 1982 Cover Star Photography Terry Jones 008 **The Head to Toe Issue** October 1982 Cover Star Scarlett Photography Thomas Degen and Terry Jones 007 **The In Future Issue** September 1982 Cover Star Photography James Palmer 006 **The Sweat is Best Issue** August 1981 Cover Star Photography Thomas Degen 005 **The Do it Yourself Issue** July 1981 Photography Thomas Degen 004 **The Dance and Stance Issue** April 1981 Creative Direction Terry Jones 003 **The i-Dye Issue** January 1981 Creative Direction Terry Jones 002 **The Star Issue** November 1980 Creative Direction Terry Jones 001 **The i-D One Issue** August 1980 Creative Direction Terry Jones

CONCLUSION

I have to dedicate this book firstly to my family — Tricia my beautiful life partner and my mother who died in a psychiatric hospital in Lancashire. I would never have entered art school without her. My unknown father who, Kayt discovered, had lived, gambled and won before dying in Las Vegas. Magnetically, Kayt, Matt and I have been drawn to Vegas with its trash aesthetic set in the middle of a beautiful desert landscape - the church of excess surrounded by God-created genius.

In 1980 Kayt was seven and Matt was four. Photographers had stayed in our house since they were born, but we never guessed then that both would choose photographic careers. Today they are major contributors to i-D. For years they have been my sounding board and I have grown to listen and learn from their viewpoint. Both are now i-D editors in LA and New York respectively and they have produced many successful covers between them.

It was only when I was reading Matt's words about his first cover that I remember how young he was when he went to live in New York. He's inherited Tricia's charm and straight-forward view point and 'life's short so enjoy it' attitude together with my bad taste, tongue in cheek irreverence. Maybe he knew that I was always trying to get a cheeky 'flash' onto a cover at Vogue without success — no nipples allowed. Kayt's brilliant Goddess cover for Winter '09 had Helena, Claudia and Eva all agree to go nude together for i-D. Her personal sensibility of contemporary sexy is always full of energy, fun and cinematic sex appeal with a great celebration of what it is to be a modern woman.

My huge thanks also must go to Edward Enninful who joined i-D as a teenager aged 18 — later becoming our youngest ever Fashion Director who today splits his time and inspiration between i-D and US and Italian 'Vogue'. Edward's talent and respect within the fashion industry has to be quite unparalleled for someone still so young.

The i-D family embraces friends, and friends of friends. It has grown internationally and continues with contributors connecting together like a growing web of spider threads. When the idea to make a covers book came into my mind while we were touring the i-Dentity exhibition in 2006, I told Tricia it would take no time — three months — it would be simple…. Matt Hawker rapidly pulled a dummy together, 300 full page covers. Easy! Then four years later I started writing my rambling notebook musings on 1st January 2010 and everything changed. How fortunate and serendipitous it was to persuade and engage Richard Buckley to edit and make sense of my randomness. Tricia and her never ending support kept the whole project on track and Dominique Fenn had the monumental task of collating and chasing while dealing with all the other day to day stuff that hits her and our in trays every day when the computer is switched on. Kate Law who has worked with me from clubber to mother put in the hours collaborating on the design with its numerous permutations and pagination reshuffles while intern helpers transcribed endless conversations, sometimes with a background of live music or crashing kitchen sounds. Rebecca Coleman had to be particularly stoic though hopefully her reward was highly educational.

Secondly, thanks has to go to everyone; every editor, stylist, photographer, model, writer, artist and intern who are too numerous to mention (always the danger that many names may not be remembered). The teams and creative communities that continue to put their energy into the concept of i-D have no price. That energy cannot be bought; i-D's heritage is their energy.

Love forever, TJ

With a very special thanks to all the sponsors without who's support, this project wouldn't have been possible.

Edited by
Terry Jones and Edward Enninful

Guest Editor
Richard Buckley

Design
Kate Law

Managing Editor/Assistant to Terry Jones
Dominique Fenn

Design Assistance
Jocelyn Lloyd

Editorial
Tricia Jones
Ben Reardon
Holly Shackleton

Project Assistance
Rebecca Coleman
Hazel Ong
Hanna Kelifa
Clare Cartwright

Terry Jones, i-D Founder

Terry Jones, born in 1945 in Northampton, England, is the Editor-In-Chief, Creative Director and Publisher of i-D. He studied graphics at the West of England College of Art in Bristol but left when a favourite tutor (Richard Hollis) resigned. Terry married Tricia in 1968, later becoming the father of two children, Kayt and Matt, who are now professional photographers themselves. For more than 30 years Terry has established himself as one of the most experimental creative directors of his generation, from the covers of 'Vanity Fair' and 'Vogue', where he was art director from 1972-77, to the innovative designs of i-D magazine, which he founded in 1980. The first issue of i-D was created at his home studio and published in the form of a hand-stapled fanzine with text produced on an IBM golfball typewriter. He has also edited and art directed numerous books including 'Catching the Moment', and 'Smile i-D' and curated many international exhibitions and advertising campaigns. With a personal approach to art direction he often refers to as 'controlled chaos', Terry continues to discover and nurture creative collaborations with photographers, writers, stylists and graphic designers. After thirty years in print, Terry's enthusiasm is unfailing and his energetic artistic vision continues to inspire.
i-Donline.com
Photography Peggy Sirota

Edward Enninful, Fashion Director

Edward Enninful was born in Ghana and moved to London with his family as a young child. Possessing a natural flair for fashion, he was spotted on the tube, aged 16, by Nick Knight who consequently asked him to model for i-D. 1991, Edward was appointed Fashion Director of i-D, becoming the youngest ever Fashion Director of an international magazine. Today Enninful's time is shared between i-D, Italian and American 'Vogue'. His fashion campaigns have included Versace, Armani, Christian Dior, Mulberry and Lanvin. Edward has worked on a staggering number of i-D covers, the first of which was singer Rozalla shot by Hugh Stewart for The Identity Issue in October 1991. One of Edward's most memorable covers was of Kristen McMenamy [The Alternative Issue, No. 150, March 1996] at a studio in North London. "We didn't have any clothes," Edward recalls, "so I drew a love heart on Kristen's chest that said Versace, because Versace had just cancelled her from the couture shows" Enninful has worked with photographers including Craig McDean, Steven Meisel, Steven Klein, Mario Sorrenti, Juergen Teller, Terry Richardson, Alasdair McLellan, Emma Summerton and Richard Burbridge and has a close working relationship and friendship with i-D Beauty Director Pat McGrath, Kate Moss and Naomi Campbell who he continues to work with on a regular basis.
Photography Emma Summerton

Richard Buckley, Writer

Born in New York in 1948, Richard grew up in Germany, Taiwan, France and various western states of the USA.
After receiving a BA at the University of Maryland, where he also did post-graduate work in film and photography, his first job as a journalist was with New York Magazine in 1979. In 1980, Richard became associate fashion editor for Daily News Record and in 1983 was named that publication's european editor and moved to Paris. He returned to New York in 1986 as fashion editor of 'WWD' and editor of 'Scene' magazine. Other magazines Richard has contributed to include 'Dutch', 'Vogue Italia', 'Mirabella', 'Vanity Fair', 'House & Garden' and 'W'. He was Editor-in-Chief of 'Vogue Hommes International' between 1999 and 2005. He now divides his time between London and Los Angeles, where he looks after his two smooth fox terriers Angus and India.
Photography Terry Jones

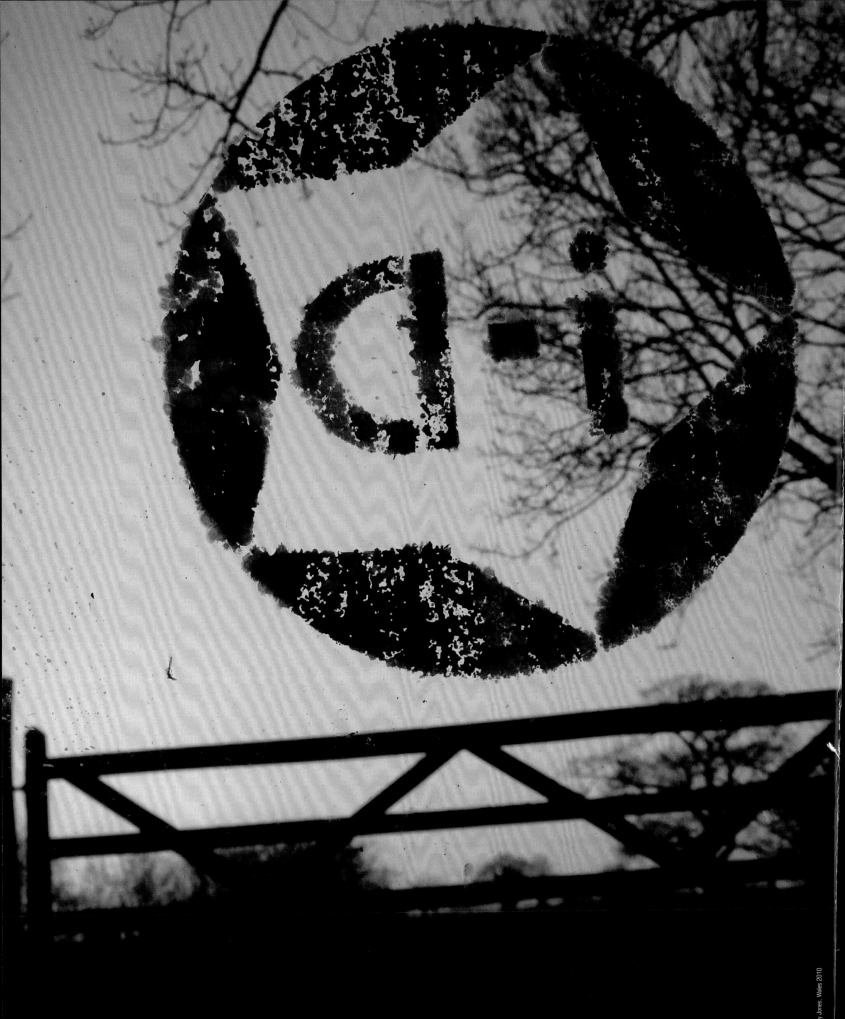